Fernand LÉGER

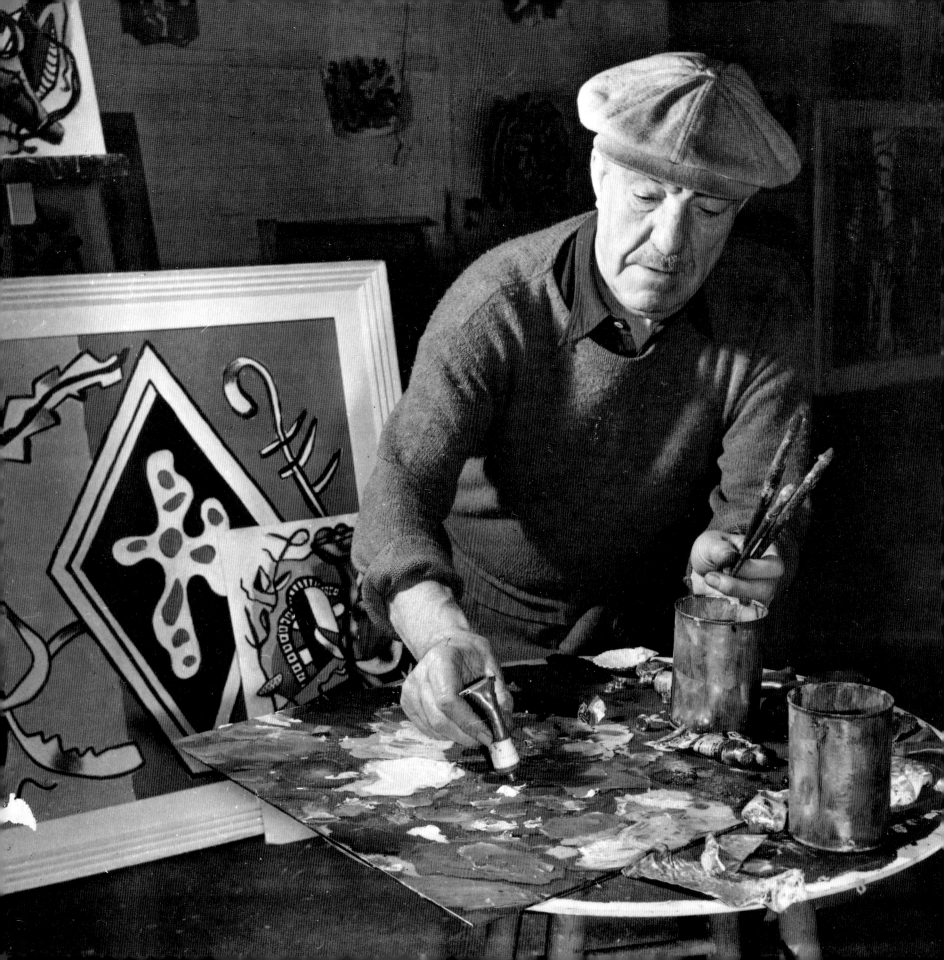

Fernand LÉGER

CAROLYN LANCHNER

With essays by

Carolyn Lanchner, Jodi Hauptman, and Matthew Affron

and contributions by

Beth Handler and Kristen Erickson

THE MUSEUM OF MODERN ART, NEW YORK

PUBLISHED IN CONJUNCTION WITH THE EXHIBITION
Fernand Léger, **at The Museum of Modern Art, New York,**
FEBRUARY 15–MAY 12, 1998, ORGANIZED BY CAROLYN LANCHNER,
CURATOR, DEPARTMENT OF PAINTING AND SCULPTURE

**This exhibition is made possible by a generous grant
from an anonymous donor**

ADDITIONAL SUPPORT FOR THE EXHIBITION IS PROVIDED BY THE
**Lily Auchincloss Foundation, Inc., and the
Estate of Mr. and Mrs. Edmund J. Kahn**

AN INDEMNITY FOR THE EXHIBITION HAS BEEN GRANTED BY THE
Federal Council on the Arts and the Humanities

THIS PUBLICATION IS MADE POSSIBLE BY A GENEROUS GRANT FROM THE
Blanchette Hooker Rockefeller Fund

PRODUCED BY THE DEPARTMENT OF PUBLICATIONS
THE MUSEUM OF MODERN ART, NEW YORK

EDITED BY DAVID FRANKEL
DESIGNED BY STEVEN SCHOENFELDER
PRODUCTION BY MARC SAPIR
PRINTED AND BOUND BY AMILCARE PIZZI S.p.A., MILAN

LIBRARY OF CONGRESS CATALOGUE CARD NUMBER: 97-075510
ISBN 0-87070-052-9 (CLOTHBOUND, MoMA/THAMES AND HUDSON)
ISBN 0-87070-053-7 (PAPERBOUND, MoMA)
ISBN 0-8109-6185-7 (CLOTHBOUND, ABRAMS)

Published by The Museum of Modern Art
11 WEST 53 STREET, NEW YORK, NEW YORK 10019
CLOTHBOUND EDITION DISTRIBUTED IN THE UNITED STATES AND CANADA
BY HARRY N. ABRAMS, INC., NEW YORK
CLOTHBOUND EDITION DISTRIBUTED OUTSIDE THE U.S. AND CANADA
BY THAMES AND HUDSON, LTD., LONDON

Cover:
FERNAND LÉGER. *Adieu New York* (GOOD-BYE NEW YORK), 1946 (DETAIL).
OIL ON CANVAS, $51\frac{3}{16} \times 63\frac{3}{4}''$ (130×162 CM).
MUSÉE NATIONAL D'ART MODERNE–CENTRE DE CRÉATION INDUSTRIELLE,
CENTRE GEORGES POMPIDOU, PARIS.
GIFT OF THE ARTIST, 1950. SEE PLATE ON P. 245

Frontispiece:
LÉGER IN HIS NEW YORK STUDIO, C. 1944–45.
PHOTOGRAPH: BY AND COURTESY LILLY JOSS

PRINTED IN ITALY

Contents

Foreword

This volume is published on the occasion of the retrospective exhibition *Fernand Léger*, held to honor one of the century's greatest artists. In addition to celebrating Léger's achievement, the exhibition extends a long tradition of the exhibition program at The Museum of Modern Art: to offer for comprehensive examination and reassessment works by major individual artists of the modern period. In 1935, when this Museum held its first Léger retrospective, the only other living European painters to whom the institution had yet devoted a monographic exhibition were Paul Klee and Henri Matisse. By 1953, when the Museum held a second Léger exhibition, the artist had won relatively wide recognition; yet that retrospective was the last such in New York. The present exhibition is intended as a long-overdue opportunity to reevaluate Léger's work in all its complexity and depth. One of the strongest and most vivid personalities of his era, Léger was the only major painter of his generation to take modernity itself as his subject, and as the century he represented draws to its close, a reexamination of his career seems especially timely.

No project of this scale can be realized without the generosity and cooperation of many people and institutions. We have been very fortunate in the support we have received, and are deeply grateful to all who have assisted us. Our thanks to the exhibition's many lenders, and to others who have contributed to its realization, are expressed elsewhere in this volume. We must acknowledge a special debt, however, to our colleagues at the Musée national d'art moderne–Centre de création industrielle, Centre Georges Pompidou, Paris, and in particular to Germain Viatte, its former director, and Werner Spies, its present director, as well as to Isabelle Monod-Fontaine and Claude Laugier. We also wish to express our appreciation of a gratifying collaboration with José Guirao, Director, and Marta González of the Museo Nacional Centro de Arte Reina Sofía, Madrid.

Thanks should also be extended to the staff of The Museum of Modern Art, almost all of whom contribute in some degree to an endeavor of this scale. Foremost among them is Carolyn Lanchner, Curator in the Department of Painting and Sculpture, and Director of the exhibition. Last year Carolyn celebrated her thirtieth anniversary on the Museum staff; her achievement on the present occasion is a noble addition to her long series of accomplishments here.

The scope and complexity of this retrospective and accompanying publication necessarily entail high costs. We are deeply grateful to the anonymous donor whose grant made the exhibition possible, to the Lily Auchincloss Foundation, Inc., and the Estate of Mr. and Mrs. Edmund J. Kahn, and to the trustees of the Blanchette Hooker Rockefeller Fund for their support of the publication. Finally, the exhibition would not have been possible without the indemnity received from the Federal Council on the Arts and the Humanities.

—Glenn D. Lowry
Director, The Museum of Modern Art

Preface and Acknowledgments

A principal aim of the exhibition that this publication accompanies is to provide an American audience with its first opportunity in over forty years to assess the work of Fernand Léger, one of the founders of twentieth-century modernism. The subject of numerous exhibitions in Europe since his death in 1955, Léger has received relatively little attention during the same period in this country. Since the exhibition organized in 1953 by The Art Institute of Chicago, which was also seen at the San Francisco Museum of Art and The Museum of Modern Art in New York, the only attempt at a full-scale survey in America was the excellent but necessarily limited retrospective held at the Albright-Knox Art Gallery, Buffalo, in 1982.

The need for the present exhibition has been revealed by more than the passing of time. Several specialized exhibitions—the Solomon R. Guggenheim Museum's *Fernand Léger: Five Themes and Variations*, 1962, which centered on the artist's last great masterpiece, *La Grande Parade*; the Whitechapel Art Gallery's *Fernand Léger: The Later Years*, 1987, focusing on work created after 1932; and the exhibition *Fernand Léger 1911–1924: The Rhythm of Modern Life*, 1994, shown at the Kunstmuseum Basel and Kunstmuseum Wolfsburg—have cumulatively contributed to an appreciation of Léger as a richer and more complex artist than either the public or many art historians generally realized. This exhibition and publication, therefore, seek to provide an account of Léger's art that will enlarge our understanding of its depth, scope, and enduring relevance.

The exhibition's main focus is Léger's paintings. Some sixty examples are included, among them many acknowledged as his greatest but also some less-known works that have been shown infrequently. In every case, however, the criteria have been to select paintings of the highest quality that, taken together, will represent every important phase of the artist's career. Space limitations have precluded a comprehensive report of Léger's activities as a draftsman, a subject itself deserving of an exhibition; accordingly, the selection of drawings has been restricted to those done in black and white and relating closely to paintings in the exhibition. Léger was also deeply interested in film, theater, and architectural collaborations; although practical constraints prevent an overview of his explorations of these areas, they are represented by objects already in the collections of the Museum's various curatorial departments.

As we wish the exhibition to demonstrate the fullness of Léger's achievement, we have likewise intended the three essays that follow as contributions to a more broadly based interpretation and contextualization of Léger as artist, human being, and powerful presence in the ongoing practice of art. Matthew Affron's essay examines the unfolding of Léger's career through the artist's attempts to grapple with the fundamental paradoxes of his endeavor: to make easel painting express the modernity of an industrialized age; to reconcile an abstract style with subjects of contemporary significance; and to use modernism as a vehicle of populist cultural politics. Jodi

Hauptman takes the city from the early part of this century to its closing years as the paradigm for an investigation of Léger's expressive strategies set against the attempts of selected contemporary artists to deal with the urban environment. My own essay traces the establishment of Léger's reputation in America and examines the country's significance to him in terms of exposure, patronage, and cultural and artistic interaction. It is hoped that these essays will complement the experience of seeing the paintings themselves, whose surfaces will always offer new possibilities.

An exhibition of this ambition owes its existence to the assistance and collaboration of a great many individuals and institutions. For the most part we have been very fortunate in the extraordinarily generous help we have received. Our most fundamental debt is to the lenders, public and private, without whom this exhibition could not have taken place. Those who have allowed us to publish their names are listed in the Lenders to the Exhibition, printed elsewhere in this publication. Here, however, we want to add our profound thanks for their indispensable contribution to this project.

The exhibition was organized in collaboration with the Musée national d'art moderne–Centre de création industrielle, Centre Georges Pompidou, Paris, and it has, as always, been a pleasure and privilege to work with our Paris colleagues. We are indebted to Germain Viatte, the former Director of the Musée national d'art moderne, and Werner Spies, its present Director, for their goodwill and support. Isabelle Monod-Fontaine and Claude Laugier, co-organizers of the Léger exhibition held at the Pompidou in the summer of 1997, were generous without reserve in sharing their expertise with us. We have benefited immeasurably from their impeccable professionalism and unfailing courtesy. We owe special thanks to Martine Silie for her efficient management of the often difficult logistics associated with our joint endeavor, and to Delphine Davenier and the very skillful and always attentive Liliane Decaen for related matters. We are also indebted to Christian Derouet, a longtime scholar of Léger's work, who was responsible for the Centre Pompidou's catalogue. Of the masses of archival material he had assembled, he allowed us access to documentation of critical importance to our research.

The version of the exhibition shown at the Centre Pompidou was seen last fall at the Museo Nacional Centro de Arte Reina Sofía, Madrid, and was the occasion for renewed cooperation between our institutions. We are grateful to José Guirao, Director, and Marta González, Conservadora–Jefe de Exposiciones Temporales, for the understanding they have brought to all our negotiations.

Many museums have made uncommon concessions so that crucial works could be included in the exhibition. Not for the first time, we owe special gratitude to the Philadelphia Museum of Art and Anne d'Harnoncourt, Ann Temkin, and Suzanne Penn. Serge Lemoine, Director of the Musée de Grenoble, and Dieter Schwarz, Director of the Kunstmuseum Winterthur, demonstrated a faith in this project that merits our particular appreciation. Other museum directors and curators to whom special thanks are due include, at the Kunstmuseum Basel, Katharina Schmidt; at the Musée national Fernand Léger, Biot, Brigitte Hedel-Samson and Nelly Maillard; at The Art Institute of Chicago, Madeleine Grynsztejn, former Curator of Twentieth Century Painting and

Sculpture, and Daniel Schulman; at the Kunstsammlung Nordrhein-Westfalen, Düsseldorf, Armin Zweite, Volkmar Essers, and Brigid Pudney-Schmidt; at the Scottish National Gallery of Modern Art, Edinburgh, Richard Calvocoressi, Patrick Elliot, and Keith Hartley; at the Tate Gallery, London, Nicholas Serota and Monique Beudert; at The Metropolitan Museum of Art, New York, William S. Lieberman and Ida Balboul; at the Musée d'Art Moderne de la Ville de Paris, Suzanne Pagé and Jacqueline Munck; at the Staatsgalerie Stuttgart, Ulrike Gauss and Karin Frank von Maur; at the Museé d'art moderne de la Communauté Urbaine de Lille, Villeneuve d'Ascq, Joëlle Pijaudier-Cabot and Savine Faupin; at the Hirshhorn Museum and Sculpture Garden, Smithsonian Institution, Washington, D.C., Neal Benezra and Phyllis Rosenzweig; and at the Kunsthaus Zürich, Christian Klemm.

Of all our private lenders, I must single out for special recognition the contribution of Maurice Jardot, distinguished Léger expert, collector, and longtime friend of the artist and this institution. Despite other commitments, he has made available Léger paintings from his collection for which we could have found no comparable examples. We are profoundly grateful for his generosity of spirit and deed.

Numerous individuals have helped us to trace and secure loans. Here we are grateful to the extraordinary efforts of Patricia Phelps de Cisneros, as well as those of Ernst Beyeler, Claudia Neugebauer, and Michel Soskine. Another who has been especially helpful both in the past and on this occasion is William Acquavella. We are immensely indebted to him for his generosity as a lender and for the patience he has preserved despite repeated time-consuming requests for assistance in connection with our application for U.S. Government indemnification.

Over the years, Honoria Murphy Donnelly and Frances Brennan have often supplied the staff of this institution with invaluable research assistance. Once again we have cause to thank them for the materials they have made available to us, the time they have spent on our behalf, and the grace and courtesy with which they have responded to our requests. Foremost among the others who have assisted us with research is Naomi Sawelson-Gorse, whose abilities contributed substantially to the project's realization. We also owe much gratitude to Nicole Althaus, Aracy Amaral, Betty Ancora, John Angeline, Vivian Endicott Barnett, Marie-Claude Beaud, Avis Berman, Claude Bernès, Nicole Bex-Delayeur, Genevieve Bonté, Dominique Bornhauser, Diane Bouchard, Chantal Bouchon, Phyllis Braff, Olive Bragazzi, Ann Brandwein, Janice Braun, George Brightbill, Edward Burns, Lee Cano, Barry Chad, David Coleman, Michèle Cone, Pierre Cornette de Saint-Cyr, Rolando Corpus, Kathy Cottong, Crosby Coughlin, Katherine B. Crum, Judith Czernichow, Carolyn A. Davis, Jo Ellen McKillop Dickie, Gail Donovan, Chantal Drouot, Alice Erskine, Andrea Farrington, Lara Ferb, Gordon Field, Jeffrey Figley, Elizabeth Fisher, Judi Freeman, Phyllis Freeman, Henry Fulmer, Carolyn Garner, Marion Glöckle, Romy Golan, Denise Gray, Maureen D. Heher, Arlene Hess, Marilyn Holt, Martin James, Carroll Janis, Stephen Jones, Lilly Joss, Dan Kany, Lillian Kiesler, Billy Klüver, Marcella Korff, Hélène Lassalle, Eddie Lawrence, John LeGloahec, Alexander Liberman, Laurent Limot, Marianne Lion-Violet, Marie Losier, Ilene Magaras, Alexander Matter, Mercedes Matter, Michele McNally, Katherine Janszky Michaelsen, Madeleine Milhaud, Martha Mock, Francine Ndiaye, Christine Nelson, Jean-Paul Oddos, Janet

Parks, Nicole Préjugé, Carol Prietto, Matthew Priewe, Kelly Purcell, Florence Raynal, William Roberts, John Richardson, Louise Rossmahler, John Russell, Bart Ryckbosch, Barbara Miller Sandford, Judith Ann Schiff, Merle Schipper, Adrian Seltzer, Jeroen de Scheemaker, Miriam B. Spectre, Darwin Stapleton, Sally Stassi, Gail Stavitsky, Judy Throm, Brigitte Vincens, Ken Wayne, Christine Weideman, Bob Weidrich, Sarah Wilson, Chloé R. Ziegler, and Anne-Marie Zucchelli.

Very special thanks are also owed to Alexander Rower, Joan Punyet Miró, Guy Loudmer, Christoph and Dominique Bürgi, Ursula Hatje, Shirley Jaffe, George Sugarman, Mme Georges Bauquier, Isabelle Maeght, Mrs. Melville Wakeman Hall, and Michèle Richet.

Within the Museum, the preparation of the exhibition and publication has drawn upon the resources of virtually every department. I am indebted to the Museum's former Director, Richard E. Oldenburg, and its present Director, Glenn D. Lowry, for their goodwill and support. Deanna Caceres, Executive Assistant in the Director's office, deserves thanks for her cheerfully given assistance. Despite unusually worrisome problems and an unmerciful workload, Kirk Varnedoe, Chief Curator of the Department of Painting and Sculpture, has always made time to assist with loan negotiations and other problems. As in the past, I stand in admiration of his abilities and deeply appreciate his confidence and trust. I also owe much gratitude to Victoria Garvin, Administrator/Assistant to the Chief Curator of Painting and Sculpture, whose ingenuity, imagination, and professional aplomb contributed in important ways to the realization of this project, and to Madeleine Hensler, Executive Secretary, for the efficiency and goodwill with which she met the additional demands it imposed. Jennifer Russell, Deputy Director for Exhibitions and Collections Support, arrived at the Museum relatively late in the preparation of the project, but her assistance, understanding, and support have been no less than invaluable. Anne Lampe, former Assistant to the Deputy Director, and Elizabeth Peterson, presently in that position, were unfailingly and effectively helpful.

Linda Thomas, Coordinator of Exhibitions, has been crucial to the accomplishment of this exhibition. Although sorely pressed by the demands of the Museum's extensive programs, she was unstintingly generous with her skill and intelligence in solving problems that sometimes seemed to threaten our ability to realize the project effectively; its existence is owed in fundamental ways to her professionalism. She has been ably assisted by Maria DeMarco, whose support and professional skills have been vital. Rosette Bakish attended to many important issues with her customary diligence, and Marie Arch was also most helpful. I also owe much to Richard L. Palmer, former Coordinator of Exhibitions, who handled the initial phases of the project with constant skill and energy.

I am particularly grateful to Mary Lea Bandy, Chief Curator of the Department of Film and Video, whose generous agreement to put the Department's galleries at the disposal of this exhibition has made it possible to represent Léger's important involvements with film, theater, book illustration, and architecture. Laurence Kardish, Curator and Coordinator of Film Exhibitions, has also been most effectively sympathetic to this aspect of our project, as has Steven Higgins. Charles Silver and Mary Corliss graciously consented to reschedule a project they were planning in the gallery of the Film Department, and I deeply appreciate their collegiality, goodwill, and the

other important ways in which they gave of their time and expertise. Anne Morra has also significantly assisted us, for which we are very grateful.

It has once again been my good fortune to have had the advice and support of Beverly M. Wolff, the Museum's Secretary and General Counsel, whose contributions have been invaluable. I cannot sufficiently thank her. Stephen W. Clark, Assistant General Counsel, has also provided crucially important assistance. Additionally, my very sincere gratitude goes to Randi Greene, Executive Secretary in the General Counsel's office.

Very particular thanks must go to Michael Margitich, Deputy Director for Development, and Monika Dillon, Director, Major Gifts, for their tireless efforts to enlist support for the exhibition. Both John L. Wielk, formerly Associate Director, Development and Membership, and Rebecca Stokes, Grants Officer, deserve gratitude for their contributions.

James Gara, Chief Financial Officer, has attended to the financial planning of the project with his customary foresight and skill. For their active interest and energetic efforts to assure the broadest dissemination of information regarding the exhibition, I am deeply grateful to Elizabeth Addison, Deputy Director for Marketing and Communications; Alexandra Partow, Assistant Director, Communications; Mary Lou Strahlendorff, Senior Press Representative; Uri Perrin and Jessica Ferraro, Press Assistants; Elisa Behnk, Marketing Manager; Lyanne Dowling, Deputy Director for Retail and Operations; Kara Orr, Paper Products Manager, Sales and Marketing; Brooke Marcy; and Ann Mara Dugourd, Graduate Intern. In the Department of Education my gratitude must go to Patterson Sims, Deputy Director for Education and Research Support, and to Chelsea Romersa, Carina Evangelista, Maribel Bastian, Elly Karp, Amy Horschak, and Christine Broderick.

The complex logistics of this exhibition have placed a considerable burden on the Department of Registration. Diane Farynyk, Registrar, Linda Karsteter, Senior Assistant Registrar, and Jon Cordova, Senior Registrar Assistant, have smoothly and proficiently coordinated a daunting volume of shipping and in-house transportation of works of art, for which we are very grateful. Meryl Cohen, former Associate Registrar, also made significant contributions from within the Registrar's office. Pete Omlor and his colleagues prepared and mounted the exhibition with care and dedication.

As usual, the Department of Conservation played a crucial role in the project. Beyond giving their customary scrupulous attention to loans entrusted to the Museum, its members have been instrumental in expanding our knowledge of Léger's working methods. I am most especially grateful to James Coddington, Chief Conservator, and to Anny Aviram, Michael Duffy, and Karl Buchberg.

Jerome Neuner, Director of Exhibition Design and Production, was invaluable in conceiving ideas for the installation of the exhibition and related matters. As always I relied on his extraordinary skills and talent; I cannot adequately express my thanks to him. Mark Steigelman and Mari Shinagawa of the same Department have also made significant contributions. Ethel Shein, Director, and her staff in the Department of Special Programming and Events have skillfully and graciously attended to organizing events involved with the opening of the exhibition. Others who have contributed in a multitude of ways are Jo Pike and Melanie Monios, Director and Assistant Director of Visitor Services, and their staff. We owe thanks to Vincent Magorrian, Director,

Building Operations, and his crew, as well as to Ronald Simoncini, Director, Security, and his vigilant guards.

An exhibition and publication of this scope are necessarily dependent on our Library and its staff, and we have been much aided by Janis Ekdahl, Eumie Imm Stroukoff, Daniel Starr, John Trause, Carol Ann Street, and Karen Mainenti. Rona Roob, Museum Archivist, is, as always, owed special thanks. Her knowledge, not only of the Library's holdings but of national and international archival sources, has been of inestimable help. We are deeply grateful to her and to Michelle Elligott, Assistant Archivist. Also of help were Leslie Heitzman and Claire Dienes. The Department of Photographic Services and Permissions most efficiently accepted the additional burdens we placed upon it, and we offer our thanks to its Director, Mikki Carpenter, and to Thomas D. Grischkowsky and Jeffrey Ryan. Kate Keller, Chief Fine Arts Photographer, and David Allison, Erik Landsberg, and Tom Griesel handled our requests for photography effectively and with grace.

The preparation of this book was a complex task and I am profoundly indebted to the members of the Department of Publications for their uncommon efforts in its realization. Osa Brown, former Director of the Department, took an informed interest in the project from the beginning. Harriet S. Bee, Managing Editor, marshaled her talent, skill, and expertise to resolve a variety of vexing issues; I am more than especially grateful to her. All of us who have written for this publication were unusually blessed in having David Frankel as its editor. His professional skills and the sensitivity and ingenuity he brings to solving problems are unmatched, as is the generosity of spirit with which these qualities are exercised. He was no less than indispensable to the accomplishment of our efforts, even as working with him turned out to be one of the hidden pleasures of organizing this project. I cannot adequately express my debt to him. I should also like to thank Marc Sapir, Production Manager, who oversaw the book's production with high professionalism. In the same department, essential contributions were also made by Nancy Kranz, Heather DeRonck, and Dale Tucker, and in the Department of Graphic Design, by Jody Hanson, Director, and Emily Waters, Assistant Director. Outside the Museum, it was once again my great good fortune to work with Steven Schoenfelder, who designed this publication with rare verve, skill, and sensitivity. He has my most sincere gratitude and admiration.

To my colleagues in the other curatorial departments of the Museum goes my deep appreciation for their support. In the Department of Drawings, special thanks are owed Margit Rowell, Magdalena Dabrowski, Christina Houstian, and Kathleen Curry. In the Department of Prints and Illustrated Books, Deborah Wye, Wendy Weitman, Robin Reisenfeld, Deborah Dewees, and Jennifer Roberts gave us invaluable help, and we are much in their debt. In the Department of Architecture and Design I am grateful to Terence Riley, Peter Reed, and most especially to Matilda McQuaid. John Elderfield, Deputy Director for Curatorial Affairs, has as always been a sympathetic support, and in his Department I should particularly like to thank Christel Hollevoet, Research Assistant, whose meticulously researched responses to queries are a wonder and delight, and Sharon Dec, whose intelligence, common sense, and goodwill are equally a marvel. In the Department of Photography, M. Darsie Alexander and Virginia Dodier have been especially helpful.

The main burden of this project has fallen on the Department of Painting and Sculpture, and particularly on the curatorial and research team that worked directly with me. Cora Rosevear, Associate Curator, was, as in the past, sensitive to problems of loan arrangements and has given much-needed help, as has her assistant, Alexia Hughes. Anne Umland, Assistant Curator, Pepe Karmel, Adjunct Assistant Curator, and Lilian Tone, Curatorial Assistant, have been patient and inventively helpful in responding to our many queries. Robert Storr, Curator, has been extremely supportive in numerous ways, including volunteering access to Léger-related material in the papers of his aunt, the collector Mrs. Gilbert W. Chapman. I appreciate his assistance greatly. Outside those who directly worked on the project, my deepest thanks must go to Kynaston McShine, Senior Curator, whose advice and redoubtable insight were always generously available.

Of the people who have worked most closely on this project, the contributions of Jodi Hauptman, Judith Cousins, and Delphine Dannaud have been critical. During the initial planning of the exhibition and publication, Jodi Hauptman, the author of one of the essays in this volume, was my principal curatorial assistant and Judith Cousins, Research Curator, was in charge of all our research endeavors. For different reasons, both had to give up their involvement; each, however, established a solid basis for the progress of her successor. I am extremely grateful to them both. Our preparations for this exhibition and publication were well underway when Delphine Dannaud arrived as an intern; her unflagging dedication and most effective work have made her a full-fledged member of the Léger curatorial team. We and the Museum owe her an enormous debt, and regret only that we cannot adequately thank her.

Last but quite the opposite of least, I would single out the three people who have been most intimately involved in this enterprise: Susan Richmond, Kristen Erickson, and Beth Handler. Each has made contributions basic to the realization of this publication and exhibition. Susan Richmond's amazing, unflappable competence has extended from the most detailed tasks to those requiring ingenious, imaginative problem-solving. I have relied on her constancy, efficiency, and good judgment as I have on her talent for languages. I owe her an immeasurable debt. When Kristen Erickson took on the job of researching and compiling the Chronology, she did so knowing that circumstances had left us severely behind schedule. Although she had far too little time, her energy, tenacity, and superb research skills and abilities, combined with a highly developed professionalism, accomplished what had seemed nearly impossible. I deeply appreciate her efforts and applaud the aplomb with which they were carried out. Beth Handler also came to this project late, but, undaunted, she mastered its manifold complexities of content and procedure in almost no time. Beyond that, her curatorial judgment and abilities have made her a true collaborator in the organization of the project. I have relied on her scholarly insights and talents throughout our preparations. Her critical support has been essential and she has my most sincere and profound gratitude. Without the labors, good spirits, and professional excellence of these three colleagues, neither exhibition nor book would have been possible.

—CL

Fernand Léger: American Connections

Carolyn Lanchner

My era was one of great contrasts,
and I am the one who made the most of it. I am the witness of my time.
—Fernand Léger, 1954

So it begins to be reasonable that the twentieth century whose mechanics, . . .
whose standardisation began in America, needed the background of Paris,
the place where tradition was so firm that they could look modern without being different.
—Gertrude Stein, 1940

During the first half of this century, America was modern and Paris was modernism. Fernand Léger was a French modernist who took modernity as his subject; he was the only major painter of his generation who did. The near-ubiquitous appearance of machine imagery in Léger's art from about 1918 to the mid-1920s, combined with a popular equation of the machine, the modern, and the American, gave Léger a unique conceptual connection to the United States. Indeed the American critic Henry McBride reported in 1938 that some observers "went so far as to say that Fernand Léger, although living and working in France, was really expressing the soul of America, machines being more prevalent here than almost anywhere else."[1]

If Léger's art seemed to partake of the American spirit, this was not the aspect of his transatlantic ties that most tangibly affected his life and work. In common with many European artists of his generation, Léger found a considerable base of support and exposure in the United States; unlike most of his peers, however, he also had a keen interest in the country itself. With the notable exception of Marcel Duchamp, few other major European artists chose to explore America as Léger did. Although he was not uncritical, and during his wartime exile declared himself "uprooted," the American scene fascinated him. Both before and after his first visit, in 1931, he counted many Americans among his acquaintances and close friends. America was a significant resource for Léger, and conversely his painting was an important example for a wider variety of American artists than is commonly recognized. In following Léger's various experiences of America, this essay aims to clarify the nature and consequences of the French artist's interactions with a culture at once so close to and yet so removed from his own.

Fernand Léger. *Le Tronc d'arbre sur fond jaune* (Tree trunk on yellow ground; detail), 1945. Oil on canvas, 44⅛ x 50" (112 x 127 cm). Scottish National Gallery of Modern Art, Edinburgh. See plate on p. 244

Léger was a special crony of Constantin Brancusi's, which lends some tenuous credence to the apocryphal story that brings Léger, Brancusi, and Duchamp together on a visit to an aviation fair in Paris around 1912. Observing the clean arabesques of a wooden propeller, Duchamp purportedly asked if any artist could possibly improve on it. Brancusi's *Bird in Space* (1928) and Duchamp's own *Bicycle Wheel* (1913) may have been delayed responses.[2] If Léger were running true to form, his answer should have been an emphatic negative. His often reiterated doctrine that no object beautiful in itself could serve the artist as what he called "raw material" would seem to have put the propeller off limits. Yet some years later a Léger painting, *Les Hélices* (Propellers) of 1918 (p. 184), was acquired by Katherine S. Dreier, whose collecting activities were as often as not guided by her friend and collaborator Marcel Duchamp.[3]

In 1912, when the encounter with the propeller supposedly took place, Léger, Duchamp, and Brancusi shared another experience, this one historically verifiable. During that year they were all visited by Walter Pach, Arthur B. Davies, and Walt Kuhn as the three Americans toured the studios of Europe looking for examples of modernist art for the Armory Show. Work by each artist was included in the show, which opened in New York in February of the next year and then traveled to Chicago and Boston. For all the masses of writing now accumulated on the Armory Show, its importance has not been overstated; it brought into being an American audience for vanguard art, and was a prime impetus in the development of some of the country's greatest public and private collections.

As for so many of his peers, the Armory Show was Léger's American debut. He was represented by two works, which, listed without dates, sizes, or titles in the catalogues of all three venues, cannot be identified. There has been speculation about which works were actually hung, but thus far no wholly secure documentation has been forthcoming.[4] The show generated the curiosity of both intellectuals and sensation seekers, elicited admiration and derision, laughter and anger, and, most important, attracted crowds in unprecedented numbers. In the immense amount of publicity surrounding the exhibition, the entries of a few artists proved irresistible to the press; any latter-day questions about which works by Brancusi, Duchamp, or Henri Matisse were included are amply answered in the flavorsome prose and slapstick caricature of contemporary accounts. Léger's work was apparently much less provocative, but a lone satirical interpretation of one of his entries did appear in a Pittsburgh paper (fig. 1); its appearance supports the contention that one of the two "*Études*" in the exhibition was the monumental *La Femme en bleu* (Woman in blue, 1912; p. 161), now in the Basel Kunstmuseum.

The Armory Show presented a broad range of contemporary avant-garde styles, but the press, captivated by the neologistic allure of "Cubism," tended to group most of the variant manifestations of the new art under this satisfying if not clearly definable rubric. In 1913, Arthur Jerome Eddy of Chicago, an idealist of the American pragmatist variety, was at work on the manuscript of *Cubists and Post-Impressionism*, which, published the following year, is the first American book to attempt an assessment of Cubism. Eddy's endeavor was, as he explained,

1. "'Lady in Blue' Cubist's Mother." *Pittsburgh Chronicle Telegraph,* May 7, 1913, p. 25

not "a plea for Cubism. . . [but] for *tolerance and intelligent receptivity . . . toward everything that is new and strange and revolutionary in life*."[5] Although Eddy's language can now seem quaint, his passion still comes through. He was a missionary who knew how to sway his audience; at one point, relying on Cubism's hazy definitions, he suggests that his readers may already be among its acolytes: "The man who laughs at a cubist picture may be a cubist—that is, an innovator—in his profession or business."[6]

Although this peculiarly expansive definition of Cubism was still unpublished in the spring of 1913, the management of Gimbel Brothers department store in Milwaukee was then behaving with an entrepreneurial initiative that, in Eddy's terms, qualified its behavior as inadvertent Cubism. Seeking "to capitalize on the Armory Show's notoriety,"[7] by mid-May of 1913 the store had assembled a mini-exhibition of ten works by seven painters: Léger, Albert Gleizes, Jean Metzinger, Pierre Dumont, Jacques Villon, Gustave Miklos, and Arpad Kesmarky. According to the account of American artist Carl Holty, a teenager in Milwaukee while the exhibition was being prepared, Gimbel's bought the paintings it would show through purchasing agents in Paris, who were instructed to pay a flat fee of $100 for each work.[8] Whether and how any bargaining may have proceeded between Léger and Gimbel's is probably forever unknowable, but a transaction undoubtedly took place. Although it is impossible to identify one of the two paintings Léger sent to Gimbel's, the other was *Essai pour trois portraits* (Study for three portraits, 1910–11; fig. 2), for some years believed lost but now in the collection of the Milwaukee Art Museum.[9]

The store's intent in organizing the exhibition is evident in an advertisement placed in the *Milwaukee Sunday Sentinel* of May 11, 1913: "The first exhibit of 'Cubist' painting. Brought to Milwaukee direct from Paris-France by the Gimbel picture department. . . . We shall be pleased if you see and study the interesting features of these Cubist and Futurist ideas that have set the whole world talking, wondering and thinking. The exhibition is free to all—and while you're here to inspect the Cubist paintings, be sure to inspect our splendid collection of oil paintings, water colors, etchings, etc."[10] After its Milwaukee debut, the exhibition traveled to department stores in Cleveland, Pittsburgh, New York, and Philadelphia. In April of 1914, almost a year after its initial opening, it returned to Milwaukee, where it was mounted in the galleries of the Milwaukee Art Institute and expanded to include 117 works by American artists.[11]

The Gimbel's touring exhibition of 1913–14 had virtually disappeared from view until 1983, when Aaron Sheon rescued it from oblivion with his *Arts Magazine* article "1913: Forgotten Cubist Exhibitions in America." It was, however, an event, as Sheon remarks, that points to a more widespread reaction to the Armory Show than would otherwise seem to have

2. Fernand Léger. *Essai pour trois portraits* (Study for three portraits), 1910–11. Oil on canvas, 76¾ x 45⅞" (195 x 116.5 cm). Milwaukee Art Museum, anonymous gift

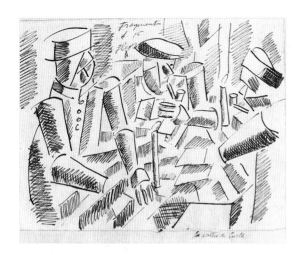

3. Fernand Léger. *La Partie de cartes* (The card game), 1916. Pen and ink on paper, 6½ x 8¾″ (16.4 x 22.3 cm). The Museum of Modern Art, New York. Gift of Mr. and Mrs. Daniel Saidenberg, 1974

been the case. Opening even before the Armory Show closed, and traveling to cities not known for their cosmopolite audiences, the exhibition benefited from the intense public curiosity that the commotion of Cubism had aroused. Its sponsorship by Gimbel's even conferred some measure of social sanction on its subject; during the show's stop in New York, *The Globe and Commercial Advertiser* declared, "Now that the new art movement has found its way to a department store, there ought to be no further doubt of its establishment as part of our American daily life, and its ultimate acceptance must be considered only as a question of time."[12]

Within about ten weeks of the closing of the Gimbel's exhibition at the Milwaukee Art Institute in mid-May of 1914, World War I had begun in Europe; by October of that year Léger was serving as a sapper in the Argonne Forest. Although he tried to secure a less perilous assignment, suggesting that the duties of a "draftsman, writer, cyclist, or chef" would be more in line with his talents, Léger spent most of the war at or close to the front.[13] Whenever he had a spare moment, he drew the activities of his companions (fig. 3), but he had almost no opportunity to work on canvas; between the last quarter of 1914 and 1917 he produced only one such painting, *Le Soldat à la pipe* (Soldier with a pipe, p. 178), done in 1916 during a leave in Paris.

Hospitalized in 1917, Léger almost immediately began to paint again. Among numerous smaller works he executed one of the key paintings of his career, *La Partie de cartes* (The card game, p. 179).[14] Near the end of his life he was to tell Dora Vallier that this was "the first picture for which I deliberately took my subject from what was going on around me. . . . Afterwards when I got back to Paris, in 1918–1919, I made the canvases that are called 'la période mécanique.'"[15] *La Partie de cartes* may not occupy quite the chronological precedence Léger assigns to it,[16] but it is nonetheless an emblem of wartime experiences that would, as he had written his friend Louis Poughon in April of 1915, return him to Paris eager to

gobble [it] up, if I'm lucky enough to go back there! I'll fill my pockets with it, and my eyes. I'll walk about in it like I've never before walked about there. . . . I'll see in things their "value," their true, absolute value, for Christ's sake! I know the value of every object, do you understand, Louis, my friend? I know what bread is, what wood is, what socks are, etc. Do you know that? No, you can't know that because you haven't fought a war.[17]

When Léger did return to Paris for good, he brought with him legacies of the war that would stay with him all his life—an identification with the ordinary working-class men who had been his companions in the trenches, and a heightened desire to make his art express the beat of life going on around him. He would often say that the slang and the inventive liberties of language that his *poilu* buddies took with accepted syntax were forms of contemporary poetry, and he sought their equivalent in his painting. Indeed his radical recasting, in *La Partie de cartes*, of a theme hallowed by Cézanne reflects his will to endow the traditional with a new voice.

The war's revelation of the "absolute value of things" was probably a factor in intensifying Léger's predisposition to focus on the "plastic possibilities of ordinary manufactured objects." Operating in tandem with this was a drive to open up pictorial conventions. In 1925 he would write,

Each artist possesses an offensive weapon that allows him to intimidate tradition. In the search for vividness and intensity, I have made use of the machine as others have used the nude body or the still life. You must never be dominated by the subject. . . . The manufactured object is there, a polychrome absolute, clean and precise, beautiful in itself; and it is the most terrible competition the artist has ever been subjected to. . . . I invent images from machines, as others have made landscapes from their imagination.[18]

In the years between 1918 and the early 1920s, Léger imagined new machines in a steady stream of major canvases such as *Les Disques* (The disks, 1918; p. 182) and *Les Éléments mécaniques* (Mechanical elements, 1918–23; fig. 4) while expanding the theme to the mechanical splendor of the city in *Les Disques dans la ville* (Disks in the city, 1920–21; p. 183) and most notably in one of his great masterpieces, *La Ville* (The city, 1919; p. 181). The city of the painting's title is of course Paris, but it is a Paris that Léger has "gobbled up, filled his pockets with it and his eyes." It is appropriate that the painting should bear a generic title; its subject has lost all geographical specificity to become "the archetypal image of the modern metropolis."[19] Today, nearly eighty years after its execution, its impact as the visual translation of twentieth-century urban experience has lost none of its force. "Never has the poetry of the first machine age," John Golding has observed, "been so grandly and proudly exalted" as in *La Ville*.[20]

"The first machine age" may have its origins in the middle of the eighteenth century, but to the generation that lived through the Great War, it seemed to dawn just after the armistice in 1918. The war had so conspicuously accelerated the pace of technological innovation that, for better or for worse, a fundamental reconstruction of the conditions of life appeared to be in progress. Léger would later say of the period that "an unleashing of forces filled the world."[21] The world he was talking about was, naturally, the "old one," the place where he lived—Paris, France. And the forces filling it were those of an ungovernable modernization, a phenomenon discerned in its earlier, tamer stages by the Goncourt brothers, who, in the 1860s, had already identified it as "*l'américanisation de la France.*" With the postwar emergence of the United States as a premier industrial power, the equation of modernization and Americanization entered popular mythology on both sides of the Ocean.

In 1919, Léger illustrated Blaise Cendrars's book *La Fin du monde filmée par l'Ange N.-D.*

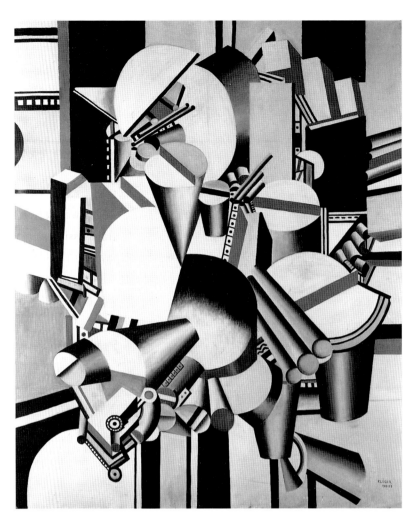

4. Fernand Léger. *Les Éléments mécaniques* (Mechanical elements), 1918–23. Oil on canvas, 83 1/16 x 65 15/16" (211 x 167.5 cm). Öffentliche Kunstsammlung Basel, Kunstmuseum. Gift of Dr. h. c. Raoul La Roche, 1956

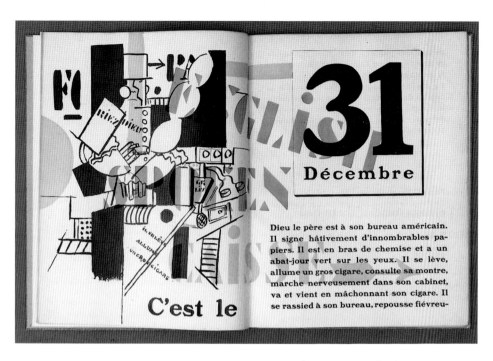

The image within the spread contains the text:

31 Décembre

Dieu le père est à son bureau américain.
Il signe hâtivement d'innombrables pa-
piers. Il est en bras de chemise et a un
abat-jour vert sur les yeux. Il se lève,
allume un gros cigare, consulte sa montre,
marche nerveusement dans son cabinet,
va et vient en mâchonnant son cigare. Il
se rassied à son bureau, repousse fiévreu-

C'est le

5. Spread from *La Fin du monde filmée par l'Ange N.-D.* (The end of the world filmed by the angel N.-D. [Notre Dame]), by Blaise Cendrars. Illustration by Fernand Léger. Pochoir in color, with line-block reproductions of ink drawings. Paris: Éditions de la Sirène, 1919. The Museum of Modern Art, New York. The Louis E. Stern Collection, 1964

(The end of the world filmed by the angel N.-D. [Notre Dame]).[22] The book's opening paragraph satirically acknowledges the businessman as the principal representative of American culture and the power behind the country's new-found international dominance. Cendrars's initial sentences don't quite claim that "God the father" is a U.S. citizen, but they do locate him in an American office, where, in shirt sleeves, he hurriedly signs innumerable papers, lights and chomps on a large cigar, walks nervously about, consults his watch, and telephones furiously. Léger's rendition of this being endows him with a sartorial decorum suitable to his station, and with a demeanor that suggests he has few doubts about the wisdom of his reign (fig. 5). In an iconic, face-forward posture, Léger's deity exhibits no interest in the elegantly executed inscription enjoining his audience to "*Riez Dieu*" (Laugh at God), a riff on the orthodox "*Priez Dieu*" (Pray to God); he is equally unconcerned with the informational announcement, "English Spoken," that joins his portrait to Cendrars's text on the facing page.

If the attire of Cendrars's frenetic American businessman, complete with green eye-shade, would seem to have been an unlikely choice for a real specimen of the type, Léger's representative displays a complacency that was very much part of the national mood after the armistice. Alone of all the participants in the Great War, the United States emerged intact and more powerful than ever. To most of its citizens, America's special destiny, the moral grounding of its value systems, and the divinely ordained nature of its prosperity seemed apparent. The ripple of cultural curiosity set off by the Armory Show seemed to have subsided; the mood of the country was isolationist, puritan, and antiforeign. As President Calvin Coolidge would later say, the business of America was business. The year 1919 saw the passage of new, more restrictive immigration laws, the beginning of Prohibition with the Volstead Act, and a "red scare."

The chauvinism and babbittry of the postwar years were not new; they only intensified attitudes that had alienated America's artists, writers, poets, intellectuals, and, perhaps, a small tolerant minority of the middle class for years. In 1905, Ezra Pound reportedly declared, "If you have any vital interest in art and letters and happen to like talking about them, you sooner or later have to leave the country."[23] And in 1915, just as Americans seemed most receptive to the new ideas discovered at the Armory Show, Van Wyck Brooks had felt called upon to lament, "Human nature itself in America exists on two irreconcilable planes, . . . stark theory and . . . stark business; and in the back of its mind is heaven knows what world of poetry, hidden away, too inaccessible, too intangible, too unreal in fact ever to be brought into the

open."[24] By 1919, Harold E. Stearns, predicting what was already taking place, was arguing that the pervasive spirit of American Puritanism would "tend to drive away our imaginative and intelligent young men to countries like France where they have not yet forgot what living means."[25] Within two years, the great American expatriate adventure in Paris was in full swing.

Léger found himself very much in the thick of the exchange of French and American energies that would animate the 1920s. The decade would bring him many useful American connections and an increased recognition by American artists and collectors even if the last did not furnish the level of patronage Léger might have desired. Most of the American writers, artists, and intellectuals arriving in Paris in the early '20s would have had a notion of Léger's ranking in the evolving hierarchy of European modernism. Perhaps some of them had seen the Armory Show, or the touring department-store exhibition at one of its stops; the majority would have read Willard Huntington Wright's 1915 assessment of Léger as, "with the exception of Picasso, . . . the most genuinely talented artist of the Cubist movement. . . . Since his first Cubist exhibits he has made a logical progress in rhythmic conception, and if his past development can be assumed as a criterion of the future it is safe to prophesy that eventually he will be the most significant man of the original group."[26] Wright was the brother of the American Synchromist painter Stanton Macdonald-Wright, who had lived in Paris and exhibited there extensively before World War I; if Willard Wright had visited his brother, or, through him, had had some other access to Léger's work, he may have had sufficient familiarity with it to predict its future responsibly.

Most of Wright's readers would have had to take him at his word. The two works that could have been seen in the Armory exhibition should have been returned to France at its close. So far as is known, the only other Léger paintings possibly in America between 1914 and at least 1920 were *Essai pour trois portraits* and another given the title *Mountain Scenery*, both of which would seem to have been purchased by Gimbel's. The former, without question, stayed in America; since the latter cannot be precisely identified, its history is unknown. It must, however, have been a painting from a series of 1911–12 showing roofs of houses surrounded by clouds and smoke.[27] Available documentation forces the conclusion that an interested American might, in the unlikely case, have found no more than four paintings by Léger in the United States from mid-1914 until the beginning of the next decade, or, with a slightly increased probability, two. Since any Léger work appearing in the Armory Show must have been completed by the beginning of 1913, a date later than the dates of the works in the Gimbel's exhibitions, no American who had not visited France immediately before or during the war could have known Léger's great "*Contrastes de formes*" series of 1913–14 (pp. 164–65), much less the machine-resplendent paintings he had been making only since 1918.

Americans who had managed to accomplish an expatriate voyage by February of 1919 could probably have seen examples of Léger's recent output in his first Paris solo exhibition, then at the Galerie de l'Effort Moderne of his new dealer, Léonce Rosenberg. Less early

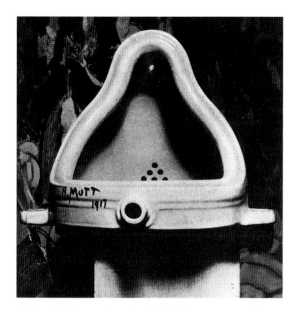

6. Marcel Duchamp. *Fountain*, 1917. No longer extant. Photograph by Alfred Stieglitz, from *The Blind Man* (New York) no. 2 (May 1917): p. 4, published by Duchamp, Beatrice Wood, and Henri-Pierre Roché

arrivals seeking an encounter with Léger's art would have had to initiate visits to his studio and the reserves of Rosenberg's gallery, or wait for such Paris occasions as the Salon des Indépendants. The first postwar Indépendants, which opened in January 1920, provided a showcase for Léger's monumental canvases *La Ville* and *Les Disques dans la ville*, and marked the return of the American artists Patrick Henry Bruce and Morgan Russell to the French art circuit already known to them from the years before 1914.[28] But even such veterans of the Paris scene as these two may have found themselves somewhat startled by the new Léger paintings included in this exhibition, *La Ville* and *Les Disques dans la ville*. It was not that they, or for that matter the newly arriving Americans, were unfamiliar with art that took the manufactured object as its subject. They had, indeed, seen the genre in more deliberately provocative and astonishing guises in such works as Duchamp's *Fountain* (1917, fig. 6), produced, with some accompanying furor, in New York during the war. What they had not seen were common industrial appurtenances displayed with the high-art panache of oil and canvas—an effrontery wholly at odds with Duchamp's.

For all their evident differences, it is nevertheless tempting to see some affinity of temperament between Duchamp and Léger. Duchamp's 1917 declaration, via Mr. Mutt, that a urinal on which the status of "Fountain" was conferred would lose its functional identity in new thoughts about that object, and Léger's later proclamation before a Sorbonne audience that the gas meter he was unwrapping was "more interesting and beautiful than the Venus de Milo,"[29] seem at least congenial. But whatever links may have sometimes existed between Léger's thought and Duchamp's are difficult to deduce from the works these artists produced in the five years before 1920. Duchamp's actual appropriations of the functional object were meant to demoralize the notion of high art, whereas Léger's efforts were bent on revitalizing it. If Léger's observation that the manufactured object is "clean and precise, beautiful in itself," and "the most terrible competition" for the artist was equally Duchamp's when he supposedly challenged Brancusi and Léger with his rhetorical question about a propeller, their reactions to the problem were opposed.

There is a great deal of humor but little irony in Léger; both his small paintings such as *Les Hélices* and his large canvases such as *Les Éléments mécaniques* (fig. 4) were conceived in the passionate belief that the traditional means of painting, properly organized, could be used to produce objects that would rival the beauty he saw in modernity. He believed that most people were caught in outworn prejudices that blinded them to the glories of the modern spectacle, and that his role was to enlist the power of art to reveal the beauty of the mechanized environment. For a while at least, he was something of an evangelist. What Léger was bringing to painting was what French critics such as Georges Bataille, André Malraux, and Jean-Paul Sartre thought the Americans William Faulkner and Ernest Hemingway were bringing to the novel. They called it "rebarbarization," meaning the process by which a literary genre is vitalized through its annexation of popular culture.[30]

Léger's evangelism was not without effect. His bright, optimistic paintings emphatically celebrating modernity had a special ability to surprise Americans who had come to Paris in search of French culture. These expatriates may not have seen those surfaces as "expressing the soul of America," but they surely made some connections between the images they were looking at and the predominant culture of their native land. In the mid-1920s the American artist Louis Lozowick would write, "Léger is one of the very few whose work pleads with American artists for an American orientation, a closer contact with their industrial civilization so rich in plastic possibilities."[31] It is likely, as Barbara Rose claims, that Léger's work had varying degrees of influence on Bruce, Stuart Davis, Charles Demuth, A. E. Gallatin, Jan Matulka, George L. K. Morris, Man Ray, Charles Shaw, and John Storrs, all of whom were in Paris during the '20s.[32] But of all those who had some direct contact with his production of the period, Gerald Murphy, along with Davis, most astutely bent Léger's pictorial tactics to an expression of modernity with a distinctively American accent.

Murphy met Léger within two months of his arrival in Paris in September of 1921. He had not yet begun to paint in earnest, and given his apparent affluence, Léger initially misjudged the direction their relationship would take: in a note to Léonce Rosenberg, postmarked November 21, 1921, Léger says that he has had a visit from some influential Americans, Mr. and Mrs. Murphy, who have already been to the gallery and admired his painting. Should they return, he wants Rosenberg to show them important examples of his work. In closing, he assures his dealer that "these are people worth the trouble. I count on you."[33] But Murphy and Léger soon formed a close friendship, and it must rapidly have become apparent that the exchange between them would not be as collector and artist. Indeed the man whom Léger had first looked to as a potential patron amazingly quickly became a fellow painter.

In tandem with Léger's often expounded explanations of his art as grounded in the maximizing of contrasts, he practiced and preached a doctrine he called "new realism," according to which the object is all important; the tenets of this principle were applicable to the making not only of pictures but of films, such as his own *Ballet mécanique* (Mechanical ballet) of 1924. "New realism" demanded that "every effort be concentrated on bringing out the values of the object." In isolation, enlarged, "a pipe—a chair—a hand—an eye—a typewriter—a hat—a foot, etc. etc. . . . can become a vehicle of entirely new lyric and plastic power."[34] Another means to enhance the object's value was to be found in the cunning blandishments of shop-window displays. The compositional artistry that Léger observed in the storefronts around him was a recurring source of delight to him, but what excited his most intense interest was the "modesty" of the objects featured in these arrangements. No aura of high cultural or social status attached to any of them. From this perception, it was not very far to the conclusion that the canvas should likewise divest itself of its "hierarchical prejudices."[35]

In his brief career, Murphy probably produced no more than fourteen paintings, of which six have survived and images exist of another four—but they are enough to reveal strong ties

7. Gerald Murphy. *Portrait*, 1928. Oil on canvas, ca. 32 x 32″ (81.3 x 81.3 cm). No longer extant

to Léger's "new realism." Around 1920, just before meeting Murphy, Léger had readmitted the human figure to his painting, but true to his "new realist" principles he assigned it no pictorial privileges; unindividuated, his figures look rather as though they had been "fathered by a piece of . . . machinery."[36] Had Murphy's career lasted long enough, perhaps he would have picked up on this aspect of Léger's practice; one of his last paintings, *Portrait* of 1928 (fig. 7), displays an eye, a footprint, a mouth, and a profile within a kind of cubistic window-dressing format remarkably like Léger's in his *Parapluie et chapeau melon* (Umbrella and bowler, 1926; p. 212). Apart from *Portrait*, the closest Murphy ever came to incorporating the human figure in his compositions was in *Library* of 1926–27, which includes a sculptured bust of Ralph Waldo Emerson, among other objects that had been in his father's library.[37] With these semi-exceptions, Murphy's subjects were always things, often isolated and enlarged, as in *Watch* of 1925 (fig. 8), and directly or indirectly related to his life in America.[38]

Although Murphy's work was to endure a long oblivion before being rediscovered and celebrated both for itself and for its anticipation of American Pop art, it was well-known and admired in 1920s Paris. When *Watch* was shown at the 1925 Salon des Indépendants, Florent Fels called Murphy a "poet and painter" who had shown that the motif of a watch was as "plastically exploitable as . . . Cézanne's apples."[39] Later in the same year, when Murphy's 1924 painting *Razor* was included in the large group exhibition *L'Art d'aujourd'hui*, both Léger and Pablo Picasso, who also had work in the show, particularly remarked Murphy's presence. Picasso sent a complimentary note, which Murphy described in a letter: "He [Picasso] apparently meant it, saying that he liked very much my pictures, that they were simple, direct and it seemed to him Amurikin—certainly not European."[40] Léger would seem to have had somewhat the same view when he elected to pronounce Murphy "the only *American* painter in Paris," despite his certain knowledge of others such as Bruce who were working there.[41] One year after these distinctions were awarded, the French/American critic and artist Jacques Mauny would assign Murphy a place "in the history of the beginnings of the American aesthetic . . . his art . . . explains the new American taste; . . . it shows us with precision the beauty of the instruments of prosaic life executed to perfection. His inoffensive taste for the mechanical is engaging."[42]

Murphy, as Archibald MacLeish later recalled, lived in Paris with great imagination. "His friends were the principal men of the twenties—Picasso and Stravinsky and Fernand Léger and, among the Americans, Dos Passos and Hemingway and Fitzgerald."[43] Early on in Murphy's stay in Paris, Léger may have been helpful in introducing

8. Gerald Murphy. *Watch*, 1925. Oil on canvas, 78½ x 78⅞″ (199.4 x 200.3 cm). Dallas Museum of Art, Foundation for the Arts Collection, gift of the artist

the American newcomer to Parisian artistic and cultural worlds, but the Murphy gift for friendship very soon made any such services unnecessary. And although Léger lived in the heart of Montparnasse, a neighborhood so favored by U.S. citizens that it was often identified as a colonial outpost, it is unlikely that, without Gerald and Sara Murphy, he would have come to know so many distinguished Americans. One of these was John Dos Passos, whose affectionate regard and admiration for both Murphy and Léger are apparent in his later memories of an afternoon in 1923 when he took the "first of many marvelous walks" with the two. Léger, he recalled,

was a hulk of a man, the son of a Norman butcher. He seemed to me to have a sort of butcher's approach to painting, violent, skillful, accurate. Combined with . . . a surgeon's delicacy of touch that showed up in the intricate gestures of his hands. . . . The two men set each other off. . . . As we strolled along Fernand kept pointing out shapes and colors. . . . Gerald's offhand comments would organize vistas of his own. Instead of the hackneyed and pasteltinted [sic] Tuileries and bridges and barges and bateaux mouches on the Seine, we were walking through a freshly invented world. They picked out winches, the flukes of an anchor, coils of rope, the red funnel of a towboat. . . . The banks of the Seine never looked banal again after that walk.[44]

Not long before this first meeting between Léger, Murphy, and Dos Passos—sometime, that is, in early 1923—Rolf de Maré, the young director of the Ballets Suédois, which had captured Paris with its 1921 production of Jean Cocteau's *Mariés de la Tour Eiffel*, commissioned Léger, Cendrars, and the composer Darius Milhaud to come up with a ballet that would reflect the "jazz age." At more or less the same time, reputedly on Léger's advice, de Maré asked Murphy to create an American ballet. The results were *La Création du monde* (The creation of the world), with sets and costumes by Léger, and *Within the Quota*, with scenario, sets, and costumes by Murphy and music by his Yale college friend Cole Porter. The ballets premiered together on October 25, 1923, at the Théâtre des Champs-Élysées; both generated highly enthusiastic responses. The critic of one dance magazine, implicitly equating their success with *Les Mariés de la Tour Eiffel*, wrote, "The Ballets Suédois have once again dared! 'One dies of not daring.'"[45]

Almost exactly a month later, the Ballets Suédois held another premiere, a continent away, at the Century Theater in New York. Edmund Wilson, the company's American publicity agent, staged an invitation-only opening that drew an influential, affluent crowd.[46] Neither *Within the Quota* nor *La Création du monde* was included in the four works presented that evening, although another ballet with sets and costumes by Léger was—*Skating Rink*. Reviews of the performances were generally indifferent to condescending to dismal. The *New York Evening Journal*'s critic found Léger's contributions to *Skating Rink* grotesque, and hoped they would not affect women's clothes.[47] When, shortly thereafter, Murphy's *Within the Quota* was presented, it was appreciated for being "at least amusing and colorful," and "blessedly brief."[48]

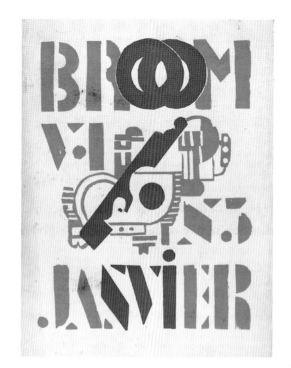

9. Fernand Léger. Woodcut, in color, used as the cover for *Broom* (Rome) 1 no. 3 (January 1922). The Museum of Modern Art Library, New York

10. Fernand Léger. *Charlie Chaplin.* Woodcut used as an illustration in *Broom* (Rome) 1 no. 3 (January 1922): 233. The Museum of Modern Art Library, New York

After its New York debut the Ballets Suédois toured America's East Coast, performing in Washington and Philadelphia as well as in many smaller cities and towns. During the tour, de Maré came to believe that *La Création du monde* was too radical for the American public, and deleted it from the program; its disappearance heralded others. By Christmas of 1923 the company would announce that "the 'ultra-modern' numbers in the repertory which aroused so much discussion . . . have been entirely eliminated and that the new program will include a number of the more traditional ballets."[49] Since *Within the Quota* was the one modernist ballet in the repertory that had not conspicuously irritated its audiences, it was the only one retained. The relative tolerance of its reception may have owed something to a viewer attitude articulated in the December 27 issue of the *New York Evening Telegram*, where it was averred that Murphy had simply made use "of the privilege of an American to make good tempered fun of his own country."[50]

Léger's experience of America as negotiated by the Ballets Suédois hardly qualified as a success, yet it had positive aspects. If Americans reacted negatively to the company's modernist imports, they nonetheless noticed those performances and the names of some of the artists associated with them. For Léger this could only have been to the good, since his American exposure at the end of 1923 was scarcely larger than it had been in the immediate postwar years. It would seem that the full sum of his paintings in America was very little more than the two paintings probably acquired by Gimbel's in 1913.[51] He was not represented in the Inaugural Exhibition of the Société Anonyme in New York in 1920, but may have been included in a group exhibition at the John Wanamaker store a year later in the same city.[52] The few Americans who read the magazine *Broom*, published by U.S. expatriates in Rome, would have seen his striking woodcut on the cover of its January 1922 issue (fig. 9), and, on inside pages, two of his renditions of one of his favorite characters, Charlie Chaplin (fig. 10).[53] *Broom*'s issue for April of the same year reproduced Léger's great painting *Les Disques* and a *Paysage animé* (Animated landscape) of c. 1921;[54] the cover of the July issue was again by Léger.[55]

Serious criticism, such as it was, tended to look at Léger benevolently. Willard Wright had done so in 1915 and Sheldon Cheney did so again in his 1924 book *A Primer of Modern*

Art, claiming that Léger's work "went deeper" than that of Gleizes, Metzinger, Juan Gris, or Francis Picabia.[56] Cheney's intention in his primer was to "lead on the interested but often puzzled Progressive Citizen."[57] In Léger's case, it appears that he could only lead by going backwards: conscientious and committed to his cause, he would presumably have wished to represent "the trend of Léger's work"[58] through an image of a relatively current work, but apparently neither works nor photographs were available, as Cheney's illustration is reproduced courtesy of Wright from the photograph the earlier author had used for his own book in 1915. And no doubt thanks to Cheney's publishers, his smoker and Wright's differ only in that Cheney's is upside-down.[59] Slightly redeeming the *Primer*'s botched attempt to represent Léger is a tiny reproduction of a Léger drawing that appears at the bottom of the last page of text.[60] Inscribed "Vernon 1918," this image of dynamically aligned, machinelike soldiers might have given Cheney's readers a hint of the contemporary "trend" of Léger's art.[61]

In the foreword to his *Primer*, Cheney acknowledges his debt to the collector John Quinn, who, he wrote, "has allowed me to see and enjoy his extraordinary collection of modern paintings and sculpture."[62] Quinn had been passionately acquiring contemporary French art since the Armory Show, and all its celebrated masters were well represented in his collection with the signal exception of Léger. Quinn was well aware of Léger through his reputation in French art circles, and specifically through Henri-Pierre Roché, whom he had engaged to find him "works of museum rank." Writing to Quinn, Roché used a hunting metaphor to describe their relationship: "I have the impression of acting like a dog trying to 'faire lever' some big birds in front of you, and you shoot them or not, as pleases you."[63] Léger appears to have been the one "big bird" who did not please Quinn, and Roché, after a couple of attempts, ceased to try to draw him to Quinn's attention. In the long run, Quinn's disdain for Léger's work had little negative effect; in the early 1920s, however, it did retard the extent of Léger's exposure to American audiences. Had Cheney been able to see a Léger painting in Quinn's collection, his presentation of the artist's work would surely have been less garbled. More important, Léger would most likely have been included in the popularly successful exhibition *Contemporary French Art*, held in New York in the spring of 1922; nearly all the paintings by Léger's peers— Picasso, Georges Braque, Matisse, and André Dunoyer de Segonzac—were lent by Quinn.[64]

Any damage that Quinn's lack of interest in Léger's art did to the artist's opportunities to increase his reputation in America was probably unknown to him. He was, however, keenly interested in securing American patronage, and knew Quinn to be one of its foremost dispensers. On at least one occasion he asked his dealer to pay particular attention to Quinn, but where Roché had failed, so too did Rosenberg.[65] Meanwhile, in contrast to Léger's ignorance of the larger American consequences of his inability to interest Quinn was his unhappy knowledge of the American failure of *La Création du monde* and *Skating Rink*. Yet in his public stance on the issue he tried to turn defeat into triumph, declaring in a lecture of 1924, "In agreeing to perform . . . *Création du monde* [de Maré] dared to impose on the public . . . a truly modern

stage. . . . His effort was rewarded with success. . . . As French propaganda his work was influential. His creations . . . have gone around the world. He came back from America, where, in spite of the huge difficulties such a trip entails, he will have been the first to have risked and presented over there an entirely French program."[66]

In light of other perspectives thrown on Léger's reactions to the Ballets Suédois fiasco by Léonce Rosenberg's papers, it is legitimate to suspect a measure of defensiveness in this public posture. On December 29, 1923, an apparently appalled Rosenberg sent Léger a note quoting news he had just heard from Picasso: "'I met Murphy yesterday who told me that the Ballets Suédois haven't had any success in New York, that there wasn't even a cat in the theater, and they asked them to stop the performance which means the ballet couldn't even be done!'" And Rosenberg demanded, "Is it true? If it's true, it's dreadful!"[67] This note must have been a knife in a wound. Léger was by no means the only artist subject to feelings of rivalry with Picasso, but his were of a singular intensity. And another sort of rivalry was at stake, in a game that the two artists played, Picasso with more relish than Léger, for the attentions of Gerald and Sara Murphy. The professional disappointment Léger must have been feeling about the fate of his ballets in America could only have been sharply aggravated by Picasso's gossipy report of his meeting with Murphy.

Picasso's touch of malice may have increased Léger's distress, but it amounted to no more than an unpleasant incident. The Ballets Suédois's disastrous reception itself, on the other hand, was an enormous blow to Léger, at least according to Rosenberg, who told Maurice Raynal, in January of 1924, that the artist "had based great hopes in America." Overstating the case considerably, Rosenberg asserted that Léger had looked successively to the Scandinavians, the Germans, and the Russians, one by one they had all failed him, and now, he said, "It's America that falls apart between his hands." Rosenberg was clearly exasperated by what he saw as Léger's overweening impatience for greater recognition and his lack of faith in his future prospects in France. With some asperity the dealer declared, "But the day when Paris gets going—that's much surer . . . than all the Scandinavian, Bolshevik or Yankee straws in the wind." To reinforce his point, he added that his brother—the successful and exclusive dealer Paul Rosenberg, just back from America with nothing whatsoever to show for a Picasso and Marie Laurencin exhibition—thought the United States would not be ready for avant-garde art for another twenty-five years.[68]

Less than six months after Léonce Rosenberg made his complaint, Katherine Dreier, America's most stalwart champion of modernism, was probably in a Sorbonne audience listening to Léger lecture on "*Le Spectacle: Lumière—Couleur—Image mobile—Objet-Spectacle.*"[69] With Duchamp, Dreier had founded the Société Anonyme (The Museum of Modern Art) in 1920 to provide a public noncommercial center for the study and promotion of modern art. By late spring of 1924, when she accepted Léger's invitation to attend his lecture, she had already

sponsored numerous group and one-person exhibitions in the United States. If she was a little tardy in recognizing Léger, Dreier explained her view of his work in the catalogue of an exhibition the Société would hold in New York in 1925: "His talent . . . took a long slow growth. . . . This slowness of growth, like that of the oak, developed a sureness and depth . . . which with increasing years will keep him one of the most powerful men in the art world."[70]

Dreier first discussed the possibility of an exhibition with Léger when she visited his studio in the summer of 1924.[71] Her formal proposal came in a letter of April 1925, full of no-nonsense details about the proper way of organizing the project. She wanted, she said, some fifteen paintings; Duchamp should help him select them; she hoped to keep them a year; she instructed him in various methods of keeping costs—which she would bear—down; and she enjoined him not to forget to put a price on each painting. On the last point she offered firm advice: "Don't have the prices too high, *if you want to sell any*, the situation in America isn't favorable . . . for the new movement. You remember that none of Picasso's paintings were sold here in New York even though Monsieur [Paul] Rosenberg brought them himself."[72] It took Léger a month to answer this formidable letter. When he did, he first apologized for the delay, explaining that he had had to wait for Duchamp, and then accepted "with great pleasure the principle of this exhibition."[73]

In the months between this initial correspondence and the exhibition's opening, on November 15, the patience and perseverance of both parties were stretched taut. Léonce Rosenberg proved implacably opposed to lending to Dreier, and Daniel-Henry Kahnweiler's Galerie Simon, which also represented Léger, was only a little less reluctant; in an August letter Léger explained that sales were picking up in Paris, both dealers had found foreign ventures of little use from a business point of view, and neither cared to risk the possibility of travel damage.[74] Dreier worried about the quality of the paintings that would be sent. One of her letters advised Léger to send "the best examples of your work because it is only the best that wins the heart of Americans";[75] another urged that the majority of the works should be his most recent, and reiterated her insistence that he keep his prices low. In the same letter Dreier also endeavored to give Léger lessons on the relevance of the exchange rate: "The public that buys is the same that travels. Duchamp will explain this in detail if you want."[76] Anxieties about the logistics of packing, shipping, customs, and the production of the catalogue embroiled them both, although the heavier burden seems to have been Dreier's.

The show that finally took place in the rented space of the Anderson Galleries (p. 269) was not only Léger's first one-man exhibition in America, it was the most important he had had anywhere, including Paris. Of the twelve oils, *La Ville*, *Le Déjeuner* (*sic*—actually *Le Grand Déjeuner*, or *Three Women*, of 1921; p. 195), and *Le Disque* (*sic*—actually *Les Disques* of 1918; p. 182) are in the very first rank of the artist's production; much later Léger himself would include the first two in the trio he singled out as the most important paintings of his entire career.[77] Even without the subsequent historical significance that would attach to all three

paintings, the presence of each must have given Dreier cause to feel a reverse gratitude to Rosenberg and Kahnweiler, whose refusal to lend current work had forced Léger to send examples from his own holdings. The hopes she had had to show Léger's most contemporary works were not, in the event, entirely frustrated; five drawings and one oil had been executed within months of the exhibition.

According to Dreier, the show opened to a crowd of more than 500, and during its two-week run received an unusual amount of notice in the press. Three days after it closed, Dreier wrote Léger, "Your exhibition has come and gone and everyone thinks it was a great success—but it was an artistic success not financial." She told him how sorry the Société Anonyme members were that they hadn't had the money to purchase *La Ville*; she was, however, happy to announce that the Société had sold four watercolors for $25 each—neglecting to add that the purchaser was her anonymous self.[78] When Léger replied wryly that he was glad the show had been a "*succès de curiosité*," Dreier answered that it had gone much farther than simple curiosity, and then attempted an explanation, curious in its own right, about the prevalence of impecunious intellectuals in America.[79]

Dreier had announced in her foreword to the exhibition's catalogue that the show could not appear in other American cities because of plans to send it to Berlin and Moscow; she had nonetheless hoped that a purchase or two would interfere with this schedule. Aside, however, from the four watercolors she had bought, and a small oil, *Paysage animé* (Animated landscape, 1921), that she managed to retain, the exhibition exited the country intact. Perhaps, though, its stars, *La Ville* and *Le Déjeuner*, had already made an impression on two intellectuals of variant pecuniary status, A. E. Gallatin and Alfred H. Barr, Jr., who would later secure the lasting presence of these works in the United States.

Brief and without financial reward though the exhibition was, its fugitive passage through New York fixed Léger's name in the public mind, and allowed the small band of individuals who seriously cared about modernism to see his art. It generated mixed notices, but in such quantities that Dreier, sending press clippings to Léger, felt obliged to explain, "When you read the reviews . . . don't be surprised at the lack of understanding shown . . . that's not what's important here, what's important is the space you receive in the newspapers, and that is extraordinary."[80] For artists who had not gone to France, and for Dreier's "impecunious intellectuals" (who might just have overlapped a little with Cheney's "interested but puzzled citizens"), the exhibition was a first opportunity.

The artist who made best use of his experience at the Anderson Galleries was Stuart Davis. As a very young man, Davis had seen Léger's work at the Armory Show, but he could have had few, if any, chances to see it since.[81] Like Murphy, he would prove able to incorporate ideas he picked up from Léger without sacrificing his own individuality.[82] In this regard he was to have a rather sharp exchange with Henry McBride, who, in a very favorable review of a 1931 Davis exhibition at the Downtown Gallery in New York, made a dubious analogy

between Davis and a "good scout." Defining his meaning, McBride told his readers,

You know what a scout is, of course? A good scout gets up in the middle of the night and goes far off in the enemy country and returns with useful information. Stuart Davis has been doing this for years. Sometimes he does it in the daytime, too, but always he returns with what you want to know. . . . The only thing wrong about Stuart Davis is that he picked the language up when out scouting. . . . I should have preferred Stuart Davis to have invented the kind of talk he now hands out. But we can't have everything and, next to the invention of a language, there is speaking it nicely—and that Stuart Davis surely does. . . . better than any other American I know of.

Retreating somewhat from his scout analogy, McBride further commented that despite "all the Braques, Légers, and Juan Grises, that loom formidably in the No-Man's Land of Mount Parnassus," Davis's pictures are always "Stuart Davisy."[83]

McBride had irritated Davis in similar fashion before, and Davis, apparently unavailingly, had already tried to argue that no American art had ever been completely divorced from European models. Among the historical examples he had offered for McBride's contemplation in an article a year earlier were John Singleton Copley, "working in the style of English portrait painters and . . . doing it better"; J. A. M. Whistler, whose "best work was directly inspired by the Japanese while he was housed and fed in England"; Albert Pinkham Ryder, whose "technique derives from Rembrandt"; and Thomas Eakins, whose work shows that he admired Rembrandt and Velázquez. Then Davis proffered his own analogy. Comparing the operations of science and art, he rhetorically asked if American inventors ignored the work of their counterparts in Europe, and furnished the answer with vernacular flourish:

Not if they can help it. If a Norwegian has the most interesting theory of atomic physics do American scientists make a bonfire of his works on the campus? Hardly. If Darwin says that the species evolved, do American educators try to keep one hundred per cent Americans from hearing it? Yes, they do in Tennessee.

Trying to make matters clear to the misguided McBride, Davis felt constrained to explain, "I did not spring into the world fully equipped to paint the kind of pictures I want to paint. It was therefore necessary to ask people for advice. . . . Chief among those consulted were Aubrey Beardsley, Toulouse-Lautrec, Fernand Léger and Picasso. This process of learning is from my observation identical with that followed by all artists."[84]

When Davis saw the Léger exhibition at the Anderson Galleries in 1925, some of what McBride called his "scout-work" was not yet accomplished. He had yet to check out Mount Parnassus, and in fact did not get to Paris until mid-1928. He apparently first met Léger in September of that year, when Elliot Paul took him to the French painter's studio. In a letter to his father, Davis described their meeting: "I went to the studio of Fernand Léger, internationally famous modernist painter. He showed me all his newest work. Very strong. Next day

11. Stuart Davis. *Egg Beater No. 4*, 1927. Oil on canvas, 27 x 38¼" (68.5 x 97.1 cm). The Phillips Collection, Washington, D.C. Acquired 1939

12. Fernand Léger. *Composition No. 7* (formerly *Abstraction*), 1925. Oil on canvas, 51 x 35¼" (130.5 x 89.4 cm). Yale University Art Gallery, New Haven. Gift of the Société Anonyme

he came to see my work. He liked the *Egg Beaters* [fig. 11] very much and said they showed a concept of space similar to his latest development and it was interesting that two people who did not know each should have had similar ideas."[85]

In common with many other European modernists, Léger continued to reap the benefits of Dreier's energies when his work was included in the Société Anonyme's *International Exhibition of Modern Art*, which ran at The Brooklyn Museum from November 19, 1926, to January 9, 1927, and then was shown in somewhat abbreviated versions at the Anderson Galleries in Manhattan, the Albright Art Gallery, Buffalo, and the Toronto Art Gallery.[86] The exhibition provoked a lot of interest, as shown in the headline "New Artists Puzzle and Intrigue Throng at Brooklyn Museum" above one of the numerous reviews the show elicited.[87] It did not, however, provoke anything like the commotion the Armory Show had. Forbes Watson explained the difference:

Ten or fifteen years ago Miss Dreier's exhibition would have started a furor. . . . There were so many Philistines in those days that they could be counted on to make enough noise to insure the success of almost any show labeled "modern." The labeled "moderns" have been in our midst so long that people know the difference between the real modern, the man who has something to say today, and the man who only has a manner. The sculpture of John Storrs, for instance, or the painting of Léger, does not irritate any one nowadays. The ex-Philistines simply yawn.[88]

About a week after Watson's ironic assessment of his fellow citizens appeared, a colleague, Royal Cortissoz, published views in the *New York Herald Tribune* that proved him at once right and wrong. Cortissoz displayed his irritation with Léger in a weary annoyance that "the new heaven and earth promised by the Armory Show" had still not produced any "eligible sites. . . . in the long run, a more or less uniform doctrinairism has proved simply a bore . . . we can only wonder about the type of mind that gets some spiritual sustenance out of, say, M. Léger's *Abstraction* 1925" (fig. 12).[89] Whether from indifference or irritation, Cortissoz reproduced the deficiently inspirational painting upside-down; the same object was purchased by Dreier during the Brooklyn exhibition's tour.[90]

The acquisition of the 1925 *Abstraction* brought Dreier's Léger holdings to a total of either two or three oils and four watercolors. Unprepossessing as the sum seems, it represents what in 1927 was probably the most extensive collection of works by Léger in American hands. Aside from the unlikely possibility that one of the paintings shown in the Armory Show had not been returned to France, and from the Gimbel's transaction of 1913, the only other Léger work that can be suspected of having been in America before the 1920s is a pen

drawing of 1912 that Arthur B. Davies may have acquired from Léger when, in the same year, he was on his Armory Show scouting tour.[91] Mary Hoyt Wiborg, Gerald Murphy's sister-in-law, had acquired one or two works by the mid-1920s, although she may not have kept them in America until the end of the decade. The pioneering collector Ferdinand Howald acquired Léger's *La Perforeuse* (The punching machine) in 1922, only four years after its execution.[92] Howald was enterprising enough to have engineered this addition to his collection all on his own, but it could be that the acquisition was suggested by Man Ray, whom Howald was then supporting during the artist's first year in Paris. The mid-1920s correspondence between Léonce Rosenberg and Léger occasionally alludes to a Mme Saltonstall, whose visits seem to end in purchases smaller than either dealer or artist had hoped; in the catalogue of the *Exhibition of Progressive Modern Painting from Daumier and Corot to Post-Cubism*, put on by Alfred H. Barr, Jr., at Wellesley College, Massachusetts, in April of 1927, a Mrs. John Saltonstall is named as a lender. Presuming this person to have been the disappointing visitor to Rosenberg's galleries, one can learn only so much about what she may have bought from the description in the catalogue: "Léger/12–14 The Death of a Steamboat/(Three water colours)."[93] Less interestingly described but even less easily identified is a watercolor *Étude* lent to The Arts Club of Chicago in December of 1926 by Robert Allerton.

Léger's meager representation in American collections in 1927 was in sharp contrast to the surge of interest in his work taking place in France in the same year.[94] For a time it looked as though Rosenberg might have been right when he insisted that America was "falling apart" for Léger; but it was a view that would have to alter with succeeding years.

When A. E. Gallatin opened his Gallery of Living Art in December 1927 in New York, there was no outward sign to indicate that this was an event of importance to Léger; at the time, the Gallery's only work by the artist was a gouache.[95] Beginning in 1929, however, Gallatin would acquire his paintings at such a pace that the Gallery could lend thirteen pieces to an exhibition that would take place at The Museum of Modern Art in 1935.[96] In the two years following that exhibition, Gallatin would make his two most significant purchases, Picasso's *Three Musicians* (1921), acquired in 1936, and Léger's *La Ville*, acquired in or around February 1937. Announcing their acquisition, Gallatin remarked, "Probably these two pictures are the most important painted so far in this century."[97] Exhibited in New York, Chicago, and Milwaukee in 1935, *La Ville* was back in France by 1936. According to Jean Hélion, it was his advice that persuaded Gallatin to buy the painting; it is difficult to believe, however, that Gallatin did not already know it from its 1935 appearance at The Museum of Modern Art, if indeed he had not seen it at the Société Anonyme exhibition ten years earlier. When Gallatin learned that the picture was available, Hélion would remember,

He bought it right away for a very small price. Léger told me he sold it for one thousand dollars. . . . But Léger was very anxious that this painting be preserved for it was beginning to crack. . . . I assume Léger was

13. Fernand Léger. Cover for the catalogue of the exhibition *Machine-Age Exposition* (New York, 1927). The Museum of Modern Art Library, New York

very pleased to be in competition with Picasso. . . . As soon as both *La Ville* and *Three Musicians* were there, they took such a power and conviction the Gallery realized itself around them.[98]

In a letter to Gallatin, Léger expressed his delight that New York, "the Great City" foreseen in *La Ville*, would be the work's final home.[99]

Housed in New York University rooms on Washington Square, and open weekdays from 8 A.M. to 9 P.M., the Gallery of Living Art provided an informal, accessible space congenial to Léger's notions that the ideal museum should be devoid of stuffy reminders of past glories and open during hours when "workers get out of their workshops."[100] If the students going in and out of the study room where the Gallery's pictures were hung were not quite the workers Léger had in mind, they were often joined by artists and others attracted by their "neighborhood museum" (p. 276).

When Gallatin's museum opened, at the end of 1927, Léger may have been represented by a single gouache but his spirit seemed present to a *New York Times* reviewer, who wrote that the gallery existed within "the framework of the machine age—heating pipes, brass gongs, fire alarm boxes forming abstract compositions after the heart of a Léger."[101] By the time of these comments, the identification of Léger with the industrial trappings of modernity had become nearly standard. Léger was the artist Jane Heap chose to do the cover for the catalogue to her May 1927 New York exhibition *Machine-Age Exposition* (fig. 13).[102] In August, *Vanity Fair* published the qualifying quiz that Barr had prepared for students taking his modern-art course at Wellesley: "Fernand Léger" was item 45 on a list headed by the question "What is the significance of the following in relation to modern artistic expression?" Answer 45 was, "French Cubist whose forms are polished and cylindrical like steel, clangorous in red and black like new fire engines."[103]

The last two years of the 1920s saw an appreciable increase in Léger's public exposure in the United States, and in the number of collectors drawn to his art. Chicago and New York, the centers of this stepped-up activity, were roughly equal in providing more viewing opportunities, but the new collectors were predominantly from the Midwest. By early 1929, when The Arts Club of Chicago held its *Loan Exhibition of Modern Paintings Privately Owned by Chicagoans*, important canvases were owned by Mrs. John Alden Carpenter, Mr. and Mrs. Walter S. Brewster, and Mr. Charles H. Worcester; all of these works would later enter the collection of The Art Institute of Chicago.[104] Indeed *Composition in Blue* (1927), belonging to Mr. Worcester, had been sold to him on the condition that it would someday be in an American museum, a promise that had enabled the American sculptor John Storrs, who was acting for Worcester, to persuade Léger to sell "directly (which he never does because of his clients) and for half of his price."[105] C. J. Bulliet reproduced the Worcester painting prominently in an article in which he seemed happily surprised at the success of the Arts Club exhibition: "Not only," wrote Bulliet, "are the people of Chicago flocking in unusual numbers to the

galleries . . . to see the wonders displayed, but St. Paul's Society of Fine Arts has invited the show . . . for the museum there. . . . It seems hardly credible that this show could be assembled only sixteen years after the famous Armory Show of 1913 of 'vile, degenerate French trash.'"[106]

A year after Chicago's display of its collecting acumen, Barr, the new director of The Museum of Modern Art, revised the Chicago concept in the two-month-old institution's third exhibition, *Painting in Paris from American Collections*. In the catalogue's foreword, Barr made the teasing remark, "The present exhibition is by no means a cross-section of painting in Paris but it does include several of the foremost living painters and twenty others who are either interesting as individuals or who represent new phases of recent European art which are not yet very familiar in America."[107] It is up to the reader to deduce which of the twenty-six artists in the exhibition are the six who must constitute Barr's elite, and the clues are not definitive. Represented in the exhibition by two oils, Léger is singled out as "beside Picasso and Braque . . . the most important living artist who has used the cubist technique consistently." Barr's modification of this judgment was laconic: "The differences between these three in temperament and taste are obvious."[108] Pierre Bonnard, André Derain, Matisse, Picasso, Georges Rouault, and de Segonzac all had five works or more in the show; of the rest, only Braque and Giorgio de Chirico with four each exceeded the maximum of three that the other artists were allotted. This apparent special representation of Braque and Chirico is reflected in the foreword, where Barr assigns unique historical significance to Braque and positions Chirico's name strategically within his own text.

Barr's last paragraph consists of a single sentence: "Bonnard, Matisse, Rouault, Derain, Picasso, Segonzac and Giorgio de Chirico—surely Paris in the early twentieth century need bow to no other period of painting."[109] The prominence Barr gave to these seven names can only have been deliberate. If they are one too many to correspond to his elect six, then perhaps the last one should be subtracted. The syntactic convention separating Chirico's name from the others and the unique use of a first name within the series may discreetly recognize that Chirico had long since stopped painting in Paris, where he had produced the "early landscapes and 'metaphysical' still-lifes" that Barr's article singles out.

Léger was probably unaware of the relative weakness of his representation in *Painting in Paris*, but he was soon to be reminded of America as a potential source of patronage. In mid-1930, the Baroness Hilla von Rebay, who had already convinced Solomon R. Guggenheim that he should assemble a museum-worthy collection, was on a scouting mission to Paris.[110] Léger's was one of several studios she visited; whether she discussed plans she was formulating for a museum or not is unclear, but she must have left him with a distinct impression of her possible usefulness. Writing to Rebay on January 28, 1931, Léger attempted flattery, saying that he often spoke of her with their mutual friends Carl Einstein and Le Corbusier; he then suggested that she do an interview in an American newspaper about her visit to him.[111] Rebay was apparently unresponsive to this overture. Around this time, Léger was trying to arrange a

trip to the United States; no doubt reasoning that a commission would provide the means, he wrote to Rebay again in March, asking her about Mr. and Mrs. Guggenheim and suggesting that he do a mural in fresco or mosaic for their home.[112] Again Rebay turned a deaf ear. Indeed once Léger actually got to America, he succeeded in irritating Rebay sufficiently to cause her to call him "a mean creature, all business and just business. He was here in order to collar orders for wall decorations. He thought that the Guggenheim estate in Port Washington was the most regal thing he had ever seen."[113] Rebay's annoyance may have contributed to a tardiness in her acquisition of Léger's art, but was not a long-term barrier. By 1939, when her dream of founding a museum was realized with the New York opening of the Museum of Non-Objective Painting (precursor to the present Solomon R. Guggenheim Museum), the collection included five paintings and four watercolors by Léger.

With the financial support of Gerald Murphy, Léger's plans to go to the United States were finally realized in the early fall of 1931. On September 29, he wrote Le Corbusier from New York: "Two days here. I'm still constantly astonished by the vertical urge of these people drunk with architecture. From my room on the thirtieth floor, the night is the most astonishing spectacle in the world, nothing can be compared to it. . . .This city is infernal. A mixture of elegance and toughness."[114]

Three days after Léger's arrival, an exhibition of his works on paper—drawings, watercolors, and gouaches—opened a three-week run at the John Becker Gallery in New York.[115] Aside from one mild-mannered, well-disposed review, the exhibition would seem to have generated very little reaction, even from Léger himself.[116] On October 1, the show's opening day, Léger wrote a reasonably long letter to his mistress, Simone Herman; nowhere does he mention the exhibition—the ostensible reason for his trip.[117]

If Léger would appear to have been less than excited by his exhibition, his reaction to the city was the opposite. On October 22, he wrote to Herman, "After three weeks in New York, I begin to think a little bit about France—for three weeks it was completely forgotten—you can't imagine the importance of a thing like this . . . the enormous attraction this city holds for me—arriving I felt something that doesn't deceive—a sort of excitement and a hard shock to the body and a stiffening of myself penetrating into that elegant geometry."[118]

One of Léger's principal guides around the city was the Austrian-born architect and sculptor Frederick Kiesler, whom the artist probably met in Vienna in 1924, two years before Kiesler's emigration to America. In the letter to Herman describing the force of his reaction to New York, Léger also mentioned a meeting he and Kiesler had had with an architect involved in designing Rockefeller Center. Describing the chief challenge of the project—how "to construct a building for 25,000 employees . . . how to maneuver this army vertically during the same hours"—Léger wrote, "I was mad with joy before this demoniacal problem."[119] He must have continued to enjoy such wonderful conundrums, for he embroidered somewhat fan-

cifully on them in his article "*New-York vu par F. Léger*," dedicated to Sara Murphy and published at the end of the year in the Paris art journal *Cahiers d'Art* (p. 272). The wonders of New York's "overloaded spectacle" include the fact, he told his French readers, that "letters thrown into the mail chutes on the fiftieth floor get hot from friction and catch fire by the time they arrive on the ground floor. They have to chill the mail chutes—too cold, and the letters will arrive with snow."[120]

Léger stayed in New York a little over seven weeks, absorbing its sights, seeing friends he had met in Paris, and making new acquaintances. On November 5, the day after attending a reception Gallatin had held in his honor, he sent a postcard to Le Corbusier: "Ran around in New York this morning with the architect, Fuller. . . . Spoke about you, and visited the building [which is the] last word [in] industrialization." Besides Léger's message, the card included two others: "My deepest respect to M. Corbusier, Buckminster Fuller," and "Greetings—John Storrs."[121]

Léger's American trip had already run longer than he had planned when he further extended it to go to a small exhibition of his work at The Arts Club of Chicago. The exhibition itself was less an event than the screening of *Ballet mécanique*, the film he had made in 1924 with the American Dudley Murphy and score by George Antheil. *Ballet mécanique* is without scenario; it opens with a woman on a swing—"a *postcard* in *motion*," Léger said[122]— and then focuses on things such as jelly molds, straw hats, artificial legs, a washerwoman, and saucepan bottoms, sometimes fragmented and all repetitively moving. According to Léger, the manner of repeating images in complex ways through mirrors was at least partially the idea of his friend Ezra Pound.[123] Shown in Chicago on November 20, 1931, the film brought serious and less serious reviews. The *Chicago Daily Tribune* sedately reported, "In spite of the nasty weather the tea for Fernand Léger, distinguished French painter, yesterday at the Arts Club, attracted one of the largest crowds ever assembled in those attractive club rooms. The crowd was so great that it overflowed from the main gallery. There M. Léger's film, 'Le Ballet Mecanique,' was shown."[124] A spirit of flippant tolerance informs the account in the *Chicago Herald and Examiner*: "Strange sounds floated through the chic doors of the Arts Club . . . late yesterday afternoon. . . . When one loud crashing phase of the music repeated itself twenty-eight times, and the pistons of a printing press worked away unceasingly on the screen, while doors opened and closed, and lights flashed, I thought I saw a meaning: 'The local room of a morning newspaper on election night.'"[125]

In "Léger as Painter, Poet and Person," an article in the *Chicago Evening Post*, Inez Cunningham showed herself insightful in a way unusual in American art criticism of the time. Remarking that the general classification of Léger as a Cubist "begs the question of his artistic definition," and making an effort to "differentiate him," she found terms such as "mechanistic" and "concretist" flawed, and elaborated on her conception of his endeavor:

The rhythmic dynamics of the twentieth century have pounded so upon his brain and nerves they have become a sort of soul song. . . . In his talk at The Arts Club . . . Monsieur Léger said that his research was purely of the object, never the subject. . . . This method which sounds so simple takes on an infinite complexity. The glass and the table become not one object isolated by its own identity from all other objects in the universe. But the beginning of a stream of objects which by their very physical likeness and unlikeness . . . are related in visual form and movement to every other object in the universe. Monsieur Léger is hoisted by his own artistic bootstraps. His purely intellectual and objective personality is finally caught upon the flood tide of imaginative impulse until the pistons of a marine engine and the arms and legs of an old woman day after day carrying fagots [sic] up a hill are one rhythm and he finds he has walked blindfold into the camp of the Romanticists. It is this very poetic quality which gives to the abstract paintings of Monsieur Léger the beauty for which they are remarkable.[126]

Cunningham had apparently interviewed Léger, and reported that he found Chicago "poetry" while "New York is mathematics."[127] To judge from his correspondence and other sources, it may be that Léger's comparison was more politic than strictly truthful; but even if Chicago did not hold for him quite the definitive edge over New York that he professed to Cunningham, he unquestionably enjoyed the ten days he spent there. Within three weeks of his mid-December return to France, the Parisian review *Plans* published his article "Chicago," dedicated to the memory of the recently deceased Rue Winterbotham Carpenter (a former president of the Arts Club, and one of Léger's first American collectors). Of his departure he wrote, "You leave with regret. Slowly and solemnly you pass by beautiful American factories which stretch all the way along the tracks for an hour. What a panorama. The huge chimneys with their smokestacks parallel to each other, like in a parade. Names are as legible as on ships. You dream of a gigantic orchestra adapted to the scene. Silhouettes of unknown machines. Eighteen chimneys in a single square, a giant organ. That is majestic, definitive."[128]

Léger had certainly undertaken his visit to America in the hope that it would yield some material profit, but he also came "to look and go on looking."[129] Despite the intensity of his reactions to "the most beautiful spectacle in the world," he was not blind to the social forces behind it; in his article "*New-York vu par F. Léger*" he comments on the disparity between rich and poor, and on the city's overall aspect as "the apotheosis of vertical architecture: a bold collaboration between architects and unscrupulous bankers" that has resulted in "an unknown, unplanned elegance."[130] When he made these observations, Léger was at the beginning of a decade in which political and economic problems would increasingly affect his daily life, heightening his already strong sense that art should have a social purpose.

The early 1930s were years of some frustration for Léger. Although his reputation was solidly established, he was chronically short of money, and he found little opportunity to satisfy his growing desire to make mural paintings. In 1933, on the occasion of a large retrospec-

tive at Zurich's Kunsthaus, *Cahiers d'Art* devoted an entire issue to Léger.[131] Among the texts it published was an excerpt from "Léger and the Cult of the Close-up," written a few years previously by the American James Johnson Sweeney.[132] Observing that Léger's recent canvases (of about 1930) were intended to be "easel pictures," as opposed to earlier experiments with mural painting, Sweeney called Léger "an architect within the picture's plane."[133] Had Sweeney written his appreciation of Léger concurrently with its publication, he might have come closer to the artist's actual state of mind.

In August of 1933, Léger delivered an admonitory lecture to a conference of architects. Warning that "worldwide catastrophe" would result from "extreme excesses," Léger drew a parallel between "American vertical architecture," which had "gone too far in forgetting that a forty-six-story building must disgorge all its human content at the same time," and "the modern architect" who had "gone too far in his magnificent attempts to cleanse through emptiness." Léger was careful to say that he admired the new raw materials of modern buildings, and the air and light that effected a "magic" dissolution of architecture's former feeling of weight and volume. But he warned his architect friends to beware: a revolution might indeed have occurred, but it had produced an individual-oriented, "easel" architecture that responded only to the demands of an "elite minority." Yet far from urging his listeners to extend their revolution to the creation of environments for the common man, Léger told them that this would be "tragic." With creative passion, Léger cast the new architecture as

a modern minotaur, drunk with light and clarity, who rears up before the little modern fellow, who has hardly gotten over his knick-knacks and his frills, and thinks of them all the time. . . . There he is the average man, a human cipher before this pitiless new reality—the modern wall. . . . My architect friends, we should be able to get together about this wall. You want to forget that painters are put into this world in order to destroy dead surfaces, to make them livable, to spare us from overly extreme architectural positions. . . . [To rescue] the modern little fellow . . . an agreement among the wall—the architect—the painter must be achieved. . . . You have wanted to dispense color yourselves . . . *allow me* to tell you . . . that is a mistake. . . . The carpenter does not make wrought iron. . . . What right have you to dispense color? . . . I am not angry, and I am waiting. I think the event is going to happen and that, arm-in-arm, the wall, you and I, we will achieve the great modern works that are to be done.[134]

One of those prominently implicated in Léger's description of the architectural revolution was his great friend Le Corbusier. For rhetorical effect, Léger's lecture theatrically exaggerated their differences; in fact the two were actively aware that it was in the interest of both of them to resolve the nuances of their aesthetic conflicts through shared projects—a realization made particularly acute by the economic hard times of the early 1930s. There were, however, few prospects. In the summer of 1934 they had hopes of collaborating on a house for the dancer and choreographer Léonide Massine. That August, Le Corbusier urged Léger to act, saying, "This 'affaire' interests me enormously, think of it, if you get the funds from Massine

to paint the entire house, including the roof, I will be delighted . . . to bow before the great decorator!"[135] The project, however, seems to have fallen through. Aside from plans for the decoration of a private house in Vézelay, Burgundy, Léger's expectations of other outside commissions were also disappointed.[136] By the beginning of 1935, he and Le Corbusier had both decided that the grass on the other side of the Atlantic might be greener and were determined to try their luck in America.

Léger's first impulse to undertake another trip to the United States was almost certainly sparked by a visit in late October of 1934 from James Johnson Sweeney, whose proposal of a one-man exhibition at the Renaissance Society in Chicago, for the spring of 1935, was more enthusiastically received by Léger than Sweeney could then know.[137] Shortly after Sweeney's departure, Léger wrote to Herman to tell her she must brush up her American English and be willing to leave for Chicago with "a *Monsieur comme ça*."[138] Léger, who was profoundly in love with Herman, wrote to her much less lightheartedly in early January, explaining that things had reached a point of such difficulty that he had to go to New York "to make some money . . . (here, there's nothing)." He hoped, he went on, to be able to stay with the Murphys for six months or a year. The most serious thing about this project, he made clear, was Herman's response; it was an adventure he couldn't consider without her.[139] Between the date of this letter and the September 1935 departure of its author and Herman for New York, Léger was absorbed in preparations for the trip.

According to Léger, his personality was transformed in attacking the difficulties posed by his travel plans. In July he wrote Herman, "I'm trying to get money together for the trip—I've never caged things this way before . . . I'm afraid it will ruin me. . . . my imagination is completely involved. . . . I write, I telephone—I'm wily . . . in a way I would not have thought myself capable . . . my horse-trader origins come back but everything is controlled by the thousand precautions I must take to cover my behind—to find the hole where I can get through—I am more of a bandit than Corbusier for that. . . !"[140]

In early spring, Léger's new-found abilities delivered an unnerving shock to some crucial American connections. During their meeting in October of 1934, Sweeney and Léger had jointly selected works for the proposed Renaissance Society exhibition, agreeing that Léger would send nothing until hearing from Sweeney that dates and logistics were settled.[141] Nonetheless, in mid-March Léger wrote to Sweeney, "The pictures are gone 10 canvases and 18 drawings and gouaches. . . . I would like the exhibition to go to New York—this is indispensable and I believe quite feasible. Think also of the Carnegie prize and do everything within your ability to sell the most possible." He appeared unaware of the high-handedness of his unilateral action, sending "a thousand best wishes" and adding in a postscript, "You are really great to have gotten this exhibition off the ground for me. Thanks again."[142] On the facing page, Léger listed the works he had sent and their prices. Addressed to Sweeney, the letter was in fact received by Eva Schütze, the president of the Renaissance Society and one of

Léger's most effective supporters. Schütze was stunned, and so, when he heard the news, was Sweeney, who immediately wrote to Schütze, "I cannot understand what could have gotten into Léger. His behavior in this situation is quite different from anything my past personal experience with him would have led me to expect as even possible."[143] In the ensuing, almost daily correspondence between the two, Sweeney withdrew from his original position that the shipment, which had been sent uninsured, should be refused and sent back at Léger's expense, but his astonishment at Léger's methods remained. He wrote Schütze, "It passes credibility almost. Still, on second thought, perhaps Léger is more intelligent than a great many people who make a fetish of insuring. Nevertheless, I would never have believed a Frenchman would have shipped ten oils and eighteen other pictures without a penny of insurance and would have followed it up with the statement that there was no use in insurance."[144]

Once recovered from Léger's unexpected move, the Renaissance Society made extraordinary efforts to arrange a tour for their Léger exhibition. By the end of April, at least seventeen museums from the East Coast to the West had been contacted; many had expressed great interest, but few could come up with the $100 fee. The first to commit was The Museum of Modern Art, which, as a consequence, became the show's opening venue, hosting it from September 30 to October 24. Besides New York, the exhibition was finally seen in only three other places: The Art Institute of Chicago, the Milwaukee Art Institute, and the Renaissance Society. In addition to the works Léger had so precipitously sent, the exhibition was variously augmented at its four venues by works borrowed from other sources.

Pursuing his own preparations from Paris, Léger wrote the Murphys among others in the hope that they would advance him funds.[145] The Murphys, whose older son, Baoth, had unexpectedly died in March, nonetheless remained Léger's "guardian angels" and for the second time supported his American adventures. Léger and Simone Herman boarded the S.S. *La Fayette* on September 25, 1935. Le Corbusier followed on the *Normandie* shortly thereafter; the painter and the architect were to have back-to-back exhibitions at The Museum of Modern Art, where Léger's show would close the day Le Corbusier's would open. And they were both optimistic about other projects the United States might bring them.

On October 4, the day the *La Fayette* docked, Léger lost no time in going to see his exhibition, which had been installed by a former student of his, the American painter George L. K. Morris. Writing to Mr. and Mrs. Solomon R. Guggenheim to thank them for a loan they had made to the show, Barr reported that "Léger, who has just landed in New York today, agrees with me that Mr. Morris has hung the pictures beautifully. Léger is very happy."[146] Where Léger's arrival in New York in 1931 had been a quiet affair, in 1935 it caused considerable stir. The Museum's publicity director alerted city editors, shipping-news reporters, and photographers to the event, promising that "M. Léger . . . has decided and amusing ideas about New York. He should be an ideal subject for an interview." In the first excitement of arrival, Léger was not as politic as he could have been at the Museum's press conference. The next morning

the *Herald Tribune* reported that he had dispensed rules for painting and had pronounced that "America has no painters. . . . America is a poor place for a painter. In Paris there is always someone who will criticize you. . . . But in America, I could do anything I wanted."[147]

Before his first day at the Museum was over, Léger gave a lecture, "The New Realism," which would be translated by Harold Rosenberg and published in the December issue of *Art Front*, a leftist magazine then edited by Stuart Davis. Much of what Léger said was a version of opinions he had given elsewhere; new, however, were his comments on

two recent feats . . . a French feat, the steamship *Normandie*, and an American feat, Radio City. The *Normandie* . . . fails to fulfill our hopes . . . of interior decoration. It is a retrograde conception which belongs somewhere between the taste of the eighteenth century and the taste of 1900. [It seems a shame to have to say this in front of an American audience, but] the French, who have a heavy artistic tradition . . . often make such errors. . . . Radio City, on the other hand, is the true expression of modern America. . . . America knows how to make things luxurious while making them simple. And it is a social luxuriousness, luxury through which crowds circulate. It was necessary to discover that.[148]

The exhibition itself, with some twenty-four oils and nineteen works on paper dating from 1911 to 1935, provided the public with a representative overview of Léger's oeuvre.[149] Included were the three great canvases *La Ville*, *Les Disques*, and *Le Grand Déjeuner*, which had already twice traversed the Atlantic for Katherine Dreier's Anderson Galleries show in 1925. The exhibition stimulated the Museum to acquire its first works by Léger; two drawings jointly listed as number 42 in the catalogue had just been purchased, and number 6, a small oil, *Deux femmes à leur toilette, 1er état* (c. 1920; also called *Breakfast*), would enter the collection within months. It would, however, be seven years before Barr could find the funds to acquire one of the great masterpieces of the Museum's present collection, *Le Grand Déjeuner*.

The exhibition attracted exceptionally large audiences in both New York and Chicago, and the press delighted in it, whether in the tradition of Armory Show spoof or in earnest examination. At The Art Institute of Chicago, Léger's works were hung in galleries adjacent to an exhibition of Rembrandt and his school; this juxtaposition, headlined in one review "Rembrandt Pitted against Modernism of Léger," provided an especially piquant provocation to the members of the press, who vied with each other in reporting on the "uttermost contrast the graphic arts can offer . . . !"[150] In a postcard to Paris, Léger pronounced the situation "very amusing."[151]

Walter Pach, in his book *Queer Thing, Painting: Forty Years in the World of Art*, published in 1938, would also contrast Léger and old master art, but in another spirit. Rebutting those who had found Léger's art too involved with aesthetics and lacking in regard for "social significance," Pach wrote,

But where one finds a man as close to the movement of thought in his time as was Léger, the reproach fails. When, years after the Armory Show, the artist had his big exhibition at the Museum of Modern Art in

New York, many a visitor had that proof of authenticity in the work which one gets in places like Haarlem or Toledo, where a single painter dominates the mind. Coming out of the museums in those two Old World cities it is common for people to exclaim over the fact that everybody in the streets has the look of a Frans Hals or a Greco. So with the Léger show: on leaving it, the pictures seemed to continue as one looked at the perspective of houses, the piling up of masses, the movement of figures.

Pach went on to remember an occasion when, trying to find a painting by Jacques-Louis David suitable for acquisition by The Metropolitan Museum of Art, he came upon the artist's *Death of Socrates*. Before sending a photograph of the painting to the Metropolitan, he showed it to Jacques Villon. Together, he says, they "marveled at the exactitude of the forms, their clearcut modeling and almost metallic finish. Villon remarked, 'Léger has some of that.' He has, and did he not possess as well something of the serious, even social, purpose implicit in David—the voice of the Revolution—my friend would not have been led to make the observation he did."[152]

One of the odder and most negative reviews of the exhibition at The Museum of Modern Art was by Lewis Mumford, in *The New Yorker*. While criticizing Léger for forgetting life "in the process of creating mechanical symbols," Mumford equally faulted him because his canvases did not reflect the latest developments in machine manufacture. Most critics saw and see Léger as a painter of hard, precisely drawn contours and of smooth slick surfaces that conceal the trace of the brush; but this is the myth. If a viewer takes the trouble to look, it becomes obvious that Léger was a painter in love with paint, and almost every canvas exhibits his enjoyment of it. He leaves *pentimenti* visible, edges are more often than not skewed, one side of a form is generally asymmetrical with the other, and large areas of bright, saturated color often cohabit with smaller patches of strange, pastel, bedroom hues. As Léger never tired of saying, his paintings are not copies of things in the visible world, but their equivalents *in paint*. Unlike many others, Mumford was apparently a visitor who took the trouble to look, but far from finding vitality in Léger's painterly touch, he found untidiness: "Léger's treatment of canvas and paint compare unfavorably not merely with machines but with the more patient craftsmanship of other painters. . . . A barn by [Georgia] O'Keeffe or an interior by [Charles] Sheeler has more of the spirit of the machine than many of Léger's more mechanical symbols." The virtue Mumford did discover in Léger was his "honest architectural intention. He has sought to give a painting the strength and impersonality of a good communal expression like a building . . . helping the eye of the architect and the ordinary spectator to look upon pure line, volume, and color as the essential ingredients of an architectural composition." Mumford's concluding paragraph opens with a sentence that may have startled its subjects: "If Le Corbusier is more of a painter than Léger, it is equally true that the latter is a sounder architect than Le Corbusier."[153]

Observations of Léger's work that the Paris-based American architect Paul Nelson would

make two years later parallel some of Mumford's, but lead him to less arid conclusions. He saw a new "spatial" quality in Léger's paintings, which, he said,

had left their frames to command the space around them even more than murals. It's possible—so to say—to measure the surface area of the wall that should exist around each one; what's more, there is a temptation to look at the surrounding space rather than the wall; . . . to turn one's back to the painting to see its reflection written in the space. . . . A painting of Léger's no longer wants a wall to hang on—it demands a room. One can't hang it just anywhere. Léger is making a true architecture necessary . . . he doesn't need dealers in paintings anymore, he needs architectural dealers.[154]

In the 1930s Léger's art was a focal point in hotly contested factional debates between those who insisted that for art to reach the masses, it must be representational and intellectually scaled down, and those who maintained a belief in the capacities and indeed the right of the public to enjoy the pleasures of modernism's aesthetic discoveries. Léger must have read Nelson's article, and could only have been gratified by its conclusion:

Léger is a kind of materialist. . . . he begins with the real problem of painting; he makes space come alive. And the more it does so, the more it is socially relevant. I insist on this point because it is so important now when we see a marked tendency to demand that artists incorporate propagandistic subjects in their work for the education of man. . . . Painting as propaganda is a bourgeois heritage, it's still easel painting.[155]

Léger's second visit to America lasted some five months, during which he attended the openings of his exhibition in its different venues, traveled with Herman, renewed old friendships, and tried to find remunerative work, especially in mural painting. The trips Léger and Herman took around the eastern United States can be partially documented in a series of cheerfully embellished postcards they sent from Chicago (fig. 14), Philadelphia, Pittsburgh, and Niagara Falls to the Murphys' second son, Patrick, then convalescing from the tuberculosis that would return to kill him the following year. Contrary to his early plans, Léger did not stay with the Murphys, although he was in frequent contact with them, as well as with the Sweeneys, the Alexander Calders, Dos Passos, Kiesler, and a variety of others.

In an amicable although annoyed tone, Léger wrote to Léonce Rosenberg on December 8 that several American sales had fallen through because the would-be buyers had told him they could purchase his works at lower prices in Paris. He then reported on the progress of his show: "I didn't want to do an exhibition for sales. I wanted to do one that would show my strongest paintings." Listing the show's itinerary, he added that Hartford and San Francisco would "without doubt" be part of the tour and that "the museums are bad vendors but there are lots of visitors who don't giggle!" At the end of the letter, Léger mentioned that he was finishing a portrait of "Madame Dale."[156]

When Léger wrote this letter, Hartford's Wadsworth Atheneum had just informed the Renaissance Society that it could not take the show. Léger's apparent confidence that the

14. Postcard from Fernand Léger (Chicago) to Patrick Murphy (Saranac Lake, New York), 1935. Collection Honoria Murphy Donnelly

exhibition would go to San Francisco must have been based on a wishful belief in the influence of Galka Scheyer. A German woman of entrepreneurial imagination, Scheyer operated in the United States—mainly from the West Coast—as a proselytizing dealer in the cause of modern art from 1924 until her death, in 1945. She had been in contact with Léger at least since the early 1930s, and may have been the intermediary in securing the large *Contraste de formes* (Contrast of forms, 1913; p. 165) for Walter and Louise Arensberg, and now in the Philadelphia Museum of Art.[157] Her efforts to secure Léger's 1935 exhibition for the Oakland Museum or one of two museums in San Francisco were politely rebuffed by the Renaissance Society on the grounds of her lack of official status at those institutions.[158] Léger, however, seems to have believed that if he could get to California, be seen in a prominent manner, and discuss the issue with Scheyer, his "pictures might go 'chez vous' after Chicago."

To this end Léger proposed organizing a "soirée" to be presented in Oakland, San Francisco, and Hollywood. According to this scheme, an entry fee of $1 would be charged for a program consisting of one of his lectures and a screening of three films—*Ballet mécanique*; *Entr'acte*, by Picabia and René Clair; and *Un Chien andalou*, by Salvador Dali and Luis Buñuel. Léger also asked Scheyer if she could help him get Charlie Chaplin's permission to produce an animated color film, to be called *Charlot Cubiste*, which he had been working on for the last two years.[159] In her response, Scheyer demurred slightly at Léger's notion of a dollar-a-head soirée, telling him that his method was unsure. Nevertheless, she would do everything she could to realize it. Such a project, she thought, would have to be supported by people from the film world, and she had accordingly already gotten in touch with Sternberg and Mamulien (*sic*).[160] With nearly equal alacrity she dispatched Léger's *Charlot Cubiste* scenario to Chaplin with the request that he authorize its realization.[161] From Rouben Mamoulian's secretary came a one-sentence reply: "As per your request, I am enclosing herewith the material referring to Ferdinand Legers [*sic*]."[162] When Léger heard that Chaplin's reply was equally unenthusiastic, he wrote Scheyer that he had suspected the possibility of a refusal and, verbally shrugging his shoulders, said, "Let's not talk about it any further." He had, however, still not lost his hopes for San Francisco, and asked Scheyer to keep up her efforts there.[163]

Mrs. Chester (Maud) Dale's commission to do the portrait Léger casually mentioned at the end of his letter to Rosenberg had seemed the herald of good things to come. Writing to Gerald Murphy in mid-November, Léger reported having made Dale the reasonable price of 15,000 francs, and hoped that the portrait would act as an inducement to further purchases. His more important news was, "Washington has okayed my working here on a collective decorative project . . . you see that things are developing favorably." [164]

By his own account, Léger enjoyed his American journey, but it did not bring the material success he was still anticipating when he wrote to Murphy. One of its greater ironies is represented by his portrait of Mrs. Dale. The trip may have been a marketing endeavor of the sort his profession has always required of its practitioners, but also invested in it was his deeply

45

held desire to create mural paintings that would bring modern art to a wider public. By the end of his stay, however, the one commission that had been realized, and that had materially supported him, was the Dale picture—the only portrait in the career of this artist whose personal manifesto had always held that painting could never be judged by its likeness to anything in the real world. It is hard to resist wondering why Dale, a sympathetic follower of Léger's work, and surely aware of the widely quoted remarks from his Museum of Modern Art press conference in October—"I have seen many beautiful women, but I have never seen a beautiful painting of a beautiful woman. But you can take an ugly woman and make a beautiful painting of her. It is the painting itself that should be beautiful"—came up with the idea of asking Léger for her portrait.[165]

Léger's optimism about the opportunities he might find for mural painting in the United States was justified by the amount of American interest in the issue at the time. Several projects came his way, but went unfulfilled;[166] his involvement with the creation of a mural for the pier of the French Line Shipping Company in New York Harbor, however, touches on later American art in a way that merits its inclusion here. Authorized by a committee of the Works Progress Administration that included Sweeney,[167] Léger was to create a vast mural environment for the pier in collaboration with the young U.S.-based artists Harry Bowden, Byron Browne, Mercedes Carles, Willem de Kooning, and George McNeil.[168] Léger apparently did considerable work on the project, which by most accounts was definitively ended when a director of the French Line objected to Léger's left-leaning politics.[169] Whether its demise was quite so clean is put into question by a letter of Léger's dated March 9, 1936, to Herman, who had left New York some five weeks previous; from shipboard two days into his return trip, Léger wrote, "The French Line project is done. I found some young collaborators [who weren't] bad at all—a tremendous excitement—it was touching and intensely felt."[170]

In 1997 Bill Berkson, reviewing an exhibition of the late work of de Kooning, reported that Léger's erstwhile young collaborator had "learned the manners of the democratizing, professional worker-in-art from Léger." And he quoted de Kooning: "His collar was frayed but clean. He didn't look like a great artist; there was nothing artistic about him. . . . You got the feeling from Léger that to be an artist was as good as to be anything else."[171] Berkson then gave this assessment of their connection: "Together with Mondrian, Léger is poignantly visible in the bright primary bands and akimbo arrangements of certain late de Koonings." In at least one of these, Berkson saw "the gaiety of vintage Ultramodern styling brought to a feverish edge."[172] Berkson implied no specific allusions to Léger in de Kooning's late paintings, but his insight stimulates a speculative observation of a representative Léger study for the French Line mural (fig. 15) in tandem with a representative late de Kooning (fig. 16).

If, as de Kooning remembered, Léger's collar was frayed, perhaps it reflected the state of his affairs. On February 3, 1936, he told Herman that there was very little to encourage him—although there were some possibilities, he was not "the man for perhaps." He also complained

of his difficulties in putting his hands on $1,000 or even $500.[173] Shortly thereafter Léger received a letter from Le Corbusier complaining that he had come back from New York with his pockets empty and was now embroiled in difficulties with Philip Goodwin of The Museum of Modern Art.[174]

Only a few days before Léger's March 7 departure from New York, Barr's historic exhibition *Cubism and Abstract Art* opened at The Museum of Modern Art. Described in the catalogue as living "in Paris with frequent visits to New York," Léger was represented by five canvases, as well as by the film *Ballet mécanique*, photographs of his curtains for the ballet *La Création du monde*, and a rug.[175] The same year, C. J. Bulliet published his own account of modernism in his book *The Significant Moderns and Their Pictures*, which classed the subjects of his investigations under such chapter headings as "The Giants," "Solitary Rebels," "The Minor Aristocracy" (the category assigned Léger), "The Women," and "The Rank and File."[176] The superficial and frankly popular address of Bulliet's book had little in common with the intellectual force and sophistication of Barr's catalogue for *Cubism and Abstract Art*, but the thinking of the two authors did display a measure of agreement. As in *Painting in Paris from American Collections* in 1930, Barr set up a hierarchy of representation, allotting the acknowledged Cubist masters Picasso, Braque, Gris, and Léger twenty-six, eight, six, and five works respectively. Although somewhat more subtle than Bulliet, Barr too seemed to feel that Léger's proper place was with the lesser nobility.[177]

15. Fernand Léger. **Study for the French Line Shipping Company mural, c. 1935–36. Gouache, silver leaf, and pencil on paper, 11 x 31¼" (28 x 79.5 cm). Collection Johnson S. Bogart**

Barr's text in *Cubism and Abstract Art* was the trigger for Meyer Schapiro's now famous essay "The Nature of Abstract Art," published in *The Marxist Quarterly* in 1937. Léger had met Schapiro during his stay in the United States and the two had liked each other immediately.[178] While it is most unlikely that Léger, whose English was close to nonexistent, would have read Schapiro's essay, it is equally unlikely he and Schapiro would not have discussed their common concerns about the social role of art. Schapiro's view that art-historical accounts of the formulations of new styles and movements should seriously weigh the societal conditions within which such changes occur would have interested Léger intensely. Far less naive than Léger about the potential of architecture and painting to introduce social change, Schapiro nonetheless understood Léger's need to believe in these art forms' potential to lead to "a new order in life." Dramatizing his argument in "The Nature of Abstract Art," Schapiro concluded, "'Architecture or Revolution!' That was in fact one of the slogans of Le Corbusier, the architect, painter and editor of the magazine *L'Esprit Nouveau*."[179]

16. Willem de Kooning. *Untitled XV*, 1982. Oil on canvas, 70 x 80" (177.8 x 203.2 cm). Private collection

The two and a half years between Léger's departure from America in 1936 and his third visit, beginning in late 1938, were full of hectic politics that often involved him in debates about the kind of art that could best communicate with the working class. The 1937 *Exposition Internationale des Arts et Techniques dans la Vie Moderne* in Paris provided him with several opportunities to make mural paintings that would demonstrate his views. Like the

mural he would later design for Consolidated Edison's exhibition at the 1939 World's Fair in New York, those of 1937 refuse any concession to social realist orthodoxy. Boldly modernist, they show Léger's crusading belief in the imaginative capability of the masses.[180] "To want to say to these men 'the modern is not for you, it's an art for the rich bourgeois,'" Léger said, was "monstrous."[181]

However much the idealist in Léger yearned for a best-of-all-possible-worlds in which his art would function as a comforting collective armchair to its mass viewers, the painter and pragmatist in him did not refuse invitations to practice his profession. In August of 1938, then, Léger sent Herman some news: "Ten days ago I had lunch with [Wallace K.] Harrison, Radio City's architect and also [Nelson A.] Rockefeller's, with Mrs. Callery. 1°) From this, decorative project for Nelson Rockefeller's apartment. I have the maquette and the plans—4,000 dollars, it may work—very supported by Callery. 2°) . . . The director of an American university will visit to talk about a three month long course concerning architecture and mural painting . . . o o o ! Ah! Ah!: So, trip to New York stay 3 months with a studio at my disposition o o o! Ah Ah Ah."[182]

The three people Léger names in this letter were to be substantially involved in his future activities in the United States. It is unclear when and through whom Léger first met Harrison. An undated letter to Le Corbusier, which he must have written during his first visit to New York, in 1931, suggests that he was then not yet acquainted with the American architect; Léger wrote, "I learned this evening that Harrison will continue with Radio City . . . will there be place for some kind of decorations in it? Can you drop him a word about this and arrange an interview after my return from Chicago?[183] There are, however, accounts placing their initial meeting somewhat earlier than 1938.[184] What surprises in such speculation is the date. Harrison's support of Léger was unstinting but it does not appear to have begun before the late

48

1930s, when he recommended the artist to Nelson Rockefeller. Thereafter Léger and the architect became close friends and, as much as possible, collaborators.

Harrison pushed Léger's idea for a "cinematic mural" for Radio City as far as he could, but in the end—by February 10, 1939—he lost to an art committee appointed by Nelson Rockefeller's conservative father, John D. Rockefeller, Jr.[185] Seven gouaches survive from this project, showing the Statue of Liberty and New York Harbor; these are the only works Léger ever made that include any elements specifically identifiable with the city (fig. 17).[186] In 1938, when Nelson Rockefeller commissioned Harrison to design a guest house at his family's compound in Pocantico Hills, the architect brought Léger into the project. The eight lectures that Léger gave at Yale in late 1938, on "the interaction of color and architecture," also resulted from Harrison's initiatives. Léger's two realized opportunities to make public murals in America—the 1939 Consolidated Edison commission and the 1952 United Nations installation—came about through Harrison. Besides the project in Rockefeller's New York apartment, the only other private mural painting Léger would do in the United States was for Harrison's own dining room in his home in Long Island.[187]

A thorough account of the Rockefeller murals has already been provided by Simon Willmoth, whose assertion, however, that they were painted outside the apartment, in a studio,[188] does not jibe with Rockefeller's recollection:

Wally [Harrison] designed two fireplaces in the living room with space for great murals around them, and our friends Henri Matisse and Fernand Léger accepted commissions to undertake murals. Matisse did the mural in Paris from full-scale drawings of the fireplace, but Léger came over to New York and actually did the painting in the apartment. I used to watch Léger with fascination as he painted and the details of the mural unfolded. After he had finished, we liked it so much that we persuaded him to do additional murals for the circular stairwell and the hallways. . . . Léger was a wonderful human being, we remained friends until his death.[189]

17. Fernand Léger. Project for a cinematic mural (never executed) for Rockefeller Center, New York, 1938–39. Seven studies for a proposed moving mural to be projected on a marble wall. Gouache, ink, and pencil on cardboard. Five 20 x 15" (50.7 x 38 cm); two 20 x 16" (50.7 x 40.5 cm). The Museum of Modern Art, New York. Given anonymously, 1966

Léger's appreciation of Rockefeller and Harrison was as keen as theirs of him. A brief collection of impressionistic descriptions of his life in New York in 1938–39 concludes,

In my five months in New York, I came to appreciate two Americans, two young men. . . . Nelson Rockefeller junior, the man "responsible for Radio-City," and his architect and friend Wallace Harrison . . . I was able to see them moving, acting, working around me. Their kindness, their tact in the middle of their tentacular telephones that they succeed in subduing. Just the right amount of time that they know how to give to worthwhile issues—not more not less. In no way are they machines, on the contrary, new men, clean, clear, precise, exact like "the atmosphere" they breathe.[190]

Mary Callery, whose encouragement of the Rockefeller project Léger had mentioned to Herman, was an exceptionally discriminating collector and a distinguished sculptor in her own right. An American resident in Europe, she would buy Léger's monumental painting *Composition aux deux perroquets* (Composition with two parrots, 1935–39; p. 233) in April of 1940, just as the "phony war" in Europe began to get hot. Her acquisition of this painting, which Léger regarded as one of the masterpieces of his career and the beginning of the directions his art would take in the five wartime years he would spend in America, had the immediate effect of alleviating some of his worries. Its purchase was, he declared, a "miracle! And it was time, since [my] dollars were beginning to evaporate!"[191] Callery had a one-day showing of the painting in her Paris studio before sending it off to New York for exhibition at The Museum of Modern Art. She would assist Léger with occasional purchases of his works throughout the war, and Léger clearly held her in affectionate regard, often sending her postcards ostensibly from members of the Parrot family (fig. 18).

18. Postcard from Fernand Léger to Mary Callery, postmarked Oakland, Calif., July 21, 1941. Private collection

Almost immediately after arriving in New York in late September of 1938, Léger spent two days visiting with his friend Alexander Calder. The two had first met in October of 1930, when Kiesler had prompted Calder to invite Léger, Carl Einstein, Le Corbusier, Piet Mondrian, and Theo van Doesburg to a performance of his circus.[192] The personalities of Léger and Calder were unusually empathetic, and each admired the other's work. In the catalogue of a Calder exhibition held in Paris in 1931, Léger had poetically equated Calder's sculptures with the music of Erik Satie, writing that for him they evoked "Mondrian, Marcel Duchamp, Brancusi, Arp. . . . Calder is in that line, he's American 100/100. Satie and Duchamp are 100/100 French. Why not meet?"[193] The regard these two held for the other was evident in several exchanges of works; when, after Léger's death, that was no longer possible, Calder from time to time purchased a work by the older artist that particularly struck him.

In November of 1938, a Calder exhibition in Springfield, Massachusetts, provided an occasion for many old friends to celebrate together. Alerting its readers to the event, a local paper advised, "During the evening Fernand Léger of Paris, France will give a short informal talk on the exhibit," and noted that "Mr. and Mrs. James Johnson Sweeney will drive to

19. Left to right: Louisa Calder, Aino Aalto, Cordelia Sargent Pond, Katherine Dreier, Siegfried Giedion, Alvar Aalto, Alexander Calder, and Fernand Léger at the opening of the Calder exhibition at the George Walter Vincent Smith Art Gallery, Springfield, Mass., 1938. A similar photograph taken on the same occasion was published in *The Springfield Union*, Wednesday, November 8, 1938, p. 6

Springfield from New York with a group of friends."[194] The next morning the same paper displayed a photograph of some of the party's formally clad guests, with the caption, "Among those at the dinner given last night in the Colony Club . . . prior to the opening of Alexander Calder's sculpture were left to right Mrs. Calder; Mrs. Aino Aalto, architect and designer of renown . . . ; Mrs. Pond [the hostess]; Miss Katherine Dreier, American painter known for her abstractionist art; Mr. Calder; Prof. Sigfried Sgiedeion [*sic*], a Swiss well known for his writing on art subjects; Fernand Léger, who with Picasso promoted cubism and who as a painter has exerted a great influence on present-day art in his native France and in this country; and Alvar Aalto noted Finnish architect and designer . . . of Finland's building in the Paris World's Fair of 1937" (fig. 19).[195]

Léger's 1938–39 American expedition fulfilled his expectations in a more satisfactory manner than had its mid-'30s predecessor, yet the failure of his Radio City "cinematic mural" project has to have been a keen artistic and financial disappointment. In an undated letter written on postcards of the 1939 World's Fair, Léger told Le Corbusier that he had no idea when he would be returning. His imprecision seems to have been linked to anticipated work. "For me," he reported, "everything is going very well here." The "*gros truc*" for Radio City was difficult, but he very much wanted to complete it. And his remark "At Harrison's I am allowed to look at everything he's doing for 'l'expo' [the New York World's Fair of 1939]" can be read as a none too veiled optimism about his own prospects. In all probability Léger's letter dates to early February of 1939.[196] His return to France by the beginning of the following month would suggest that his disappointment came quickly, and permits speculation that he was taken somewhat unawares.

Léger was writing to Le Corbusier not to impart his own news but to report on two missions he had agreed to undertake for his friend. The first was an affair that had been going on for over three years. After the closing of Le Corbusier's 1935 exhibition at The Museum of Modern Art, the Museum had kept his model for the Palais des Soviets, but had not yet compensated him for it.[197] Léger too made little headway, for he wrote, "What had to be done has been done. But don't forget that I am in the country of slowness— . . . Everything is weighed and well-considered and calculated as soon as an affair involves more than 10 dollars. I'm going to tickle Bar [sic]—since Nelson is lost in a sea of business."

Léger's second task on behalf of Le Corbusier was to attempt to turn Hilla Rebay's thoughts in his friend's direction as she contemplated suitable architects for Solomon Guggenheim's museum. Reporting on his efforts, Léger sounds aggrieved by Le Corbusier's too hasty behavior: "Saw the Baroness. You shouldn't have written. When I spoke with her, she told me with a superior air, 'Yes, I have a letter from Corbusier.'"

By September of 1939, six months after Léger's return to Paris, France was again at war with Germany. Early on, the war was more theory than fact: only half worried, Léger wrote Sara Murphy in October that thanks to friends in high places, he might be appointed director of camouflage, or perhaps minister of propaganda in a neutral country, and in December he let her know that he was still awaiting the call to camouflage France.[198] In another six months, though, German troops advancing from Flanders had forced him to join the panicked crowds fleeing south. Writing to the Murphys from Vichy in September, he said, "If I manage to get to you, I will tell you about our departure . . . life on the road and the battle of trains," on a more upbeat note adding, "If nothing else works out, then one could camouflage American airplanes, boats, clouds, Radio City etc."[199] The ever dependable Murphys had already cabled him funds, and Léger's last American expedition was underway.[200]

On November 12, 1940, Léger reached Hoboken, New Jersey, one of the first to arrive of the many European artists and intellectuals who would spend the war years in American exile. Léger's previous visits had earned him a certain status as a person of interest, and a few weeks later *The New Yorker*, in its "Talk of the Town" section, devoted nearly three-quarters of a page to his doings. Under the heading "Muralist," the magazine's roving editor reported,

When we heard at a dinner party . . . that the French painter Fernand Léger was living at the University Club and that he was trying to rent an unoccupied church as a studio, we looked him up at once. In sober fact Léger is now living and working at 328 East Forty-second Street, where a friend, Herbert Matter, a photographer, is sharing his studio with him, but the report about him was not without basis. On his arrival a few weeks ago, he was put at the University Club by Philip Goodwin, the architect; he left after a week or so, however, without once dropping in at the squash courts. Moreover, he did look around for a church for a while, but gave up. Léger, who is fifty-nine, seems much the same as on his past visits here—rugged,

ruddy, gentle and full of curiosity. . . . He likes shooting galleries, marionette shows, and the photomicroscopic enlargements of tiny under-sea animals in the Museum of Natural History, which he has used in some of his paintings. He considers Fourteenth Street the most beautiful thoroughfare in New York.[201]

At almost the same moment that the *New Yorker* article appeared, Léger wrote to his wife, Jeanne, that he had been staying at "*le Club,*" which was free and comfortable but impossible to work in. His most significant news was that he had been engaged to teach at the college "where Darius is."[202] Léger's reference was to his old collaborator on *La Création du monde,* Darius Milhaud, who was then teaching at Mills College in Oakland, California. In late May, just before going to California, Léger wrote to Le Corbusier describing his life and work in the United States:

I am working a lot. Perhaps the imagination itself is more creative and rapid here. . . . Interest in painting is still enormous here = of course, a very comfortable atmosphere for a guy like me—but the old Norman is always there and the grass just isn't the same here—at my age one can no longer assimilate . . . in spite of good friends, and a pleasant milieu which goes from the [José] Serts to Calder to Sweeney and a number of others. . . . Personally lots of work. Around a dynamic element, "*les Plongeurs*" is freer and more violent than the "*Perroquets*" you saw in Paris. I'm in a fight with the human body and pure color.[203]

Léger's grandest geographical experience of America came in crossing the continent from New York to San Francisco to begin his summer teaching at Mills. He tried to describe it to Herman: "One of the most beautiful memories of traveling will be my bus trip—Texas and Arizona. Monumental. . . . It's as big as New York but part of nature. In an oven of heat, you would have screamed, yelled before an epic parade of giant cactus, rocks, sand, oil wells in perspective, and plants balancing like the sexes of horses and around that, violent odors that change every ten miles. . . . And some clouds rolling in the blue above."[204]

Léger's impulse toward American peregrinations had always been stimulated by openings of his own shows; in this regard 1941 kept him quite busy. Before leaving for California, he had made a quick New York/Chicago round trip for an exhibition, organized by the Arts Club, that subsequently went to Mills College, the San Francisco Museum of Modern Art, and then, circulated by the Western Association of Art Museum Directors, to southern California and other parts of the West Coast. Coinciding with Léger's summer semester of teaching, the exhibition's first venue at Mills provided the artist with time to develop the "*Plongeurs*" (Divers) series that he had described to Le Corbusier; without a studio, however, and living in a dormitory room, Léger had to confine himself to drawing. The basic exhibition consisted of one painting—the enormous *Composition aux deux perroquets,* owned by Callery—and twenty-four works on paper. When, however, it moved across the bay to San Francisco, it was enriched by twenty new drawings of *plongeurs,* as well as by other works borrowed from collectors in the area. Reviews were for the most part politely superficial, but one enthusiastically noted, "His 'Divers'

series, which incidentally is being shown for the first time, is thrilling stuff. Something, maybe it is America, has happened to the renowned M. Léger. His designs are looser, more sinuous."[205]

When the exhibition reached the Stendahl Galleries in Los Angeles, Léger was on hand and able to compensate for his vain efforts of five years before—finally giving a lecture and accompanying screening of *Ballet mécanique* before California audiences. Members of the press were in general warmer about the exhibition than their northern colleagues had been. After asserting that Léger's "pen and ink drawings of the figure" were "as masterly and fluid as those of Rodin and Matisse," Kenneth Ross in the *Pasadena Star-News* reported the results of an interview with Léger. Questioned about American painting, "his expression . . . went indifferent, almost blank until he exploded with admiration . . . for the men who painted the American scene during the middle of the 19th century . . . Inman, Bingham, Audubon and Catlin. . . . Léger then went on to deplore the European influence which followed this native art and from which America is only now beginning to recover. He holds great faith in the future of American art."[206]

For anyone who had ever cared about painting in America, Ross's inquiry would have had particular relevance in the early 1940s. The old issue of whether American artists could or should convert European modernism to their own ends had embroiled aesthetic debate at least since the Armory Show, but with the sudden presence of émigré European artists in the United States during the war years it took on a broader and sharper edge. The future of American art had long preoccupied only a small group; now it was suddenly an issue of national prominence. In December 1941, *Fortune* used a Léger work for its cover, and ran a long section on "The Great Flight of Culture." Pointing out that no suitable melting pot existed for the new immigrants, nor were there any naturalization laws applicable to art and ideas, the article reaches the conclusion that "for better or for worse [America] cannot escape European influences more powerful than those exerted by the mere transatlantic interaction of past generations."[207]

The *Fortune* article coincided with Sidney Janis's article "School of Paris Comes to U.S.," published in the European/American review *Decision*. Separately interviewing Léger and Mondrian, Janis recounted that, independently of each other, both artists had found that they had been working more rapidly in the United States than abroad, and that the mood and rhythm of the American environment had inspired a new vitality in their work. In light of this experience, Janis asked Léger why so many American "abstract painters lacked the inventive and provocative qualities to give their work substance." Léger's reply—that "the environment was also very decorative and that it was necessary to see through this superficial aspect"—was more anodynic than analytical.[208]

Several years later, in a 1946 interview published in *Les Lettres françaises* to celebrate his return to France, Léger was as optimistic about the future of American painting as he had been with Ross, and considerably more thoughtful than in his response to Janis. The European influence, he said, had effected a rupture, and he foresaw the development of young American

painting in a fusion of the spirit of American primitive painting with the lessons of the School of Paris. Further on, responding to the question of the U.S. reception of his own art, Léger said, "A whole American elite is nostalgic for that which is not American. That elite accounts for the success of our trans-Atlantic art."[209] This remark hit on a trait peculiar to America that many of its citizens thought had been hobbling its art for years. Thomas Craven, a conservative critic whose fulminations about America's "everlasting kow-towing to the French" did not obscure some clarity of vision, put the matter this way: "Art in America is an affectation of caste. It has ceased to be work and has become genteel behavior; it has ceased to function as a social need and has become the property of dilettantes."[210]

If an American elite had indeed welcomed Léger, the Justice Department was less hospitable. During the summer he spent in California, Léger's application for an extension of his visa was pending, and he had enlisted Nelson Rockefeller and Archibald MacLeish, then Librarian of Congress, to vouch for him. Whether owing to their intervention or not, the extension was granted. News of this appears to have reached Léger in September, when "Fernando de Californie" sent postcards to the Murphys announcing, "Departement Justice! accords me six months but forbids selling paintings or opening a school!! Charming." Despair, however, seems to have been remote, as he immediately added, "Curious phenomenon this Hollywood. It is something without dimensions, elastic where a few 'copains,' me included, discuss things—saw Clair—Renoir Stravinski (magnificent Dürer with French wines) we could have believed we were in Versailles!"[211] (fig. 20).

20. Postcard from Fernand Léger to Gerald Murphy, sent in an envelope postmarked Carmel, Calif., September 22, 1941. Collection Honoria Murphy Donnelly

Shortly after getting back to New York in October of 1941, Léger wrote Alfred Neumeyer, director of the Mills College Art Program: "Being interested now mostly in big canvases, . . . requiring much more concentration . . . I realize that New York is less the proper place. . . . I am just thinking that the best solution would be a teaching in any college or university for the whole year . . . [this] is a very important thing for my future life in the U.S.A."[212] Neumeyer applied to some seven institutions from the East to the West Coast on Léger's behalf; whether from aesthetic and political conservatism or negative assessments of the candidate's English, the responses were all negative.[213]

Léger himself had to find adequate spaces in which to work, and did so, but none of them was long-term; jokingly but in earnest, he asked Calder in September 1944, "Do you know of anything—it doesn't matter where? One big room—would work. Empire State is offering me its 60th floor—lease 3 years and Pan Am."[214] When in Paris, Léger worked from 1913 until 1955 in the same Montparnasse studio. It is difficult to imagine that the relatively nomadic conditions of his American exile did not trouble him, yet he managed to produce well over 100 paintings during the five years it lasted.

The work Léger executed in America divides into three main segments, in more or less chronological groupings by order of inception: "*Les Plongeurs,*" with related groups of acrobats and dancers; the Rouses Point landscapes; and the "Cyclists." The possible origins of the "*Plongeurs*" in Léger's experience of watching swimmers in Marseilles, and in Meyer Schapiro's introduction of the artist to the Beatus Commentary, have been extensively discussed elsewhere.[215] A considerable literature likewise exists on the landscapes showing abandoned farm machinery entangled with vegetation that were inspired by Léger's summers in an old farmhouse at Rouses Point, near Lake Champlain, New York, as well as on the succeeding "Cyclists" series.[216] Within less than a year of his return to France, where he arrived at the beginning of 1946, Léger's thoughts on his American paintings were published in *The Museum of Modern Art Bulletin:*

Near Lake Champlain . . . I was even more struck by the broken down farm-machines I would come across abandoned in the fields. For me it became a typical feature of the American landscape, this carelessness and waste and blind and ruthless disregard of anything worn or aged. . . . most notable . . . in the work I have done in America is . . . a new energy—an increased movement . . . as in the *Plongeurs.* . . . For me the contrast in the United States between the mechanical and the natural is one of great anti-melodic intensity. But bad taste is also one of the valuable raw materials . . . it is all here for the painter to organize and get the full use of its power. Girls in sweaters with brilliant colored skin; girls in shorts dressed more like acrobats in a circus than one would ever come across on a Paris street. If I had only seen girls dressed in "good taste" here I would never have painted my Cyclist series, of which *La Grande Julie* in the Museum was the culmination.[217]

Although solidly supportive of Léger, The Museum of Modern Art made its only material contribution to the well-being of the now famous but still chronically impecunious artist when it purchased *La Grande Julie* (Big Julie, 1945; p. 243) in 1945. Its acquisition of *Le Grand Déjeuner,* in 1942, had had the effect of making one of Léger's great masterpieces available to the public view, but the funds that bought the work went into the pockets of the dealer Paul Rosenberg. Léger was represented occasionally by the Buchholz Gallery, New York, and by the Paul Rosenberg Gallery, now transplanted to New York, and his steadier New York dealers were at this point Germain Seligman and Valentine Dudensing. Their sales were insufficient to provide him with a secure income. In each of the five years Léger spent in America, he was the subject of at least two solo exhibitions; yet the contents of his wallet did not keep pace with his growing fame. There were always loyal friends who could be counted upon in emergencies, but Léger's financial situation was in precarious balance during most of his stay.

Outside the three main groups of paintings that were executed in America is the single masterwork *Les Trois Musiciens* (Three musicians, 1944; p. 242). Studies for *Les Trois Musiciens* go back to a drawing of 1924–25. After seeing Picasso's work of the same title, Léonce Rosenberg had warned Léger in 1925 that it was so powerful, Léger would have to deliver an equiv-

alent "knock-out punch" to retain any hope of staying in the ring with the Spaniard. In the dealer's opinion, a drawing of musicians Léger had made the year before could be elaborated to meet the challenge.[218] Whatever Léger may have thought about Rosenberg's judgment, he did not act on this advice until 1944.

Since Picasso's *Three Musicians* and Léger's *La Ville* had been hanging together in Gallatin's Gallery of Living Art since 1937, Léger would have seen his work in proximity with Picasso's on several occasions. And in 1943, when the Gallatin collection was transferred from its longtime quarters at New York University to the Philadelphia Museum of Art, Léger, along with Duchamp, Mondrian, Amédée Ozenfant, and others, attended a gala opening lunch there, on May 14 of that year. Philadelphia's *Evening Bulletin* reported public interest to be so great that "some of the fans even stood in line hoping to get a glimpse of some of the international celebrities such as Marcel Duchamp" and "the dynamic Fernand Léger. . . . Standing before his eight foot high painting called 'The City' he dominated the preview. . . . Only Picasso's painting 'Three Musicians' hung across the gallery on an opposite wall seems able to compete for attention."[219] If an American journalist could catch a whiff of competition in the air, it is likely that the veteran French painter sensed it also. Without further speculation on the spirit that moved Léger to produce his magisterial *Trois Musiciens* in 1944, it is safe to assume that its eventual disposition would have especially interested him. By 1955, the galleries of The Museum of Modern Art could furnish the ring in which Léger's *Trois Musiciens* and *Le Grand Déjeuner*—retitled by Barr *Three Women*—could face off with Picasso's other version of *Three Musicians* and his *Three Women at the Spring*.[220]

In the year Léger finally executed his *Trois Musiciens*, he was invited by Hans Richter to collaborate along with Calder, Duchamp, Max Ernst, and Man Ray in making the film *Dreams That Money Can Buy*. That August he sketched out his ideas for his segment of the film to Richter: "My notion is to do something with the kind of mannequins of brides there are on Grand Street and some other things from the Jewish quarter on Avenue B."[221] Léger followed up on this idea, and his contribution to the film, "The Girl with the Prefabricated Heart," utilized props culled from the shops of downtown Manhattan. In April of 1946, shortly after his return to France, Léger explained that in making *Dreams That Money Can Buy*, he and his collaborators had, in a "French spirit," banded together in New York to revive a kind of fantasy in film that Hollywood had banished.[222]

"French spirit" took on a new urgency after the liberation of Paris, on August 25, 1944. Busy with various projects and exhibitions, however, Léger seems to have been in no hurry to leave New York. In May of 1945, he wrote to Louis Carré, who had gradually taken over as Léger's principal dealer in Paris, "I can't complain about my stay here. I've been able to renew myself entirely."[223] Almost in passing he added that he had been able to buy some 200 blankets and other necessities for war-deprived people in Normandy. In fact Léger had initiated this project with his friend Maurice Gagnon, the art historian and critic whom he had met

through his 1943 exhibition in Montreal, and it would drag on from April through December of 1945 before any goods could actually be sent.[224] The only allusion made in the letter about his own return to France is the rather vague salutation, "I hope to see you soon."

Complicating whatever plans Léger might have wished to make were his difficulties in trying to obtain a return visa. By August of 1945 he was thoroughly exasperated with the matter. Writing to Le Corbusier, he said he had been waiting for three months, and had even visited the French ambassador, to whom he had given a gouache. He had not pressed the issue, however, because a mosaic project for Indianapolis had appeared to be his—but "like so many others seems to be quietly fading away." His new idea was that Le Corbusier should support his petition by declaring to the authorities that he could not complete any project without Léger as his "color assistant."[225] Whatever turned the bureaucratic wheels, the visa was granted, the mosaic project fell through, and by the end of December 1945 Léger had left for France with five crates containing some 57 paintings and 125 works on paper he had made in America.[226]

In 1915 the young Léger, anticipating his return to Paris from the front, had wanted to "gobble up" the city, "to fill his pockets" with it. In 1946 an older Léger was possessed by a more gentle urge. He wrote about his rediscovery of the walls of Paris, and of France, in language that recalls nothing so much as his love letters to Herman: "The American wall," he says, "is a geometric abstraction—an obstacle. . . . here, it's round, curved, half-curved, it turns, it's velvet, if you caress it you go on feeling it on the ends of your fingers." The social attitudes of the older Léger had changed as well, and he contrasted the multiplying technological advances that were making destruction more and more efficient with the forces of creation, which moved at the same pace they had in the Middle Ages—"You still have to wait nine months for your kid, a tenth of a second and you're annihilated."[227]

Within months of Léger's arrival in Paris in January 1946, the Galerie Louis Carré showed a number of his American paintings. The Parisian press almost unanimously confirmed the earlier judgments of American critics, and of Léger himself, that his work showed a renewed vitality. Typical is André Warnod's review from *Le Figaro*: "Fernand Léger is showing some paintings he brought back from America at Louis Carré's. They mark a step in the evolution of the artist and are an enrichment of his work and French art. His painting has become more direct . . . almost more realist and more intensely colored. . . . Reds, blues, yellows, greens spread across his canvases without being imprisoned within the contours of figuration."[228]

Léger had been running his own painting academy with various collaborators since the early 1920s, and back in Paris he almost immediately resumed teaching. Sometime around 1948, his school was officially recognized by the American authorities who dispensed G.I. Bill stipends, and for the next few years it was one of two or three principal destinations for a new generation of American artists looking for inspiration in Paris. Individual as they are, the comments of Al Held, who enrolled in a rival academy in 1949, show attitudes about Léger shared

by many of his ex-G.I. contemporaries. "At the time," Held relates, ". . . I went to a couple of his crits and disliked him immensely. . . . Sam Francis was a student of Léger. . . . I'm a great admirer of Léger. It's interesting that when I had the chance to study with him or see him or be connected with him in some way I absolutely couldn't stand him, couldn't abide his things. And now I just feel like I'm sitting in his lap."[229] Francis didn't have Held's antipathy for the older painter, but shared little aesthetic agreement with him. He later recounted that he had liked and respected Léger but when he asked for criticisms of some of his own paintings, the *maître*'s response had been, "Well, I can't criticize that. It is what it is. I don't like it very much but it is totally what it is. It has nothing to do with what we teach here."[230] Léger's remarks show his recognition of the authenticity of Francis's work just as they flatly refuse any association with it. For his part, Francis and most of his American peers found nothing that they seemed able to use in either vintage or contemporary Léger.

Throughout the 1950s, Léger's art appeared relevant to the predominant styles of painting in the United States in the same ratio that he thought obtained between his teaching and Francis's paintings. In the next decade the balance shifted when Pop art annexed the old master of machine imagery to its family tree. Since then, associations of his work to that of Roy Lichtenstein, Andy Warhol, Tom Wesselmann, and James Rosenquist, among others, have become so routine that the wider scope of his direct and indirect influence has often been obscured.

The genius of any artist must to some degree lie in an ability to convert the ideas of others to his or her own ends. Picasso, the acknowledged champion of twentieth-century aesthetic thievery, tended to prey on the individual artist; Léger was more of a buccaneer, plundering collectively. As John Golding has observed, "No other major twentieth-century artist was to react to, and to reflect, such a wide range of artistic currents and movements. Fauvism, Cubism, Futurism, Purism, Neo-Plasticism, Surrealism, Neo-Classicism, Social Realism: his art experienced them all. And yet he was to remain supremely independent as an artistic personality."[231] Léger's uniquely broad-based appropriation and assimilation of his era's principal visual discoveries resulted in an art of generous potential to those sharp-eyed enough to see it.

The stylistic diversity among the artists who admit a debt to Léger is as surprising as his own ability to meld Cubism and Social Realism. At random, and beginning with his former students, there is Robert Colescott ("I've been a robber"[232]); Louise Bourgeois ("Léger turned me into a sculptor"[233]); and the sculptural witness of Richard Stankiewicz. Outside his students, among those who have testified to his importance are Richard Lindner, Arshile Gorky, and de Kooning. Speaking about an experience shared with the generation that came of age in late-1930s New York, Philip Guston recalled going to the Gallery of Living Art: "It was the most provocative and stimulating permanent collection in N.Y. at that time. [Among the specific works important to me were] Picasso['s] . . . *Three Musicians* and the large Léger *The City*. The Gallatin collection caused me to change and evolve my whole conception of painting then. Most crucially." Milton Resnick's account complements Guston's: "I especially

21. Brice Marden. *11 (To Léger)*, 1987–88. Oil on linen, 84 x 60"
(213.4 x 152.4 cm). Collection Linda and Harry Macklowe,
New York

liked Léger's *The City* because it seemed to me that was the way to paint living in New York where there is no perspective and every corner was an encounter or experience never a sky or horizon."[234]

Looking at Brice Marden's 1987–88 painting *11 (To Léger)* (fig. 21), the critic Brooks Adams concludes that Marden's homage should be associated with Léger's complete oeuvre, not simply the "classic Cubism" it most closely resembles.[235] If we look at some representative Légers—*Contraste de formes* of 1913 (p. 164), *Élément mécanique* of 1924 (p. 203), *Les Plongeurs* of 1941–42 (p. 239), and *Les Constructeurs, état définitif* of 1950 (p. 257)—in juxtaposition with the Marden homage, it becomes clear that Adams is right. Marden's painting, like these four, performs the legerdemain of presenting a pictorial structure that reads simultaneously as volumetric and planar. Léger's finesse in making flatness and solidity cohabit accounts for his unique ability to straddle opposing lines in the century's endless quarrel between figuration and nonfiguration. Even formalism's high priest, Clement Greenberg, conceded that methods he might have been expected to deplore had some virtue when he wrote of Léger's art in the Paris magazine *L'Age Nouveau* in 1949,

It is the conflict between on the one hand his reluctance to abandon volume, mass, and sculptural form and on the other the energy he devotes to that endeavor in his art that creates continual drama in the painting of Fernand Léger. . . . Up to a certain point, he is ready to abandon . . . "pre-cubist" space, but he can't do without relief. He tries to compromise. . . . The shadows that give volume to cylindrical forms . . . are applied in ribbon-like, regular bands to form a surface that tends to suppress illusions of mass and depth. Yet a chronic contradiction between sculpturally rendered form and an emphasis on the planar quality of the surface remains. . . . In "Le Grand déjeuner" (Modern Art Museum) [*sic*] or the more recent "Three Bicycles" in which the sense of flatness dominates, the result is a masterpiece of equilibrium—dramatic in itself.[236]

Marden's *11 (To Léger)* leads Adams to some interesting, persuasively advanced suggestions about Léger's further connections with American painting. Explaining his thought processes, Adams says that Marden's drips inevitably made him think about Jackson Pollock, which, in turn, made him wonder if Léger's "*Plongeurs*" series, extensively seen in America during the war years, could not have some relevance to Pollock's allover dripped paintings. Adams does no more than make the suggestion, but it is enough to bring out the affinities between the sinuous surface movement, looping arabesques, and play of light in the "*Plongeurs*" and Pollock's skeins of poured paint. Further, Adams finds Léger's immense *Composition aux deux perroquets* a bridge between the '30s "neo-mannerist" mural style of Pollock's old teacher, Thomas Hart Benton, and the later, abstract Pollock.[237] Areas of cross-hatching in the Marden canvas raise for him the question of a possible relation to the "*Contrastes de formes*" series, and also to the *Dutch Wives* (1975) of Jasper Johns. Were there one, Adams implies, it would be no more surprising than William Rubin's demonstration that Frank Stella's "Cones and

Pillars" (fig. 22) owe something to Léger's *Éléments mécaniques* of 1918–23 (fig. 4).[238] Adams then observes that Stella's "Protractor" series of the 1960s has obvious affinities with the targets of both Johns and Kenneth Noland, the ancestry of which in Léger's disks, and in those of Robert Delaunay, has long been propounded.[239]

Adams also draws a comparison between Léger and Warhol as filmmakers, and is convincing in pointing out similarities of effect between Léger's film *Ballet mécanique* and Warhol's *Empire* (1964), *Vinyl* (1965), and *The Chelsea Girls* (1966). Léger's never realized idea of making a twenty-four-hour film offers an obvious parallel with Warhol's thinking.[240] And Adams finds affinities if not direct connections between Léger's work and various other American artists, from Leon Golub to David Salle to Jeff Koons and more.[241] Whether one specifically agrees or not, it is demonstrable that Léger's art has been useful to American art across generational and stylistic boundaries.

Léger's after-the-fact relevance has been remarked by at least three commentators whose positions in the art world were not particularly close. In 1962, reviewing the Guggenheim's exhibition of the late work, Henry Geldzahler closed with the observation, "Léger's work continues to look modern, even contemporary. . . . [the] most impressive work of the last years is open and lateral, the space tends to read up and down and sideways, rather than in and out and . . . the dissociation of form and color has reached the point where it is tempting to read away the drawing in black paint." This leaves "an abstract composition of blocks and curving rectangles of pure color that looks remarkably like the work of the younger American painters. Léger remains relevant to an audience other than the one he intended to reach."[242]

Six years later, an exhibition at the Perls Galleries, New York, elicited a review by Amy Goldin titled "Léger Now" and one by the relatively conservative *New York Times* critic John Canaday called "Léger Alive and Well." Beginning by defining the class of beings who are our contemporaries—"those who address themselves to whatever we experience as our present condition"—Goldin thereupon claims Léger as a contemporary. What makes him so is his "psychological detachment—the 'inexpressiveness' and his complementary engagement with the physical. . . . Spiritual presence or emotional impact is interpreted with startling directness, as physical density and volume. . . . A direct visceral appeal somehow transforms having a body into something the spectator *shares* with the image. . . . Moreover, oddly central to the physicality of this art is its humorousness. There is definitely something comical in Léger, something dopey, a highly physical, utterly non-verbal *wit*." Léger's humor is not, Goldin says, of the "boulevardier" variety but is "something closer to the sexual humor of Miró or

22. Frank Stella. *La vecchia dell'orto*, 1986. Mixed mediums on etched magnesium, aluminum, and fiberglass, 10' 7" x 12' 8¾" x 3' 6¼" (322.6 x 388 x 107.3 cm). Musée national d'art moderne–Centre de création industrielle, Centre Georges Pompidou, Paris

Oldenburg, but deeper. . . . You can see the same sort of thing in the choreography of Yvonne Rainer. As if there were something comical about having a body."[243] For those viewers of today or tomorrow who react to Léger's art as Goldin did, the artist is in little danger of losing his topicality.

Canaday finds Léger's "inexhaustible capacity to surprise" bemusing; the effect is such that it is "as if Léger were still alive and modifying his style under the influence of current vogues." Seeking an explanation, Canaday deduces that, coincidental relationships aside, Léger has either been "prophetic or even quite directly a roadsign" observed by contemporary painters "en route to their destinations." The review's ensuing remarks reveal their author's slightly retrograde bias: "Léger in no way seems left behind. It is as if he had tried, successfully, to capitalize on the exuberance and wit of pop art while distilling away its crassness, and to bring colorism back to its proper function as an interdependent element . . . while making the most of what the Stellas and others have managed to show us about creating maximum impact of one color field against another."[244]

In 1967, the year before Goldin and Canaday found contemporary vitality in Léger, the artist's work provoked a French critic to some bitterly grumpy remarks. Throughout his article "The Léger Legacy," a review of an exhibition he had seen in Chicago, Marcelin Pleynet's tone is doleful, but he concludes by endowing Léger with considerable historical importance. After remarking that the show has been disappointing, Pleynet finds the bright side: "It nonetheless gave us a whole series of canvases, gouaches, sketches and drawings which are still useful for understanding a problem which it will one day be necessary to examine in detail (and no doubt through Léger first of all) if we are to understand that mysterious something which has sterilized for almost 30 years what is vainly called the School of Paris."[245]

Whatever insidious qualities Léger's art may have embodied for the School of Paris, his role in the formation of the New York School has generally been seen as relatively neutral. Present art-historical suspicions of linear genealogy notwithstanding, the claim that he was a vital ancestor was made early on. At a 1949 symposium organized by Robert Goldwater on "The State of American Art," Greenberg gave his opinion that "there is a definitely American trend in contemporary art." After identifying such artists as Pollock, Gorky, de Kooning, and David Smith as figures in this trend, he went on to "hazard the opinion that they are actually ahead of the French artists who are their contemporaries in age." This emerging American art, Greenberg predicted, "promises to become an original contribution . . . and not merely a local inflection of something developed abroad." And he was quite clear that while Paul Klee, Hans Arp, Joan Miró, Alberto Giacometti, early Wassily Kandinsky, and German Expressionism were all implicated in the gestation of the new art, its ur-fathers were Matisse, Picasso, and Léger.[246]

Greenberg always seemed more discomfited by what he saw as Léger's artistic lapses than by those he discovered in the artist's peers; although he often acceded Léger high approval, the

rating appears the result of a battle the artist has barely won. An exception is the article Greenberg wrote after seeing Léger's 1953 retrospective at The Museum of Modern Art. The first paragraph announces with no ambivalence, "Léger's full-scale retrospective . . . reveals him as a major fountainhead of contemporary style, along with Matisse, Picasso and Mondrian." The caveat comes in the next sentence, but it is administered democratically: "The sequence of promise, fulfillment, and decline that the exhibition unfolds is much like that which we already saw in the Matisse, Picasso and Braque retrospectives." The rest of the article expands on this observation until the penultimate paragraph, in which Greenberg concedes,

Not all the things Léger has done since the 1920s are to be put on the debit side . . . there is the final and largest version of the *Bicyclist* series . . . which has an old-fashioned popular-print kind of picturesqueness and compactness that is satisfying if not quite moving; there is also the large *Three Musicians* (1944), whose solidity likewise pleases even if it is a little too bland; which can be said, too, of the masterfully undulating chiaroscuro in the large *Adam and Eve* (1939). No one but an artist who had, or once had had, greatness in him could have painted any of these pictures.[247]

This exhibition that elevated Léger to a position of parity with his peers in Greenberg's esteem had been organized by the artist's old friend and loyal supporter Katharine Kuh for The Art Institute of Chicago. Consisting of fifty-nine paintings, thirty works on paper, several theater and decorative designs, and lithographs for Léger's new book *Cirque*, the exhibition was in Chicago from April 2 until May 17, 1953, and then traveled to the San Francisco Museum of Modern Art, where it was seen during the summer, and finally, in the fall, to The Museum of Modern Art. Writing to Léger about the opening at the Art Institute, Kuh mentioned that Curt Valentin and Sidney Janis had been there, as well as Andrew Ritchie, a Trustee of The Museum of Modern Art, who had liked it so much he wanted to extend its showing in New York.[248]

The Chicago exhibition was accompanied by numerous complementary events, one of them originally unscheduled: having seen the exhibition, the head of one of Chicago's leading advertising firms was so struck by "the practical influence of his work . . . apparent everywhere in such different directions as fabrics, product design, advertising design and illustration, packaging, posters, direct mail, store window display, and even typography" that he persuaded Kuh to reserve an evening especially for Chicago's advertising people.[249] Programmed from the beginning were various screenings of *Ballet mécanique*, and a series of lectures, including one by Ozenfant, "The Great Decade 1920–1930, As I Saw It."

Among other old ties, Ozenfant and Léger had jointly run the Académie Moderne in Paris in the 1920s, and had both been represented by Léonce Rosenberg. Appropriate as Ozenfant was to the task, Léger, the well-traveled enthusiast of his own openings, would have been the preferred lecturer; it was, however, the high moment of American hysteria about Communism, and Representative George Dondero of Michigan had made it his special task to eradicate "Red art termites." Dondero had publicly called Daniel Catton Rich, director of the Art

Institute, an "art distortionist" and adherent of "international art thugs . . . seeking to advance Communism."[250] Dondero had also on more than one occasion castigated Léger before Congress, with a sort of deluded malice that Molière might have appreciated: "I call the roll of infamy . . . dadaism, futurism, . . . cubism, surrealism, abstractionism. . . . Cubism aims to destroy by designed disorder. . . . Abstractionism aims to destroy by the creation of brainstorms. . . . The four leaders of the Cubist group were Picasso, Braque, Léger, and Duchamp. . . . Léger and Duchamp are now in the United States to aid in the destruction of our standards and traditions."[251] At the moment Representative Dondero was alleging these things, Léger had not been in America for four years, but one of his last acts before exiting had been to join the Communist Party. For all his friends in high places, he had no hope of obtaining a visa for his 1953 exhibition. At Kuh and Rich's request, however, Léger sent a cable to be read in his absence at the opening. He gave his health as his reason for not coming, and asked that his excuses be made to his many friends in Chicago, of whom he had the most excellent memories, as he did also for "your great city and your beautiful museum that I would so much have liked to see again."[252]

Léger died in the summer of 1955 without going to America again. In the year before his death, he unknowingly enriched his legacy to the country that had both rebuffed and cherished him with the execution of *La Grande Parade* (The great parade, p. 259). The summa of both his life and the work of his last fifteen years, this huge painting is generally acknowledged among the masterworks of his oeuvre, and, thanks to the efforts and eye of Thomas M. Messer, has been in the collection of the Solomon R. Guggenheim Museum, New York, since 1962.

Clowns, dancers, and acrobats had inhabited Léger's paintings since at least 1918, but beginning with the series of *plongeurs*, cyclists, and campers initiated in the United States, they became a near obsessive theme. With virtuoso structural finesse, *La Grande Parade* sweeps them all up to perform in a pictorial spectacle that reflects Léger's vision of the world. The great bands of blue, orange, and red independently sweeping across the surface of the canvas derive from a theory of color Léger claimed was inspired by the flashing lights of Broadway. There, people in the passing parade moved from moment to moment in and out of arcs of brilliant green, red, and blue—a phenomenon Léger transposed to canvas with swaths of color freed from contour.[253]

The "parade" of the picture's title relates to New York's thoroughfare only indirectly; its specific reference is evidently to the circus. In 1946, soon after his return to France, Léger had begun working on a project based on this theme for the art-book publisher Efstratios Tériade. Léger had very much wanted his good friend Henry Miller to write a text that would illustrate the lithographs he was making for the proposed book, and, in the hope of spurring Miller on, he sent the American author several drawings that he thought conveyed the spirit of their mutual endeavor. In one (fig. 23), Léger underscored their collaboration by juxtaposing two heads of clowns—at the lower left corner, his own, and next to his, Miller's. As it finally

turned out, and with no breach of friendship, Léger himself wrote the text to the book, titled simply *Cirque*.[254]

The painting *La Grande Parade* speaks eloquently in its own terms, yet its resonance expands with Léger's description from *Cirque* of the climactic moment when the parade begins:

The takings depend on this parade and so it is powerful and dynamic. The instruments play at full blast. The big drum takes on the trombones and the trumpets fight the kettle drums. All this uproar is projected from a raised platform. It hits you full in the face and slams against your chest. It's like a party whistle. Behind, to the side, in front, appearing and disappearing, figures, limbs, dancers, clowns. . . . The music, linked with the glare of the spotlights, sways the whole aggressive mass.[255]

23. Fernand Léger. Spread, pp. 76–77, for *Cirque* (Circus). Paris: Tériade Éditeur, 1950. Lithograph printed in black. The Museum of Modern Art, New York. The Louis E. Stern Collection, 1964

Léger loved the roundness of the circus and the roundness of life; in *La Grande Parade* the great spherical red "C," for *Cirque*, is echoed in the breasts of the figures, in the barbells, in the calliope, and in further curves and circles rhyming with each other throughout the picture. In *Cirque*, he wrote, "The whole of life is a circuit. Should you wish to embark on a journey you will find yourself back where you started from."[256] Lest anyone think Léger was but a spectator, he climbed into his pictorial clown suit and, upright, third from left, makes music for the troupe.

If *La Grande Parade* did not come into the Guggenheim's possession until 1962, the group of Légers assembled by Rebay and her patron was already impressive in 1955, when Léger died. By that time the Gallatin and Arensberg collections were in place at the Philadelphia Museum of Art, and most of Léger's early Chicago supporters had given their works to The Art Institute of Chicago. Of the great public holdings of Léger's art, The Museum of Modern Art's was the most in flux; acquiring *Les Trois Musiciens* and *Les Plongeurs* in the year of their author's death, the Museum went on occasionally adding major paintings to its collection, notably with the gift of the Sidney and Harriet Janis collection in 1967 and the Nelson Rockefeller bequest in 1979. While other museums and individuals scattered across the country owned examples of Léger's work, the public opportunity to see it at mid-century was centered, as it is now, in the institutions enumerated above.

Léger claimed that a bridge existed between Paris and New York, between France and America; it was, he said, the works of art that the New World had chosen from the Old.[257] At his death, he knew that his role as a bridge builder had not been insignificant.

Notes

1. Henry McBride, "Fernand Léger's Abstractions," *The New York Sun*, Saturday, February 26, 1938, p. 12.

2. See Ann Temkin, "Brancusi and His American Collectors," in Friedrich Teja Bach, Margit Rowell, and Temkin, *Constantin Brancusi 1876–1957*, exh. cat. (Philadelphia: Philadelphia Museum of Art, and Cambridge, Mass., and London: The MIT Press, 1995), p. 51 and note 4, p. 69. Temkin has Duchamp observe "a shiny metal propeller." In at least one instance, Léger described the propeller as made of wood. See Dora Vallier, "La Vie fait l'œuvre de Léger: Propos de l'artiste recueillis par Dora Vallier," *Cahiers d'Art* (Paris), 1954, p. 140. Reprinted as Vallier, "La Vie fait l'œuvre de Fernand Léger," *L'Intérieur de l'art: Entretiens avec Braque, Léger, Villon, Miró, Brancusi (1954–1960)* (Paris: Éditions du Seuil, 1982), p. 63.

3. It is not known when Katherine Dreier acquired *Les Hélices*. See Robert L. Herbert, Eleanor S. Apter, and Elise K. Kenney, eds., *The Société Anonyme and the Dreier Bequest at Yale University: A Catalogue Raisonné* (New Haven and London: Yale University Press, 1984), p. 400.

4. Recounting her discovery of *Essai pour trois portraits* in 1952, Katharine Kuh, in Avis Berman, "An Interview with Katharine Kuh," *Archives of American Art Journal* 27 no. 3 (1987): 34–35, recalled that Léger had told her he had sent it to America for the Armory Show. However, it was demonstrably in the Gimbel's department-store exhibition in Milwaukee (see pp. 17–18) before the Armory Show closed its Boston showing. Close to forty years after he had been approached by the emissaries of the Armory Show in 1912 and the organizers of the Gimbel's exhibition in early 1913, Léger must have confused these two events. Aaron Sheon, "1913: Forgotten Cubist Exhibitions in America," *Arts Magazine* (New York) 57 no. 7 (March 1983): 103, points out that *Essai pour trois portraits* could not have been in the Armory Show because of the conflict in dates with the Gimbel's exhibition. Sheon argues that *La Femme en bleu* was one of the works in the Armory Show, based on the cartoon spoofing this painting in the *Pittsburgh Chronicle Telegraph*, May 7, 1913, which almost undoubtedly appeared because of the painting's inclusion in the Armory Show. See fig. 1.

5. Arthur Jerome Eddy, *Cubists and Post-Impressionism*, 1914 (reprint ed. Chicago: A. C. McClurg & Co., 1919), p. 65.

6. Ibid., p. 62.

7. Sheon, "1913," p. 94.

8. Ibid., p. 94. Unless otherwise noted, all information on the touring department-store exhibition comes from Sheon.

9. See note 4. Owing to its reproduction in the *Philadelphia Public Ledger*, August 10, 1913, *Essai pour trois portraits* can be securely identified as one of the two Léger paintings in the Gimbel's exhibition.

10. Gimbel's newspaper advertisement, quoted in Sheon, "1913," p. 98.

11. According to Sheon, "1913," p. 101, Léger's *Essai pour trois portraits* and Pierre Dumont's *Cathédrale de Rouen* (Rouen Cathedral), both now in the Milwaukee Art Museum, were not in this expanded version of the exhibition.

12. *The Globe and Commercial Advertiser* (New York), quoted in ibid.

13. Léger, letter to Louis Poughon, August 17 [1914], in Christian Derouet, ed., *Fernand Léger: Une Correspondance de guerre à Louis Poughon, 1914–1918*, *Les Cahiers du Musée national d'art moderne* (Paris) hors-série/archives, 1990, letter 1, p. 9.

14. According to a letter of December 7, 1917, from Léger to his childhood friend Poughon, *La Partie de cartes* was painted during November of that year in Paris between hospital stays. See Derouet, ed., *Une Correspondance de guerre*, letter 42, p. 84, and note 4, p. 98.

15. Léger, quoted in an interview with Vallier, "La Vie fait l'œuvre de Fernand Léger," 1954, p. 151. Reprinted in Vallier, "La Vie fait l'œuvre de Fernand Léger," *L'Intérieur de l'art*, p. 68.

16. See Christopher Green, "Out of War: Léger's Painting of the War and the Peace, 1914–1920," in Dorothy Kosinski, ed., *Fernand Léger 1911–1924: The Rhythm of Modern Life*, exh. cat., with a foreword by Katharina Schmidt and Gijs van Tuyl (Munich and New York: Prestel, 1994), p. 46.

17. Léger, letter to Poughon, April 12, 1915, in Derouet, ed., *Une Correspondance de guerre*, letter 12, p. 35. The translation is Green's in "Out of War," p. 51.

18. Léger, *Propos d'artistes* (Paris: La Renaissance du Livre, 1925), pp. 98, 99. Reprinted in Léger, *Functions of Painting*, ed. Edward F. Fry, trans. Alexandra Anderson, with a preface by George L. K. Morris (New York: The Viking Press, 1973), p. 62. From the series *The Documents of 20th-Century Art*, ed. Robert Motherwell and Bernard Karpel.

19. John Golding, "Léger and the Heroism of Modern Life," *Visions of the Modern* (London: Thames and Hudson, 1994), p. 124. First published in the catalogue of the exhibition *Léger and Purist Paris*, organized by Golding and Green and held at the Tate Gallery, London, in 1970.

20. Ibid., p. 125.

21. Léger, "Couleur dans le monde," *Europe* (Paris) 47 nos. 4–7 (1938): 100. Translated from the French by the author. Unless otherwise noted or quoted from *Functions of Painting*, all translations are by the author.

22. Blaise Cendrars, *La Fin du monde filmée par l'Ange N.-D.* (Paris: Éditions de la Sirène, 1919).

23. Ezra Pound, quoted in Malcolm Bradbury, *Dangerous Pilgrimages: Transatlantic Mythologies and the Novel* (New York: Viking Penguin, 1996), p. 250. Bradbury gives no specific citation for the source of Pound's comment.

24. Van Wyck Brooks, *America's Coming of Age*, 1915 (reprint ed. New York: Octagon Books, 1975), p. 27.

25. Harold E. Stearns, *Liberalism in America: Its Origin, Its Temporary Collapse, Its Future* (New York: Boni and Liveright, 1919), p. viii.

26. Willard Huntington Wright, *Modern Painting Its Tendency and Meaning*, 1915 (reprint ed. New York: Dodd Mead and Company, 1923), pp. 256–57. Barbara Rose, in "Les Thèmes modernes dans la peinture américaine" (also appearing as "American Art and the Modern Theme" in the same volume), *Léger et l'Esprit Moderne*, exh. cat. (Paris: Musée d'Art Moderne de la Ville de Paris, 1982), pp. 183–84, incorrectly states that Wright reproduced two paintings, *Rooftops* and *Houses and Smoke*. Although Wright's index refers the reader to these two paintings on p. 256, that page actually reproduces only the painting now known as *Les Fumeurs* (The smokers, 1911–12; p. 159). Rose considerably overstates the case in claiming Wright's mention of Léger as the basis for the establishment of "Léger's dominant role in the formation of the American avant-garde before Léger himself had returned from the front."

27. For the only type of painting in Léger's oeuvre between 1912 and early 1913 that could be described as "Mountain Scenery," see Georges Bauquier, *Fernand Léger: Catalogue Raisonné 1903–1919* (Paris: Adrien Maeght Éditeur, 1990) vol. I, nos. 25–30, pp. 50–56; no. 32, pp. 58–59; nos. 36–37, pp. 66–69; and no. 41, pp. 76–77. Léger's letter of June 21, 1917, to Jeanne Lohy, his future wife, seems to make clear that he believes paintings of his are in America, although it does not clarify what they are, why they are there, or which Americans he counsels his wife to see.

28. See exhibition catalogue for the Salon des Indépendants (Grand Palais, Paris, January 28–February 29, 1920). Although it is impossible to determine from the salon's catalogue whether the definitive versions of *La Ville* and *Les Disques dans la ville* were the paintings shown, it is more than likely that Léger would have wanted to show his most impressive work in this first postwar salon. Christopher Green, in *Cubism and Its Enemies: Modern Movements and Reaction in French Art, 1916–1928* (New Haven and London: Yale University Press, 1987), p. 127, identifies one of the paintings as the definitive version of *La Ville*, but does not provide a source; he does, however, quote a review of the salon by Roger Allard that would support the supposition that Léger's entries were unusually important paintings.

29. See Léger, in Derouet, ed., *Fernand Léger: Une Correspondance d'affaires. Correspondances Fernand Léger–Léonce Rosenberg 1917–1937*, *Les Cahiers du Musée national d'art moderne* (Paris) hors-série/archives, 1996, letter 165, note 2, p. 115. Derouet here connects Roland Tual's account of Léger's performance with a gas meter to a lecture Léger gave on June 1, 1923; however, Tual's memory of the lecture of "around 1925" has it take place at the Sorbonne, whereas the June 1, 1923, lecture was given at a location on the Boulevard Saint-Germain. Léger did give a lecture, "Le Spectacle," at the Sorbonne on May 31, 1924 (invitation in the Katherine S. Dreier Papers, The Yale

Collection of American Literature, Beinecke Rare Book and Manuscript Library, Yale University). Patrick Waldberg, "Garlands for Léger," in *Homage to Fernand Léger* (special issue of *XXe Siècle Review*, Tudor Publishing Co., New York, 1971, ed. G. di San Lazzaro), p. 57, also cites Tual's recollection of the event as having taken place in 1925 with a Sorbonne study group.

30. See John Atherton, "Americans in Paris," in Denis Hollier, ed., *A New History of French Literature* (Cambridge, Mass., and London: Harvard University Press, 1989), p. 909.

31. Louis Lozowick, "Fernand Léger," *The Nation* (New York) 121 no. 3154 (December 16, 1925): 712.

32. Rose, *Les Thèmes modernes dans la peinture américaine*, p. 178.

33. Léger, letter to Rosenberg, November 21, 1921, in Derouet, ed., *Une Correspondance d'affaires*, letter 117, p. 95.

34. Léger, "A New Realism—The Object (Its Plastic and Cinematographic Value)," *The Little Review* (New York) 11 no. 2 (Winter 1926): 7.

35. Léger, "The Machine Aesthetic: The Manufactured Object, the Artisan, and the Artist," 1923, in *Functions of Painting*, p. 56.

36. Léger's phrase to describe a young mechanic, in ibid., p. 61.

37. See William Rubin, *The Paintings of Gerald Murphy*, exh. cat. (New York: The Museum of Modern Art, 1974), p. 39, for a reproduction of *Library*.

38. See ibid., p. 34, for the significance of Murphy's watch.

39. Florent Fels, "*Le Salon des Indépendants*," *L'Art Vivant* (Paris) 1 no. 6 (March 20, 1925): 27.

40. Murphy, quoted in Rubin, *The Paintings of Gerald Murphy*, p. 30.

41. Ibid., p. 30 and note 82, p. 46.

42. Jacques Mauny, "New York 1926," *L'Art Vivant* (Paris) 2 no. 25 (January 1, 1926): 58.

43. Archibald MacLeish, "Foreword," in Rubin, *The Paintings of Gerald Murphy*, p. 7.

44. John Dos Passos, *The Best of Times* (New York: The New American Library, 1966), p. 146.

45. Jean B.-Berty, "*Les Ballets Suédois au Théâtre des Champs-Élysées*," *La Danse* (Paris) 4 no. 38 (November 1923), n.p. Berty gives "Banville"

as the source of his quotation.

46. This and subsequent references to the American tour of the Ballets Suédois in America are dependent on Gail Levin, "The Ballets Suédois and American Culture," in Nancy Van Norman Baer, *Paris Modern: The Swedish Ballet 1920–1925*, exh. cat. (San Francisco: Fine Arts Museums of San Francisco, 1995), pp. 122–24.

47. Ibid.

48. Ibid.

49. "Swedish Ballet Here Again Christmas Night," *New York Telegraph*, December 23, 1923, as quoted in ibid., p. 124.

50. "Swedish Ballet in Fine Program," *New York Evening Telegram*, December 27, 1923, as quoted in ibid.

51. Ferdinand Howald had acquired *La Perforeuse* (The punching machine, 1918) in 1922, and would give it to the Columbus Museum of Art in 1931. See Katherine Wallace Paris, ed., *Catalog of the Collection* (Columbus, Ohio: Columbus Museum of Art, 1978), p. 69. A Léger drawing was included in the *Exhibition of Contemporary Art* at the Penguin (Club), New York, which opened on March 16, 1918; a work of his may have been included in a subsequent Penguin exhibition in November of 1918, but I have been unable to verify this.

52. Rose, in "*Les Thèmes modernes dans la peinture américaine*," p. 181, incorrectly states that Léger was included in the Inaugural Exhibition of the Société Anonyme in 1920. See "Exhibitions and Loans by the Société Anonyme, 1920–39," in Herbert, Apter, and Kenney, eds., *The Société Anonyme and the Dreier Bequest at Yale University*, p. 776.

53. *Broom* (Rome) 1 no. 3 (January 1922): 232, 233.

54. *Broom* 2 no. 1 (April 1922). *Les Disques* is reproduced on p. 49 and *Paysage animé* on p. 79.

55. *Broom* 2 no. 4 (July 1922).

56. Sheldon Cheney, *A Primer of Modern Art* (New York: Boni and Liveright, 1924), p. 108.

57. Ibid., p. vii.

58. Ibid., p. 109.

59. Ibid., p. 108.

60. Ibid., p. 370.

61. The reproduction is most likely of the print reproducing a Léger drawing that appears as the first illustra-

tion in Cendrars, *J'ai tué* (Paris: À La Belle Édition, 1918), n.p., which was illustrated by Léger.

62. Cheney, *A Primer of Modern Art*, p. viii.

63. Henri-Pierre Roché, quoted in Temkin, "Brancusi and His American Collectors," p. 56.

64. *Contemporary French Art*, at The Sculptors Gallery, New York, March 24–April 10, 1922.

65. Léger, letter to Léonce Rosenberg, postmarked July 24, 1922, in Derouet, ed., *Une Correspondance d'affaires*, letter 129, p. 99.

66. Léger, "The Spectacle: Light, Color, Moving Image, Object-Spectacle," 1924, in *Functions of Painting*, pp. 41–42. Reprinted from *Bulletin de l'Effort Moderne*.

67. Rosenberg, letter to Léger, December 29, 1923, in Derouet, ed., *Une Correspondance d'affaires*, letter 186, p. 125.

68. Rosenberg, letter to Maurice Raynal, January 14, 1924, in Derouet, ed., *Une Correspondance d'affaires*, letter 188, note 4, p. 127.

69. See invitation to lecture of May 31, 1924, in the Katherine S. Dreier Papers, Yale University. This may have been the lecture at which Léger displayed a gas meter "as beautiful as the Venus de Milo." See note 29 in this essay and p. 22.

70. Dreier, introduction to *Fernand Léger*, exh. cat. (New York: The Anderson Galleries, 1925), p. 3. The exhibition ran from November 16 to 28, 1925.

71. See Dreier, letter to Léger, April 23, 1925. In the Katherine S. Dreier Papers, Yale University.

72. Ibid.

73. Léger, letter to Dreier, May 21, 1925. In the Katherine S. Dreier Papers, Yale University.

74. See Rosenberg, in Derouet, ed., *Une Correspondance d'affaires*, letter 268, pp. 177–78.

75. Dreier, letter to Léger, June 19, 1925. In the Katherine S. Dreier Papers, Yale University.

76. Dreier, letter to Léger, July 16, 1925. In the Katherine S. Dreier Papers, Yale University.

77. Léger, letter to Alfred H. Barr, Jr., November 13, 1942. In The Museum of Modern Art Archives: Alfred H. Barr, Jr., Papers. 1.5.50. Published in Robert L. Herbert, ed., *Léger's "Le*

Grand Déjeuner" (Minneapolis: The Minneapolis Institute of Arts, 1980), Appendix F, p. 71. The third work Léger singled out was *Composition aux deux perroquets* (Composition with two parrots, 1935–39; p. 233).

78. Dreier, letter to Léger, December 2, 1925. In the Katherine S. Dreier Papers, Yale University.

79. Léger, letter to Dreier, December 24, 1925; Dreier, letter to Léger, January 20, 1926. Both in the Katherine S. Dreier Papers, Yale University.

80. Dreier, letter to Léger, December 2, 1925. In the Katherine S. Dreier Papers, Yale University.

81. Elizabeth Hutton Turner, "Paris: 'Capital of America,'" in *Americans in Paris (1921–1931)*, exh. cat. (Washington, D.C.: The Phillips Collection, 1996), p. 164.

82. Rose, in "*Les Thèmes modernes dans la peinture américaine*" p. 181, implies that Stuart Davis saw Léger's work at the first Société Anonyme exhibition in 1920; but nothing by Léger was included in that show (see note 52).

83. McBride, "Stuart Davis Comes to Town," *The New York Sun*, April 4, 1931. Reprinted in Diane Kelder, ed., *Stuart Davis* (New York: Praeger Publishers, 1971), p. 191.

84. Davis, quoted in letter to Henry McBride, in McBride, "The Palette Knife," *Creative Art* (New York) VI (February 1930): sup. 34. Reprinted in Kelder, ed., *Stuart Davis*, pp. 109–10.

85. Davis, letter to Edward Davis, September 17, 1928. Collection of Earl Davis. Quoted in Karen Wilkin, *Stuart Davis* (New York: Abbeville Press, 1987), p. 120. See also Turner, "Paris: 'Capital of America,'" p. 31, with a slightly altered quotation.

86. See Herbert, Apter, and Kenney, eds., *The Société Anonyme and the Dreier Bequest at Yale University*, p. 777, for exact exhibition dates and a list of the other artists included.

87. "New Artists Puzzle and Intrigue Throng at Brooklyn Museum," *The Brooklyn Citizen*, Sunday, November 28, 1926, p. 9.

88. Forbes Watson, "A Hard Nut to Crack," *The World*, Sunday, November 28, 1926, p. 9M.

89. Royal Cortissoz, "Modernistic Art and—What of It? An International Exhibition At the Brooklyn

Museum," *New York Herald Tribune*, Sunday, December 5, 1926, section VI, p. 11.

90. See Herbert, Apter, and Kenney, eds., *The Société Anonyme and the Dreier Bequest*, p. 405.

91. See *The Estate of the Late Arthur B. Davies*, auction catalogue (New York: American Art Galleries, 1929). The auction was held on April 16 and 17 of that year; the drawing Davies owned was lot no. 74.

92. See Paris, ed., *Catalog of the Collection*, p. 69.

93. See Rosenberg, in Derouet, ed., *Une Correspondance d'affaires*, letter 196, p. 131, and Barr, *Exhibition of Progressive Modern Painting from Daumier and Corot to Post-Cubism* (Wellesley, Mass.: The Art Museum of Wellesley College, 1927).

94. See Malcolm Gee, *Dealers, Critics, and Collectors of Modern Painting: Aspects of the Parisian Art Market between 1910 and 1930* (New York and London: Garland Publishing, Inc., 1981), p. 59, and Léger, in Derouet, ed., *Une Correspondance d'affaires*, letter 369, note 1, p. 238.

95. Gail Stavitsky, "The Development, Institutionalization, and Impact of the A. E. Gallatin Collection of Modern Art," Ph.D. dissertation (New York University, 1990), p. 138 and, for the catalogue of the opening exhibition, Appendix V.

96. See *The Bulletin of The Museum of Modern Art* (New York) 3 no. 1 (October 1935), which acted as a catalogue for the exhibition.

97. A. E. Gallatin, quoted in "New York University Gets Léger's 'The City,'" *Springfield Republican*, March 14, 1937, Microfilm 1293, frame 687, as quoted in Stavitsky, "The Development, Institutionalization, and Impact of the A. E. Gallatin Collection," p. 357.

98. Jean Hélion, in an interview with Stavitsky, June 18 and 20, 1986, pp. 4–5, 25, as quoted in Stavitsky, "The Development, Institutionalization, and Impact of the A. E. Gallatin Collection," pp. 356–57.

99. Léger, letter to Gallatin, postmarked January 27, 1937. In the A. E. Gallatin Collection, The New-York Historical Society, New York.

100. Léger, "Art and the People," in *Functions of Painting*, p. 145. Reprinted from *Arts de France*

(Paris) no. 6 (1946): 39.

101. Elizabeth Luther Cary, "Gallery of Living Art. . . ," *The New York Times*, December 18, 1927, p. 12, as quoted in Stavitsky, "The Development, Institutionalization, and Impact of the A. E. Gallatin Collection," p. 139.

102. *Machine-Age Exposition*, 119 West 57th Street, New York, May 16–28, 1927.

103. Reprinted in Barr, *Defining Modern Art: Selected Writings of Alfred H. Barr, Jr.*, ed. Irving Sandler and Amy Newman (New York: Harry N. Abrams, Inc., 1986), pp. 56–61.

104. *Loan Exhibition of Modern Paintings Privately Owned by Chicagoans*, The Arts Club of Chicago, Wrigley Building, Chicago, January 4–18, 1929.

105. Mrs. John Storrs, letter to Mr. Worcester, September 11, 1928. In the Curatorial Files of The Art Institute of Chicago. For a reproduction of *Composition in Blue*, see Bauquier, *Fernand Léger Catalogue Raisonné*, vol. III, no. 518, p. 216. A close version of it, *Composition* (formerly in the Gallatin collection and now in the Philadelphia Museum of Art), is reproduced in this catalogue, p. 205.

106. C. J. Bulliet, "Arts Club Show Is Going Visiting," *The Chicago Post Magazine of The Art World*, January 15, 1929, p. 3.

107. Barr, "Foreword," *Painting in Paris from American Collections*, exh. cat. (New York: The Museum of Modern Art, 1930), p. 11.

108. Ibid., pp. 13–14.

109. Ibid., p. 16.

110. Joan M. Lukach, *Hilla Rebay: In Search of the Spirit In Art* (New York: George Braziller, 1983), pp. 61, 62, 64.

111. Léger, letter to Hilla von Rebay, January 28, 1931. In the Hilla Rebay Papers, Solomon R. Guggenheim Museum, New York.

112. Léger, letter to Rebay, March 11, 1931. In the Hilla Rebay Papers.

113. Rebay, letter to Rudolf Bauer, October 18, 1931. In the Hilla Rebay Papers.

114. Léger, letter to Le Corbusier, September 29, 1931. In the Fondation Le Corbusier, Paris.

115. *Fernand Léger: An Exhibition of Drawings, Watercolors and Gouaches*, John Becker Gallery, New York, October 1–23, 1931.

116. Ralph Flint, "Exhibitions in New York," *The Art News* (New York) XXX no. 2 (October 10, 1931): 11.

117. Léger, letter to Simone Herman, October 1, 1931. Published in Derouet, ed., *Fernand Léger: Lettres à Simone*, with a preface by Maurice Jardot (Paris: Éditions d'Art Albert Skira S.A. and Musée national d'art moderne, Centre Georges Pompidou, 1987), letter 10, p. 31.

118. Léger, letter to Herman, October 22, 1931, in ibid., letter 13, p. 36.

119. Ibid.

120. Léger, "New-York vu par F. Léger," dedicated to Sara Murphy, *Cahiers d'Art* (Paris) 6 nos. 9–10 (1931): 438. Reprinted and trans. as "New York" in *Functions of Painting*, p. 86.

121. Léger, Buckminster Fuller, and John Storrs, postcard to Le Corbusier, dated November 5 and postmarked 1931. In the Fondation Le Corbusier. Léger seems to refer to a single building in the phrase "the last word in industrialization." The two most remarkable buildings recently completed in New York were the Chrysler Building (finished in 1930) and the Empire State Building (finished in May of 1931); it would seem likely that he meant one of these.

122. Léger, "Ballet Mécanique," c. 1924, in *Functions of Painting*, p. 51.

123. Léger credited Ezra Pound and Dudley Murphy with "the multiple transformation of the projected image" in his essay "Ballet mécanique," published in the exhibition catalogue for the *Internationale Ausstellung neuer Theatertechnik*, an exhibition at a music and theater festival in Vienna, September 24–October 20, 1924. Here quoted from Standish D. Lawder, *The Cubist Cinema* (New York: New York University Press, 1975), p. 137. For an extended account of Pound's involvement with *Ballet mécanique*, see John Tytell, *Ezra Pound: The Solitary Volcano* (New York: Anchor Press, Doubleday, 1987), pp. 189–90.

124. "Arts Club Is Crowded for Showing of Léger's Film," *Chicago Daily Tribune*, November 21, 1931, p. 17.

125. *Chicago Herald and Examiner*, November 21, [1931].

126. Inez Cunningham, "Léger as Painter, Poet and Person," *Chicago Evening Post*, Tuesday, November 24,

1931, p. 7.

127. Ibid.

128. Léger, "Chicago" (dated November 1931), *Plans* (Paris) 2 no. 11 (January 1932): 68. Cited here from an undated manuscript translation in the Newberry Library, Chicago, p. 5, with slight alterations by the author.

129. Léger, "New York," in *Functions of Painting*, p. 86.

130. Ibid., p. 85.

131. "Exposition Fernand Léger au Kunsthaus de Zurich," *Cahiers d'Art* (Paris) 8 nos. 3–4 (1933).

132. "Léger and the Cult of the Close-up," *The Arts* (New York) XVII no. 8 (May 1931): 562.

133. Ibid.

134. According to Derouet, ed., *Fernand Léger: Lettres à Simone*, letter 50, note 2, p. 256, the lecture was given on August 9, 1933. Under the title "The Wall, the Architect, the Painter," it is translated in *Functions of Painting*, pp. 91–99, where it is described as previously unpublished. It was, however, published in French as "*Discours aux architectes*" in *Quadrante* (Milan) 11 no. 5 (September 1933): 44–47.

135. Le Corbusier, letter to Léger, August 10, 1934. In the Fondation Le Corbusier.

136. In 1934, London Film Productions invited Léger to collaborate on costumes and decor for Alexander Korda's movie *Things to Come*, then being made from the H. G. Wells novel *The Shape of Things to Come*. Although Léger traveled to London to work on the project, and was paid for some portion of it (see Léger, letter to Gerald Murphy, July 27, 1935; in the Collection of Honoria Murphy Donnelly), he seems to have been replaced by László Moholy-Nagy. See Peter de Francia, *Fernand Léger* (New Haven and London: Yale University Press, 1983), p. 64 and note 49, p. 268; Derouet, ed., *Fernand Léger: Lettres à Simone*, letter 91, note 1, pp. 259–60; and Ruth Ann Krueger Meyer, "Fernand Léger's Mural Paintings 1922–55," Ph.D. dissertation (University of Minnesota, 1980), p. 210 and note 21, pp. 236–37. Meyer has Léger working with his friend the American architect Paul Nelson on a competition for the decor of a theater in Chicago in

1937–38, and Olivier Cinqualbre, "*Un Rendez-vous à jamais reporté*," in Derouet, *Fernand Léger*, exh. cat. (Paris: Éditions du Centre Pompidou, 1997), p. 260, reproduces a sketch of a Nelson/Léger project inscribed "Chicago WGN radio station *Competition* by Paul Nelson, architect and Fernand Léger, painter 1938." Cinqualbre also describes the project's failure (p. 261). But *Lettres à Simone* includes a letter postmarked October 25, 1934, in which Léger writes, "Finished a decorative project for an auditorium Chicago (competition)" (letter 93, p. 127). Since it is unlikely that Léger would have worked on two competitions for a Chicago theater project during the last half of the 1930s, it must be assumed that he did a substantial amount of work on it around the time of his October 1934 letter to Herman.

137. Letters from James Johnson Sweeney to Eva Schütze—nos. 0441 (March 30, 1935) and 0449 (April 3, 1935), in the Renaissance Society Papers, Archives of American Art, Smithsonian Institution—mention Sweeney's visit to Léger to suggest an exhibition at the Renaissance Society. A letter from Léger to Herman postmarked October 29, 1934—letter 94, p. 128, in Derouet, ed., *Fernand Léger: Lettres à Simone*—indicates that someone had just proposed to the artist a "fairly astonishing" project for Chicago.

138. Léger, letter to Herman, postmarked October 29, 1934. In Derouet, ed., *Fernand Léger: Lettres à Simone*, letter 94, p. 128.

139. Léger, letter to Herman, postmarked January 6, 1935. In ibid., letter 97, p. 132.

140. Léger, letter to Herman, postmarked July 27, 1935. In ibid., letter 106, p. 142.

141. Sweeney, letter to Schütze, March 30, 1935. No. 0441 in the Renaissance Society Papers.

142. Léger, letter to Sweeney, March 15, 1935. No. 0433 in the Renaissance Society Papers.

143. Sweeney, letter to Schütze, March 30, 1935. No. 0441 in the Renaissance Society Papers.

144. Sweeney, letter to Schütze, April 5, 1935. No. 0452 in the Renaissance Society Papers.

145. Léger, letter to Gerald Murphy, July 27, 1935. In the Collection of Honoria Murphy Donnelly.

146. Barr, letter to Mr. and Mrs. S. R. Guggenheim, October 4, 1935. Exhibition No. 42A, Exhibition File, The Museum of Modern Art, Department of Registration.

147. "Léger Advises Painters Not to Use Beautiful Women as Their Models," *New York Herald Tribune*, October 5, 1935, p. 9.

148. Léger, "The New Realism," *Art Front* (New York) 2 no. 8 (December 1935), p. 10. Reprinted in *Functions of Painting*, p. 113. The text in square brackets appears only in the *Functions of Painting* version.

149. "Fernand Léger Exhibition," *The Bulletin of The Museum of Modern Art* (New York) 3 no. 1 (October 1935). This issue of the *Bulletin* also includes an article by Morris, "Fernand Léger versus Cubism."

150. Delos Avery, "Art Show Bewilders/Rembrandt Pitted against Modernism of Léger/He Wins with Crowd," *Chicago Herald and Examiner*, December 20, 1935, p. 34.

151. Léger, letter to his wife, Jeanne Léger, December 20, 1935. In the Fondation Le Corbusier.

152. Walter Pach, *Queer Thing, Painting: Forty Years in the World of Art* (New York and London: Harper & Brothers Publishers, 1938), pp. 181–82.

153. Lewis Mumford, "The Art Galleries. Léger and the Machine," *The New Yorker* (New York), October 19, 1935, pp. 73–74.

154. Paul Nelson, "*Peinture spatiale et architecture à propos des dernières œuvres de Léger*," *Cahiers d'Art* (Paris) 12 no. 1–3 (1937): 86.

155. Ibid., p. 8.

156. Léger, in Derouet, ed., *Une Correspondance d'affaires*, letter 388, p. 252.

157. Galka Scheyer first mentions the Arensbergs to Léger in a letter of August 15, 1933; without referring to them by name, she tells him that friends with a "magnificent collection" would like to exchange the painting they have by him for another, explaining that the one they own was chosen for them by a friend (almost undoubtedly Duchamp, who often acted as the Arensbergs' agent). After receiving photographs of

Léger's works that would be available for this exchange, Scheyer writes to Léger on March 21, 1934, to say that although her friends had been interested in them, they were more drawn to another, "blue, white and a little orange," that had been lent by "Seligman of New York" to an exhibition they had seen. Léger seems to have understood from this brief description that the painting "in question . . . was a size 60 fig. canvas 1913–1914 . . . that used to belong to Galerie Seligmann" (Léger, letter to Scheyer, April 7, 1934). The Jacques Seligmann & Co. Papers at the Archives of American Art, Smithsonian Institution, preserve an image of the *Contraste de formes* now in the Philadelphia Museum of Art (p. 165) as part of the Arensberg bequest, with the notation that it had been sold to Arensberg. All correspondence between Léger and Galka Scheyer may be found in the Galka Scheyer Papers, Archives of American Art, Smithsonian Institution. (The original Scheyer papers are in the Blue Four–Galka Scheyer Archives, Norton Simon Museum of Art, Pasadena, Calif.)

158. See correspondence between William Eisendrath and Scheyer, 1935, in the Renaissance Society Papers.

159. Léger, letter to Scheyer, n.d. In the Galka Scheyer Papers. Léger's probably exaggerated report that his exhibition had had 10,000 visitors in three weeks would imply that the exhibition had then been open at The Museum of Modern Art (he is writing from New York) for three weeks, thus dating his letter to the end of October 1935.

160. Scheyer, letter to Léger, November 8, 1935. In the Galka Scheyer Papers.

161. Scheyer, letter to Charles Chaplin, December 4, 1935. In the Galka Scheyer Papers.

162. Florence Rapport, "Sec'y to Rouben Mamoulian," letter to Scheyer, November 29, 1936. In the Galka Scheyer Papers.

163. Léger, letter to Scheyer, December 27, 1935. In the Galka Scheyer Papers.

164. Léger, letter to Gerald Murphy, dated "Saturday 16," probably written two days before his December 18

departure for Chicago. In the Collection of Honoria Murphy Donnelly.

165. "Léger Advises Painters Not to Use Beautiful Women as Their Models," p. 9.

166. See Simon Willmoth's excellent account, "Léger and America," in *Fernand Léger: The Later Years*, exh. cat. (London: Whitechapel Art Gallery, 1988), pp. 43–54 and *passim*. See also Meyer, "Fernand Léger's Mural Paintings," pp. 205, 206.

167. See Barr, letter to Nelson A. Rockefeller, January 15, 1957. The Museum of Modern Art, Department of Painting and Sculpture Fernand Léger Collection file.

168. Mercedes Carles, later Mercedes Matter, remembers walking around the city with Léger and Arshile Gorky. After Léger's departure for France, she and Gorky would send him photographs of store windows they thought would particularly interest him. Mercedes Matter, personal conversation with Kristen Erickson of The Museum of Modern Art, March 25, 1997.

169. See Burgoyne Diller, supervisor of the New York City WPA–FAP (Works Progress Administration–Federal Art Projects) mural division, "The Artist Speaks," *Art in America* (New York) 3 no. 4 (August–September 1965): 205.

170. Léger, letter to Herman, March 9, 1936. In Derouet, ed., *Fernand Léger: Lettres à Simone*, letter 125, p. 168.

171. Willem de Kooning, quoted in Bill Berkson, "As Ever, De Kooning," *Art in America* (New York) 85 no. 2 (February 1997): 68. See also Sandler, "Conversations with de Kooning," *Art Journal* (New York) 48 no. 3 (Fall 1989): 216.

172. Berkson, "As Ever, De Kooning," p. 68.

173. Léger, letter to Herman, February 3, 1936. In Derouet, ed., *Fernand Léger: Lettres à Simone*, letter 119, p. 160.

174. Le Corbusier, letter to Léger, February 20, 1936. In the Fondation Le Corbusier.

175. Barr, *Cubism and Abstract Art*, exh. cat. (New York: The Museum of Modern Art, 1936), p. 214.

176. Bulliet, *The Significant Moderns and Their Pictures* (New York: Covici Friede Publishers, 1936), pp. ix–xii.

177. The works enumerated are those Barr listed in the first of the eight categories into which he divided the exhibition. In the order of listing in the catalogue, they are as follows: "Painting and Sculpture; African Negro Sculpture; Photography; Architecture; Furniture; Typography and Posters; Theatre; and Films." Léger was additionally represented by two photographs of his curtains for the 1923 ballet *La Création du monde* in the "Theatre" section, a strip reproduced from his 1924 film *Ballet mécanique* in "Films," and a rug in "Furniture." Picasso was additionally represented, in "Theatre," by the manager's costume for the Diaghilev-produced ballet *Parade* of 1917 and a color reproduction of the set for the same company's ballet *Le Tricorne* of 1919, and in "Furniture" by a rug.

178. For an account of Meyer Schapiro's meeting with Léger, see Helen Epstein, "Meyer Schapiro: 'A Passion to Know and Make Known,'" *Art News* (New York) 82 no. 5 (May 1983): 61.

179. Schapiro, "Nature of Abstract Art," *Marxist Quarterly* 1 no. 1 (January–March 1937): 97.

180. For a reproduction of Léger's Consolidated Edison mural for the New York World's Fair of 1939, see Willmoth, "Léger and America," p. 47. For reproductions of his murals for the 1937 fair in Paris, see Sarah Wilson, "Fernand Léger, Art and Politics 1935–1955," in *Fernand Léger: The Later Years*, pp. 58, 59.

181. Fernand Léger, "Le Nouveau réalisme continue," first published in *La Querelle du Réalisme* (Paris: Editions Sociales Internationales, 1936), trans. and reprinted in *Functions of Painting*, p. 115. This translation is from Wilson, "Fernand Léger, Art and Politics 1935–1955," p. 58.

182. Léger, letter to Herman, August 1938. In Derouet, ed., *Fernand Léger: Lettres à Simone*, letter 171, p. 222.

183. Léger, letter to Le Corbusier, n.d. In the Fondation Le Corbusier.

184. See, for example, Victoria Newhouse, *Wallace K. Harrison, Architect* (New York: Rizzoli, 1989), p. 29, suggesting that Léger met Harrison in 1927 through his wife's childhood friend, Mary Callery.

185. On February 10, 1939, Léger wrote to his wife, Jeanne, that the

Radio City mural project had fallen through because of John D. Rockefeller. The letter is reprinted in Bauquier, *Fernand Léger, Vivre dans le vrai* (Paris: Adrien Maeght Éditeur, 1987), p. 181.

186. Harrison gave these gouaches to The Museum of Modern Art in 1966.

187. For an account of the execution of the mural in Harrison's home and a reproduction of it, see Willmoth, "Léger and America," p. 49.

188. Ibid., p. 48.

189. Nelson A. Rockefeller, quoted in William S. Lieberman, *The Nelson A. Rockefeller Collection: Masterpieces of Modern Art* (New York: Hudson Hills Press, 1981), p. 16. The arrangement by which Léger worked in the apartment while Matisse worked in France caused Matisse anxiety when he heard from Christian Zervos that Léger was doing a fireplace mural. On January 12, 1939, he wrote to his son, the dealer Pierre Matisse in New York, demanding to know "by the first boat" whether Léger was doing a second fireplace mural or had been hired to replace Matisse's own in the event that it did not please. In the Pierre Matisse Foundation, New York.

190. Léger, "Choses d'Amérique," first published in *La Nouvelle Revue Française* (Paris) no. 308 (May 1, 1939). Reprinted in Léger, *Mes Voyages* (Paris: Éditeurs Français Réunis, 1960), pp. 76–77.

191. Léger, letter to Herman, December 19, 1939, in Derouet, ed., *Fernand Léger: Lettres à Simone*, letter 196, p. 246.

192. From the chronology established by The Alexander and Louisa Calder Foundation, New York, for its forthcoming catalogue raisonné. See also Derouet, ed., *Fernand Léger: Lettres à Simone*, letter 177, note 1, p. 271.

193. Léger, "Erik Satie illustré par Calder. Pourquoi pas?" in *Alexander Calder: Volumes—Vecteurs—Densités/Dessins—Portraits*, exh. cat. (Paris: Galerie Percier, 1931), n.p.

194. "Calder Reception Tonight in Art Museum," *Springfield Morning Union*, November 8, 1938, p. 6.

195. "Assembled for Opening of Calder Exhibit," *Springfield Morning Union*, November 9, 1938, p. 7. "Sigfried Sgiedeion" was the Swiss art historian Siegfried Giedion.

196. On February 18, 1939, Le Corbusier wrote Léger a letter that shows he had not yet received news about his own concerns that Léger had included in the letter quoted here. This and the postcards are in the Fondation Le Corbusier.

197. The misunderstanding between the Museum and Le Corbusier on this matter persisted for years, and was finally resolved in the mid-1950s.

198. Léger, letters to Sara Murphy, October 5 and December 1, 1939. In the Collection of Honoria Murphy Donnelly.

199. Léger, letter to Gerald and Sara Murphy, September 18, 1940. In the Collection of Honoria Murphy Donnelly.

200. In a cable dated September 16–17, 1940, to Gerald and Sara Murphy, Léger explained that he could not get his hands on dollars and requested the Murphys to cable him $350 which he would later repay. The Murphys cabled the money immediately. Both cables in the Collection of Honoria Murphy Donnelly.

201. "Muralist," "Talk of the Town" section, *The New Yorker*, January 4, 1941, p. 10.

202. Léger, letter to Jeanne Léger, January 18, 1941. Quoted in Bauquier, *Vivre dans le vrai*, p. 204.

203. Léger, letter to Le Corbusier, May 28, [1941]. In the Fondation Le Corbusier.

204. Léger, letter to Herman, July 21, 1941. In Derouet and Shunsuke Kijima, eds., *Fernand Léger*, exh. cat. (Bunkamura Museum of Art) (Tokyo: The Tokyo Shimbun, 1994), p. 65.

205. Emilia Hodel, "Léger's Paintings Shown Here," *The San Francisco News*, August 16, 1941, p. 8.

206. Kenneth Ross, "Art and Artists," *Pasadena Star-News*, September 20, 1941, p. 3. In the Stendahl Art Gallery Papers, Archives of American Art, Smithsonian Institution.

207. "The Great Flight of Culture," *Fortune* (New York) 24 no. 6 (December 1941): 102.

208. See Sidney Janis, "School of Paris Comes to U.S.," *Decision* (New York) II nos. 5–6 (November–December 1941): 89, 90.

209. Léger, quoted in Léon Degand, "Le Retour d'un grand peintre," *Les Lettres françaises* (Paris) 6 no. 103 (April 12, 1946): 1.

210. Thomas Craven, *Modern Art The Men The Movements The Meaning* (New York: Simon and Schuster, 1934), p. 265.

211. Léger, postcard to Gerald and Sara Murphy, September 22, 1941. In the Collection of Honoria Murphy Donnelly.

212. Léger, letter to Alfred Neumeyer, October 19, [1941]. In Mills College Art Gallery Papers, Oakland, Calif.

213. The colleges and universities approached were the University of Washington, Seattle; the University of Illinois, Urbana-Champaign; the University of Chicago; The Art Institute of Chicago; Smith College Museum of Art, Northampton, Mass.; and Vassar College, Poughkeepsie, N.Y. See correspondence between Alfred Neumeyer and these institutions in the Mills College Art Gallery papers.

214. Léger, letter to Alexander Calder, September 12, 1944 (postmarked September 13). In The Archive of the Alexander and Louisa Calder Foundation.

215. See Willmoth, "Léger and America," pp. 49–51, for a discussion of the relation of the "*Plongeurs*" to the Beatus Commentary, an illustrated manuscript of the commentary of the Beatus on the Apocalypse of St. John.

216. See Martin S. James, "Léger at Rouses Point, 1944 [*sic*]: A Memoir," *The Burlington Magazine* (London) CXXX no. 1021 (April 1988): 277–82; Willmoth, "Léger and America," pp. 43–54; and Siegfried Giedion, "Léger in America," *Magazine of Art* (Washington, D.C.) 38 no. 8 (December 1945): 295–99. According to James, the title of his article is incorrect and should give the year as 1945, the only one in which he joined Giedion in Rouses Point.

217. Léger, quoted in an interview with Sweeney, "Eleven Europeans in America," *The Museum of Modern Art Bulletin* (New York) XIII nos. 4–5 (1946): 14, 15.

218. Rosenberg, letter to Léger, March 6, 1925, in Derouet, ed., *Une Correspondance d'affaires*, letter 246, p. 165.

219. Walter E. Baum, "Gallatin Art Visitors Come, See and Try to Deci-

pher," *The Evening Bulletin–Philadelphia*, May 19, 1943, p. 16 E.

220. Sandler, "Conversations with de Kooning," p. 216, reports that de Kooning told a story about Léger comparing his *Trois Musiciens* with Picasso's at The Museum of Modern Art. Since Léger never returned to New York after his late 1945 departure, and Picasso's painting was acquired by the Museum in 1949, and Léger's own in 1955, the story must be fantasy.

221. Léger, letter to Hans Richter, n.d. Forwarded by Richter to Calder on August 20, 1944. In The Archive of the Alexander and Louisa Calder Foundation.

222. Léger, interview with François Gromaire, in *L'Écran français* (Paris) 4 no. 40 (April 3, 1946): 11.

223. Léger, letter to Louis Carré, May 16, 1945 in Derouet, *Fernand Léger*, 1997, p. 337.

224. France Desmarais, "La Présence de Fernand Léger sur la scène artistique montréalaise des années quarante," Maîtrise dissertation (Université du Québec, Montreal, 1993), pp. 129 and 302.

225. Léger, letter to Le Corbusier, September 12, [1945]. In the Fondation Le Corbusier.

226. James—then the assistant to Giedion, Léger's neighbor at Rouses Point—made a packing list for Léger, and kindly made a copy available to us. For an account of Léger at Rouses Point, see James, "Léger at Rouses Point, 1944: A Memoir," pp. 277–82. One painting Léger took back to France was a still life he had painted in 1928, and had bought back, through Jacques Seligmann, from an auction at Parke-Bernet on April 13, 1944, in which it was lot 87. See O. A. Liechti of Jacques Seligmann & Co., Inc. letter to Léger, April 15, 1944. In the Jacques Seligmann & Co. Papers.

227. Léger, letter to Le Corbusier, October 1946. In the Fondation Le Corbusier.

228. André Warnod, "*Le Courrier des Arts*," *Le Figaro* (Paris), April 19, 1946, p. 2.

229. Al Held, in "The Held/Cummings Tapes," an interview with Paul Cummings conducted on November 19 and December 12, 19, and 30, 1975, and January 8, 1976, for the

Oral History project of the Archives of American Art, Smithsonian Institution. Reprinted in *Al Held: Italian Watercolors*, exh. cat. (Champaign, Ill.: Krannert Art Museum and Kinkead Pavilion, University of Illinois at Urbana-Champaign, 1993), p. 48.

230. Sam Francis, quoted in an interview with Yves Michaud, "*Sam Francis, Paris années 50*," *Art Press* (Paris) 127 (July–August 1988): 18.

231. Golding, "Léger and the Heroism of Modern Life," p. 123.

232. Robert Colescott, quoted in Calvin Tomkins, "Artist's Easel: Paint It Black," *The New Yorker* (New York), May 19, 1997, p. 62.

233. Paul Gardner, *Louise Bourgeois* (University Series on Women Artists) (New York: Universe Publishing, 1994), p. 23.

234. Philip Guston, response to questionnaire sent by Susan C. Larsen, stamped September 8, 1977, in Stavitsky, "The Development, Institutionalization, and Impact of the A. E. Gallatin Collection," p. 538; Milton Resnick, response to Stavitsky questionnaire, postmarked August 5, 1988, in ibid., p. 540.

235. Brooks Adams, "*Un Léger pour les années 80*," *Art Press* (Paris) 127 (July–August 1988): 4–5.

236. Clement Greenberg, *L'Age Nouveau* (Paris) no. 42 (1949): n.p. (between pp. 32 and 33).

237. Adams, "*Un Léger pour les années 80*," p. 6.

238. See William Rubin, *Frank Stella 1970–1987*, exh. cat. (New York: The Museum of Modern Art, 1987), pp. 142–44.

239. Adams, "*Un Léger pour les années 80*," p. 6.

240. Ibid., p. 7. Léger first mentioned the idea of a twenty-four-hour film in "*À propos du cinéma*," 1930, first published in *Plans* (Paris) no. 1 (January 1931): 83–84, and reprinted in *Functions of Painting*, pp. 103–4. He was still developing the idea in 1949, when he wrote to Henry Miller on the subject (Léger, letter to Henry

Miller, August 11, 1949, in the Henry Miller Papers, University of California, Los Angeles).

241. Ibid., *passim*.

242. Henry Geldzahler, "The Late Léger: Parade of Variations," *Art News* (New York) 61 no. 1 (March 1962): 68.

243. Amy Goldin, "Léger Now," *Art News* (New York) 67 no. 8 (December 1968): pp. 24, 25, 26. See also Nelson, who, in "*Peinture spatiale et architecture*," p. 85, says that looking at Léger's paintings makes him conscious of the "weight of my body, I want to place my arms solidly on a table."

244. John Canaday, "Léger Alive and Well," *The New York Times*, November 24, 1968, p. D 27.

245. Marcelin Pleynet, "The Léger Legacy," *Art News* (New York) 65 no. 10 (February 1967): 77.

246. Greenberg's commentary is published in Robert Goldwater, "A Symposium: The State of American Art," *Magazine of Art* (Washington, D.C.) 42 no. 3 (March 1949): 92.

247. Greenberg, "Master Léger," first published in *Partisan Review* (New York) 21 (January–February 1954): 40–47, reprinted in *Art and Culture* (Boston: Beacon Hill Press, 1961), pp. 103–4.

248. Kuh, letter to Léger, April 3, 1953. In the Katharine Kuh Papers, The Art Institute of Chicago Archives.

249. Edward Weiss, of Weiss & Geller, Inc., Advertising, Chicago, memo to advertising firms in Chicago, April 22, 1953. In the Katharine Kuh Papers, The Art Institute of Chicago Archives.

250. George A. Dondero, "Modern

Art Shackled to Communism," August 16, 1949, *Congressional Record*–House, p. 11813.

251. Ibid., p. 11812.

252. Léger's cable arrived on February 23, 1953. See also Kuh, letter to Daniel Catton Rich, February 13, 1953. In the Daniel Catton Rich Papers, The Art Institute of Chicago Archives.

253. See Vallier, *L'Intérieur de l'Art*, pp. 72–73.

254. Léger, *Cirque* (Paris: Tériade Éditeur, 1950). My account of the attempted Miller/Léger collaboration is based on Rebecca Rabinow's "'Cirque': A Fernand Léger & Henry Miller Story," *The Print Collector's Newsletter* (New York) XXVI no. 6 (January–February 1996): 209–12.

255. *Léger's Circus*, with trans. by Peter de Francia, exh. cat. (London: The South Bank Centre, 1988), p. 16.

256. Ibid., p. 7.

257. Léger, "Paris New York—New York Paris," 1941, in *Mes Voyages*, p. 1.

Imagining Cities

Jodi Hauptman

For Charles Baudelaire, writing in 1863, modernity cannot be specifically defined anymore than it can be physically grasped. To describe the modern condition, the poet resorts to metaphors of atmosphere: fluidity, vapors, ephemeral gases, and liquids.[1] But however ephemeral modernity seems to Baudelaire, the site in which these vapors are most pervasive, the place in which their sensations are most likely to soak us in "atmosphere," is the city. In cafés and along boulevards, in the multitudes of passersby and the crowds of strangers, in the glimmer of bright lights and the haze of colorful fashions—here, in the metropolis, the urban wanderer sees and experiences modern life. According to Baudelaire, to capture this fleeting spectacle—to be the paradigmatic "painter of modern life," a "kaleidoscope gifted with consciousness"—the artist must throw himself into the urban crowd, must "set up his house in the heart of the multitude, amid the ebb and flow of motion, in the midst of the fugitive and the infinite."[2] For Baudelaire, the modern is inseparable from the city.

Almost sixty years after the publication of Baudelaire's landmark text "The Painter of Modern Life," Fernand Léger threw himself into the urban environment, taking in, with close attention and pleasure, the metropolis's spectacle and speed, qualities, it must be noted, that had vastly multiplied since the poet's day. Like Baudelaire, Léger found the essence of the modern in the city, and, as a latter-day incarnation of the "painter of modern life," he translated modernity into visual form. But while Léger's interests echo Baudelaire's, the two men's descriptions differ considerably. Léger's characterizations of the modern are no less evocative than Baudelaire's "atmospheres" and "floating existences," but they are far more substantial, taking the form of palpable eruptions and disruptions, near-violent contrasts and jarring dissonances. In his preface to *Le Spleen de Paris*, Baudelaire explains that modern life requires a new language, "a poetic prose, musical without rhythm and without rhyme, supple enough and rugged enough to adapt itself to the lyrical impulses of the soul, the undulations of reverie, the jibes of consciousness. . . . It was, above all, out of my exploration of huge cities, out of the medley of their innumerable interrelations, that this haunting ideal was born."[3] Calling similarly for a new language—this time a visual one, of course—Léger writes, "Present-day life, more fragmented and faster moving than life in previous eras, has had to accept as its means of expression an art of dynamic divisionism. . . . The modern conception is not simply a passing abstraction, valid only for a few initiates; it is the total expression of a new generation whose needs it shares and whose aspirations it answers."[4] And like Baudelaire, who went

Fernand Léger. *La Ville* (The city; detail), 1919. Oil on canvas. 91 x 117½" (231.1 x 298.4 cm). Philadelphia Museum of Art. A. E. Gallatin Collection. See plate on p. 181

beyond mere rhetoric in putting his new language into practice, Léger, in his paintings, presents viewers with a Paris of tall buildings, rapid transport, and busy and decorated streets.

With their dynamic structures based on fragmentation and contrast, Léger's urban canvases well reflect the experience of modernity in the first few decades of the twentieth century. My inquiry here, however, focuses on how his suggestions and strategies might still be relevant today. Can we extend the terms of Léger's interpretations of metropolitan environments? Are his methods applicable to representing current urban spaces and conditions? Léger's favorite cities—Paris, New York, Chicago—remain centralized and crowded, but they have been joined by a host of others that exhibit a more marked diversity in space, plan, and organization. We now travel the highways of sprawl cities like Los Angeles, Osaka, Las Vegas, and Atlanta. We pass through cities that are largely transfer points—places where crowds of people go just to get somewhere else (France's Lille, for example)—and we must reckon with enormously populated municipalities like São Paulo, Mexico City, Shanghai, and Guangzhou. Yet even as the nomenclature of urbanism changes—we now speak of edge cities, cybercities, networks, exopolises, technoburbs, freeways, sprawls, malls, switchboards—today's cities and their representations remain sites of conflict, of human needs and moral values, nostalgia and desire, power and social division: of meaning itself.

This essay has two aims: first, to examine Léger's interest in and work about the city, and second, to explore more recent responses to urbanism as a subject. In moving from the early part of this century to its closing years, from Léger to a range of artists of today, the goal is not to find direct descendants of the French painter, work "inspired" or "influenced" by him, or projects that echo or mirror his oeuvre, but instead to track and discuss both similar and changing methods of addressing the city over the century. Various in form and strategy, the projects chosen offer both microcosmic looks at particular artists and macrocosmic views of cities themselves. The city, we will see, maintains a strong hold on artists, but we will also find that this fascination today results less from the distraction of our eyes by metropolitan spectacle, and the buffeting of our bodies by speed, than from the disembodiment of continuous flow, the fragmentation of corporeal integrity, the hypnotic vision of the daydream, the imaginary and optical spaces of virtuality, and the dispersed gaze of boundless and boundaryless urbanism.

POST BILLS! Fernand Léger and the City

In Franz Kafka's novel *Amerika*, Karl Rossmann travels to New York City and is met upon his arrival not only by the Statue of Liberty (a knife has replaced her glowing torch) but by the vitality of the city's harbor:

A flat barge laden with a mountain of barrels . . . went past, almost completely obscuring the daylight. . . . Here and there curious objects bobbed independently out of the restless water . . . submerged again and sank before his astonished eyes; boats belonging to the ocean liners. . . . A movement without end, a

restlessness transmitted from the restless element to helpless human beings and their works!

Like the other arriving passengers, Rossmann cannot refrain from "gaz[ing] at the changing scene."[5] He will soon find that this restlessness without end—this traffic—not only exists at the port but is the defining characteristic of the city itself.

Like Rossmann, critic Mark Anderson writes, Kafka himself "was fascinated by traffic patterns in the modern city and, more important, by the aesthetic spectacle and metaphysical dilemmas these patterns implied."[6] In *Amerika* he does not limit his use of the word "*verkehr*," or "traffic," to the congestion of cars and people on city streets, but applies it to all kinds of circulation—commercial, monetary, sexual, and social.[7] The pulse of this "never ending traffic" is not only associated with but presented as the source of the metropolis's varied, fluctuating, and spectacular sensations: visual, aural, and olfactory. From his uncle's apartment, Karl watches, fascinated, at the *verkehr* below: "mornings and evenings and in the dreams of the night a never ending traffic pulsed along this street which, seen from above, looked like an inextricable confusion, forever newly improvised, of distorted human figures and the tops of moving vehicles of all types, and from which arose a new, variegated, wilder confusion of noises, dust and smells."[8] In *Amerika*, Kafka comes to understand the modern city through its diverse traffic; *verkehr* is his metaphor for modernity and modern life.

If for Kafka it is *traffic*—its unending stream, its confusion, its rootlessness, its stylized motion and rhythms, its timetables, its accidents, its tinge of money—that is the perfect emblem of modernity and the modern city, for Léger that metaphor is the *billboard*. The billboard, Léger explains, brutally cuts across the landscape, rupturing the even spacing of the city and announcing its messages for all to hear and see. For the painter, the billboard "shouting in a timid landscape," and the signs that "flash," enlivening the "interminable walls" and the "saddest and most sinister surfaces" of buildings, awaken the eye, the ear, and also desire and the pocketbook.[9]

Both traffic and the billboard exacerbate what Ben Singer calls the "*neurological* conception of modernity"—a quicker, more chaotic, and fragmented condition confronting the individual with a heightened intensity of sensory stimulation.[10] The force of both the billboard and traffic depends on motion, speed, flux, and circulation. Léger's primary interest in the billboard is in the way it captures modern vision, an experience of the world mainly defined by rapid movement. "If pictorial expression has changed, it is because modern life has necessitated it," Léger writes:

The thing that is imagined is less fixed, the object exposes itself less than it did formerly. When one crosses a landscape by automobile or express train, it becomes fragmented; it loses its descriptive value but gains in synthetic value. The view through the door of the railroad car or the automobile windshield, in combination with the speed, has altered the habitual look of things. A modern man registers a hundred times more sensory impressions than an eighteenth-century artist.[11]

The billboard is simultaneously a response to modernity's more-rapid conditions, its expanding stimulation, fragmentation, and flux, and an extension of them. To one poster designer the billboard is not merely a display but an "announcing machine":[12] immense in size and printed with a simple and easily read design that displays concise information, it can be taken in at a glance through an automobile window or from a city bus. The billboard must be distracting enough to capture a driver's attention within a split second, but not so complicated as to hold it and cause a wreck. The designer of these signs thus balances the slower pace and vision of the stroller with the rapid and kinetic motion of the automobile. For either viewer, though, the billboard adorns the city, creating contrasting displays of color, type, and image (fig. 1). Revealing an outlook similar to Léger's, Louis Chéronnet, writing in 1926, glorified the billboard as a shrine of dynamic modernity: "Excessive, hallucinatory, the billboard imposes itself everywhere, whatever the speed of the passerby or the thoughts that absorb him. It surges like a cathedral. Its frescoes come out of the ground, its vertical masses and planes run together in the assault on story-heights and its spires thrust themselves into the heavens it has conquered. It is in the image of our existence: multiple and simultaneous."[13]

By including billboard imagery and lettering in his paintings and by glorifying posters in his writings, Léger inserted himself squarely into French debates over outdoor advertising's decorative or disruptive presence, a battle that by the 1920s had been raging for more than thirty years. In his 1922 article "Contemporary Achievements in Painting," Léger blasted "the stupefying and ridiculous organization that pompously calls itself, 'The Society for the Protection of the Landscape.'"[14] The expansion of outdoor advertising resulted not only from expanding economies but from shifts in traditional selling practices, from the bins of local merchants to the sale of "brand-name packaged goods . . . each requiring a name, stylized logo, and campaign of publicity that would attract the customer's preference."[15] In addition to commissioning the construction of billboards, companies promoted themselves through posters glued on trams, circular pasting boards called Morris columns, and directly on walls, hawking everything from newspapers to biscuits.[16]

Beginning in 1881 and accelerating in the early 1900s, business interests battled self-appointed defenders of the landscape.[17] French journalists debated whether or not the increase in advertising "augured well for French industry and commerce" or would incite immoral chaos.[18] The poster, warned one critic, Maurice Talmeyr, "already destroys as pleasure does, and it will destroy like rage."[19] Another wrote, "The principal fault of the modern poster is above all its dimensions, more and more enormous, and also its permanence, its immutability. If it was formerly a transitional thing, something fugitive and almost discreet, it has become, by the force of natural laws, the obsessing vision our gaze can't ever shake the habit of, which pursues the poor traveler in his every move . . . ever bigger—because of the competition—ever redder or bluer."[20] Although a vehement opponent of the poster, Talmeyr perceptively explained the way it "reflected the frenzied pace of urban life" and "assaulted city dwellers"—

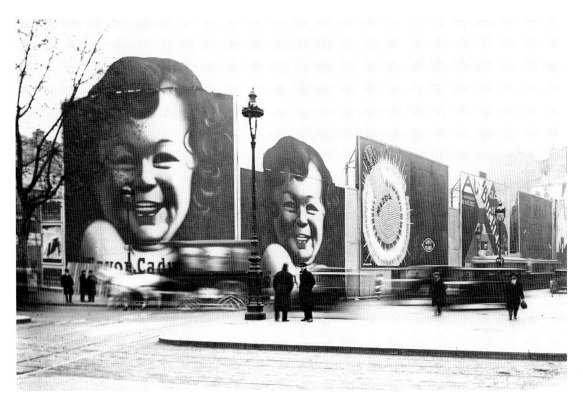

1. Advertising billboards by Machils for Cadum soap. Paris, c. 1925

the very qualities that Léger and other artists would have defined as its modernity. But even in illuminating the poster's role as a significant new technology of communication, the writer remained harshly critical of its presence: "Triumphant, exultant, brushed down, pasted, torn in a few hours and continually sapping the heart and soul with its vibrant futility, the poster is indeed the art, and almost the only art of this age of fever and laughter, of violence, ruin, electricity and oblivion."[21]

Fascinated by the poster's vitality and speed, Léger reversed such negative assessments. Sharing the artist's interest in and approval of vernacular spectacle, the poet Guillaume Apollinaire was known to join him in touring the "urban iconography of billboards and street signs."[22] Translating his own experience in the city into writing in "*Zone*" (1912), Apollinaire described a solitary walker exploring the urban poetry of the city's catalogues, posters, and newspapers.[23] Fifteen years later one of Léger's closest collaborators, Blaise Cendrars, also equated advertising with poetry, calling it "the flower of contemporary life."[24] Along with the internal-combustion engine, the ball bearing, and money, Cendrars selected advertising as one of the "seven marvels of the modern world," and asked, "Have you ever thought about the sadness that streets, squares, stations, subways, first class hotels, dance halls, movies, dining cars, trips, highways, nature would all exhibit without the innumerable billboards . . . without lumi-

nous signboards"?[25] In the view of another group of city dwellers, the Surrealists, advertising was not only a marker of modernity but a source of the marvelous. For them the meeting of posters on a city wall exemplified objective chance, while their pictures and texts, made mysterious by tears and gaps, helped transform the city into a "forest of symbols."[26]

Critic Félix Fénéon, recognizing the value of the *affiches* covering Paris, "enjoined his readers to rip advertisements from the walls where they were posted and to use them in the decoration of their living quarters."[27] Léger too borrowed from the walls of the city, but in a different way: instead of tearing posters off the wall, he re-created them as elements in his paintings. In works like *La Ville* (The city, 1919; p. 181), *Le Marinier* (Bargeman, 1918; p. 185), and *Les Disques dans la ville* (Disks in the city, 1920–21; p. 183) we see abstractions of billboards: fragments of type, bright colors, simple signs like arrows, and geometricized human forms. The city and its decoration are perfect subjects for the strategies of fragmentation and contrast that Léger most often used to construct his pictures.

The monumental *La Ville* is not a cityscape in any traditional sense: the artist provides no means of understanding the space and direction of streets, the location and size of buildings, the movement of pedestrian and vehicular traffic. Instead, the painting provides viewers with the *sensation* of living in or moving through the modern city. Léger condenses the effects of the metropolis's expansion of population, commercial activity, and visual and aural stimulation into abstracted but still recognizable signs. We see billboard lettering and imagery, the boundaries of streets, scaffolding, buildings, mechanized bodies, and billowing smoke. The size of the canvas envelops us; we are inside this bustling environment, ready to climb up the stairs and move into the metropolitan crowd. Léger expresses the new complexity and simultaneity, crowds and chaos, primarily through his use of fragmented planes and of contrasts and ruptures in shape and color. He believed that *La Ville* was revolutionary because of its ability to achieve depth and dynamism without resorting to old-fashioned imitative techniques like chiaroscuro and modeling. Overlapping and layered planes depict urban density, and fragments show the speed of urban experience. The broken views of billboard texts and images indicate not only the multiple stimuli available in the city but, even more, the speed with which residents traverse urban space. Moving through streets and plazas, one catches only glimpses of objects and images. "It is certain," Léger writes, "that the evolution of the means of locomotion and their speed have a great deal to do with the new way of seeing."[28] The oscillation between emerging and receding elements only further intensifies movement and animation.

In addition to including signs and advertising to exacerbate the beat of urban rhythms, *La Ville* alludes to the billboard in its very size and shape. Léger himself distinguished between mural and easel painting, and placed this particular work in the mural camp. It might make still more sense, though, to think of the piece in a different category entirely—as a "billboard painting." Léger even linked it to the birth of advertising, which for him and his friend Cendrars occurred at Paris's place Clichy—the location, as Cendrars once remarked to Léger, of

the largest and most extraordinarily colorful posters in Paris.[29] In *La Ville*, billboards both measure distance and show the necessary redundancy of commercial messages, which ensure maximum impact through one's repeated encounters with them. Using a range of images and texts, Léger catalogues the city's variety of signs. The bright white letters running vertically down a black ground in the middle of the painting, for example, seem to indicate the passage from day to night, for this appears to be a flashing *electric* signboard, a kaleidoscopic spectacle that simultaneously defines the structure on which it is mounted and dematerializes the built environment.

Léger's representation of the contrast, fragmentation, and simultaneity of city life is not limited to painting. Having employed cinematic techniques like cutting, juxtaposition, close-up, and isolation of images in creating *La Ville*,[30] he turned to film itself with *Ballet mécanique* (Mechanical ballet, 1924). Standish Lawder has described the way this film captures the "pulsating energies of modern urban life, its rhythms and its forms, even its flashes of amusing incongruity. . . . [Léger's] film is a spectacle in constant movement, infused with presence of modern machinery in motion, rushing pell-mell from and to nowhere, full of fragmented images and aggressive signals of advertising . . . like the city."[31] Léger's original sketches for the film indicate that he planned to include a shot of an entire page of newspaper advertising, as well as familiar mascots like the Cadum baby, a hugely enlarged and grinning infant's face that had been disseminated widely over the walls of Paris for the purposes of hawking soap (fig. 1).[32] Léger focused on this particular advertisement, according to Lawder, because "'Le bébé Cadum' was an omnipresent billboard image of monumental vulgarity, and yet it delivered its message with such powerful visual impact that it automatically came to Léger's mind as the obvious example of modern advertising."[33]

Although the Cadum baby did not find its way into *Ballet mécanique*, the film's driving force nonetheless remains the rhythm and experience of commercial media. Léger makes this explicit in a segment composed only of text. White forms appearing around the edges of a black screen rapidly move toward the center, forming a large zero. This is followed immediately by a sentence presented in block letters and with "maximum graphic force": "*On a volé un collier de perles de 5 millions*" (Pearl necklace worth 5 million stolen; fig. 2). Over the course of the sequence the message is broken into fragments, "all bouncing off the screen in a rapid-fire sputtering rhythm."[34] With this sequence of vividly moving text, Léger echoes the experience of driving past posters plastered on city walls, or of quickly glancing at a newspaper, by selecting a single sentence "and then disassembl[ing] it, play[ing] with it, breaking it into fragments, stretching them out through space and time, as it were, like an eye scanning a newspaper, overlapping image and afterimage."[35] With this breakdown of text the artist tests a hypothesis about language's transformation in modern life that he had proposed ten years earlier in "Contemporary Achievements in Painting." There he had argued that because of the period's ever more crowded sensory landscape, language had grown "full of diminutives and

2. Fernand Léger and Dudley Murphy. *Ballet mécanique* (Mechanical ballet), 1924. Still from black and white film in 35 mm., 12 minutes

abbreviations."[36] In *Ballet mécanique*, Léger offers a headline—itself already an "abbreviation" of a story—that he then further fragments and tears apart.

The billboard activates language, letters, words, and numbers as a vibrant part of the urban spectacle. Fascinated with this display of public writing, Léger told this story: "On a main street two men carry gigantic golden letters in a wheelbarrow; the effect is so startling that everyone stops to look at it. *There is the origin of modern performance. . . .* The street thought of as one of the fine arts?"[37] Léger took the initiative of directing such a modern performance in a series of illustrations for Cendrars's *La Fin du monde filmée par l'Ange N.-D.* (The end of the world filmed by the angel N.-D. [Notre Dame], 1919). Written as a film scenario but never produced in celluloid, *La Fin du monde* is the story of the futile attempt by "God the Father" to convert the inhabitants of Mars, aided along the way by the angel of Notre-Dame. In the end the "film" is rewound and the world is restored. Working closely with Cendrars's text, Léger provided illustrations of the angel, the church building, general views of Paris, the fusion of the human and the architectural, and more abstract machineries. What is most striking about these pages is the way typographic elements both interrupt and define the compositions. Art historian Christopher Green commends Léger for achieving in these works "a fully simultanist alliance between the verbal and the visual."[38]

In the illustration for chapter 5, "*La Fin du monde*," Léger presents the Cathedral of Notre Dame, a boat floating on the Seine, and an exploding Eiffel Tower—its head blasted off by the scene's internal energy (fig. 3). Most striking about this work is the confusion of negative and positive space. Léger's lettering—both handwritten and "stenciled"—seems at once to define the surfaces of city walls and to cause their disappearance, leaving letters suspended like reflections of an electric sign or words caught in a mirror. The area above the boat looks like the arch of a stone bridge, off which dive two stick figures. On this surface we read the stenciled word "*ETE*," or "Summer," and the graffitied phrase "*Les autobus tournent. . .*" But when our eyes move left, this area becomes less a solid surface than the open air that defines the shaft of Paris's most famous monument. In this view, "*ETE*" and the letters circling above, "*La Grande Rou*," appear not so much written as resonating in the air, like voices generated from the Eiffel Tower's radio antennae.

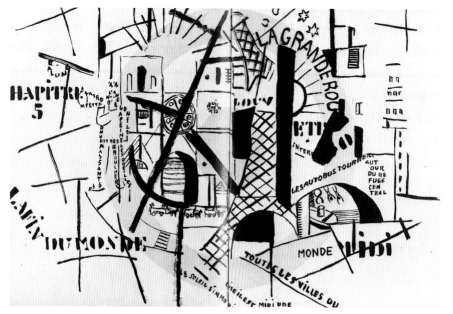

3. Fernand Léger. Illustration for spread in *La Fin du monde filmée par l'Ange N.-D.* (The end of the world filmed by the angel N.-D. [Notre Dame]), by Blaise Cendrars. Pochoir in color, with line-block reproductions of ink drawings. Paris: Éditions de la Sirène, 1919. The Museum of Modern Art, New York. The Louis E. Stern Collection, 1964

Léger had included hand-drawn renderings of stenciled letters in paintings prior to 1919, but in *La Fin du monde* they are the dominant element. By making these letters look mechanical without the aid of actual stencils, Léger reenacts, within his own work, the art of the street; he functions as a designer, a typographer, a maker of advertisements. In light of his interest in the transformation of words and letters into visual elements, it is no wonder that he turned to the typographer as a pictorial subject. Green speculates that it was Léger's collaboration with printmakers to create the illustrations for Cendrars's 1918 *J'ai tué* that inspired him to devote a series of paintings to these engineers of type.[39] With its easel, gears, and page of text, *Le Typographe* (The typographer, 1918; p. 187) displays Léger's familiarity with the printer's studio.

If Léger saw the billboard as the primary emblem of modern existence, he also, albeit less explicitly, saw the typographer as modernity's exemplary figure. Just as Walter Benjamin, in his search for "Ur-forms of contemporary life," chose the flaneur, the prostitute, and the ragpicker as types whose shared condition he believed "saturates modern existence," Léger chose the typographer as a figure through whom he could understand the modern city.[40] And in exploring the typographer's function and importance in a world increasingly defined by spectacle and signs, Léger, I would suggest, began to identify with him. "Present-day life," he insisted, "more fragmented and faster moving than life in previous eras, has had to accept as its means of expression an art of dynamic divisionism."[41] The typographer's—and Léger's—abilities are up to the task; both are able to bring together violent contrasts of color, to decorate "those interminable walls of governmental and other buildings,"[42] and to bring dissonant forms into vital conflict. In collaborating with Cendrars on *La Fin du monde*, Léger actually played the part of the typographer, using fonts and point size to activate the space of the illustrations as well as the Paris of the author's text. He clearly enjoyed this role, for he reprised it in his design of movie posters, creating publicity materials for both Abel Gance's *La Roue* (The wheel, 1922; fig. 4) and Marcel L'Herbier's *L'Inhumaine* (The inhuman woman, 1923). His posters for these films combine mechanical imagery and text in lively rhythmic patterning.

4. Fernand Léger. Study for poster for Abel Gance's film *La Roue* (The wheel, 1922), 1922. Gouache on paper, 16⅛ x 12³⁄₁₆" (41 x 31 cm). Private collection

In 1914, Ludwig Meidner offered unsolicited advice to his fellow artists in his "Directions for Painting Images of the Metropolis." Criticizing the pastoral qualities of work by Claude Monet and Camille Pissarro ("They had painted urban architecture like brooks, boulevards like flower beds"), Meidner explained that the real beauty of the city lay in its most *unnatural* features, its manmade or manufactured elements: "tumultuous streets, the elegance of iron suspension bridges, the gasometers . . . the howling colors of the Autobuses and express locomo-

tives, the rolling telephone wires, the harlequinade of the advertisement pillars."[43] For Meidner, the city street was "a bombardment of whizzing rows of windows, of rushing beams of light between vehicles of many kinds, of a thousand leaping spheres, tatters of people, advertisements, and droning, formless, masses of color."[44] Five years after Meidner published his "Directions," Léger, in *La Ville* and other works, unknowingly met their challenge, giving pictorial form to textual descriptions of "rushing beams of light," "leaping spheres," and "masses of color." In his work and through his writings, Léger offered rules and set standards for an art that would be "significant in its own time"[45]—and, as with Meidner, essential to this significance was the demand that artists concentrate on or, at the very least, learn from the city, allowing their viewers to experience what it feels like to live there.[46] Léger's emblems, like the billboard rupturing the cityscape, and symptomatic figures, like the typographer, would surely have met with Meidner's approval. More important, they provided visualizations of the *sensations* and *effects* of spectacles like the gigantic Cadum baby, and of the rapid movements of trains and automobiles.

Always intrigued by the city, Léger, by the late 1920s, had shifted his interest from the billboard, the poster, and the typographer to the window display and the shop decorator. Describing what for him had become the most remarkable visual arrays to be seen in the city, he wrote in 1928,

The central element of the street, is the object rather than the poster, which fades into a secondary position and disappears. . . . Economic pressure has brought the merchant to his knees before his merchandise. . . . One fine day, he put a shoe or a leg of lamb on display in his shop window, getting a perspective. His taste and imagination did the rest. . . . Then the store can be considered one of the fine arts, for it is majestically dressed by a thousand hands that daily make and remake the modern stores' pretty scenery.[47]

Following a promise made fourteen years earlier, Léger continued, in his writings and in his work, to "be a sensibility completely subject to the new state of things," to capture and represent "the creative spirit of these external manifestations."[48] By then long familiar, the billboard could no longer reenact modernity's rupture of space and time in any vivid way, but in Léger's view speed and dissonance were no longer the point. Remaining contemporary, he turned to the *object* in all of its decorative, plastic, and sculptural presence, highlighting, as the modern's new emblem and new type, the store window and the merchandiser.

With Léger's lesson in mind, we might ask how a work of art, to borrow the artist's instructions, can "be significant in its own time" while "endur[ing] beyond the epoch of its creation."[49] What are the external conditions that need to be addressed? What kind of directions should contemporary artists follow? To answer these questions I now turn to a small group of projects that focus, as Léger's *La Ville* did, on the contemporary city. A vast amount of recent art could easily fit into this broad category, but instead of offering a long list of artists and works, I will focus in depth on a select five, representing a variety of mediums and methods: a

photographer, an installation artist, an architect, a writer, and only one painter. This group addresses urbanism through strategies ranging from excavating childhood to imagining fantastic cities, from listening to urban noises to writing texts, from exploring metropolitan transit to deciphering the language of advertising, and much more. Their views and interpretations of the contemporary city are disparate, but at least one thread links them both to each other and back to Léger, thus creating both a (kind of) legacy and a (kind of) tradition: that link is the use of fragmentation as an aesthetic and rhetorical strategy. Over and over again these artists (and others I surveyed but did not include here) present the noise, flux, and activity of the city through the accumulation of fragments, envision urban space through the rupturing of surfaces and texts, and reclaim metropolitan memory through the historian's archival collection of castoffs and debris.[50]

This continued deployment of fragmentation, dissonance, and contrast not only is relevant to the realms of aesthetics and representation but suggests a consistency in the state of the city itself—and in our understanding of it. These artists, however, were not chosen for discussion here because their work perfectly matches Léger's program, strategies, or point of view, and this essay does not claim to describe a simple transition from the early-twentieth-century modern to the late-twentieth-century postmodern, from the machine city to the cybercity. Instead it enacts what ideally will be a fruitful dialogue between earlier visions and conceptions of the city and those of today. The questions asked here include, What takes the place of the billboard and the typographer in these artists' projects as emblems of contemporary life, as metaphors for our cities and their sensations? Is the city still figured as a site of dynamic division or has it become a continuous unending sprawl? What is the benefit to the present-day or future urban dweller of art that excavates and navigates the contemporary city, tracks the movement of its transportation and communication systems, and maps the wanderings of its inhabitants? We will soon see that there is no such thing as a single or simple answer. Instead of discovering a holistic or consistent portrait of today's city, we will explore multiple, layered, and fragmented views.

Lari Pittman's Urban Groove

Flipping through the catalogue for a mid-career exhibition of Lari Pittman's work, I am struck, even before reaching the paintings' glaring light and colors, by the extensive titles assigned to them. Contradiction pervades Pittman's choices of words: insistence and resignation; hoping, waiting, but not liking; effete and vigorous; religious and secular. Not only are contrast and contradiction characteristic of Pittman's titles, they are the very forces that drive his work. His paintings comprise jarring shapes, figures, and texts, multiple events happening all at once, vibrating colors and clashing forms. Pittman describes his use of contrast this way: "When you look at the paintings, it's not confusion that you're looking at, but a simultaneity of events in

6. Sonia Delaunay-Terk and Blaise Cendrars. *La Prose du Transsibérien et de la petite Jehanne de France* (The prose of the Transsiberian [Express] and of little Jehanne de France). Pochoir in color. Paris: Éditions des Hommes Nouveaux [Cendrars], 1913. The Museum of Modern Art, New York. Purchase, 1977

time. That's the layering in the painting. It's not about confusion. It's about being able to circumnavigate through the painting, where there is something horrific and really silly, disturbing and very buoyant."[51]

Contrast, simultaneity—isn't this the lexicon of the early twentieth century? Léger certainly thought so; he described modern life as "a state of contrasts." And for the Futurist artist Umberto Boccioni, "The intoxicating aim of our art" was "the simultaneousness of states of mind."[52] In fact virtually all of the major art movements of the early twentieth century incorpo-

5. Giacomo Balla. *Dinamismo di cane al guinzaglio* (Dynamism of a dog on a leash), 1912. Oil on canvas, 35⅜ x 43¼" (89.8 x 109.8 cm). Albright-Knox Art Gallery, Buffalo, New York. Bequest of A. Conger Goodyear and Gift of George F. Goodyear, 1964

rated, in some fashion, investigations of contrast and simultaneity. Before turning to Pittman's deployment of these strategies, we might briefly review their legacy.

For the Futurists, simultaneity aided in the representation of movement, as in the multiplied legs in Giacomo Balla's *Dinamismo di un cane al guinzaglio* (Dynamism of a dog on a leash, 1912; fig. 5), and served to juxtapose disparate temporalities. The Orphism of Robert Delaunay and Sonia Delaunay-Terk stressed simultaneity of hue: "The dynamic counterpoint of otherwise dissonant colors when observed in complementarity."[53] Cendrars and Delaunay-Terk extended the definition of simultaneity by bringing together image and text in the collaborative *"livre simultané"* that they titled *La Prose du Transsibérien et de la petite Jehanne de France* (The prose of the Transsiberian [Express] and of little Jehanne de France, 1913; fig. 6).[54]

Technological developments, specifically advances in communications, provided experiences of simultaneity outside the canvas and the artist's book.[55] The telegraph, telephone, newspaper, and cinema all brought faraway events and disparate temporalities closer together. Apollinaire once exclaimed, "Open up a newspaper. Immediately ten, twenty different events jump out at you. The two big headlines printed daily on the front page of *Paris Midi*, isn't that Simultaneist poetry?"[56] By 1912 the wireless telegraph had become the most important means of international communication, linking countries in "an instantaneous worldwide network."[57] Soon the telephone would provide even more direct communication, removing the waiting time for a response.

Both the telephone and the telegraph allowed for the more-rapid dissemination of news around the world. In 1896, when telephones were used to report returns in the U.S. presidential election, "Thousands sat with their ear glued to the receiver the whole night long, hyp-

notized by the possibilities unfolded to them for the first time."[58] Cinema was able to show these invisible connections in visual and narrative terms through the American movie-director Edwin S. Porter's innovative use of cross-cutting.[59] With *The Great Train Robbery* (1903), Porter broke from the main action to show events occurring simultaneously, thus expanding film's story-telling possibilities.

Communication technologies linked faraway people by cables and wires, and cinema displayed such connections, but for most artists and writers interested in the visual or literary effects of simultaneity, the metropolis offered by far the most fruitful subject. The poet Henri-Martin Barzun, for example, declared in 1913 that city life proved "the existence of simultaneous realities."[60] A *New York Times* journalist clearly agreed: "Few New Yorkers realize that all through the roar of the big city there are constantly speeding messages between people separated by vast distances, and that over housetops and even through the walls of buildings and in the very air one breathes are words written by electricity."[61]

In Paris, the Eiffel Tower functioned as the nexus of the city's simultaneous temporal, visual, and, through the radio antenna mounted on its top, aural events. Discussing the confluence of the tower's multiple stimuli, Cendrars focused in particular on this antenna: describing the monument's "sounding line," he praised it for shining "with all the magnificence of the aurora borealis with your radio waves."[62] Robert Delaunay depicted the tower as inextricable from the city in which it stands; adjacent buildings both melt into the iron structure and frame its space (fig. 7). Cendrars admired Delaunay for tackling such a difficult subject; his efforts, the poet wrote, constituted "an unforgettable drama: the struggle of an artist with a subject so new that he didn't know how to capture it, to subdue it."[63]

While Delaunay's paintings of the Eiffel Tower put Paris's simultaneous realities into visual form, Apollinaire, in his *Calligrammes*, revealed the city's and simultaneity's aural dimension. Where else but in the city is sound at its most overlapped and orchestral? The first of Apollinaire's visual poems, "*Lettre-Océan*," translates the written into the aural word and depicts the symphonic buildup and performance of simultaneous voices, traffic noises, and commercial messages (fig. 8). The poem's title expresses this formation, showing the shift from the written postcard or letter, which travels by ship across the ocean, to the telegraph, a method both more instantaneous and more nearly linked to the spoken word.[64] Apollinaire's description of the city in "*Lettre-Océan*" comprises not buildings and plans but the onomatopoeic effects of gramophones (*zzzz*), buses (*rororotingting*), and sirens (*HouHouHou*). Apollinaire, according to Roger Shattuck, "depicts a world mapped out in acoustical space."[65] In "*Lettre-Océan*," "messages go forth in visible waves" through the megaphone, the radio tower, the street activity, and the telegraph lines, while sound effects and multiple voices are rendered in "a comic strip version of vocal amplification."[66]

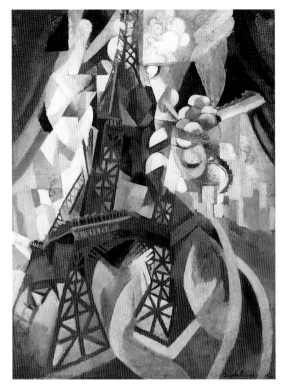

7. Robert Delaunay. *La Tour rouge* (Red Eiffel Tower), 1911–12. Oil on canvas, 49¼ x 35⅛" (125 x 90.3 cm). Solomon R. Guggenheim Museum, New York

8. Guillaume Apollinaire. "*Lettre-Océan*," from *Les Soirées de Paris* (Paris) 25 (June 15, 1914): 340–41. The Museum of Modern Art Library, New York

As one can see from even this short discussion, simultaneity is a primary feature of the language of modernism, and is most effective when deployed to represent and understand the city. From the early part of the century, artists and writers used simultaneity to reflect not only the way the city looked, with its myriad flashing stimuli (as in Léger's paintings), but also what it sounded like, offering an experience of the aural bombardment of noises in the street and messages in the home. Pointing out the importance of such stereophonic sound to the metropolis's aural and visual noise, curator Laura Hoptman perceptively renames simultaneity "the urban groove."[67]

Like Léger, Apollinaire, and Robert Delaunay, Lari Pittman works to the beat of this urban groove, proving that simultaneity remains a viable strategy for depicting the urban experience of the late twentieth century. Like Léger's *La Ville*, Pittman's paintings are arenas for jarring confrontations among and between temporalities, spaces, texts, colors, and shapes, offering multiple viewpoints, complex relationships between space and time, and ornamental decorations and repetitions. Albeit indirectly, the artist puts himself into this history of representing the city (and echoes both the writings and the pictures of Léger) when he explains that in his paintings he seeks to represent "a simultaneous world."[68] Pittman carefully distinguishes simultaneity from chaos: "I've never viewed my work as chaotic. It's very ordered and about what might appear to be opposites but occurring simultaneously and occupying, very happily and with no problem, the same pictorial space."[69]

Although wildly visual, Pittman's work even more vibrantly maps *acoustical* space. Like the gramophones and buses of Apollinaire's "*Lettre-Océan*," blaring megaphones, cars, slogans, computer terminals, printers, satellite dishes, and open-mouthed figures fill these canvases, all spewing out waste or information (it is often difficult to distinguish between the two) in tracks expressed by winding lines, cartoon bubbles, arrows, and bursts of light. Pittman's work is in fact all about sound, presenting in paint something like the "comic strip version[s] of vocal amplification" that Shattuck finds in Apollinaire.[70] Reading texts like "Sassy!," "Go for it!," and "Love-sexi!" in his images, all written enlarged, in bright colors, and positioned emerging out of megaphones, we can just about hear them shouted out as well; viewers become listeners (fig. 9). Auditory elements appear throughout Pittman's work—the roar of a car's engine, the blast of its horn, the laughter of happy but devilish clowns, the sound of the credit-card machine. Pittman's "urban groove" is in fact a cacophony of voices, street noises, and commercial messages.

Critic Dave Hickey calls this exultant din Pittman's "street language," stressing its distinctly urban quality.[71] Likening the cadence of Pittman's voice to a strange amalgamation of Christopher Marlowe's *Faust*, Walt Whitman's *Leaves of Grass*, and Andy Warhol's series of Maos, Hickey describes "the language of the street bubbling just beneath the sleek artifice."[72] The locale to which Hickey refers is not just any city, but one in particular: Los Angeles, the place where these paintings were created and with which they are in dialogue. Pittman's paint-

9. Lari Pittman. *A Decorated Chronology of Insistence and Resignation #30*, 1994. Acrylic, enamel, glitter on two wood panels, 6'11" x 13'4" overall (210.8 x 406.4 cm). Collection Robert Conn, San Diego

ings bring the noise and distraction of Los Angeles into the quiet and sanitized space of the gallery (another example of simultaneity). Of his *An American Place* (1986), Hickey writes, "Its shrewd pastiche of floral and architectural detail was so exquisitely evocative of the palm-ragged city beyond it, so perfectly in tune with the palpable atmosphere of Los Angeles, that the painting itself, far from seeming incongruous in the space, conspired with the surrounding sprawl of the city to make the museum itself seem contrived."[73]

Like Léger, Pittman incorporates the imagery of signs, billboards, advertisements, and posters into his compositions. Through their very size, these huge works (at least one, *Like You*, 1995, is twenty-six feet long) cannot help but allude to billboards, outdoor advertising, and other public messages meant to address, briefly, a population in perpetual and automated motion. Commerce too invades these raucous scenes, with credit-card symbols appearing as their imaginary sponsors. And as Pittman translates noise into form, the shapes, colors, and texts of his paintings contrast as much as the sounds do: words stretch across the canvas in opposite directions and in different sizes, fonts, and styles. Complementary colors vibrate against each other, making whole scenes optically bounce. This din is compressed into shallow visual spaces; depth is created not by one-point perspective, or by modeling, but by overlapping and layering—as in Léger's works from the late teens and '20s. Also like Léger, Pittman reduces his figures to flat shapes or silhouettes. Adding to the dynamism of his paintings are his renderings of transparent swaths of white, which create the illusion of reflective and glittery surfaces.

87

10. Lari Pittman. *Once Inverted, Now Throw-Away and Expo-nential*, 1996. Oil on prepared wood with framed work on paper attached, 60 x 48″ (152.4 x 121.9 cm). Private collection, London

While Pittman's scenarios appear eminently public, they also address the elision of the barrier between public and private, between street and house. *Once Inverted, Now Throw-Away and Exponential* (1996, fig. 10) makes the collapse of boundaries clear: showing an image within an image, the work seems to describe an interior space, like a living room with a framed painting hanging on the wall, but Pittman covers this "interior" with objects and messages usually found outside, from pastoral trees, exotic plants, farmhouses, and pink glowing rivers to (post)industrial electrical towers, satellite dishes, bridges, and brick buildings. The artist's "interior"—if we can call it that—offers no respite from the metropolis pressing in from outside; instead it is so thoroughly a part of the uncontrolled obsolescence and exponential growth hinted at in the work's title that the walls themselves begin to reflect rather than deflect the visual din of the street. The framed work within offers no solace either: it depicts an equally crowded landscape of elements that echo the large canvas, including a satellite dish, strange flowers, and glass-and-steel structures.

The consistent reappearance of the satellite dish in Pittman's work suggests that the loss of boundaries between public and private results, at least in part, from television. Televised messages transmitted into houses and apartments subject residents to a persistent song of need, consumption, and desire. The "predella" running along the bottom of *Like You* (fig. 11) makes this invasion menacingly clear: schematic drawings acting as peep shows into the domestic, these panels present the hearth, the home's most sacred site, corrupted by advertising messages relayed from the outside—"Little Black Dress!" "Drop-Dead Ele-gant!" "Décolleté!" And just as the public has entered the home through communication technologies like television and more recently the Internet, Pittman creates an exterior world populated by what is ordinarily considered private, an immodest landscape of breasts, buttocks, and men's briefs. In a world of simultaneity, the private and the public, the sacred and the profane, are one and the same.

The simultaneity in Pittman's work extends to the dimension of time. In *This Discussion, Beloved and Despised, Continues Regardless* (1989), spirals of transparent arrows not only create the illusion of a circular force, churning and swirling the painting's elements, but also call up those hypnotic spirals used in science fiction films and television to indicate a move back into the past, or into a different and mysterious space.[74] The journeys indicated by the nause-

ating circular movement in those movies threaten bodily integrity and resist rational thought, and Pittman's flat spirals act similarly as vertiginous maelstroms, pulling the viewer visually and carnally into the unfamiliar time-space of the painting. Another optical trick the artist uses is the silhouette, which also brings disparate eras into reach. In the same painting, flat dark outlines of men, women, and children evoke the colonial period, and link the America of the past to the one of today. As a trace or shadow of the sitter, the silhouette opens up yet another set of temporalities, "the illogical conjunction of the *here-now* and the *there-then*. . . . its reality that of the *having-been-there*."[75] These silhouettes, along with the reference to continuity in the work's title, express time as a chain, from being there, to leaving a trace, to incorporating that shadow of a self into a different temporal moment.

Pittman's urban groove, visual, temporal, and aural, has a two-way beat. First, a horizontal chainlike pulse moves from object to object (or, in art historian Rosalind Krauss's words, from part-object to part-object), from body to buttocks to breast to penis to tree branch and back to body again.[76] And second, we experience a shift back and forth between simultaneous realities in depth, what Lane Relyea describes as an "erotic spatial play . . . [an] alternation between advance and withdrawal."[77] Standing in front of a Pittman painting like *A Decorated Chronology of Insistence and Resignation #1* (1992), a viewer feels two simultaneous rhythms, not only from side to side, a response generated by the work's extreme horizontality, but from front to back, from a desire to move close in for an examination of details to the need for a long view, as with a billboard or a movie screen. This chain of substitutions, this movement from close-up to long view, is a "groovy" way of playing out the mechanisms of desire: the role of the carnal in the optical, and the impossibility of satisfaction. But it also implies a threat, for in our movements back and forth we see both a continuous attempt at control and the

11. Lari Pittman. *Like You*, 1995. Oil and enamel on mahogany panel, 8' x 26' (243.8 x 792.5 cm). The Eli Broad Family Foundation, Santa Monica

beginnings of its loss, the approach and the retreat of form into formlessness, the shift back and forth between the bounded object and the *informe*.[78] Dan Cameron describes this movement to the brink of formlessness as Pittman's display of the "permeability of the human organism. Trapped in its bodily husk, its consciousness straining to link up with others of its kind, the self is defined in Pittman's work as unceasingly craving sustenance from the ebb and flow of life around it."[79]

How, though, does this beat speak or, better, sing the street? An answer might be found in Le Corbusier's and Amédée Ozenfant's discovery of desire in the geometry of the city. "Far from being cold or distancing," they write, "geometry tempts. Geometry seduces."[80] As an example they compare the heaps of meat lying in the village butcher's stalls with the urban merchant's transformation of his goods into "elegant friezes" and "precise pyramids"; such order, they say, "causes jubilation to stir in us."[81] In Pittman's work—one thinks, say, of the grid askew in *For Now Inside, Later to be Released upon Maturation* (1988)—we find continued resistance to regular harmony. As opposed to the "jubilation" sparked by Le Corbusier's and Ozenfant's order, Pittman finds urban energy and desire at the point where order breaks down, where the refuse of metropolitan streets coalesces with the waste of the body, where the hyperstimulation of street signs and billboards provokes corporeal cravings and pleasures, where architectural spaces are filled with body parts, where buildings are overrun with the flow of bodily fluids, where architectural ornament is studded with penises and breasts, where the atmosphere is thick with exclamations and whispers of "Go for it!" and "Kiss, Kiss!"

A Decorated Chronology of Insistence and Resignation #30 (1994, fig. 9) explodes with temporal, visual, and aural simultaneity. As in Léger's *La Ville*, which depicted Paris in all its verve and vitality, its pulse and beat, this painting not only describes Los Angeles but shows us what it is like to live there. Here city and salesman are one; commerce and its messages are amplified and intensified in a space characterized by twin obsessions of desire and need. Cameron sees in Pittman's work a "high-intensity sensorial engagement . . . in which everything happens at the same time, and overlaps occur in the most unexpected places and combinations."[82] A Baudelairean "kaleidoscope gifted with consciousness," Pittman is a late-twentieth-century flaneur accepting and then re-presenting messages from the street. Announcements barrage us in the form of lights, texts, and imagined sounds. These last are insinuated by conical megaphones that shoot and shout out words like "Sassy!" and "Love-sexi!" A satellite dish becomes a giant book, but instead of the language of literature we are treated to slang: "Cum n' git it!" and "Hey Girl!" Emblems like "Mastercard" and "Visa" dot the streetscape, as if announcing their sponsorship of urban space. No people roam this terrain; instead, cars are filled with cutout clowns in pilgrim hats, while muscular comic-strip jocks tumble through the air. A bare hand on one side of the painting transmutes into the kind of slender-fingered manicured one shown on the home shopping networks, adorned with rings and diamonds, on the other. The "insistence" of the title, then, might be the resilience of the messages that perpetually blare at

us both in the privacy of our homes and out on city streets—and perhaps the "resignation" is our giving in. The painting suggests that there is probably no way to fight today's commodified simulations, and isn't it better anyway, when faced with clowns in a fast-moving sports-car, to resign rather than to insist? Doesn't it make sense to throw oneself into the morass, accepting the host of messages as the very condition of modernity? To borrow a tired yet succinct expression, If you can't beat 'em, join 'em.

Julie Becker's Metropolitan Labyrinths

"Now let me call back those who introduced me to the city. For although the child, in his solitary games, grows up at closest quarters to the city, he needs and seeks guides to its wider expanses."[83] With these evocative words, Walter Benjamin welcomes us to his essay "A Berlin Chronicle" and, even more, to his Berlin, the city of his childhood. This poignant text is Benjamin's effort to lose himself in the city—to perform the "art of straying," opening himself up to the speech of "signboards and street names, passers-by, roofs, kiosks, or bars."[84] For Benjamin, Berlin is invested with the imagination of childhood. In city portraits like this one he shows that to describe the city as an adult is to mine one's earliest experiences, and that the conjuring of childhood memories can result in an urban map. Benjamin extends his personal reminiscences of Berlin through his investigation of collective memory, explaining that "a childhood speaks to [the flaneur], which is not the past of his own youth, in all its recency, but a childhood lived far earlier, and it matters little whether that childhood be an ancestor's or his own."[85] Jeffrey Mehlman has discussed the significance of places like Berlin's Tiergarten, covered market, cafés, deserted streets, communist youth assembly halls, and public sculpture as locales for Benjamin's experience and containers of his memory: "It is as though a dream-web, woven out of the delights and misperceptions of childhood, the stuff of what Freud called the 'unconscious,' has come to invest less the subject's body (as in Freud) than the complex topography of a city."[86] The goal in Benjamin's excavation of Berlin is to reactivate childhood dreams and fantasies in jarring juxtaposition to the present (he calls this a "dialectical interchange"), and thus to effect "a decisive awakening."[87]

No less taken than Benjamin with the nexus between the city and the mythology of childhood, the contemporary artist Julie Becker shifts the location and topos of her urban investigation. Instead of the liveliness of streets, Becker provides the mystery of corridors; instead of the monumentality of public and private structures, she explores the serial repetition of identical rooms; instead of the city or arcade, she presents the hotel. Having transferred the wonder of urban spaces to building interiors, she replaces Benjamin's storefronts with a maze of anonymous rooms, the magic of his winding streets with doors and hallways. Yet Becker's "metropolis" is just as phantasmagoric as Benjamin's Berlin; for both the artist and the writer, it is childhood that offers the key to the city.

12. Julie Becker. *Researchers, Residents, a Place to Rest*, 1993–96. Installation, c. 10 x 30 x 40′ (3 x 9.1 x 12.1 m). "Optional entrance, first space." Installation view at the Bienal Internacional São Paulo, 1996. The Museum of Contemporary Art, Los Angeles. Promised gift of Carol and Arthur Goldberg in honor of, and kind affection for, Stuart Regen and Shaun Caley

13. Julie Becker, *Researchers, Residents, a Place to Rest*, 1993–96. Installation, c. 10 x 30 x 40′ (3 x 9.1 x 12.1 m). "Middle section." Installation view at the Bienal Internacional São Paulo, 1996. The Museum of Contemporary Art, Los Angeles. Promised gift of Carol and Arthur Goldberg in honor of, and kind affection for, Stuart Regen and Shaun Caley

14. Julie Becker. *Researchers, Residents, a Place to Rest*, 1993–96. Installation, c. 10 x 30 x 40′ (3 x 9.1 x 12.1 m). "Backroom." Installation view at the Bienal Internacional São Paulo, 1996. The Museum of Contemporary Art, Los Angeles. Promised gift of Carol and Arthur Goldberg in honor of, and kind affection for, Stuart Regen and Shaun Caley

We see all this in Becker's installation *Researchers, Residents, a Place to Rest* (1993–96), which reconstructs the gallery in which it is set as three connected rooms.[88] Decorated with a generic office desk and lamp, the first room functions as a reception area, "a place usually used for waiting, receiving mail or messages, meeting visitors; an interstitial zone" (fig. 12).[89] Passing through a corridor, the viewer enters the second region, which contains two cardboard models holding miniature pieces of furniture, pictures, and other household objects—structures, in other words, evoking dollhouses and architectural maquettes, but also, the artist notes, train sets and laboratory mazes (fig. 13).[90] Strategically placed clip-on lights illuminate details of the tiny rooms, and Becker provides traces of "human" activity: the rooms are all in states of disarray, like scenes of a crime. Alongside the models, cardboard refrigerator-boxes lie about the room. Often used by the homeless for shelter, and by children as imaginary castles, these boxes link the installation both to the pathology of city streets and to the urban playground.[91] The third section suggests both an artist's studio and a mad scientist's workshop. This "brain center," as Becker calls it, is filled with the detritus and debris from the invention and construction of the entire installation, and scattered through it are a worktable, an easy chair, a copy machine, slides and viewers, magazines, an iron, and, for endurance, a coffee-maker (fig. 14).[92]

Having encountered only traces of human presence thus far, in this last room we also finally meet the work's protagonists—albeit vicariously, in composition-book diaries left for our perusal. Becker's inhabitants are Eloise, the little girl who lives in Manhattan's grand Plaza Hotel in Kay Thompson's well-known 1950s children's book, and Danny Torrance, the little boy in Stanley Kubrick's 1980 film *The Shining* (based on the novel by Stephen King), whose clairvoyant abilities intensify when his father moves the family to the shut-down and spirit-filled Overlook Hotel in the Rockies for the winter.[93] In Thompson's book, Eloise takes her readers on a tour of the Plaza, describing her daily routine and the mischief she makes down corridors and in banquet halls with doormen and waiters (fig. 15). All of these locations and characters are refigurations of streets, playgrounds, and classmates. Despite childhood nightmares about monsters in closets, Eloise's environment is a blissful one. Unfor-

15. Kay Thompson. Page from *Eloise*, with drawing by Hilary Knight. New York: Simon & Schuster, 1955, p. 8

tunately, Danny's situation is neither happy nor safe. The corridors of the hotel he lives in may be perfect for riding a tricycle, but the Overlook turns out to be less a playground than a haunted house in which a child's father is doomed to repeat, for eternity, a horrific crime against his family.[94]

"This installation," Becker writes, "creates mazelike situations and multiple ways for the viewer to enter and exit, through which he or she can access and assimilate information, create connections, pick up cues, and construct or find narrative events."[95] Although built for adult viewers, *Researchers, Residents, a Place to Rest* is infused with the fantasy life of children. Critics have called the installation a "tormented fun house" and "a Magic Theatre";[96] by focusing on Becker's allusions to and visualizations of the hotel, however, the viewer might also see the work as an imploded city, a metropolitan labyrinth moved inside.[97] For the hotel, as a number of authors have argued, is a key element of twentieth-century urban topography, even a metaphor for the contemporary city. James Clifford, for example, has described the history of Paris in the 1920s and '30s as "travel encounters," a series of "New World detours through the Old," of "departures, arrivals, transits," in which the hotel is the primary locale for metropolitan circulation. Like train stations, airport terminals, and hospitals, the hotel is a liminal space where "you pass through, where the encounters are fleeting, arbitrary."[98] The novelist Joseph Conrad, Clifford points out, described his age (the early twentieth century) as one "in which we are encamped like bewildered travelers in a garish, unrestful hotel."[99] Perhaps it was this quality of bewilderment that made the hotel so ripe for the Surrealist imagination. Not only were Parisian hotels "homes away from home to the Surrealists," they were also "launch-

16. Brassaï. *Le Maréchal Ney* (Marshal Ney), 1932. Black and white photograph, 10¹³⁄₁₆ x 7¹¹⁄₁₆" (27.5 x 19.5 cm). Musée national d'art moderne–Centre de création industrielle, Centre Georges Pompidou, Paris

17. Joseph Cornell. Untitled (called "Auriga" or "Hotel de l'Etoile"), 1954. Painted, glazed wooden box with paper backing for a construction of wood, glass, paint, book illustrations, and clippings, 19 x 13½ x 7¹⁄₁₆" (48.3 x 34.3 x 18 cm). The Art Institute of Chicago. The Lindy and Edwin Bergman Joseph Cornell Collection, 1982

ing points for strange and wonderful urban voyages, *Nadja, Paysan de Paris*—places of collection, juxtaposition, passionate encounter."[100] Brassaï's photograph *Le Maréchal Ney* (Marshal Ney, 1932; fig. 16) offers a striking visualization of the Surrealist conception of the hotel: the illuminated letters H-O-T-E-L float in the fog like a lure. The glowing letters, and the dematerialization of the building's structure, suggest the placelessness of the hotel: even when you are there, you are nowhere, or on your way somewhere else. As opposed to the honor and permanence of the monumental statue, the hotel's glowing light pictures the danger and seduction of transience, the mystery of continual deferment.

The hotel's transient quality, and its association with exotic places and glamorous travel, were captured by Joseph Cornell, who, while lacking travel experience himself, fell in love with the evocative names of faraway institutions found in his collection of Baedeker guides: "Hotel de l'Etoile," "Hotel du Nord," "Hotel du Cygne," "Grand Hotel de l'Observatoire." These places represented for him the world travel and physical flight of the ballerinas of whom he was an avid fan. Thus the distinctly melancholic series of hotel box-constructions, with their decrepit walls, cracked windows, constellations, yellowing hotel ads, and empty perches, evoke Cornell's inability ever to possess the dancers whose spirits infuse these places and the impossibility of his reaching these wondrous locales (fig. 17).

In addition to providing a stop on the Surrealist passage through the city, the hotel has frequently appeared in films, most often as a "carnivalized space" that offers its guests the opportunity to break out of the limitations of their everyday lives.[101] The epitome of this genre, Edmund Goulding's *Grand Hotel* (1932), with Greta Garbo and Joan Crawford, brings together disparate professions and social classes, and liberates guests to choose new identities, disrupt hierarchies, and play new parts (fig. 18). One character in the film alludes to the circulating momentum on which all activities at the hotel are based: "The Grand Hotel. People come. People go. And nothing ever happens." He is only half right, for things do happen, things that would be impossible under normal conditions, and they are precisely what make the hotel such a fantasy-filled environment.[102]

By the 1960s, the carnival of the Grand Hotel, with the optimism and freedom it implied, had become its opposite. The hotels in Jean-Luc Godard's film *Alphaville* (1965), with their tranquilizers, seductresses, and surveillance, are microcosms of state repression (fig. 19).[103] And it is by way of Alphaville—the other Paris, the one lost in darkness—that we travel from Berlin's Grand Hotel to Los Angeles, Becker's home and reference point, and also the site of an establishment appropriated by Fredric Jameson to explore postmodernity and the city's related shift from center to sprawl. Postmodernism, Jameson argues, implies "a mutation in built space . . . we do not yet possess the perceptual equipment to match this new hyperspace. . . . The new architecture, therefore, . . . stands as something like an imperative to grow new organs, to expand our sensorium and our body to some new, as yet unimaginable, perhaps ultimately impossible, dimensions."[104] As his paradigm for this hyperspatial architecture depen-

18. Edmund Goulding. *Grand Hotel*, 1932. Still from black and white film in 35 mm., 115 minutes. The Museum of Modern Art Film Stills Archive, New York

19. Jean-Luc Godard. *Alphaville*, 1965. Still from black and white film in 35 mm., 98 minutes. The Museum of Modern Art Film Stills Archive, New York

dent on the "lexicon and syntax" of postmodernism, Jameson fixes on John Portman's Bonaventure Hotel, a structure based on pure *implosion*.[105]

"A total space, a complete world, a kind of miniature city," the Bonaventure has a reflective glass skin that turns the building's exterior into a giant reflecting mirror. This external shell not only "repels the city outside" but makes it impossible to see the building's structure at all—passersby are left only with distorted images of the hotel's surroundings.[106] The lack of grand entrances constitutes a further rejection not only of the local neighborhood but of the entire surrounding metropolis. The interior, with its greenhouse roof, artificial lake, climbing elevators, and dramatic central atrium decorated with hanging streamers, prevents a clear understanding of spatial relationships; voids seem crowded, and losing one's way is common (fig. 20). In this interior city, "people movers" (elevators and escalators) replace streets, so that the urban wanderings of Benjamin's flaneur are "underscored, symbolized, reified and replaced by a transportation machine which becomes the allegorical signifier of that older promenade we are no longer allowed to conduct on our own."[107] The Bonaventure, like the postmodern condition, Jameson argues, "has finally succeeded in transcending the capacities of the individual human body to locate itself."[108] Inside the hotel and outside in the unmappable city of Los Angeles, body and structure are equally decentered, space is confused and confusing, perception unclear.

In *Researchers, Residents, a Place to Rest*, Becker intensifies the implosion and decentering suggested in Jameson's view of the Bonaventure and in postmodernism more generally. Location and direction continually unwind in her installation, but Becker's implosion is less the violent pull of inward collapse—like a building exploding in on itself—than a centrifugal force propelling exterior to interior, expansive to miniature. The installation choreographs a move from the hotel's life-size walls, rooms, and corridors to the smaller structures of refriger-

20. John Portman & Associates. Los Angeles Bonaventure Hotel, Los Angeles, Calif., 1977

95

21. Stanley Kubrick. *The Shining*, 1980. Still from color film in 35 mm., 146 minutes. The Museum of Modern Art Film Stills Archive, New York

ator boxes and, finally, to the still smaller miniature models.[109] Like dollhouses, these tiny buildings represent what Susan Stewart calls "the tension between two modes of interiority . . . center within center, within within within," and Becker further directs attention to the interior by her disregard for their exterior decoration.[110]

Despite the pull of this inward-pointing force, we never reach an absolute center, and as we move through the installation we continue our boundless and labyrinthine wandering. Installed within an unfamiliar, unkempt, and unnavigable area, Becker's models deceive us into thinking we can find location and direction, a smaller mirror to the space we currently inhabit. Yet these rooms, with their shifts of scale, indecipherable architecture, unnatural lighting, and surreal sense of crimes and tragedies, offer no solace or home for the lost and wandering nomad. Becker's models do not provide the "perfectly complete and hermetic world" of the dollhouse,[111] but instead present the kind of interiority found when two facing mirrors enact an infinity of reflections—like the repetition of identical doors, hallways, and public spaces that so terrifies Danny Torrance in *The Shining*'s Overlook Hotel (fig. 21). Given Danny's gift of telepathy (the "shining" of the film's title), this terrifying placelessness seems also to exist within his own mind, which opens out uncontrollably to access faraway realms of time and space. In *Researchers, Residents, a Place to Rest*, the nowhere of the hotel joins the unending, ungridded, and octopuslike metropolitan (postmodern) sprawl.

The junk piled up in the work area both denies location and extends the sense of fragmentation found in this installation and induced in our bodies within it. For a child, though, such disorder, the perfect terrain for hide-and-seek, is part of the fun. "I am all over the hotel," Eloise exclaims, "Half the time I am lost."[112] From the description of her days at the Plaza, it is clear that the other half of the time Eloise spends wreaking havoc: from writing her name in red crayon across a lobby mirror (the image on the cover of my own childhood copy of the book), to running a stick across the doors in a hallway to disturb staff and guests, to harassing switchboard operators. In insinuating Eloise and Danny into her installation, Becker invites us to envision the hotel as a playground. She also turns to another children's activity that enlivens the detritus of the city: the collection. Children salvage castoffs and transform them into their own magical talismans. These trinkets, the critic Roger Callois writes, "are not beautiful but brilliant. . . . Bodies of this sort possess a magnetism which sensibly enhances a somewhat mysterious character of their nature: here is a metal which folds, which crumples. . . . They spirit him away to the world of adventure. . . . They appear as booty lifted from a universe compared to which the real is weak and pale."[113] Benjamin turned this game of collecting into a form of theoretical praxis, and described the child's—and his—particular interest in places where things are "being visibly worked upon. They are irresistibly drawn by the detritus generated by building, gardening, housework, tailoring, or carpentry. . . . In using these things they do not so much imitate the works of adults as bring together, in the artifact produced in play, materials of widely differing kinds in a new, intuitive relationship. Children thus

produce their own small world of things within the greater one."[114] Becker's installation offers a re-creation of just such a junk-filled construction site.

In a short essay on Becker's *Researchers, Residents, a Place to Rest*, Chris Kraus asks, "Where do Danny's and Eloise's inner lives converge?"[115] My answer is, within a hotel. And with its series of repeating and repetitive rooms and mazelike corridors, this hotel is also a city— which brings us, once again, back to Léger. In comparison to Becker's maelstrom of gathered objects and shards of mirror, Léger's ruptured spaces, his fragments of shapes and colors, seem orderly, controlled, and marching-band rhythmic. The city/hotel to which Becker refers is thus no longer Léger's thoroughly modern and mechanized metropolis, nor Nadja's marvelous Paris, that "forest of symbols"; it is the hyperspatial sublime of Los Angeles and of the Bonaventure Hotel, bewildering, fractured, fragmented, reflective, repetitious, endlessly expansive. The fragments and castoffs found in Becker's installation are not simply playthings for children— they are the building blocks of this continually discontinuous and disassembling city.

Public or Virtual? Martha Rosler's Space Travel

A film begins with the sounds of footsteps tap, tap, tapping on terrazzo floors, and with shots of long fluorescent-lit corridors, men in uniform, and groups of figures rushing by. Reminiscent of a variety of anonymous public spaces and institutional settings, this place that is anywhere and nowhere does have a name: it is Paris. In his 1967 film *Playtime*, Jacques Tati transforms this city of romance, history, and light into the generic modernist metropolis of steel, chrome, plastic, and transparent and mirrored glass. Our welcome to this particular Paris takes place in the airport. As we watch a group of chattering American tourists file through and out of the airline terminal and into a bus, we might begin to anticipate the kind of comedic antics familiar from Tati's earlier films, taking place this time around the place de la Concorde, at the top of the Eiffel Tower, and in and around the pews of Notre Dame. We are soon, however, both disappointed and entranced: Tati's Parisian playground looks like any other glass-and-steel city—the director presents it as an extension and replica of the airport. We do, at moments, catch glimpses of the Eiffel Tower in a tourist poster, or of the Arc de Triomphe as reflected in a building's plate-glass windows or doors, but for the most part Paris's landscape is shown as a series of generic and indistinguishable high-rise structures, their inhabitants circulating through streets and offices like items on a conveyor belt (fig. 22). For Tati, the contemporary city has become the nowhere of the airport.

In an ongoing series of photographs taken in airport terminals beginning in 1979, and in an essay on the issues they address, artist Martha Rosler reinforces Tati's view of the airport as a place emptied of content and experience. And although Rosler makes no direct connection between city and terminal, as Tati does in the opening scenes of *Playtime*, her pictures and text offer the airport as the site of a transmission and flow echoed not only in the workings of pro-

22. Jacques Tati. *Playtime*, 1967. Still from color film in 70 mm., 155 minutes

23. Martha Rosler. *Untitled (J.F.K.)*, 1990. From the series "in the place of the public," 1979–present. Chromogenic color print. Edition of six. 26⅝ x 40" (67.6 x 101.6 cm). Courtesy Jay Gorney Modern Art, New York

duction in advanced industrialized countries but in our characteristic experience of other public—and for my purposes urban—spaces.[116] Rosler's 1993 installation *in the place of the public* defines airport and city as similar transfer stations, connector points in a world increasingly conceptualized as a series of tangled networks. As electronic links between and within urban centers continue to expand, the communal and memorial purposes of the built environment rapidly alter. And when we make actual visits to these places, we often barely pass through.[117] These new cities, Rosler writes, transform the "public" from "collectivity to surveyed transience," and airport travelers and other kinds of traffic are "constituted only as a regulated flow."[118]

What, then, does Rosler have to say about this situation? The airport, she explains, "suggests the meeting point of theories of time and of space, of schedules and of layouts."[119] As a result of her own journeys, Rosler became interested in "the movement of bodies through darkened corridors and across great distances," and also in how air travel empties out actual experience. She began to take color photographs with a pocket camera whenever she traveled.[120] Made in many different countries and terminals over a number of years, the photographs present two distinct types of view: the first is a long shot in deep space, showing hallways and corridors, sites of circulation and transfer—the very activity that both characterizes and activates

24. Martha Rosler. Untitled, 1990. From the series "in the place of the public," 1979–present. Chromogenic color print. Edition of six. 26⅝ x 40" (67.6 x 101.6 cm). Courtesy Jay Gorney Modern Art, New York

the airport terminal (fig. 23); the second compresses depth into a flat picture plane, and the subject matter shifts to advertisements, posters, maps, and other kinds of airport signage. Rosler does not rephotograph these posters at random, but selects those in which pictures, text, media, or communications systems either allude to the circulation of travel or point to still other kinds of flow. Photographs of banks of telephones suggest auditory communication and traffic (fig. 24); shots of advertisements for televised and textual news and information sources like CNN and the *Wall Street Journal*, and of vending machines from which the bored can purchase a daily paper, support Rosler's belief that in airports the movement of information parallels the passage of bodies. In the airport, Rosler writes, "Desire is always infinitely deferred, and meaning is elsewhere and otherwise."[121] Hence the artist offers glowing maps for plotting journeys, and banks of light boxes displaying other travel possibilities, all infinitely tantalizing and enticing. At the airport, travelers are never where they want to be; they are always on their way, and there are always better places to go. Thus not only travelers but desire perpetually circulates.

Rosler exhibits these photographs both individually and as elements in an installation. In the gallery, black and gray vinyl lettering mounted directly on the wall initiates a dialogue

with the pictures. Sentences, phrases, and single words in different type sizes make a "white-noise hiss" that Rosler equates with the perpetual din of even the quietest airport. These texts refer to the airline terminal's typical architectural details—its institutional facade, its brightly lit atrium—and call attention to sensory experiences that cannot easily be captured by photographs: trace odors of stress and hustle (olfactory), background noise (auditory), and imperceptible airflow (touch). They also make metaphors out of airport travel, likening its passages, plazas, and expanses to boulevards, intestines, vaginas, birth canals, and hospitals. Longer texts connect this contemporary form of circulation to more traditional flows and sites of movement, including the river, the brothel, the parchment manuscript, the border, the meeting, and the conversation, all of which look rather charming and harmless in comparison with Rosler's more current vocabulary ("capital costs," "mergers and acquisitions," "total surveillance") and her photographs' neon-red passageways, ice-cold gray-and-white marble floors, and greenishly glowing fluorescent-lit rotundas.

For this project's theoretical framework Rosler turns to the French writer Henri Lefebvre, who analyzed spatial relationships in the city and concluded that capitalism was to blame for a shift from what he termed "real space" to "abstract space."[122] For Lefebvre, banks, businesses, the world of commodities and their related structures—airports, motorways, information lattices—have created overarching and infectious networks that obscure history, wealth, and accumulation. We increasingly integrate our homes into such systems of networks, so that as the language of urbanism develops it is progressively more characterizable by Rosler's lexicon of "flow, transmission, data, bit, byte."[123] Nor is Lefebvre the only thinker to report on the extension of networks and the loss of the metropolis's history and center. Jameson, David Harvey, and Edward Soja have all offered a variety of terms equivalent to Lefebvre's "abstract space": urban sprawl, hyperspace, exopolis, edge city.[124] Describing the transition from public plaza to airport, from machine city to cybercity, M. Christine Boyer argues that "electronic telecommunications have reformulated our perception of space and time, so that we experience a loss of spatial boundaries or distinctions, so that all spaces begin to look alike and implode into a continuum, while time has been reduced to obsessive and compulsive repetitions."[125] And Mark C. Taylor and Esa Saarinen, arguing that "the modern metropolis is being displaced by the postmodern netropolis [as in the Internet]," have envisioned computer cyberspace as a city.[126]

All of these theorists exploit objects and real situations to make their arguments—if Jameson's monument to simulation is the Bonaventure Hotel, Soja focuses on Orange County, California—but it is in the realm of fantasy and science fiction that we see ideas about networks, data, and transmission most fully (and admittedly hyperbolically) played out. The inventor of the term "cyberspace" is science fiction writer William Gibson, who, in his 1984 novel *Neuromancer*, not only created a neologism but crystallized a new genre of writing: cyberpunk. *Neuromancer* takes place in the twenty-first century, when the value of information has

replaced that of money. The plot maps two simultaneous planes of existence, the real and the virtual; but these are so intertwined that it is impossible to tell them apart. True, the "virtual" world of cyberspace is accessible only by "jacking in" to computer terminals, and the mind can move freely there without the hindering weight and substance of the body; but despite this distinction between body and mind, real and virtual, both spaces, both cities, are equally disorienting, making it almost impossible to measure space or locate place. ("Real" urban centers have become megasprawls, with names like "BAMA" and "Freeside."[127]) And both are characterized by simulation: *Neuromancer* is full of descriptions of "futuristic" visual expression appearing in both worlds—translucent planes of color, screen travel, holograms, parasitic structures, identical towers of data, neon molecules, and ghost hieroglyphs, to name just a few.[128] In Gibson's view, urban space mirrors the electronic spaces of information and circulation; the city, in *Neuromancer*, is an "endless neon haze of data."[129] And even with its talk of megabytes and novas, Gibson's cyberspace is not so far from Lefebvre's abstract space. The cities of *Neuromancer* are ruled by giant corporations that own the data—and as in the invisible financial networks of our own day, in cyberspace data functions as currency.[130]

In her essay on airports, Rosler offers her own, more basic version of virtuality. The words "virtual reality" evoke complex computer programs, ravishing graphics, electronically wired masks and gloves, and visual pleasure. The experience demands saying goodbye to the body; this glide through space and time is mainly optical. But while virtuality generally requires sophisticated equipment and software, there have long been other—albeit more primitive—ways to achieve the sensation of rapid disembodied travel. A method described by Rosler is a favorite of New York City children, who can press their faces against the front window of subway cars to imagine traveling through mysterious (virtual) worlds. Jammed against the pane of glass, one feels the long subway car as more an extension of the body than a vehicle in which to travel, and, for brief moments between the rapidly appearing stops, one becomes a cyborg moving through space.[131] Defined only by pinpoints of light, the subway tunnel transmutes into a starry sky or a science fiction city, resembling designs for computer and video games. Most amazing is the way the very structure of Manhattan disappears; there is no sense of being on a train lodged below a working city. And the path down which the former-body/now-cyborg moves is not straight; it is closer to the multiplied paths of cyberspace. In New York City, then, there is a second metropolis, perhaps the unconscious of the first, that does not echo the flat grid above ground but replaces it with a three-dimensional one and adds curves and twists, all allowing swift passage without traffic and crowds. Visitors to this below-ground municipality experience the instantaneity of circulation rather than the *durée* of wandering through parks, plazas, and streets.[132]

It is with this image of "effortless, unencumbered . . . flight" on subway trains that Rosler begins her analysis of airports and airline travel.[133] While her childhood memory of the New York City subway might initially seem irrelevant to the high-speed, technically elaborate air-

plane, an understanding of the potential "virtuality" of the subway experience—its "flight," "circulation," "power"—makes it clear that the two share much in common. In *Neuromancer* we see a hyperbolized version of Rosler's childhood train rides: having leapt from subway to airplane, it is just another short jump to the travels of the novel's protagonist, Case, jacked into the computer. The city, in all cases, is reduced to a virtual passage through light and sound, a bodiless journey. While there is certainly pleasure in these rides, Rosler warns us of the dangers of complete submission to virtuality: the losses of history and community, to name only two. In one of her photographs, an illuminated billboard (an advertisement for the *Wall Street Journal*) exclaims, without a trace of irony, "Maybe there is a substitute for experience."[134]

While Rosler's conception of the airport and her memory of the subway bear a similarity to Gibson's cyberspace, her ideas can also be related to the writings of French theorist Paul Virilio, whose texts often verge on science fiction. Virilio has been investigating shifts in urbanism's space and time. Inventing a new term for the city, "overexposed," he focuses on its simultaneous dispersion and concentration.[135] The airport is a perfect example of what he means by "overexposure": concentrated within its bounds is an entire city (malls, restaurants, hotels, childcare), but its function is to funnel people continuously through hallways and terminals and send them on to the next transfer station. Just as technology is hidden outside the windowless corridors of airports, the overexposed city's transformations are "disguised by the immateriality of its parts and networks."[136] The metropolis is thus an interface in which an "electronic topology" replaces urban property, "'near' and 'far' simply cease to exist," "telematics replaces the doorway," the "opening of city gates" becomes "the opening of shutters and televisions," and "public greeting" becomes "audience and surveillance."[137] In this urban environ there is no chronological or historical time, but only that of the instant. As in the airport, people in the Overexposed City "occupy transportation and transmission time instead of inhabiting space. . . . With the new instantaneous communications media, arrival supplants departure; without necessarily leaving, everything 'arrives.'"[138]

Rosler's view of the airport—which functions also as a kind of representation of the city—is mediated by computer codes, television screens, and global networks. These are what characterize movement, stimulation, and action not only in airline terminals but in all public and even private spaces. Rosler's aim in this body of work is not merely to research the history of airports, or to examine the kinship between air travel and cyberspace, but to search for *public space*, to identify the factors that have resulted in our "terminal" condition, our crisis of space and time, our finding (or losing) ourselves in a placeless place, both anywhere and nowhere. Searching for what can be found "in the place of the public," Rosler finds only "blind turns" and "infinite deferral."[139] Describing her search as a journey in a short wall text that accompanies her installation (a text written in a style closer to science fiction than to her typically weighty prose), the artist elaborates, "We reached a terrain unlike any we had seen before. It was composed of rubble and bits of unfamiliar stone. . . . The air was still and crys-

talline. . . . Certainly there was a glare overhead that made raising the eyes difficult. Thus it was that I could not discern whether I was indoors or out, whether it was truly day or truly night. . . . Although I felt a humming in the air, I realized eventually that I was hearing only my blood pulse."[140]

With virtuality replacing structure, and travel over optic fibers taking the place of movement down streets, public space and the feeling of being part of a community have disappeared. In the airport, Rosler explains, "Everything and everyone is weightless, anomic, and the appeal is to consumerism, not to sociality. There is no middle ground between imperial citizenship and the vacuum."[141] Citing the comment by Walter Wriston, former CEO of the banking company Citicorp, that "the 800 telephone number and the piece of plastic [the credit card] have made time and space obsolete," architect and critic Michael Sorkin also mourns the loss of public space: "Computers, credit cards, phones, faxes, and other instruments of instant artificial adjacency are rapidly eviscerating historic politics of propinquity, the very cement of the city. . . . Obsessed with the point of production and the point of sale, the new city is little more than a swarm of urban bits jettisoning a physical view of the whole, sacrificing the idea of the city as the site of community and human connection."[142] Sorkin's metaphor for this new, dispersed and asocial city is the theme park. Characterized by "ageography," surveillance, and simulations, the city-as–theme park "presents its happy regulated vision of pleasure . . . as a substitute for the democratic public realm, and it does so appealingly by stripping troubled urbanity of its sting."[143]

Sorkin is not alone in turning to the amusement park in order to explicate urbanism; about seventy years earlier, Léger had presented the circus as a carnivalesque twin of the quotidian city. In his *Deux Acrobates* (Two acrobats, 1918) and *Cirque Médrano* (1918) we see the spectacle of *La Ville* costumed and intensified. Urban wanderers become acrobats, city streets transmute into rings and trapezes, while crowds are unchanged: they remain spectators. "Go to the circus," Léger implores, for its "rotation of masses, people, animals, and objects."[144] From his description of the circus's "dynamic aggression of a collective mass that assaults the spectator," its "nebulous, inconsistent crowd," and its "persuasive" gate money, however, we learn that we don't really have to go *to* the circus; in the city its dynamism is all around us.[145] Léger writes, "Our modern space no longer looks for its limits; from hand to mouth it is obliged to accept a domain [like the circus] of unlimited action. We plunge into it, we live in it, we have to survive in it."[146]

The imagery of theme park and circus returns us once again—with a circulating force and flow characteristic of both airports and cyberspace, of networks, currencies, and codes—to Tati's Paris. The director conceives of the city not only as an airport but as a theme park or carnival for "play." Rosler's search for the public cannot end in Paris, for here space itself has been reduced to beautiful but deceptive reflections. What can be found, however, is resistance— in the very body of Tati. And perhaps resistance is all Rosler can ask for. Tati's simultaneously

clownish and acrobatic physical comedy—bumping into glass walls, misunderstanding and mis-using various technologies, and breaking the regulated flow of circulation and transportation—certainly illuminates the deficiencies of the contemporary city's generic, characterless, and hyperautomated condition. His disruption of the order mandated by the architecture of containment and flow, while hilarious, is also liberating, offering (metaphorical) transgression as the beginnings of a needed history and community. But his floundering goes even farther, making cracks in the pristine glass walls of the (now not so) monolithic metropolis. It is in these fissures, perhaps, that a new playground, a new urban public space, can be formed.

BIG! Rem Koolhaas's Extra-Large City

In 1842, the author Victor Hugo asked, "Why should we be surprised that human intelligence has left architecture for the printer's shop?" Hugo's question was a reaction to what he saw as a weakening (he calls it an "emaciation") of architecture's role in public life as story-teller and moral guide. Tracking a slow deracination of the built environment from the Gothic to his own day, the writer believed that architecture had relinquished to the book the role it had once played through the cathedral's narration and enactment of biblical tales and Christian ritual.[147] In 1998, 156 years later, we might put a more positive spin on his question. For one architect, Rem Koolhaas, has indeed, albeit temporarily, left architecture for the printer's shop, creating the monumentally scaled tome *S,M,L,XL* (1995); yet his book is not a rejection, as Hugo's question implies, but a manifesto on architecture and the city's current and future conditions. Koolhaas uses the print shop not as an escape, then, but as a *return* to architecture, to structure, to the city.

Described as a "novel about architecture" in the explanatory block-print text covering the book's back cover, *S,M,L,XL* "combines essays, manifestoes, diaries, fairy tales, travelogues, a cycle of meditations on the contemporary city."[148] How does Koolhaas propose to view, live in, experience, and build the city today? What is the importance of scale ("bigness" and "lite," in Koolhaas's semiology) in assessing, inhabiting, and constructing the metropolis? What are Koolhaas's strategies of representation? We will find that it is Koolhaas's return to the print shop—to language—that offers the means by which he can both explicate and navigate the city. But before we open the covers and begin our journey inside this peculiarly objectlike volume, who are our guides? Koolhaas himself is a founding member of the Rotterdam-based architectural firm the Office of Metropolitan Architecture (O.M.A.). His company's name, as well as his notorious "retroactive" manifesto, *Delirious New York* (1978), prove his long-standing interest in and ambitions for the city. Graphic designer Bruce Mau shares full authorship of *S,M,L,XL*; best known for his designs for the *Zone* journal and books, this former art director of *I.D.* magazine is not only the designer of choice for a range of artists and publishers, but has set new standards for graphic arts.[149]

Employing Salvador Dali's "paranoid critical method," Koolhaas's first urban book, *Delirious New York*, considers Manhattan as a living theory. "Once identified," Koolhaas explains, this theory

should yield a formula for an architecture that is at once ambitious and popular. . . . Manhattan has consistently inspired in its beholders *ecstasy about architecture*. . . . Manhattanism is the one urbanistic ideology that has fed, from its conception, on the splendors and miseries of the metropolitan condition—hyper-density—without once losing faith in it as the basis for a desirable modern culture. *Manhattan's architecture is a paradigm for the exploitation of congestion.*[150]

In support of his argument, Koolhaas examines such disparate monuments as the Empire State Building, the Waldorf Astoria Hotel, Rockefeller Center, and Coney Island, and comes to a critical conclusion that will inform his work on *S,M,L,XL*: Manhattan—this most representative of modern urbanisms—is characterized by a "Culture of Congestion." Rather than offering a critique of this condition, however, Koolhaas vows to throw himself into it. He plunges even deeper in *S,M,L,XL*.

The author characterizes his book as a novel, and while its traditional novelistic elements are few and far between, the book does have a kind of narrative, a track from interior to exterior, from S to XL. Its endpapers mark the extremities of this passage. A photograph of O.M.A.'s cluttered office opens the book, showing where the energy for the project was generated. Superimposed on this photograph is a graph plotting the increases and decreases in the firm's workforce from 1972 to 1993. This endpaper is only the first of sixteen pages of office photographs, all of them overlaid with charts of the firm's work, including income, expenditures, turnover, and travel, and thus functioning as a prologue in two languages—descriptive and statistical. One reviewer of the book explains, "The graphs give us, in broad-stroke fashion, a clear sense of the scale of this enterprise: its international client base, its use of money, its global range of human resources. The photos show us an office which is caught up in the whirlwind of creative chaos: tables covered with the debris of model-making, bookshelves crammed with the detritus of past projects, a kitchen area strewn with the remains of a fast-food feeding frenzy."[151] Despite its ability to diagram the office's activities outside of the work space, this section portrays a world unto itself. Messy interiors take on the monumentality of landscapes.

At the other end, XL closes the book. Instead of an office photograph, Koolhaas presents the front page of the newspaper the *Hong Kong Standard*. A photograph of a crowd of admirers in front of a gigantic billboard painted to commemorate Deng Xiaoping's 1992 tour of southern China cuts across the center of the page. Koolhaas's text is thus bookended by S and XL, and his narrative moves from the limitations of privacy to the boundlessness of publicity.

The conjunction of private and public in which the text is framed reinforces the nature of the book form itself, an object with a publicly displayed exterior and a hidden and private

25. O.M.A., Rem Koolhaas, and Bruce Mau. *S,M,L,XL*. New York: The Monacelli Press, 1995. The Museum of Modern Art Library, New York

interior. Since the covers of a book close us out, opening them up is like baring a secret. More than just an enigmatic prize, however, the interior of a book also acts as a disruption, defacing the clean and finite totality of the book as object.[152] With their hardbound covers, thickness, and weight, all books present themselves as objects, and *S,M,L,XL*'s industrial-metallic cover and its excessive heft, girth, and density—at 1,346 pages, six pounds, and approximately three inches thick, it is closer in scale to a brick or a tablet than to a dime-store paperback—intensify its objectness (fig. 25). Yet despite its weight and size, the contents make a significantly stronger impact. The abstract singularity of the exterior gives way, to borrow Jacques Derrida's words, to "the disruption of writing . . . its aphoristic energy . . . [its] necessary violence."[153] This energy and violence perfectly characterize the eruptive forces trapped inside.

This book is BIG, and even before opening its covers one is struck by the multitude of ways the author and designer foreground size. The title of the book, and also its organizing principle—S, M, L, and XL indicate succeeding chapters—is merely a series of letters, but these are immediately recognizable as a generic scale of sizes. In addition to the block letters spelling the title and the names of the authors and publisher on the front cover and binding, the back cover includes a description of the book's purpose. Instead of functioning as a mere appendage to the book's design, this text defines the entire back cover, and with words like "massive," "accumulation," "splendors," "globalization," and "world" as clues, we know we are about to experience something extra large.

The contents of *S,M,L,XL* are a dynamic combination of photographs, cartoons, maps, architectural drawings and diagrams, scale models, texts (whether written by Koolhaas or selected from published theory, literature, and art history), reproductions of works of art, and an A-to-Z dictionary that runs the length of the book. These elements function as a montage of contrasting fragments, mixing together images and type, presented in energetic and often clashing combinations. Organization is only provided by scale, so that architectural projects, elsewhere generally presented according to chronology, location, or typology, are here grouped by size. Colored pages and colored text add still further vibrancy.

This multiplication of elements resembles less the ordered columns of books than the visual language of the city street. In earlier eras, Léger's fragmented planes and clashing colors, and Dada artists' clippings from photographs, newspapers, magazines, and urban detritus, offered perfect visual, stylistic, and aesthetic analogues to the experience of an ever louder, faster, and more stimulating urban environment. Koolhaas's book can be placed in these traditions—although his beautiful images, orderly juxtapositions, and seamless edges offer a far more harmonious vision. The multiplicity of elements and voices in his text makes reading it akin to walking in the city (fig. 26). No longer does the reader follow a clear path from beginning to end; instead the book, infected with the fragmentary experience of the metropolis, encourages each reader to wander, and to construct his or her own maps and stories out of an unlimited set of variables. Bombarded by a structure of interruption rather than of continuity,

the reader/wanderer (like Baudelaire's flaneur, or his descendants the Situationists, who in the 1950s and '60s, through a process called a *dérive*, mapped the unconscious of Paris[154]) is free to interpret chosen signs in a multitude of ways, to shift the range of focus from long to close-up views, to peer into faces as they pass by. This new kind of book has more to do with "botanizing the asphalt" (Baudelaire) and "psychogeography" (Guy Debord) than any text either writer could have imagined.[155]

Koolhaas justifies the size and scale of *S,M,L,XL*, and offers prescriptions for the contemporary city and the architecture that constitutes it, in his manifesto on "Bigness," called "Bigness or the problem of large," which introduces the book's section "L."[156] To define the term "Bigness," Koolhaas makes metaphors of monuments in the landscape, describing his study of the "problem of large" as akin

26. O.M.A., Rem Koolhaas, and Bruce Mau. *S,M,L,XL.* New York: The Monacelli Press, 1995. Spread, pp. 1166–67, showing Rem Koolhaas/O.M.A., proposal for Euralille, Lille, in photographs by Hans Werlemann. The Museum of Modern Art Library, New York

to the need of those who climb Mount Everest: "Because it is there." He also predicts Bigness's inevitable decline: the clumsiness, slowness, inflexibility, and difficulty of existence on a grand scale caused the extinction of the dinosaur, and will ultimately cause the decline and disappearance of Bigness in urbanism. The architect traces an ancestry for contemporary Bigness in the technological achievements of the nineteenth century, calling the confluence of such developments as the elevator, electricity, air conditioning, and steel an "architectural Big Bang." Technologies like these may together account for building height, but Koolhaas does not limit Bigness to verticality. "Beyond a certain critical mass," he writes, "a building becomes a Big Building"—so big that these structures "can no longer be controlled by a single architectural gesture." Compositions and details no longer matter, and the facade no longer reveals what goes on inside: "What you see is no longer what you get."

Koolhaas finds Bigness everywhere, "attaining megaproportions that stretch and distort the very idea of the city."[157] With his manifesto on the subject he calls for an entirely new way of thinking, a fresher kind of urbanism. For critic John Rajchman, Koolhaas's Bigness is "not 'colossal' or 'sublime,' it is labyrinthine, and the point is not to find a way out but rather to find new ways of moving about within its complexities and specificities, reinventing and reassembling its paths."[158] In practice, Bigness involves chance, a willingness to open oneself up to uncharted possibilities. In this sense Koolhaas can be seen to return to Surrealism, this time, however, deploying not Dali's "paranoid critical method" but Breton's marvelous, his objective chance.

Small, Medium, Large, Extra-Large
Office for Metropolitan Architecture
Rem Koolhaas and Bruce Mau
Edited by Jennifer Sigler
Photography by Hans Werlemann
1995 The Monacelli Press

27. O.M.A., Rem Koolhaas, and Bruce Mau. *S,M,L,XL*. New York: The Monacelli Press, 1995. Spread, title pages. The Museum of Modern Art Library, New York

Koolhaas's interest in Bigness relates to his notion of the tabula rasa. Reaching an enormous or Big size, buildings, Koolhaas insists, break with context. Containing entire cities within themselves, they no longer need to respond to the space or history around them. While Koolhaas rejects context, his theory of bigness is not dystopian but wildly utopian: "In a landscape of disarray, disassembly, disclamation, the attraction of Bigness is its potential to reconstruct the Whole, resurrect the Real, reinvent the collective, reclaim maximum possibility." Koolhaas rejects the dematerialization and disappearance of building messianically predicted by "cybermystics." Instead, showing true optimism, he affirms that wholeness and realness are possible.

In addition to expressing Bigness in the direct and aggressive form of his manifesto, Koolhaas refers to scale in both the shape and the reading experience of his book. The collage of elements in *S,M,L,XL*, with its cuts, montages, and voice-overs, takes its inspiration from the cinema—and its large size alludes to the wide screen. Susan Stewart explains that "the printed text is cinematic before the invention of cinema. The adjustable speed of narration, the manipulatability of the visual, turns the reader into a spectator enveloped by, yet clearly separated from, the time and space of the text."[159] Koolhaas thus presents reading's extension of time as a quality of Bigness. His case studies—like the images of Singapore in the book's closing section, "The Generic City," and his designs for the Kunsthal II in Rotterdam, the Netherlands, a project called "Life in the Box?"—reinforce the sense of duration through long sequences of photos and text (in the latter, from Samuel Beckett's *Waiting for Godot*) that run across entire sequences of pages.[160]

Besides referring to the wide screen of the old-time movie theater (and even to the smaller ones of the urban multiplex), Koolhaas uses the double-page spread to invoke that similarly shaped—and similarly Big—space of display, the billboard. *S,M,L,XL* puts the reader in the unusual position of needing a long view to take in its larger image. The typical novel is designed to lie in the palm of the hand or across the lap, and is of a physical size that provokes the need to bring the text closer to the eyes. On the title page of *S,M,L,XL*, however, large (close to one inch high) letters march in an orderly fashion across the double-page spread, spelling out the book's title, its authors, its editor, its photographer, and its publisher (fig. 27). The spread is impossible to take in all at once from a normal reading distance; the viewer needs either to read across slowly, from letter to letter, or to move the book away to take in the whole thing, an experience closer to scanning a large sign than to reading a book.

Koolhaas's use of the billboard is a reminder of Léger's vision of urban rupture, but today these large signs painted on city walls and scattered along suburban strips provide less a radical break in their environs than a defining (and monotonous) element of them. The artist Ed

Ruscha, in his book *Every Building on the Sunset Strip* (1966), showed the ubiquity of these signs through a series of photographs representing the length of a Hollywood street, a kind of still film-strip based on serial accumulation and revealing the dull repetition of both signs and structures in the sprawling exurban environment (fig. 28).[161] A few years later, Robert Venturi, Denise Scott Brown, and Steven Izenour thoroughly excavated a similar region—Las Vegas—and wrote an analysis and manifesto on the importance of the strip and its messages. Their 1977 book *Learning from Las Vegas* analyzes "the visual reality of the Strip, where architectural language, reduced to a minimum, is compensated for by an excess of verbal messages that are perceived as only so much visual 'noise.'"[162] "The Flamingo sign," they exclaim, "will be the model to shock our sensibilities towards a new architecture."[163]

For Venturi and his coauthors it is the automobile, rather than the pace and position of a wanderer on foot, that offers the optimal vantage point and speed for experiencing and understanding the strip, and for best perceiving its large and catchy signs. "The automobile-oriented commercial architecture of urban sprawl," they write, is "our source for a civic residential architecture of meaning."[164] Installed at regular and repeated distances facing oncoming traffic, the billboard performs a spatial function, helping us to navigate by providing position and orientation. Venturi's "counter-project for Boston City Hall" takes Las Vegas's lessons to their logical extreme, showing that structure is less important than sign: from the top of a generic square warehouse, a giant and glowing billboard screams "I AM A MONUMENT" (fig. 29).[165] Like this half-serious proposal, Las Vegas's signboards express "verbal and symbolic connections through space, communicating a complexity of meanings through hundreds of associations in a few seconds from very far away."[166] In addition to helping us navigate space, billboards have for Venturi an important "symbolic function," offering fast and full messages to those driving by. Rather than puncturing the landscape, as Léger imagined, Venturi's billboards serve a variety of purposes, including navigational, semiotic, and decorative.[167]

Acknowledging all this, Koolhaas exploits the billboard's multiple qualities by deploying it as architectural form.[168] His proposed Karlsruhe Zentrum für Kunst und Medientechnologie (1989–92), presented in *S,M,L,XL*, is "a museum of media art; a museum of contemporary art; research and production facilities for music, video, and virtual reality; a theater for media; lecture hall; media library (a future Hochschule für Media); etc. It represents a laboratory open to the public—a huge apparatus to investigate, once and for all, the elusive connection between *Kunst* and technology, a Darwinian arena where classical and electronic media can compete with and influence each other."[169] While the art/technology battle can certainly be

28. Edward Ruscha. *Every Building on the Sunset Strip*, 1966. First two leaves of photo-offset-printed book in foil-covered slipcase. Slipcase: 7¾ x 5¾ x ⅝" (19.7 x 14.6 x 1.6 cm). Book unfolds to a length of 27' (823 cm). The Museum of Modern Art, New York

29. Robert Venturi. *I Am a Monument*, c. 1968. From Venturi, Denise Scott Brown, and Steven Izenour, *Learning from Las Vegas: The Forgotten Symbolism of Architectural Form*, 1972 (reprint ed. Cambridge, Mass., and London: The MIT Press, 1977), p. 156

30. O.M.A., Rem Koolhaas, and Bruce Mau. *S,M,L,XL*. New York: The Monacelli Press, 1995. Spread, pp. 700–701, showing model for the "media façade" of Rem Koolhaas/O.M.A., proposal for the Zentrum für Kunst und Medientechnologie (ZKM), Karlsruhe, in photograph by Hans Werlemann. The Museum of Modern Art Library, New York

described as a fight for the survival of the fittest, Koolhaas's "Darwinian" reference also describes the struggle of making architecture in the city today. In Karlsruhe, Koolhaas responds to and extends the site's "media domain," which includes trains and a station as well as the Autobahn's on and off ramps. One wall of the building is an electronic billboard: "activities of the center leak out and are projected in real time alternating with commercial messages, railway network bulletins, CNN, etc. The screen faces a ramp that leads directly to the ZKM entrance. . . . At certain moments passengers in the IDZ to Milan see a flash of this spectacle."[170] Koolhaas's proposal thus engages with the already existing visual stimulation of the city, becoming part of a landscape already populated with billboards, signs, traffic, and transport (fig. 30).

An entry under "billboard" in Koolhaas's dictionary shows these signs' usefulness as visual reference points: "When Nancy wakes up, the covers are on the floor, and for a moment she does not remember where she is. Her digital watch says 2:43. Then it tells the date. In the darkness she has no sense of distance, and it seems to her that the red numeral could be the size of a billboard, only seen from far away."[171] With this definition of "billboard" Koolhaas emphasizes that exaggeration (and the billboard and Bigness are certainly that) is best measured in relationship to the self. According to Stewart, "The body has served as our primary mode of understanding and perceiving scale."[172] The relationship between body and size is underlined in the very reading of the book. Not only are architectural models photographed as if they were life-size, but the continual shifts in scale between photographs and plans, and the physical weight of the book on our lap, make us continuously aware of our corporeal presence.

In "Bigness or the problem of large," Koolhaas writes, "Bigness transforms the city from a summation of certainties into an accumulation of mysteries."[173] Can any of these mysteries be solved? The solution, I believe, is to be found not in the architect's exploitation of the billboard but in the dictionary of *S,M,L,XL*. As a glossary, Koolhaas's words offer a key to his mysterious text, and also to the inscrutable city.

This dictionary not only provides a running commentary on the pictures and texts in the book but makes, by example, an important point about contemporary culture—to use Koolhaas's term, the "culture of congestion." In place of dictionary definitions, pronunciations, and etymologies copied from *Webster's*, the authors have accumulated their definitions through the act of quotation, exploiting a wide variety of sources: novels, theoretical texts, TV shows, movies, advertisements, commentaries on art and architecture, and material from Koolhaas's and O.M.A.'s own writings. Excerpts from these texts are presented as definitions for a select group of words. The sources range from Daniel Defoe's *Robinson Crusoe*, 1719 (for the word "collapsed"), to Donald Trump's *Trump: Art of the Deal*, 1987 (for "popular"), to cite only two examples.

Set in a column running down the left-hand side of the left-hand pages throughout the

1,300-odd pages of the book, the dictionary interrupts the smooth flow of chapters and narratives, heightening the book's already vigorous conflict and contrast (fig. 26). Not simply textual, these words and definitions act like a chorus of voices commenting on the state of the city. Their commentary, however, does not praise the variety of metropolitan carols, as in Walt Whitman's "I Hear America Singing," or accurately reproduce the American vernacular, like the dialogue written by Mark Twain. Instead the dictionary undermines the very idea of originality: voices can only speak someone else's words, can only endlessly quote what has been heard before. Like Jorge Luis Borges's character Pierre Menard, who is doomed to rewrite word for word the text of *Don Quixote*, we are in the realm of simulation, where originality no longer exists, and rehearsal and repetition are the only means of composition.[174] Koolhaas extends this noise even further by offering, at the end of the book, a second dictionary of sources, which functions as a more concise mirror to the first.

The effect of these multiple dictionaries and multiplications of words is extraordinary. A glossary is ordinarily intended to aid the reader in navigating a text—to offer definitions relevant to a book's contents so that the reader can better understand the author's motives and interests, to guide (and perhaps control) the narrative journey. Koolhaas's dictionary, instead, threatens meaning and taxonomy. This resistance to interpretation returns us once again to Borges, and to his story about the "Chinese encyclopedia" in which

animals are divided into (a) belonging to the Emperor, (b) embalmed, (c) tamed, (d) sucking pigs, (e) sirens, (f) fabulous, (g) stray dogs, (h) included in the present classification, (i) frenzied, (j) innumerable, (k) drawn with a very fine camelhair brush, (l) et cetera, (m) having just broken the water pitcher.[175]

Like this absurd system of classification, or like encyclopedias and catalogues in general, Koolhaas's book demonstrates that dictionaries, as critic Brian Wallis writes, are "fictional and contradictory constructions. . . . [the] cultural codes we live by, the orders of discourse we follow, all manners of representation—are not natural or secure, but are arbitrary and historically determined."[176] Translating language into structure, we can only conclude that Koolhaas means space and architecture to be understood—if their meaning can be deciphered at all—in a similarly mediated way.

The place of language in *S,M,L,XL*—free-floating, contextless—seconds Koolhaas's theory of Bigness. In his manifesto and in his building projects, Koolhaas exclaims, "Fuck context!" By breaking with architectural scale, composition, tradition, transparency, and ethics, Bigness also forces a break with the "urban tissue." "Not only is Bigness incapable of establishing relationships with the classical city—*at most it coexists*. . . . Bigness no longer needs the city: it competes with the city; it represents the city; it preempts the city; or better still, it *is* the city. . . . Bigness, through its very independence of context, is the one architecture that can survive, even exploit, the now-global condition of the tabula rasa."[177] In *S,M,L,XL*, language is equated with building and structure; whether through quotation or through radical

breaks with the city, both are similarly unmoored.

In assembling quotations for his dictionary, Koolhaas acts as a collector, even a cannibal. His ravenous appropriations can be compared to those of Benjamin, who, in his *Passagenwerk* (1927–40), constructed a text almost completely out of quotations.[178] Rolf Tiedemann compares Benjamin's "entire project to a blue-print for an eventual edifice whose building blocks would be provided by the documentary quotation and whose mortar would in turn be supplied by the theoretical reflections."[179] Recalling the structure of the *Passagenwerk*, Koolhaas juxtaposes on the same pages an alphabetical arrangement of quotations and his own commentary arranged in the form of photographs, drawings, and text.[180] In this, as Richard Sieburth says of Benjamin, "it resembles that polyphonic play of language which [Mikhail] Bakhtin terms heteroglossia—different voices, different discourses refracting each other in dialogue."[181]

The bringing together of quotations, then, removes the order and control of the single author and leaves readers facing accumulating fragments. By acting as a "recording device," Koolhaas denies his own authority: as Sieburth says of Benjamin, "the words he copies are after all, not *his*, but belong to other voices, other eras and, for the most, adopt a language . . . that is not his own."[182] But where Benjamin, in immersing himself in the lexicon of the quotation, "vanishes into the intertextual murmur of the Archive," Koolhaas instead throws himself into the din of the metropolis, absorbs his quotations from the "culture of congestion," borrows from "the cities of exacerbated difference."[183] In collecting and re-presenting his dictionary, Koolhaas "illuminates the condition of architecture today," and reveals the city as fragmented, clashing, and layered.[184] It is as if Léger had brought together the colored planes of *La Ville* and the ruptured headlines of *Ballet mécanique*. But rather than the exultant beauty and clearly defined rhythm of Léger's machine parts, limbs, and consumer goods, both Benjamin and Koolhaas offer far more contradictory and uncertain views.

31. Pieter Bruegel the Elder. *The Tower of Babel*, c. 1564. Oil on panel, 23⅝ x 29⁵⁄₁₆" (60 x 74.5 cm). Museum Boijmans Van Beuningen, Rotterdam

Like Benjamin's arcade, Koolhaas's city is a ruin, all pieces and fragments—aural, visual, textual. Mirroring *S,M,L,XL*'s dictionary, this urban environment represents infinite temporal moments colliding in a building, along a street, across a plaza. Koolhaas does not adopt Léger's billboard as an emblem for the city; instead he chooses Babel and its tower—no overriding voice but the din of voices, no singular vision but a collage of images, no master narrative but a dictionary of dispersed and ever-shifting meanings (fig. 31). In Koolhaas's view, Babel's punishment for the hubris of building—the multiplication of languages—becomes a utopia into which delirious visitors throw themselves "like a surfer to the waves."[185]

In an essay in *S,M,L,XL*, "What Ever Happened to Urbanism?" Koolhaas presents these ideas directly. "If there is to be a 'new urbanism,'" he writes, "it will not be based on the twin fantasies of order and omnipotence; it will be the staging of uncertainty; it will no longer be concerned with the arrangement of more or less permanent objects but the irrigation of territories with potential; it will no longer aim for stable configurations but for the creation of enabling fields that accommodate processes that refuse to be crystallized into definitive

form."[186] If Koolhaas's utopia is Babel, no wonder his dictionary offers four different definitions of that city—the more meanings, and the greater the enactment of difference, the better. With these definitions, which are also quotations, Koolhaas associates the city-as-Babel with ruin, foolishness, mobility, and infinite meaning—as well as, of course, with Bigness.[187] In each of the "Babel" entries we face unjustifiable but admirable optimism: the desire to build and rebuild Babel is also the overwhelming need to build and rebuild the city. And as Léger understood, if a project is to be futile, is there one any better than this? To this question Koolhaas responds, "More than ever, the city is all we have."[188]

City Views

The 110-story elevator ride that takes a visitor to the top of the World Trade Center, and thus to the top of Manhattan, is more than a movement from ground level to sky; this vertical journey demarcates a move upward but also a shift in power, from being one among many to being a singular entity—a shift in experience from body to eye. Elevation, as Michel de Certeau explains, "transfigures" the World Trade Center visitor into a "voyeur."[189] The desire to see the city from a distance has a long history, from medieval and Renaissance birds-eye-view perspective drawings to the photographs of nineteenth-century Paris that Nadar managed to shoot from the precarious position of a hot-air balloon. Being able to look down from above provides both pleasure and power—to see is to control (fig. 32). The view "allows one to read . . . [the city], to be a solar Eye, looking down like a god. The exaltation of a scopic and gnostic drive: the fiction of knowledge is related to this lust to be a viewpoint and nothing more."[190]

While the "pedestrian who is for an instant transformed into a visionary" may enjoy a feeling of exhilaration, this view from on high is a fiction based on misunderstanding and alienation.[191] To see the city as it really is, to experience its endless traffic and labyrinthine streets, to understand its simultaneous temporalities and frantic pace, one has to ride the elevator 110 stories back down to ground level.[192] This return, however, is not without its losses. Easily readable and writable from above, the ever fragmented city resists capture, penetration, and decipherment from below; from within, the city is impossible to represent.[193]

In his evocatively written novel *Invisible Cities*, Italo Calvino shows the impossibility of definitively representing the city. The book is composed as a series of dialogues between the emperor Kublai Khan and the explorer Marco Polo. Seeking to gain and maintain control of an empire that once "had seemed to us the sum of all wonders" but has fallen into "formless ruin," Kublai Khan has enlisted Polo not only to travel to the far reaches of his atlas but to come back to him and describe the sights en route; complete knowledge, he hopes, will bring total possession.[194] Frustrating the disembodied and alienated eye of the emperor—who remains in his castle, hoping for the kind of panoramic view found on the top of Manhattan's highest tower—the sensitive and perceptive Marco Polo stresses the impossibility of the con-

32. "Aerial View of Bustling Lower Manhattan." Picture postcard. Photograph: Aziz Rahman

trol his employer desires. Having mined the depths of each of the cities he has visited, the explorer warns of the transcendent view's illusoriness: Khan can never be a "solar eye," but is destined to remain "an emblem among emblems."[195]

Polo cannot fully carry out his employer's wishes, but he does demonstrate methods of navigating cities, and enumerates the factors that result in urban formation, mood, and decline. He describes, for example, the misplaced desires of the inhabitants of Zoebide, who, in their futile attempt to capture a woman they once saw in their dreams, turn their city into a trap in which they themselves are ultimately encaged.[196] Through tales of Zaira, Polo demonstrates that a city is made not so much of buildings as of "relationships between the measurements of its space and the events of its past: the height of a lamppost and the distance from the ground of a hanged usurper's swaying feet . . . the height of the railing and the leap of the adulterer who climbed over it at dawn."[197] Memories and past events—public and private—function as the city's building blocks, so that everywhere in the metropolis, from the corners of the streets to the antennae of lightning rods, stories and cities are written. Polo learns that cities are split and torn, like Beersheba, which has a good and virtuous side that is suspended in the sky, while its base wants and bubbling disgusts fester in the muck below.[198] In Leonia, Polo discovers that cities continually refashion themselves, that a city changes with every moment in time, but that this drive for contemporaneity also has a price: every judgment of obsolescence marks an addition to the rubbish heap outside its walls, and the gradual rise of a mountain ever more nearly threatening the city with a landslide.[199]

Even given such infinitely wide-ranging descriptions of place, Kublai Khan continues to search for the shortcut that would lead to complete understanding, finally looking to chess as a model for the "invisible order that sustains cities, on the rules that decreed how they rise, take shape and prosper, adapting themselves to the seasons, and then how they sadden and fall into ruins."[200] The games between Khan and Polo, dashing the emperor's hopes, not only reinforce the multiplicity of cities and their forms but do something far worse. Intended to reduce urban spaces to their essences, the games actually leave Khan empty-handed: "By disembodying his conquests to reduce them to the essential, Kublai had arrived at the extreme operation: . . . [The empire and each of its cities] was reduced to a square of planed wood: nothingness."[201]

Along with its phantasmic glimpses of the relationships between structure and memory, desire and building, vision and dream, *Invisible Cities* offers lessons about the impossibility of representation, and the worth and wonder of navigation as opposed to control. In this dazzling morass, Marco Polo does offer an ideal city, conceived in the knowledge of all those he has visited. Built piece by piece in his imagination, this city is composed only of fragments, is discontinuous in space and time, and comprises multiple views. But Polo's utopia—which, it turns out, is where we already live—demands constant vigilance, for it can easily slip from a promised land, a New Atlantis, into a nightmare, a Brave New World, "the inferno where we live everyday." Simply accepting a city's condition will hasten the decline to dystopia. Thus

the urbanite must consistently and continuously "seek and learn to recognize who and what, in the midst of the inferno, are not inferno, then make them endure, give them space."[202]

Marco Polo not only provides guidance and warning, he also acts as historian and clairvoyant, offering Khan a chronology of past cities and expectations for the future. The building of cities, he explains, will continue as long as urbanism's "catalogue of forms" remains rich.[203] But even far in the future, when the catalogue is exhausted, Polo assures us, construction will not cease: antiform, *informe*, un-form will replace form, resulting in the proliferation of cities characterized by unrestrained endlessness and octopuslike sprawl. For Calvino, the endless building and rebuilding of cities—and the desire that motivates the process—are metaphors for human history. And so, indeed, is the city itself—as long as our experience remains *within* the metropolis, and does not submit to the lure of the totalizing gaze.

With its juxtapositions of temporalities, stimulations, and fragmented experiences, the city also reveals history not as "a cumulative, additive narrative in which the uninterrupted syntagm of time flows homogeneously from past to future, but rather a montage where any moment may enter into sudden adjacency with another."[204] Alluding to the links between the metropolis and history, architect Arata Isozaki has described the city as "a thing perpetually in a state of ruin," adding that for him, "the moment of ecstasy is when everything is built and vanishes in catastrophe."[205] These metaphors of ruin, heaps of rubbish, and fragmentation propel us backward into the future, like Benjamin's angel of history, who watches unable to act "while the pile of debris before him grows skyward."[206] Thus the invisibility of Calvino's cities is not only that they can never be fully seen or completely pictured, but that the history they metaphorically represent can never be smoothly told.

City views ranging from those of Fernand Léger through the more recent investigations of Lari Pittman, Julie Becker, Martha Rosler, Rem Koolhaas, and finally Italo Calvino make it clear that the richest vistas are not totalizing but appear in startling ruptures, surreal juxtapositions, unmoored fragments, slices of time, and urban refuse, all of them charged with both individual memory and collective history. Kublai Khan could never be satisfied or comfortable with such multiplicity, difference, limitlessness, and ephemerality, and he accuses Polo of smuggling "moods, states of grace, elegies" into his descriptions rather than providing facts, statistics, and precise documentation. But Khan's resistance and hubris are self-defeating. Polo's recollections of each and every one of his cities are rich and satisfying: in his evocations of his travels, all we can see—but this is more than enough—are "the exhalations that hang over the roofs of the metropolises, the opaque smoke that is not scattered, the hood of miasmata that weighs over the bituminous streets. Not the labile mists of memory nor the dry transparence, but the charring of burned lives that forms a scab on the city, the sponge swollen with vital matter that no longer flows, the jam of past, present, future that blocks existences calcified in the illusion of movement: this is what you would find at the end of your journey."[207]

33. *Holland House Library after Air Raid, Kensington, London,* October 23, 1940. Black and white photograph. Royal Commission on the Historical Monuments of England, London

Notes

Winding my way through twentieth-century cities, I was expertly guided by the wisdom and advice of a variety of fellow urban (and suburban) dwellers. Anthony Barzilay Freund, Maria Gough, Laura Hoptman, Lilian Tone, Lynn and Paul Zelevansky, and Greg Clarick all made creative suggestions, shared interesting ideas, and patiently listened. Shaun Caley of Regen Projects, Carol Greene of GreeneNaftali Gallery, and Rodney Hill of Jay Gorney Modern Art provided invaluable images and information. This essay could not have been completed without Lisa Hostedler's research assistance and the expertise and enthusiasm of the entire Léger team: Beth Handler, Susan Richmond, and Kristen Erickson. I have also appreciated David Frankel's patient and skillful editing, and I owe my greatest debt to Carolyn Lanchner for her brilliant insights and, even more, for her consistent encouragement and faith.

1. See Marshall Berman, "Baudelaire: Modernism in the Streets," *All That Is Solid Melts into Air: The Experience of Modernity* (New York: Penguin Books, 1982), p. 144. Berman is addressing Charles Baudelaire's essays "The Painter of Modern Life" and "Heroism of Modern Life." See also Linda Nochlin, *The Body in Pieces: The Fragment as a Metaphor of Modernity* (New York: Thames and Hudson, 1994), p. 24, which discusses Berman's description of Baudelaire's metaphors.
2. Baudelaire, "The Painter of Modern Life," 1863, in *The Painter of Modern Life and Other Essays*, trans. and ed. Jonathan Mayne (London: Phaidon Press, Ltd., 1964), p. 9.
3. Baudelaire, "Preface: To Arsène Houssaye," *Le Spleen de Paris*, 1869. Published in English as *Paris Spleen*, trans. Louise Varèse (New York: New Directions, 1947), pp. ix–x.
4. Fernand Léger, "The Origins of Painting and Its Representational Value," 1913, in *Functions of Painting*, ed. Edward F. Fry, trans. Alexandra Anderson, with a preface by George L. K. Morris (New York: The Viking Press, 1973), pp. 8, 10.
5. Franz Kafka, *Amerika*, trans. Willa and Edwin Muir (New York: Schocken Books, 1962), p. 17.
6. Mark Anderson, "Kafka and New York: Notes on a Traveling Narrative," in Andreas Huyssen and David Bathrick, eds., *Modernity and the Text: Revisions of German Modernism* (New York: Columbia University Press, 1989), p. 142.
7. Ibid., p. 143. Anderson's essay provides an extensive analysis of the word *verkehr*.
8. Kafka, *Amerika*, pp. 38–39. Quoted here as translated in ibid., pp. 155–56.
9. Léger, "Contemporary Achievements in Painting," 1914, in *Functions of Painting*, pp. 12–13.
10. Ben Singer, "Modernity, Hyperstimulus, and the Rise of Popular Sensationalism," in Leo Charney and Vanessa R. Schwartz, eds., *Cinema and the Invention of Modern Life* (Berkeley: University of California Press, 1995), p. 72.
11. Léger, "Contemporary Achievements in Painting," p. 11.
12. Cassandre, quoted in John Barnicoat, *Posters: A Concise History*, 1972 (reprint ed. New York: Thames and Hudson, 1994), p. 78.
13. Louis Chéronnet, "*La Publicité moderne: La Gloire du panneau*," *L'Art vivant* (Paris) 2 (August 1926): 618. For the English translation of this passage and a thorough discussion of the poster form, see Kirk Varnedoe and Adam Gopnik, *High and Low: Modern Art and Popular Culture*, exh. cat. (New York: The Museum of Modern Art, 1990), p. 300 and throughout the chapter.
14. Léger, "Contemporary Achievements in Painting," p. 12.
15. Varnedoe and Gopnik, *High and Low*, pp. 235–36.
16. For a discussion of the French "rash of advertising gigantism," see Jeffrey Weiss, *The Popular Culture of Modern Art: Picasso, Duchamp, and Avant-Gardism* (New Haven and London: Yale University Press, 1994), pp. 59–73.
17. Anxiety about the poster was not limited to Parisians. In 1912 a special commission was established in New York City to investigate the "excesses of billboards." See Varnedoe and Gopnik, *High and Low*, p. 250.
18. These debates are discussed in Marcus Verhagen, "The Poster in Fin-de-Siècle Paris: 'That Mobile and Degenerate Art,'" in Charney and Schwartz, eds., *Cinema and the Invention of Modern Life*, pp. 108, 118.
19. Maurice Talmeyr, "L'Âge de l'affiche," *La Revue des deux mondes* (Paris), September 1, 1896, p. 212. Quoted in ibid., p. 115.
20. P. Raveau, "*La Guerre à l'affiche*," *La Publicité* (Paris) 9 (December 1911), pp. 149–50. Quoted in Varnedoe and Gopnik, *High and Low*, p. 249.
21. Talmeyr, "L'Âge de l'affiche," p. 216. Quoted in Verhagen, "The Poster in Fin-de-Siècle Paris," p. 115.
22. Rosalind Krauss, "The Motivation of the Sign," in *Picasso and Braque: A Symposium*, ed. Lynn Zelevansky (New York: The Museum of Modern Art, 1992), p. 281.
23. "Zone" appears in Guillaume Apollinaire, *Alcools* (Paris: Éditions Gallimard, 1913), and in English translation in *Alcools*, trans. Donald Revell (Middletown, Conn.: Wesleyan University Press, and Hanover, N.H.: University Press of New England, 1995).
24. Blaise Cendrars, "Advertising= Poetry," 1927, in *Selected Writings of Blaise Cendrars*, ed. and trans. Walter Albert (New York: New Directions, 1966), p. 240.
25. Ibid., pp. 242, 241.
26. André Breton, *L'Amour fou* (Paris: Éditions Gallimard, 1937), published in English as *Mad Love*, trans. Mary Ann Caws (Lincoln: University of Nebraska, 1987), p. 15. Breton is quoting Baudelaire's "*Correspondances*," *Les Fleurs du Mal* (1857; published in English as *The Flowers of Evil*, trans. Marthiel and Jackson Mathews, New York: New Directions, 1955). Another example of Surrealism's interest in the billboard appears in Robert Desnos's Surrealist novel *La Liberté ou l'amour* (Paris: Aux Éditions du Sagittaire, 1927), in which billboards come to life and do battle in Paris's streets.
27. Verhagen, "The Poster in Fin-de-Siècle Paris," p. 109. Fénéon's suggestion foreshadows the *décollage* or anonymous lacerations of later artists such as Jacques de la Villeglé, Mimmo Rotella, and Raymond Hains. See Christopher Phillips, "When Poetry Devours the Walls," *Art in America* (New York) 78 no. 2 (February 1990): 139–45.
28. Léger, "Contemporary Achievements in Painting," p. 12.
29. From a conversation between Léger and Cendrars reprinted in Varnedoe and Gopnik, *High and Low*, p. 424, note 125. The conversation was published in its entirety in *Entretien de Fernand Léger avec Blaise Cendrars et Louis Carré sur le paysage dans l'oeuvre de Léger* (Paris: Louis Carré, 1956).
30. Christopher Green, *Léger and the Avant-Garde* (New Haven and London: Yale University Press, 1976), p. 183.
31. Standish Lawder, *The Cubist Cinema* (New York: at the University Press, 1975), p. 167.
32. The idea of projecting an entire page of a newspaper may have been sparked by Gerald Murphy's set design for the 1923 Ballet Suédois production *Within the Quota*. The backdrop for the ballet was the blown-up front page of a newspaper, complete with tabloid-style headlines. See ibid., pp. 154–55.
33. Ibid., pp. 257–58, note 70. The *bébé Cadum* remained a part of Léger's imagination. By 1928, when Léger felt that window design had become more exciting than billboards, he would write, "Only that one enormous object, the Cadum Baby, persists." See Léger, "The Street: Objects, Spectacles," 1928, in *Functions of Painting*, p. 79. The giant baby also makes appearances in René Clair and Francis Picabia's 1924 film *Entr'acte* and in Desnos's novel *La Liberté ou l'amour*.
34. Lawder, *The Cubist Cinema*, pp. 153–54.
35. Ibid., p. 154.
36. Léger, "Contemporary Achievements in Painting," p. 11.
37. Léger, quoted in Lawder, *The Cubist Cinema*, p. 167.
38. Green, *Léger and the Avant-Garde*, p. 181. *La Fin du monde filmée par l'Ange N.-D.* was published by Éditions de la Sirène, Paris, in 1919.
39. Ibid., p. 153. Green also believes that the beginnings of the subject of the typographer can be traced to Léger's wartime drawings of soldiers, or *poilus*.
40. See Susan Buck-Morss, "The Flâneur, the Sandwichman and the Whore: The Politics of Loitering," *New German Critique* (New York) 13 no. 3 (Fall 1986): 101, 104.
41. Léger, "The Origins of Painting," p. 8.
42. Léger, "Contemporary Achievements in Painting," p. 13.
43. Ludwig Meidner, quoted in Charles W. Haxthausen, "'A New Beauty': Ernst Ludwig Kirchner's Images of Berlin," in Haxthausen and Heidrun Suhr, eds., *Berlin Culture and Metropolis* (Minneapolis:

University of Minnesota Press, 1990), p. 63.

44. Ibid., pp. 63–64.

45. Léger, "Contemporary Achievements in Painting," p. 11.

46. See ibid., pp. 16–17, for an example of Léger's lessons in which he notes that his "research comes . . . from the modern environment."

47. Léger, "The Street: Objects, Spectacles," pp. 78–79.

48. Léger, "Contemporary Achievements in Painting," p. 14.

49. Ibid., p. 11.

50. For a fascinating analysis of the role of fragmentation in stimulating new modes of reading, see Paul Zelevansky, "Attention SPAM®," forthcoming in SubStance, published by the University of Wisconsin Press through the Departments of French and Italian, University of California, Santa Barbara.

51. Lari Pittman, quoted in Paul Schimmel, "An Interview with Lari Pittman," in Howard N. Fox, Lari Pittman, exh. cat. (Los Angeles: Los Angeles County Museum of Art, 1996), p. 71.

52. Umberto Boccioni et al., "The Exhibitors to the Public," 1912, in Futurist Manifestos, ed. and trans. Umbro Apollonio (New York: Viking Press, 1973), pp. 45–50.

53. Marjorie Perloff, The Futurist Moment: Avant-Garde, Avant Guerre, and the Language of Rupture (Chicago: at the University Press, 1986), p. 8. See chapter 1 of Perloff's book for a more extensive discussion of simultaneity.

54. The book is discussed in ibid., pp. 2–43. It includes simultaneities of a number of kinds: the telescoping of vast distances through train travel, the mixing together of disparate colors, the juxtaposition of present and past.

55. For an extensive discussion of these technological developments and their relationship to artistic production, see Stephen Kern, The Culture of Time and Space: 1880–1918 (Cambridge: Harvard University Press, 1983).

56. Apollinaire, quoted in Roger Shattuck, "Apollinaire's Great Wheel," The Innocent Eye: On Modern Literature and the Arts (New York: Washington Square Press, 1984), p. 257.

57. Kern, The Culture of Time and Space, p. 69.

58. Quoted in ibid., p. 70.

59. See Pam Cook, ed., The Cinema Book (London: The British Film Institute, 1985), pp. 208–10. D. W. Griffith extended and developed Porter's discovery, generating suspense through perfectly timed cross-cutting. It should be noted that the Futurists were great fans of cinema, particularly because, as Filippo Tommaso Marinetti wrote, it offered a "sense of simultaneity and omnipresence . . . a fleeting sense of life in the world" (see the September 1916 manifesto "The Futurist Cinema," in Marinetti: Selected Writings, ed. R. W. Flint, trans. Flint and Arthur Coppotelli, New York: Farrar, Straus & Giroux, 1972, p. 207). See also Kern's discussion of simultaneity and film in The Culture of Time and Space, pp. 70–72.

60. Henri-Martin Barzun, Voix, rythmes et chants simultanés (Paris, 1913), pp. 25–46. Discussed in Kern, The Culture of Time and Space, p. 72.

61. Quoted in ibid., p. 67.

62. Cendrars, "Tower," 1913, the second of "Nineteen Elastic Poems," in Blaise Cendrars: Complete Poems, trans. Ron Padgett (Berkeley: University of California Press, 1992), pp. 55–57.

63. Cendrars, "The Eiffel Tower," 1924, trans. Esther Allen in collaboration with Monique Chefdor, in Chefdor, ed., Modernities and Other Writings (Lincoln: University of Nebraska Press, 1992), pp. 105–6.

64. See Apollinaire, Calligrammes: Poems of Peace and War (1913–1916), trans. Anne Hyde Greet (Berkeley: University of California Press, 1980). Shattuck, in "Apollinaire's Great Wheel," p. 249, explains that the title "Lettre-Océan" refers to "a recently introduced service of ship-to-ship or ship-to-shore wireless message." My understanding of Apollinaire's poem owes much to Shattuck's wonderful analysis.

65. Ibid., p. 259.

66. Ibid.

67. Laura Hoptman, conversation with the author, 1997.

68. Pittman, quoted in Dan Cameron, "Sweet Thing," Artforum (New York) 31 no. 4 (December 1992): 58.

69. Pittman, quoted in Fox, "Joyful Noise: The Art of Lari Pittman," Lari Pittman, p. 21.

70. Shattuck, "Apollinaire's Great Wheel," p. 259.

71. Dave Hickey, "The Self-Reliant Seductress Visits the Museum," in Fox, Lari Pittman, p. 30.

72. Ibid., p. 29.

73. Ibid., p. 30.

74. One thinks, for example, of the television show The Twilight Zone. An interest in the spiral and its pulse can also be seen in Marcel Duchamp's Rotoreliefs; see Krauss's analysis of Duchamp's interest in optics in the third chapter of her book The Optical Unconscious (Cambridge, Mass.: MIT Press, 1993).

75. Roland Barthes, "The Rhetoric of the Image," Image-Music-Text, trans. Stephen Heath (New York: Hill and Wang, 1977), p. 44.

76. See Krauss's discussion of the "part-object" in The Optical Unconscious, p. 137.

77. Lane Relyea, "Lari Pittman," Artforum (New York) 35 no. 1 (September 1996): 105.

78. This reading of Pittman's work is inspired by Krauss's discussion of Duchamp's Rotoreliefs in The Optical Unconscious, pp. 95–146.

79. Cameron, "Sweet Thing," p. 59.

80. Le Corbusier and Amédée Ozenfant, quoted in Krauss, The Optical Unconscious, p. 161. See also Ozenfant and Charles-Édouard Jeanneret (Le Corbusier), "Formation de l'optique moderne," La peinture moderne (Paris: Editions G. Crès, n.d.), pp. 63–69.

81. Ibid.

82. Cameron, "Sweet Thing," p. 58.

83. Walter Benjamin, "A Berlin Chronicle," 1932, in Reflections, ed. Peter Demetz, trans. Edmund Jephcott (New York: Schocken Books, 1986), p. 3.

84. Ibid., pp. 8–9.

85. Benjamin, Das Passagenwerk, 1927–40 (unfinished), quoted in Jeffrey Mehlman, Walter Benjamin for Children: An Essay on His Radio Years (Chicago: at the University Press, 1993), p. 3.

86. Mehlman, Walter Benjamin for Children, p. 3.

87. Ibid., and Richard Sieburth, "Benjamin the Scrivener," Assemblage (Cambridge, Mass.) 6 (June 1988): 10.

88. This work was first shown at the Bienal Internacional São Paulo as part of the North American Section, 1996.

89. Julie Becker, project statement, Universalis: 23, exh. cat. (São Paulo, 1996), p. 162.

90. Ibid.

91. In a recent interview, Becker explained that "the refrigerator boxes are also people—they take on human characteristics. Each of the boxes can be seen as a different side of oneself. The box faced into the corner . . . is supposed to be the gloomy or depressed box." Quoted in "Bernhard Bürgi: In Conversation with Julie Becker," in Julie Becker, Researchers, Residents, a Place to Rest, exh. cat. (Zurich: Kunsthalle Zürich, 1997), p. 19.

92. Ibid., p. 35.

93. Kay Thompson, Eloise, with drawings by Hilary Knight (New York: Simon and Schuster, 1955). For many years the Plaza Hotel has prominently displayed a portrait of Eloise in its lobby. It is only in Becker's third room that the appearance of, for example, a miniature Palm Court (a space at the Plaza) in one of the models finally makes sense. It should be noted that Becker makes specific reference to the Stanley Kubrick film of The Shining, not to the novel by Stephen King on which the film is based.

94. The reader should be aware that in addition to Eloise and Danny, Becker includes other inhabitants in her installation. The "residents" of her title are associated with specific rooms in the two models. Textual profiles of these residents, composed, we can only imagine, by the "researchers," can be found in the workshop. In addition, Becker introduces another figure, the Hollywood celebrity psychic Voxx, who has a popular radio show in Los Angeles. Becker has videotaped an interview with Voxx that is one of a number of tapes playing on the workshop's television. Becker also includes a tiny painting of her in one of the models.

95. Becker, artist's statement in Universalis: 23, p. 162.

96. Chris Kraus, in a short description of Becker's work in ibid., p. 160.

97. It is interesting to note that

Becker has described the area of the installation with the refrigerator boxes as "almost 'on the edge of town.'" "Bernhard Bürgi: In Conversation with Julie Becker," p. 19.

98. James Clifford, "Documents: A Decomposition," in Sidra Stich, Anxious Visions: Surrealist Art, exh. cat. (Berkeley: University Art Museum, and New York: Abbeville Press, 1990), pp. 177, 195.

99. Joseph Conrad, quoted in ibid., p. 195.

100. Clifford, in ibid., p. 197.

101. See James Hay, "Castelli in aria: The Myth of the Grand Hotel," Popular Film Culture in Fascist Italy: The Passing of the Rex (Bloomington: Indiana University Press, 1987), pp. 37–63.

102. Michel Foucault might call the hotel a "heterotopia," an infinitely open alternative site where things happen that would be impossible in one's everyday life. See his "Of Other Spaces," Diacritics (Ithaca) 16 no. 1 (Spring 1986): 22–27.

103. Alphaville, released in 1965, is set in an imaginary future, but was, amazingly enough, filmed in the Paris of the time. Through careful choices of locations and props, and wonderful use of shadow and light, Jean-Luc Godard was able to make the city almost completely unrecognizable.

104. Fredric Jameson, "Postmodernism, or the Cultural Logic of Late Capitalism," New Left Review (London) 146 (1984): 80. Published subsequently in expanded form as Postmodernism, or, The Cultural Logic of Late Capitalism (Durham, N.C.: Duke University Press, 1991).

105. Ibid., p. 81.

106. Ibid.

107. Ibid., p. 82. Jameson continues, "This is a dialectical intensification of the autoreferentiality of all modern culture, which tends to turn upon itself and designate its own cultural production as its content."

108. Ibid., p. 83. For Jameson, the architecture of the Bonaventure reflects the growth of "global multinational and decentered communicational network[s] in which we find ourselves caught as individual subjects." See p. 84.

109. Becker describes entering a "delirium of digression" in con-

structing this installation. "Bernhard Bürgi: In Conversation with Julie Becker," p. 33.

110. See Susan Stewart's discussion of the dollhouse and other exaggerated forms in *On Longing: Narratives of the Miniature, the Gigantic, the Souvenir, the Collection* (Durham, N.C.: Duke University Press, 1993), p. 61. Of the dollhouse Stewart writes, "The dollhouse, as we know from the political economy of Ibsen, represents a particular form of interiority, an interiority which the subject experiences as its sanctuary (fantasy) and prison (the boundaries or limits of otherness, the inaccessibility of what cannot be lived experience)" (p. 65).

111. Ibid., p. 62.

112. Thompson, *Eloise*, p. 45.

113. Roger Callois, "The Myth of Secret Treasures in Childhood," *VVV* (New York) 1 (June 1942): 4–5.

114. Benjamin, "One-Way Street," 1923–26 (first published 1928), *Reflections*, p. 69. Borrowing an observation made by Benjamin H. D. Buchloh in reference to Jean Dubuffet, we might interpret Becker's regression to childhood imagery and interests—getting lost, creating collections out of debris—as the result of the "blight of urban industrial life and the new consumer culture." See Buchloh, "From Detail to Fragment: Décollage Affichiste," *October* (Cambridge, Mass.) 56 (Spring 1991): 101–2.

115. Kraus, text in *Universalis: 23*, p. 161.

116. Martha Rosler, "in the place of the public: observations of a frequent flyer," 1993, p. 2. This essay was written to accompany Rosler's series of photographs "in the place of the public." A version of it, never formally published, has been available through the gallery Jay Gorney Modern Art, New York. A revised version of the essay was published as "In the Place of the Public: Observations of a Traveller," *Architectural Design* (London) 64 no. 5/6 (May/June 1994): 8–15.

117. Airports and, increasingly, businesses are often located far outside cities, allowing us to avoid the urban center in our travels.

118. Rosler, "in the place of the pub-lic," p. 13.

119. Ibid., p. 11.

120. Ibid., p. 2.

121. Ibid., p. 18.

122. See Henri Lefebvre, *The Production of Space*, 1974, trans. Donald Nicholson-Smith (Oxford: Blackwell, 1991). Rosler uses a quotation from Lefebvre on a photostat in her installation and as an epigraph to her essay on air travel. The quotation, from Lefebvre's "Space: Social Product and Use Value," in J. W. Freiberg, ed., *Critical Sociology* (New York: Irvington, 1979), pp. 285–95, reads, "Capitalism and neocapitalism have produced an abstract space that is a reflection of the world of business on both a national and international level, as well as the power of money and the 'politique' of the state. This abstract space depends on vast networks of banks, businesses, and great centers of production. . . . There is also the spatial intervention of highways, airports, and information networks. In this space, the cradle of accumulation, the place of richness, the subject of history, the center of historical space, in other words, the city, has exploded."

123. Words from Rosler's wall text, *in the place of the public*, Jay Gorney Modern Art, New York, 1993.

124. See Jameson, "Postmodernism, or The Cultural Logic of Late Capitalism"; David Harvey, *The Condition of Postmodernity* (Oxford: Blackwell, 1990); and Edward W. Soja, *Postmodern Geographies: The Reassertion of Space in Critical Social Theory* (New York: Verso Press, 1988). For a feminist response to these authors see Rosalyn Deutsche, *Evictions: Art and Spatial Politics* (Cambridge: MIT Press, 1996).

125. M. Christine Boyer, *Cybercities: Visual Perception in the Age of Electronic Communication* (New York: Princeton Architectural Press, 1996), p. 19.

126. Mark C. Taylor and Esa Saarinen, quoted in ibid., p. 228. See Taylor and Saarinen, *Imagologies* (New York: Routledge, 1994).

127. William Gibson, *Neuromancer* (New York: Ace Books, 1984). The acronym "BAMA" stands for the single city running the length of the eastern U.S. seaboard, comprising the former individual cities of Boston, Atlanta, and Manhattan. "Freeside" Gibson describes as "brothel and banking nexus, pleasure dome and free port, border town and spa. Freeside is Las Vegas and the hanging gardens of Babylon, an orbital Geneva and home to a family inbred and most carefully refined" (p. 101).

128. Ibid., pp. 61, 225, 241, etc.

129. *Neuromancer* begins, "The sky above the port was the color of television, tuned to a dead channel." Ibid., p. 3.

130. For more on Gibson's novel and on cyberspace generally see Scott Bukatman, *Terminal Identity: The Virtual Subject in Postmodern Science Fiction* (Durham, N.C.: Duke University Press, 1993), especially chapter 2, "Terminal Space."

131. The cyborg—an amalgamation of flesh, metal, and sensors or eyes—is the perfect term for the result of this transformation. See Donna Haraway, "A Cyborg Manifesto: Science, Technology and Socialist-Feminism in the 1980s," *Simians, Cyborgs, and Women* (New York: Routledge, 1989), pp. 149–81.

132. Krauss defines *durée* as "the kind of extended temporality that is involved in experiences like memory, reflection, narration, proposition." See her article "Rauschenberg and the Materialized Image," *Artforum* (New York) 13 no. 4 (December 1974): 37.

133. Rosler, "in the place of the public," p. 1.

134. Even a traditional communication device such as the newspaper is infected with the lure of virtuality.

135. Paul Virilio, "The Overexposed City," *Lost Dimension* (New York: Semiotexte, 1991), pp. 9–27.

136. Ibid., p. 13.

137. Ibid., pp. 12–14.

138. Ibid., pp. 14–15.

139. Words from Rosler's wall text, *in the place of the public*, Jay Gorney Modern Art, 1993.

140. Statement on wall board in installation at Jay Gorney Modern Art, 1993.

141. Rosler, "in the place of the public," p. 22.

142. Michael Sorkin, ed., *Variations on a Theme Park: The New American City and the End of Public Space* (New York: Hill and Wang, 1992), pp. xi, xiii.

143. Ibid., p. xv.

144. Léger, "The Circus," 1950, in *Functions of Painting*, p. 172.

145. Ibid., pp. 174, 175, 175.

146. Ibid., p. 177.

147. Victor Hugo, *Notre-Dame de Paris* (Paris: Gallimard, 1842), pp. 206–7, 198. Translated in Stanislaus von Moos, *Venturi, Rauch & Scott Brown: Buildings and Projects* (New York: Rizzoli International Publications, 1987), pp. 55–56. It is interesting to note that Léger recalls Hugo's worries about the book's "murder" of the building in his essay "The Origins of Painting," p. 9.

148. O.M.A., Rem Koolhaas, and Bruce Mau, *S,M,L,XL* (New York: The Monacelli Press, 1995). Jennifer Sigler was the book's editor and Hans Werlemann its photographer.

149. In the discussion that follows, with no intention of underestimating Mau's contribution to *S,M,L,XL*, for concision I refer to Koolhaas as the book's author.

150. Koolhaas, *Delirious New York*, 1978 (reprint ed. New York: The Monacelli Press, 1994), p. 10.

151. Will Novosedlik, "Leviathan," *Print* (New York) L no. IV (July/August 1996): 92.

152. See Jacques Derrida, *Of Grammatology*, trans. Gayatri Chakravorty Spivak (Baltimore: Johns Hopkins University Press, 1976), p. 18. See also Stewart's discussion of the relationship between miniature and book in *On Longing*, pp. 37–69.

153. Derrida, *Of Grammatology*, p. 18.

154. Guy Debord's method of mapping the city is called a *dérive*, French for "drift" or "drifting." The *dérive* is a "matter of opening one's consciousness to the unconscious of urban space; the *dérive* meant a solo or collective passage down city streets, a surrender to and then pursuit of alleys of attraction, boulevards of repulsion." See "Definitions," *Internationale Situationiste* (Paris) no. 1 (June 1958), reprinted in Iwona Blazwick, ed., *An endless adventure . . . an endless banquet . . .: A Situationist Scrapbook* (London: ICA and Verso Press, 1989), p. 22. Quote from Greil Marcus, "Guy Debord's *Mémoires*: A Sit-uationist Primer," in Elisabeth Sussman, ed., *on the Passage of a few people through a rather brief moment in time: The Situationist International, 1957–1972*, exh. cat. (Boston: Institute of Contemporary Art, 1989), p. 127.

155. Benjamin described Baudelaire's *flânerie* as "botanizing the asphalt." See Benjamin, *Charles Baudelaire: A Lyric Poet in the Era of High Capitalism*, trans. Harry Zohn (London: N.L.B., 1973), p. 36. In the language of the Situationists, the study of the unconscious of place is "psychogeography," in which "every building, route, and decoration expanded with meaning or disappeared for the lack of it." Marcus, "Guy Debord's *Mémoires*," p. 127.

156. "Bigness or the problem of large" appears on pp. 494–516 of *S,M,L,XL*. The type begins in a large point size and becomes smaller and smaller as the text goes on. Unlike the rest of the book, this manifesto is presented with no interruptions from photographs or drawings apart from a frontispiece.

157. John Rajchman, "Thinking Big," *Artforum* (New York) 33 no. 4 (December 1994): 47.

158. Ibid., p. 49.

159. Stewart, *On Longing*, p. 9.

160. "The Generic City" begins on p. 1,238 of *S,M,L,XL*; "Life in the Box?" begins on p. 430.

161. See Thomas Crow, *The Rise of the Sixties* (New York: Harry N. Abrams, 1996), p. 84.

162. Von Moos, *Venturi, Rauch & Scott Brown*, p. 53.

163. Robert Venturi, Denise Scott Brown, and Steven Izenour, *Learning from Las Vegas: The Forgotten Symbolism of Architectural Form* (Cambridge, Mass., and London: MIT Press, 1977), p. 161.

164. Ibid., pp. 87–90.

165. Ibid., p. 156.

166. Ibid., p. 13.

167. For Stewart the billboard provides an example of the myriad types of exaggeration that surround us and help to make meaning. Associating the gigantic with public space (as opposed to the private world of the miniature), Stewart finds that the "most fundamental relation to the gigantic is articulated

in our relation to landscape. . . . we are enveloped by the gigantic, surrounded by it, enclosed within its shadow" (*On Longing*, p. 71). In addition to its spatial and metaphorical impact, Stewart sees the billboard as a visualization of the imposition of the commodity on all parts of life. In the American imagination, she explains (p. 101), giants used to populate tall tales; now, however, Paul Bunyan has become the Jolly Green Giant. Mythological figures are useful today merely as salesmen or corporate mascots. The meaning of the gigantic has thus shifted from the natural to the industrial world of exchange.

168. In 1967, for the National Football Hall of Fame in New Brunswick, N.J., Venturi proposed a structure that was both a building and a billboard. His entry was not selected. See his "A Bill-Ding-Board Involving Movies Relics and Space," *Architectural Forum* (New York) 128 no. 3 (April 1968): 74–79.

169. See *S,M,L,XL*, p. 686.

170. Ibid., p. 696.

171. The definition for "Billboard" in *S,M,L,XL* is quoted from a Bobbie Ann Mason short story, "Nancy Culpepper," *Shiloh and Other Stories* (New York: Perennial Library, 1985).

172. Stewart, *On Longing*, p. 101. Stewart's book includes an investigation of the ways in which metaphors of exaggeration mediate life experiences.

173. Koolhaas, *S,M,L,XL*, p. 501.

174. Jorge Luis Borges, "Pierre Menard, Author of the Quixote," in Brian Wallis, ed., *Art after Modernism: Rethinking Representation* (New York: The New Museum of Contemporary Art, 1984), pp. 3–11.

175. This is Michel Foucault's description of Borges's story. See Foucault, *The Order of Things: An Archaeology of the Human Sciences* (New York: Random House, 1970), p. xv.

176. Wallis, "Introduction," in Wallis, ed., *Art after Modernism*, p. xiv.

177. Koolhaas, *S,M,L,XL*, pp. 514–15.

178. "To write history," Benjamin explains, "therefore means to *quote* history . . . the concept of quotation implies that any given historical object must be ripped out of its context." In "N [Re the Theory of Knowledge, Theory of Progress]," in Gary Smith, ed., *Benjamin: Philosophy, Aesthetics, History* (Chicago: at the University Press, 1983, 1989), p. 67.

179. Rolf Tiedemann, quoted in Sieburth, "Benjamin the Scrivener," p. 21. Originally from Tiedemann's introduction (in German) to Benjamin, *Das Passagenwerk, Gesammelte Schriften* (Frankfurt am Main: Suhrkamp, 1971–82), 5:12.

180. Koolhaas's extensive accumulation of reproductions of works of art and found photographs also serves as a commentary on the text.

181. Sieburth, "Benjamin the Scrivener," p. 21.

182. Ibid., p. 19. Breton characterized the Surrealist poet as a "recording device"; quoted in ibid.

183. Ibid. Koolhaas discussed the term "cities of exacerbated difference" in a lecture at Columbia University, New York, on March 26, 1997.

184. Quotation from the text on back cover of *S,M,L,XL*.

185. Koolhaas, in "Foreplay," the preface to *S,M,L,XL*, pp. 42–43. This quotation is part of a stretch of text overlaid across photographs of open pages of a first edition of *Delirious New York*.

186. Koolhaas, "What Ever Happened to Urbanism?," *S,M,L,XL*, p. 969.

187. The sources for "Babel" in Koolhaas's dictionary are Fritz Lang's scenario for *Metropolis*, Fyodor Dostoyevsky's *The Demons*, Roland Barthes's "The Eiffel Tower," and Franz Kafka's "The Great Wall of China."

188. Koolhaas, "What Ever Happened to Urbanism?," p. 971.

189. Michel de Certeau, "Walking in the City," *The Practice of Everyday Life*, trans. Steven Rendall (Berkeley: University of California Press, 1984), p. 92.

190. Ibid.

191. Ibid.

192. In initiating his investigation of Los Angeles, Reyner Banham writes, "So, like earlier generations of English intellectuals who taught themselves Italian in order to read Dante in the original, I learned to drive in order to read Los Angeles in the original." Banham, *Los Angeles: The Architecture of Four Ecologies* (London: Penguin Press, 1971), p. 23.

193. De Certeau, "Walking in the City," p. 93.

194. Italo Calvino, *Invisible Cities*, 1972, trans. William Weaver (New York: Harcourt Brace Jovanovich, 1974), pp. 5, 23.

195. Ibid., p. 23.

196. Ibid., pp. 45–46.

197. Ibid., p. 10.

198. Ibid., pp. 111–13.

199. Ibid., pp. 114–16.

200. Ibid., p. 122.

201. Ibid., p. 123.

202. Ibid., pp. 164–65.

203. Ibid., p. 139.

204. Sieburth, "Benjamin the Scrivener," p. 14.

205. Arata Isozaki, quoted in Peter Conrad, "Cityscape: Rebuilding Potsdamer Platz," *The New Yorker* (New York), April 28 and May 5, 1997, p. 223.

206. Benjamin, "Theses on the Philosophy of History," 1940, *Illuminations*, ed. Hannah Arendt, trans. Harry Zohn (New York: Schocken Books, 1968), pp. 257–58.

207. Calvino, *Invisible Cities*, pp. 98–99.

Léger's Modernism: Subjects and Objects

Matthew Affron

Contemporary achievements in painting are the result of the modern mentality and are closely bound up with the visual aspect of external things that are creative and necessary for the painter. . . . contemporary painting is representative, in the modern sense of the word, of the new visual state imposed by the evolution of the new means of production.

—Fernand Léger, "Contemporary Achievements in Painting," 1914

Fernand Léger's reputation rests on his development and defense of an aesthetic of the machine. We think of Léger as a painter who based his work on a special engagement with the artifacts of industrialized civilization: gears and engines, bottles and pipes, the objects of mass production and everyday use. This artist found the visual aspect of mechanical forms both inherently creative and useful for his aesthetic purposes; he looked to these forms for elements of subject matter as well as models of visual style. The large *Élément mécanique* (1924, p. 203), for instance, establishes a link to the mechanical in the clockwork interarticulation of its geometrical components and in the metallic sheen of its parts. Yet the materiality of the metallic elements is systematically undercut as their volumes empty into flattened planes, and austere linearity is everywhere balanced by the sensuous vibration of undiluted color. What is palpably clear is that this imaginary contraption produces nothing but abstract visual sensation.

The present essay proposes an examination of Léger's ambition, defined in a text of 1914, "Contemporary Achievements in Painting," to make abstract art that would be "representative, in the modern sense of the word, of the new visual state imposed by the evolution of the new means of production."[1] Leger's era, as he understood it, was defined by the industrialization of work and leisure, by the rationalization of resources and time, by a speeding up of feeling, thought, and perception. This acceleration had caused a rupture in the domain of the visual, sweeping away old habits and imposing dramatically more rapid, dynamic, and condensed ways of seeing. The role of the modern artist, Léger believed, was to interpret the extraordinary spectacle of the material quotidian. And if he took inspiration from that spectacle in developing his art, he hoped in turn to express—indeed to transform—contemporary perceptions of the everyday. An investigation of the means of production underlying contemporary material and mental existence provided a logic for Léger's aestheticism. It also suggested a way to relate modern painting to the social world.

Fernand Léger. *Composition à la main et aux chapeaux* (Composition with hand and hats; detail), 1927. Oil on canvas, 97⅜ x 72¹³⁄₁₆" (248 x 185 cm). Musée national d'art moderne–Centre de création industrielle, Centre Georges Pompidou, Paris. See plate on p. 213

Léger continued, after 1914, to affirm the perspectives expressed in his early essay "Contemporary Achievements in Painting." My topic here, however, is the painter's work of the period between the two world wars, and his changing interpretation of a painting "representative of the new means of production." Three phases stand out. Léger developed his aesthetic of the mechanical in the decade after World War I, with compositions such as the *Élément mécanique* of 1924. Then, in the period corresponding roughly to the onset of the Great Depression, 1930–35, when the modernism for which he stood was thrown into crisis, Léger reconsidered his fundamental positions in such pictures as *Feuilles de houx* (Holly leaves, 1930; p. 218) and *Grandes Queues de comètes* (Large comet tails, 1930; fig. 1). In these paintings he shifted his attention from industrial to very different sorts of objects, generally

1. Fernand Léger. *Grandes Queues de comètes* (Large comet tails), 1930. Oil on canvas, three panels, overall: 78¾ x 106¹³⁄₁₆" (200 x 270 cm). Collection Paul and Adrien Maeght, Paris

natural—and when manufactured, inevitably hand hewn. Yet the principles of Léger's abstraction and the underlying vision of his art were reaffirmed and indeed advanced in this transformation. Finally, in the last moment considered in this essay, the half decade preceding World War II, the painter endeavored to align his work with a leftist and populist political movement in France, the Front Populaire. *Travailler* (Working, 1937; fig. 2), a mural combining painting and photomontage, is testimony to his determination to make his political vision explicit without abandoning his fundamental aesthetic positions.

2. Fernand Léger. *Travailler* (Working), 1937. Mural combining painting and photomontage (the right edge cropped in this photograph), 13'1½" x 45' 11³⁄₁₆" (400 x 1,400 cm), in the Pavillon des Temps Nouveaux, *Exposition Internationale des Arts et Techniques dans la Vie Moderne*, Paris, 1937. Photograph published in Le Corbusier, *Des Canons, des munitions? Merci! . . .* (Boulogne-sur-Seine: Éditions de l'Architecture d'Aujourd'hui, 1938), p. 112. The Museum of Modern Art Library, New York

The Advent of the Object

The mechanical element, like everything else, is only a means, not an end.
But if one wants to do powerful work that has toughness and plastic intensity, if one wants to do organic work, if one wants to create and obtain the equivalence of the "beautiful object" sometimes produced by modern industry, it is very tempting to make use of its elements as raw material.
—Léger, "Notes on the Mechanical Element," 1923

The machine, Léger declared in 1923, is, for an artist, a means to an expressive purpose: the goal of plastic intensity.[2] While what he called the *élément mécanique* (the mechanical element) had first appeared in his work just a few years earlier, in 1918, his ideal of plastic intensity—or maximum abstract dynamism—dates from before World War I, when he made his name as a Cubist painter. The pictures of this period include landscapes, urban views, nudes and figure studies, still life compositions, and nonrepresentational works. If the subjects are various, they are linked by a technique of abstraction: objects and figures are decomposed into arrays of semiautonomous geometrical forms, color is distributed in complementary relationships, and the picture surface is animated by organized linear oppositions. In *La Noce* (The wedding, 1911; p. 158), for example, as the members of a wedding party are intermingled with fragments of a bird's-eye view over the houses and trees of a small town, standard spatial and temporal unities are replaced by an interplay of substance and ephemerality, closeness and distance. *Contraste de formes* (Contrast of forms, 1913; p. 164) offers both pure form and brute matter; geometrical solids, roughly sketched and pigmented, are presented in rhythmic opposition. Purged of conventional figural expressivity, the stair-climbers of *L'Escalier* (The staircase, 1914; p. 166) confront the viewer with a clamorous and inhuman presence. Léger based his technique on the idea that representation should be conceptual rather than perceptual. Turning away from the realism of imitation, he argued that painting should realize an equivalent of natural perception, the "new realism" of line, form, and color in mutual interaction. Furthermore, the ordering of these three plastic components needed to be dynamic and dissonant, for the sake of expressive output. The picture should be structured on contrasts of form.

No subject would be better suited to the materialization of these ideas than the mechanical element. And from this choice of subject the painter derived three aesthetic axioms or working propositions. First, the well-constructed, efficient mechanical object provides the modern painter with a model of abstract composition. As Léger put it, *"The art object* (picture, sculpture, machine, object), its value rigorous in itself, made out of concentration and intensity, [is] antidecorative, the opposite of a wall. The coordination of all possible plastic means, the grouping of contrasting elements, the multiplication of variety, radiance, light, brought into focus, life force, the whole [is] united, isolated, and embodied in a frame."[3] The abstract easel painting, like a machine turning in perfect alignment, offers a satisfying demonstration

of structural exactitude, harmony, and controlled force. This principle finds a literal translation in works, such as *Les Hélices* (Propellers, 1918; p. 184) and *Le Mouvement à billes* (Ball bearings, 1926; p. 214), that take industrial forms as their subject matter. In *Les Hélices*, fragments of airplane propellers combine with visually forceful but generalized volumes, planes, and cylinders. The parts never come to rest; this apparatus is in perpetual transformation. *Le Mouvement à billes* clarifies Léger's rendering of the object, but does not fundamentally transform the use he makes of it: a circular assemblage of steely ball-bearings, suspended at the upper right of the picture, establishes relations of similarity and difference, in color, shape, and form, with a brightly colored post and the elements of a typewriter.

In the early 1920s, machines and mass-produced things became favorite subjects of Léger's art and a recurring motif in his theoretical writings. Offering organized and dynamic relationships of line, volume, and color, the machine functioned as a paradigm of aesthetic harmony and a model for a painting practice that made the investigation of plastic relationships its fundamental goal. It also served as the vehicle for Léger's personal articulation of general Cubist aesthetic precepts. Rather than imitating the machine in paint, he hoped to locate the perception of a more essential reality in its inherent qualities of artifice and abstraction. He set up the machine as the epitome of expressive form and as proof that the beauty that is the raw material of creative perception is to be found literally throughout the everyday environment. "The Beautiful is everywhere; perhaps more in the arrangement of your saucepans on the white walls of your kitchen than in your eighteenth-century living room or in the official museums. . . . *The polychromed machine object is a new beginning. It is a kind of rebirth of the original object.*"[4] The modern easel painting, according to Léger, establishes a special link to the modern machine-object in approaching a higher kind of form. But Léger was also interested in connecting his painting with a long artistic tradition that, he believed, similarly emphasized conceptual over imitative procedures. This tradition included "primitive" and archaic art of all kinds, popular art, Romanesque and Gothic art, and the work of a sequence of French masters beginning with Fouquet and Clouet and continuing with their successors the Le Nain brothers, Poussin and Ingres, Cézanne and Henri Rousseau. The logic of this category, as Léger defined it, lay in its opposition to the art of the Italian Renaissance, personified by Raphael and Leonardo, and to the academic teaching of the École des Beaux-Arts. Léger attacked the Renaissance for a slavish imitation of nature that quashed aesthetic inventiveness and for a decadent preoccupation with official subjects and aesthetic hierarchies. This preoccupation, handed down as bad cultural education, had blinded subsequent generations to the truly dynamic and changing essence of beauty.[5]

Yet Léger never limited himself to mechanical themes. In the decade following 1918, he investigated a wide variety of subjects, including the human figure, interiors, cityscapes and landscapes, and still life. *Le Mécanicien* (The mechanic, 1920; p. 193) depicts a worker in an abstract space that we take to be a factory. *L'Homme au chien* (Man with dog, 1921; fig. 3) re-

situates Léger's humanoids, now seen at leisure, in a suburban environment; a connection to the industrial world is nonetheless retained, as this landscape incorporates factory structures without, however, losing its harmony. And *Three Women* (also called *Le Grand Déjeuner*, 1921; p. 195) transposes a nineteenth-century subject, three odalisques, into a modernized interior.

A second of Léger's working propositions or axioms addresses the viewer's response to the object. The beautiful object, the artist noted, is animated by two distinct but interrelated aesthetic qualities: the tangible and concrete dimension of construction, and the variable, fantastic dimension of colored and reflected light, which animates form. Believing that color appeals to the imagination and the emotions with a special forcefulness, Léger proposed that viewers tend to react instinctively, spontaneously, and in advance of any consideration of a given object's practical merits or utility to the pull of eye-catching form—to a "good-looking bicycle" or a "beautiful automobile," for example. The useful object's beauty is perceptible at first glance and rewards a type of aesthetic contemplation that, free and disinterested, is fundamentally abstract. Sociologically, its appeal is inherently vernacular and communal rather than cultivated or elitist. Léger explained, "Personally I think that the initial judgment of the manufactured object, particularly among the masses, frequently concerns its degree of beauty."[6] The aesthetic of the machine thus became for Léger the place where a modernist and a popular sensibility might meet. The sources of the painter's identification with the French working class lay in his experiences as a soldier in the engineer corps during World War I. Léger, a Parisian artist of provincial and petit-bourgeois origins, developed a great affinity for the workers and peasants who were his comrades in these years; taking to heart a mythology that had taken hold both at home and on the front lines, he idealized the common soldier for his courage, for his resourcefulness under difficult circumstances, and for his sense of community.[7] After the war, in the early 1920s, Léger's populism led him to develop a cult of the worker.[8] Meanwhile, contacts with Russian artists and writers—the painters Alexandra Exter, Mikhail Larionov, and Natalie Gontcharova, and other expatriates living in Paris, as well as visitors like Vladimir Mayakovsky, whom he met in 1922—prompted a keen interest in aesthetic, social, and political matters in the Soviet Union.[9] An individualist in his art, Léger would always be concerned in social terms with the collective.

Building on its predecessors, a third of Léger's axioms finally clarifies the social and political aspirations at the heart of his appropriation of the machine. As Léger understood it, the ascendance of the machine was accomplished in the aftermath of World War I. That conflict

3. Fernand Léger. *L'Homme au chien* (Man with dog), 1921. Oil on canvas, 25⁹⁄₁₆ x 36¼" (65 x 92 cm). Private collection

had fundamentally reoriented the European experience of modernity toward a recognition of the essential power of technology. Postwar European society, Léger further observed, had assimilated the wartime revision of values in terms of spiraling industrial expansion, commercial competitiveness, and the proliferation of technologically based entertainments. The struggle, in other words, had moved from the military battlefield to an entirely different arena: the streets of the big city. "After four years of this paroxysm," Léger stressed, "modern man finds himself on a social plane that is not peace; he finds himself on another plateau where economic war leaves him no room to breathe. It is another state of war as lamentable as the first."[10]

It was from this principle, finally, that Léger defined the utility of modern art. "There is a need for beauty scattered around the world," he wrote. "It is a question of quantity and demand. It is a matter of satisfying it. Now I realize that we [artists] are still *very useful* 'as producers.'"[11] The modern painter was to be understood as a kind of producer, which, in Léger's terms, meant one who confronts the tumult of modern life, uses it as raw material, and makes and displays works of art that not only respond in some profound way to the contemporary but also contribute meaningfully to the creation, construction, and organization of a new age. In reiterating this idea in essays for small modernist publications and sending his paintings to exhibitions across Europe, Léger emerged soon after the war as a leading French interpreter of a developing international Constructivist aesthetic. The implications of this stance were made manifest in March of 1922, when he was featured prominently in the inaugural issue of a Berlin art magazine called *Veshch/Gegenstand/Objet*, a short-lived journal founded by the Russian painter and designer El Lissitzky and the writer Ilya Ehrenburg to help promote links between intellectuals and artists in the Soviet Union and their colleagues across Europe. Its title was a compound of the Russian, German, and French forms of a single noun: Object. In aesthetic terms, that noun connoted an attitude of objectivity, clarity, economy, and order, and underscored the editors' allegiance to a technologically inspired modernism. Politically, the magazine linked the Constructivist aesthetic to a spirit of internationalism and proposed it as the basis for a reconstruction of European culture.[12]

The first issue of *Veshch* contained a series of statements by Western painters and sculptors on the state of contemporary art. The survey began with a short essay by Léger in which the painter recounted his discovery of the aesthetic of the object.[13] This statement was accompanied by a reproduction of *La Ville* (The city, 1919; p. 181), one of his most important compositions of the period. The elements of a cityscape are distributed across the picture surface as identifiable fragments: stenciled letters peel off advertising billboards in the center; a balcony railing suggests a building facade; pieces of metal girder stand for construction machinery, scaffolding, electrical pylons. The few human figures who walk down a stairway at the center of the lower zone are armored semiautomatons, while advertising panels above contain larger, brightly colored human representations, pictures within the picture. No element of this city is seen as a discrete whole. We perceive them all as parts, which are interrelated through

strong formal rhythms: contrasts of colors, similarities of shape, geometrical continuities. An abstract visual synthesis translates the dynamism of the modern city.

Despite his deserved reputation as an esthete of technology, Léger was by no means an unthinking proponent of mechanization. On the contrary, his left-leaning politics rested upon a critique of the effects of contemporary capitalism, and he feared that the industrialization of both work and leisure might finally fly out of control, with disastrous effects for European city-dwellers. As Léger understood it, solutions to the dilemma were suggested by examples of visual organization, whether fortuitous or planned, within the grandiose urban spectacle. The street itself provided useful models. Most notable in this regard is Léger's contemplation of the display of commodities in the sidewalk shop window: "Industry and commerce, swept along in a frantic competitive race, have been the first to grab everything that could serve as an attraction. They admirably sense that a shop window, a department store must be a spectacle. They had the idea of creating a pervasive, persuasive atmosphere by using only the objects at their disposal. . . . It's a spell, a fascination, knowingly manipulated."[14] Léger admired the window dresser's craft and purpose: the maximum realization of the humble commodity's visual power within a well-organized display. The painter's attitude toward the modern means of production was thus manifestly redemptive in character and intent, for he believed that the solutions to the problems inherent in industrialization were prefigured within aspects of the productive sphere. Yet if, for Léger, a more careful control of the spectacle of industry emerged as a social necessity, he also knew that a general regulation of the spectacle of modernity was unlikely to be worked out in the wider economic arena anytime soon, and he therefore conceived of a response within the domain of art. In *Composition à la main et aux chapeaux* (Composition with hand and hats, 1927; p. 213), the artist transposes mass-produced things out of the contexts of their utility, abstracts their appearance, and redeploys them in a harmonious and self-contained painted composition. In art, if not yet in life, machines and other articles of mass production would make the passage from quantity to quality, from overload to composure.

The appropriation of the machine marked the moment of Léger's ultimate self-realization as an artist. The mechanical element, he declared in his 1923 essay "Notes on the Mechanical Element," was only a means, not an end, but the appropriation of the machine led him to consider other questions that, by virtue of their collective nature, transcended the boundaries of the easel-painting medium as he had defined them. First, Léger considered the relation of modern painting to other modern means of visual representation, especially the arts of mechanical reproducibility and the technologies of mass culture. Second, he reflected upon mural painting.

Léger's response to the mass media was tempered by an emphatic sense of cultural hierarchy. Film, color photography, and popular theater and literature he regarded as extremely influential vehicles for group entertainment and instruction, for the transmission of what he called narrative, sentimental, and representational subjects to a broad public. This was an

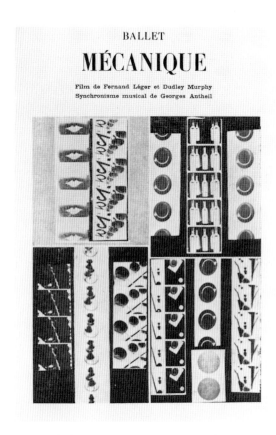

BALLET

MÉCANIQUE

Film de Fernand Léger et Dudley Murphy
Synchronisme musical de Georges Antheil

4. Fernand Léger and Dudley Murphy. *Ballet mécanique*
(Mechanical ballet), 1924. Stills from black and white film in
35 mm., 12 minutes. Shown here as published in Léger, "*Ballet
Mécanique*" (July 1924), *L'Esprit Nouveau* (Paris) no. 28 (January
1925): 2,336. The Museum of Modern Art Library, New York

advantage for painters: so great was the power of these new mediums that they effectively absolved painting from those responsibilities, leaving it free to develop other dimensions of the visual. The mechanization of visual culture, Léger argued, had triggered an epochal shift in the historical development of art and now validated, indeed mandated, the advancement of abstract painting.[15]

All this notwithstanding, Léger was eager to mine the visual forms of mass culture for raw materials, to seek out examples of mechanical beauty in its brute state, and thereby to establish an exchange between painting and the mechanical arts. He found a point of contact in the photographic and cinematic close-up, where the illustrative value of the image gives way to intensified formal expressiveness. "The cinema of the future," Léger wrote in 1923, lay in the "*personification of the enlarged detail*, the individualization of the fragment, where the drama begins, is set, and stirs. The cinema competes with life in this way. . . . The object by itself is capable of becoming something absolute, moving, and dramatic."[16] In Léger's own work, these reflections were not limited in their application to his famous collaboration with the filmmaker Dudley Murphy, which resulted in the production of the short modernist film *Ballet mécanique* (Mechanical ballet) of 1924 (fig. 4). They also informed both Léger's painting and his views on art. Using the same reasoning that he applied in his analysis of the shop-window display, Léger sought and found in the cinema an important example of the theory of expression that informed all of his work during the 1920s. Focusing on fragments of human figures or objects, magnifying them, and loosening visual conventions through drastic shifts in scale and disruptions of spatial continuity, film—like painting—led the viewer to discover the beauty underlying the mundane, or what he called the "new realism."[17]

In discussions of art's communal function, Léger turned repeatedly to the examples of mural painting and architectural polychromy. Here his deployment of color and form proceeded according to a logic exactly the inverse of the one that he applied to easel painting. Whereas the abstract canvas generated its power from a structure of total visual containment within its frame, the mural painting depended upon its function within the environment. "*Ornamental art*," Léger explained, is "dependent on architecture, its value rigorously relative (fresco tradition), accommodating itself to the necessities of place, respecting live surfaces and acting only to destroy dead surfaces. ([It is] a materialization in abstract, flat, colored surfaces, with the volumes supplied by the architectural and sculptural masses)."[18] In the early 1920s, Léger developed these ideas in discussions with modernist architects, especially his close associate Le Corbusier, and began placing his own works within architectural and decorative-arts exhibition structures.[19] One such example was the installation of a nonrepresentational composition of 1924–25 in an architectural project realized by Robert Mallet-Stevens for the 1925 *Exposition Internationale des Arts Décoratifs et Industriels Modernes*, the entryway of a model French embassy. Perfectly flat but dynamic in their asymmetrical interlock, the colored planes of this composition find a clear rapport with the stripped-down surfaces and volumes of Mallet-

5. Robert Mallet-Stevens. Entrance hall for a French embassy, *Exposition Internationale des Arts Décoratifs et Industriels Modernes*, Paris, 1925, featuring *Peinture murale* (Mural painting), 1924–25, by Fernand Léger. Photograph from *L'Amour de l'art* (Paris) 6 no. 8 (August 1925): 291. The Museum of Modern Art Library, New York

Stevens's interior, while at the same time inflecting and concentrating its geometry with chromatic energy (fig. 5).[20]

Beyond the question of the decoration of particular architectural spaces, Léger regarded collaboration with architects as the most promising ground for his intervention in the social world. In purely speculative terms, this reflection closed the circle that began with his amazed response to the modern urban spectacle. Questions of architectural polychromy led Léger to a vision of the total orchestration of the metropolitan site: "Let's take a street; ten red houses, six yellow houses. Let's exploit beautiful materials—stone, marble, brick, steel, gold, silver, bronze; let's avoid dynamism completely. A static concept must be the rule; all the commercial and industrial necessities will be developed, instead of being sacrificed—a constant anxiety in society. Color and light have a social function, an essential function."[21] The painter, Léger asserted, is the architect of that social function.

This discussion of the axioms and reflections exhibited in Léger's work and thought of the 1920s and beyond needs finally to be understood in terms of a series of oppositions that has the machine-object at its center: the real and the ideal, the useful and the beautiful, the individual and the collective. Léger neither conceived of these oppositions, nor presented them in his work, as conflictual. He aspired, in fact, to maintain them in a state of tension, or, better, in a calculated state of balance that eschewed the temptation of extremes and the resolution of synthesis.

In the works that closed the decade of the 1920s, Léger used this tension to revise the form and composition of his easel painting. *Clés et danseuses* (Keys and dancers, 1930; fig. 6) exemplifies this shift in approach. Figures, objects, and abstract shapes float through a shallow void, as if released from the dense geometrical settings of earlier years: two female dancers, a cluster of ordinary house keys, ribbon shapes and lines, a curved and corrugated plane. The

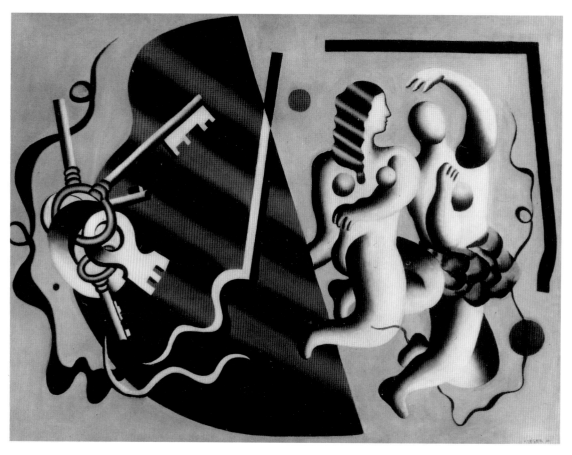

6. Fernand Léger. *Clés et danseuses* (Keys and dancers), 1930. Oil on canvas, 38³⁄₁₆ x 51³⁄₁₆″ (97 x 130 cm). Private collection

rectangular picture field is divided more or less vertically into two, with all compositional relationships rhyming across the breach. Splayed out in space on the left side, the prosaic bunch of keys establishes expressive parity with the dancing figures on the right. This strategy of opposition through apposition generates no significant narrative, and indeed is designed to preclude it. The assembling of the radically heterogeneous reaches a point of culmination in *La Joconde aux clés* (Mona Lisa with keys, 1930; p. 223), where another cluster of keys is mingled with a bright-red can of sardines, abstract shapes, and a fractured grid against an amorphous background. The most surprising element in this picture, of course, is the eerily tinted replica of the figure from Leonardo's portrait of Mona Lisa.[22] In opposing and equating the old master portrait—or, rather, the hand-painted citation of a postcard reproduction of the Louvre's best-known work—and the outsized keys, a repeated icon of Léger's painting of this period, the artist intended a historical provocation. Indeed he sought above all else to subvert naturalism, which he saw as the restraint that subject matter had traditionally imposed upon composition. It was this subversion that he had promoted, from the beginning, as the hallmark of modernism in painting.

Deus ex Machina

The advent of the mechanical in the present century is certainly a major event. An unbridled, all-embracing romanticism has taken us over. We have "deified" the machine, motors. . . .
—Léger, "'Deus ex Machina,'" 1930

The Parisian art world of 1930, in the view of Léger and of many of his colleagues and observers, was a community in crisis. The Wall Street Crash of October 1929 had sparked a slump in the economies of both the United States and Europe. It had also shaken not only the international art market but the foundations of the main aesthetic discourses of French modernism. If French artists, critics, and other interested parties adopted a vocabulary of uncertainty and malaise in and around 1930, it was because the crisis had forced them to confront fundamental and ongoing questions regarding the basic values of modern art—economic, social, and aesthetic.[23] Accordingly, in a 1930 essay with the punning and ironic title "'Deus ex Machina,'" Léger reassessed the modernist machine style and announced a redirection in his aesthetic of objects. Looking back over more than a decade of machinist painting, Léger concluded that artists, swept away by their enthusiasm for the machine, had failed to exert the precision, clarity, and equilibrium necessary to art. Too often, overwhelmed by the machine's novelty, they had fallen into an artistically sterile mechanolatry. And Léger did not exempt himself from this analysis.

"I believe," wrote Léger, "that we've reached the upper limit here. It will end; we'll become interested in other things. There are microbes, fish, submarines, astronomy, etc. . . . When I think that there are not two similar ears in the world. . . ."[24] In evoking the theatrical convention of the deus ex machina in its title, Léger's 1930 essay suggested that a disengagement from industrial subjects might point the way to a solution to the current crisis. The painter had already refocused his eye on the natural world, taking up seashells, leaves of holly, and roses, for example, as subject matter. *Grandes Queues de comètes*, painted on a folding screen in 1930, presents astronomical bodies in the night sky (fig. 1).

Unlike the sudden and definitive resolution that accompanies the deus ex machina, however, the shift marked by these compositions of the 1930s was evolutionary and provisional. In deploying objects in neutral tones against an absolutely continuous red-orange background, *Les Troncs d'arbres* (Tree trunks, 1931; p. 220) and other works recall the general structure of Léger's compositions from the early 1920s. The contours of the object have softened, the interlock of forms has relaxed, and the object's depiction has become more elaborate, but the artist's characteristic response to the visual power of the mundane remains intact. In Léger's system, organic forms are no less liable than mechanical and industrial ones to an overtly abstract and antinaturalist system of visual composition.

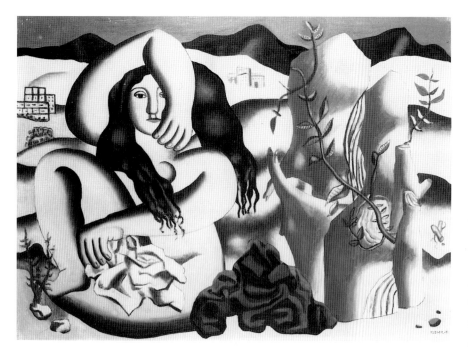

7. Fernand Léger. *La Baigneuse* (The bather), 1931. Oil on canvas, 38³/₁₆ x 51³/₁₆″ (97 x 130 cm). Private collection

When the human figure appears in works of this period, in the 1930 *Clés et danseuses* (fig. 6), for example, or in *La Baigneuse* (The bather, 1931; fig. 7), it is usually articulated in relation to abstract forms, simple implements, or organic objects. Almost invariably female, these bodies are presented in idealized nudity as dancers, bathers, or simply the eternalized nude of art. A trio of women, Léger's version of the three graces, occupies the left half of the *Composition aux trois figures* (Composition with three figures, 1932; p. 228). The chalky-white bodies leave an impression of rigidity and heaviness, and the far-off glances convey extreme emotional reserve; yet these effects are countered by the expressive bending and arching of the arms. Accompanying objects—the ornamental bouquet held by one of the women, the section of rope that undulates in space around the rectilinear section of fence, the fence itself, the bright blue cipher of sky that runs down the center of the picture—mimic those gestures, intensifying their abstract rhythm.

Léger's treatment of the female nude and his method of representing gender have fundamental implications for the meaning of his modernism. In the years immediately following the war, he had depicted a world divided into distinct spheres of human activity: work and commerce in a city inhabited by the mechanic or the pedestrian; men at leisure in the suburban landscape; and interiors occupied either by odalisques or by mothers with their children. This separation of spheres of activity had been accentuated by a separation of the sexes, as Léger linked men with labor and outdoor pursuits, women with the interior and the home.[25] But in the pictures of the end of the 1920s, identifiable environments are replaced by an abstract and amorphous pictorial space, eliminating the social signification of setting. These canvases concentrate on the body as a discrete object, treating it with Léger's customarily high degree of stylization—deeroticizing it, abstracting it through binary oppositions with inanimate things, and isolating it against bright backgrounds of ungraded color.

This approach to the female nude registered, in one respect, as another facet of Léger's ongoing assault on artistic tradition. He adopted a subject that was at the foundation of Renaissance and academic art training and practice, but then turned decidedly away from these precedents in treating it as a device in an abstract form-making exercise. In the final analysis, however, compositions like *Clés et danseuses* and *La Baigneuse* need also to be understood as part of a long artistic tradition in terms of their treatment of gender. Around 1930 Léger conceived of the female nude, like the simple implements (the bunch of house keys) and

fragments of nature (the tree trunk) with which he most often contrasted it, as abstract visual form. The possibility of this approach in turn depended on a very old aesthetic legacy—inherited from antique and medieval philosophy, and developed in its modern form in the nineteenth century—that saw creative perception and artmaking as the union of two opposing principles: on the one hand, matter and sensation, which are coded as feminine, and on the other, mind and the capacity for handling pure form, which are understood as masculine.[26] In Léger's art, the abstract female nude becomes the epitome of form shaped by the artist's intelligence and eye, the substance of a higher abstraction; his use of the nude underscores the dependence of modernist notions of form and creativity upon old hierarchies of sexual difference. Thus when Léger returned to the depiction of the male form in *Adam et Ève* (Adam and Eve, 1935–39; p. 229), presenting the originary couple as a pair of gymnasts, he stressed that difference by placing a clothed Adam beside his nude Eve.

With *Adam et Ève* and other compositions from the beginning of the new decade, Léger also established himself as one of a number of Paris-based painters who promoted, as the path toward the renewal of abstract art, the blending of biological, "primitivizing," and archaizing form with geometrical construction.[27] For Léger this new tendency functioned as the basis of a continuing artistic alliance with Le Corbusier. Accompanied by Charlotte Perriand, an associate of the architect, the two men combed the beaches of the Atlantic Coast for natural, processed, or mechanical forms—stones, fish bones, industrial detritus—that had been reshaped and purified by the action of nature. These found artifacts prompted them to reflect on "the great events of nature, the true laws, variety, unlimited invention, possessing powers of extraordinary plasticity, revealing the specific qualities of matter."[28]

Léger noted in 1934, "*I picked out* personally, from among discarded scraps, the object that serves as armature for my present work."[29] This pursuit resulted in the group of ink-and-gouache drawings, from 1933–34, that were exhibited in 1934 in the Paris gallery show *Objets par Fernand Léger*.[30] Most of these works depict natural rather than synthetic objects, organic or rustic rather than manufactured things. They derive their expressive effects from a dense linear surface, vibrantly colored backgrounds, and a monumentalization of scale that emerges as the object's dimensions compete with those of the page itself. Fragments of apple-tree roots and sides of butchered beef suggest a preindustrial and rural way of life. *Silex blanc sur fond jaune* (White flint on yellow background, 1932; p. 217), a study of a flint, evokes the prehistory of technology. The tools of labor, always a concern for Léger, are here in effect nature's elemental raw materials.

In these pictures, faith in the earth modulates the cult of the machine. Léger's writings of the period are similarly suffused with an idealization of the landscape and a call for a new harmony between nature and industry. In one essay of 1933, Léger reminded modern Europeans, his "proud" contemporaries, that "if the factory that manufactures beautiful and shiny knives is beautiful too, if its metal is fascinating, the knife that comes out of it 'is made' *for*

peeling potatoes. The great thrust of science has caused us to forget the natural extent of earthy values." Resting his argument on the pre-Romantic authority of Jean-Jacques Rousseau's "humanitarian *idyllism*," and reminding his readers that money is fragile and does not create happiness, Léger made explicit the anticapitalist current that runs through this and other essays of this period.[31] In comments for the catalogue to an exhibition of works by Elisabeth Blair, one of his American students, at New York's John Becker Gallery in March 1933, he connected this stance to techniques of painting:

Separating the object from the subject, isolating it, giving it plastic evaluation by opposing it to contrasting forms, that is the new and precise picture which must be achieved. The essential is the object. Error consists in forgetting that grain, cotton, wool are vital objects and in being interested in them only because of their value in gold, their speculative value. The economic purpose is not "to make millionaires out of gasoline" but to distribute gasoline according to demand and need. Wall Street is an abstraction.

The text continues by contrasting the quantifying and destructive mental habits of the financier with the painter's qualitative glance: "Observation of the object changes the rhythm of the picture and also of life, which goes too fast. Slowing up is necessary. . . . 1933=Time is no longer money."[32]

The intellectual and programmatic context for these reflections was established by Léger's alignment, around 1931, with a small group of antiestablishment political thinkers and social critics and a Paris periodical called *Plans*. The *Plans* group studied the impact of mechanization upon the key domains of human activity and production: economics, technical and scientific knowledge, urbanization, and social relations. Accepting the impact of the machine as fundamental, but rejecting capitalist solutions to the deployment of the means of production, they proposed a corporatist and regionalist reorganization of those functions as the basis for the construction of a new European order. Le Corbusier, a founding member of the group, used *Plans* to promote his comprehensive urban schemes as the architectural dimension of this effort.[33]

Léger associated himself closely with Le Corbusier's project. In an important lecture at an architectural conference held on a sea crossing to Athens in mid-1933, Léger stressed, as he had in the 1920s, the necessity of the painter's collaboration in the constructive and social practice of architecture.[34] And after returning from Athens he often spoke of ancient Greek art and society as the sources of a "sentiment of objectivity" that might serve as the spiritual model for the renewal of France following the crisis of the early 1930s: "The relationship between the true and the beautiful is constant and [they are] closely linked to one another. The ancient Greeks were already conscious of this balance. . . . Let us conceive of a society illuminated at its interior by honesty, frankness, an ultramodern code that would punish falsehood with death, that would banish forever money and banks, these intermediaries that have done so much harm. . . . "[35]

In fact Léger would soon have the opportunity to develop the ideas he expounded in his

lecture to the architects. While he did not realize large-scale murals during this period, he periodically worked on the decoration of architectural surfaces and spaces, usually in direct connection with Le Corbusier. In April 1934, Léger and Le Corbusier traveled to Burgundy to visit the house in Vézelay of a mutual friend, the architect Jean Badovici, where Léger planned a wall painting in the courtyard. Returning in June of 1936 to execute the mural with the assistance of a local artisan-painter, Léger covered his wall, a squarish surface with a top edge that stepped down from right to left, with a series of brightly colored ribbon-forms, angled shapes, and flat planes (fig. 8). The design functioned to puncture the wall plane and thereby destroy its blank uniformity; instead of decorating the wall, Léger intended to use color to animate the space of the courtyard. He later commented, "The courtyard at the back [of the house] was enclosed by a wall on which the sun never shone. . . . By applying pure colors in dynamic opposition, sometimes with the aid of modeling, sometimes by a purely flat application, I found that I had given it a true dynamic value. . . . The wall had become mobile, luminous. . . . It had brought joy."[36]

Léger also participated in the creation of murals for architectural interiors designed by members of the Union des Artistes Modernes (UAM), an association devoted to the

8. Stages in the preparation of Fernand Léger's outdoor mural at the home of Jean Badovici, Vézelay, France, 1934–36. Photographs published in Badovici, "*Peinture murale ou peinture spatiale,*" *L'Architecture d'Aujourd'hui* (Boulogne-sur-Seine) 8 no. 3 (March 1937): 77

promotion of French modernist architecture and design.[37] A project for the 1935 *Exposition Universelle et Internationale* in Brussels involved the outfitting of spaces for a prototypical "young man's home" that included among its rooms a private gymnasium designed by René Herbst and a study that Charlotte Perriand furnished with objects realized in the course of her work with Le Corbusier. Works by Léger appeared in both rooms. One of his recent composi-

9. Charlotte Perriand. Study in "young man's home," French section, *Exposition Universelle et Internationale*, Brussels, 1935, featuring a composition with aloes, c. 1934–35, by Fernand Léger. Photograph published in *L'Architecture d'Aujourd'hui* (Boulogne-sur-Seine) 5 no. 1. (October 1935): 61

10. René Herbst. Gym in "young man's home," French section, *Exposition Universelle et Internationale*, Brussels, 1935, featuring *La Salle de culture physique* (Exercise room, 1935), by Fernand Léger. Photograph published in *L'Architecture d'Aujourd'hui* (Boulogne-sur-Seine) 5 no. 1. (October 1935): 60

11. Fernand Léger. *La Salle de culture physique* (Exercise room), 1935. Oil on canvas, 7' 8½" x 13' (235 x 396 cm). Private collection, Tokyo

tions, on the theme of the aloe plant, was displayed in the study alongside a number of natural objects arranged on shallow wall-mounted ledges (fig. 9). Together with those found forms, Léger's easel painting demonstrated the applicability of the natural and poetic object to the visual animation of an interior.[38] The painter also contributed a large panel, *La Salle de culture physique* (Exercise room, 1935; figs. 10 and 11), for the apartment's gym. This work was designed to establish a visual dialogue with the room's equipment and the activities to be performed there. Four arms reach up for a ball; an exercise rope is coiled around the posts of a set of climbing bars; three humanoids line up like gymnasts at the lower right; a dumbbell floats in midair overhead. Léger applies his customary compositional strategies—contrasts of form, relations of shape, drastic shifts in scale, the interplay of monochrome objects and bright backgrounds—in placing generic athlete-figures and sports paraphernalia against a shocking yellow background and a deep-blue sky form.

Léger described this decoration as an exercise in "visual popularization." His sense of that concept, as it applied to this particular project, can be understood through his comments in a letter to a friend that contained, as an enclosure, a postcard reproduction of one of the panels' preparatory studies. The reproduction struck him as being "pretty and popular like a view of Marseilles—very 'Côte d'Azur' postcard!" He went on to remark, "I like this; it's an absolutely successful vulgarity."[39] Léger had in mind the literal meaning of the vulgar: that which is ordinary rather than rarefied, that which is shared by all, that which is expressed in a common vocabulary. This project, like the Vézelay mural, provides a tangible example of Léger's interest in architectural collaboration for the advancement of progressive ends. Inescapably, however, as a work designed for a virtual private residence, it could realize his collectivist social ideal only incompletely. The painter would confront this issue again soon.

A 1935 exhibition marked the continuation of Léger's fruitful collaboration with Le Corbusier. *Les Arts dits primitifs dans la maison d'aujourd'hui*, presented by the publisher and art dealer Louis Carré in Le Corbusier's private apartment and studio on the outskirts of Paris, involved the installation of a selection of historical and modern objects: a fifteenth-century Benin bronze, a pre-Columbian pot, modernist sculptures by Henri Laurens and Jacques Lipchitz, and easel paintings by Pablo Picasso, Georges Braque, and Le Corbusier. There were also

two works by Léger: an easel painting whose title we do not know, and a tapestry that, with the exception of the addition of a decorative border and the reversal of the image, duplicated the *Composition aux trois figures* of 1932 (p. 228).[40] The show's chief attraction was a polychrome cast of the Moscophoros (Calf-Bearer), an Archaic votive sculpture from the museum at the Acropolis in Athens (figs. 12 and 13).

The organizer of several exhibitions of African, Oceanic, and pre-Columbian objects during this period, Carré was interested in presenting works of art as emblems of metastylistic trends that cut across time and geographical boundaries. He explained:

Art is a perpetual rebeginning. The Greeks had their primitives, their classical period, their Baroque; we do too, and we are now entering into a new archaic *Pléiade*. The cycle begins again. But the canons of beauty do not change and we find them again, young and strong, in these sixth-century works, just as they were in the purest forms of Negro art.[41]

This narrative of historical return, with its emphasis on the archaic and the "primitive" as opposed to the academic, corresponded to views long held by Léger, as well as by Le Corbusier.[42] The same ideas were to motivate Carré's 1935 show.

The Calf-Bearer, polychromed by Le Corbusier himself, became the bearer of the vitalist aesthetic that he shared with Léger.[43] The placement of the piece in close proximity to Léger's tapestry can only be understood as purposeful. Given the architect's and the painter's mutual interest in the use of painting and sculpture to animate spaces, neither could have failed to appreciate and underscore the visual interplay of the statue's blue and red tones with the tapestry's continuous yellow background; indeed Le Corbusier specifically discussed their juxtapo-

12. *Les Arts dits primitifs dans la maison d'aujourd'hui*, exhibition organized by Louis Carré in the home of Le Corbusier, Paris, 1935. Installation view. Cast of the Moscophoros (Calf-Bearer), an Archaic sculpture of c. 560 B.C., with a tapestry after Léger's *Composition aux trois figures* of 1932 (1935, point d'Aubusson–stitched silk and wool, 90⅝ x 108½″ [230.1 x 275.5 cm]). Photograph published in *L'Architecture d'Aujourd'hui* (Boulogne-sur-Seine) 5 no. 7 (July 1935): 85

13. *Les Arts dits primitifs dans la maison d'aujourd'hui*. Installation view. Cast of the Moscophoros, the Léger tapestry, a bronze from Benin, a sculpture by Henri Laurens, and the Le Corbusier painting *La Pêcheuse d'huîtres* (Female oyster-fisher, 1935). Photograph published in *L'Architecture d'Aujourd'hui* (Boulogne-sur-Seine) 5 no. 7 (July 1935): 85

sition in an article published a decade later.[44] The Calf-Bearer and the figures in the tapestry established a dialogue on the basis of their shared stasis, frontality, and fixity of gaze. The tapestry after Léger's *Composition aux trois figures* thus demanded to be read in a specific cultural frame, the one to which the painter had looked with unabashed optimism in his writing on the lessons of ancient Greece. This installation enacted Léger's ideal of aesthetic objectivity a half-decade after the crisis of 1930.

Modern Art and Collective Aesthetics: Léger and the Front Populaire

This July 14, 1935, will mark a date in the social and national rectification of France. . . . We are coming out of a gray and confused time. In full awareness of its historical importance, I welcome this event and pledge my enthusiastic participation.

—Léger, *"Nous sommes dans la lumière,"* 1935

With this declaration, one of a series published by prominent French intellectuals in the periodical *Monde* on July 14, 1935, Léger celebrated the birth of the Front Populaire, a coalition formed by center and leftist parties and organized labor around a common political goal: the defense of the French republic against the threat of fascism in Europe. The painter hoped that artists would assume an active cultural role in this new pacifist and populist union. On the day of the French national holiday in 1935, when the Front Populaire was publicly consecrated in an enormous Paris rally, Léger announced his "enthusiastic participation" in the cause.[45]

Léger's political mobilization had been prepared over the course of the preceding year by his membership in a Communist-led confederation of writers and artists, the Association des Écrivains et Artistes Révolutionnaires (AEAR). Since early 1932, the AEAR had endeavored to build a united front of workers and progressive French intellectuals. Léger's involvement with the organization began with the first annual AEAR painting salon, of January–February 1934. In the manifesto announcing the exhibition, the organizing committee proposed that as Europe became polarized between the regressive forces of fascism and the revolutionary response of the left, artists would have to rethink their traditional isolation and announce their engagement in the politics of the antifascist and workers' movement.[46] Yet the show that emerged in response to this call—comprising works by painters both well-known and obscure, in a range of naturalist, Expressionist, Surrealist, and Cubist-related and abstract idioms—provided no clear formula for the fundamental revision of values demanded by the committee.

Léger's contribution, the 1930 *La Joconde aux clés* (p. 223), underlined the ambiguities of the AEAR project. By virtue of its inclusion in the exhibition alone, the picture functioned as a token of the painter's adherence to the antifascist cause. But neither this canvas nor those

that Léger would send to the association's subsequent salons could resolve the fundamental question posed by his participation. While his aesthetic of objects had always presumed, at least on the level of theory, a deep congruence between modernist aesthetics and popular sensibility, the precise character and value of that relationship were open to a great deal of debate—a debate that did in fact develop as Léger assumed a leadership role within the AEAR. He would argue his aesthetic position in essays and interviews for the association's publications, and in lectures at its Paris headquarters, the Maison de la Culture;[47] in January 1939 he would be elected to the executive committee of the group's painting and sculpture section.[48] But in the context of the AEAR, the painter's machine aesthetic met with frequent opposition.

When the question "Where is painting headed?" was put to AEAR-affiliated painters by *Commune*, the association's journal, in 1935, most of the respondents agreed that painting was headed toward closer engagement with the needs and interests of the working class. There was little consensus, however, on the specific means to that end. Léger, repeating his often quoted position on the matter, asserted that modern art would connect with collectivist sensibilities on the common ground of an engagement with the modern object, where art meets industry, beauty intersects with utility, and aesthetic needs harmonize with material necessities. "The object is a *social value*," Léger declared. "Cubism imposed the object on the world. It is Cubism that taught commerce and industry to make use of the object." When the interviewer pressed Léger on this point, the painter pointed to the 1935 panel *La Salle de culture physique* (fig. 11), hanging at the time on the studio wall: "Yes, painting takes on a social character in basing itself on the object. Painting becomes accessible to everyone and can be used in schools, in stadiums, in public monuments, etc." Again the interviewer pressed Léger on the "social value" of the object: why not, instead, a more direct and didactic commemoration of the struggles of the day? Insisting on the basic premise of his Cubism, Léger responded that his own art had no room for a realism of description, revolutionary or not.[49]

Léger's position on the politics of abstraction kept him at the center of Front Populaire painting controversies. These culminated in a series of public debates organized by the Maison de la Culture in May and June of 1936, and partially published as *La Querelle du réalisme*. Adopting the doctrine of Socialist Realism, the writer Louis Aragon challenged modern painters to abandon the principle of aesthetic autonomy for a technique of documentary realism and, in support of the historical struggle of the French working class, to depict the great social themes of the day.[50] Aragon would soon attack Léger, one of his favorite targets during this period, for failing to work in this way. How, Aragon demanded, could the aesthetic of the machine, founded as it was in scenarios of capitalist production, exchange, and consumption, serve the interests of the worker? How could Léger not see that in refusing a representational art he was simply representing merchandise, the sublimated product of an alienated social order?[51]

Aragon's objection was echoed by the Marxist critic and philosopher Walter Benjamin, who took up the same topic in an unpublished book review of 1939. Benjamin based his analysis of Léger on a larger critique of the concept of "aura," the quasi-mystical enchantment that, he argued, was the source of easel painting's aesthetic and social power. Unapproachable in its rarity, paradoxical in its suggestion of intimate contact with the individual sensibility of the artist-creator, the easel painting produced modes of aesthetic reception that were essentially passive and individualist, that affirmed the alienated structure of social relations under capitalism, and that therefore ran counter to the political interests and cultural sensibilities of the working class. The dissolution of the aura of the artwork, Benjamin concluded, would occur not in the painting of mechanical beauty but in another sector of visual representation: the mass media.[52] "One must ask," wrote Benjamin, "whether cubism was not a reactionary phenomenon insofar as it composed, or rather analyzed, the object not in accordance with its emergence in the productive process but, as it were, as a self-contained organism."[53] In Benjamin's view, Léger's translation of the mechanical object into the terms of the autonomous easel painting was simply an affirmation of the traditional auratic distinction between the aesthetic domain, on the one hand, and the productive sphere, on the other.

Léger's response to these attacks was emphatic: if the people had no access to modern art, it was the fault of a social order that deprived them of the leisure necessary to the accomplishment of aesthetic cultivation. A representational art of popular subjects, in his estimation, would never do the people justice; nor would such an art solve the fundamental political dilemma. "This is an insult to these men of a new world, who ask nothing better than to understand and to go forward," declared Léger. "It is officially to pronounce them incapable of rising to the level of that new realism which is their age—the age in which they live, in which they work, and which they have fashioned with their own hands. They are told that *le moderne* is not for us; it is for the rich, a specialized art, a bourgeois art, an art that is false from the bottom up." Léger's confidence was based in his belief that social change would lay the groundwork for aesthetic progress in modernist terms. "It *is* possible," he insisted, "for us to create and to realize a new collective social art; we are merely waiting for social evolution to permit it."[54]

Léger saw the Front Populaire government, which lasted from May 1936 to April 1938, as a catalyst for that social evolution. He was energetic in seeking state patronage and enjoyed the support of Georges Huisman, secretary general of Beaux-Arts, and other officials. The state's first purchases of paintings by Léger took place in August 1936, when *La Danse* (The dance, 1929; p. 222) was acquired for the Musée de Grenoble and *Composition aux trois figures* for the Musée National du Luxembourg in Paris. Other purchases followed in 1937 and 1938. The Paris *Exposition Internationale des Arts et Techniques dans la Vie Moderne*, which opened under the auspices of the Front Populaire in May 1937, provided an occasion for visual-arts commissions on a massive scale. Five of the fair's pavilions contained murals by Léger.[55]

Léger regarded these mural projects as opportunities to collaborate with architects, to

engage aesthetically with the crowd, and finally to realize the social potential of modernist art.[56] He also saw these commissions as a chance to try out a variety of approaches and techniques, including abstract decoration, the incorporation of symbolic representation, and, in an experiment that was indicative of both the character and the limits of his thought on modern art's political power, the combination of painting and photography. For the UAM pavilion, an exhibit of the group's architectural and design work, Léger organized the production of a decorative mural, *Accompagnement d'architecture* (Architectural accompaniment), conceived as a collaboration among three painters: himself, Albert Gleizes, and Léopold Survage. The result was a wall-sized band of interconnected shapes against a continuous background. Although collaborative in conception, the composition had an evident tripartite structure; each section revealed clearly the hand of its maker. Léger produced a second mural, *Le Syndicalisme ouvrier* (Trade unionism), for the Hall d'Honneur of the Pavillon de la Solidarité, a structure designed by Robert Mallet-Stevens to commemorate the traditions of French social unity. For this work Léger connected several objects pertinent to the assigned theme of organized labor—hammers, shovels, rope, a medallion inscribed with five human profiles. While most of his colleagues conveyed their designated topics through figural vignettes, Léger worked on the level of the emblem, approximating in his design the symbolic structures of trade union logos.[57]

The metaphorical intention of the mural for the Pavillon de la Solidarité was expanded into the larger allegorical ambition of the third mural painting, *Le Transport des forces* (Power transmission), conceived for the Palais de la découverte, the "palace of discovery"—the fair's museum of science and technology. In this monumental canvas, executed by three of his students in a warehouse in northeast Paris (figs. 14 and 15), a mountainous and verdant environment is intersected by a rainbow and waterfall and framed by the structure of a power installation.[58] Although the landscape is essentially continuous and legible, its component parts are selectively amplified, schematized, and integrated both for-

14. Fernand Léger and his students executing *Le Transport des forces* (Power transmission) for the Palais de la découverte, *Exposition Internationale des Arts et Techniques*, Paris, 1937. Photograph by Thérèse Bonney

15. Fernand Léger. *Le Transport des forces* (Power transmission), 1937. Oil on canvas, 16′ 4⅞″ x 32′ 9¹¹⁄₁₆″ (500 cm x 10 m). Palais de la découverte, Paris

16. Moï Ver (Moses Vorobeichic). Spread from *Paris: 80 Photographies de Moï Ver* (Paris: Éditions Jeanne Walter, 1931), n.p.

mally and conceptually. The massive green-tinted waterfall, which cascades from the very top of the image and seems to generate the rainbow as a kind of spur along its way, serves as the composition's central spine. The brilliant white power station and the elements of metal scaffolding contrast with the fluid and atmospheric forces of nature. Amplifying the ideas introduced in some of Léger's landscapes of the 1920s, the mural depicts the concerted interaction of the natural and the technical. The awesome force of nature, exhibited in the waterfall, and the awesome force of technology, exhibited in the industrial plant, can work together in perfect and exuberant harmony for the betterment of mankind, this allegory suggests. It also makes a parallel statement, inescapable if implicit, about the power and progress of art.

Two further projects for the exposition, because they incorporated photography, enacted a different confrontation between art and industry. Léger had declared his interest in the photographic medium as far back as 1931, in his introduction to *Paris*, a volume of photographs by Moï Ver (Moses Vorobeichic), a young Lithuanian who was attending evening drawing classes at Léger's Académie Moderne. An abstract meditation on life in the streets of the French capital, the book uses intricate effects of superimposition, multiplying perspectives, and the manipulation of framing (fig. 16). In his introduction, Léger applauds what he understands as a subversion of the photograph's value as document, and claims that the medium's historical development is leading it toward the realization of purely plastic works. Like the eye of the painter, the lens of the photographer will fix on the essential abstract beauty of the world. The product of photography, he explains, "must be objective, precise, and gripping in its concision, clarity, and incisiveness. The Beautiful is everywhere around us, it teems, but 'you've got to see it,' isolate it, frame it through the lens." Léger's use of the lexicon of the aesthetic of objects in this text signals his intention to declare a close affinity between the photograph and the painting, and the essay closes, appropriately, with a homage to two of the leading exponents of modernist photography, Lissitzky and László Moholy-Nagy.[59] Some years later, in an essay whose title in English would be "Advent of the Object," Léger would reflect on the photograph's ability to generalize an aesthetic whose reach, in easel painting, was necessarily lim-

ited. The technique of photo-fragments, deployed in the illustrated press, on book jackets, and in the decorative arts, brought the abstract way of seeing to the world of mass information and publicity, commerce, and industry.[60]

Léger came to large-scale photomontage in 1937 through his collaboration with Charlotte Perriand, who had already made use of the technique in didactic displays for architectural interiors.[61] For the Paris exposition of that year, Perriand was called upon to organize two photomural installations and secured Léger's participation in both. One of these projects involved murals for an outdoor annex to the exposition's Centre Rural, a functioning model village that displayed farm products from different regions of France and illustrated the Front Populaire's program of economic, technical, and social modernization within the agricultural sector. Three panels clearly bore Léger's mark, the largest of them depicting a landscape inhabited by numerous figures (fig. 17). The countryside is seen as an environment for recreation and festivity, both contemporary and traditional. The large photographic fragments depict a hunting dog, women in Breton dress, a musician, football players, a figure who may be a fisherman, and two children reading. The image's unifying thread is an abstract painted landscape rendered in bands of bright color; a target shape directs the eye to the center of the composition, where three hands are raised in a triumphal salute, their fists closed around roses. This panel, a great frieze mixing painting and photography, commemorated one of the central platforms of the Front Populaire's social reform policy: the promotion of holidays for the working class. Two smaller murals flanked the entranceway to this outdoor display.

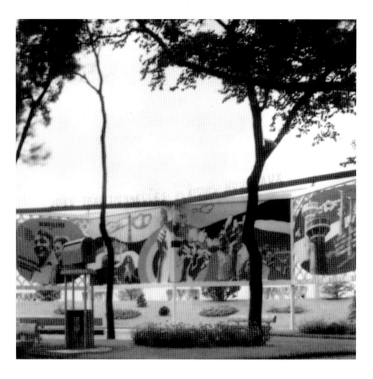

17. The open-air display at the Centre Rural annex, *Exposition Internationale des Arts et Techniques dans la Vie Moderne*, Paris, 1937, showing mural combining painting and photomontage by Fernand Léger and Charlotte Perriand. Installation view. Photograph (detail) by François Kollar, who also took the photographs used by Léger and Perriand in the mural

What did the experiment with the photograph offer Léger? It was a chance to take up a visual technique, montage, the power of which had been demonstrated by the modernist photographers whom Léger admired. It allowed him to work abstractly with photography following the principles he had outlined in the introduction to Moï Ver's book. And the theory of composition that he applied was adapted from his own Cubism: the presentation of highly particularized and autonomous fragments, and the linking of those fragments in formal contrast. Even the juxtaposition of the monochromatic and the brightly colored, predictable given this work's mixture of media, had a precedent in Léger's easel painting, where it was purely a formal option.[62] Finally, and this point is explicit in Léger's reflection on photography and publicity in "Advent of the Object," the photographic mural allowed the artist to popularize his aesthetic of objects. The deployment of the photograph with a graphic composition connoted first and foremost the advertising billboard, and ultimately Léger's mural had less to do with Cubist painting than with the photographic environments of ideological persuasion that were being constructed with increasing frequency at the great public expositions and fairs of the later 1920s and 1930s. As was pointed out by many visitors, the 1937 exposition was awash in large-scale photomontage in the service of politics.[63]

143

Léger had an opportunity to develop the architectural application of the photomural at the same 1937 exposition in the Pavillon des Temps Nouveaux, an exhibition structure built by Le Corbusier on a terrain adjacent to the annex of the Centre Rural. The interior display was organized as a meandering circuit past 1,600 square meters of drawings, diagrams, architectural plans, dioramas, text-and-image billboards, and polychromed photomontage panels relating to the themes of urban history, city renewal, and agrarian reform.[64] Photography was deployed in a state of maximum concentration on one of the second-floor platforms, at a point close to the end of the visit. Here a so-called "conversation room" was designed as a place where the viewer might rest, read, and discuss the pavilion's messages; but the chamber was left empty due to insufficient funds, and its sole contents were wall-to-wall panels representing what Le Corbusier considered the four essential functions or conditions of existence in the modern city: habitation, recreation, transportation, and work.

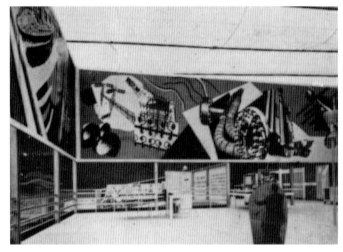

18. Fernand Léger. *Travailler* (Working), 1937. Mural combining painting and photomontage, 13' 1½" x 45' 11³⁄₁₆" (400 cm x 14 m), in the Pavillon des Temps Nouveaux, *Exposition Internationale des Arts et Techniques dans la Vie Moderne*, Paris, 1937. Installation view. Photograph in Le Corbusier, *Des Canons, des munitions? Merci! . . .* (Boulogne-sur-Seine: Éditions de l'Architecture d'Aujourd'hui, 1938), p. 112. The Museum of Modern Art Library, New York

Léger, who reportedly oversaw the production of all four murals, was individually credited with the panel entitled *Travailler* (figs. 2 and 18).[65] Once again he mixed hard-edged and abstract color planes with photographic enlargements: a propeller, a 150,000-volt electrical pylon, a set of high-tension insulators, and other artifacts of industry. Many of these elements were drawn from a photo-essay by François Kollar, *La France travaille* (France at work), which, across more than a thousand images, presented a portrait of the French labor force, albeit with an emphasis on industrial and agrarian workers rather than artisans or members of the liberal professions.[66] In Léger's *Travailler*, calculated discontinuities of shape and spatial orientation ensure that the parts retain their individual character, but the elements, by virtue of their juxtaposition, also approach a kind of unity as components of a larger and entirely imaginary mechanism. A single worker stands at the controls of an industrial motor, framed by its great oval. *Travailler*, one of Léger's many celebrations of labor, derived a polemical dimension from its inclusion as a component in the general decorative program of the Pavillon des Temps Nouveaux, a building that Le Corbusier called a "museum of popular education devoted to urbanism (city and country)." Like virtually every other message conveyed in the building, whether text or image, this mural helped to connect the architect's urban-renewal proposals to the political agenda of the Front Populaire, and to publicize them before a large audience of French citizens.

It is essential to bear in mind that Léger regarded the import of his 1937 photomurals as primarily ideological, and that he also continued to make a sharp distinction between matters of politics and matters of art, between the street and the artist's studio. A declaration of 1939 makes this particularly clear. The Front Populaire political union had by now been broken, its affiliated cultural associations disbanded. In an atmosphere of approaching war, the periodical *Cahiers d'Art* questioned Léger on art and the impending conflict. "We [painters] are too close to a state of purism to intervene directly in social action," wrote the artist in response.

"Weapons alone must answer weapons if we are attacked by barbarous regimes and the struggle leaves no room for the arts." Then, wanting to qualify the statement, Léger quickly shifted gears. "However, during a revolutionary crisis, we might have recourse to the knowledge of the artist. For example, he would be capable of creating close-ups, of putting together photomontages, of enhancing films with additions of dramatic color, etc." He continued far more emphatically, "For those whom we call abstract artists such works are naturally nothing more than an escape route, outside of their true expression, a way to serve to the best of their abilities, and nothing more. In the studio, our hands and spirit should be left free to pursue plastic research, as one leaves scientists to their laboratory work, above the fray."[67]

Thus the paintings that emerged from Léger's studio during the period of the Front Populaire demonstrate the continuity of principles and methods that the painter had developed at the beginning of the 1930s. In *Nature morte aux fruits sur fond bleu* (Still life with fruit on blue ground, 1939; fig. 19), for example, the emphasis is again primarily abstract and biological. Fruits and plants, geometrical shapes and humanoid forms, all extremely schematic in notation, are positioned against continuous backgrounds. *Composition aux deux perroquets* (Composition with two parrots, 1935–39; p. 233)—at more than thirteen feet in width, Léger's most ambitious canvas of the Front Populaire period—sums up much of the artist's work of this decade: four acrobats hold their sinuous poses in equilibrium on the left and at the center of the composition. The opposing structure of wooden posts, sunk into the earth at the lower right, helps to bring the buoyancy of Léger's abstraction down to earth. And the sobriety of the amorphous yellow-brown background is punctuated by bright red, blue, and green tones in the clothing of two figures, in the fabric that drapes over the wooden framework, in the cloud overhead, and in the coloration of the two birds mentioned in the title.

A letter of 1939 helps to define the objectives that led Léger to bring together the main elements of his formal and thematic repertoire in the immense *Composition aux deux perroquets*. In this text the painter reaffirms the notion of new realism or "Cubist realism," restates his commitment to the idea of plastic contrast, and imagines the application of these principles in a future generation of abstract compositions:

We have all achieved a *Reality*, an indoor reality—but there is *perhaps* another one possible, more outdoors. We can knock ourselves out over this but also catch the brass ring. The new thing in this type of big picture is an *intensity ten times greater* than its predecessors. We get this intensity by the application *of contrasts*—of pure tones and groupings of form. . . . that is a solution for the *big* picture.[68]

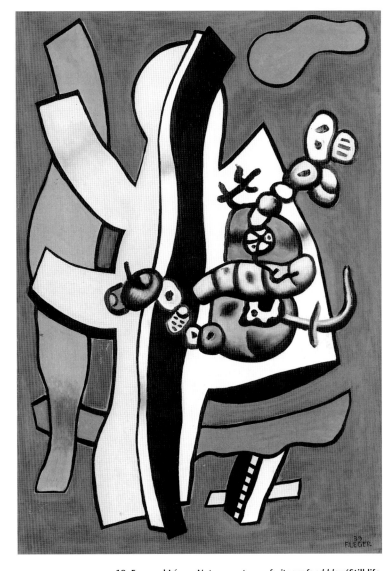

19. Fernand Léger. *Nature morte aux fruits sur fond bleu* (Still life with fruit on blue ground), 1939. Oil on canvas, 51¾₁₆ x 35¾₁₆" (130 x 89 cm). Courtesy Galerie Beyeler, Basel

145

Composition aux deux perroquets, perhaps the prototype for the expanded visual concept that Léger imagined, embodies the tension spelled out in this text. If Léger proposed a move toward an "outdoor reality," his final purpose was the generation of ever more dynamic visual effects, "an intensity ten times greater" than he had previously achieved, but not different in kind from the abstract intensity that he had described in the 1923 "Notes on the Mechanical Element." He planted the wooden structure of the *Composition aux deux perroquets* in the ground, yet the visual structure of the picture remained autonomous. While moved to participation in the Front Populaire by a desire to serve, Léger was nevertheless left, at the end of the experience, with an enduring refusal to give up the independence of the aesthetic.

At the end of the Front Populaire period, Léger reconfirmed the principle of visual contrast as the determining feature of his work. This rule had its expression in the machinist easel paintings of the early 1920s and in the organicist compositions that followed. It found its complement in Léger's mural concept, and was adapted in his experiments combining painting with photography. Léger was willing to be a public person, to make pronouncements, take part in marches, sign manifestos, and participate in committees. But his leftist and partisan sympathies could never displace the axioms and premises that were the foundations of his work. For if, according to the painter's claim of 1914, this work aimed to be "representative, in the modern sense of the word, of the new visual state imposed by the evolution of the new means of production," it did not intend to represent the struggles that accompanied the stages of that evolution. Léger staged, instead, the advent of the object, the object of art. He presented it full-blown and self-sufficient, as an emblem of human fulfillment achieved.

Notes

I thank Kevin Murphy, Sophie Rosenfeld, and Howard Singerman for their suggestions.

1. Fernand Léger, "Contemporary Achievements in Painting," 1914, in *Functions of Painting*, ed. Edward F. Fry, trans. Alexandra Anderson (New York: The Viking Press, 1973), p. 11. With the exception of quotations from this volume and where otherwise noted, all translations in this essay are by the author.

2. Léger, "Notes on the Mechanical Element," 1923, in *Functions of Painting*, p. 28.

3. Léger, "The Machine Aesthetic: Geometric Order and Truth," 1923, in *Functions of Painting*, p. 64.

4. Léger, "The Machine Aesthetic: The Manufactured Object, the Artisan, and the Artist," 1923, in *Functions of Painting*, pp. 52–53, 54.

5. See Léger, "Notes on Contemporary Plastic Life," 1923, in *Functions of Painting*, p. 26; "Correspondance," *Bulletin de l'Effort Moderne* (Paris) no. 4 (April 1924): 11; "The Machine Aesthetic: The Manufactured Object, the Artisan, and the Artist," p. 52; "The Machine Aesthetic: Geometric Order and Truth," pp. 62–63; and "Notations on Plastic Values," in *Fernand Léger*, exh. cat. (New York: Anderson Galleries, 1925), p. 10. On Léger's modernist historicism see Christopher Green,

Léger and the Avant-Garde (New Haven and London: Yale University Press, 1976), pp. 230–33, and Robert L. Herbert, "Léger, the Renaissance, and 'Primitivism,'" in *Hommage à Michel Laclotte. Études sur la peinture du Moyen Age et de la Renaissance* (Paris: Electa/Réunion des musées nationaux, 1994), pp. 642–47.

6. Léger, "The Machine Aesthetic: The Manufactured Object, the Artisan, and the Artist," p. 55.

7. Based on pictures and letters of the period, Green has interpreted Léger's wartime experience in "Out of War: Léger's Painting of the War and the Peace, 1914–1920," in Dorothy Kosinski, ed., *Fernand Léger, 1911–1924: The Rhythm of Modern Life*, exh. cat. (Munich and New York: Prestel, 1994), pp. 45–55.

8. See John Golding, *Fernand Léger: The Mechanic*, exh. cat. (Ottawa: National Gallery of Canada, 1976).

9. Vladimir Mayakovsky's account of his 1922 meeting with Léger is translated in Wiktor Woroszylski, *The Life of Mayakovsky* (New York: The Orion Press, 1970), pp. 337–38. On Léger's politics see Peter de Francia, *Fernand Léger* (New Haven and London: Yale University Press, 1983), and Sarah Wilson, "Fernand Léger, Art and Politics 1935–1955," in *Fernand Léger: The Later Years*, exh. cat. (London: Whitechapel Art Gallery, 1987), pp. 55–75.

10. Léger, "The Spectacle: Light, Color, Moving Image, Object-Spectacle," 1924, in *Functions of Painting*, p. 37. The analogy between commercial competition and military conflict is foregrounded in the artist's wartime letters, which are published in Christian Derouet, ed., *Fernand Léger: Une Correspondance de guerre à Louis Poughon, 1914–1918, Les Cahiers du*

Musée national d'art moderne (Paris), hors-série/archives (1990): 70. See also on this theme Eric Michaud, "Art, War, Competition: The Three Battles of Fernand Léger," in *Fernand Léger, 1911–1924: The Rhythm of Modern Life*, pp. 57–63.

11. Léger, "Notes on Contemporary Plastic Life," p. 25. Translation corrected by the author.

12. See El Lissitzky and Ilya Ehrenburg, "The Blockade of Russia Is Coming to an End," 1922, trans. Stephen Bann in Bann, ed., *The Tradition of Constructivism* (New York: Da Capo Press, 1974), pp. 53–57. See also Manfredo Tafuri, "U.S.S.R.-Berlin, 1922: From Populism to 'Constructivist International,'" *The Sphere and the Labyrinth: Avant-Gardes and Architecture from Piranesi to the 1970s*, trans. Pellegrino d'Acierno and Robert Connolly (Cambridge: The MIT Press, 1987), pp. 119–48.

13. Léger, statement in *Veshch-Gegenstand-Objet* (Berlin) no. 1/2 (March/April 1922): 16 (mispaginated as p. 15).

14. Léger, "The Spectacle," p. 36. This theme was much discussed by advertising professionals as well as by modern artists, who drew many different lessons from the art of window display and the act of looking at shop windows. Léger thought of window dressing as a modern popular art, and, following a familiar avant-gardist theme, as a resource for the renewal of modernist painting. Marcel Duchamp took a different tack in engaging with shop windows and their contents, the commodities that he appropriated as "readymades," in order to imagine a way of undermining certain norms of modernist thinking and practice. Molly Nesbit has compared these two examples in *Atget's Seven Albums* (New Haven and London: Yale University Press, 1992), pp. 198–202. See also Jean-Paul Bouillon, "The Shop Window," in Jean Clair, ed., *The 1920s: Age of Metropolis*, exh. cat. (Montreal: Montreal Museum of Fine Arts, 1991),

pp. 162–81.

15. Léger, "The Origins of Painting and Its Representational Value," 1913, in *Functions of Painting*, pp. 9–10.

16. Léger, "The Machine Aesthetic: Geometric Order and Truth," p. 65.

17. An early statement of this, one of Léger's favorite themes, is "A Critical Essay on the Plastic Quality of Abel Gance's Film *The Wheel*," 1922, in *Functions of Painting*, pp. 20–23.

18. Léger, "The Machine Aesthetic: Geometric Order and Truth," p. 64. Translation modified and corrected by the author.

19. On Léger's architectural collaborations, see Simon Willmoth, "Le Mur, l'architecte, le peintre. Fernand Léger et ses collaborations artistiques, 1925–1955," in Hélène Lassalle with Joëlle Pijaudier, eds., *Fernand Léger* (Milan: Mazzotta, 1990), pp. 45–58.

20. On this composition, see Green, *Léger and the Avant-Garde*, p. 298.

21. Léger, "The Spectacle," p. 46.

22. Léger describes the happenstance that led to his appropriation of Leonardo's portrait in an interview with Dora Vallier, quoted in Claude Laugier and Michèle Richet, eds., *Oeuvres de Fernand Léger (1881–1955)* (Paris: Musée national d'art moderne, 1981), p. 61, n. 7.

23. See Romy Golan's discussion of this important question in *Modernity and Nostalgia: Art and Politics in France between the Wars* (New Haven and London: Yale University Press, 1995). See also Jean Laude, "La Crise de l'humanisme et la fin des utopies. Sur quelques problèmes de la peinture et de la pensée européennes, 1929–1939," in *L'Art face à la crise, 1929–1939* (Saint-Etienne: Centre Interdisciplinaire d'Étude et de Recherches sur l'Expression Contemporaine, 1980), pp. 295–391.

24. Léger, "'Deus ex machina,'" *L'Intransigeant* (Paris), January 27, 1930, p. 5.

25. See Herbert, *Léger's "Le Grand Déjeuner,"* exh. cat. (Minneapolis: Minneapolis Institute of Arts, 1980), especially pp. 26–30.

26. See Lynda Nead, *The Female Nude: Art, Obscenity, and Sexuality* (London: Routledge, 1992), especially pp. 5–33. David Summers analyzes gender as an aspect of the idea of artistic form in "Form and Gen-

der," *New Literary History* (Charlottesville, Va.) 24 no. 2 (Spring 1993): 243–71.

27. Gladys Fabre discusses this trend in Fabre with Ryszard Stanislawski, *Paris 1930: Arte abstracto, arte concreto*, exh. cat. (Valencia: IVAM Centre Julio González, 1990), pp. 379–409.

28. Le Corbusier, "*Lyrisme des objets naturels*," *La Bête noire* (Paris) no. 5 (October 1, 1935): 4. Le Corbusier incorporated these forms into his own abstract easel paintings. Green discusses these works in "The Architect as Artist," in Michael Raeburn and Victoria Wilson, eds., *Le Corbusier: Architect of the Century*, exh. cat. (London: Arts Council of Great Britain, 1987), especially pp. 124–26.

29. Léger, "Avènement de l'objet," *Le Mois* (Paris) no. 41 (June 1934): 221. Charlotte Perriand's analysis of the power of these objects is reprinted in *Charlotte Perriand. Un Art de vivre*, exh. cat. (Paris: Musée des Arts Décoratifs, 1985), p. 31.

30. This exhibition, *Objets par Fernand Léger. Gouaches-dessins 1933–34* (at the Galerie Vignon, Paris, April 16–28, 1934), was partially reconstructed in *Fernand Léger: La Poésie de l'objet, 1928–1934*, an exhibition, with catalogue, at the Cabinet d'art graphique, Musée national d'art moderne, Paris, in 1981.

31. Léger, "Au pays de Jean-Jacques," *L'Intransigeant* (Paris), May 15, 1933, p. 8.

32. Léger, "Introduction," in *12 Paintings by Elisabeth Blair* (New York: John Becker Gallery, March 1–25, 1933), n. p.

33. On *Plans*, see Mary McLeod, "Bibliography: *Plans*," *Oppositions* (New York) no. 19/20 (Winter/Spring 1980): 185–89.

34. Léger, "Discours aux architectes," *Quadrante* (Milan) 11 no. 5 (September 1933): 44, 47. This lecture was delivered at the fourth annual Congrès International d'Architecture Moderne (C.I.A.M.), held in 1933 on board the S.S. *Patris*, sailing from Marseilles to Athens.

35. Léger, "Le Beau et le vrai," *Beauxarts* (Paris), n.s., 73 no. 58 (February 9, 1934): 2. This text is an excerpt from a lecture Léger delivered in February 1934, with the title "De l'Acropole à la Tour Eiffel"; the entire

text is republished in Roger Garaudy, *Pour un réalisme du XXe siècle. Dialogue posthume avec Fernand Léger* (Paris: Éditions Bernard Grasset, 1968), pp. 225–44.

36. Léger, "Revival of Mural Art," trans. Douglas Lord, *The Listener* (London) 18 no. 450 (August 25, 1937): 409.

37. Léger joined this group in November 1934.

38. I have not been able to identify this particular variant of a theme that Léger painted on several occasions in 1934 and 1935.

39. Léger, letters of April 9 and July 18, 1935, in Derouet, ed., *Fernand Léger: Lettres à Simone* (Paris: Éditions d'Art Albert Skira/Musée national d'art moderne, 1987), pp. 138 and 141.

40. The production of this tapestry at the workshops in Aubusson was coordinated by Marie Cuttoli, director of the Galerie Myrbor in Paris, who had worked to promote a revival of the art of tapestry in collaboration with modern artists since the 1920s.

41. Louis Carré, quoted in Pierre Voisin, "Où les sculptures qui datent de 25 siècles apparaissent du plus heureux modernisme," *Paris-Midi*, April 8, 1934.

42. Léger's "primitivism" is analyzed by Herbert in "Léger, the Renaissance, and 'Primitivism.'" Le Corbusier outlined the exhibition's rationale in a statement for its checklist; this text is reprinted in *L'Architecture d'aujourd'hui* (Boulogne-sur-Seine) 5 no. 7 (July 1935): 83.

43. For Le Corbusier's claim to have painted the Moscophoros cast himself, see Jean Petit, *Le Corbusier luimême* (Geneva: Rousseau, 1970), p. 80.

44. For Le Corbusier's comments on the interplay of the statue and the tapestry see his "L'Espace indicible," *L'Architecture d'aujourd'hui* (Boulogne-sur-Seine), November–December 1946, p. 14. See also Luisa Martina Colli, "La Couleur qui cache, la couleur qui signale: L'Ordonnance et la crainte dans la poétique corbuséenne des couleurs," in *Le Corbusier et la couleur* (Paris: Fondation Le Corbusier, 1992), pp. 20–34.

45. Léger, "Nous sommes dans la lumière," *Monde* (Paris) 8 no. 344 (14 July 1935): 7. This short statement is

one of a series of declarations by scientists, writers, and artists in celebration of the Front Populaire. Pascal Ory has analyzed the cultural politics of this movement in *La Belle Illusion. Culture et politique sous le signe du Front Populaire, 1935–1938* (Paris: Plon, 1994).

46. "L'Exposition de l'A.E.A.R.," *Monde* (Paris) 7 no. 293 (February 10, 1934): 8.

47. A lecture given by Léger at the Maison de la Culture was later published as "Peinture 1937—couleur dans le monde" in the bulletin of the group's painting and sculpture section, *Peintres et sculpteurs de la Maison de la Culture* (Paris) no. 5 (May 1938): 42–45. An expanded version of this text was subsequently published as "Sur la peinture" in *L'Exposition 1937 et les artistes à Paris* (Paris: Éditions Arts Sciences Lettres, 1937), pp. xx–xxix.

48. This election is reported in *Peintres et sculpteurs de la Maison de la Culture* (Paris) no. 10 (January–February 1939): 106.

49. Léger, interviewed in "Où va la peinture?," *Commune* (Paris) no. 21 (May 1935): 944–46.

50. Louis Aragon, in *La Querelle du réalisme* (Paris: Éditions Sociales Internationales, 1936, reprint ed. Paris: Éditions Cercle d'Art, 1987), pp. 85–97. This intervention by Aragon was translated into English by J.J.S. (James Johnson Sweeney) in *Transition* (New York) no. 25 (Fall 1936): 93–103. On the development of the realism debate within the painting section of the Maison de la Culture, see Wilson, "'La Beauté révolutionnaire'? Réalisme Socialiste and French Painting 1935–1954," *Oxford Art Journal* (Oxford) 3 no. 2 (October 1980): 61–69.

51. Aragon, "Le Réalisme à l'ordre du jour," *Commune* (Paris) no. 37 (September 1936): 30.

52. See Walter Benjamin, "The Author as Producer," 1934, in *Reflections*, ed. Peter Demetz, trans. Edmund Jephcott (New York: Harcourt Brace Jovanovich, 1978), pp. 220–38, and "The Work of Art in the Age of Mechanical Reproduction," 1936, in *Illuminations*, ed. Hannah Arendt, trans. Harry Zohn (New York: Schocken Books, 1969), pp. 217–51.

53. Benjamin, corrections to the manuscript of a review of vol. 16 of the *Encyclopédie française* (*Arts et littératures dans la societé contemporaine*, ed. Pierre Abraham, Paris: Comité de l'Encyclopédie française, 1935), in Benjamin, *Gesammelte Schriften*, ed. Rolf Tiedemann and Hermann Schweppenhäuser with Christoph Gödde, Henri Lonitz, and Gary Smith (Frankfurt am Main: Suhrkamp Verlag, 1989), vol. 7, tome 2, p. 673. In this book review, Benjamin analyzes a short 1935 essay by Léger, "La Peinture et la cité," in that volume of the *Encyclopédie française* (section 70, p. 6). I thank Ciaran Cronin for the Benjamin translation.

54. Léger, "The New Realism Goes On," 1936, in *Functions of Painting*, p. 115. On Léger's concept of "new realism," see Derouet, "Le 'Nouveau réalisme' de Fernand Léger. La Modernité à contre-pied," *Cahiers du Musée national d'art moderne* (Paris) no. 19/20 (June 1987): 136–45, and Hélène Lassalle, "Art Criticism as Strategy: The Idiom of 'New Realism' from Fernand Léger to the Pierre Restany Group," trans. Ann Cremin, in Malcolm Gee, ed., *Art Criticism Since 1900* (Manchester: at the University Press, 1993), pp. 199–218.

55. For an overview of the fair, see *Paris 1937. Cinquantenaire de l'Exposition Internationale des Arts et des Techniques dans la Vie Moderne*, exh. cat. (Paris: Institut Français d'Architecture/Paris-Musées, 1987).

56. See Léger, "Sur la peinture."

57. These murals are illustrated in Willmoth, "Le Mur, l'architecte, le peintre."

58. The assistants were Pierre Wemaëre and the Danish painter Asger Jorn, two artists who would continue their collaboration in the production of abstract tapestries during the 1940s and '50s, and a student named Grekoff. On Léger and his academy, see Fabre, "L'Atelier Fernand Léger, période 1937–1955," in *Paris-Paris, création en France 1937–1957*, exh. cat. (Paris: Musée national d'art moderne, 1981), pp. 190–95.

59. Léger, "Introduction," in Moï Ver, *Paris: 80 Photographies de Moï Ver* (Paris: Éditions Jeanne Walter, 1931), n. p.

60. Léger, "Avènement de l'objet," pp. 220–21.

61. Perriand had mixed photographic elements with other kinds of documents, including maps and informational panels, in an exhibit on urban poverty at the 1936 *Exposition de l'habitation* in Paris and in a 1937 mural decoration on the theme of life on the French farm for the office of Georges Monnet, the Front Populaire's minister of agriculture.

62. Methods of collage and montage had always been marginal to Léger's work, and would continue to be so. A few oil paintings of the World War I period incorporate pieces of pasted paper; see Georges Bauquier with Nelly Maillard, *Fernand Léger: Catalogue raisonné* (Paris: Adrien Maeght Éditeur, 1990), vol. 1, 1903–1919, cats. 94–97. *Ballet mécanique*, the film of 1924, is an important demonstration of cinematic montage. Combining drawing, photo-fragments, and writing, *La Joconde amoureuse de Charlot*, published in the art periodical *14, rue du Dragon* (Paris) no. 1 (March 1933): 11–12, summarizes, in a single image, the action of a 1921 script for an unrealized animated film, *Charlot cubiste*; it is reproduced by Derouet in "Léger et le cinéma," in *Peinture-cinéma-peinture*, exh. cat. (Paris: Hazan, 1989), p. 141. A small work on paper entitled *Le Petit Cheval n'y comprend rien* (The little horse doesn't get it, c. 1935) incorporates photographs of two female dancers and a horse; it is reproduced in Aragon, *L'Oeuvre poétique* VI ([Paris]: Livre Club Diderot, 1975), p. 8.

63. The photographer and historian of photography Gisèle Freund surveyed this matter in "La Photographie à l'exposition," *Arts et métiers graphiques* (Paris) no. 62 (March 15, 1938): 37–41. See also Christian Bouqueret, "La Photographie. Photographes et images à l'Expo," in *Paris 1937. Cinquantenaire de l'Exposition Internationale des Arts et des Techniques dans la Vie Moderne*, pp. 414–24. On the politics of photomontage, see Benjamin H. D. Buchloh, "From Faktura

to Factography," in Richard Bolton, ed., *The Contest of Meaning: Critical Histories of Photography* (Cambridge, Mass.: The MIT Press, 1989), pp. 49–80. Derouet describes Léger's views on advertising in "Léger et la publicité, ébauche d'un grand débat," in *Art & Publicité 1890–1990*, exh. cat. (Paris: Centre Georges Pompidou, 1990), pp. 358–67.

64. Le Corbusier published a monograph on the Pavillon des Temps Nouveaux, entitled *Des Canons, des munitions? Merci! Des logis, S.V.P.* (Boulogne-sur-Seine: Éditions de l'Architecture d'Aujourd'hui, 1938). On the role of photographic visualization within this architect's work and thought, see Daniel Naegele, "Photographic Illusionism and the 'New World of Space,'" in *Le Corbusier: Painter and Architect*, exh. cat. (Aalborg: Nordjyllands Kunstmuseum, 1995), pp. 83–117.

65. According to Léon Gischia, one of the collaborators, Léger supervised the production of all four panels. Gischia, interview with the author, Paris, May 18, 1990.

66. *La France travaille*, vols. I and II (Paris: Horizons de France, 1932). This project is described and partially reproduced in Anne-Claude Lelieur and Raymond Bacholleet, *La France travaille: François Kollar* (Paris: Chêne, 1986). Kollar worked with Perriand in the production of photomurals at the agriculture ministry and at the 1937 Exposition's Centre Rural.

67. Léger, response to "Enquête," *Cahiers d'Art* (Paris) 14 nos. 1–4 (1939): 72.

68. Léger, letter to unknown correspondents, September 11, 1939, in Bauquier, *Fernand Léger. Vivre dans le vrai* (Paris: Adrien Maeght Éditeur, 1987), p. 191.

Plates

Introductions by Beth Handler

1909–1914

Early Work

The realistic value of a work of art is completely independent of any imitative character. . . .
Pictorial realism is the simultaneous ordering of three great plastic components: Lines, Forms, and
Colors. . . . The impressionists were the first to reject the absolute value of the subject and to consider
its value to be merely relative. . . . From now on, everything can converge toward an intense realism
obtained by purely dynamic means. ¶ Pictorial contrasts used in their purest sense (complementary
colors, lines, and forms) are henceforth the structural basis of modern pictures.
—Fernand Léger, "The Origins of Painting and Its Representational Value," 1913

If pictorial expression has changed, it is because modern life has necessitated it. . . . The view
through the door of the railroad car or the automobile windshield, in combination with the speed, has
altered the habitual look of things. A modern man registers a hundred times more sensory impressions
than an eighteenth-century artist; so much so that our language, for example, is full of diminutives
and abbreviations. The compression of the modern picture, its variety, its breaking up
of forms, are the result of all this.
—Fernand Léger, "Contemporary Achievements in Painting," 1914

In a lecture he gave in May of 1913, Léger began, "I am going to attempt, as far as it is possible, to answer one of the questions most often asked about modern pictures. I put this question in its simplest form: 'What does that represent?' . . . In painting, what constitutes what we call realism?"[1] The issue of realism, of what is represented in painting—or, put differently, of the visual relationship between a painting and the historical moment and context of its making—would concern the artist throughout his career. Between 1910 and 1914, Léger's strategies moved from explorations of Cézannian form and color through a Cubistic planar dynamism to a pure abstraction, finally ending in an adaptation of abstract elements to representational means. In this way his pictorial language developed its own plastic laws while simultaneously embracing modernity's "new visual state."[2] The suspension of this language between aesthetic autonomy and worldly engagement was precisely the quality through which it would simultaneously become modern and extend the tradition of painting.

Léger destroyed most of his early canvases in 1908, but the few works surviving display an Impressionist-derived breakdown of form into discrete strokes of color.[3] The Impressionist and Post-Impressionist subordination of line and form to color presages Léger's later interest in autonomous color; in 1910, however, the issue of color was still troublesome to him. The

nearly monochromatic *La Couseuse* (Woman sewing) of 1909–10 vigorously announces his inclination toward volumetric solidity, reflecting the influence of Cézanne's interest in form while also displaying the tendency to "fatten volumes"[4] that distinguished Léger from his Cubist peers: "The characteristically Cubist assembling of surfaces to form a composition," he was to remember, "was never my strong point."[5]

Such strategies found full expression in *Nus dans la forêt* (Nudes in the forest, 1909–10), which, like *La Couseuse*, shows a favoring of volume over planar diversity and color. The artist would later state, "I spent two years struggling with the volumes in the *Nus dans la forêt*. . . . [The painting], for me, consisted of a battle between volumes. I felt that I could not cope with colors. Volume alone sufficed."[6] Called "tubist" to distinguish Léger's cylindrical shapes from the Cubists' more planar ones,[7] *Nus dans la forêt* also differentiates itself from Cubism in its subject matter of workers, as opposed to the Cubists' landscapes, still lifes, and occasional portraits. The subject, meanwhile, rephrases a time-honored theme of painting—figures in nature—but the old distinction between figure and ground or environment has been significantly collapsed: the workers' distorted and geometric muscularity effects their vigorous cohesion with the twisted and angled volumetric elements of the forest.[8]

This kind of fusion of figure and ground was, of course, also explored in Cubism, and indeed Léger's *La Noce* (The wedding, 1911) and *Les Fumeurs* (The smokers, 1911–12) move closer to Cubism in the rhythmic play of their fragmentary linear and planar elements. Léger also eliminates some of the volumetric solidity of the figures in *Nus dans la forêt*. Even so, figurative elements remain more distinct from their visual surrounds than in the classic Cubism of the time. In *La Noce*, arrangements of faceted interlocking figures punctuate sometimes amorphous passages that suggest white smoke. Houses and trees are much reduced in scale in comparison to the figures, and, in the case of the trees, are standardized. Pockets of color—blue, green, pink—play against the somber tones of the more planar and fragmented areas of figuration. All of these elements establish an undulating space that falls in a vertical and centrifugal sweep. In its subject matter, a wedding, the painting observes an event both contemporary and traditional, conveying Léger's contrasting commitment to both modes.

Léger's rejection of one-point perspective in *La Noce* and *Les Fumeurs*, and the accompanying sense that the subject is being observed from many different viewpoints, reflect the persuasiveness for the Parisian avant-garde (certainly including the Cubists) of Henri-Louis Bergson's idea of *durée*, or "duration"—a concept asking that reality be experienced as a temporal process encompassing both the present and the past. *Les Fumeurs* confirms the luminous passages in *La Noce* as smoke, and its theme recalls Cézanne's smokers, but it also suggests the influence of Jules Romains's idea of *Unanimisme*. For Romains, smoke was one of many urban elements that united city dwellers with their environment and with each other. Léger never admitted a debt to Romains, but in *Les Fumeurs* the ascending smoke provides a compositional link between the figures and the houses, which are already conjoined by the similarity and

partial integration of their geometric forms. What most closely interested Léger, however, was simply the view from his apartment: "I . . . take . . . the visual effect of curled and round puffs of smoke rising between houses. . . . Here you have the best example on which to apply research into multiplicative intensities. Concentrate your curves with the greatest possible variety without breaking up their mass; frame them by means of the hard, dry relationship of the surfaces of the houses, dead surfaces that will acquire movement by being colored in contrast to the central mass and being opposed by live forms; you will obtain a maximum effect."[9] The artist would also write, "The soft smoke rising over a harsh mechanistic environment or out of modern architecture . . . produces a clash of contrasts."[10]

With *La Femme en bleu* (Woman in blue, 1912), the smoke of the earlier pictures evolves into more precisely defined geometric planes. Like *La Couseuse*, the painting depicts a familiar theme—a woman sitting before a table—but compositionally it is more broken, chromatically it is more varied, and the earlier painting's illusion of volumetric solidity is much diminished. Also reduced are the more obviously representational areas that had characterized *La Noce*, at the same time that the painting's planes of color are endowed with a new heartiness. The consequence is that *La Femme en bleu* moves toward integrating representation more thoroughly with abstraction. The female figure, her head shown in partial profile, occupies the central, vertical axis. Elements suggesting tables with objects on them are set to her left and right. While her hands recall those in *La Noce*, her torso is broken into patterns of cubes and semicircles, an almost systematic cancellation of the earlier painting's distinction between surface emphasis and illusions of three-dimensional form. Color is used not only descriptively— to demarcate the woman's torso, for example—but as an independent pictorial force: notice how the planes of dark blue conspire to oppose the more ethereal white shapes and the more mottled light-blue passages. Austere black planes, selectively positioned to recede or advance, further heighten the spatial play between surface and depth. This role of color in the painting suggests Léger's association with Robert Delaunay, along with whom he was called an "Orphic Cubist" by Guillaume Apollinaire in 1913. Léger himself stated in around 1910 that he and Delaunay had begun "to liberate pure color in space."[11]

Contraste de formes (Contrast of forms, 1913, in The Museum of Modern Art) logically extends the abstract tendencies of *La Femme en bleu*. In his lecture of May 1913, as well as in another lecture given a year later, Léger argued that art must acknowledge its time not through the naturalistic representation of contemporary subject matter ("visual realism") but by transforming that subject matter through explicitly pictorial devices—a "realism of conception."[12] In "the modern picture . . . ," Léger argued, "the painter . . . uses a subject in the service of purely plastic means. . . . the contemporary painter . . . must not become an imitator of the new visual objectivity, but be a sensibility completely subject to the new state of things."[13] The way to capture the contrasts of the modern environment was through "pictorial contrasts."[14] In *Contraste de formes*, then, colors, lines, and forms interact to create a completely nonob-

jective statement—Léger's first, and the first to emerge from Cubist initiatives. This interaction results in a mass of geometric shapes organized around a vertical central axis. The shapes are mostly dependent on line for definition; nonetheless, their colors—red, blue, orange, green, yellow, white, black—assert their independence by floating within lines' boundaries, or at times existing completely outside of them. Line too is both dependent and independent, relying on color for subtly three-dimensional articulation while at times remaining distinct from that articulation. Patches of unpainted canvas enhance the painting's flatness and declare its status as object.

This art of what Léger called "dynamic divisionism"[15] was founded on formal contrasts among basic pictorial elements, but it also related to the "modern mentality" and was, the artist explained, "bound up with the visual aspect of external things,"[16] with "present-day life, more fragmented and faster moving than life in previous eras."[17] He stressed that art must have "an affinity with its own time,"[18] an affinity that, paradoxically, would allow it to "lay claim to pure classicism, that is, to a lasting quality independent of the period of its creation."[19] In fact, despite its abstraction, *Contraste de formes* has a latent representational quality, fusing the human figure and its fragmented environment. The ascending segments of tubular forms on the left and right seem to allude to arms, and the more circular forms in the center, abutted by the chain of rectangles, to a torso. Read in this way, these elements assume a forceful mechanical presence that appears to move dramatically forward from the canvas. Léger realized a similar theme in several works entitled *L'Escalier* (The staircase, 1913–14) and in *La Sortie des Ballets Russes* (Exit the Ballets Russes, 1914). The last is a scene of sheer movement, mechanistic yet figurative, and viewed in a foreshortened perspective. Maintaining the plastic oppositions of *Contraste de formes*, Léger composes the figures as amalgamations of ascending cones located between brightly colored stairways. All traces of individuality are jettisoned. We can clearly distinguish three heads—the black and white ellipses—and the bodies that go with them, but an excess of figure-related elements trails behind them all, in a device recalling the Futurist depiction of movement. Raillike forms projecting diagonally toward the viewer enhance this sense of movement, and accentuate the picture's lack of perspectival confluence. "Realism of conception," then, is less imitative of than competitive with observed reality, for it aggressively maintains its own laws, in reaction to the "new visual state" of the world around it. Plastic elements declare themselves as such. From this point on, Léger would try to balance between addressing himself directly to the elements of painting—line, form, color—and using those elements to address subject matter in the world beyond them.

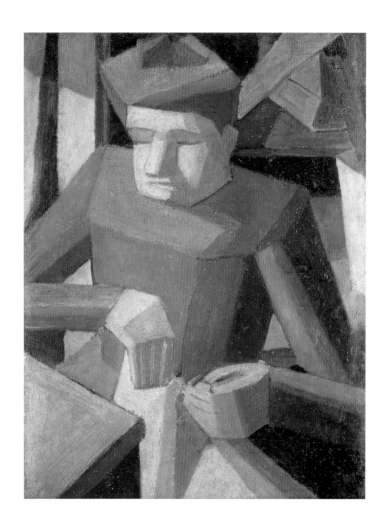

La Couseuse (Woman sewing), 1909–10

Oil on canvas. 28⅜ × 21¼″ (72 × 54 cm). Musée national d'art moderne–Centre de création industrielle, Centre Georges Pompidou, Paris. Gift of Louise and Michel Leiris, 1984

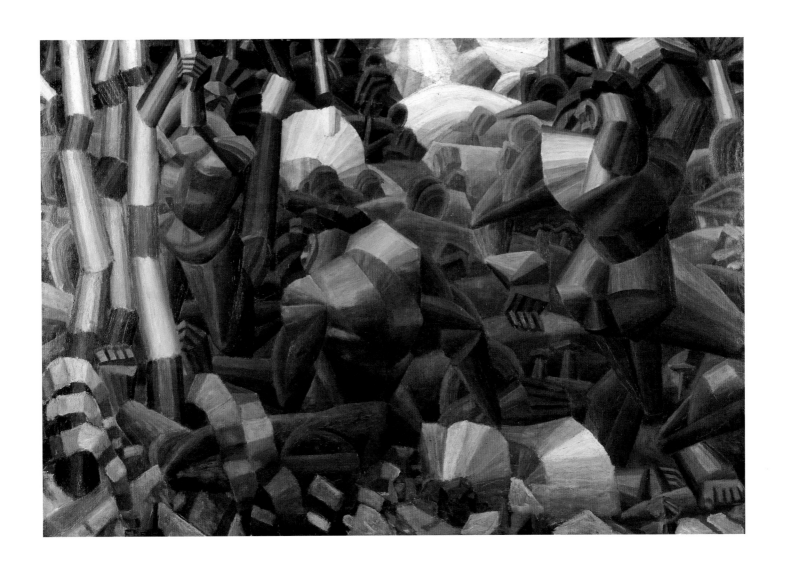

Nus dans la forêt (Nudes in the forest), 1909–10
Oil on canvas. 47¼ × 66¹⁵⁄₁₆″ (120 × 170 cm). Kröller-Müller Museum, Otterlo

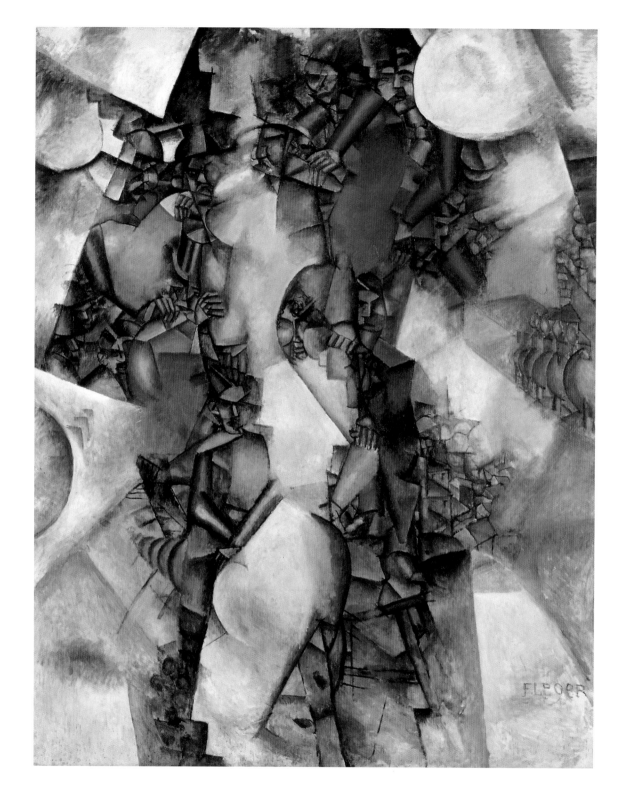

La Noce (The wedding), 1911

158 Oil on canvas. 101⅟₁₆ × 81⅛″ (257 × 206 cm). Musée national d'art moderne–Centre de création industrielle, Centre Georges Pompidou, Paris. Bequest of Alfred Flechtheim, 1937

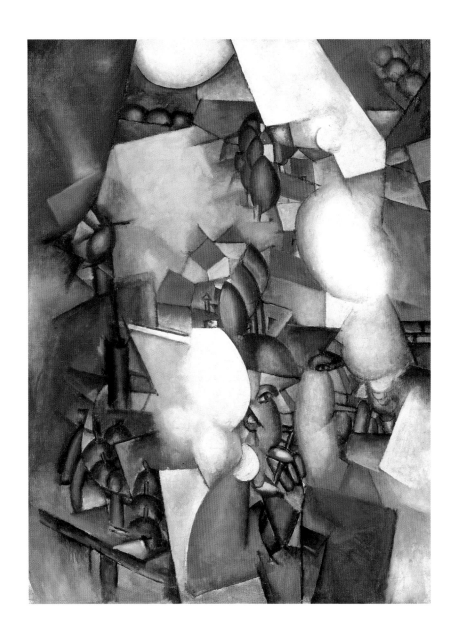

Les Fumeurs **(The smokers), 1911–12**

Oil on canvas. 51 × 38″ (129.5 × 96.5 cm). Solomon R. Guggenheim Museum, New York

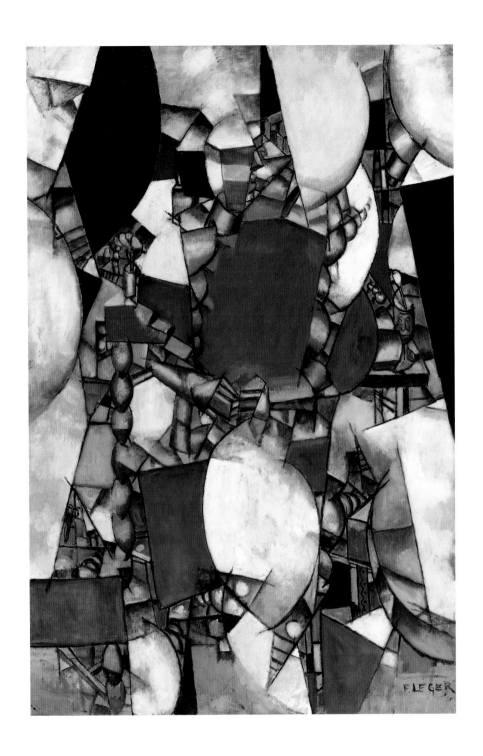

La Femme en bleu **(Woman in blue), 1912**
Oil on canvas. 76 × 51³⁄₁₆″ (193 × 130 cm). Öffentliche Kunstsammlung Basel, Kunstmuseum. Gift of Dr. h.c. Raoul La Roche

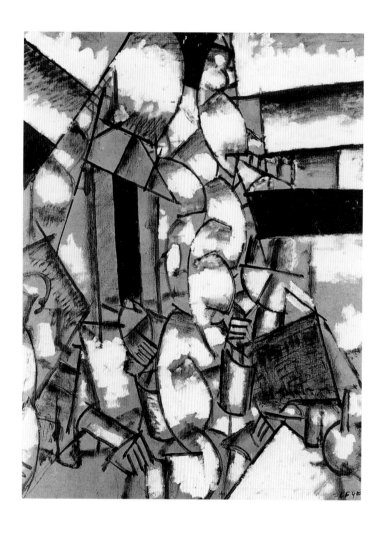

Composition aux deux figures, or *La Fumée* (Composition with two figures, *or* Smoke), c. 1910–12
Ink and gouache on paper. 25⁹⁄₁₆ × 19½″ (64.9 × 49.5 cm). Stedelijk Museum, Amsterdam

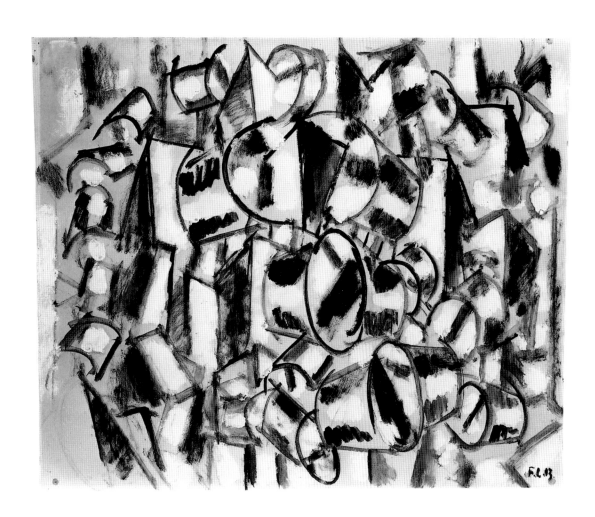

Contraste de formes (Contrast of forms), 1913

Ink and gouache on paper. 17⅝ × 21⁵⁄₁₆″ (44.8 × 54.2 cm). Collection A. Rosengart

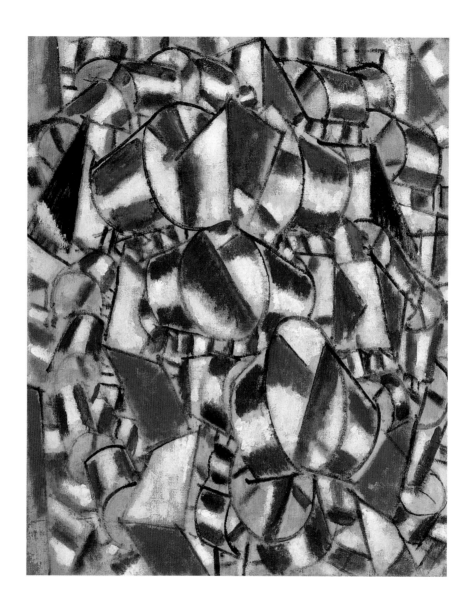

Contraste de formes (Contrast of forms), 1913
Oil on canvas. 39½ × 32″ (100.3 × 81.1 cm). The Museum of Modern Art, New York. The Philip L. Goodwin Collection, 1958

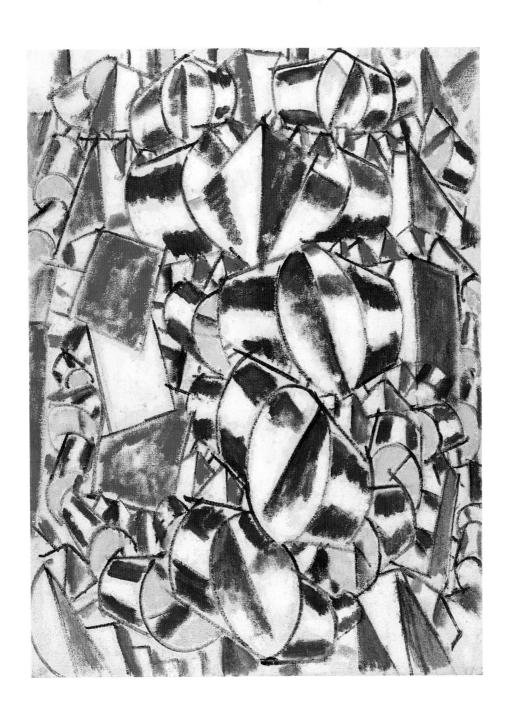

Contraste de formes (Contrast of forms), 1913
Oil on burlap. 51¼ × 38⅞″ (130.2 × 97.6 cm). Philadelphia Museum of Art. The Louise and Walter Arensberg Collection

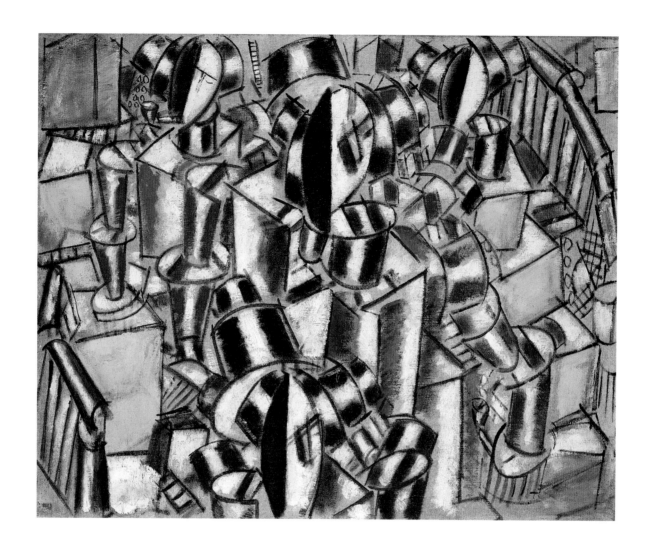

L'Escalier (The staircase), 1914
Oil on canvas. 31⅞ × 39⅜″ (81 × 100 cm). Öffentliche Kunstsammlung Basel, Kunstmuseum. Gift of Dr. h.c. Raoul La Roche

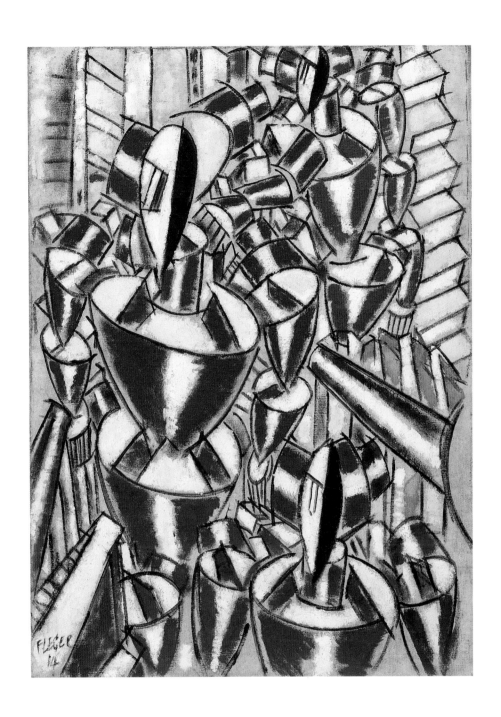

La Sortie des Ballets Russes (Exit the Ballets Russes), 1914

Oil on canvas. 53¼ × 39½" (136.5 × 100.3 cm). The Museum of Modern Art, New York. Gift of Mr. and Mrs. Peter A. Rübel (partly by exchange), 1958

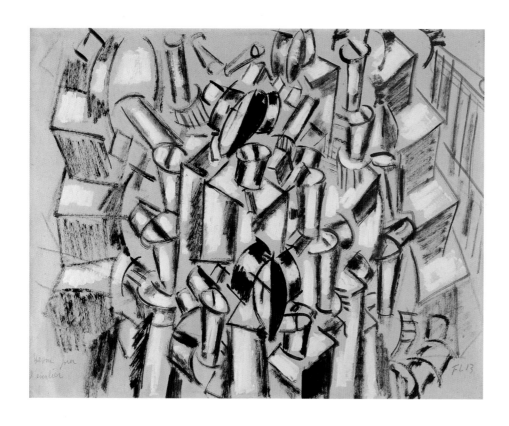

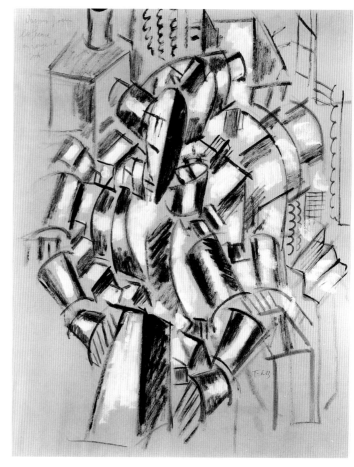

Dessin pour "L'Escalier" (Study for *The staircase*), **1913**
Gouache and oil on paper. 19 × 25″ (48.2 × 63.5 cm). Private collection

Étude pour "La Femme en rouge et vert" (Study for *Woman in red and green*), **1913**
Opaque watercolor and charcoal with graphite inscription on paper. 25½ × 19⅝″ (64.8 × 49.8 cm). Philadelphia Museum of Art. A. E. Gallatin Collection

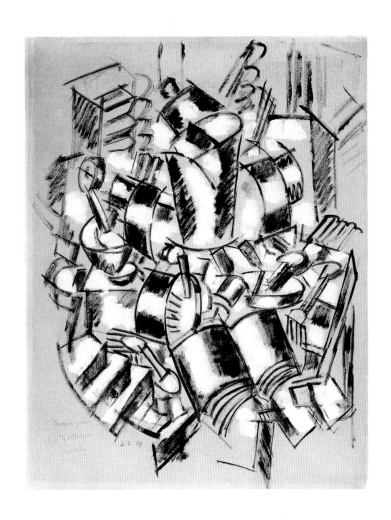

Nature morte sur une table (**Still life on a table**), **1914**
Gouache and charcoal on paper. 25½ × 19⅛″ (64.8 × 49.2 cm). Lent by The Metropolitan Museum of Art, New York. Gift of Mr. and Mrs. William R. Acquavella, 1986

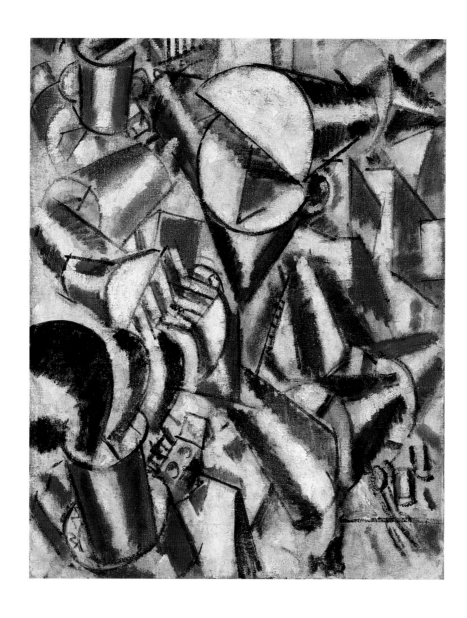

Femme cousant **(Woman sewing), 1914**
Oil on canvas. 36⅜ × 28⅜″ (93 × 72 cm). Morton G. Neumann Family Collection

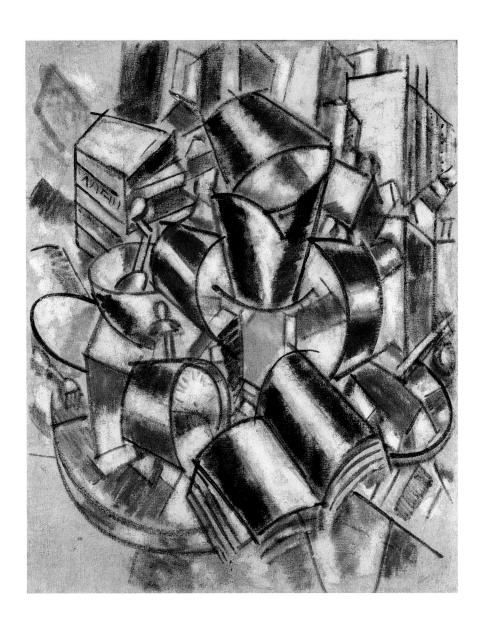

Nature morte: réveille-matin **(Still life: alarm clock), 1914**

Oil on canvas. 39⅜ × 31⅞″ (100 × 81 cm). Kunstmuseum Winterthur. Bequest of Clara and Emil Friedrich-Jezler, 1973

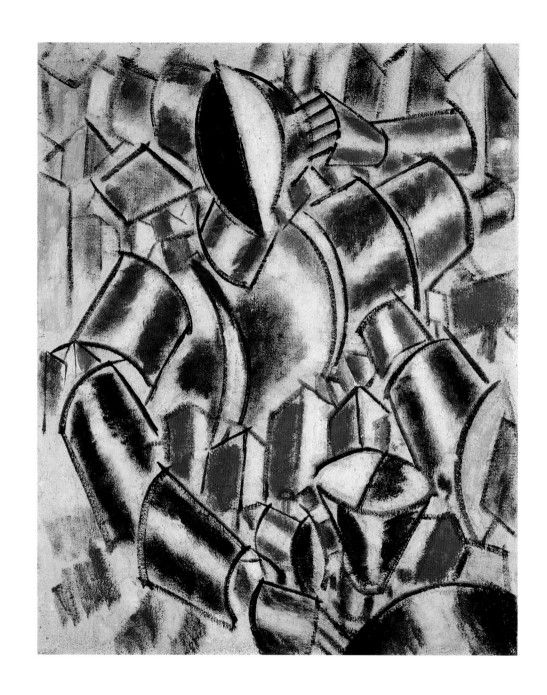

Femme devant une table (Woman before a table), 1914

Oil on canvas. 39⅜ × 31⅞" (100 × 81 cm). Collection Mr. and Mrs. Donald B. Marron, New York

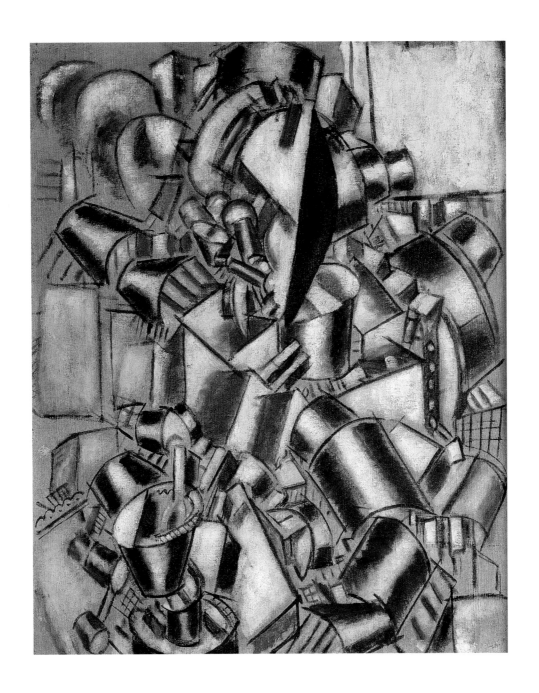

Le Fumeur (The smoker), 1914
Oil on canvas. 39⅜ × 31⅞″ (100 × 81 cm). Private collection

1914–1920

World War I and the Mechanical Period

It was those four years [of World War I] which threw me suddenly into a blinding reality that was
entirely new to me. . . . Suddenly I found myself on an equal footing with the whole French people.
Posted to the sappers, my new comrades were miners, laborers, artisans who worked in wood or metal.
I discovered the people of France. And at the same time I was suddenly stunned by the sight of the
open breech of a .75 cannon in full sunlight, confronted with the play of light on white metal.
It needed nothing more than this for me to forget the abstract art of 1912–13.

—Fernand Léger, in Arts (Paris), 1949

A new criterion has appeared in response to a new state of things. Innumerable examples of
rupture and change crop up unexpectedly in our visual awareness. . . . The advertising billboard,
dictated by modern commercial needs, that brutally cuts across a landscape is one of the things that has
most infuriated so-called men of . . . good taste. . . . And yet, this yellow or red poster, shouting in a
timid landscape, is the best of possible reasons for the new painting; it topples the whole sentimental
literary concept and announces the advent of plastic contrast. . . . The poster is
a piece of modern furniture that painters immediately knew how to use.

—Fernand Léger, "Contemporary Achievements in Painting," 1914

Léger entered the French army in August 1914, at the very start of World War I. Spending
much of the next four years at the front, he would produce many drawings of soldiers, guns,
aircraft, and town and landscape scenes, as well as several paintings on wood. *Le Soldat à la pipe*
(Soldier with a pipe, 1916) is based on drawings completed at the front, but its elaboration in
paint on canvas came while Léger was on leave in Paris. In this work he further developed the
mechanical treatment of the figure that he had begun to explore before the war.[1]

Le Soldat à la pipe reveals Léger's admiration of the common soldier—for him emblematic
of the "whole French people"—and marks the beginning of what he called a "return to the
subject, [while] trying still to set plastic contrasts against each other."[2] Thematically the work
is linked to *Les Fumeurs* of 1911–12, but the gentle smokers of that earlier work are trans-
formed into a "gun-metal" aggregation of forms with a machinelike corporeality that nonethe-
less retains an intensely human aspect.[3] The torso comprises two vertical cones linked by four
diagonal ribs; the arms are partly disjointed cylinders. Even the smoke—mechanical in its
metallic-gray hue, and in the regularity of its form, a chain of circles—is closer to the imagery
of modern weaponry than to the amorphous, luminous renditions of smoke in earlier Léger

paintings. The exception to the principle of mechanization is the patch of red that constitutes part of the soldier's head. Suggesting blood, the red asserts the inescapable vulnerability of the human body, despite its resilient armor.

This tribute to the ordinary soldier's utility as a weapon of war lacks the dimension of heroic narrative that another artist might have brought to the subject; Léger's particular fascination with man as machine took the form of a joy in "practical reality."[4] The large *Partie de cartes* (The card game, 1917), painted while Léger was convalescing from an illness, has the sort of monumentality expected in depictions of great events—a major battle, for instance—but describes a subject more reminiscent of genre scenes than of the theatrics of history painting. Léger would later remember, "When the boys played cards I stayed with them and watched; I did drawings and sketches: I wanted to catch them. That was the origin of *La Partie de cartes*. Those fellows made a great impression on me and the urge to draw them was quite spontaneous. . . . *La Partie de cartes* [was] the first picture for which I deliberately took my subject from what was going on around me."[5] It is principally the soldiers' medals, and the sergeant's stripes worn by the picture's pipe-smoking central figure, that indicate that these card-players have any military role at all.[6] (The forms of their hats or helmets might offer another clue, and their bodies once again have a metallic sheen, as in *Le Soldat à la pipe*.) The work thus refuses any presentation of the drama of warfare in deference to a realistic depiction of the banalities of the ways time passes for soldiers.

La Partie de cartes favors solid-looking, architecturally resonant shapes in the soldiers' bodies, with juxtapositions of blue, red, yellow, gray, white, and green enhancing this dynamism of form. Yet in the background Léger also moves farther in a planar direction he had explored the year before in *Le Soldat à la pipe*, where he had built up this part of the painting out of gray vertical planes and diagonal lines. Also as in the earlier piece, he touches the human body with red, particularly in the figure on the left, but the shapes in which the color falls are now more geometrical. The expanse of ascending mustard components certainly describes a table, but perhaps also recalls the scorched terrain upon which battles are fought and soldiers live. The various mutations of basic geometric forms, the sweep of the table, the affinity of the playing cards with the picture plane, and the simultaneity of different views of the figures create a shallow but dynamic perspectival recession. The cards, and the foreground's fragment of newspaper (an echo of Cubism), ground impulses toward abstraction in easily recognizable representational devices. All of these elements collaborate to forge a relation of conceptual empathy between pictorial structures, the human form, and the machine environment of modern life.

Discharged from the army in 1918, Léger returned to Paris. In the work he quickly began to produce, his appraisal of modernity's "new visual state"[7] was amply manifest: "I like the forms necessitated by modern industry and I use them: a smelting furnace will have thousands of colored reflections both more subtle and more solid than a supposedly classical subject."[8]

Yet Léger also maintained the importance of contrast: "I . . . model in pure and local color, using large volumes. I could do without tasteful arrangements, delicate shading, and dead backgrounds. . . . It is my ambition to achieve the maximum pictorial realization by means of plastic contrasts. I couldn't care less for convention, taste and established style, if there is any of this in my painting it will be found out later. Right now, I'm going to do some living."[9]

In *Les Disques* (The disks, 1918), a vertical conglomeration of flat circular components is set against a near-flat backdrop of lines and largely rectangular areas of color. The lines sometimes seem to represent the more intricate architectural details of a city—cast-iron railings, say, and other building elements. The four clusters of circles are arranged along an axis of orange, red, and brown diagonal planes. The disk motif recalls works by Robert Delaunay,[10] but Léger avoids his colleague's symbolic use of color, at the same time that he abandons the steely palette of his two wartime paintings on canvas. As he would remember much later, "'Four Years Without Color.' ¶1918: Peace. . . . Living forces, now unleashed, filled the world. . . . Color takes over. It is going to dominate everyday life. One will have to adjust to it."[11]

Some of the stylistic traits of *Les Disques* are familiar from Synthetic Cubism: the coherent arrangement of flat planes, the potential independence of color from any mimetic description of form, and an overall "interlocking" geometry.[12] Yet the painting, although abstract, deliberately evokes machine parts, a subject rare in Cubism. Its various disks suggest not only a machine in movement—perhaps the wheels of a train—but also the fragmentation precipitated by the new machinery, which not only forced dramatic changes in society but altered the continuum of everyday experience.[13] Yet *Les Disques* in no way imitates the industrial object; rather, it proclaims a state of rivalry. "Today," Léger wrote in 1923, "we are in competition with the [industrial] 'beautiful object'; it is undeniable. . . . If, pushing things to extremes, the majority of manufactured objects and 'store spectacles' were beautiful and had plasticity, we artists would no longer have any reason to exist."[14]

Other paintings from this period, such as *Les Hélices* (Propellers, 1918), demonstrate the artist's continuing fascination with machine parts: "Aeroplane propellers . . . strike everyone as being objects of beauty, and they are very close to certain modern sculptures."[15] It is important to note, however, that Léger was interested not only in machines and their products but also in human interaction with them. In *Le Marinier* (Bargeman, 1918) the figure is fully integrated into the industrial landscape, his body parts reduced versions of the mechanical elements that surround him. *La Pipe en bois* (The wooden pipe, 1918) alludes to the compositional structures of *Le Soldat à la pipe*, in that the pipe and surrounding pistonlike forms echo the similar shapes that constitute the pipe and body described in the earlier painting, and initially articulated in figures such as those in *La Sortie des Ballet Russes* of 1914. In *Le Typographe* (The typographer, 1918), where the human form is subsumed in partially modeled planes of color, man becomes machine in the most abstract, synthetic way. It is a close-to-nonfigu-

rative formulation of a figurative subject matter, reinforced by its allusions to the flat surfaces of typography.

La Ville (The city, 1919) describes the metropolis as a cacophonous landscape of shallow, colored, and colliding planar elements punctuated by figures, architecture, and advertising motifs. The vertical pole traversing the canvas stabilizes it only somewhat. The dense pictorial collisions in *La Ville* elaborate on Léger's prewar concern with expressing the simultaneity of visual and tactile experience. The elision of transitional passages between motifs—the quick edit—recalls the cinematic vision reflected in a book to which Léger contributed images, typography, and design, Blaise Cendrars's *La Fin du monde filmée par l'ange N.-D.* (The end of the world filmed by the angel N.-D. [Notre Dame]), published in the same year that *La Ville* was painted.[16]

Léger was fascinated by the extent to which cities had become battlegrounds for the strategies of advertising. "Modern life," he had written in 1914, "is often in a state of contrasts. . . . The most common example is the harsh, sharp advertising billboard, with violent colors and lettering, that cuts across a melodious landscape. . . . All these events are subjects to paint."[17] The energy of the city in *La Ville* resonates powerfully through color, and its handling reflects Léger's observations of the street advertising of his time:

In *La Ville*, I composed a picture exclusively with pure, flat colors. Technically, that picture was a plastic revolution. One could achieve depth and dynamism without modulation or chiaroscuro. It was advertising that first drew the consequences. The pure tones of the blues, reds, and yellows break away from this picture and invade posters, shop windows, roadside signs, and traffic lights. Color had become free. It was a reality in its own right. It had a new activity, entirely independent of the objects which, till then, had contained and supported it.[18]

Léger's appropriation of motifs from his earlier works sustains this use of color. Disks appear in the cityscape, most emphatically in the collision of a yellow, white, red, and green disk with the stencil-like typography of the letter "R" at the lower left. Figures appear as simplified articulations of color—as in some advertising posters—or as anonymous, gun-metal-gray, compartmentalized forms. Ascending circles of smoke are decidedly weighty. Léger translates the physical experience of the modern city into an equivalent pictorial adventure.

Les Disques dans la ville (Disks in the city, 1920–21) sets the mechanical devices of *Les Disques* within the cityscape as demarcated in *La Ville*; overtly nodding to both of the earlier works, the painting represents a summation of the artist's concern with mechanization and urbanity. Eventually, however, Léger would broaden his definition of plastic realism to include the classical.

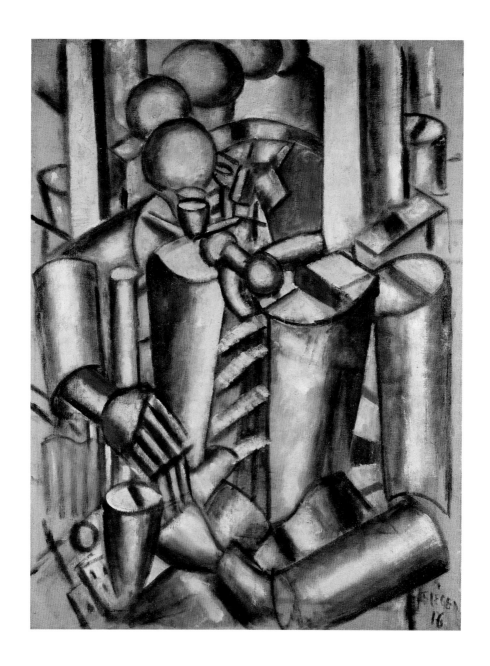

Le Soldat à la pipe (Soldier with a pipe), 1916

Oil on canvas. 51³⁄₁₆ × 38³⁄₁₆″ (130 × 97 cm). Kunstsammlung Nordrhein-Westfalen, Düsseldorf

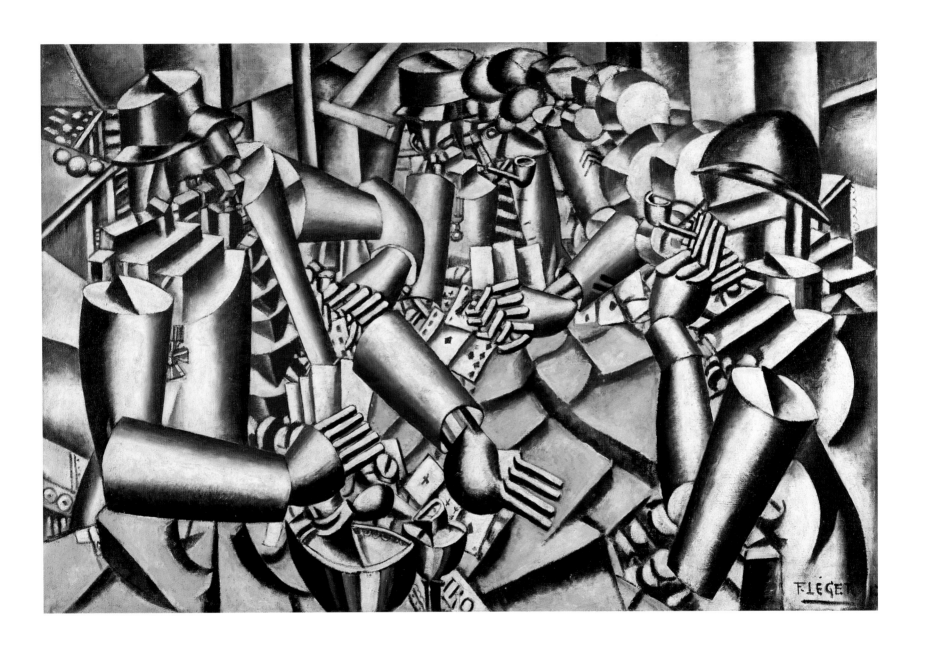

La Partie de cartes (The card game), 1917
Oil on canvas. 50¹³⁄₁₆ × 76″ (129 × 193 cm). Kröller-Müller Museum, Otterlo

La Ville (The city), 1919
Oil on canvas. 91 × 117½" (231.1 × 298.4 cm). Philadelphia Museum of Art. A. E. Gallatin Collection

Les Disques (The disks), 1918
Oil on canvas. 94½ × 70⅞″ (240 × 180 cm). Musée d'Art Moderne de la Ville de Paris

Les Disques dans la ville (Disks in the city), 1920–21

Oil on canvas. 51¹⁄₁₆ × 63¼″ (130 × 162 cm). Musée national d'art moderne–Centre de création industrielle, Centre Georges Pompidou, Paris. Gift of Louise and Michel Leiris, 1984

Les Hélices (Propellers), 1918

Oil on canvas. 31⅞ × 25¼″ (80.9 × 65.4 cm). The Museum of Modern Art, New York. Katherine S. Dreier Bequest, 1953

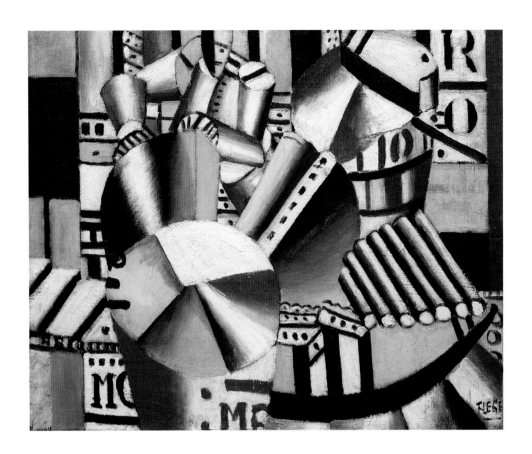

Le Marinier **(Bargeman), 1918**

Oil on canvas. 18⅛ × 21⅞" (45.8 × 55.5 cm). The Museum of Modern Art, New York. The Sidney and Harriet Janis Collection, 1967

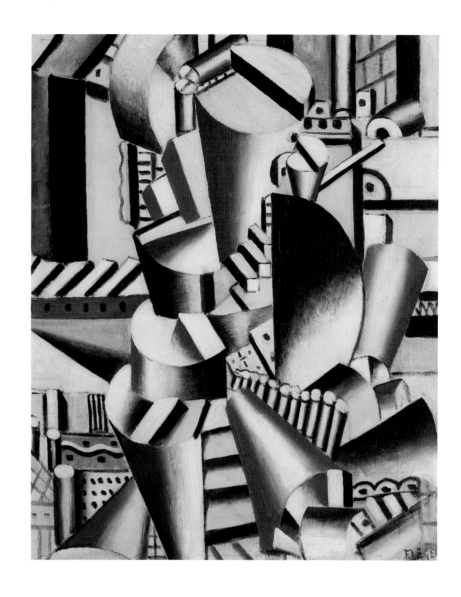

La Pipe en bois (The wooden pipe), 1918
Oil on canvas. 32 × 26″ (81.3 × 66 cm). Private collection

Le Typographe (The typographer), 1918
Oil on canvas. 97⅜ × 71⅝″ (248 × 182 cm). Private collection, Europe

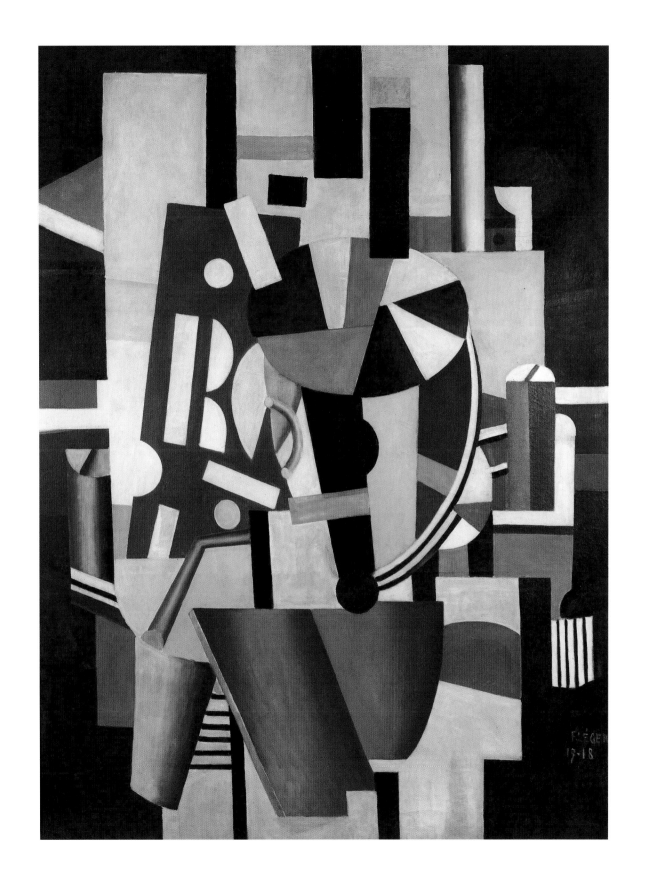

1920–1924

The Call to Order

Among a thousand pictures are there two beautiful ones? Among a hundred machine-made objects, thirty are beautiful, and they resolve the problem of Art, being beautiful and useful at the same time. The artisan regains his place, which he should always have kept, for he is the true creator. It is he who daily, modestly, unconsciously creates and invents the pretty trinkets and beautiful machines that enable us to live.

—Fernand Léger, "The Machine Aesthetic: The Manufactured Object, the Artisan, and the Artist," 1923

I had broken down the human body, so I set about putting it together again and rediscovering the human face. . . . I wanted a rest, a breathing space. After the dynamism of the mechanical period, I felt a need for the staticity of large figures.

—Fernand Léger

We live in a geometric world, it is undeniable. . . .

—Fernand Léger, "Notes on the Mechanical Element," 1923

After 1920, Léger's painting took on a more precise, static quality reflecting the *rappel à l'ordre*, the "call to order" then dominating the Paris avant-garde. A strong influence on his work of these years was Purism, a movement based on a reevaluation of Cubism and founded by the painters Charles-Édouard Jeanneret (also well-known as the architect Le Corbusier) and Amédée Ozenfant. Léger met Jeanneret and Ozenfant in around 1920; in 1924, he joined the faculty of an art school, the Académie Moderne, where he and Ozenfant would teach.

An art of geometry, mathematical laws, and scientific analysis, Purism posited man as the arbiter of order, and rhetorically celebrated machines and machine-made objects for the presumed precision of their functioning. Its adaptation of neo-Platonist concepts to contemporary pictorial means coincided with the avant-garde's renewed interest in seemingly universal systems of proportion, reason, and equilibrium. The Purists' admiration of industrial products and of the efficiency and discipline of the modern paralleled that of Léger, who nonetheless felt that Purism was "too self-contained and therefore too narrow."[1] His paintings' insistent realism set them apart from Purism's theoretical armature, and from its attempts to represent archetypal objects and orders. Léger believed that "there are no categories or hierarchies of Beauty—this is the worst possible error. The Beautiful is everywhere; perhaps more in the arrangement of your saucepans in the white walls of your kitchen than in your eighteenth-cen-

tury living room or in the official museums."[2] Thus he could praise the aesthetic sense of a shopkeeper whom he watched spend an hour arranging seventeen waistcoats in a store window: "Men like this. . . incontestably have a concept of art—one closely tied to commercial purposes, but one that is a plastic achievement of a new order and the equivalent of existing artistic manifestations."[3]

Le Mécanicien (The mechanic, 1920) reflects this belief in the working-class artisan as the embodiment of the new technology's rationality. (When an aviation show was installed near the Salon d'Automne in around 1912, a mechanic had come over from it to see the art—"a sixteen-year-old," Léger would remember, ". . . blissfully contemplating the nude women in gold frames; . . . he—in his clothes of a modern worker, blazing with color—killed the whole exhibition. Nothing more remained on the walls than vaporous shadows in old frames. The dazzling kid who looked as though he had been fathered by a piece of farm machinery was the symbol of the neighboring [aviation] exhibition, of the life of tomorrow, when Prejudice will be destroyed."[4]) Unlike the figures in *Le Soldat à la pipe* and *La Partie de cartes*, the mechanic is organically human. The metallic physicality described in the earlier works is replaced by a definite if somewhat static musculature and pale flesh tones only minimally inflected with gray. Yet an objectifying impulse remains, apparent in the simplified modeling and the composite corporeal structure; the right hand, for example, almost floats free, and the fingers, as in some earlier works, are like levers. The unnaturally regular planes of the face and hair also have an assembled look. It is a body constructed of parts, as a machine is; yet these parts represent not man as machine, but man within a machine economy. The mechanic's mustache, rings, and tattoo point to his individuality. Léger's appropriation of an earlier motif of his own further personalizes the piece: once again he paints a smoker in a transforming ambience, but now the figure's unity with the environment comes through his own internal composition.[5]

The influence of De Stijl is clear in the yellow, white, black, and red background planes in *Le Mécanicien*, but Léger tempers De Stijl's firm geometries by including machine parts, however abstracted and still.[6] A memory of Henri Rousseau is also present in the "'architectural'" stability of the figure and its perhaps deliberate affinities with Rousseau's *Portrait of Pierre Loti* of c. 1891.[7] In addition, the combination of a frontally viewed torso with a face seen in profile suggests art of Ancient Egypt and the Near East.[8] The high stylization of such ancient art could also have played a part in Léger's renditions of a traditional Western subject matter, the female nude, in *Three Women* (also called *Le Grand Déjeuner*, 1921). The painting, Léger said, shows "every time's subject."[9]

In looking to art of the past, Léger was intent on finding representational strategies that seemed relatively independent of their subject matter. Renaissance art, for example, he felt had fallen into "the error of *imitation*, of the servile copy of the subject, as opposed to the so-called primitive epoch that is great and immortal precisely because it invented its forms and methods."[10] This is not to say that Léger indiscriminately admired pre-Renaissance art and

indiscriminately disliked art in the Renaissance tradition; indeed he valued such artists as Poussin, Courbet, and Seurat, precisely for their explorations of pictorial potential. What Léger sought was an art of traditional means that would express the conditions of twentieth-century modernity, particularly the primacy of the machine: "The contemporary environment is clearly the manufactured and 'mechanical' object; this is slowly subjugating the breasts and curves of woman, fruit, the soft landscape—inspiration of painters since art began."[11]

Three Women sets three female figures on and around a couch in a geometrically vibrant interior. With the partial exception of the earth-colored figure on the right, the women's bodies are resolved in terms of anatomical distortions so radical that the viewer might be discovered mentally piecing them together like puzzles. The repetitiveness of the elements into which they are broken down is most obvious in the similarity of their round heads, and in their stiff, triply echoed vertical ripples of hair. The classic quality of the painting's theme, and the nudes' suggestion of marble and terra-cotta sculptures, return us to art history, but the contemporary enters in the way the body parts are assembled, the sharp upending of the patterned floor, the rectangular demarcations of the background, and the stylized furniture. Unlike *Le Mécanicien*, *Three Women* treats the body as generic; the women are anonymous, their forms repeating almost interchangeably. Another distinction between these works is the women's placement in domestic space, with dog and side table, whereas the male mechanic occupies the realm of work. As always with Léger, contrast is a fundamental principle, evident here in the juxtaposition of the mechanical and the organic, the classical and the contemporary.[12]

La Lecture (Reading, 1924) distills the machine-informed classicism of *Three Women* by reducing the earlier work's compositional intricacies. Two figures appear against another background of geometric shapes. In the depiction of faces, body parts, book pages, the right-hand figure's necklace, and the stylized flowers, line has more descriptive weight than before. Horizontal masses like those defining the legs of the reclining figure in the earlier picture appear here at the canvas's far right, but have become more abstract still. This nonmimetic direction is underscored by the anatomical inconsistency of the women's bodies, most obviously in the left-hand figure's left arm. The bald figure on the right also leans toward the nonobjective. Léonce Rosenberg, Léger remembered, "looked at the painting and said: 'But the woman hasn't any hair! She looks flayed. It's unpleasant to look at. Be reasonable and give her some!' . . . But. . . . I simply could not. Where the hair was I needed a form that was both rounded and defined. . . . I could not add any hair."[13]

With *Élément mécanique* (Mechanical element, 1924, in the Musée national d'art moderne) Léger once again addresses machinery: "Each artist possesses an offensive weapon that allows him to intimidate tradition. In the search for vividness and intensity, I have made use of the machine as others have used the nude body or the still life."[14] Like *Les Disques*, the painting centers on a vertical sweep of machine parts, but Léger reduces their number and replaces the earlier planar background elements with a field of red. The result is that the work

becomes a study "emphasizing plasticity rather than mechanical movement."[15] With Purist finesse, a second *Élément mécanique* (1924, Kunsthaus Zürich) delivers a planar homogenization of understated objects with the suggestion of a human form. The difference is that where the Purists tended to limit the specificity of their still lifes in the name of a neo-Platonist idealism, Léger retains his allusions to machinery,[16] through the white-and-gray shape resembling a typewriter in the center of the canvas and the graceful mechanical interaction of the fragmented planes. Again, though, he favors pictorial contrast over recognizability:

The mechanical element is *only a means and not an end.* I consider it simply plastic "raw material," like the elements of a landscape or a still life. . . . Instead of opposing comic and tragic characters and contrary scenic states, I organize the opposition of contrasting values, lines, and curves.

I oppose curves to straight lines, flat surfaces to molded forms, pure local colors to nuances of gray. These initial plastic forms are either superimposed on objective elements or not, it makes no difference to me. There is only a question of variety.[17]

Le Siphon (The syphon, 1924), inspired by a Campari advertisement,[18] shows a glass, a hand holding a soda bottle, and other objects harder to identify, and reasserts the attraction to advertising that Léger had earlier expressed in *La Ville*. Easily legible devices like the hand and bottle contrast with the more defiantly nonmimetic approach seen, for example, in the rectangle of flat planes in the background, which looks very much like some of Léger's mural paintings from the period. Yet Léger took recourse to the semblance of commercial realism not in order to copy that style but to achieve its ability to convey "the intrinsic plastic value of the object, its pictorial equivalence."[19]

Le Siphon also parallels Léger's interest in cinema. He had already designed a poster for Abel Gance's film *La Roue*, released in 1922. That film, he thought, involved a "plastic state" as well as a "dramatic" and "emotional" one, and in that plastic state "the mechanical element . . . becomes *the leading actor.* . . . *[This] actor object* . . . is presented to us through an infinite variety of methods, from every aspect: close-ups, fixed or moving mechanical fragments, projected at a heightened speed that approaches the state of simultaneity and that crushes and eliminates the human object, reduces its interest, pulverizes it."[20] Léger's own *Ballet mécanique* of 1924 features rapid cuts among close-ups of mass-produced objects, now shot straight on, now fragmented, now optically manipulated. The film is resolutely nonnarrative and abstract. Léger also associates the human form with the machine—in Kiki de Montparnasse's automatically repeated smiles, the rhythmic movement of a woman on a swing, and a tribute to Charlie Chaplin as a construction of moving wooden parts. Mechanical elements are viewed as no less worthy of attention than the fragmented human form. The same, of course, is true in *Le Siphon*. In film, Léger wrote, "The hand is an object with multiple, changeable meanings. Before I saw it in the cinema, I did not know what a hand was!"[21] The full implications of Léger's interest in cinema for his painting would be realized in the years to come.[22]

Le Fumeur (The smoker), 1921

Pencil on paper. 12¹⁄₁₆ × 9⁷⁄₁₆″ (31 × 24 cm). Collection Klaus Hegewisch, Hamburger Kunsthalle

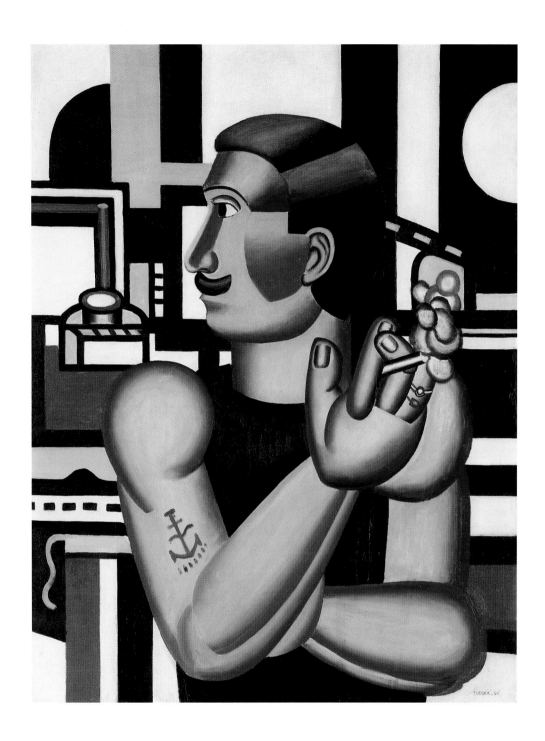

Le Mécanicien (The mechanic), 1920
Oil on canvas. 45⁷⁄₁₆ × 34⁷⁄₈″ (115.4 × 88.6 cm). National Gallery of Canada, Ottawa

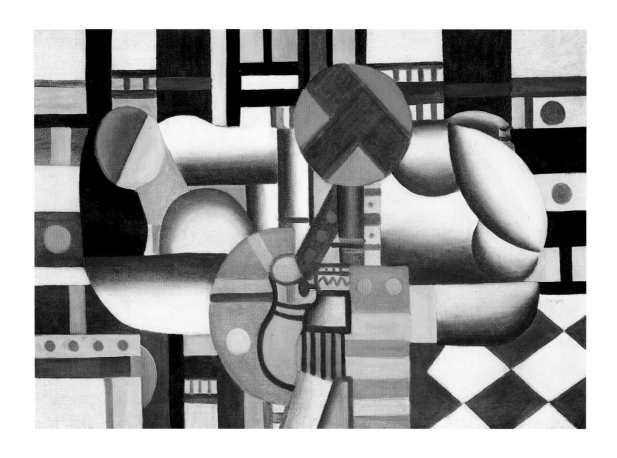

Femme et nature morte **(Woman and still life), 1921**
Oil on canvas. 25 9/16 × 36¼" (65.5 × 92 cm). Scottish National Gallery of Modern Art, Edinburgh

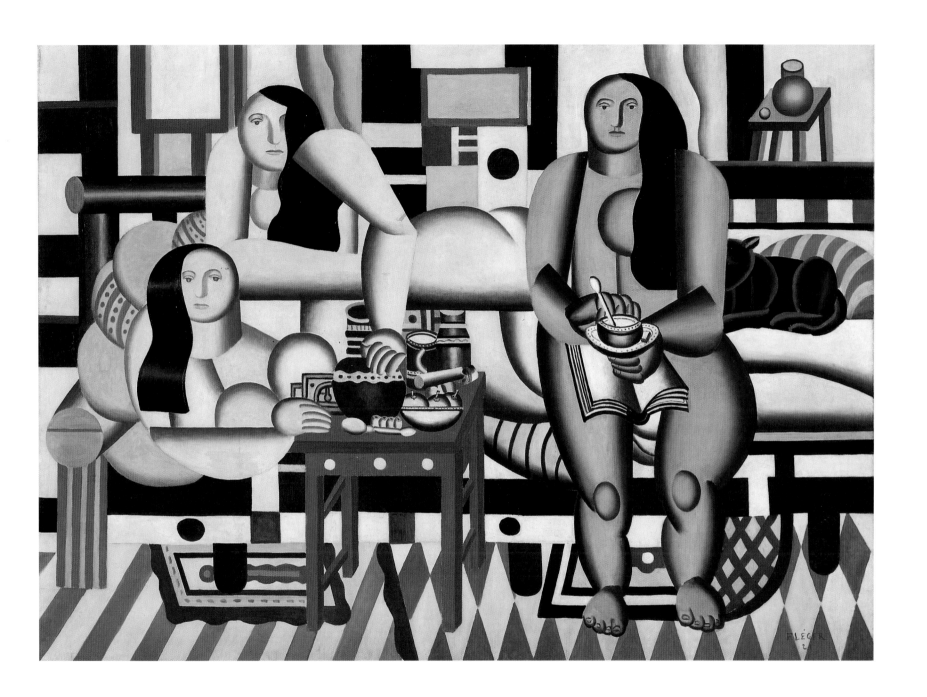

Three Women (*Le Grand Déjeuner*), 1921
Oil on canvas. 72¼ × 99″ (183.5 × 251.5 cm). The Museum of Modern Art, New York. Mrs. Simon Guggenheim Fund, 1942

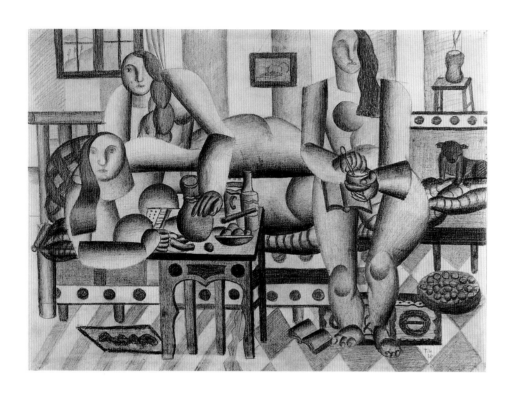

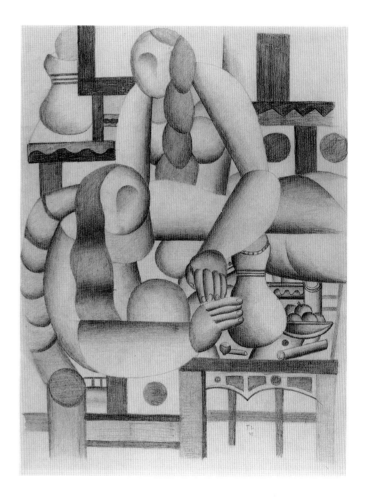

Étude pour "Le Grand Déjeuner" (Study for *Le Grand Déjeuner*), 1920
Pencil on paper. 14½ × 20¼″ (36.8 × 51.4 cm). Kröller-Müller Museum, Otterlo

Étude pour "Le Grand Déjeuner" (Study for *Le Grand Déjeuner*), 1921
Pencil on paper. 19³⁄₁₆ × 14⅜″ (48.8 × 36.5 cm). Kröller-Müller Museum, Otterlo

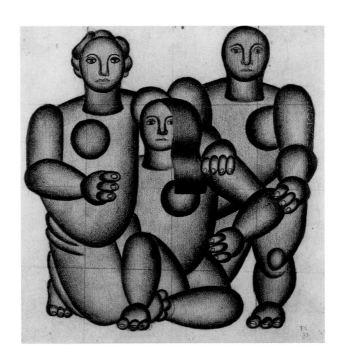

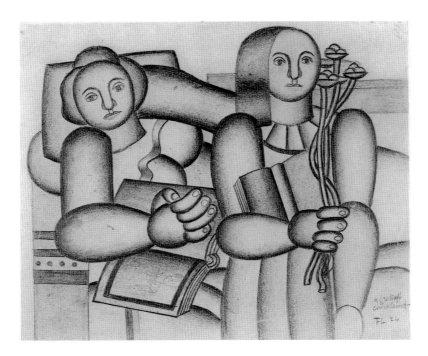

Composition aux trois femmes **(Composition with three women), 1923**
Pencil on paper. 12⅝ × 12⅝″ (32 × 32 cm). Musée d'art moderne de la Communauté Urbaine de Lille, Villeneuve d'Ascq. Gift of Geneviève and Jean Masurel

Étude pour "La Lecture" **(Study for *Reading*), 1924**
Pencil on paper. 9¹/₁₆ × 12⅝″ (23 × 32 cm). Musée national d'art moderne–Centre de création industrielle, Centre Georges Pompidou, Paris. Gift of Louise Leiris (Paris), 1986

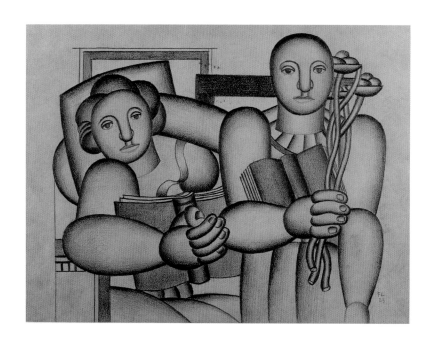

***Étude pour "La Lecture"* (Study for *Reading*), 1923**

Pencil on bister paper. 10⅝ × 14⁹⁄₁₆″ (27 × 37 cm). Musée d'art moderne de la Communauté Urbaine de Lille, Villeneuve d'Ascq. Gift of Geneviève and Jean Masurel

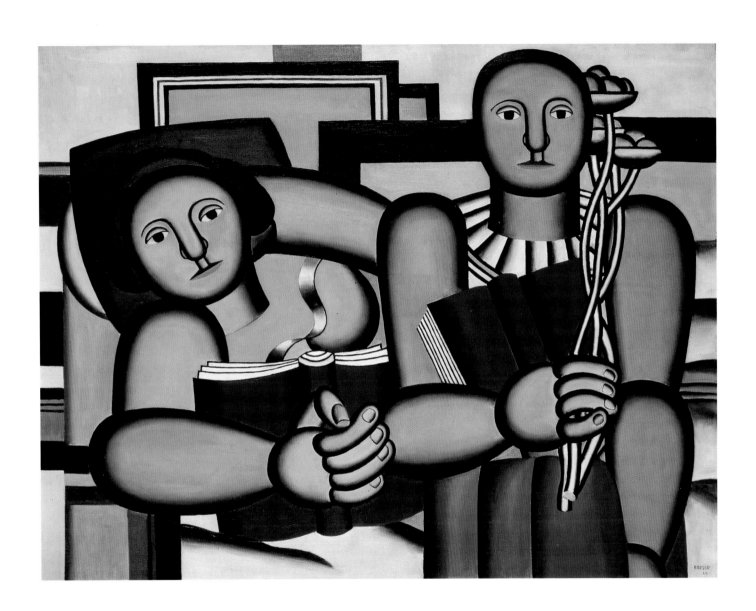

La Lecture (Reading), 1924

Oil on canvas. 44⅞ × 57½" (114 × 146 cm). Musée national d'art moderne–Centre de création industrielle, Centre Georges Pompidou, Paris. Bequest of Eva Gourgaud, 1965

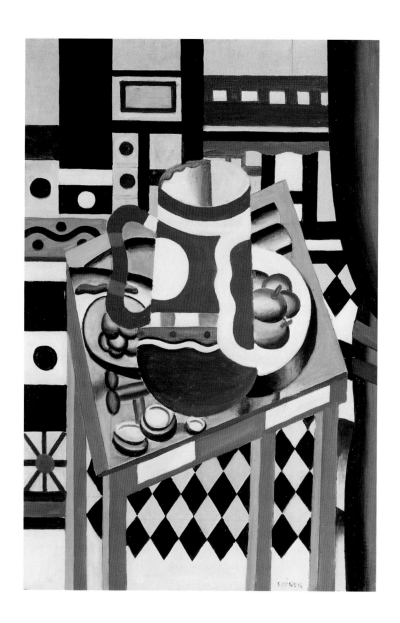

Nature morte à la chope (Still life with a beer mug), 1921–22

Oil on canvas. 36¼ × 23⅝″ (92.1 × 60 cm). Tate Gallery, London. Purchased with assistance from the Friends of the Tate Gallery, 1976

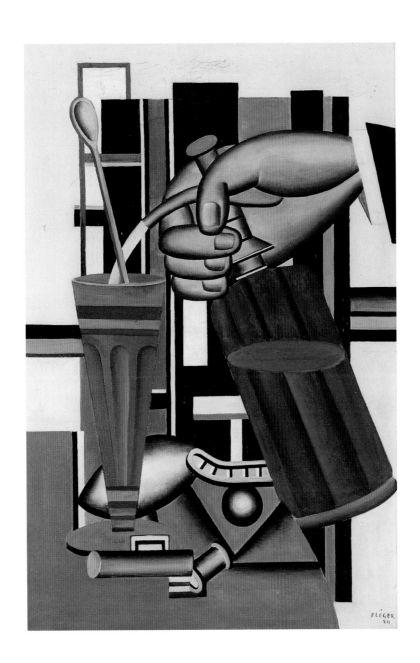

Le Siphon (The syphon), 1924
Oil on canvas. 35¹³⁄₁₆ × 23⅝" (91 × 60 cm). Collection Rafael Tudela Reverter, Caracas

***Éléments mécaniques* (Mechanical elements), c. 1924**

Pencil on paper. 12⁹⁄₁₆ × 9⁷⁄₁₆″ (31.9 × 24 cm). Musée national d'art moderne–Centre de création industrielle, Centre Georges Pompidou, Paris

***Les Éléments mécaniques* (Mechanical elements), 1923**

Pencil on paper. 11½ × 9½″ (29.2 × 24.2 cm). Private collection

Élément mécanique (Mechanical element), 1924

Oil on canvas. 57½ × 38¹⁄₁₆″ (146 × 97 cm). Musée national d'art moderne–Centre de création industrielle, Centre Georges Pompidou, Paris. Bequest of Eva Gourgaud, 1965

Élément mécanique (Mechanical element), 1924
Oil on canvas. 38⅛₆ × 51⅛₆″ (97 × 130 cm). Kunsthaus Zürich

Composition, 1923–27
Oil on canvas. 50½ × 38¼″ (128.3 × 97.1 cm). Philadelphia Museum of Art. A. E. Gallatin Collection

1925–1932

The Monumental Object and Objects in Space

Should the street be considered as one of the fine arts? Perhaps, but in any case,
the present element, the central element of the street, is the object rather than the poster,
which fades into a secondary position and disappears. . . . [The object] belongs to the realm
of pure plasticity, the sculptural and constructive realm. . . . The detail isolated
and enlarged a thousand times. . . . This aesthetic of the isolated object.
—Fernand Léger, "The Street: Objects, Spectacles," 1928

Cinema gives "the fragment" personality; it sits in a frame, and thereby creates a
"new realism" whose implications may be incalculable. ¶A collar button, put under the
projector, magnified a hundred times, becomes a radiating planet. A brand-new lyricism
of the transformed object comes into the world.
—Fernand Léger, "Speaking of Cinema," 1931

I made the objects in space so as to be sure of my objects. I sensed that I could not put
my object on a table without diminishing its value as an object.
—Fernand Léger, 1954

In his essay "*Ballet Mécanique*," written around 1924, Léger remarked that "machines and fragments of them . . . ordinary manufactured objects . . . [are] the current plastic problem."[1] This was not, of course, a new idea for him, but he was beginning to act on it in a new way, combining techniques of close-up, fragmentation, and montage borrowed from cinema with, at least early on in these years, a sense of exactness, stillness, and harmony influenced by Purism. Through these techniques he arrived at what he called a "new realism"—"the event of objectivity as a very new contemporary value."[2] By "objectivity" Léger seems to refer to the display of familiar objects in an unfamiliar way that demands a fresh perception of them from the viewer. To cite visual devices producing this effect, Léger turned to cinema: "A herd of sheep walking, filmed from above, shown straight on the screen, is like an unknown sea that disorients the spectator. ¶That is objectivity. ¶The thighs of fifty girls, rotating in disciplined formation, shown as a close-up—that is beautiful and that is objectivity."[3]

The distortions of the "actor object"[4] in the *Ballet mécanique* film, dependent on the dynamic motion of cinema, found counterparts in the static plastic distortions of Léger's paintings. In *L'Accordéon* (The accordion, 1926), the isolated instrument becomes a near-architec-

tural motif of flat colored planes and purposeful line. Largely vertical forms are balanced by a taut rendition of the instrument's horizontal array of valves. A tube of blue has a metallic shimmer that contrasts with the solidity of the bright orange and red planes. Curved elements create a tension with the picture's straight and right-angled lines, so that, for example, the straight yellow bar broken by a row of small black rectangles has undulating edges, and plays against the arc of thick black and white lines on the right and against the round-cornered blue piping to the left.

While *Le Mouvement à billes* (Ball bearings, 1926) depicts a greater number of objects than does *L'Accordéon*, it is nevertheless more radically simplified. For one, it abandons the background of vertical colored planes seen in *L'Accordéon*. Instead, the objects sit in a gray field framed by a black outline (the latter preserved from the other work). Planar elements do appear here, but now they are integrated into the arrangement of objects, so that they in effect become objects themselves; the vertical black rectangle, for example, may not be readily identifiable, but the fact that the red vessel seems to sit behind it gives it an object's presence. And the ring of ball bearings hanging in front of this rectangle sets it back in the picture space, reinforcing its innate tendency toward visual recession. The objects have lost machinery's intricacy; meticulously placed, they are represented frontally in a stabilized, montagelike arrangement. The manipulation of scale preserves the architectonic stature of the piece. There is no narrative in this painting: "The object by itself is capable of becoming something absolute, moving, and dramatic."[5] This is underscored by the disjunctive variety of the painting's collection of objects (a ball-bearing movement, a vessel or vase, a shaped post or baluster, and the keys of a typewriter), which bear no utilitarian relationship to each other.[6]

In *Ballet mécanique*, Léger had discovered that he could use movement to create cinematic analogies to the formal contrasts of painting: "Thanks to the camera, I then made objects move that [normally] never do, and I saw that they took on an objective meaning; but it was an objectivity in movement as opposed to the fixed objectivity of painting which asserts itself by means of contrast."[7] *Composition à la main et aux chapeaux* (Composition with hand and hats, 1927) moves in the reverse direction, adapting cinematic movement to painting through serial repetitions of motifs—hats, bottles, spoons, and life-belt-like rings. (Some of these forms also appear in *Ballet mécanique*.) In addition the painting uses a variety of modes of representation: the three hats set one above the other on the band of blue to the left are perceptually equivocal, moving between flatness and contradictory readings of volume (are we looking at their protruding tops or at their sunken interiors?), while the gray bowler near the bottom edge is more representationally developed, and recognizably domed—yet there is little or no modeling to suggest three-dimensionality.

Human body parts are equally inconsistent: the disembodied hand holding the bowler is delicately modeled, the profile is rigid and immobile. Discussing film, Léger was to write, "From the dramatic viewpoint, a single hand which slowly appears on the screen and reaches

toward a revolver is more dramatic than if one beholds the whole actor."[8] *Composition à la main et aux chapeaux*, then, shows body parts detached from the body. As pictorial elements, they are more or less equal in importance to the other objects in the painting; the large profile may be central in the canvas, but it shares that space with a pipe, the black plane, and the pair of rings. "In contemporary modern painting," Léger argued, "the object must become the *leading character* and dethrone the subject. Then, in turn, if the person, the face, and the human body become objects, the modern artist will be offered considerable freedom."[9] In the painting of earlier eras, the body would have been likely to have a certain compositional centrality; here, represented as a fragment, it becomes just one object among many.

In *Nu sur fond rouge* (Nude on a red background, 1927), Léger replaces the machine in his 1924 *Élément mécanique* (Musée national d'art moderne) with an isolated, neoclassical female figure that retains the mechanical plasticity of the earlier piece. (There is a precedent for this approach in the *Nus sur fond rouge* of 1923, not in the present exhibition.) Where the *Three Women* of 1921 had set its female figures in a recognizable room, Léger's work of the second part of the decade more frequently eliminates all traces of architectural or other context. *La Feuille de houx sur fond rouge* (Holly leaf on red background, 1928), *Feuilles de houx* (Holly leaves, 1930), and *Les Troncs d'arbres* (Tree trunks, 1931) feature similarly neutral grounds, but here vegetal forms replace human ones. The buoyancy of these leaves and trees hovering in space distinguishes them from the apparently weighty body in *Nu sur fond rouge*, while the lack of spatial foundation enhances their "objectivity." The figures in *La Danse* (The dance, 1929) are similarly airborne, and subtle modeling articulates the flesh, linking the figures to the airy shaded patches punctuating the translucent gray background. Further enlivening this gravely comic dance are the uncoiling flower and the floating cloth, the odd, almost prehensile heaviness of which in no way seems to impede the graceful progress of the apparently preoccupied and levitating duo. When multiple objects and abstract forms are depicted, the sense of movement is created by the compositional play between them, as in *Composition* (1930).

Léger's democratic approach to his motifs, his refusal of familiar compositional or thematic priorities and hierarchies, reaches an apex in *La Joconde aux clés* (Mona Lisa with keys, 1930):

One day I had painted a bunch of keys on a canvas. They were my own. I had no idea what I was going to place next to them. I needed something absolutely different from the keys. When I had finished working I went out. I had hardly gone a few steps when what did I see in a shop window? A postcard of the Mona Lisa! I understood at once. What could provide a greater contrast to the keys? She was what I needed. And that's how the Mona Lisa came into the picture. And following this I added a tin of sardines. It all added up to the sharpest possible contrast.[10]

Léger's appropriation of Leonardo's famous painting, then, responded to a desire for "contrast" rather than any feelings of respect or affection: "As far as I am concerned the Mona Lisa is an

object like any other."[11] Yet this claim of neutrality may have been a little disingenuous, for as we have seen, the artist was critical of Renaissance art, which, he said, "is considered by the whole world as an apogee, a summit, an ideal to strive for. . . . *This is the most colossal error possible.* The sixteenth century is a period of nearly total decadence in all the plastic areas."[12] And if the mechanically produced postcard from which Léger worked must already have looked quite different from the painting in the Louvre, he pushes the discrepancy farther: his Mona Lisa lacks the landscape environment of Leonardo's, and the detailed articulation of the clothing—not to mention the fact that her skin is greenish in tone, she no longer looks the viewer in the eye, and, of course, she is not smiling.

Perhaps, though, Léger's borrowing is not so much disdainful in itself as a reflection of the state of images in the modern world: the postcard he stumbled on, and reproductions like it, had already rendered the Mona Lisa banal. Over a decade earlier, Marcel Duchamp, in *L.H.O.O.Q.* (1919), had suggested that a mass-produced print of the Mona Lisa image might appear as a somewhat impertinent substitute for the time-honored painting. Léger, on the other hand, desacralizes not painting itself but only certain types of it. *La Joconde aux clés* is full of pictorial invention. The keys, which are painted in grisaille, are set against a midnight-blue disk, which is broken by a segment of the same orange color that hovers in amorphous clouds over the work's surface. A triangular flag on a pole, which emerges at an angle from the left, contributes steeply falling diagonals that animate the composition, as do the floating swirl of black ribbon and the vertically stacked ascending white rectangles. All of these forms, including the Mona Lisa and above her the can of sardines, are organized by a loose, fragmented grid of vertical and diagonal black lines, and appear against the vaporous clouds—black, white, and pale blue as well as orange—that almost obscure the mottled gray field.

An echo of Surrealism, a strong force in the Paris avant-garde of the 1920s, might seem to appear in the unexpectedness of the juxtapositions in *La Joconde aux clés*, but as we have seen, Léger aimed for a "new realism" rather than the kind of exploration of the unconscious pursued by the Surrealists. It was a realism combining not just the abstract and the representational but several different modes of the representational, from the modeled but stylized keys, painted in tonalities of black and white, to the brightly colored, simply rendered can of sardines (perhaps evoking a "primitive" style), to the sophistication symbolized by the Mona Lisa—or rather by its printed permutation, a reference to yet another register of reproduction. The combination of these various modes reflects the artist's growing interest in the aesthetic tastes of working people. As he had said in 1923, "It is necessary to distract man from his enormous and often disagreeable labors, to surround him with a pervasive new plastic order in which to live."[13] In the works he would produce in the following decade, Léger would try to establish this popular "new plastic order."

Le Miroir (The mirror), 1925
Oil on canvas. 51 × 39¼″ (129.6 × 99.6 cm). The Museum of Modern Art, New York. Nina and Gordon Bunshaft Bequest, 1994

L'Accordéon (**The accordion**), 1926
Oil on canvas. 51⅛ × 35⅟₁₆″ (130.5 × 89 cm). Stedelijk Van Abbemuseum, Eindhoven

Parapluie et chapeau melon (Umbrella and bowler), **1926**
Oil on canvas. 51¼ × 38¼″ (130.1 × 98.2 cm). The Museum of Modern Art, New York. A. Conger Goodyear Fund, 1959

Composition à la main et aux chapeaux (Composition with hand and hats), 1927
Oil on canvas. 97⅜ × 72¹³⁄₁₆″ (248 × 185 cm). Musée national d'art moderne–Centre de création industrielle, Centre Georges Pompidou, Paris

Le Mouvement à billes (Ball bearings), 1926
Oil on canvas. 57½ × 44⅞" (146 × 114 cm). Öffentliche Kunstsammlung Basel, Kunstmuseum. Gift of Dr. h.c. Raoul La Roche

Composition, **1930**

Oil on canvas. 57¼ × 38⅛″ (146.7 × 96.9 cm). Private collection, New York

Étude de draperie **(Study of drapery), 1930**
Pencil on paper. 10⅝ × 8¼″ (27 × 21 cm). Musée national d'art moderne–Centre de création industrielle, Centre Georges Pompidou, Paris

La Ceinture **(Belt), 1930**
Pencil on paper. 10⁷⁄₁₆ × 7¹⁄₁₆″ (26.5 × 18 cm). Private collection. Gift to the City of Belfort, France

Silex blanc sur fond jaune (White flint on yellow background), 1932
Gouache and ink on paper. 20⅟₁₆ × 27¹⁵⁄₁₆″ (51 × 71 cm). Private collection. Gift to the City of Belfort, France

Les Deux Silex, or *Silex jaunes sur fond beige* (Two flints, or Yellow flints on beige background), 1932
Gouache and ink on paper. 19⁵⁄₁₆ × 26⅛″ (49 × 67 cm). Private collection. Gift to the City of Belfort, France

***Feuilles de houx* (Holly leaves), 1930**
Oil on canvas. 36¼ × 23⅝" (92 × 60 cm). Private collection. Gift to the City of Belfort, France

La Feuille de houx sur fond rouge (Holly leaf on red background), 1928
Oil on canvas. 36¼ × 25⁵⁄₁₆″ (92 × 65 cm). Private collection, Paris

Les Troncs d'arbres **(Tree trunks), 1931**

Oil on canvas. 36¼ × 25⁹⁄₁₆″ (92 × 65 cm). Private collection. Gift to the City of Belfort, France

Nu sur fond rouge (Nude on a red background), 1927

Oil on canvas. 51¼ × 32″ (130.1 × 81.4 cm). Hirshhorn Museum and Sculpture Garden, Smithsonian Institution, Washington, D.C. Gift of Joseph H. Hirshhorn Foundation, 1972

La Danse (The dance), 1929

Oil on canvas. 50¹³⁄₁₆ × 35⁷⁄₁₆″ (129 × 90 cm). Fonds national d'art contemporain, Ministère de la Culture, Paris. Dépôt au Musée de Grenoble

La Joconde aux clés (**Mona Lisa with keys**), **1930**
Oil on canvas. 35¹³⁄₁₆ × 28⅜" (91 × 72 cm). Musée national Fernand Léger, Biot

1932–1940

The Grand Subject

The human body is of no weightier plastic interest than a tree, a plant, a piece of rock,
or a pile of rope. It is enough to compose a picture with these objects, being careful to choose those
that may best create a composition. . . . There is neither an abstract picture nor a concrete one.
There is a beautiful picture and a bad picture. There is the picture that moves you and the one that
leaves you indifferent. . . . If I isolate a tree in a landscape, if I approach that tree, I see that
its bark has an interesting design and a plastic form; that its branches have dynamic violence which
ought to be observed; that its leaves are decorative. Locked up in "subject matter," these
elements are not "set in value." It is here that the "new realism" finds itself.
—Fernand Léger, "The New Realism," 1935

It is possible for us to create and to realize a new collective social art; we are merely waiting
for social evolution to permit it. . . . leisure . . . is the cardinal point of this discussion. . . . At no
period in the history of the world have workers had access to plastic beauty, for the reason that they
have never had the necessary time and freedom of mind. Free the masses of the people, give them
the possibility of thinking, of seeing, of self-cultivation—that is all we ask; they will then be
in a position to enjoy to the utmost the plastic novelties that modern art has to offer.
—Fernand Léger, "The New Realism Goes On," 1936

A growing ambition of Léger's in the 1930s was the development of pictorial values that would lend themselves convincingly to a popular art. This desire was influenced by French and American debates around the relationship of aesthetics to politics and society.[1] "*New-York vu par F. Léger,*" for example, an essay Léger published after his first visit to New York, in 1931, reveals his socially concerned eye by commenting on the stratification he saw in that city's enclaves of rich and poor.[2]

Although Léger admired and was fascinated by the industrially produced objects, the billboards, and so on, of "low culture" (as opposed to the fine arts of painting and sculpture), as time passed he made less use of them in his paintings. Instead he focused increasingly on the human figure and organic forms, and with these on what he called the "grand subject."[3] By "grand subject" Léger meant the use of a legible iconography that would appeal to the masses, combined with a plastic autonomy meant to reeducate them in visual terms. Despite his desire for an art that could reach a wide audience, he did not want to phrase his "grand subjects" in any of the pictorial languages then broadly popular (Social Realism and its American counter-

parts, for example), nor did he favor heroicizing or propagandistic painting. In fact he wanted to deny his images any subject or story as popularly understood, for it was the pictorial shell that was crucial to him: "We must master the subject in painting. The painting must emerge, not the subject. . . . if we use a subject without painting, the result will be a poor illustration, not a painting; it will be a story, not a painting; it will be literature, not painting. Painting must not be neglected; painting first, then the subject."[4]

What would make a purely pictorial art popular, Léger believed, would be its possession of a "plastic beauty"[5] that could provide the masses with a sort of aesthetic relief. Art, he optimistically thought, could offer the working man a refuge from the speed of modernity and the toils of labor.[6] Indeed three major paintings from this period, all recombining the same or similar motifs, display an equanimity, a purposely tranquil cadence, in contrast with Léger's earlier investigations of the urban and technological rhythms of modernity. He wrote in 1937,

Speed is the contemporary law. It flows over us and dominates us; this is a transitional era; let us accept it as it is.

But let us recognize that a new plastic life is born out of this chaos. A new order is trying to emerge. . . . In this fast-moving and complex life that shoves us around, slices us up, we must have the strength to remain unhurried and calm, to work beyond the disintegrating elements that surround us, to conceive of life in its unhurried and peaceful sense. . . . The natural phenomenon or the beautiful object cannot be copied; the artist must make something as beautiful as nature.[7]

Art thus had a certain degree of autonomy from society: "A free way must always be left for artists. This way is the one that leads toward Beauty—toward the work of art that is above social and economic battles."[8] Even as Léger's political activity increased during the course of the decade—in the mid-1930s he aligned himself with the French political party the Front Populaire—he would attempt to abide by this dictum.[9] Through these ideas Léger arrived at the idea of a "new realism," a term he had used in the 1920s but through which he now tried to combine his artistic and political inclinations more forcefully.

Composition aux trois figures (Composition with three figures, 1932) extends Léger's concern with the human figure as a monumental form. Three women, depicted in firm frontality, stand in a columnlike group to the left; a fence or ladder, a rope, and an abstract, elongated, cloudlike form appear to the right. The contours of these elements, for the most part organically rounded but for the geometric posts of the fence, resonate in rhyming curves throughout the canvas. Where works from the preceding period of Léger's art—*La Danse* of 1929, for example—might set the figures floating against their grounds, the women in *Composition aux trois figures* have a classical robustness and weight, and although we cannot see their feet, which the edge of the canvas crops out, they seem stable and firmly rooted. The women's uplifted arms tell us that they are not at rest, but they seem to be holding a pose rather than caught in motion. Machinery and its products are gone; in their place are older, even ancient

kinds of artificial objects—the rope and the wooden fence in the painting's right half. The shape of the cloudlike form, which is almost as weighty and earthbound as the other elements, mirrors, on a larger scale, the shape of the flowering branch held by the lowest figure, serving to link the human and the inanimate halves of the picture. Even so, the lack of interaction between these two halves denies any strong suggestion of narrative. So, too, does color, as Léger places the elements against a yellow ground that is itself a plastic presence rather than a rendering of a natural environment. As such, color, considered like an object, helps provide the freedom of plastic contrast demanded by Léger's "new realism": "Color has a reality in itself, a life of its own."[10]

Unlike earlier works by Léger, with their machinery, mechanics, and soldiers, *Composition aux trois figures* lacks any contemporary specificity. Nude, the figures are timeless. They are also rendered with a certain deliberate naïveté, for example in the simplicity of their anatomical construction. This is perhaps accounted for by Léger's interest in the "primitive" or pre-Renaissance epochs of art history: "I was attracted to Romanesque sculptures, to the completely reinvented figures and the freedom with which the Romanesque artist constructed them. He does not copy, he creates, in a totally anti-Renaissance fashion. I can say that in Romanesque sculpture I have found a starting point for distortion."[11] The "primitive" was for Léger a source of visual tools by which a popular contemporary art could distinguish itself from art in the Renaissance tradition, which was steeped in "individualism."[12] The "distortion" that he saw in Romanesque sculpture allowed him to use the human figure—an easily recognizable element of wide appeal—without resorting to narrative.

In *Composition aux deux perroquets* (Composition with two parrots, 1935–39), Léger depicts recognizably contemporary clothing, and the idiosyncratic inclusion of the parrots might also have a vernacular appeal. He considered this painting one of his most important; in 1942, he would say, "If I look back to my work, three major pictures are dominating all of it. *La Ville*, *Le Grand Déjeuner*, and *Composition aux perroquets* [sic]."[13] The painting multiplies the elements of *Composition aux trois figures* while maintaining the earlier work's compositional armature. Four figures now occupy the left half of the canvas, two women rendered in flesh tones, a man and a woman in grisaille. The dancing or acrobatic poses of the women recall the circus, a type of popular entertainment Léger greatly admired. The blue cloud, fence, and rope are also held over from the earlier picture. The fence now seems more firmly grounded in the earth, and the rope has been displaced from it by a pliant but weighty pink cloth, which echoes the flowing heaviness of the figures. In the left half of the painting, only the two poles on the ground seem subject to a gravitational pull; the figures themselves appear suspended within the vaporous mottled background. The two halves of the painting are less rigorously separated than before: a piece of rope now seems to cross over to the left half, where it wraps itself around one of the women, and the blue cloud too has been repositioned horizontally to conjoin left and right. Where the stalk of flowers in *Composition aux trois figures* had been

plucked from the ground, in this work a flower emerges forcefully from the rocks at the base of the fence, suggesting the vigor of nature.

Exhibited in 1940–41 at The Museum of Modern Art, *Composition aux deux perroquets* was described as "a new mural painting."[14] Indeed the large size of this and other canvases of the period demonstrates Léger's interest in mural painting, which he considered the "collective art of tomorrow."[15] In 1935 and 1937 he designed murals for expositions in Brussels and Paris respectively, and he also sought mural commissions during his trips to the United States in 1935–36 and 1938–39, completing projects for Nelson Rockefeller and for Wallace K. Harrison's Consolidated Edison Building at the 1939–40 World's Fair. Léger wanted his paintings to be a "collective," public experience,[16] and he saw large-scale mural art as offering important possibilities in this respect. He was also interested in the mural's interaction with the architectural setting. In 1933, he talked of how the "imposing plastic mass" of Romanesque and Gothic cathedrals had "stirred and held man in past centuries. Let's consider them, their planes and their surfaces: color and sculptural form simultaneously achieved beauty and a collective meaning."[17]

Working on *Adam et Ève* (Adam and Eve, 1935–39) during the same years that he produced *Composition aux deux perroquets*, Léger aimed for more compositional and thematic tension between the organic and the human elements. The positions of figures and inanimate forms are reversed from the larger work, the two figures moving to the right-hand half of the canvas, the fence and cloth to the left. The bottoms of both fence and figures are cropped by the picture's lower edge. The cloth draped over the fence has been given a stronger sense of volume and colored the deep blue of the clouds above, as if they might hang on a fence as easily as the piece of fabric does. The extremely energetic plant held by the woman symbolizes Léger's belief in the power of color; in an essay of 1938 he wrote, "Color is a vital necessity. It is raw material indispensable to life, like water and fire. Man's existence is inconceivable without an ambience of color." He went on to discuss the colors of the countryside in the years before World War I, the colorlessness of the war years, and the cacophonous palette of modern advertising, billboards, and commodities. The painter now must "organize this whole riot of colors"[18]—precisely what Léger does in *Adam et Ève* and *Composition aux deux perroquets*, through the natural motifs of the parrots, the plants, and even Adam's snake, which suggests the artist's daydream of a "sea serpent, a hundred yards long, luminous and colored," emerging from the water during an ocean voyage.[19]

Where other paintings of Léger's deny any easy narrative reading, *Adam et Ève* is linked, of course, to the story of Adam and Eve. Yet the drama of the tale is minimized; it is only the title, the snake, and the applelike tattoo that clue us in. "I am taking up a grand subject," Léger remarked, "but, I repeat, my painting is still object-painting. . . . My figures continue to grow more human but I keep to the plastic fact, no eloquence" and, he added, perhaps a little self-deceptively, " . . . no romanticism."[20]

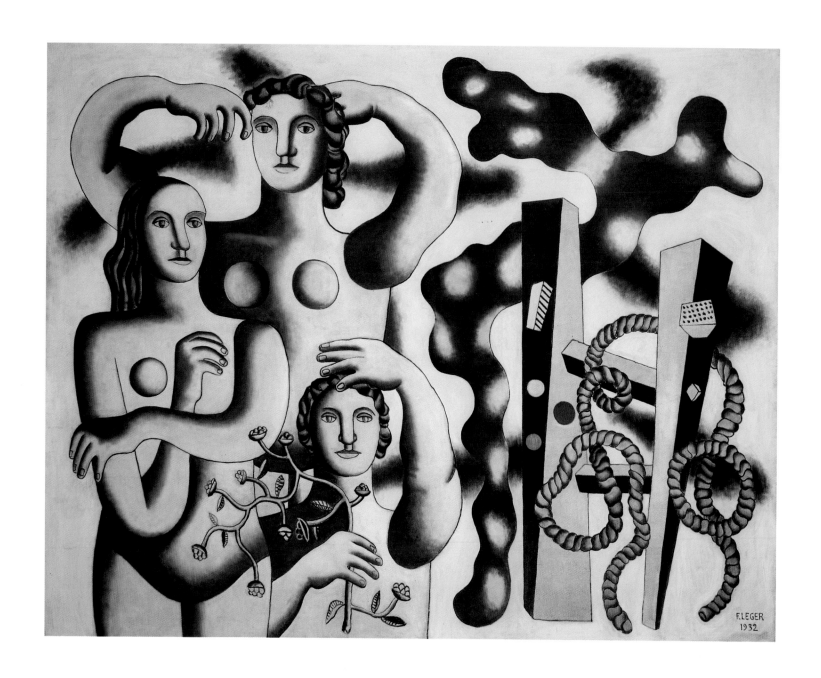

Composition aux trois figures (**Composition with three figures**), 1932
Oil on canvas. 71⅝ × 90⁹⁄₁₆″ (182 × 230 cm). Musée national d'art moderne–Centre de création industrielle, Centre Georges Pompidou, Paris

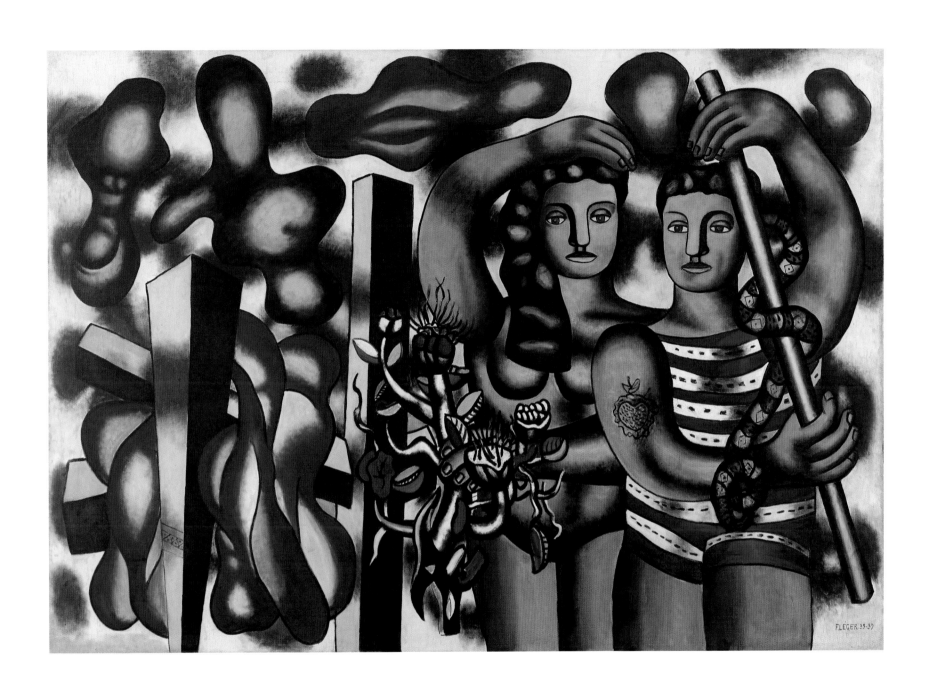

Adam et Ève (Adam and Eve), 1935–39

Oil on canvas. 7'5¼" × 10'7¼" (228 × 324.5 cm). Kunstsammlung Nordrhein-Westfalen, Düsseldorf

Pied et mains (Foot and hands), 1933

Pen and ink on paper. 12¼ × 9¾" (32.4 × 24.8 cm). The Museum of Modern Art, New York. Purchase, 1935

Les Deux Mains (Two hands), 1933

Ink on paper. 11¹¹⁄₁₆ × 14¹³⁄₁₆" (29.7 × 37.7 cm). Öffentliche Kunstsammlung Basel, Kupferstichkabinett. Karl August Burckhardt-Koechlin Fund

Cordage et quartier de bœuf (Rope and quarter of beef), 1933
Ink on paper. 14¹¹⁄₁₆ × 12⅜″ (37.3 × 31.5 cm). Musée national d'art moderne–Centre de création industrielle, Centre Georges Pompidou, Paris

Serrure (Lock), 1933
Ink on paper. 13 × 15⅜″ (33 × 39 cm). Musée national d'art moderne–Centre de création industrielle, Centre Georges Pompidou, Paris

Composition aux deux perroquets **(Composition with two parrots), 1935–39**

Oil on canvas. 13′1½″ × 15′11⁵⁄₁₆″ (400 × 486 cm). Musée national d'art moderne–Centre de création industrielle, Centre Georges Pompidou, Paris. Gift of the artist, 1950

1940–1945

The Years in America

During these years in America I do feel I have worked with a greater intensity and achieved more expression than in my previous work. In this country there is a definitely romantic atmosphere in the good sense of the word—an increased sense of movement and violence. . . . I prefer to see America through its contrasts—its vitality, its litter and its waste. . . . What has come out most notably . . . in the work I have done in America is in my opinion a new energy— an increased movement within the composition.

—Fernand Léger, in James Johnson Sweeney, "Eleven Europeans in America," 1946

Léger spent the first half of the 1940s as an exile in the United States, during the German Occupation of France.[1] Unlike his drawings and a few paintings from World War I, when he was actually a witness to the fighting, his work of this period did not address the war. Fascinated by America's "unbelievable vitality. . . . You must go fast—there is no time to lose," Léger allowed that the "intensity of contrasts of movement" in the United States was what he had "tried to express in painting."[2] Yet he also felt that America had simply brought to fruition issues he had been addressing throughout his career: "My work," he argued, "continues and develops completely independently of where I happen to be located geographically," for "the work of art is the result of an interior state. . . . Perhaps the rhythm or the climate of New York enables me to work faster. That's all."[3] More particularly, Léger saw his work of these years as the continuation of a development of "figures in space" begun in the mid-'30s with *Composition aux deux perroquets*.[4]

In 1940, while waiting in Marseilles for passage to New York, Léger had spent some time watching swimmers, and was captivated. This was the beginning of his *"Plongeurs"* (Divers) series, which was further sparked by the "contrast of movement" he found in the United States:

In 1940 I was in Marseilles, when I worked on the *Divers*, five or six men diving. . . . I left for the United States and then one day I went to a swimming pool. . . . It was no longer five or six divers, it was two hundred at once. It was impossible to tell whose head, leg, and arm belonged to whom. One could no longer distinguish. So then I mixed the limbs in my picture together and understood that in this way I was much closer to the truth than Michelangelo when he occupied himself with every individual muscle. . . . The figures painted in the Sistine Chapel don't fall, they stay put. . . . One can distinguish their toenails. I assure you that when those fellows in Marseilles jumped into the water I had no time to observe the details, and my divers really fall.[5]

In *Les Plongeurs sur fond jaune* (Divers on a yellow background, 1941) and *Les Plongeurs* (The divers, 1941–42), however, the central mass of intertwined, organically rendered figures and body parts appears less controlled by gravity's downward pull than hovering within an indeterminate atmospere. Léger felt that these works reflected his effort "to translate the character of the human body . . . [moving] in space without any point of contact with the ground."[6] The vertiginous figures are further activated by careful modeling and variations in scale, and their sinuous curves resonate in rhythmic interplay with flat, free-floating, biomorphically shaped planes of color. Léger arranges these elements so as to heighten their contrast: "To achieve a maximum of power, even violence, on a wall; that is my ultimate aim. . . . The only way I can achieve this power is through unrelenting application of the most absolute contrasts: planar elements in pure colors, modeled elements in grisaille, realistic objects."[7]

The works of the "*Plongeurs*" series stand as emblems of physical energy, sensation, and pleasure. Another theme that emerges clearly in certain of Léger's American paintings is nature's animation and vigor. In *La Forêt* (The forest, 1942), the canvas is dominated by an oblique, near-vertical blue beam, but its regular geometries compete with the elongated, sinuous organic forms entwining it, which vary rhythmically in scale and color so that they dance through the canvas. A bird contributes to the sense of an antigravitational atmosphere in which objects float. The work is resolutely organic and colorful, far from the machine-influenced, earthbound severity of the earlier forest scene *Nus dans la forêt*.[8]

Léger's interest in nature was stimulated when, in the summers of 1943–45, he vacationed on a farm he rented in northern New York State, in Rouses Point, a small French-speaking village near Lake Champlain. There he was struck by the skeletons of farm machinery abandoned in the fields, creating a contrast "of great antimelodic intensity"[9] between the mechanical and the natural:

Only the economic question counts. The dollar is king. . . . A farmer's plow meets an accident; he abandons it in the field and has another brought out. It isn't repaired, it's replaced. It isn't a matter of waste. The American has figured out that the salary of the repairer, the hours of work he's lost, the complication would cost more than simply buying a new machine. . . . I painted . . . a group of American landscapes . . . inspired by the contrast presented by an abandoned machine—become old scrapiron—and the vegetation which devours it. Nature eats it. It has disappeared, under the weeds and wild flowers. The opposition between this pile of twisted metal and the marguerites which decorate it produces a vivid charm.[10]

Léger saw New York as something of the opposite case—a nature all its own. In *La Ville* of 1919 and other paintings of the time, the artist, then living in Paris, had set out to capture the modern urban experience. But New York—the "most colossal spectacle in the world"—he thought inexpressible through painting; in 1931, he had said that "it is madness to think of employing such a subject artistically. One admires it humbly, and that's all."[11] (Léger did however believe that New York was "more suited to cinema,"[12] and in 1939 had set out to address

the city through studies for a literally cinematic mural, unfortunately unrealized, in which his images were to be projected onto a white marble wall at Rockefeller Center.[13]) New York might lack natural elements—it "has no trees," he had told his French audience—but it had its own "natural beauty, like the elements of nature; like trees, mountains, flowers."[14] The source of this paradoxical "natural beauty" was the city's character as a technological wonderland. Léger was particularly impressed by its neon lights, which appealed to his belief that "color is a vital necessity":[15]

It is not imaginary. It is what you see. In 1942 . . . I was struck by the neon advertisements flashing all over Broadway. You are there, you talk to someone, and all of a sudden he turns blue. Then the color fades—another one comes and turns him red or yellow. . . . the color of neon advertisement is free: it exits in space. I wanted to do the same in my canvases. . . . I could never have invented it. I am not capable of such fantasies.[16]

In *Adieu New York* (Good-bye New York, 1946), Léger integrates this urban color with both natural and machine-made elements, rephrasing his interest in the contrast between the two. Color emancipates itself from line in this painting, acting instead as a free-floating, independent abstract agent, for example in the sideways red "T" around which the composition is organized. (Léger had experimented with this way of using color much earlier, in *La Femme en bleu* of 1912,[17] and it recalls his interest in the Impressionists, who he thought had "freed color."[18]) In 1945, however, Léger had stated that "abstract art . . . has contributed all that it can contribute."[19] In *Adieu New York*, then, he shows his abstract patches of color along with objects, usually motifs from his earlier work: a wire fence, a tree trunk, leaves, geometric beams, and abstract but cloudlike forms. To these he adds a line of neckties and a banner, resembling a piece of scrapiron, bidding Manhattan adieu. A similar sentiment appears in *Le Tronc d'arbre sur fond jaune* (Tree trunk on yellow ground, 1945), in which fragmented letters almost read "US LOVE."[20]

The lives and fates of working people were always a vital issue for Léger, as his decision to join the French Communist party in October 1945 reflects. Viewing artists and workers as natural allies, he went so far as to assert that most artists came from a "working-class or lower-middle-class background," and to liken the artist's way of "transpos[ing] objects, forms, and colors" to the people's ability to "'transpose reality'" through the vividness of their language and slang. "Society," he argued, should bring about the meeting of "these two poles"—representing the working class and artists.[21] Léger had faith in the natural discrimination of the "man of the people." "When a man of the people gets dressed," the artist once wrote, "he chooses: he chooses a blue tie or a red tie. . . . He has taste."[22]

Léger's admiration for such sartorial expression is evident in *Les Trois Musiciens* (Three musicians, 1944, after a drawing from 1924–25), in which he stresses color and decorative flourishes to the maximum by setting the painting's three entertainers against a vibrant red and yellow background that is further enlivened by the red, green, and orange of their clothes.

Léger had long been interested in how working people spend their free time, and believed that without leisure it would be impossible for them fully to enjoy art. Paintings like the *"Plongeurs"* series and *Les Acrobates en gris* (The gray acrobats, 1942–44) exemplify his interest in popular recreation. In *Les Trois Musiciens*, Léger uses the theme of public entertainment to involve his public with an exploration of pictorial form.

Much as he praised the innate taste of working people, Léger also reveled in the vulgarity he found in the United States, including the vulgarity of color:

Bad taste is . . . one of the valuable raw materials for the country. Bad taste, strong colors—it is all here for the painter to organize and get the full use of its power. Girls in sweaters with brilliant colored skin; girls in shorts dressed more like acrobats in a circus than one would ever come across on a Paris street. If I had only seen girls dressed in "good taste" here I would never have painted my "Cyclists" series, of which *La Grande Julie* . . . was the culmination.[23]

La Grande Julie (Big Julie, 1945), divided in half vertically, separates the mechanical and the figurative and gives each equal importance. On the left, the robust cyclist wears a red cap and an orange outfit, and carries a yellow flower. These colors set up a tension and balance with the black plane against which Julie stands; the plane of yellow with its abstract red cross, on the right, completes this rhythmic chromatic interplay. Meanwhile the bicycle, placed vertically and at the same height as the cyclist, is for the most part rendered with a decorative panache almost at odds with the economy and simplicity of its black and white description. Although delicate ornamentation appears in the delineation of its gears, it is largely made up of oval forms that maintain hardly any of its mechanical structure. Rather, it becomes an anthropomorphic form, seeming to twine languorously around the woman's arm: "The bicycle seems to be alive; an animal who refuses to go forward or back, a will that man must take into account."[24]

In *La Grande Julie*, Léger is far from his former depictions of the figure as merged with an industrialized urban environment. Instead, the human and the mechanical blend in entities that are predominantly organic. People are no longer shown as defined by machine culture; rather, the machine becomes the vehicle—literally and symbolically—through which access to nature, leisure, and, it follows, relief from labor is gained. From this point on, nature, leisure, and labor would be Léger's subjects. He wanted his "new realism" to be easily legible to a broad public yet rooted in the principles of pictorial contrast as deeply as any art he had previously produced.

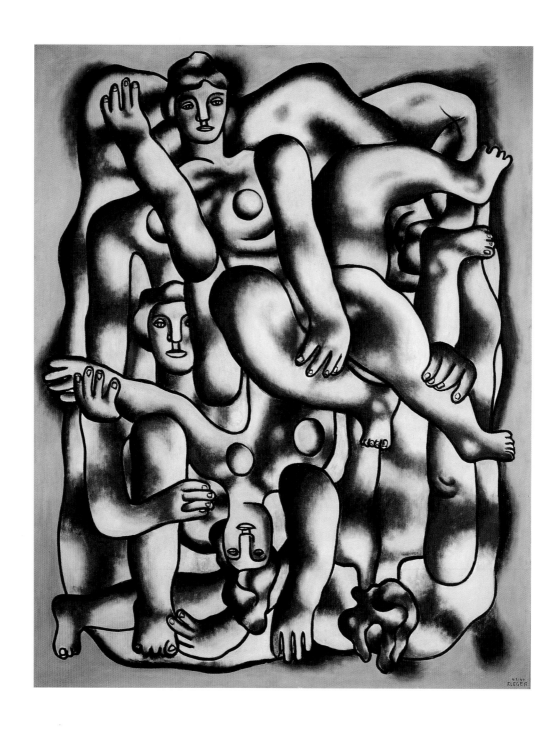

Les Acrobates en gris (The gray acrobats), 1942–44

Oil on canvas. 72¹⁄₁₆ × 57⅞″ (183 × 147 cm). Musée national d'art moderne–Centre de création industrielle, Centre Georges Pompidou, Paris. Purchased in 1981

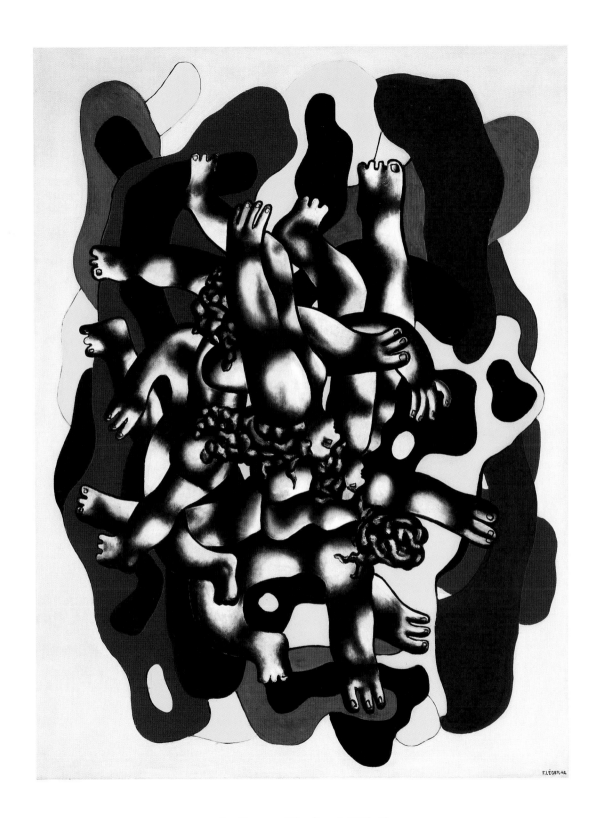

Les Plongeurs (The divers), 1941–42
Oil on canvas. 90 × 68″ (228.6 × 172.8 cm). The Museum of Modern Art, New York. Mrs. Simon Guggenheim Fund, 1955

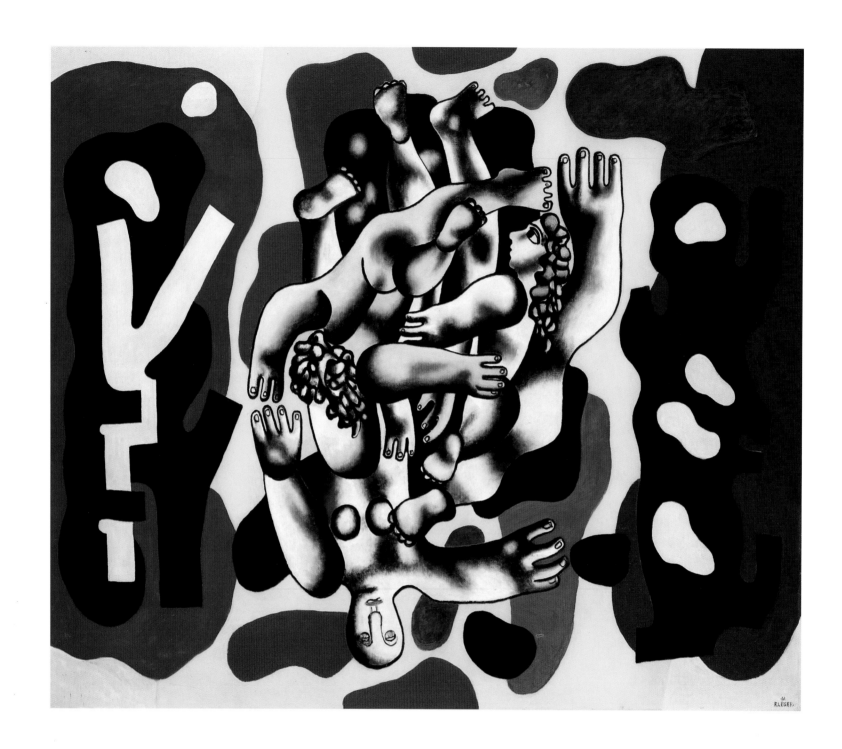

Les Plongeurs sur fond jaune **(Divers on a yellow background), 1941**
Oil on canvas. 73½ × 85¾″ (186.7 × 217.8 cm). The Art Institute of Chicago. Gift of Mr. and Mrs. Maurice E. Culberg, 1953

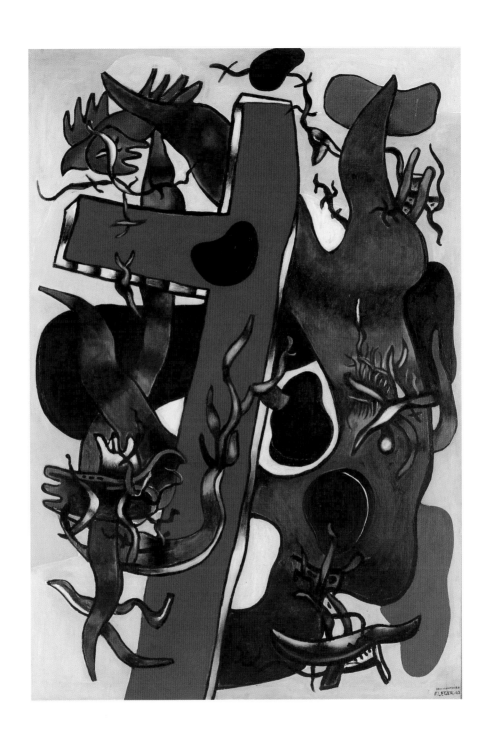

La Forêt (The forest), 1942

Oil on canvas. 71⅜ × 50″ (182 × 127 cm). Musée national d'art moderne–Centre de création industrielle, Centre Georges Pompidou, Paris

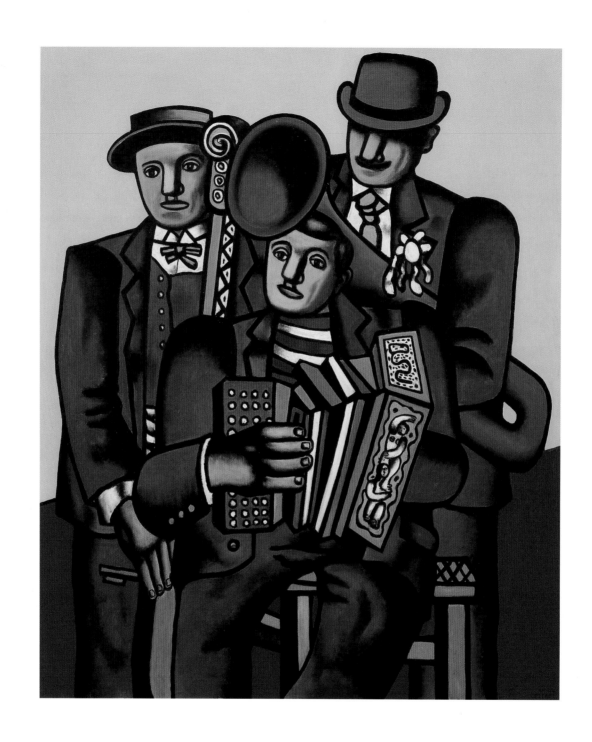

Les Trois Musiciens **(Three musicians), 1944 (after a drawing of 1924–25; dated on canvas 24–44)**
Oil on canvas. 68½ × 57¼″ (174 × 145.4 cm). The Museum of Modern Art, New York. Mrs. Simon Guggenheim Fund, 1955

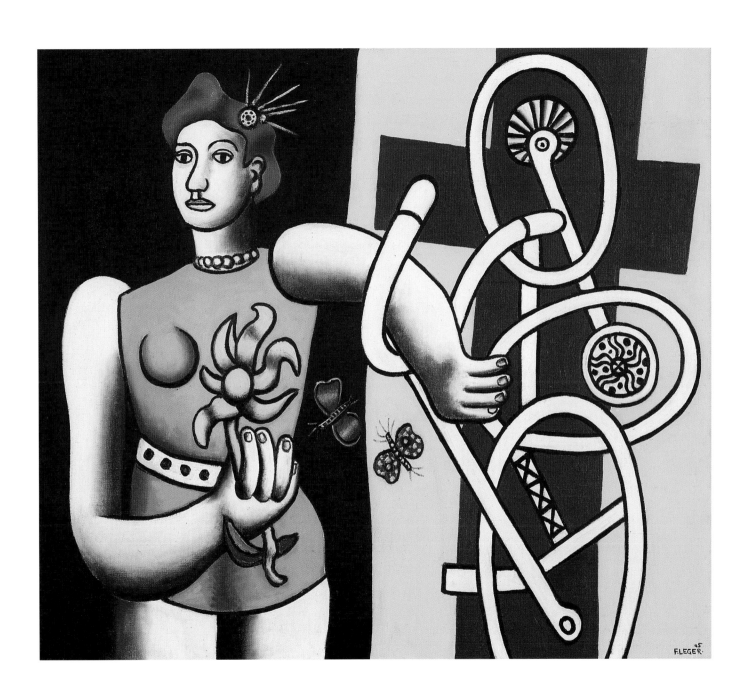

La Grande Julie (Big Julie), **1945**
Oil on canvas. 44 × 50⅛″ (111.8 × 127.3 cm). The Museum of Modern Art, New York. Acquired through the Lillie P. Bliss Bequest, 1945

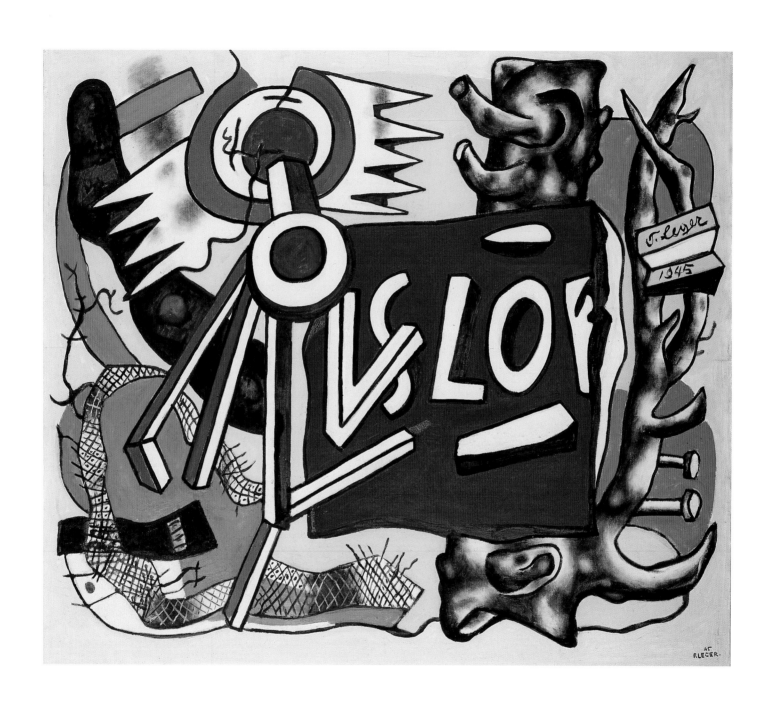

Le Tronc d'arbre sur fond jaune (Tree trunk on yellow ground), 1945

Oil on canvas. 44⅛ × 50″ (112 × 127 cm). Scottish National Gallery of Modern Art, Edinburgh

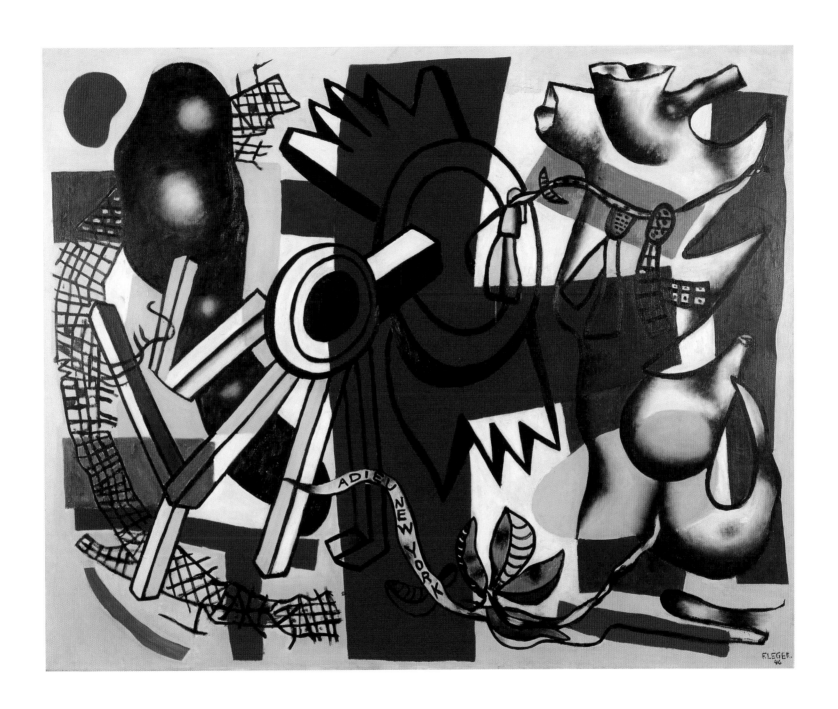

Adieu New York **(Good-bye New York), 1946**
Oil on canvas. 51 3/16 × 63 3/4" (130 × 162 cm). Musée national d'art moderne–Centre de création industrielle, Centre Georges Pompidou, Paris. Gift of the artist, 1950

1946–1955

Late Work

It is inexcusable that after five years of war, the hardest war of all, men who have been heroic actors in this sad epic should not have their rightful turn in the sanctuaries. The coming peace must open wide for them doors that have remained closed until now. The ascent of the masses to beautiful works of art, to Beauty, will be the sign of a new time.
—Fernand Léger, "The Human Body Considered as an Object," 1945

We are witnessing a return to the broad subject, which must be comprehensible to the people. ¶The people, tied down, bent over their work all day long, without leisure activities, are completely overlooked by our bourgeois epoch; that is the tragedy of today.
—Fernand Léger, "Mural Painting and Easel Painting," 1950

When depicting the human form, Léger moved back and forth over the years between creating a recognizable space and using a monochromatic or abstract background, as in *La Grande Julie*. Just a year before painting that work, for example, he had addressed the same theme of recreation in *Les Loisirs* (Leisure, 1944), this time posing six characters and two bicycles (one of them with the anthropomorphic stature of the bicycle in *La Grande Julie*) in a rural scene. The landscape, however, is reduced to essentials—a fence, a cloud, rocks, flowers—and the sky challenges the descriptive and narrative side of painting by its deep and unnatural red. The figures too are simplified, and are rendered in vivid, near-flat blocks of color. *Les Loisirs* has some of the abstract tendency of *La Grande Julie*, but it is also a genre painting, describing working-class leisure (note that the woman and child on the right wear acrobats' costumes, reflecting Léger's long-standing interest in the circus). And even while the work indicates Léger's social concerns, it recalls art history's many renderings of the same theme.

Remaking *Les Loisirs* several years later, Léger looked for inspiration to an earlier socially engaged painter, Jacques-Louis David. "Which young artist," he wrote, "is tough enough to solve pictorial problems in both human and plastic terms? . . . After having done *Le Mécanicien*, *Les [Trois] Musiciens*, *Le Grand Déjeuner*, and *La Ville*, I was often worried by the problems arising from pictures of great subjects. . . . This had been David's territory, and we have fled from it. I'm returning there, for he approached the solution to it."[1] For Léger, David's work was "an immediate art without any subtlety, comprehensible to all."[2] It also managed to be representational and narrative while maintaining "nonanecdotal" plastic values—"the application of contrasts, the pure tones and the groups of forms."[3] Léger had been introduced to David's

work probably sometime before 1910, and in 1934 he had written a performance piece (unrealized), *La Mort de Marat suivi de sa pompe funèbre*, on a subject depicted in one of David's best-known paintings, *The Death of Marat* (1793). The bicentennial of David's birth, celebrated in June of 1948, set the mood for Léger to model a picture of his own after the same work.[4]

Les Loisirs, hommage à David (Leisure, homage to David, 1948–49) obviously rephrases the earlier *Les Loisirs*, adding birds and more clouds and foliage, and making the boy in the earlier work's center a girl holding a flower. The sky, too, is now blue. But the most important change is that this time the lounging orange-clad girl in the foreground holds a paper inscribed "*Hommage à Louis David*"—a reference to *The Death of Marat*, which shows the slain leader of the French Revolution holding a letter from his murderer, Charlotte Corday, and which David also inscribed "À Marat." Given this clue, moreover, the girl's pose—seated, legs outstretched, the left arm high, the right hanging down—can now be seen as echoing David's positioning of the dead leader in his bath. *Les Loisirs, hommage à David*, then, clearly honors the explicitly political *Death of Marat*—yet it is itself only circuitously political, almost a playful parody. Replacing Marat, dead and unattended, with a vibrant young woman and her friends or family, it has none of David's morbidity; instead, it attempts "to convey general ideals such as the common welfare, equality, freedom."[5] Its critical impulse is expressed partly through its reference to a painter of revolution, but also through its subject matter—leisure—and its technique.

Léger's ennoblement of leisure in a natural surround, as a respite from labor, posits the stability of nature against the changes forced by technology. "An oak tree," he wrote in 1950, "that can be destroyed in twenty seconds takes a century to grow. . . . progress is a word stripped of its meaning, and a cow that nourishes the world will always go two miles an hour."[6] (The later *La Partie de campagne, 1er état* [The country outing, first state, 1952–53] would similarly glorify rural recreation, setting its figures in an "earthy Arcadia."[7]) As for technique, in 1950 Léger would argue that total abstraction, "freedom in art," was exhausted, and that "new subjects" had to be found. He nonetheless insisted that the "return to the subject" was possible without "destroying the abstract." "Easel painting's intensive discoveries," he wrote, "must not be abandoned—quite the opposite. ¶New subjects, envisaged with the contribution of the freedoms that previous experimentation has offered, must emerge and establish themselves."[8]

Léger still insisted on the importance of "three great plastic components: Lines, Forms, and Colors,"[9] just as he had in 1913. In 1950, he wrote,

The plastic life, the picture, is made up of harmonious relationships among volumes, lines, and colors. These are the three forces that must govern works of art. If, in organizing these three essential elements harmoniously, one finds that objects, elements of reality, can enter into the composition, it may be better and may give the work more richness. But they must be subordinated to the three essential elements mentioned above.[10]

One consequence of this argument is that in Léger's art the human form itself becomes a kind of object; depicted as volume, line, and color, it loses some of painting's potential for psycho-

logical insight, or for a sense of personal individuality. "The human figure," Léger wrote, "remains purposely *inexpressive*."[11] Thus the figures in *Les Loisirs, hommage à Louis David* are somewhat stiff, their limbs are near-autonomous appendages, and their faces receive a linear articulation that makes them rather unemotional. Color is saturated, loud, and substantial; with volume and line, it is in fact as much the work's subject as is the group of figures. There is, of course, an expressivity in *Les Loisirs, hommage à Louis David*—a mood of contentment and pleasure—and there may also be a suggestion of the family portrait.[12] Yet the pictorial manner counteracts any implication of narrative. If there *is* a narrative, it is that of Léger's relationship to David, and to the plastic traditions of French painting.

This embrace of French tradition may relate to Léger's pleasure at returning to France after World War II. In a lecture of 1946, he announced his "joy . . . in rediscovering my country. . . . I have faith in France." Yet he also noticed changes: "none of the exteriors look the same."[13] The postwar process of reconstruction was marking the nation, a theme Léger addressed in the several paintings entitled *Les Constructeurs*. Once, while traveling, he saw

three pylons for high-tension cables . . . being built along the road. Men were perched on them, working. I was struck by the contrast between them, the metallic architecture which surrounded them, and the clouds above. Lost in the rigid, hard, hostile surroundings the men appeared tiny. I wanted to render this in my paintings. . . . I evaluated the human factor, the sky, the clouds, and the metal in the most exact terms.

If I have stressed the figures of my workers more, if they are depicted with greater individualization, it is because the violent contrast between them and the metallic geometry surrounding them is of maximum intensity. . . . Modern life consists of daily contrasts. These must form part of our present outlook.[14]

Over nine feet high and seven feet wide, *Les Constructeurs, état définitif* (Construction workers, final state, 1950) reclaims the monumental scale of *Composition aux deux perroquets*. The clouds and rope of the earlier painting also remain, but replacing the isolated length of fence is an enveloping armature of girders. Men toil purposefully here, but impassively. Their rigid bodies have a constructed quality—the arms of the four workers in the foreground, for example, are almost disengaged. Further, the stripe and dot prints on two of their shirts are picked up in similar patterns in the girders. Yet their rounded forms contrast with the pylons' hard geometry. Man and metal are far more separate, in fact, than in some of Léger's earlier work, but where he once honored the machine, he now views the environment it conditions as "rigid, hard, hostile." Again he looks to nature for relief: branches lie at the men's feet. In the 1951 poem-painting *Les Mains, Hommage à Maïakovski* (Hands, homage to Mayakovsky), Léger made an overt analogy between modern workers and nature: "Their trousers are like mountains, like tree trunks." He went on, "Their hands are like the tools they use/The tools like their hands . . . They are unlike those of their bosses. . . . But the time is approaching when the machines will work for THEM/They will have hands like their employers/WHY NOT."[15] Paintings like *Les Constructeurs*, then, reflect views on not only technology but society and politics.

L'Acrobate et sa partenaire (The acrobat and his partner, 1948) and *La Grande Parade, état définitif* (The great parade, final state, 1954) return Léger to his beloved circus. Explaining the attraction, he composed a cheerful attack on the rectilinear principle in modern life, proposing as an alternative the circle: "The world is round," "everything is round," and "life is a circuit," he wrote, and "nothing," finally, "is as round as the circus."[16] Léger saw the circus as a "spectacle," a term he also used to describe "unexpected . . . daily phenomena." The city street, for example, offered an "exterior spectacle" that "shatters our nerves and drives us crazy"; to compete with it, and to "distract . . . [people] from their daily exhaustion," theater must be fast-moving, and must both erase the apparatus of stardom and eliminate the proscenium arch, joining audience and action. The circus had already achieved all this with its "'plastic passages.'"[17] Léger saw the circus as a natural wonder offering a respite from the mechanical: "The machine makes things geometric. . . . Go to the circus. Leave your rectangles, your geometric windows, and go to the country of circles in action."[18]

L'Acrobate et sa partenaire rejoices in vertiginous rotundity. The acrobat is a "human serpent . . . [a] wheel in the air."[19] His body spins before a brightly colored target, which magnifies his dizzying movement. Meanwhile a woman, a cat, and a chair stand stationary, fulfilling Léger's enduring principle of pictorial contrast. A beam and a girderlike form provide vertical stability, while the acrobat's curving flower, and the plantlike forms at the right and top of the canvas, ground pictorial movement in the organic.

The volumetric solidity of the figures in *L'Acrobate et sa partenaire* recalls Léger's work of the '30s. With *La Grande Parade*, that solidity is rejected, as Léger forcefully dissociates line from form. The result is "a rotation of . . . people, animals, and objects."[20] Monumental in scale—it is about thirteen feet wide—*La Grande Parade* brings Léger's investigation of popular entertainment to a climax. Geometric planes of diaphanous primary and secondary colors move through a friezelike organization of figures. Lying both in front of and behind the figures, these planes also define a space. Rendered in a black line here and there articulated by further color and shading, the performers are full of activity. The diagonals of a stagelike platform on the left, a totemic pole on the right, and ropes, weights, and other props economically create a sense of place: the circus.

In 1913, Léger had asked, "In painting, what constitutes what we call realism?"[21] The answer lay in the meeting of two worlds: the aesthetic forms of painting and the appearances of modern life. Uniting plastic contrast and pictorial integrity with contemporary subject matter, the artist was able to integrate the two. The paired red arcs that overlie the right half of *La Grande Parade* can be seen as creative, free-associative articulations of this fusion: abstract, they also literally represent the circus (C is for *cirque*), and convey a sense of both its movement and its roundness, in the big top and the ring. It was through inventions like these that Léger made of himself both a modern painter and a painter of modernity.

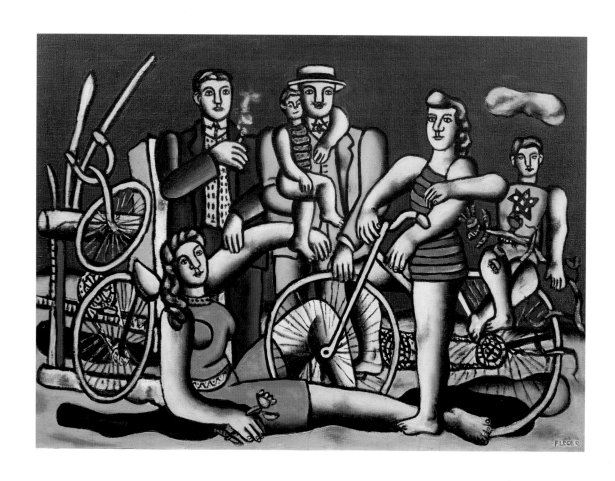

Les Loisirs **(Leisure), 1944**
Oil on canvas. 25⁹⁄₁₆ × 36¼″ (65 × 92 cm). Private collection, New York

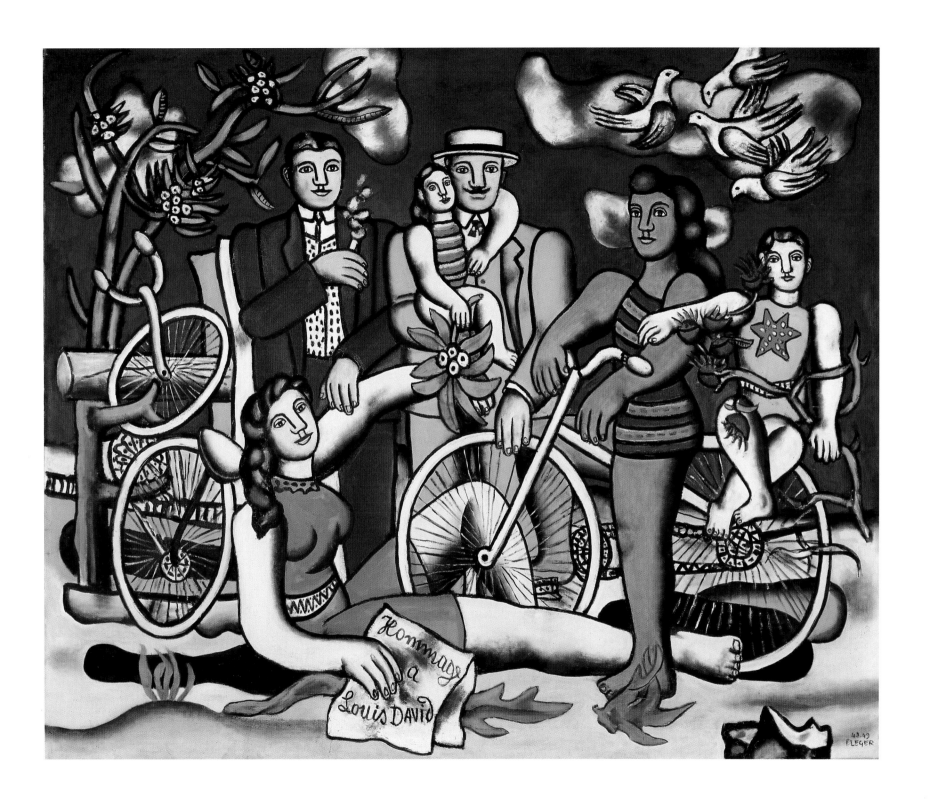

Les Loisirs, hommage à David **(Leisure, homage to David), 1948–49**
Oil on canvas. 60⅝ × 72¹³⁄₁₆″ (154 × 185 cm). Musée national d'art moderne–Centre de création industrielle, Centre Georges Pompidou, Paris

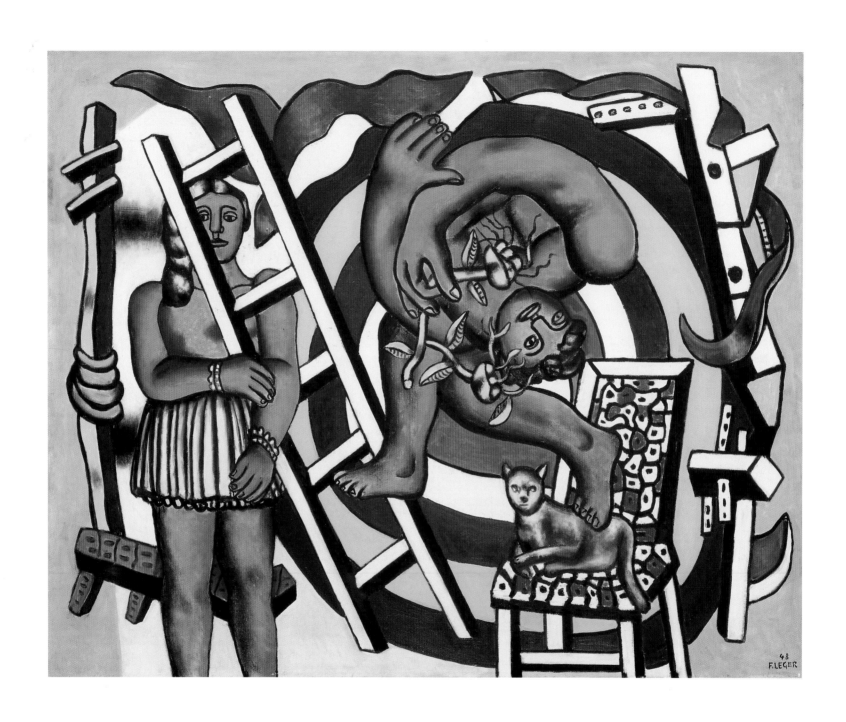

L'Acrobate et sa partenaire (**The acrobat and his partner), 1948**
Oil on canvas. 51¼ × 64″ (130.2 × 162.6 cm). Tate Gallery, London. Purchased 1980

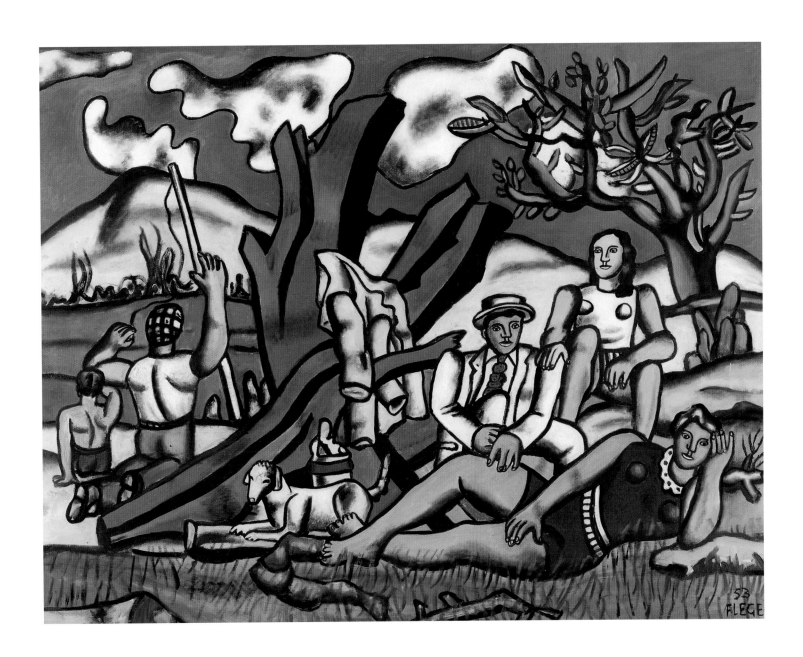

La Partie de campagne, 1^{er} état (The country outing, first state), 1952–53
Oil on canvas. 44⅞ × 57½″ (114 × 146 cm). Private collection

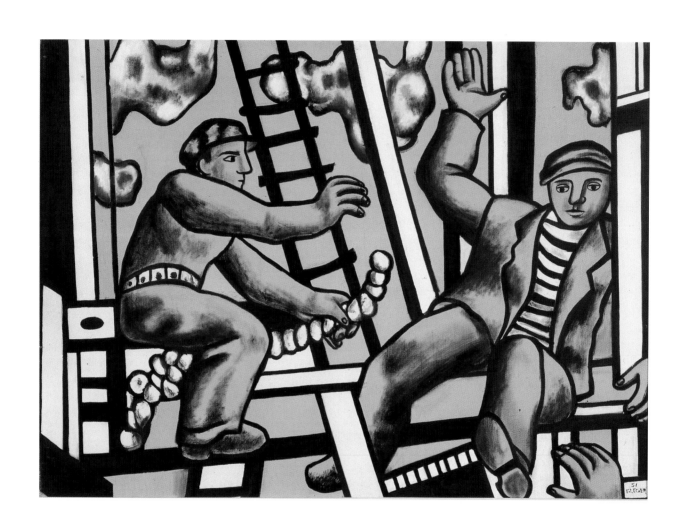

Les Constructeurs (Construction workers), 1951
Oil on canvas. 37⅝ × 50⅛″ (95.5 × 128 cm). Collection Emily Fisher Landau, New York

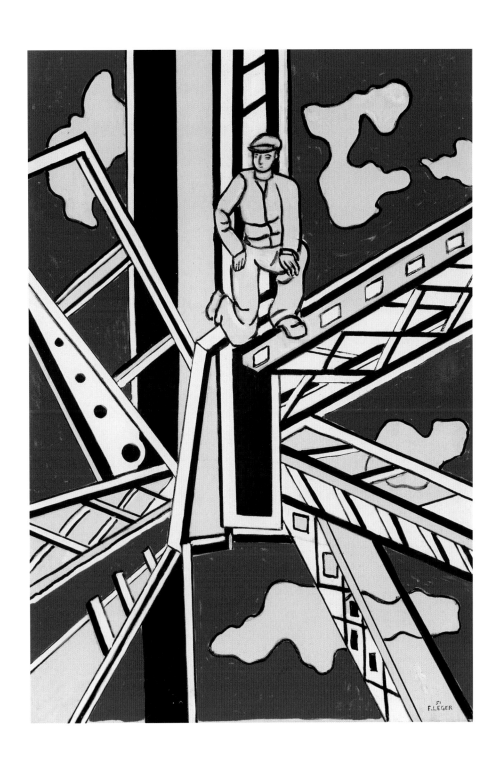

Les Constructeurs (Construction workers), 1951
Oil on canvas. 51 × 34¼″ (129.5 × 88.3 cm). The Menil Collection, Houston

Les Constructeurs, étude de tablier (Construction workers, study of overalls), 1951
Ink on paper. 25⅜ × 19⅞″ (64.5 × 50.5 cm). Graphische Sammlung, Staatsgalerie Stuttgart

Le Profil à la corde: Étude pour "Les Constructeurs" (Man in profile with rope: Study for *Construction workers*), 1951
Ink and pencil on paper. 25⅜ × 19⁹⁄₁₆″ (64.5 × 49.7 cm). Scottish National Gallery of Modern Art, Edinburgh

Étude de bras et jambes (Study of arm and legs), 1951
India ink on paper. 24¹³⁄₁₆ × 18⅞″ (63 × 48 cm). Private collection. Courtesy Galerie Jan Krugier, Ditesheim & Cie., Geneva

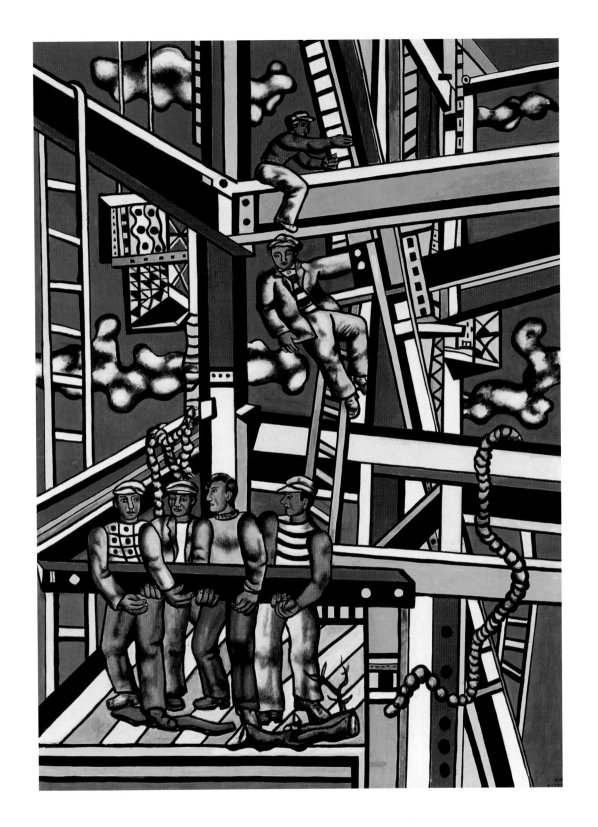

Les Constructeurs, état définitif (Construction workers, final state), 1950
Oil on canvas. 118⅛ × 89¼″ (300 × 228 cm). Musée national Fernand Léger, Biot

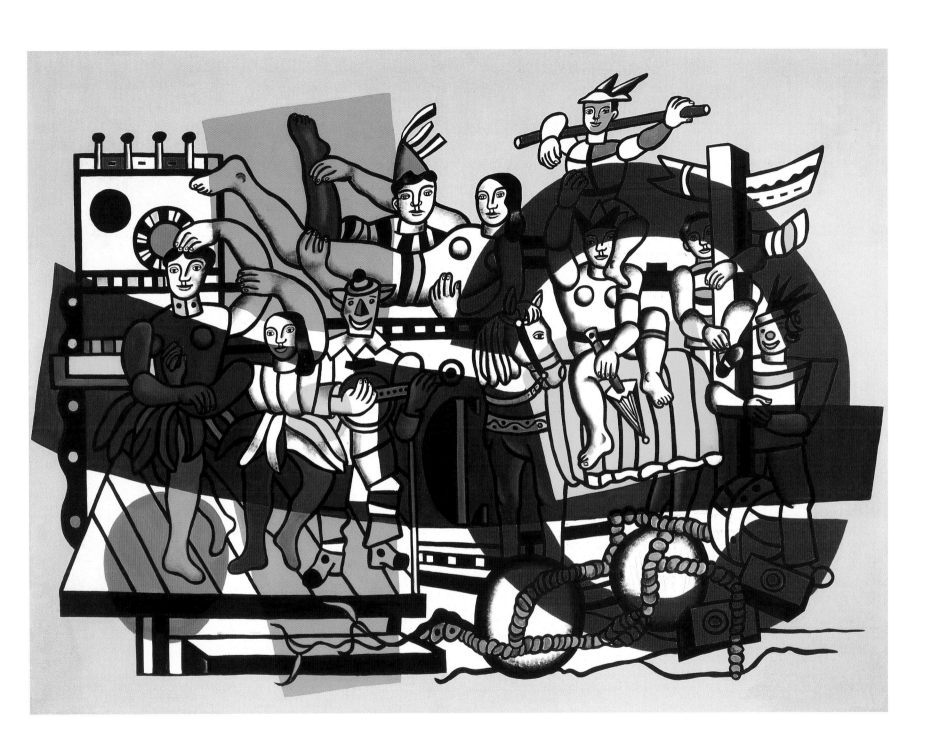

La Grande Parade, état définitif (The great parade, final state), 1954
Oil on canvas. 9'9¼" × 13'1½" (299 × 400 cm). Solomon R. Guggenheim Museum, New York

Notes to the Plate Introductions

I wish to express my sincerest gratitude to David Frankel for his most generous assistance and to Carolyn Lanchner for her extraordinary guidance.

1909–1914

1. Fernand Léger, "The Origins of Painting and Its Representational Value," 1913, in *Functions of Painting*, ed. Edward F. Fry, trans. Alexandra Anderson, with a preface by George L. K. Morris (New York: The Viking Press, 1973), p. 3.
2. Léger, "Contemporary Achievements in Painting," 1914, in ibid., p. 11.
3. Accounts of the date of Léger's destruction of his early works range from 1908 to 1913.
4. Léger, quoted in Dora Vallier, "*La Vie fait l'œuvre de Léger: Propos de l'artiste recueillis par Dora Vallier*," *Cahiers d'Art* (Paris) 29 no. 2 (October 1954): 149. Reprinted as Vallier, "*La Vie fait l'œuvre de Fernand Léger*," *L'Intérieur de l'art: Entretiens avec Braque, Léger, Villon, Miró, Brancusi (1954–1960)* (Paris: Éditions du Seuil, 1982), p. 67.
5. Léger, quoted in D. H. Kahnweiler, "A Tall Redheaded Norman," in *Homage to Fernand Léger* (special issue of *XXe Siècle Review*, Tudor Publishing Co., New York,

1971, ed. G. di San Lazzaro), p. 4.
6. Léger, quoted in Vallier, "*La Vie fait l'œuvre de Léger*," 1954, pp. 149–50, and "*La Vie fait l'œuvre de Fernand Léger*," 1982, p. 67.
7. Louis Vauxcelles, in *Gil Blas* (Paris), September 30, 1911. Quoted in Fry, *Cubism* (New York and Toronto: Oxford University Press, 1966), p. 19 and note 14, p. 192.
8. See Christopher Green, *Léger and the Avant-Garde* (New Haven and London: Yale University Press, 1976), pp. 13–18, and Werner Schmalenbach, *Fernand Léger*, trans. Robert Allen with James Emmons (New York: Harry N. Abrams, Inc., 1976), p. 74.
9. Léger, "Contemporary Achievements in Painting," p. 16.
10. Léger, "Notes on Contemporary Plastic Life," 1923, in *Functions of Painting*, p. 26. See Green, *Léger and the Avant-Garde*, pp. 22–38, and Judy Sund, "Fernand Léger and Unanimism: Where There's Smoke. . . ," *Oxford Art Journal* (Oxford) 7 no. 1 (1984): 49–56. Although Léger did not admit a debt to Romains, he did know him. See Claudine Chonez, "*Dernière journée avec F. Léger*," *Les Nouvelles Littéraires* (Paris) no. 1460 (August 25, 1955): 2.
11. Léger, "Modern Architecture and Color," 1943, in *Functions of Painting*, p. 150. See Green, *Léger and the Avant-Garde*, pp. 73–74; Peter de Francia, *Fernand Léger* (New Haven and London: Yale University Press, 1983), pp. 20–22; and Schmalenbach, *Fernand Léger*, p. 80.
12. Léger, "The Origins of Painting," p. 5. See also his "Contemporary Achievements in Painting," pp. 11–19.

13. Léger, "Contemporary Achievements in Painting," p. 14.
14. Léger, "The Origins of Painting," p. 7.
15. Ibid., p. 8.
16. Léger, "Contemporary Achievements in Painting," p. 11.
17. Léger, "The Origins of Painting," p. 8.
18. Ibid.
19. Ibid., p. 4.

1914–1920

1. See Green, *Léger and the Avant-Garde*, pp. 117–18.
2. Léger, quoted in Kahnweiler, "A Tall Redheaded Norman," p. 4.
3. See Green, *Léger and the Avant-Garde*, p. 118.
4. Léger, quoted in "*Que signifie: être témoin de son temps?*," *Arts* (Paris) no. 205 (March 11, 1949): 1.
5. Léger, quoted in Vallier, "*La Vie fait l'œuvre de Léger*," 1954, pp. 140, 151, and "*La Vie fait l'œuvre de Fernand Léger*," 1982, pp. 62, 68. Translations based on Schmalenbach, *Fernand Léger*, p. 94, and Green, "Out of War: Léger's Painting of the War and the Peace, 1914–1920," in Dorothy Kosinski, ed., *Fernand Léger 1911–1924: The Rhythm of Modern Life*, exh. cat., with a foreword by Katharina Schmidt and Gijs van Tuyl (Munich and New York: Prestel, 1994), p. 46. See also Carolyn Lanchner, "Fernand Léger: American Connections," in the present volume, notes 15 and 16, p. 66.
6. Green, *Léger and the Avant-Garde*, p. 134.
7. Léger, "Contemporary Achievements in Painting," p. 11.
8. Léger, "Correspondance," March 1922, *Bulletin de L'Effort Moderne* (Paris) no. 4 (April 1924): 11. Quoted here as translated by Charlotte Green, as "A Letter," in John Golding and Christopher Green, eds., *Léger and Purist Paris*, exh. cat. (London: Tate Gallery, 1970), p. 85.
9. Ibid.
10. See Green, *Léger and the Avant-Garde*, pp. 186–88, and Schmalenbach, *Fernand Léger*, p. 98.
11. Léger, "Color in the World," 1937, in *Functions of Painting*, p. 120.
12. See Fry, *Cubism*, pp. 33–35.
13. See de Francia, *Fernand Léger*, p. 47, and Green, *Léger and the Avant-Garde*, pp. 187–90.

14. Léger, "Notes on Contemporary Plastic Life," pp. 24–25.
15. Léger, "The New Realism Goes On," 1936, in *Functions of Painting*, p. 116.
16. See Green, *Léger and the Avant-Garde*, pp. 173–84. On Léger's interest in the city, see Jodi Hauptman, "Imagining Cities," in the present volume.
17. Léger, "Contemporary Achievements in Painting," pp. 25–26.
18. Léger, quoted in *Fernand Léger, 1881–1955*, exh. cat. (Musée des Arts Décoratifs) (Paris: Éditions Fernand Hazan, 1956), p. 123. Quoted here as translated by Schmalenbach in his *Fernand Léger*, p. 102.

1920–1924

1. Léger, quoted in de Francia, *Fernand Léger*, p. 71. On Léger and Purism see ibid., pp. 71–74; Green, *Léger and the Avant-Garde*, pp. 192–285; and Golding, "Léger and the Heroism of Modern Life," and Green, "Léger and L'Esprit Nouveau," in Golding and Green, eds., *Léger and Purist Paris*, pp. 8–23, 25–82.
2. Léger, "The Machine Aesthetic: The Manufactured Object, the Artisan, and the Artist," 1923, in *Functions of Painting*, pp. 52–53.
3. Ibid., p. 56.
4. Ibid., pp. 60–61.
5. See Green, *Léger and the Avant-Garde*, pp. 197–99, 210–11.
6. See ibid., pp. 211–13.
7. For Henri Rousseau's influence on Léger, see Lanchner and William Rubin, "Henri Rousseau and Modernism," in *Henri Rousseau*, exh. cat. (New York: The Museum of Modern Art, 1985), pp. 62–67. See also fig. 36, p. 64, and plate 7 in that publication .
8. In 1919, the year before Léger painted this work, he may have seen the Louvre's reopened Egyptian and Assyrian galleries, which had been closed during the war. See Green, *Léger and the Avant-Garde*, pp. 199–202, 233.
9. Léger, letter to Alfred H. Barr, Jr., November 20, 1943. In The Museum of Modern Art Archives: Alfred H. Barr, Jr., Papers. I.5.50. Published in Robert Herbert, *Léger's "Le Grand Déjeuner"*, exh. cat.

(Minneapolis: The Minneapolis Institute of Arts, 1980), Appendix G, p. 72.
10. Léger, "The Machine Aesthetic: The Manufactured Object, the Artisan, and the Artist," p. 57.
11. Léger, "Correspondance," p. 11. Quoted here as translated in Golding and Green, eds., *Léger and Purist Paris*, p. 86.
12. See Herbert, "Léger's *Le Grand Déjeuner*," *Léger's "Le Grand Déjeuner"*, pp. 9–37.
13. Léger, quoted in Vallier, "*La Vie fait l'œuvre de Léger*," 1954, pp. 152–53, and "*La Vie fait l'œuvre de Fernand Léger*," 1982, p. 70. Quoted here as translated by de Francia in his *Fernand Léger*, p. 87.
14. Léger, "The Machine Aesthetic: Geometric Order and Truth," 1923, in *Functions of Painting*, p. 62.
15. De Francia, *Fernand Léger*, p. 50.
16. See Green, *Léger and the Avant-Garde*, pp. 265–68.
17. Léger, "Notes on Contemporary Plastic Life," pp. 24–25.
18. See Green, *Léger and the Avant-Garde*, p. 273.
19. Léger, "A Critical Essay on the Plastic Quality of Abel Gance's Film *The Wheel*," 1922, in *Functions of Painting*, p. 21. See also Green, *Léger and the Avant-Garde*, pp. 270–75.
20. Léger, "A Critical Essay on the Plastic Quality of Abel Gance's Film *The Wheel*," p. 20.
21. Léger, "The Machine Aesthetic: Geometric Order and Truth," p. 65.
22. On Léger and film, see Judi Freeman, "*L'Événement d'Objectivité Plastique*: Léger's Shift from the Mechanical to the Figurative 1926–1933," in *Fernand Léger: The Later Years*, exh. cat. (London: Whitechapel Art Gallery, 1987), pp. 19–32; Green, *Léger and the Avant-Garde*, pp. 275–85; Schmalenbach, *Fernand Léger*, p. 122; and de Francia, *Fernand Léger*, pp. 64–67.

1925–1932

1. Léger, "Ballet mécanique," c. 1924, in *Functions of Painting*, p. 48.
2. Ibid., pp. 48, 50.
3. Ibid., p. 51. See also Freeman, "*L'Événement d'Objectivité Plastique*," pp. 19–32.
4. Léger, "A Critical Essay on the

Plastic Quality of Abel Gance's Film *The Wheel*," p. 20.

5. Léger, "The Machine Aesthetic: Geometric Order and Truth," p. 65.

6. See Freeman, "*L'Événement d'Objectivité Plastique*," p. 26.

7. Léger, quoted in Vallier, "*La Vie fait l'œuvre de Léger*," 1954, pp. 160–61, and "*La Vie fait l'œuvre de Fernand Léger*," 1982, p. 79. Quoted here as translated in Kosinski, ed., *Fernand Léger 1911–1924*, p. 73. See Freeman, "*L'Événement d'Objectivité Plastique*," pp. 25–26.

8. Léger, "The New Realism," 1935, in *Functions of Painting*, p. 110.

9. Léger, "The Human Body Considered as an Object," 1945, in *Functions of Painting*, p. 132.

10. Léger, quoted in Vallier, "*La Vie fait l'œuvre de Léger*," 1954, p. 160, and "*La Vie fait l'œuvre de Fernand Léger*," 1982, p. 77. Quoted here as translated by de Francia in his *Fernand Léger*, p. 111.

11. Léger, quoted in *Fernand Léger, 1881–1955*, p. 216. Quoted here as translated by de Francia in his *Fernand Léger*, p. 111.

12. Léger, "The Machine Aesthetic: The Manufactured Object, the Artisan, and the Artist," p. 57.

13. Léger, "The Machine Aesthetic: Geometric Order and Truth," p. 64.

1932–1940

1. On the relationship between aesthetics and politics as it concerns Léger, see Matthew Affron, "Léger's Modernism: Subjects and Objects," in the present volume; Charlotta Kotik, "Léger and America," in *Fernand Léger*, exh. cat. (Albright-Knox Art Gallery, Buffalo, N.Y.) (New York: Abbeville Press, 1982), pp. 41–59; and Ina Conzen-Meairs, "Revolution and Tradition, the Metamorphosis of the Conception of Realism in the Late Works of Fernand Léger," Simon Willmoth, "Léger and America," and Sarah Wilson, "Fernand Léger, Art and Politics 1935–1955," all in *Fernand Léger: The Later Years*, pp. 11–18, 43–54, and 55–75.

2. "*New-York vu par F. Léger*," 1931, appears under the title "New York" in *Functions of Painting*, pp. 84–90. See also Kristen Erickson's Chronology in the present volume, p. 272, and Lanchner, "Fernand Léger:

American Connections," for a discussion of Léger and America.

3. Léger, quoted in André Verdet, *Fernand Léger* (Zurich: Verlag der Arche, 1957), p. 32.

4. Léger, quoted in Nadia Léger, "Are They Sisters?," in *Homage to Fernand Léger*, p. 35. See Conzen-Meairs, "Revolution and Tradition," pp. 12–13.

5. Léger, "The New Realism Goes On," p. 116.

6. See Conzen-Meairs, "Revolution and Tradition," pp. 13–14.

7. Léger, "Color in the World," pp. 121, 128, 130–31.

8. Ibid., p. 129.

9. See Affron, "Léger's Modernism," for a discussion of Léger's political activities and their relation to his artistic production.

10. Léger, "The New Realism," p. 110.

11. Léger, quoted in Conzen-Meairs, "Revolution and Tradition," p. 14.

12. Léger, "The New Realism Goes On," p. 115.

13. Léger, letter to Barr, November 13, 1942. In The Museum of Modern Art Archives: Alfred H. Barr, Jr., Papers. I.5.50. Published in Herbert, *Léger's "Le Grand Déjeuner"*, Appendix F, p. 71.

14. Unidentified quotation in Willmoth, "Léger and America," p. 48.

15. Léger, "Color in the World," p. 126.

16. Léger, "The New Realism Goes On," p. 115.

17. Léger, "The Wall, the Architect, the Painter," 1933, in *Functions of Painting*, p. 98. On Léger's mural projects and politics, see Affron, "Léger's Modernism," Willmoth, "Léger and America," and Wilson, "Fernand Léger, Art and Politics 1935–1955."

18. Léger, "Color in the World," pp. 119, 121.

19. Ibid., p. 121.

20. Léger, quoted in Verdet, *Fernand Léger*, pp. 32–33. Quoted here as translated by Conzen-Meairs in "Revolution and Tradition," p. 12.

1940–1945

1. On Léger and America, see Lanchner, "Fernand Léger: American Connections," Kotik, "Léger and America," and Willmoth, "Léger and America."

2. Léger, quoted in André Warnod, "America Isn't a Country—It's a World," *The Architectural Forum* (New York) 84 no. 4 (April 1946): 54, 62. Reprint of "*L'Amérique, ce n'est pas un pays, c'est un monde, dit Fernand Léger*," *Arts* (Paris) no. 49 (January 4, 1946): 1–2.

3. Léger, quoted in *Fernand Léger, 1881–1955*, pp. 36–37.

4. Léger, quoted in *Fernand Léger*, exh. cat. (Paris: Grand Palais, Réunion des Musées nationaux, 1971), catalogue no. 133.

5. Léger, quoted in *Fernand Léger, 1881–1955*, p. 296. Quoted here as translated by Schmalenbach in his *Fernand Léger*, p. 146, and Kotik in her "Léger and America," p. 50.

6. Léger, quoted in Warnod, "America Isn't a Country," p. 62, and "*L'Amérique, ce n'est pas un pays*," p. 1.

7. Léger, quoted in *Fernand Léger, 1881–1955*, p. 302. Quoted here as translated by Karin von Maur in her "Rhythm and the Cult of the Body, Léger and the Ideal of a 'New Man,'" in *Fernand Léger: The Later Years*, p. 40.

8. See Willmoth, "Léger and America," p. 52, and Katharine Kuh, *Léger* (Urbana: The University of Illinois Press, 1953), p. 58.

9. Léger, quoted in James Johnson Sweeney, "Eleven Europeans in America," *The Museum of Modern Art Bulletin* (New York) XIII nos. 4–5 (1946): 15.

10. Léger, quoted in Warnod, "America Isn't a Country," pp. 54, 58, 62, and "*L'Amérique, ce n'est pas un pays*," p. 2.

11. Léger, "New York," pp. 84, 85.

12. Léger, quoted in Sweeney, "Eleven Europeans in America," p. 13.

13. See Lanchner, "Fernand Léger: American Connections," fig. 17, pp. 48–49.

14. Léger, "New York," pp. 85, 87.

15. Léger, "Color in the World," p. 119.

16. Léger, quoted in Vallier, "*La Vie fait l'œuvre de Léger*," 1954, p. 154, and "*La Vie fait l'œuvre de Fernand Léger*," 1982, pp. 72–73. Quoted here as translated by Kotik in her "Léger and America," p. 52.

17. See Kuh, *Léger*, p. 62.

18. Léger, "The New Realism," p. 109.

19. Léger, "The Human Body Considered as an Object," p. 135.

20. See Claude Laugier and Michèle Richet, *Léger: Oeuvres de Fernand Léger (1881–1955)* (Paris: Collections du Musée national d'art moderne, 1981), p. 88.

21. Léger, "The Human Body Considered as an Object," pp. 134–35.

22. Léger, "Art and the People," 1946, in *Functions of Painting*, p. 145.

23. Léger, quoted in Sweeney, "Eleven Europeans in America," p. 15.

24. Léger, "The Circus," 1950, in *Functions of Painting*, p. 171.

1946–1955

1. Léger, quoted in Roger Garaudy, *Pour un réalisme du XXe siècle. Dialogue posthume avec Fernand Léger* (Paris: Éditions Bernard Grasset, 1968), pp. 206–7.

2. Léger, quoted in Conzen-Meairs, "Revolution and Tradition," p. 15.

3. Léger, quoted in Garaudy, *Pour un réalisme du XXe siècle*, p. 207.

4. See Lanchner and Rubin, "Henri Rousseau and Modernism," p. 66 and note 113, p. 67, and Wilson, "Fernand Léger, Art and Politics 1935–1955," pp. 60–65.

5. Conzen-Meairs, "Revolution and Tradition," p. 16.

6. Léger, "The Circus," p. 177. See Conzen-Meairs, "Revolution and Tradition," p. 15.

7. Conzen-Meairs, "Revolution and Tradition," p. 15.

8. Léger, "The Problem of Freedom in Art," 1950, in *Functions of Painting*, pp. 165–66.

9. Léger, "The Origins of Painting," p. 4.

10. Léger, "Modern Painting," 1950, in *Functions of Painting*, p. 168.

11. Léger, "How I Conceive of the Figure," 1952, in *Functions of Painting*, p. 155.

12. See de Francia, *Fernand Léger*, p. 196.

13. Léger, "Art and the People," pp. 147–48.

14. Léger, quoted in Garaudy, *Pour un réalisme du XXe siècle*, p. 210. Quoted here as translated by de Francia in his *Fernand Léger*, pp. 198–99.

15. Léger, quoted in de Francia, *Fernand Léger*, pp. 203–4.

16. Léger, "The Circus," pp. 171–72.

17. Léger, "The Spectacle: Light, Color, Moving Images, Object-Spectacle," 1924, in *Functions of Painting*, pp. 35–47.

18. Léger, "The Circus," p. 172.

19. Ibid., p. 171.

20. Ibid., p. 172.

21. Léger, "The Origins of Painting," p. 3.

Chronology

Kristen Erickson

Note: Where possible, mentions of Léger's paintings include references (as B #) to the catalogue raisonné by Georges Bauquier: *Fernand Léger: Catalogue raisonné* (Paris: Adrien Maeght Éditeur, 1990–96 [vols. 1–5]). As this catalogue is currently complete only to 1937, no references can be given after this date. No reference to Bauquier is given where it has not been possible to identify a work precisely.

Where a work of art is included in the current exhibition, the reader is referred to the relevant plate in this catalogue. Figure references given in the Chronology refer to documentary images reproduced elsewhere in this volume.

Unless otherwise noted, dates given for correspondence are those inscribed on the letter by its author. If the dating is by postmark, this is so indicated. Dates given in Léger's correspondence and other writings take precedence over those given in secondary source material.

The principal published sources of Léger's correspondence are Christian Derouet, ed., *Fernand Léger: Lettres à Simone* (Paris: Éditions d'Art Albert Skira S.A. and Musée national d'art moderne, Centre Georges Pompidou, 1987); Derouet, ed., *Fernand Léger: Une Correspondance de guerre à Louis Poughon, 1914–1918, Les Cahiers du Musée national d'art moderne* (Paris) hors-série/archives, 1990; and Derouet, ed., *Fernand Léger: Une Correspondance d'affaires. Correspondances Fernand Léger–Léonce Rosenberg 1917–1937, Les*

Cahiers du Musée national d'art moderne (Paris) hors-série/archives, 1996. In addition, Judi Freeman's article "'Chère Janot': Fernand Léger and His Wartime Correspondence, 1914–1917," *Apollo* (London) no. 142 (October 1995): 40–43, should be consulted for Léger's correspondence with his first wife, Jeanne Lohy; and numerous letters are reprinted in Bauquier, *Fernand Léger: Vivre dans le vrai* (Paris: Adrien Maeght Éditeur, 1987), and in *Fernand Léger: Sa vie, son oeuvre, son rêve* (Milan: Edizioni Apollinaire, 1971).

For further information about Léger's exhibitions, the reader is advised to consult the Exhibition History in this volume.

Whereas in other parts of this catalogue titles for Léger's works are given in both French and English, in the Chronology only French titles are given.

Unless otherwise noted, translations from the French are by the author.

In keeping with the focus of Carolyn Lanchner's essay in this volume, the Chronology addresses Léger's years in America in greater detail than other parts of his life.

1881

February 4. Joseph Fernand Henri Léger is born in Argentan, Orne, in northwestern France. He is the only child of Henri Armand Léger, a thirty-five-year-old cattle breeder, and Marie Adèle Daunou, twenty-seven years old.

1884

February 15. The artist's father dies suddenly.

C. 1885–1888

Schooling at the Couvent de Saint-Jacques, a Benedictine *école maternelle*.[1]

C. 1888–1897

Schooling at the Collège d'Argentan (later the Collège de Mézeray), where he meets André Mare, Louis Poughon,

and Henri Viel, who will become his lifelong friends. Discovers a passion for drawing and caricature.

Transfers to the Collège de Tinchebray, a religious boarding school in Tinchebray.

Becomes an apprentice to M. Corbin, an architect in Argentan.

1897

Begins a two-year apprenticeship with an architect in Caen, Normandy.

Top: Léger as a baby.
Above: Léger as a student at the Collège d'Argentan

1900

Around this time goes to Paris, where he works as an architectural draftsman.

1902

Begins a year of military service in the Second Régiment du Génie de Versailles, an engineers' regiment.

1903

Moves back to Paris and starts painting seriously.

Applies to the École des Beaux-Arts, but is rejected and admitted instead to the École des Arts Décoratifs. Prefers to become an independent, nonenrolled student of two teachers at the École des Beaux-Arts, Jean-Léon Gérôme and, after Gérôme's death in 1904, Gabriel Ferrier. Also studies at the Académie Julian. Works part-time as an architectural draftsman and photographic retoucher.

From 1903 to 1904, shares Paris studios with childhood friend André Mare, first at rue Saint-Placide, then at avenue du Maine.

1906

Due to ill health, winters in Corsica, in the village of Belgodère, where his childhood friend Henri Viel is a public official. Paints several Corsican landscapes.

1907

In the spring, moves to the neighboring port of Île Rousse, Corsica. A local businessman, Ernest Blasini, allows him to stay in the unoccupied Château Piccioni, where he sets up a studio and remains through the end of the season.

Leaves Corsica, returning to Argentan and Paris. In the autumn is living on the rue de l'Hôtel de Ville, Argentan.

October 1–22. Salon d'Automne, Grand Palais, Paris. Léger's first submission to this annual exhibition comprises five paintings from Corsica. The first major

Léger in Corsica, c. 1906–7

retrospective of the work of Paul Cézanne is held at the same salon, one year after the artist's death. Léger almost certainly sees and is influenced by this exhibition. He will exhibit regularly in the Salon d'Automne through 1922.

Before November 22, the first sale of a Léger painting, *Gamins au soleil* (1907, B 13).

Late in the year, returns to Corsica, staying again at the Château Piccioni and remaining through June 1908.

1908

June. Leaves Corsica.

Around this time, begins a friendship with Constantin Brancusi.

Destroys most of his works of this and previous years.[2]

1909

Takes a studio at La Ruche (The beehive), a building in the Vaugirard quarter of Paris that is home to Alexander

Archipenko, Henri Laurens, Jacques Lipchitz, Robert Delaunay, Marc Chagall, and Chaim Soutine during this period.[3] Léger develops close friendships with Guillaume Apollinaire, Max Jacob, Pierre Reverdy, Henri Roussel, Maurice Raynal, Ilya Ehrenburg, and many other artists and writers while staying at La Ruche, and this is probably where he meets Blaise Cendrars, who also frequents the building.[4]

1910

Completes *La Couseuse* (1909–10, B 19; p. 156) and *Nus dans la forêt* (1909–10, B 20; p. 157).

March 18–May 1. Salon des Indépendants, Cours de la Reine, Paris. In his first appearance in this salon, Léger exhibits *Femme couchée*, two works called *Étude*, and two works called *Nature morte*. He will exhibit regularly in the salon through 1923, and will appear in a thirty-year survey of its exhibitions held in 1926.

Swedish artist Nils Dardel goes to Paris to study with Henri Matisse. Within the next several years he will make the acquaintance of Léger.

Meets members of the Abbaye de Créteil group. Formed in 1906 by Alexandre Mercereau, Albert Gleizes, Georges Duhamel, and others, the group is named for their meeting place at Créteil, southwest of Paris. They have moved to Paris in 1908, and Léger eventually joins their gatherings at the Closerie des Lilas, a Montparnasse café. He also attends soirées at Mercereau's home.

Joins Sunday-afternoon gatherings of the Puteaux group at the studios of Raymond Duchamp-Villon, František Kupka, and Jacques Villon in Puteaux,

a Paris suburb near Neuilly. The group includes Guillaume Apollinaire, Marcel Duchamp, Gleizes, Kupka, Roger de la Fresnaye, Marie Laurencin, Henri Le Fauconnier, Jean Metzinger, Walter Pach, and Francis Picabia.

1911

By April 21, moves to 14, avenue du Maine, in Montparnasse.[5]

April 21–June 13. Salon des Indépendants, Quai d'Orsay, Paris. Léger exhibits *Nus dans la forêt* (B 20) (catalogued as *Nu dans un paysage*) and two drawings, and serves on the hanging committee. The painting is hung in a Cubist room along with works by Delaunay, Gleizes, Laurencin, Le Fauconnier, and Metzinger, marking Léger's public debut as a member of the Parisian avant-garde.

Summers at his mother's home in Argentan.

September 30. Critic Louis Vauxcelles, in an article in *Gil Blas* (Paris), labels Léger a "tubist."

By October, moves to 13, rue de l'Ancienne-Comédie. There he paints "*Fumées sur les toits*," a series inspired by the view of rooftops and smoke from his window.

October 1–November 8. Salon d'Automne, Grand Palais. Léger's *Essai pour trois portraits* (1910–11, B 24; fig. 2, p. 17) is hung in a Cubist room that is harshly criticized in French newspapers. He also lends a work to André Mare's *Cabinet de travail*, an exhibition in the same salon to which Duchamp-Villon, La Fresnaye, Laurencin, and Villon contribute as well.

1912

March 20–May 16. At the Salon des Indépendants, Quai d'Orsay, Léger exhibits a painting catalogued as *Composition avec personnages*—probably *La Noce* (1911, B 23; p. 158).[6]

April. First publication of the review *Soirées de Paris*, edited by Apollinaire.

Léger is visited by the organizers of the Armory Show, to be held in New York in 1913—Arthur B. Davies, Walt Kuhn, and Walter Pach.[7]

October 1–November 8. Salon d'Automne, Grand Palais. Léger exhibits *La Femme en bleu* (1912, B 39; p. 161) and another painting.[8] He also contributes *Essai pour trois portraits* (B 24) to the *Maison Cubiste*, an exhibit held in an architectural setting created by Duchamp-Villon.

1913
During 1913–14, Léger, Cendrars, Apollinaire, and Jacob frequent the Cirque Médrano, the popular Montmartre circus, founded in 1875 (as the Cirque Fernando), that beginning in 1897 starred the clown Girolamo Médrano. Léger will later paint numerous works on the circus theme, some of them based directly on the Cirque Médrano.

February 17–March 15. *International Exhibition of Modern Art* (the Armory Show), organized by the Association of American Painters and Sculptors, Inc., at the Armory of the 69th Infantry, New York. Two works by Léger, each identified only as *Étude*, are exhibited. The exhibition will travel to The Art Institute of Chicago (March 24–April 16)

and Copley Hall, Boston (April 28–May 19).[9]

March 19–May 11. Salon des Indépendants, Quai d'Orsay. Léger's *Modèle nu dans l'atelier* (1912–13, B 40) is exhibited (although his name does not appear in the catalogue).[10]

May 5. Léger presents a lecture, "*Les Origines de la peinture et sa valeur représentative,*" at the Académie Wassillief, Paris.[11]

C. May 11–c. late June. *Exhibition of "Cubist" and "Futurist" Pictures*, Gimbel's Department Store, Milwaukee, Wisconsin, includes paintings by seven young artists: Léger, Gleizes, Metzinger, Villon, Pierre Dumont, and the Hungarians Gustave Miklos and Arpad Kesmarky. Two works by Léger are included: *Essai pour trois portraits* (B 24) and *Mountain Scenery*.[12] The exhibition will travel to William, Taylor, Son & Co., Cleveland (June 20–July 8), Boggs and Buhl, Pittsburgh (July 10–16), Gimbel's Department Store, New York (c. July 20–30), Gimbel's Department Store, Philadelphia (c. August 1–8), and the Milwaukee Art Society (April 16–May 12, 1914).

Meets Jeanne Lohy, his future wife, a native of Les Andelys, Normandy, born in 1895.

Apollinaire publishes *Les Peintres Cubistes, Méditations esthétiques* (Paris: Éditions Figuière), which declares the emergence of a new movement—Orphism—that includes Delaunay, Picabia, Duchamp, and Léger.

October 20. Daniel-Henry Kahnweiler and Léger sign an exclusive three-year contract, assuring that Kahnweiler will purchase all of Léger's oil paintings at guaranteed prices as his sole dealer. Georges Braque, André Derain, Juan Gris, and Pablo Picasso are also under contract with Kahnweiler by this time.

After October 20, moves to 86, rue Notre-Dame-des-Champs, in Montparnasse, where Le Fauconnier previously had his studio. Léger will keep this studio for the rest of his life.

Works on the painting series "*Contrastes de formes*" (pp. 164–65).

1914
May 9. Gives the lecture "*Les Réalisations picturales actuelles,*" at the Académie Wassillief.[13]

Léger (left) during World War I

August 2. Is mobilized as a sapper in the Premier Régiment du Génie de Versailles, an engineers' regiment. Throughout World War I, Léger will correspond with his childhood friend Louis Poughon and with Jeanne Lohy.[14] Beginning in mid-August, he begs Poughon, a lawyer with connections to government officials, to help him get a reassignment to something less dangerous and more suited to his background.

By October 5, is in the Argonne Forest, which in the summer of 1915 will be the scene of the most violent fighting on the Western Front. Léger will remain there through September 1916.

Late October. Lohy moves to Léger's studio, where she will remain during the rest of the war, acting as a liaison between Léger and artists and collectors in Paris.

1915
January. Daniel-Henry Kahnweiler, who is of German origin, seeks asylum in Switzerland. His art collection, which includes many works by Léger, is seized by the French government, and he remains in exile until 1920.

Through Nils Dardel, Léger meets Rolf de Maré, a wealthy Swedish landowner and later the founder of the Ballets Suédois. Early in the year, also through

Dardel, de Maré purchases Léger's *L'Escalier* (1914, B 71).[15]

August 19–26. During a leave in Paris, sells a collage to Dardel. Later in the year, a war painting will follow. As far as is known, the only paintings Léger executes at the front are on wood, as he has no access to canvas.

October. Is assigned to be a stretcher-bearer.

On leave in Paris sometime during the war, meets the Russian revolutionary Leon Trotsky.[16]

1916
Dardel plans an exhibition (never realized) of Léger's work in Sweden.[17]

Second half of January. During a leave in Paris, paints *Le Soldat à la pipe* (B 100; p. 178).

April–June. Negotiates with Michael Brenner, who represents the Washington Square Gallery in New York, to sell his works in the United States. Apparently no agreement is reached.[18]

After August 7. Furlough in Paris.
During one of his furloughs in 1916, Léger accompanies Apollinaire to the Ciné Montparnasse, where he sees his first Charlie Chaplin film. Chaplin's films will have a strong influence on both Léger's paintings and the films he will make later.[19]

September 9. Leaves the Argonne for the front in Verdun, arriving by October 2. After the end of the months-long battle there, Léger will remain in Verdun through December for the cleanup operation, making sketches of the ruined town and dead soldiers.

1917
By January 9 is in Champagne, where he remains at least through April 25.

January 11. Writes to Lohy urging her to contact Serge Diaghilev of the Ballets Russes about collaborating on a ballet. Suggests that Natalie Gontcharova and Mikhail Larionov might intercede on his behalf.[20]

By February 13 has sold a prewar painting and two drawings of Verdun to Diaghilev, who gives Léger and Lohy a box at the Ballets Russes. Larionov is instrumental in arranging Diaghilev's purchases.

September 9–November. Is hospitalized at the Hôpital St. Joseph, Montrouge, having suffered an attack of rheumatism during a leave in Paris.

By November 21, is transferred to the Hôpital du Gouvernement Italien, Quai d'Orsay, Paris. Stays in the hospital during the week but has Sundays free.[21]
During his convalescence in Paris, completes *La Partie de cartes* (1917, B 102; p. 179), which shows three soldiers playing cards. On December 5, this painting and four drawings are sold to Léger's new dealer, Léonce Rosenberg. De Maré purchases a small version of *La Partie de cartes* (then called *En front*).

December 7. Participates in the first *Montjoie!* festival, organized in Paris to celebrate the reunion of Blaise Cendrars, Riccioto Canudo, Erik Satie, Léger, and other artists who have returned from the war.

December 10. Apparently after a brief leave, reenters the Hôpital Italien in Paris, remaining there through early 1918. With Poughon's assistance, tries to get discharged from the army.

1918
Léonce Rosenberg's gallery at 19, rue de la Baume, Paris, takes the name Galerie de l'Effort Moderne. Léger and Rosenberg negotiate a contract.

March 14. Is hospitalized at the Hôpital Militaire, Villepinte, where he remains until May 31, having been diagnosed with pulmonary tuberculosis.[22]

C. April 10. Gives *Nature morte sur carton* (1917, B 103) to the doctor who cares for him at the Hôpital Villepinte, Dr. Bigard.

June. The bombardment of Paris leads to a mass exodus. By the 18th of the month, having been recently discharged, Léger is in Argentan for the first time in four years.

July. Summers in a house near the Seine in Vernon, Eure; plans to remain there through July and spend August in Niort, Deux-Sèvres, or nearby.

July. Visits Monet's home at Giverny, probably accompanied by Cendrars, but finds the gardens "*trop impressioniste.*" Tells Rosenberg, "A vegetable garden is better constructed than a flower garden and is quite brightly colored."[23]

Collaborates with Cendrars on the book *J'ai tué* (Paris: À La Belle Édition), published this year with five illustrations by Léger.

July 1. Léger and Rosenberg sign a contract with different terms for wartime and for the postwar period.[24]

November 9. Death of Apollinaire. On November 13, Léger and Cendrars attend his funeral.

1919
February 5–28. *Oeuvres par Fernand Léger*, an exhibition at the Galerie de l'Effort Moderne. Coinciding with the exhibition, on February 16, are a poetry reading by Cendrars and a concert by Erik Satie.

Spring. Executes a series of preliminary works culminating in a final version of *La Ville* (B 163; p. 181), which exemplifies his "*période mécanique.*" The painting is partly inspired by posters and publicity in the streets at the place Clichy.[25]

June 28. Renewal of his designation as unfit for military service.

July. Returns to Vernon after a period in Paris. Ragnar Hoppe, art critic and curator at the Nationalmuseum of Stockholm, visits him there.

July 3. Cendrars's poem "*Construction,*" dedicated to Léger, is published. It begins,

Color, color, and more colors. . . .
Here's Léger who grows like the sun
in the tertiary epoch.[26]

October. Cubist artists under contract with Rosenberg found a new Section d'Or, a group aiming to raise awareness of avant-garde artists of different countries and to stage musical performances and literary readings in conjunction with exhibitions.[27] Léger serves on a committee charged with promoting the group's ideas. Their first exhibition will be held in March 1920.

October 28. Travels to Oslo, Norway, for an exhibition at the Galerie Tivoli (October 25–November 10) at the invitation of Ragnar Hoppe. Sells several watercolors in order to finance the trip.

Visits London on his way back from Norway and sees a performance of the Ballets Russes.

Cendrars's *La Fin du monde filmée par l'Ange N.-D.* is published in Paris by

purchases Léger's *Le Pont du bateau* (1919, B 175) for Rolf de Maré.

1920

January. Léger and Rosenberg discuss annulling their contract. (Rosenberg's difficult financial situation is causing him to revise the system of contracts he has used in previous years.)

By January, has proposed to Rosenberg a book with original prints and poems by Cendrars entitled *Cirque*. It will be realized much later, in 1950, without Cendrars's collaboration.

January 28–February 29. Salon des Indépendants, Grand Palais. Léger exhibits *La Ville* (1919, version unknown) and *Les Disques dans la ville* (1919, version unknown).

February. Daniel-Henry Kahnweiler returns to Paris to rebuild his business as an art dealer. In September he will reopen his gallery under a new name, Galerie Simon (named for his new partner, André Simon), at rue d'Astorg. Léger will reestablish his association with Kahnweiler and agree to sell part of his output through him.

May 26. Is present at a Dada festival at the Salle Gaveau, a notorious event that features performances by Paul Éluard, André Breton, Francis Picabia, and Tristan Tzara, among others. Constantin Brancusi, Albert Gleizes, and Jean Metzinger also attend.

June. The first monograph on Léger, by Maurice Raynal, is published by Éditions de l'Effort Moderne, Paris.

Poet Ivan Goll's *Die Chaplinade. Eine Kinodichtung* is published in Dresden. A personal homage to Charlie Chaplin, it includes reproductions of two Léger drawings of "*Charlot cubiste*."

October. Amédée Ozenfant and Charles-Édouard Jeanneret (Le Cor-

busier) found the journal *L'Esprit Nouveau*. Léger meets them around this time.

October 25. The Ballets Suédois open at the Théâtre des Champs-Élysées, Paris.

Sometime this year, de Maré purchases *Le Soldat à la pipe* (B 100).

1921

From this year until 1924, Ezra Pound lives at 70 bis, rue Notre-Dame-des-Champs, near Léger's studio. They develop a friendship.

January 23–February 28. Salon des Indépendants, Grand Palais. The catalogue lists three works by Léger: *La Femme couchée* (1921, possibly B 298), *La Femme et l'enfant* (1921, possibly B 292 or 293), and *Les Deux Femmes et la nature morte*.

By April, Léger is dividing his time between his Montparnasse studio and a new house in Fontenay-aux-Roses, a suburb of Paris.

May 13. Riccioto Canudo publishes in *Cinéa* the first manifesto for the Club des amis du septième art, the first "ciné-club." The club has developed in 1920 through informal gatherings at the Café Napolitain in Paris, and includes artists, such as Léger; writers like Blaise Cendrars and Jean Cocteau; musicians including Arthur Honegger and Maurice Ravel; and professional filmmakers including Louis Delluc, Marcel L'Herbier, and Jean Epstein.

May 30. Auction of the collection of German dealer Wilhelm Uhde, which, like the possessions of many Germans resident in France, has been confiscated by the French government and sold to repay war debts; a work by Léger is sold from it.

June 13 and 14. First sale of Kahnweiler's extensive art collection, which

has also been seized by the French government. Léonce Rosenberg serves as expert adviser to the auction and is harshly criticized by many artists supportive of Kahnweiler. Subsequent auctions will occur on November 17 and 18, 1921, and July 4, 1922. Forty paintings by Léger dating from 1910 to 1914 and a group of his drawings from 1904 to 1914 are dispersed.

After June. Harold Loeb, founder of the new American literary magazine *Broom*, meets Léger in Paris. He visits numerous artists seeking contributors to the journal, which will make its debut in November. Léger will design covers for the January and June 1922 issues (see fig. 9, p. 26).

During this period, Léger offers Kahnweiler first refusal on new works. A rivalry develops between Kahnweiler and Rosenberg.

September. Gerald and Sara Murphy arrive in Paris. They study with Natalie Gontcharova and under her supervision work for the Ballets Russes, repainting set designs. They are introduced to Léger by late fall and soon become close friends. Through the Murphys, Léger will meet Archibald MacLeish, Ernest Hemingway, and John Dos Passos.

Through Cendrars, meets filmmaker Abel Gance, then working on *La Roue* (first screened in 1922). Cendrars assists Gance with the shooting and editing of certain sequences, which Léger watches. Léger designs a poster for the film (fig. 4, p. 81) and writes his "*Essai critique sur la valeur plastique du film d'Abel Gance, La Roue*," which will be published in *Comoedia* the following year.[28]

André Malraux's *Lunes en papier*, the first book with original woodcuts by Léger, is published by Kahnweiler's Galerie Simon.

Jeanne Lohy (later Jeanne Léger), c. 1915

Éditions de la Sirène, with illustrations by Léger.

Designs covers for November and December issues of *The Plowshare*, Woodstock, New York.

December 2. Marries Jeanne Lohy, in Paris.

December 19. Is in London, probably with Jeanne, attending a performance of the Ballets Russes.

Late 1919 or early 1920. Nils Dardel

Léger's curtain design (graphite, watercolor, gouache, and india ink on paper, 1921) for the Ballets Suédois ballet *Skating Rink* (1922). Dansmuseet, Stockholm

1922

January 20. Premiere of Rolf de Maré's ballet *Skating Rink*, performed by the Ballets Suédois, at the Théâtre des Champs-Élysées, Paris. Léger has designed the sets, costumes, and makeup, which are inspired by Charlie Chaplin's character in *The Rink* (released in France in 1917). The choreography is by Jean Börlin and the music by Arthur Honegger.

The Constructivist tract *A vse takin ona vertitsia* (And yet the world goes round) is published in Moscow and elsewhere by Ilya Ehrenburg. The cover bears a reproduction of a Léger design.

April 10. Léger's mother dies. He inherits from her a farm in Lisores, near Vimoutiers, Normandy, where he will spend many summers.

August–September. Léger and Jeanne vacation with Daniel-Henry and Lucie Kahnweiler in Germany and Austria.

September 21. The American collector Ferdinand Howald, of New York and Columbus, Ohio, purchases *La Perforeuse* (1918, B 118) from Léonce Rosenberg. In 1931, Howald will donate the work to the Columbus Museum of Art.

Léger in Constantin Brancusi's studio, c. 1922. Photograph by Brancusi

chicken between the boulders, the tree trunks, the ovoid heads and tapering birds."[29]

February 10–March 11. Salon des Indépendants, Grand Palais. The salon includes *Projet d'ensemble pour un hall* (1922), a collaborative work comprising

Through the Communist poet and novelist Elsa Triolet, becomes friendly with the Russian poet Vladimir Mayakovsky.

1923

January 2. Léger and Harold Loeb dine in Brancusi's studio. Loeb will recall the evening in his memoirs: "Like a gnome in a grotto, Brancusi cooked a

a painting by Léger with a frame by the Hungarian-born sculptor Joseph Csaky. The ensemble has been conceived as a decoration for the country home of couturier and art collector Jacques Doucet, to be designed by the architect Robert Mallet-Stevens in 1924 (never completed).

February 23. *Grand Bal Travesti/Transmental*, Salle Bullier, Paris, organized by the Union des Artistes Russes. Léger designs costumes and a theater box for the ball.

June. John Dos Passos arrives in Paris and meets Léger through Gerald Murphy.

June 1. Gives the lecture "*L'Esthétique de la machine*," at the Baraque de la Chimère, boulevard St. Germain.[30]

July 6. Soirée du Coeur à Barbe, Théâtre Michel, Paris. This event, sponsored by Tchérez, a Dada-affiliated group of Russian actors, includes performances of works by Darius Milhaud, Erik Satie, and Igor Stravinsky; readings of poems

by Cocteau, Apollinaire, Tristan Tzara, and others; and the screening of three films, most importantly what was then called *The Smoke of New York* (or, in France, *Fumées de New York*, 1920) and is now known as *Manhatta*, by Charles Sheeler and Paul Strand. Léger is likely to have attended and to have seen *Manhatta*.

Late summer/early autumn. Works on Marcel L'Herbier's film *L'Inhumaine*, creating the set for a scientific laboratory; Mallet-Stevens designs much of the architecture. Léger also designs a publicity poster for the film.

Léger's laboratory set for Marcel L'Herbier's film *L'Inhumaine* (1923)

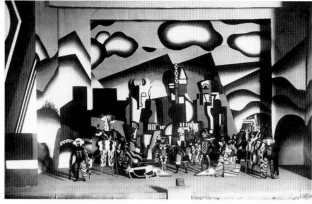

Maquette of Léger's sets and costumes for the Ballets Suédois ballet *La Création du monde* (1923). Dansmuseet, Stockholm

Above: Léger and his students at the Académie Moderne, Paris, c. 1924. Photograph by Thérèse Bonney.
Right: frames from *Ballet mécanique* (1924), the film Léger made with Dudley Murphy

Above: Léger and his painted-wood *"Charlot cubiste"* figure (c. 1924). Photograph by Thérèse Bonney

October 25. Premiere of the ballet *La Création du monde*, performed by the Ballets Suédois, at the Théâtre des Champs-Élysées. Léger has created sets and costumes and Cendrars has written the scenario. The music is by Milhaud, who has met Léger for the first time through collaboration on the project. The ballet is inspired by African myths, and Léger studies African sculpture to develop ideas for his costumes.

On the same evening at the same theater, the Ballets Suédois perform the jazz ballet *Within the Quota* for the first time. On Léger's recommendation, Gerald Murphy designs the sets and costumes, assisted by his wife, Sara; the music is by Cole Porter. The ballet tells the story of a Swedish immigrant seeking his fortune in the United States, and will be performed on what will prove to be the company's only American tour, in 1923–24.

Léger, Rudolph Valentino, Jacques Hébertot, and Philippe Soupault visit René Clair's studio in Joinville during the shooting of Clair's first film, *Paris qui dort*.[31]

November. Resigns from the Salon des Indépendants, writing to its president, Paul Signac, that he objects to the alphabetical organization of the overall exhibition without consideration for groups or movements, and to the segregation of foreign artists simply by nationality.

November 25. At the Century Theater, New York, the Ballets Suédois begin their American tour with four works including *Skating Rink*. Three days later they perform *Within the Quota*. The company tours the East Coast, performing in a total of twenty-six towns and cities, through March 1, 1924. *La Création du monde* is initially part of the program, but due to the negative response of conservative audiences and critics, de Maré cancels it. West Coast performances too are canceled, and by the end of 1923, all modern works except *Within the Quota* are eliminated from the program.

Publication of Ivan Goll's *Le Nouvel Orphée* (Paris: Éditions de la Sirène), with four prints by Léger depicting Charlie Chaplin.

1924
January. Begins teaching at the Académie Moderne, a school located in the same building as his studio at 86, rue Notre-Dame-des-Champs. Initially shares instruction with Othon Friesz and later with Amédée Ozenfant. His early students include the Swedish artists Otto G. Carlsund, Erik Olson, and Franciska Clausen; the Brazilian artist Tarsila do Amaral; the Swiss-born American Florence Henri; the French artist Marcelle Cahn; and the Russian Nadia Khodossievitch.

February. Responses to Léonce Rosenberg's survey "Where is modern painting going?" (*Où va la peinture moderne?*) are published in the dealer's new *Bulletin de l'Effort Moderne*. Léger's reads, "I know nothing about it. And if I did, I probably wouldn't make it anymore."[32]

Summer. Is visited at his studio by Katherine Dreier, the American collec-

tor and supporter of contemporary art. In 1920, with Marcel Duchamp, Dreier has founded the Société Anonyme, a forum for the study and exhibition of modern art.[33]

May 31. Gives the lecture "*Le Spectacle*" at the Sorbonne before an association called the Groupe d'Études Philosophiques et Scientifiques pour l'Examen des Idées Nouvelles. Dreier may attend the lecture.[34]

By July, has completed *Ballet mécanique*, a film without scenario. He collaborates on the film with Dudley Murphy, an American who has made one earlier film, *High Speed* (1922). Murphy has previously worked with Man Ray, who also collaborates on *Ballet mécanique* during its early stages. Murphy, his wife Katherine Murphy, and Kiki de Montparnasse appear in the film, which has a musical accompaniment by George Antheil. Several versions of the film are made, including one with coloring by Gustav F. O. Brock.[35]

Sometime this year, the German painter Willi Baumeister travels to Paris to make the acquaintance of Léger and Le Corbusier. Léger and Baumeister will develop a lifelong friendship.

July 11. *Bal Olympique: Vrai Bal sportif costumé*, Taverne de l'Olympia, Paris. The ball, dedicated to Apollo and organized by the Union des Artistes Russes, features costumes by Gontcharova and Léger.

August. Visits Italy with Léonce Rosenberg, arriving in Venice by August 7, in Siena by August 10, in Florence by August 15, in Ravenna by August 18, and then in Rome, where they are received by Giorgio de Chirico. The trip lasts approximately four weeks. Léger is struck by the mosaics in San Vitale, Ravenna.[36]

By September 24, has arrived in Vienna

for an "international exhibition of new theater techniques" (*Internationale Ausstellung neuer Theatertechnik*) organized by Frederick Kiesler for the Theater- und Musikfestspiele der Stadt Wien (September 24–October 20). Kiesler's Space Stage, an elevated theater in the round designed for Vienna's Konzerthaus, is featured in the exhibition. Léger delivers an address and shows *Ballet mécanique* for the first time in public.

December 4. Premiere of the Dada ballet *Relâche* ("No performance"), by Francis Picabia, with music by Erik Satie and choreography by Jean Börlin, performed by the Ballets Suédois at the Théâtre des Champs-Élysées, Paris. (The premiere had been scheduled for November 27; ironically it was canceled due to Börlin's illness.) In place of an intermission, René Clair's film *Entr'acte* is shown. Based on a scenario by Picabia, this twenty-one-minute film features music by Satie and includes in its cast Duchamp, Picabia, de Maré, Satie, Man Ray, Börlin, and others. Along with Duchamp, Brancusi, Man Ray, Kiki de Montparnasse, and many others, Léger attends the premiere and praises both the ballet and the film in print.[37]

1925

March 17. Final performance of the Ballets Suédois, after which de Maré disbands the company.

April–October. *Exposition Internationale des Arts Décoratifs et Industriels Modernes*, Paris. Léger contributes a mural to the French Ambassador's Pavilion, designed by Robert Mallet-Stevens (fig. 5, p. 129), and his *Le Balustre* is hung in Le Corbusier's Pavillon de L'Esprit Nouveau.

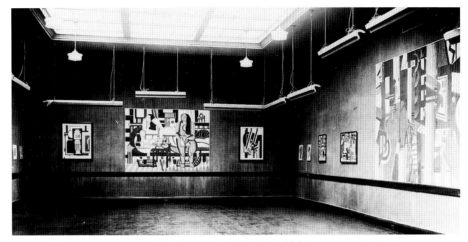

Fernand Léger, installation view, exhibition organized by the Société Anonyme at the Anderson Galleries, New York, November 16–28, 1925

Paul Léon, director of the École des Beaux-Arts, orders the mural painting removed on opening day, but public protests lead to its return.

May 3, 10. *Ballet mécanique* is shown in Berlin.

August/September. Sometime during this period, the Baron and Baroness Gourgaud purchase works by Léger from Léonce Rosenberg. The Baroness (née Eva Gebhard) is a wealthy American who, with her husband, will acquire a large collection of modern art.

October 1. Premiere of *La Revue nègre* at the Théâtre des Champs-Élysées, Paris. The final act is Josephine Baker's "*Danse Sauvage*." With the assistance

of the Mexican artist Miguel Covarrubias, then living in New York, Léger has been instrumental in bringing Baker to Paris.[38]

November 16–28. *Fernand Léger*, at the Anderson Galleries, New York. Léger's first solo exhibition in the United States, it is organized by Katherine Dreier of the Société Anonyme. According to Dreier's correspondence with Léger (December 2), five hundred people attend the opening.[39] Dreier anonymously buys four watercolors from the show: *Study for "Le Disque"* (1918), *Study for "La Ville"* (1919), *Ladder* (1923), and *Umbrella* (1925), all of which she will later give to the Yale University Art Gallery. Under different organizational auspices, the exhibition will travel to Berlin and Moscow.

November 30–December 21. *Exposition Internationale de l'Art d'Aujourd'hui*, at the Salle du Syndicat des Négociants en Objets d'Art, Paris. Organized by the Polish painter Victor Poznanski, the exhibition includes eight works by Léger. Gerald Murphy, Patrick Henry Bruce, Piet Mondrian, Picasso, Gleizes, and Ozenfant also exhibit, as well as many of Léger's students, including Marcelle Cahn, Otto Carlsund, Franciska Clausen, and Florence Henri.

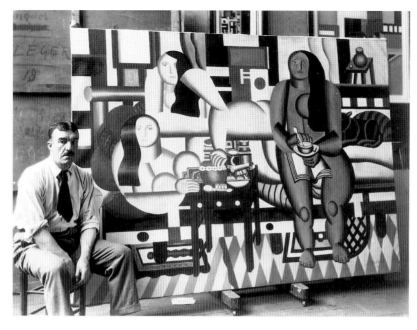

Léger and *Three Women* (also called *Le Grand Déjeuner*, 1921), 1926. Photograph by Thérèse Bonney

1926

Publication of the first issue of the journal *Cahiers d'Art*, by Christian Zervos.

January. Stays with Gerald and Sara Murphy at their house, Villa America, in Antibes. Visits Nice on January 18 and Monte Carlo on January 22.

February 1. Leaves Antibes and returns to Paris via Marseilles.

February 27–March 15. *The International Theatre Exposition*, at the Steinway Building, New York, organized by Frederick Kiesler and Jane Heap (editor of *The Little Review*). Léger exhibits designs for *La Création du monde* and *Skating Rink*, and his text "A New Realism" appears in the catalogue.

March 14. *Ballet mécanique* is shown for the first time in New York, at the Klaw Theater, along with Marcel L'Herbier's film *L'Inhumaine* (shown as *The New Enchantment*). On the same day, *Ballet mécanique* premieres in London at the New Gallery Cinema, where it is screened with Robert Wiene's film *The Cabinet of Dr. Caligari*.

Early summer. First showing of *Ballet mécanique* in Paris, at the Studio des Ursulines, where it is screened with Clair's film *Entr'acte*.[40]

June 26. Léger writes to Lucie Kahnweiler of his intention to live apart from Jeanne. They separate but never

divorce, choosing instead an open marriage. She will develop a long-term relationship with the writer André de Richaud.

November 19, 1926–January 9, 1927. The Société Anonyme's *International Exhibition of Modern Art*, organized by Katherine Dreier with the help of Duchamp, is held at the Brooklyn Museum, Brooklyn, New York. Approximately 308 works by 106 artists representing twenty-three countries are included in this, the largest and most significant exhibition of modern art in America since the Armory Show. Three oils by Léger are exhibited: *Abstraction, Circus* (*Le Cirque*, 1918; B 109), *Abstraction* (1920), and *Abstraction* (*Composition No. 7*) (1925, B 433; fig. 12, p. 32). The latter will be purchased in 1927 by Katherine Dreier for the Société Anonyme.[41] Carl Einstein writes the catalogue essay on Léger. Works by several of the artist's students—Cahn, Clausen, Carlsund, and Ragnhild Keyser—also appear. Léger has helped with the selection of Danish, Swedish,

and Norwegian art. The exhibition will travel to the Anderson Galleries, New York (January 25–February 5), the Albright Art Gallery, Buffalo (February 25–March 20), and the Toronto Art Gallery (April 1–24).[42]

November 29. Léonce Rosenberg writes to Katherine Dreier that Léger's market is "booming" in Paris.[43]

1927

Publication of Maurice Raynal's *Anthologie de la peinture en France de 1906 à nos jours*, which includes a section on Léger's art.

January 5–29. *Twenty European Artists*, at the Oakland Art Gallery, Oakland, California, an exhibition organized by Galka Scheyer and circulated by the Western Association of Art Museum Directors. Léger is included.

By March 31, Paul Rosenberg, Léonce Rosenberg's brother, has purchased five paintings from Léger and is becoming an active dealer in his work. Rosenberg will include Léger in the exhibition *Oeuvres*

de quelques peintres du XXe siècle, at the Galerie Paul Rosenberg in Paris in May and June of this year. Over the next decade Léger's work will appear regularly at his Paris gallery.[44]

April 11–30. *Exhibition of Progressive Modern Painting from Daumier and Corot to Post-Cubism*, at The Art Museum of Wellesley College, Wellesley, Massachusetts. The exhibition is organized by Alfred H. Barr, Jr., then teaching in the college's Department of Art History, and includes three small Léger watercolors loaned by Gladys Saltonstall.

Léger designs the catalogue cover for the exhibition *Machine-Age Exposition* (fig. 13, p. 34), at 119 West 57th Street, New York (May 16–28; Léger does not exhibit in the show). Organized by Jane Heap of *The Little Review* and societies from Belgium, the Soviet Union, Czechoslovakia, Poland, and Austria, the show includes photographs, sculpture, architectural decorations, and actual machine parts.

By July 25, American collector Albert Eugene Gallatin has purchased a Léger watercolor. He also buys a Léger gouache, *Vases* (1926), from Kahnweiler this year.[45]

By July 29, is in Vichy, where he remains for much of August.

December 13, 1927–January 25, 1928. Opening exhibition of the Gallery of Living Art (later the Museum of Living Art), a museum space devoted to experimental, nonacademic art and founded by Gallatin at New York University, on Washington Square in New York. The first exhibition includes Léger's gouache *Vases* and other examples from Gallatin's collection, as well as works lent by Ferdinand Howald, the Wildenstein gallery, Philip L. Goodwin, and other collectors.

Possibly this year, meets American

architect Wallace K. Harrison, who will become a close friend and supporter.[46]

1928

March. Final solo exhibition at the Galerie de l'Effort Moderne, Paris, which closes this year.

September. Léger and Stuart Davis exchange studio visits.[47]

Sometime this year, the New York art dealer Sidney Janis meets Léger in Paris and thereafter visits him regularly.[48]

C. September 4–11. American sculptor John Storrs, then residing in Mer, Loir-et-Cher, buys *Composition en bleu* (1927, B 518) directly from Léger for Charles H. Worcester of Chicago, who will later donate it to The Art Institute of Chicago.

December. Efstratios Tériade's monograph on Léger is published by Éditions "Cahiers d'Art," Paris.

1929

February. The French journal *Sélection (Chronique de la vie artistique et littéraire)* publishes a special issue dedicated to Léger.

Spring. The American painter George L. K. Morris studies with Léger for the first time; he will return to Léger's studio in the spring of 1930.

Spring and summer. A. E. Gallatin is in Paris, and by June has purchased Léger's *L'Échafaudage* (1919, B 168), which goes on view in his Gallery of Living Art in New York in mid-November.[49]

Executes four paintings on the theme of the seasons for Léonce Rosenberg's new Paris apartment.[50]

Visits Gerald and Sara Murphy's son Patrick, who suffers from tuberculosis, in Montana-Vermala, Switzerland.

1930

January 18–March 2. The third exhibition at The Museum of Modern Art, *Painting in Paris from American Collections*, includes two works by Léger: *Follow the Arrow* (*Le Passage à niveau*, also called *Sketch for the Railway Crossing*, 1919; B 181), lent by Mrs. John Alden

Above: Léger with Alexander Calder's wire sculpture *Fernand Léger* (1930), 1934. Below: Léger in his studio, 1931. Photograph by A. E. Gallatin

Carpenter, and *Composition with a Vine* (1929), lent by Paul Rosenberg and Co.

Sometime this year, meets film director Serge Eisenstein in Paris. Gives him a small painting and dedicates to him his essay "À propos du cinéma."[51]

April 18–May 1. Exhibition of the Cercle et Carré group at the Galerie 23,

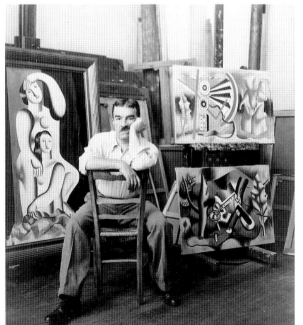

Paris, includes two works by Léger. The group has been founded the previous year, and Léger, Ozenfant, and a number of Léger's former pupils have joined, including Franciska Clausen, Nadia Khodossievitch, Marcelle Cahn, and Alexandra Exter.

June. Meets Simone Herman, a painter born in Antwerp in 1905. By October she will have enrolled in his academy, and the following year they will begin a romantic liaison that will last through the decade.

June 4. László Moholy-Nagy calls on Léger, bringing with him Hilla von Rebay, who is in Paris selecting works for the new collection of Solomon R. Guggenheim. Guggenheim visits Léger before June 24 and purchases *Composition* (1925, B 400).

Summer. Gallatin purchases Léger's *Dish of Fruit* (1925) in Paris.

October. On the advice of Frederick Kiesler, Alexander Calder invites Léger, Carl Einstein, Le Corbusier, Mondrian, and Theo van Doesburg to view a performance based on his sculptural work *Circus*. This may mark the first meeting between Léger and Calder.[52] In the same year, Calder creates a wire portrait of Léger.

1931

April 23 and May 13. Gallatin visits Léger in his Paris studio and acquires *La Feuille verte* (1930, B 724) and *Composition avec figures* (1931, B 776), which will go on view in New York at

Gallatin's Gallery of Living Art on November 2.

Writes the preface to the catalogue for the exhibition *Alexander Calder: Volumes—Vecteurs—Densités/Dessins—Portraits*, at the Galerie Percier, Paris (April 27–May 9). Léger's text is entitled *"Erik Satie illustré par Calder. Pourquoi pas?"*

July 14–August 11. Visits Gerald and Sara Murphy in Bad Aussée, in the Austrian Tyrol. They are joined by Zelda and Scott Fitzgerald.

September 27–December 8. Makes his first trip to the United States, for an exhibition of his works on paper at the John Becker Gallery, New York (October 1–23). Leaves from Cherbourg on September 22 on the *Europa*, arriving in New York on September 27.

By October 18, Léger and Hilla Rebay have visited Solomon Guggenheim's estate in Port Washington, New York. Léger seeks a commission from the Guggenheims for a mural decoration, but does not receive one.

October 21 and 24. Alice Roullier of The Arts Club of Chicago invites Léger to show his works there.[53]

Before October 22, has visited Atlantic City, New Jersey.

November 4. Gallatin holds a reception in Léger's honor at the Gallery of Living

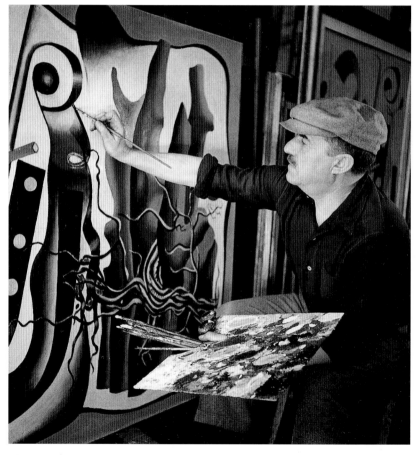

NEW-YORK vu par F. LÉGER

Léger's article *"New-York vu par F. Léger"* in *Cahiers d'Art*, 1931

Art. An exhibition of recent acquisitions (which has opened on November 2) includes *La Feuille verte* and *Composition avec figures*.

November 5. In a postcard to Le Corbusier, describes touring New York with architect Buckminster Fuller and John Storrs.

November 16. Arrives in Chicago, where he stays with John Becker's mother, Mrs. Benjamin Becker.

November 20. Screening of *Ballet mécanique* at The Arts Club of Chicago, accompanied by George Antheil's music for pianolo. Léger gives a lecture and attends a reception in his honor. A small exhibition is held concurrently at the Arts Club (through November 28). On November 24, *Ballet mécanique* is shown at the Renaissance Society, University of Chicago.

Late November. Writes an essay, "Chicago," dedicated to the memory of Rue Winterbotham Carpenter, a former

president of The Arts Club of Chicago, recently deceased.[54]

November 26. Leaves Chicago for New York, arriving the following day.

December 8. Leaves for Paris with the American author and curator James Johnson Sweeney on the *Bremen*.[55]

Publishes the essay *"New-York vu par F. Léger,"* dedicated to Sara Murphy, in *Cahiers d'Art*.[56]

December 28. Publishes the essay "Wall Street" in *L'Intransigeant* (Paris).

1932
January 4. Publishes the essay *"Vingt-quatre heures ou la vie d'un journal à Chicago"* in *L'Intransigeant* (Paris).

Resumes teaching at his school, the Académie Moderne, now located in the Académie de la Grande Chaumière. Nadia Khodossievitch becomes increasingly involved in the teaching. The school will later move several times,

Léger painting *Composition au tronc d'arbre* (1931)

ending at the square Henri-Delormel, near Denfert-Rochereau.

C. August 10–September 20. Spends the summer at his farm in Normandy.

1933

April–c. May 7. Visits Zurich for his exhibition at the Kunsthaus (April 30–May 25). Screens *Ballet mécanique* and gives a lecture at the museum. A special issue of *Cahiers d'Art* dedicated to Léger is published concurrently with this exhibition.

Summer. Galka Scheyer sees Léger during a visit to Paris.

July 29–August 13. Attends the 1933 meeting of the Congrès Internationaux d'Architecture Moderne, which takes place on board the *S.S. Patris* as it sails from Marseilles to Athens, Greece. Le Corbusier directs the conference, the theme of which is "The Functional City." Léger presents a lecture entitled "*L'Architecture devant la vie.*"[57] Alvar Aalto, Charlotte Perriand, and Siegfried Giedion are among the other participants.

August 14–23. Stays with Gerald and Sara Murphy in Antibes. Around August 22, visits Nice and meets Somerset Maugham and Henri Matisse.

1934

February 8. Gives a lecture at the Sorbonne entitled "*De l'Acropole à la Tour Eiffel,*" which stems from his trip to Greece the previous year.[58]

Before March 19, Léger and James Joyce see the play *La Porteuse de pain*, based on the novel by Xavier de Montepin.

Before March 26, film producer Alexander Korda invites Léger to design costumes and sets for *Things to Come*, a film based on H. G. Wells's novel *The Shape of Things to Come*.[59]

March–April. Visits architect Jean Badovici in Vézelay, Burgundy. Completes a maquette for a fresco to be painted on a wall of Badovici's courtyard (*Projet pour une peinture murale*, 1934,

Léger's watercolor *Sara Murphy*, painted during a sailing trip with the Murphys on their boat *The Weatherbird*, 1934. Collection Honoria Murphy Donnelly

B 852). The fresco will be completed in 1936 (fig. 8, p. 135).[60]

Summer. A. E. Gallatin makes two studio visits to Léger and acquires the gouache *Accordion* (1926), the study *Mother and Child* (1924), and *Composition* (1923–27, B 519; p. 205).

Léger's Académie Moderne is renamed the Académie d'Art Contemporain. Between this year and 1938, the artist Louise Bourgeois will be in Paris, attending several art schools, including the Académie d'Art Contemporain. A period of study with Léger, she will later

say, "turned [her] into a sculptor."[61]

July 20–August 12. Visiting Gerald and Sara Murphy at the Villa America in Antibes, Fernand and Jeanne Léger accompany the Murphys on a sailing trip from Gibraltar to Antibes aboard their boat *The Weatherbird*. Léger paints numerous watercolors during this trip. He also writes the manuscript for a never realized performance project, *La Mort de Marat suivi de sa pompe funèbre*.

C. August 15. Travels to London to collaborate on Alexander Korda's *Things to Come*. Korda will not use Léger's numerous drawings for the film, but will pay him for his work.[62]

September 8. Travels with Simone Herman to Copenhagen and to Stockholm, where Rolf de Maré, Otto Carlsund, and Ragnar Hoppe have prepared a small retrospective of his work at the Galerie Moderne (September 12–26). *Ballet mécanique* and *Entr'acte* are screened. Will return to London after about ten days and be back in Paris by mid-October.

Is solicited to become a member of the Union des Artistes Modernes, an organization of painters, sculptors, architects, and decorative artists formed in reaction to the rejection of nonacademic decorative arts at the Salon des artistes décorateurs of 1929. Charlotte

Perriand, René Herbst, and Robert Mallet-Stevens are among the founders of the group, which promotes social art adapted to the technology of the period. Their first exhibition has been in 1930; Léger will join in 1935.

Léger and his wife Jeanne, Paris, 1935. Photograph by Mrs. Gilbert W. Chapman

1935

By January, has begun planning his second trip to the United States.

April 27–November 3. The *Exposition Universelle et Internationale* in Brussels includes an architectural exhibit, *La Maison du jeune homme*. Paintings by Léger hang in two different rooms of this "young man's home" (figs. 9–11, p. 136): in the study, which is designed by Charlotte Perriand, a composition with aloe (c. 1934–35), and in the gym, designed by René Herbst, the *Salle de*

polychrome exposition in a white-washed Paris. He also makes designs for an illuminated Eiffel Tower, an idea that he will explore for many years.

September 25. With Simone Herman, leaves Le Havre on the S.S. *La Fayette* for New York, arriving there on October 4.

culture physique (1935, B 873). Léger travels to Brussels with Perriand to see the exhibition.

May 18 and 29. Gallatin visits Léger's studio and acquires three works: *Étude pour "La Femme en rouge et vert"* (1913, p. 168), *Study for a Mural* (1925), and the early ink drawing *Nude Woman Kneeling* (1911).

July 27. Asks the Murphys for money for a visit to the United States; they forward him funds.

August. In the journal *Vu* (August 1935), Léger, Le Corbusier, and other artists respond to the question, "What would you do if you were organizing the Exposition of 1937?" Léger proposes a

His first major American retrospective has just opened at The Museum of Modern Art (September 30–October 24), and will travel to The Art Institute of Chicago, the Milwaukee Art Institute, and the Renaissance Society at the University of Chicago.[63] He misses the opening but on October 4 gives a lecture at The Museum of Modern Art entitled "The New Realism."[64] He also gives an interview published in the *New York Herald Tribune* (October 5).

October 18. Screening at The Museum of Modern Art of the version of *Ballet mécanique* that is hand-colored by Gustav Brock, and of René Clair's film *Entr'acte*. Léger presents a lecture, "Painting and Advance-Guard Films." George Antheil plays both the accom-

Left: A postcard that Léger sent to Gerald and Sara Murphy, showing the place Blanche, Paris, with his additions, n.d. Collection Honoria Murphy Donnelly.
Above: Léger arriving in New York on the S.S. *La Fayette*, October 4, 1935. Photograph by Sam Falk.
Below: Léger, Louisa Calder, Simone Herman, and Alexander Calder at the Avery Memorial of the Wadsworth Atheneum, Hartford, Conn. Photograph published in the *Hartford Times*, December 7, 1935

panying music for *Ballet mécanique* and, with Henry Brant, Satie's music for *Entr'acte*.

November 13. In New York, A. E. Gallatin hosts a dinner in Léger's honor that is attended by Charles Shaw, Henry McBride, Alexander Calder, Alfred Barr, James Johnson Sweeney, and the modern-art collector Katherine Warren.

November 16. Léger sends Galka Scheyer in Los Angeles the scenario of an animated cartoon he has been working on, entitled *Charlot Cubiste*, and asks her to obtain Charlie Chaplin's permission to use the image of his film character, called in France "Charlot." Scheyer will write to Chaplin on December 4, enclosing the scenario, but Chaplin will turn Léger down.[65]

Works on a mural project for the French Line pier in New

York Harbor, sponsored by the federal government's Works Progress Administration (fig. 15, p. 47). Collaborators include Harry Bowden, Byron Browne, Mercedes Carles (later Matter), Willem de Kooning, and George McNeil. The project is ultimately abandoned.

C. December 7. Léger, Simone Herman, and Alexander and Louisa Calder visit Hartford, Connecticut, to make plans for the Paper Ball, to be held there in February 1936.

December 15. Léger and Herman visit Niagara Falls.

December 18. Léger and Herman go to Chicago. The trip coincides with the showing of Léger's retrospective at The Art Institute of Chicago (December 19, 1935–January 19, 1936). Léger attends the opening and gives a lecture.

December. Is commissioned to paint the portrait of Mrs. Chester (Maud) Dale (1935, B 866), which he executes while in Chicago.

1936

Sometime this year, Paul Nelson, an American architect living and working in Paris, invites Léger, Jean Arp, and Joan Miró to collaborate on a maquette for a theoretical "Suspended House" (1936–38). Léger paints a miniature mural for a circular dining room. The original maquette is accidentally destroyed and Léger, Miró, and Calder create works for a second (now in the collection of The Museum of Modern Art, New York).

January 30. Simone Herman departs for Paris.

Before February 13, sees the Charlie Chaplin film *Modern Times*.

February 9–16. The first Hartford Festival, at the Wadsworth Atheneum, Hartford, Connecticut. Léger attends the

Léger with Sara Murphy (left) and Ada MacLeish at the Paper Ball, Hartford, Conn., February 15, 1936. Photograph by Richard Myers

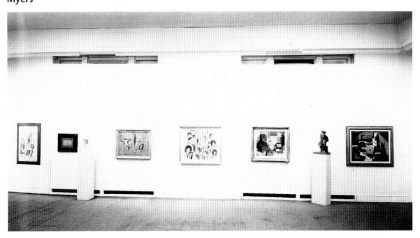

Cubism and Abstract Art, **installation view, exhibition at The Museum of Modern Art, March 2– April 19, 1936. Photograph by Beaumont Newhall**

Paper Ball, the festival highlight, held on February 15 and featuring a procession of guests dressed in paper costumes designed by Pavel Tchelitchew, Alexander Calder, and others. Léger, Sara Murphy, and Archibald and Ada MacLeish dress in gypsy costume. George Balanchine, Lincoln Kirstein, and Pierre Matisse are also present. Léger lodges with the family of Marie Bissell, chair of the ball, in Farmington, Connecticut.

Returns to New York and stays with the Murphys at the Russel Hotel.

March 2–April 19. *Cubism and Abstract Art*, at The Museum of Modern Art, New York. This exhibition, organized by Alfred Barr, includes five paintings by Léger.

March 7. Leaves for Paris on the *S.S. Champlain*.

April. Léger's work is shown for the first time at the Katharine Kuh Gallery, Chicago.

Sometime this year, Léger speaks to workers at the Renault car factory in the Paris suburb of Boulogne-Billancourt. Special art courses are organized by the company for the workers, several of whom join Léger's academy.

May 24. With Le Corbusier, participates in a procession before the Mur des Fédérés at the Père Lachaise cemetery, organized by the Confédération Générale du Travail and honoring those who died during the suppression of the Paris Commune of 1870.

Joins the Communist-backed intellectual organization Association des Écrivains et Artistes Révolutionnaires, which this year becomes the Organisation des Maisons de la Culture.[66]

May 29. Participates in a debate entitled "*La Querelle du réalisme*," organized by

Louis Aragon and the Association des Peintres et Sculpteurs de la Maison de la Culture. Takes up a position against Aragon and "Socialist Realism," and argues that public misunderstanding of modern art is due to the present social order, not to the works themselves. His views are published; Aragon responds in print the following month.[67]

June 7. Writes to Simone Herman from Vézelay, where he is executing his fresco for the home of architect Jean Badovici (*Mur libre*, undated, B 853).

December 15. Premiere of the ballet *David Triomphant*, choreographed by and starring Serge Lifar, at the Théâtre de la Maison Internationale des Étudiants Universitaires, Paris. Léger has designed the decor and costumes, which he has based on playing cards. The ballet is danced again on May 26, 1937, at the Théâtre de l'Opéra, Paris.

By the end of the year A. E. Gallatin has acquired *La Ville* (B 163) for his gallery at New York University, which has been renamed the Museum of Living Art.

1937

March 19. John Dos Passos visits Léger on his way to Spain. They go to Chartres together.

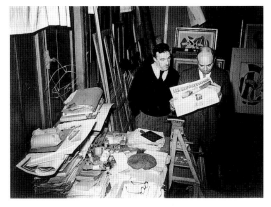

Léger and John Dos Passos in Léger's studio, 1937. Photograph by Thérèse Bonney

Late April. Visits Paul and Francine Nelson at their home in Varengeville, on the Normandy coast. Alexander and Louisa Calder and Teeny Matisse (later Teeny Duchamp) are also there.[68]

May 24–November 2. *Exposition Internationale des Arts et Techniques dans la Vie Moderne*. Léger contributes to numerous pavilions at this Paris exposition: with Albert Gleizes and Léopold Survage, he paints a mural for the pavilion of the Union des Artistes Modernes; with Charlotte Perriand, he helps to create outdoor photomurals at the Centre Rural (fig. 17, p. 143); he contributes the mural *Travailler* to Le Corbusier's Pavillon des Temps Nouveaux (figs. 2 and 18, pp. 122 and 144); and he paints a mural for the Pavillon de la Solidarité of the Confédération Générale du Travail, the largest trade-union organization in France. On April 12, his mural *Transport des forces* (B 932) is installed at the exposition's Palais de la découverte. The mural, which depicts the creation of hydroelectric power, has been painted earlier in the year by Léger's students from his preparatory drawings (see figs. 14 and 15, p. 141).[69]

June. Sees the English critic Douglas Cooper and also Pierre Matisse, who is organizing a Léger exhibition at his New York gallery for February of the following year.

October 18. *Naissance d'une cité*, by Jean-Richard Bloch, is performed at the Vélodrome d'Hiver in the Palais des Sports, as part of the *Exposition Internationale des Arts et Techniques*. Léger creates costumes and decor for this theatrical event.

Transport des forces is shipped to London for Léger's solo exhibition at the London Gallery (October 14–November 13).

November 27. Travels to Helsinki for his joint exhibition with Alexander Calder at Artek, a center for modern furniture and interior decoration (November 29–December 12). Sees the architect and designer Alvar Aalto, who also attends the opening. Stays for about three weeks and tries without success to get a visa to go to Russia.

1938

February 15. Lectures to miners in Lille.

C. May. The South African architectural historian Rex Martienssen calls on Léger in his Paris studio.[70] Martienssen and Léger travel to Brussels together to see Léger's exhibition at the Palais des Beaux-Arts (May 14–June 5).

The Museum of Living Art, with Léger's *La Ville* (1919) on the back wall. Photograph by Peter Stackpole. Published in *Life Magazine*, May 2, 1938

Early August. Meets with Wallace K. Harrison and the American sculptor Mary Callery to discuss a commission to decorate Nelson Rockefeller's New York apartment, which Harrison has recently redesigned. By September 9, Rockefeller accepts Léger's proposal.

Léger, New York, 1941. Photograph by Herbert Matter

September 15. Leaves from Le Havre aboard the *S.S. Île de France* for his third visit to the United States. Arrives in New York on September 21, planning to stay six months. His trip is a result of the commission to decorate Rockefeller's Fifth Avenue apartment. Léger's first project is to create murals for a circular staircase linking two floors of the apartment. These murals, apparently painted in situ, are completed by the end of the year. He is then commissioned to paint a mural over the fireplace in a sitting room, opposite a mural by Matisse. The fireplace mural will be completed in 1939.[71]

By September 27, has visited Alexander Calder for two days. Also spends time with the Greek architect Stamos Papadaki and with Amédée Ozenfant, then living in the United States.

Mid-October. Simone Herman joins Léger in the United States.

November 8. Attends the opening of an Alexander Calder exhibition at the George Walter Vincent Smith Art Gallery, Springfield, Massachusetts (November 8–27). Gives an informal talk on the exhibition. Also in attendance are Simone Herman, Alvar and Aino Aalto, Katherine Dreier, James Johnson Sweeney, Pierre Matisse, and Siegfried Giedion (see fig. 19, p. 51).

Autumn. Gives a series of eight lectures at the School of Fine Arts, Yale University. The final two lectures, seemingly more formal in nature, are "Color in the World" and "Architecture and Painting." Given on December 2 and 9, they are accompanied by a screening of *Ballet mécanique* and *Entr'acte*. The lectures are given in French with a member of the faculty acting as an interpreter.[72]

C. December. Visits John Dos Passos in Provincetown, Massachusetts, with Herman.

1939

Designs a "cinematic mural" for Rockefeller Center to be executed with Wallace Harrison (see fig. 17, pp. 48–49). The mural is planned as an animated film moving at the same rate as the escalators in the Radio City building. By February 10, the project is rejected by an art committee appointed by John D. Rockefeller, Jr.

Receives a commission from Nelson Rockefeller for a roof design at Hawes

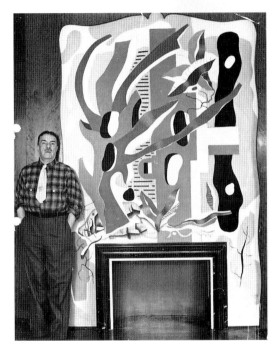

Léger with his fireplace mural for Nelson Rockefeller's apartment, New York (c. 1938–39)

House in Pocantico, New York (designed by Harrison and built in 1939). Designs a cut-out shape in a roof connecting two wings of the house.

Early March. Returns to France, traveling via Cannes.

April 30. The 1939/1940 World's Fair opens in Flushing Meadow, New York. The fair's theme is "Building the World of Tomorrow." While in America, Léger has designed a mural representing differ-

ent sources of energy for the north wall of Harrison's Consolidated Edison Building at the fair. Workers paint the final mural using Léger's preliminary sketches. At the end of the fair, the building and Léger's mural are destroyed. Léger also creates a model for a large fountain that is never completed.

Before July 22. Spends several days at Christian Zervos's home in Vézelay.

After September 3. Shortly after France's declaration of war against Germany, goes to his farm in Normandy, where he remains for about three months, making occasional trips to Paris.

September 9. Is made Chevalier de la Légion d'Honneur.

May 10–September 30. The Museum of Modern Art exhibition *Art in Our Time*, celebrating the Museum's tenth anniversary and the opening of its new building, includes three works by Léger: *Under the Trees* (*Les Maisons sous les arbres*, 1913; B 65), loaned by Walter P. Chrysler, Jr.; *Luncheon* (*Le Grand Déjeuner*, later called *Three Women*, 1921, B 311; p. 195), loaned by Paul Rosenberg; and *Composition* (1917–18, B 146), loaned by Mary Callery.

1940

March. The French minister of education commissions a decorative project from Léger for an aviation center in Briey, near Nancy.

April 15. Mary Callery has a one-day showing in her Paris studio of Léger's recently completed painting *Composition aux deux perroquets* (1935–39, B 881; p. 233). In July this monumental painting is loaned to The Museum of Modern Art in New York.

June 13. Spends time at his home in Normandy. Then, with the Germans approaching, departs for the South of France with his wife Jeanne. While he goes to Bordeaux, she travels on to Marseilles.

Summer. Paul Rosenberg leaves France for New York. Most of his twentieth-century pictures, including many Légers, are seized by the Nazis, but he is able to remove some of his stock and establishes a new gallery in New York.

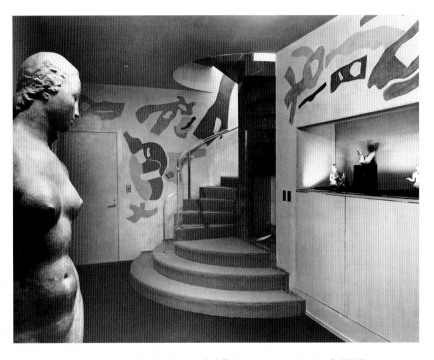

Léger's murals for the stairwell of Nelson Rockefeller's apartment, New York (1938)

By July 10, is in Toulouse with Jeanne. Goes to Marseilles the following day, and applies for a U.S. visa.

C. early August. Goes to Vichy and spends six days negotiating to get a visa.

September. Spends the month in arrangements for exile. By September 8, is back in Marseilles, awaiting permission to leave. Before September 16, learns from Wallace K. Harrison of a probable appointment lecturing at Yale University. On September 18 is back in

Vichy. On September 30 is in Barcelona, and writes to Le Corbusier, "En route toward New York after tomorrow—Lisbon."[73]

October 2. Arrives in Lisbon. Writes to Jeanne on November 1, "I've got a bunk on an American boat. Thanks to the intervention of the minister of propaganda!"[74]

November 3. Departs for the United States from Lisbon on the S.S. *Exeter*, arriving in Hoboken, New Jersey, on November 12. Jeanne remains in France.[75]

November 15. Is invited by Alfred Neumeyer, director of the Mills College Art Gallery, Oakland, California, to teach at Mills College during the summer of 1941.

By November 18, is staying at the University Club on Fifth Avenue while looking for a studio. Architect Philip L. Goodwin, a Trustee on the Acquisition

277

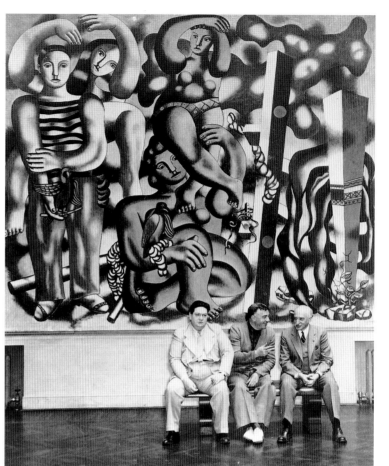

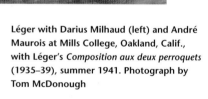

Léger in his studio at 80 W. 40th Street, New York, c. 1941–43

Committee of The Museum of Modern Art, supports Léger and tries to find him commissions.

By December, has moved to the Tudor Hotel, 328 East 42nd Street, where he stays with the artists Herbert and Mercedes Matter. Mercedes Matter has worked with Léger on the French Line murals in 1935.

Jacqueline Lignot-Roux, Léger's companion, joins him in New York and stays with him at the Matter home. Roux has training as an art historian, and in the United States she serves as Léger's assistant, translating many of his lectures into English.[76]

December 27–January 12. *Composition aux deux perroquets* (B 881) is exhibited at The Museum of Modern Art.

1941
January 6–March 4. Walter P. Chrysler's collection, including thirty-one works by Léger, is exhibited at the Virginia Museum of Fine Arts, Richmond.

Sometime this year, develops a friendship with the author Henry Miller, whom he meets in New York.

April 22. Is granted an extension of temporary permission to stay in the United States.

Goes to Chicago for his solo exhibition at The Arts Club of Chicago (May

23–June 14), which includes *Composition aux deux perroquets* (B 881), loaned by Mary Callery. Gives a lecture and screens *Ballet mécanique*.

By late May, has moved to the Beaux-Arts Building, a studio apartment building for artists at 80 West 40th Street. Kurt Seligmann, photographer Thomas Bouchard, and Florine Stettheimer also live there during this period.

Léger teaching at Mills College, Oakland, Calif., summer 1941. Photograph by Tom McDonough

Gerald and Sara Murphy commission two paintings from Léger for their New York apartment: *Red Decoration* (1941) and *Blue Decoration* (1941).

Late June. Travels by bus to San Francisco for a summer teaching engagement at Mills College, Oakland. Jacqueline Roux accompanies him. Darius Milhaud and André Maurois are also on the summer teaching staff.

Léger with Darius Milhaud (left) and André Maurois at Mills College, Oakland, Calif., with Léger's *Composition aux deux perroquets* (1935–39), summer 1941. Photograph by Tom McDonough

The Arts Club of Chicago exhibition travels to Mills College and opens on June 29. While at Mills College, Léger completes at least 20 "Plongeurs" drawings, which are added to his exhibition as it tours the West Coast.

July. Is investigated by the Immigration and Naturalization Service in connection with an application to remain in America. Nelson Rockefeller writes a letter to the INS in Léger's support. By August 15, is granted another extension of temporary stay until March 1, 1942, provided he ceases from any engage-

ment in domestic business: he is not allowed to accept commissions and fees for paintings, nor may he conduct a private art school. He is allowed to teach art at an American university.[77]

August 12–September 7. An expanded version of the Mills College exhibition is shown at the San Francisco Museum of Art, where, on August 21, Léger lectures on the origins of modern art. The Western Association of Art Museum Directors then circulates the show to the Stendahl Art Galleries, Los Angeles, and other West Coast venues.

After August 21. Leaves San Francisco with Roux, arriving in Los Angeles around August 31.

September 11. Attends the opening of the exhibitions *Composition with Two Parrots* and *Recent Gouaches and Drawings* at the Stendahl Art Galleries. Theodore Schempp hangs the show and purchases a work. *Ballet mécanique*, René Clair's *Entr'acte*, and two films by Man Ray, *The Star of the Sea* and *Enak-Bakia*, are screened in conjunction with the exhibition.

Before September 15. Lunches with Clair and dines with Igor Stravinsky in Los Angeles. Also sees Alexander Korda.

September 22. Goes to Carmel to conduct a two-week symposium for professional painters at the Carmel Art Institute under the direction of John Cunningham. Between September 26 and October 2, gives a lecture series at the Carmel Playhouse. Talks include "Anamatographic Art and Modern Painters" and "Development of Modern Art from Assyrians to Today."

October 1–4. Del Monte Art Gallery, Hotel del Monte, Del Monte, California. A group show of "important French moderns" presented by Theodore Schempp and Earl Stendahl includes

Léger's cover design for *Fortune* magazine, December 1941

Braque, Picasso, Léger, Degas, Gris, Renoir, and Miró. In connection with the show, Léger gives a talk, "These Artists as I Know Them," on October 1.

October 4. Leaves Carmel and returns to New York by train.

October 19. Writes to Alfred Neumeyer at Mills College, asking for help in securing teaching positions at American universities. Neumeyer writes to many colleagues but fails to find a post for Léger.

December 11. Sends Archibald MacLeish, Librarian of Congress, the manuscript of a play he has written, *Guerre et Paix*, hoping the library can fund its production.

December. The cover of this month's issue of *Fortune* magazine carries a design commissioned from Léger.

1942
Mid-January. Travels to Washington, D.C., and Virginia.

March. The Museum of Modern Art acquires *Le Grand Déjeuner* (B 311) from Paul Rosenberg. Alfred Barr renames it *Three Women*, to echo

Léger in New York, c. 1940–45. Photograph by Thérèse Bonney

Picasso's *Three Musicians* (1921).

March 3–28. Pierre Matisse Gallery, New York. The exhibition *Artists in Exile* includes Léger, Matta, André Breton, Ossip Zadkine, Piet Mondrian, Yves Tanguy, André Masson, Max Ernst, Amédée Ozenfant, Pavel Tchelitchew, Jacques Lipchitz, Marc Chagall, Kurt Seligmann, and Eugene Berman. George Platt Lynes photographs the artists in the gallery.

June. *La Ville* (B 163) is reproduced in the French edition of the Nazi propaganda magazine *Signal* in an article discussing decadent art in the United States.

Late July/early August. Vacations in Franconia, New Hampshire.

August 22. Stays with James Johnson Sweeney and his wife Laura in Osterville, Massachusetts. Returns to New York around September 5.

August. Is included in the inaugural exhibition of the Musée national d'art moderne, Paris.

Sometime this year, paints a mural on the "*Plongeurs*" theme for Wallace K.

Harrison's home in Huntington, Long Island. Later paints complementary designs on the floor of Harrison's circular swimming pool.

December 14. A. E. Gallatin's Museum of Living Art is closed at New York University. His collection is placed on extended loan (and later donated) to the Philadelphia Museum of Art.

1943
During this year, lectures in Washington, D.C., on behalf of the organization France Forever, and also at the Harvard University School of Architecture and at New York's Institut Français.

Thomas Bouchard begins filming *Fernand Léger in America, His New Realism*

Léger and Thomas Bouchard sitting before a model of Léger's *La Forêt* (1942), c. 1945. Photograph by Bouchard

in Léger's New York studio. Music by Edgard Varèse is chosen to accompany the film, which will be completed in 1945.[78]

After March 23. Travels to Montreal for the purpose of renewing his visa. On the

279

way, discovers Rouses Point, near Lake Champlain, where his train stops for several hours.

April 9. Returns to the United States.

May 14. Opening of Gallatin's collection in its new home at the Philadelphia Museum of Art. Jean Hélion lectures on the collection. Accompanied by Jacqueline Roux, Léger attends the opening, including a luncheon for New York newspaper and magazine critics, which

Léger and Hilla von Rebay at Franton Court, her house in Connecticut, early 1940s

is also attended by a number of other artists including Marcel Duchamp. Léger also gives an informal gallery talk and is photographed for Philadelphia's *Evening Bulletin* in front of *La Ville* (B 163).

Between May 15 and May 28, returns to Montreal for his solo exhibition at the Dominion Gallery (May 29–June 9), organized by art historian and critic

Maurice Gagnon. On May 28, gives a slide lecture, "*Les Origines de la peinture moderne*," at the École du Meuble. Screens *Ballet mécanique* and *Entr'acte*.

While in Montreal, meets Père Marie-Alain Couturier, with whom he discusses plans for a subterranean church in Chicago (never realized).

July 1. Arrives in Rouses Point, a rural village with many French-speaking inhabitants, and spends the summer at an old farm. Abandoned farm machinery overgrown with vegetation inspires many drawings and gouaches.

C. December 15. Goes to Washington, D.C., seeking funding from South American embassies for *Bolivar*, an opera that will eventually premiere in Paris in 1950 with sets and costumes designed by Léger.

1944

Before March 13, goes to Washington, D.C., and delivers a lecture on the origins of modern painting.

May 1. Is in St. Louis, Missouri, where he lectures on "The Arrival of Color in

Léger with *La Ville* (1919) at the opening of the A. E. Gallatin Collection at the Philadelphia Museum of Art, May 14, 1943. Photograph published in the *Philadelphia Evening Bulletin*, May 19, 1943

Léger and Jacqueline Lignot-Roux in Léger's New York studio, c. 1944–45. Photograph by Lilly Joss

Modern Painting and Its Expansion throughout the World" at Washington University. An exhibition of his paintings opens at the Book Shop in St. Louis on April 30.

C. June 23. Goes to Rouses Point with Jacqueline Roux for the summer, again staying in an old farmhouse. Siegfried Giedion, then working on his book *Mechanization Takes Command*, stays nearby, and spends time with Léger and Roux. Giedion writes an essay for a book on Léger that will be published by Éditions de l'Arbre, Montreal, in 1945.

Before July 14, goes to Montreal, probably accompanied by Giedion, and spends two days with Maurice Gagnon. Returns to Rouses Point by July 14.

July. Enlists Hilla Rebay's assistance in finding a new studio in New York.

C. August. Works on "The Girl with the Prefabricated Heart," a sequence, with music by Broadway composer Jean

Latouche, for Hans Richter's film *Dreams That Money Can Buy* (1944–46). Marcel Duchamp, Alexander Calder, Max Ernst, Darius Milhaud, Victor Vicas, and Man Ray will contribute

Léger, Man Ray (far left), and others at the opening of *Modern Art in Advertising, Designs for the Container Corporation*, exhibition at The Art Institute of Chicago, April 1945. Photograph by Gordon Coster

Léger in his New York studio, c. 1944–45. Photograph by Lilly Joss

pieces to this composite film. It will premiere at the San Francisco Museum of Art in 1947.

October 3. Returns to New York, still looking for a new studio.

October. Designs the cover for this month's issue of *View*, which includes James Johnson Sweeney's essay "Léger and the Search for Order."

October 10. Moves to the Tudor Hotel, at 328 East 42nd Street (where he previously lived with Herbert and Mercedes Matter in 1941).

Before October 15, goes to Chicago for his solo exhibition at the Institute of Design (October 14–November 8), then

directed by László Moholy-Nagy. With Moholy-Nagy, Alice Roullier (chair of the Exhibition Committee at The Arts Club of Chicago), and Walter Paepcke (president of the Container Corporation of America), attends a gathering at the home of Bobsy Goodspeed (later Mrs. Gilbert Chapman), an active member and former president of The Arts Club of Chicago.

1945

Designs the cover for *The Happy Rock, a Book about Henry Miller* (Berkeley, California: Bern Porter, 1945).

January 6. Lectures at the Fogg Art Museum, Harvard University, on color in architecture.

January 10–February 20. Mary Callery's collection of works by Léger and Picasso

is shown at the Philadelphia Museum of Art.

February 25. Travels to Montreal on his way to Quebec City, where he arrives the following day. Serves on the jury for the *Grand Prix de la peinture*, a prize administered by the government of the Province of Quebec.

March 13–April 11. *European Artists in America*, an exhibition organized by Juliana Force at the Whitney Museum of American Art, New York, featuring refugee artists living in the city. Léger exhibits seven works: *Composition à l'oiseau* (1942), *Les Plongeurs circulaires* (1942), *Plongeurs en noir et bleu* (1942–43), and several drawings.

By April 12, has moved to 77 Lexington Avenue.

Léger and Maurice Gagnon raise money to buy blankets and other goods to be sent to war victims in France.[79]

Top: the farmhouse Léger rented at Rouses Point, New York, 1945.
Bottom: Siegfried Giedion and Léger at Rouses Point, 1945. Both photographs by Martin S. James

Before April 27, goes to Chicago for the opening of *Modern Art in Advertising, Designs for the Container Corporation*, an exhibition at The Art Institute of Chicago (April 27–June 23) featuring advertising designs by numerous artists for Walter Paepcke's Container Corporation of America. Two works by Léger are included, and the exhibition catalogue includes his essay "The Relationship between Modern Art and Contemporary Industry." Man Ray and László Moholy-Nagy are also present for the opening.

May 9. Is in Quebec City, where he lectures on color in architecture. The following day he gives the same lecture at the Jardin Botanique de Montréal.

During this period, collaborates with Gagnon, Père Couturier, Siegfried Giedion, Samuel Kootz, François Hertel, and James Johnson Sweeney on the book *Fernand Léger: La Forme humaine dans l'espace* (Montreal: Éditions de l'Arbre, 1945). Plans and edits much of the book himself.[80]

Spends a last summer at Rouses Point with Jacqueline Roux. Giedion again lives nearby. On July 27 visits Saranac Lake, New York. Remains at Rouses Point at least through September 12.

September. Seeks a visa to return to France. Attributes the difficulty he has in obtaining this visa to his leftist political views.

By October, has returned to New York from Rouses Point.

By October 9, has received a visa for his return to France.

October 18. Through correspondence with Jean-Richard Bloch, a Communist writer and intellectual and, with Louis Aragon, copublisher of the journal *Ce*

Léger and Nadia Khodossievitch with students, c. 1945–46. Photograph by Sanford Roth

Soir, joins the French Communist party.

November 27, 1945–January 10, 1946. *Annual Exhibition of Contemporary American Painting*, Whitney Museum of American Art. One painting by Léger, catalogued as *American Landscape*, is included. (After World War II, with the continued immigration of European artists, the Whitney Annuals sometimes include foreign artists working in the United States.)

After December 8, returns to France, traveling via Le Havre. Before his return, his Paris school is reopened in Montrouge as the Atelier Fernand Léger, under the direction of Nadia Khodossievitch and Georges Bauquier.

1946
January. Is in Normandy, at his farm. Returns to Paris at the end of the month.

February 15–March 15. *Art et Résistance*, an exhibition at the Musée national d'art moderne, Paris. Léger sends *Composition aux deux perroquets* (B 881).

After his return to Paris, paints *Adieu New York* (1946, p. 245).

April 5. Thomas Bouchard's film *Fernand Léger in America, His New Realism* has its first official showing, at the Sorbonne, where it is screened by the Travail et Culture association.

April 10. Gives the lecture *"L'Art et le peuple"* at the Sorbonne for the Travail et Culture association.[81]

April 12–May 11. *Fernand Léger: Oeuvres d'Amérique, 1940–1945*, an exhibition at the Galerie Louis Carré, Paris.

Through Père Couturier, receives a commission to create a mosaic for the facade of L'Église Notre-Dame-de-Toute Grâce, at Assy in Haute-Savoie. The work is called *Les Litanies de la Vierge* (1946); the church will be dedicated on August 4, 1950.

October 4–November 10. Salon d'Automne, at the Musée des Beaux-arts de la Ville de Paris. Léger presides over the hanging of three rooms of young painters; he also exhibits his own *Adam et Ève* (1935–39, B 880; p. 229).

1947
February 17. Writes to Henry Miller about a book project with Efstratios Tériade on the theme of the circus. Léger has already completed twenty color and twenty black-and-white maquettes. He asks Miller to write the accompanying text. By March 5, Miller has agreed to work on the project; Léger sends Miller drawings of clowns for inspiration.[82]

April 30. Delivers the lecture *"Quelques*

aspects de la peinture moderne," at the Sorbonne, under the auspices of the Travail et Culture association.

Summer. The Atelier Fernand Léger moves to 104, boulevard Clichy. During this period approximately 100 students are enrolled.

By July 2, Léger has received Miller's completed text for *Cirque*, but finds it unsatisfactory and asks him to change it. Miller declines, and the following year will publish the text instead as *The Smile at the Foot of the Ladder* (New York: New Directions Publishing Corp.). Léger will eventually write his own text for *Cirque*.

1948
During this period, many American artists, most on the G.I. Bill, join Léger's school. Between 1948 and 1951, Sam Francis, Richard Stankiewicz, Kenneth Noland, Beverly Pepper, Jules Olitski, Sidney Geist, and Robert Colescott study with Léger.

May 28. Premiere of *Le Pas d'acier*, a ballet choreographed by Serge Lifar with music by Sergey Prokofiev, at the Théâtre des Champs-Élysées, Paris. Léger designs the costumes and decor, which consist of reflective metal sculptures. The ballet will be performed again at the same theater in 1952.

C. May–June. Léger and his students execute a mural, *Les Femmes au conseil*, at the Porte de Versailles, Paris, for the *Exposition Internationale des Femmes*.[83]

August 25–28. Goes to an international peace congress sponsored by UNESCO in Wrocław, Poland. Is part of the French delegation, which also includes Paul Éluard and Le Corbusier.

Léger 1912–1948, installation view, exhibition at the Sidney Janis Gallery, New York, September 21–October 16, 1948. Photograph by Oliver Baker

September 21–October 16. The Sidney Janis Gallery opens in New York with its first exhibition, *Léger 1912–1948*, which includes nineteen works.

Michigan Congressman George A. Dondero leads a group of American congressional representatives in verbal and printed attacks on Léger and other modern artists whom they regard as agents of communism. Their crusade against modern artists, recorded in heated debates in Congress during the late 1940s and 1950s (transcribed in the *Congressional Record*), will continue for several years.[84]

Eugène Guillevic's poetry collection *Coordonnées*, about German concentration camps, is published, with illustrations by Léger (Geneva and Paris: Éditions des Trois Collines).

Late in the year, Hilla Rebay acquires *Modèle nu dans l'atelier* (B 40) for the Solomon R. Guggenheim Museum, New York.

Léger and Efstratios Tériade, c. 1952–54. Photograph by Alexander Liberman

1949

Begins to study ceramics with a former student, Roland Brice, at Brice's studio in Biot, in the Alpes-Maritimes.

Executes prints for several deluxe books and albums: Arthur Rimbaud's *Les Illuminations*, a project initiated by the Swiss editor Louis Grosclaude and published by Éditions des Gaules, Lausanne, with fifteen lithographs by Léger and a preface by Henry Miller; a special issue of the journal *Derrière le miroir* (nos. 20 and 21), published by Éditions Pierre à Feu, Galerie Maeght, Paris; and *Poésie des mots inconnus*, an album containing Dada poems and illustrations by various artists, published by Le Degré 41, Paris, and edited by Iliazd (Ilia Zdanevitch).

Douglas Cooper publishes his book *Fernand Léger et le nouvel espace* (Geneva: Éditions des Trois Collines).

August 11. Writes to Henry Miller about the idea of a film tracing the life of an ordinary couple for twenty-four hours. Léger has been developing this idea since 1930.

October 20–December 18. *20th Century Art from the Louise and Walter Arensberg Collection*, an exhibition at The Art Institute of Chicago, includes four works by Léger: *Contraste de formes* (1913, B 52; p. 165), *La Ville* (1919, B 159), *Le Typographe* (1919, B 190), and *L'Homme à la canne* (1920, B 211; here catalogued as *Figure of a Man*).

1950

Cirque, a *livre d'artiste* by Léger, is published in Paris by Tériade (fig. 23, p. 65). It includes thirty-four color and twenty-nine black-and white lithographs.

March 14–21. Tours Switzerland, lecturing on painting and architecture in Geneva, Lausanne, Bern, Zurich, and Basel.

May 12. Premiere of *Bolivar*, an opera in four acts with music by Darius Milhaud and a libretto by Madeleine Milhaud adapted from Jules Supervielle's play of 1936, at the Opéra de Paris. Léger designs the sets and costumes.

Creates mosaics for the crypt at the American War Memorial in Bastogne, Belgium, commemorating soldiers killed during the Battle of the Bulge. The monument, designed by Georges Dedoyard, is dedicated by U.S. President Harry S Truman on July 16, 1950.

November 15. Is named Officier de la Légion d'Honneur.

November 29, 1950–January 21, 1951. *Art Sacré: Oeuvres françaises des XIXe et XXe siècles*, an exhibition at the Musée national d'art moderne, Paris, includes work by Léger.

December 1. Jeanne Léger dies.

1951

Publication of Ivan Goll's *Les Cercles Magiques*, with reproductions of six drawings and a cover by Léger created specifically for it (Paris: Falaize).

Léger's desk, c. 1952–54. Photograph by Alexander Liberman

May–October. Ninth Triennale, Palazzo dell'arte e il parco, Milan. A small exhibition of seven Léger paintings is shown during July in the Triennale's exhibition of industrial and decorative arts. Léger also exhibits a mural designed for a prototype dwelling unit created by Jean de Mailly.

In conjunction with Léger's exhibition *Les Constructeurs et sculptures polychromes*, at the Maison de la Pensée Française, Paris (June 2–October 7), the book *Les Constructeurs* is published by

Falaize, Paris, with text by Claude Roy, a poem by Paul Éluard, and a print by Léger. After the exhibition closes, Léger exhibits some of his "*Constructeurs*" works in the canteen at the Renault factory in Boulogne-Billancourt.

June 15–July 13. *Paris Masters, 1941–1951*, an exhibition at The Arts Club of Chicago, includes six works by Léger, catalogued as *Lady with Parrot* (1943, lent by Mr. and Mrs. Harold Rome, New York), *Butterfly and Woman* (1943, lent by Saidenberg Gallery, New York), and four works lent by Louis Carré. This is the Arts Club's first exhibition in new galleries designed by Mies van der Rohe, who oversees the hanging.

C. July 20. Katharine Kuh, curator at The Art Institute of Chicago, visits Léger's studio to plan a forthcoming retrospective. Nadia Khodossievitch shows Kuh the studio because Léger is ill.[85]

September 16. Consecration of the Église du Sacré-Coeur at Audincourt,

near the Swiss border, with stained-glass windows designed by Léger depicting the instruments of Christ's Passion. The seventeen windows are fabricated by craftsman Jean Barillet using Léger's preparatory drawings.

February 2–March 4. *Les Peintres témoins de leur temps*, an exhibition at the Musée d'Art Moderne de la Ville de Paris, organized to profit the Maison Nationale de Retraite des Artistes et de l'Aide aux Artistes. The theme of the exhibition is work, and Léger designs for it a blazon depicting a worker and a bicycle. Although he does not submit paintings to this year's show, he will exhibit in its successors in later years.

1952

February 21. Marries Nadia Khodossievitch, his former student and assistant. They move to a new house, Gros Tilleul, at Gif-sur-Yvette, in the valley of the Chevreuse.

March. Participates in the exhibition *Témoignage pour Henri Martin*, held at the Union des Femmes Françaises, Paris.

March. Delivers the lecture "*La Peinture moderne devant le monde actuel*" at the Maison de la Pensée Française, Paris.[86]

April 10–May 25. *Fernand Léger*, Kunsthalle, Bern. Léger goes to Bern for the opening and delivers a lecture on architecture and color.

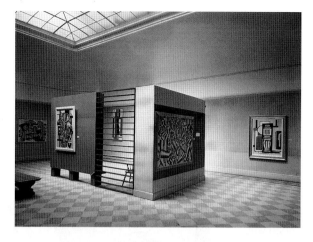

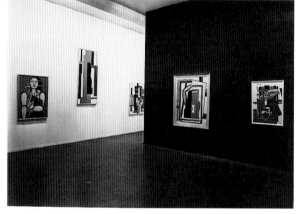

Above: *Léger: A Survey of His Art*, installation view, exhibition at the San Francisco Museum of Art, June 11–September 2, 1953. Below: the same exhibition in installation at The Museum of Modern Art, New York, October 20, 1953–January 3, 1954

From left: Roland Brice, Georges Bauquier, Pablo Picasso, André Verdet, Nadia Khodossievitch, and Léger at Picasso's home in Vallauris, 1952

May and June. Meets frequently with Katharine Kuh about the Léger retrospective she is organizing for The Art Institute of Chicago.

June/July. Hans Richter's film *Dreams That Money Can Buy*, which includes Léger's section "The Girl with the Prefabricated Heart," is screened in Paris.

June 14–October 19. XXVI Venice Biennale. A room is devoted to Léger, with seventeen works on view. Léger visits Venice during the exhibition.

July 13. Premiere of the ballet *L'Homme qui voulait voler* at the Château d'Amboise, in the Loire Valley, as part of the program *Quatre Gestes pour un génie*, which honors the 500th anniversary of the birth of Leonardo da Vinci. Léger designs the costumes and decor for this

ballet, which features music by Maurice Jarre and choreography by Janine Charrat.

August–September. Bruce Gregory, a former student of Léger's, realizes the two mural designs that Léger has created for the General Assembly Building of the United Nations headquarters, New York. Wallace K. Harrison is chief architect of the United Nations project and designer of this building.

September. Completes the ceramic mural *La Femme au perroquet* for the Hôtel de la Colombe d'Or, Saint-Paul-de-Vence.

December 12–19. Participates in a Communist-sponsored peace congress in Vienna, organized under the auspices of the World Peace Council, headquartered in Prague.[87]

1953

January. *Le Cubisme (1907–1914)*, an exhibition at the Musée national d'art moderne, Paris, includes work by Léger.

Tristan Tzara's *La Face intérieure* is published with a cover design, frontispiece,

and lithographic illustration by Léger (Paris: Seghers).

April 2–May 17. *Léger: A Survey of His Art*, an exhibition at The Art Institute of Chicago, organized by Katharine Kuh. Léger's application for a U.S. visa that would enable him to attend the exhibition is rejected, presumably because of his membership in the Communist party. Kuh publishes a monograph on Léger to coincide with the exhibition (Urbana: The University of Illinois Press). The exhibition will travel to the San Francisco Museum of Art (June 11–September 2) and The Museum of Modern Art, New York (October 20, 1953–January 3, 1954).

May 7. A special evening for Chicago's advertising community is held in the Léger exhibition. Edward Weiss, a Chicago advertising executive, initiates this event because he recognizes the influence that Léger's work has had on "fabrics, product design, advertising design and illustration, packaging, posters, direct mail, store window display, and even typography."[88]

Publication of Paul Éluard's *Liberté* (Paris: Seghers), with original prints by Léger.

May 12. Amédée Ozenfant delivers a lecture at The Art Institute of Chicago, "The Great Decade 1920–1930, as I Saw It," in connection with the Léger exhibition.

Designs a scarf in memory of Julius and Ethel Rosenberg, an American couple who are put to death in June after being convicted by the American government as Communist spies. Numerous artists make paintings to honor them for the Salon d'Automne of 1953.

C. November. Léger gives Kuh the painting *Composition à la statuette* (1950) in thanks for the organization of his retrospective.

Léger in his studio at Gif-sur-Yvette, leaning on *La Partie de campagne* (1953) and standing before *La Grande Parade, état définitif* (1954). Photograph by Robert Doisneau

1954

February 4. Delivers a lecture, "*Cinquante ans de continuité constructive: de l'Impressionisme aux Constructeurs*," at the Sorbonne.

April–May. *Les Peintres témoins de leur temps*, Musée Galliera, Paris. The third in this series of exhibitions takes the theme "*L'Homme dans la ville*," and includes work by Léger. The exhibition will travel to the Hôtel de Ville d'Avignon in July and The Municipal Art Gallery, Tunis, in October.

Designs stained-glass windows for the University of Caracas, Venezuela, at the request of the architect Carlos Luis Villanueva, a fellow member of the organization Groupe Espace. Models for the project are exhibited at the Musée national d'art moderne, Paris, before being shipped to Caracas.

Creates a mosaic for the opera house of São Paulo, Brazil, designed by architect Oscar Niemayer.

September. Attends the dedication of a renovated church in Courfaivre, Switzerland, for which he has designed new stained-glass windows.

Designs a mosaic mural for Paul Nelson's American-French Hospital at Saint-Lô; the mural is a memorial to citizens of the town who were killed by American bombing during the invasion of Normandy. It will be completed posthumously. Also works with Nelson on Badin House in the Paris suburb of Sceaux, painting metal panels for the fenestration grid on the front of the house, which will be completed the following year.

1955

March 14–21. Travels through Switzerland lecturing on painting and architecture under the auspices of *Carreau*, a Swiss journal. In connection with his talks he screens *Ballet mécanique*, *Entr'acte*, and Thomas Bouchard's *Fernand Léger in America, His New Realism*.[89]

March–May. The fourth exhibition of *Les Peintres témoins de leur temps*, Musée Galliera, Paris. Léger contributes *La Baignade* (1954).

Designs a mural for the Gaz de France plant at Alfortville, a southwestern suburb of Paris, with a combination of mosaic and ceramic relief sculpture. This project will be completed posthumously.

July. Visits Czechoslovakia for the Congress of the Sokols in Prague. According to Louis Aragon's memorial (*L'Humanité*, August 18, 1955), Léger planned to follow up this trip with a visit to Moscow.

July. Exhibits in the São Paulo Bienal and wins the Grand Prize.

July 31. Purchases Mas St. André, a house in Biot.

August 17. Léger dies suddenly of a heart attack at his farm at Gif-sur-Yvette. He is buried there on August 20.

August 19–September 30. A memorial exhibition is organized at The Museum of Modern Art, New York.

July 15–September 1. At the first Documenta exhibition in Kassel, West Germany, wreaths are laid before works by Léger and Willi Baumeister, who has died several weeks after Léger.

1956

Paul Éluard's book *Un Poème dans chaque livre* is published, with a frontispiece by Léger (possibly printed before his death).

1957

December 7. Nadia Léger marries Georges Bauquier.

1959

La Ville, a book including prints that Léger had worked on before his death, is published by Tériade. Léger's printer, Fernand Mourlot, completes the project in collaboration with Nadia Léger.

1960

The Musée Fernand Léger is inaugurated in Biot. On January 27, 1969, it becomes a national museum.

Notes

Judith Cousins, Curator, Research, in the Department of Painting and Sculpture at The Museum of Modern Art, initiated much of the preliminary research for this chronology and suggested many fruitful avenues of investigation. The author also wishes to express sincere gratitude to Delphine Dannaud, intern in the Department of Painting and Sculpture, for her work on this chronology from its early stages through to its conclusion. Her dedication to the Léger project was matched by a seemingly endless enthusiasm for pursuing difficult research questions. Susan Richmond contributed to the editing process in many ways with the extraordinary precision characteristic of her. Special thanks are due to David Frankel for his masterful remixing of the Chronology and his ever astounding problem-solving abilities. Finally, I have been inspired and guided by Carolyn Lanchner at every step of the way, and am ever in awe of her knowledge and curatorial vision. It has been both an honor and a pleasure to be part of her Léger *équipe*.

1. Léger's early schooling is chronicled by his childhood friend Louis Poughon in Christian Derouet, ed., *Fernand Léger: Une Correspondance de guerre à Louis Poughon, 1914–1918, Les Cahiers du Musée national d'art moderne* (Paris) hors-série/archives, 1990, pp. 101–4. Unless otherwise noted, Léger's correspondence with Poughon is quoted from this source.
2. There is some debate about when Léger destroyed his early works, with accounts ranging from 1908 to 1913.
3. Accounts of Léger's move to La Ruche conflict, but it is clear from Salon d'Automne catalogues that he moved there either in late 1908 or early 1909.
4. Several sources claim that Léger met Blaise Cendrars at La Ruche. In Blaise Cendrars, ed., *Entretien de Fernand Léger avec Blaise Cendrars et Louis Carré sur le paysage dans l'oeuvre de Léger* (Paris: Louis Carré, 1956), Cendrars indicates that he and Léger met in 1911, and Léger points out that they met at La Ruche. But Cendrars also says, in his *Blaise Cendrars vous parle…* (Paris: Denoël, 1952), *"Je n'ai pas connu Léger à La Ruche. C'est encore plus ancien"* (p. 111).
5. This move occurred before the opening of the Salon des Indépendants of 1911, and Léger's comment in a letter to Robert Delaunay—*"L'atelier me convient"*—postmarked May 3, 1911, suggests he had moved there recently, probably in late April. The letter is reproduced in Derouet, "Chronology," in *Fernand Léger*, exh. cat. (Paris: Musée national d'art moderne, Centre Georges Pompidou, 1997), p. 297.
6. For the identification of *Composition avec personnages* as *La Noce*, see Christopher Green, *Léger and the Avant-Garde* (New Haven and London: Yale University Press, 1976), p. 39.
7. See Walter Pach, *Queer Thing, Painting: Forty Years in the World of Art* (New York and London: Harper and Brothers, 1938), p. 181.
8. There is some confusion about the other work Léger exhibited. See Aaron Sheon, "1913: Forgotten Cubist Exhibitions in America," *Arts Magazine* (New York) 57 no. 7 (March 1983): 107, and Derouet, ed., *Fernand Léger: Une Correspondance d'affaires. Correspondances Fernand Léger–Léonce Rosenberg 1917–1937, Les Cahiers du Musée national d'art moderne* (Paris) hors-série/archives, 1996, letter 316, note 1, pp. 205–6.
9. See Carolyn Lanchner, "Fernand Léger: American Connections," in the present volume, for a discussion of Léger's submission to the Armory Show.
10. See Derouet, "Chronology," in *Fernand Léger* (Musée national d'art moderne), p. 301; Derouet, "Chronology," in *Fernand Léger*, exh. cat. (Tokyo: The Tokyo Shimbun, 1994), p. 220, which gives the title *La Femme nue*; and Green, *Léger and the Avant-Garde*, p. 53.
11. *"Les Origines de la peinture et sa valeur représentative"* was published in *Montjoie!* (Paris) 1 no. 8 (May 29, 1913): 7 and 1 nos. 9–10 (June 14–29, 1913): 9–10. It appears in English in Léger, *Functions of Painting*, ed. Edward F. Fry, trans. Alexandra Anderson, with a preface by George L. K. Morris (New York: The Viking Press, 1973), pp. 3–10.
12. In a review entitled "Onlookers Gasp at Cubist Art" in the Cleveland *Plain Dealer*, July 1, 1913, p. 17, *Mountain Scenery* is described as "clear as mud. . . . Léger had wonderful technique. He takes a handful of paint and throws it on the canvas, seasons it with salt and pepper, and puts it in the sun to dry." Quoted in Sheon, "Forgotten Cubist Exhibitions in America," p. 99.

13. *"Les Réalisations picturales actuelles"* was published in *Soirées de Paris* (Paris) 3 no. 25 (June 15, 1914): 349–56. Reprinted in *Functions of Painting*, pp. 11–19.
14. Léger's war correspondence with Poughon is published in Derouet, ed., *Fernand Léger: Une Correspondance de guerre*.
15. For more information on Rolf de Mare's purchases of Léger's work, see Judi Freeman, "'Chère Janot': Fernand Léger and His Wartime Correspondence, 1914–1917," *Apollo* (London) no. 142 (October 1995), and Freeman, "Fernand Léger and the Ballets Suédois," *Paris Modern: The Swedish Ballet 1920–1925*, exh. cat. (San Francisco: Fine Arts Museum of San Francisco, 1996).
16. In an essay of 1949, Léger writes, "The idea of multicolored towns had come to me during the 1914–18 war, on one of my leaves. I had met Trotsky in Montparnasse. He was enthusiastic about this idea. He envisaged the possibility of a polychrome Moscow." Léger, "A New Space in Architecture," *Functions of Painting*, p. 158. Trotsky lived in Paris from 1914 until 1916, when he was expelled from France.
17. Freeman, "Fernand Léger and the Ballets Suédois," note 19, pp. 104–5, reprints a list of the works Nils Dardel planned to include.
18. In "'Chère Janot,'" p. 42, Freeman notes that Léger discussed this possible arrangement with Michael Brenner in correspondence with Jeanne Lohy from the Argonne during April, May, and June of 1916.
19. Léger's Cubist drawings of "Charlot" (Charlie Chaplin's French nickname) appeared in several publications and in the opening sequence of his film *Ballet mécanique* (1924). He also wrote a scenario for an animated cartoon to be entitled *Charlot Cubiste*; the film was never produced, for Chaplin refused to grant him permission. See correspondence from 1935 between Léger and Galka Scheyer, who acted as his intermediary with Chaplin, in the Galka Scheyer Papers, Archives of American Art, Smithsonian Institution (original papers in the Norton Simon Museum of Art, Pasadena, Calif.).
The date of Léger's viewing of the

Chaplin film in Paris is uncertain. For Léger's account of it see Léger, *Chroniques du jour* (Paris) 7 no. 708 (December 31, 1926), a special number devoted to Chaplin, pp. 243–44. In March 1916, Apollinaire, after being injured, returned to Paris from the front and underwent several months of treatment in the hospital. By August he was again active in the Paris art scene. Léger was on leave in Paris during August and returned to the Argonne by September, so their viewing of the Chaplin film might have occurred during August of this year.
20. Freeman, "'Chère Janot,'" p. 43.
21. Most Léger scholars have asserted that Léger was gassed during 1917 and was hospitalized for this reason. But his letters of the period, and his hospital admittance card, reveal his ailments as rheumatism, pulmonary tuberculosis, gastritis, and weak nerves. His hospital papers are reproduced in *Fernand Léger: Sa vie, son oeuvre, son rêve* (Milan: Edizioni Apollinaire, 1971), n.p. Léger later claimed to have been gassed—see *Fernand Léger, 1881–1955*, exh. cat. (Musée des Arts Décoratifs) (Paris: Éditions Fernand Hazan, 1956), p. 114, but he may have been building on a myth by then commonly believed. He also wrote to Poughon (n.d.), and to Léonce Rosenberg in a letter postmarked September 10, 1917, about his illness, and described it as rheumatism. See Derouet, ed., *Fernand Léger: Une Correspondance de guerre*, letter 39, p. 82, and Derouet, ed, *Fernand Léger: Une Correspondance d'affaires*, letter 2, p. 21.
22. *Fernand Léger: Sa vie, son oeuvre, son rêve* reproduces Léger's hospital admission paper.
23. *"Un jardin de légumes s'architecture bien mieux qu'un jardin de fleurs et c'est très coloré."* Derouet, ed., *Fernand Léger: Une Correspondance d'affaires*, letter 36, p. 39. See also Cendrars, ed., *Entretien de Fernand Léger*, pp. 18–19, which discusses a visit by Cendrars and Léger to Giverny.
24. The contract is transcribed in full in Derouet, ed., *Fernand Léger: Une Correspondance d'affaires*, letter 34, pp. 35–38, and reproduced in *Fernand Léger: Sa vie, son oeuvre, son rêve.*

25. See Cendrars, ed., *Entretien de Fernand Léger*, p. 25. See also Jodi Hauptman, "Imagining Cities," in the present volume, p. 78.

26. *De la couleur, de la couleur et des couleurs/Voici Léger qui grandit comme le soleil de l'époque tertiaire*. No. 19 of *Dix-Neuf Poèmes Elastiques* (Paris: Au Sans Pareil, 1919). Quoted here from *Blaise Cendrars Complete Poems*, trans. Ron Padgett (Berkeley, Los Angeles, and Oxford: University of California Press, 1992), p. 80.

27. The group took its name from the Section d'Or founded in 1912, which included many Cubists and developed out of meetings of the Puteaux group. Léger participated in the earlier group's salon, held at the Galerie de la Boétie, Paris, October 10–30, 1912. See Derouet, ed., *Fernand Léger: Une Correspondance d'affaires*, letter 70, note 1, p. 70, for more about the later Section d'Or.

28. *Comoedia* (Paris), December 1922. Reprinted in *Functions of Painting*, pp. 20–23.

29. Harold Loeb, *The Way It Was* (New York: Criterion Books, Inc., 1959), p. 151.

30. Published in part, and in English translation, as "The Esthetics of the Machine: Manufactured Objects, Artisan and Artist" in *The Little Review* (New York) 9 no. 3 (Spring 1923): 45–49, and 9 no. 4 (Autumn/Winter 1923–24): 55–58, with a dedication to Ezra Pound. Published in full, in two parts, as "*L'Esthétique de la Machine: L'Objet Fabriqué—L'Artisan et L'Artiste*" in *Bulletin de l'Effort Moderne* (Paris) no. 1 (January 1924): 5–7, and no. 2 (February 1924): 8–12. Reprinted in a different English translation as "The Machine Aesthetic: The Manufactured Object, the Artisan, and the Artist" in *Functions of Painting*, pp. 52–61.

31. René Clair, "*Les Films du mois*," *Le Théâtre et Comoedia illustré*, cinema supplement to *Film*, March 1923. Quoted in Green, *Léger and the Avant-Garde*, p. 277.

32. "*Je n'en sais rien du tout. Et si je le savais, il est probable que je n'en ferais plus.*" Léger, in "*Réponse à notre enquête: 'Où va la peinture moderne?'*," *Bulletin de l'Effort Moderne* (Paris) no. 2 (February 1924): 5.

33. In Katherine Dreier's letter to Léger of April 23, 1925, she mentions her visit of the previous summer. Katherine S. Dreier Papers, The Yale Collection of American Literature, Beinecke Rare Book and Manuscript Library, Yale University.

34. The lecture, dedicated to Rolf de Maré, was published in *Bulletin de l'Effort Moderne* (Paris) no. 7 (July 1924): 4–7, no. 8 (October 1924): 5–9, and no. 9 (November 1924): 7–9. Reprinted in *Functions of Painting*, pp. 35–47. Dreier's attendance is suggested by an invitation to the lecture in the Katherine S. Dreier Papers, Yale University.

35. Although *Ballet mécanique* is generally credited to Léger alone, Dudley Murphy had the technical expertise Léger lacked and played an important role in its realization. Man Ray suggests in his memoirs that Murphy approached him to make the film, but that he backed out when he discovered that Murphy wanted him to finance it. He also indicates that Léger then agreed to finance the film and that it had "a certain success, with Léger's name." See Man Ray, *Self Portrait* (Boston: Little, Brown and Co., 1963), pp. 266–67. In his essay "Americans in Paris: Man Ray and Dudley Murphy," in Jan-Christopher Horak, ed., *Lovers of Cinema: The First American Film Avant-Garde 1919–1945* (Madison: The University of Wisconsin Press, 1995), William Moritz argues for a much larger role by Man Ray and Murphy than has previously been documented. See also Standish D. Lawder, *The Cubist Cinema* (New York: at the University Press, 1975), pp. 117–67, and Green, *Léger and the Avant-Garde*, pp. 281–84.

36. According to Derouet, ed., *Fernand Léger: Une Correspondance d'affaires*, letter 219, note 1, pp. 147–48, their itinerary is documented in a series of postcards that Rosenberg sent to Picasso. Léger himself recalls the voyage in "*Chez les cubistes, notre enquête—1*," *Bulletin de la vie artistique* (Paris) 5 no. 21 (November 1, 1924): 486.

37. Léger, "*Vive Relâche*," *L'Action* (Paris), December 18, 1924.

38. See Joséphine Baker and Jo Bouillon, *Joséphine* (Paris: Éditions Robert Laffont, 1976), p. 65, and Malcolm Bradbury, *Dangerous Pil-*

grimages: Transatlantic Mythologies and the Novel (New York: Viking, 1995), p. 323.

39. Dreier, letter to Léger, December 2, 1925. In the Katherine S. Dreier Papers, Yale University.

40. There are conflicting accounts of the Paris premiere of the film, but both Lawder, *The Cubist Cinema*, p. 187, and Christian Viviani, "*Les Spectacles de Fernand Léger: Le Ballet mécanique*," in *Fernand Léger et le spectacle*, exh. cat. (Paris: Éditions de la Réunion des musées nationaux, 1995), p. 120, argue that it occurred at the Studio des Ursulines.

41. Robert L. Herbert, Eleanor S. Apter, and Elise K. Kenney, eds., *The Société Anonyme and the Dreier Bequest at Yale University: A Catalogue Raisonné* (New Haven and London: Yale University Press, 1984), p. 405.

42. Léger's role in selecting works is documented by the manuscript "Notes taken Monday evening November 1st," p. 2, in the Katherine S. Dreier Papers, Yale University. Originally scheduled to close January 1, the show was extended to January 9.

43. Rosenberg, letter to Dreier, November 29, 1926, Société Anonyme Papers, Correspondence "Rosenberg Gallery," The Yale Collection of American Literature, Beinecke Rare Book and Manuscript Library, Yale University. Quoted in Matthew Affron, "Fernand Léger and the Spectacle of Objects," Ph.D. thesis, Yale University, December 1994, p. 63.

44. Léonce Rosenberg wrote to Dreier on March 31, saying that his brother Paul, who had not previously worked with Léger, was helping to keep the artist's prices up. See Derouet, ed., *Fernand Léger: Une Correspondance d'affaires*, letter 368, note 3, p. 236.

45. Gail Stavitsky, "The Development, Institutionalization, and Impact of the A. E. Gallatin Collection of Modern Art," Ph.D. thesis, New York University, May 1990, vol. 1, p. 75, note 257, citing Henry McBride papers, Archives of American Art, Smithsonian Institution.

46. According to Victoria Newhouse, *Wallace K. Harrison: Architect* (New York: Rizzoli, 1989), p. 29,

Léger met Harrison in 1927 through Mary Callery. See Lanchner, "Fernand Léger: American Connections," in the present volume, pp. 48–49 and note 184, regarding a possible later date for their meeting.

47. See Karen Wilkin, *Stuart Davis* (New York: Abbeville Press, 1987), p. 120, and Elizabeth Hutton Turner, *Americans in Paris (1921–1931)*, exh. cat. (Washington, D.C.: The Phillips Collection, 1996), p. 31.

48. Sidney Janis, interview with Helen Franc, June 1967. The Museum of Modern Art Library, New York.

49. Stavitsky, "The Development, Institutionalization, and Impact of the A. E. Gallatin Collection," p. 164, citing Henry McBride papers, Archives of American Art, Smithsonian Institution, and p. 610, citing an announcement issued by the Gallery of Living Art, October 17, 1929.

50. Giorgio de Chirico, Auguste Herbin, Jean Metzinger, and Georges Valmier also completed decorative works for this apartment.

51. "*À propos du cinéma*" was published in *Plans* (Paris) no. 1 (1931): 80–84. Reprinted in *Functions of Painting*, pp. 100–104.

52. Alexander Calder's invitation to Léger is documented in the chronology established by The Archive of the Alexander and Louisa Calder Foundation, New York, for the forthcoming Alexander Calder catalogue raisonné. See also Derouet, ed., *Fernand Léger: Lettres à Simone* (Paris: Éditions d'Art Albert Skira S.A. and Musée national d'art moderne, Centre Georges Pompidou, 1987), note 177.1, p. 271; Peter de Francia, *Fernand Léger* (New Haven and London: Yale University Press, 1983), p. 125; and Turner, *Americans in Paris*, pp. 45, 167.

53. For information on Léger's relations with The Arts Club of Chicago, see the Club's papers in the Newberry Library, Chicago.

54. "Chicago" was published in *Plans* (Paris) 2 no. 11 (January 1932): 63–68. Reprinted and trans. in *Léger et l'esprit moderne*, exh. cat. (Paris: Musée d'Art Moderne de la Ville de Paris, 1982), pp. 273–74.

55. The Museum of Modern Art

Archives: Sound Recordings of Museum-Related Events, Subgroup A #53.8. James Johnson Sweeney lecture, November 18, 1953.

56. *Cahiers d'Art* (Paris) 6 nos. 9–10: 437–39. Reprinted and trans. as "New York" in *Functions of Painting*, pp. 84–90.

57. Published under the title "*Discours aux architectes*" in *Quadrante* (Milan) 11 no. 5 (September 1933): 44–47. Revised and reprinted as "The Wall, the Architect, the Painter" in *Functions of Painting*, pp. 91–99.

58. Extracts from this lecture were published in Léger, "*Le Beau et le vrai*," *Beaux-Arts* (Paris) 73 no. 58 (February 9, 1934): 2.

59. Before March 26, Léger received a visit from either Alexander Korda or his brother, Vincent Korda, the film's art director. Léger, letter to Herman, March 26, 1934. In Derouet, ed., *Fernand Léger: Lettres à Simone*, p. 101.

60. Léger began working on this fresco in 1934, completing *Projet pour une peinture murale* (B 852) that year. His correspondence with Herman discusses the early stage of the project; see Derouet, ed., *Fernand Léger: Lettres à Simone*, letters no. 72, p. 102, and no. 75, p. 105. However, a postcard to Herman dated June 7, 1936, not published in *Lettres à Simone* but appearing in Derouet, "*Léger parle*," in *Fernand Léger* (The Tokyo Shimbun), p. 55, indicates that Léger is still working on the project two years after starting it: "*suis ici où j'exécute ma peinture murale de Badovici. Ça va j'ai détruit un mur.*" The completed mural (B 853) was removed in 1960 and later deposited in the Musée national d'art moderne, Paris.

61. Louise Bourgeois, quoted in Paul Gardner, *Louise Bourgeois* (New York: Universe Publishing, 1994), p. 23.

62. See Léger, letter to Gerald Murphy, July 27, 1935. Collection of Honoria Murphy Donnelly.

63. The exhibition was organized by the Renaissance Society at the University of Chicago. Léger, in an undated postcard to de Maré, from New York, said that the show would travel to Prague and London, but there is no evidence that it did so.

287

Postcard in the collection of the Dansmuseet, Stockholm, and reprinted in *Léger och Norden*, exh. cat. (Stockholm: Moderna Museet, 1992), letter 56, p. 96.

64. Excerpts from "The New Realism" were published in a translation by Harold Rosenberg in *Art Front* (New York) 2 no. 8 (December 1935): 10. Reprinted in *Functions of Painting*, pp. 109–113.

65. Galka Scheyer Papers. The manuscript of *Charlot Cubiste* is published in Pierre Descargues, *Fernand Léger* (Paris: Cercle d'Art, 1955), pp. 17–18. According to Giovanni Lista, *Fernand Léger et le Spectacle*, exh. cat. (Biot: Musée national Fernand Léger, 1995), p. 36, Léger began working on an animated version of *Charlot Cubiste* around the early 1920s.

66. For further information about Léger's participation in this association, see Affron, "Fernand Léger and the Spectacle of Objects," pp. 201–210, and his "Léger's Modernism: Subjects and Objects," in the present volume, p. 138ff.

67. Léger, *"Le Nouveau Réalisme continue,"* *La Querelle du réalisme* (Paris: Éditions Sociales Internationales, coll. "Commune," 1936); Aragon, *"Le Réalisme à l'ordre,"* *Commune* (Paris). Léger's text also appeared as "Painting and Reality: a discussion," trans. Maria Jolas, *Transition* (New York) no. 25 (Fall 1936): 104–8, and as "The New Realism Goes On" in *Functions of Painting*, pp. 114–18.

68. In the chronology established by The Archive of the Alexander and Louisa Calder Foundation for the forthcoming catalogue raisonné.

69. For a fuller account of Léger's contribution to the 1937 *Exposition Internationale*, see Affron, "Léger's Modernism: Subjects and Objects," p. 140ff.

70. An account of the visit is published in the *South African Architectural Record* (Johannesburg) 27 no. 8 (August 1942): 237–39.

71. There are conflicting accounts of the Nelson Rockefeller mural sequence. Rockefeller's personal recollection was that Léger painted first the fireplace mural, then the stairwell murals, in situ. See William S. Lieberman, *The Nelson A. Rockefeller Collection: Masterpieces of Mod-*

ern Art (New York: Hudson Hills Press, Inc., 1981), p. 16, and Cary Reich, *The Life of Nelson A. Rockefeller: Worlds to Conquer 1908–58* (New York: Doubleday, 1996), p. 152. Ruth Ann Krueger Meyer, in "Fernand Léger's Mural Paintings 1922–55" (Ph.D. dissertation, University of Minnesota, 1980), p. 223, does not specifically state which project was first. Léger himself, however, in a letter to Christian Zervos of December 28, 1938, clearly states that the stairwell murals have been completed by this date, and that he has received a second commission for the fireplace mural. (The letter is reprinted in Derouet, *Fernand Léger* [Musée national d'art moderne], p. 333.) The fireplace mural is signed 1939.

72. See the Katherine S. Dreier Papers, Yale University, and the *Yale News*, December 3 and 9, 1938. No specific documentation has been found regarding the first six lectures. The series was undoubtedly arranged by Wallace K. Harrison, then a faculty member of the Yale School of Fine Arts. Derouet, in the chronology of *Fernand Léger* (Musée national d'art moderne), p. 333, says that Léger gave his lecture series at Yale with Amédeé Ozenfant and Alvar Aalto. On March 15, 1939, Ozenfant delivered the lecture "Form—From Prehistoric to Modern Times," as part of the Ryerson Lectureship series; on April 18, 1939, Aalto lectured on "The Problem of Humanizing Architecture" and on an unknown date gave another talk, "Architecture and Its Relation to the Other Fine Arts and to Daily Life." There seems, however, to be no direct link among the three artists' engagements.

73. *"En route vers N.Y. après demain—Lisbonne."* Léger, letter to Le Corbusier, September 30, 1940. In the Fondation Le Corbusier, Paris.

74. *"Ai obtenu un 'matelas' sur bateau*

Américain. Grâce à intervention du Ministre de la Propagande!" Léger, quoted in Georges Bauquier, *Fernand Léger, Vivre dans le vrai* (Paris: Adrien Maeght Éditeur, 1987), p. 202.

75. Derouet, *Fernand Léger* (Musée national d'art moderne), p. 335; Derouet, *Fernand Léger* (The Tokyo Shimbun), p. 226; and François Mathey, *"Biographie,"* in *Fernand Léger 1881–1955*, p. 36, state that Léger came to the United States in the company of Jacqueline Rey. Madame Rey is not identified, and the passenger list for the *S.S. Exeter* shows no evidence of anyone by that name arriving on the same day as Léger. Shortly after Léger's arrival in America, however, Jacqueline Lignot-Roux (who also used just the name "Roux"), his companion, joined him in New York. Previous references to Madame Rey may be erroneous references to Madame Roux.

76. Mercedes Matter recalls Léger leaving her house one day to meet Madame Roux's ship. Mercedes Matter, personal conversation with Kristen Erickson of The Museum of Modern Art, March 25, 1997. Madame Roux is purported to be the goddaughter or granddaughter of Maréchal Philippe Pétain. Ibid., and Judith Cousins of The Museum of Modern Art, personal conversation with Madeleine Milhaud, June 29, 1996.

77. T. B. Shoemaker, Deputy Commissioner Legal Branch of an unidentified Washington office, memo to Mr. Edward F. Prichard, Jr., Special Assistant to the Attorney General. Library of Congress,

Archibald MacLeish collection.

78. According to correspondence between Léger and Iris Barry, December 16, 1943 (Barry to Léger), and December 22, 1943 (Léger to Barry), in The Museum of Modern Art Department of Film and Video, Film Archive Correspondence Files, Bouchard was granted permission to use the cutting rooms and projection studios at The Museum of Modern Art. His daughter, Diane Bouchard, however, asserts that he worked in his own studio. Letter to Kristen Erickson of The Museum of Modern Art, September 20, 1997.

79. For this and further information on Léger in Montreal, see France Desmarais, *"La Présence de Fernand Léger sur la scène artistique montréalaise des années quarante,"* M.A. Thesis, Université du Québec, Montreal, August 1993, p. 286.

80. Ibid., pp. 234–40.

81. *"L'Art et le peuple"* was published in the Communist-backed journal *Arts de France* (Paris) no. 6 (1946): 36–42. Reprinted in *Functions of Painting*, pp. 143–48.

82. Correspondence between Léger and Henry Miller, Henry Miller Collection #110, Special Collections, University of California, Los Angeles.

83. This mural is reproduced in Sarah Wilson, "Fernand Léger: Art and Politics 1935–1955," in *Fernand*

Léger: The Later Years, exh. cat. (London: Whitechapel Art Gallery, 1988), p. 65.

84. For more information, see the George Dondero Papers, Archives of American Art, Smithsonian Institution.

85. On Katharine Kuh's organization of Léger's 1953 retrospective, see the Katharine Kuh papers, The Art Institute of Chicago Archives.

86. *"La Peinture moderne devant le monde actuel"* is published in *Les Lettres Françaises* (Paris) 11 no. 405 (March 13, 1952): 1, 9.

87. An account of the Vienna conference is published in the *New York Times*, December 13, 1952, p. 20.

88. Edward Weiss, memo to Chicago advertising executives, April 22, 1953. In the Katharine Kuh papers, The Art Institute of Chicago Archives.

89. An advertisement in *Carreau* (Lausanne) no. 4 (March 1950) announces the film *Fernand Léger à New York*; this is almost certainly Bouchard's film.

Selected Bibliography

Compiled by Kristen Erickson

Léger's Correspondence

Derouet, Christian, ed. *Fernand Léger: Lettres à Simone*. With a preface by Maurice Jardot. Paris: Éditions d'Art Albert Skira S.A. and Musée national d'art moderne, Centre Georges Pompidou, 1987.

———. *Fernand Léger: Une Correspondance de guerre à Louis Poughon, 1914–1918. Les Cahiers du Musée national d'art moderne* (Paris), hors-série/archives (1990).

———. *Fernand Léger: Une Correspondance d'affaires. Correspondances Fernand Léger–Léonce Rosenberg 1917–1937. Les Cahiers du Musée national d'art moderne* (Paris), hors-série/archives (1996).

Freeman, Judi. "'Chère Janot': Fernand Léger and His Wartime Correspondence, 1914–1917." *Apollo* (London) no. 142 (October 1995): 40–43.

Léger och Norden. See under "Monographs and Exhibition Catalogues."

Catalogues Raisonnés

Bauquier, Georges. *Fernand Léger: Catalogue raisonné*. Paris: Adrien Maeght Éditeur. Vols. 1 (1903–19), 1990; 2 (1920–24), 1992; 3 (1925–28), 1993; 4 (1929–31), 1995; 5 (1932–37), 1996.

Saphire, Lawrence. *Fernand Léger: The Complete Graphic Work*. New York: Blue Moon Press, 1978.

Major Interviews with Léger

Cendrars, Blaise, ed. *Entretien de Fernand Léger avec Blaise Cendrars et Louis Carré sur le paysage dans l'oeuvre de Léger* (1954). Paris: Louis Carré, 1956.

Vallier, Dora. "*La Vie fait l'oeuvre de Fernand Léger: Propos de l'artiste receuillis par Dora Vallier*." *Cahiers d'Art* (Paris) 29 no. 2 (October 1954): 133–75. Reprinted as Vallier, "*La Vie fait l'œuvre de Fernand Léger*," *L'Intérieur de l'art: Entretiens avec Braque, Léger, Villon, Miró, Brancusi (1954–1960)* (Paris: Éditions du Seuil, 1982).

Monographs and Exhibition Catalogues

Bauquier, Georges. *Fernand Léger, Vivre dans le vrai*. Paris: Adrien Maeght Éditeur, 1987.

Bazaine, Jean. *Fernand Léger: Peintures antérieures à 1940*. Paris: Louis Carré, 1945.

Cahiers d'Art (Paris) 8 no. 3–4 (1933). *Exposition Fernand Léger au Kunsthaus de Zurich*, special issue on Léger, with essays by Blaise Cendrars, Guillaume Apollinaire, Siegfried Giedion, André Salmon, H. Laugier, Darius Milhaud, et al.

Cassou, Jean, and Jean Leymarie. *Fernand Léger: Drawings and Gouaches*. Greenwich, Conn.: New York Graphic Society, 1973. First published in French by Éditions du Chêne, Paris, 1972.

Cooper, Douglas. *Fernand Léger et le nouvel espace*. Geneva: Éditions des Trois Collines, 1949.

———. *Fernand Léger: Dessins de Guerre 1915–1916*. Paris: Berggruen & Cie, 1956.

Couturier, M.-A., Maurice Gagnon, et al. *Fernand Léger, 1938–44: La forme humaine dans l'espace*. Montreal: Les Éditions de l'Arbre, 1945.

De Francia, Peter. *Fernand Léger*. New

Haven and London: Yale University Press, 1983.

———. *On Léger's "The Great Parade"*. Carel Weight, general ed. London: Cassell and Co., 1969.

Delevoy, Robert L. *Léger*. Geneva: Éditions d'Art Albert Skira, 1962.

Deroudille, René. *Léger*. Paris: Bordas, 1968.

Derouet, Christian. *Léger et la poésie de l'objet*. Exh. cat. Paris: Musée national d'art moderne, Centre Georges Pompidou, 1981.

———, ed. *Fernand Léger*. Exh. cat. Paris: Éditions du Centre Pompidou, 1997.

Derouet, Christian, and Shunsuke Kijima, eds. *Fernand Léger*. Exh. cat. for an exhibition at the Bunkamura Museum of Art, Tokyo. Tokyo: The Tokyo Shimbun, 1994.

Descargues, Pierre. *Fernand Léger*. Paris: Éditions Cercle d'Art, 1955.

Diehl, Gaston. *Fernand Léger*. Paris: Flammarion, 1985. Also published in English under the same title by Crown Publishers, New York, 1985.

Elgar, Frank. *Léger: Peintures 1911–1948*. Paris: Éditions du Chêne, 1948.

Fauchereau, Serge. *Fernand Léger: A Painter in the City*. New York: Rizzoli, 1994.

Fernand Léger. Exh. cat. for an exhibition at the Albright-Knox Art Gallery, Buffalo, N.Y. New York: Abbeville Press, 1982.

Fernand Léger, 1881–1955. Exh. cat. for an exhibition at the Musée des Arts Décoratifs, Paris. Paris: Éditions Fernand Hazan, 1956.

Fernand Léger: Sa vie, son oeuvre, son rêve.

Milan: Edizioni Apollinaire, 1971.

Fernand Léger: The Later Years. Exh. cat. London: Whitechapel Art Gallery, 1987.

Fernand Léger et le spectacle. Exh. cat. Biot: Musée national Fernand Léger, 1995.

Füglister, Robert L. *Fernand Léger: "Akrobaten im Zirkus"*. Basel: Öffentliche Kunstsammlung Basel, 1964–66.

Garaudy, Roger. *Pour un réalisme du XXe siècle. Dialogue posthume avec Fernand Léger*. Paris: Éditions Bernard Grasset, 1968.

George, Waldemar. *Fernand Léger*. Paris: Gallimard, 1929. From the series "*Les Peintres Nouveaux*."

Green, Christopher. *Léger and the Avant-Garde*. New Haven and London: Yale University Press, 1976.

Grosclaude, Louis. *Autour de Fernand Léger*. Lausanne: Louis Grosclaude, 1970.

Jardot, Maurice. *Léger*. Paris: Éditions Fernand Hazan, 1956.

———. *Léger: Dessins*. Paris: Éditions des Deux Mondes, 1953.

Kosinski, Dorothy, ed. *Fernand Léger 1911–1924: The Rhythm of Modern Life*. Exh. cat. for an exhibition at the Kunstmuseum Wolfsburg and the Kunstmuseum Basel. With a foreword by Katharina Schmidt and Gijs van Tuyl. Munich and New York: Prestel, 1994.

Kuh, Katharine. *Léger*. Urbana: The University of Illinois Press, 1953.

Lassalle, Hélène. *Fernand Léger*. Lieusaint: Centre National de Documentation Pedagogique, 1991.

Laugier, Claude, and Michèle Richet, eds. *Léger: Oeuvres de Fernand Léger (1881–1955)*. Paris: Collections du Musée national d'art moderne, Centre Georges Pompidou, 1981.

Léger och Norden. Exh. cat. Stockholm: Moderna Museet, 1992. Includes Léger's correspondence with Nils Dardel, Rolf de Maré, Maurice Raynal, and Otto Carlsund. Also published as *Léger og Norden*,

by the Henie-Onstad Kunstsenter, Høvikodden, 1992.

Les Lettres Françaises (Paris) no. 582 (August 25–31, 1955). Hommage à Fernand Léger, special issue on Léger.

Maurois, André. *Mon ami Léger*, and Fernand Léger, *Comment je conçois la figure*. Paris: Louis Carré, 1952.

Neret, Gilles. *Fernand Léger*. Paris: Nouvelles Éditions Françaises, 1990.

Raynal, Maurice. *Fernand Léger. Vingt tableaux*. Paris: Éditions de "L'Effort Moderne," 1920. From the series "*Les Maîtres du Cubisme*."

Roy, Claude. *Fernand Léger: Les Constructeurs*. Paris: Falaize, 1951.

Schmalenbach, Werner. *Fernand Léger*. Trans. Robert Allen with James Emmons. New York: Harry N. Abrams, Inc., 1976.

———. *Léger*. Paris and New York: Harry N. Abrams, Inc., 1988. From the series "Ars Mundi."

Seghers, Pierre. *Fernand Léger: Propos et présence*. Paris: Éditions d'art Gonthier-Seghers, 1959.

Tériade, E. *Fernand Léger*. Paris: Éditions "Cahiers d'Art," 1928.

Vallier, Dora. *Carnet Inédit de Fernand Léger*. Paris: Éditions "Cahiers d'Art," n.d. [1958?].

Verdet, André. *Fernand Léger*. Florence: Sansoni, 1969.

———. *Fernand Léger. Le Dynamisme pictural*. Geneva: Éditions Pierre Cailler, 1955.

———. *Fernand Léger*. Zurich: Verlag der Arche, 1957.

Wakakuwa, Midori. *Léger*. Tokyo: Shinchosha, 1976.

XXe Siècle Review. Homage to Fernand Léger, special issue on Léger, ed. Gualtieri di San Lazzaro. New York: Tudor Publishing Co., 1971.

Zadova, L. *Fernand Léger*. Moscow: Isskusstvo Publishers, 1970.

Zervos, Christian. *Fernand Léger: Oeuvres de 1905 à 1952*. Paris: Éditions "Cahiers d'Art," 1952.

Sélection (Antwerp) troisième série vol. 8 (February 1929). Special issue titled *Fernand Léger*.

Dissertations

Affron, Matthew. "Fernand Léger and the Spectacle of Objects." Ph.D. dissertation, Yale University, 1994.

Desmarais, France. "*La Présence de Fernand Léger sur la scène artistique montréalaise des années quarante*." M.A. thesis, Université du Québec, 1993.

McQuillan, Melissa Ann. "Painters and the Ballet, 1917–1926: An Aspect of the Relationship between Art and Theatre." Ph.D. dissertation, New York University, 1979.

Meyer, Ruth Ann Krueger. "Fernand Léger's Mural Paintings 1922–55." Ph.D. dissertation, University of Minnesota, 1980.

Léger's Writings

Entries in this section are arranged by decade in chronological groups, within which they are listed alphabetically. Some of Léger's writings have appeared in more than one English translation, including a number of the essays in the collection Functions of Painting, *which were translated for the occasion from the French collection* Fonctions de la peinture, *and often differ slightly from the earlier translations that could have been read by Léger's English-speaking contemporaries. For convenience, readers are usually directed below to* Functions of Painting *rather than to* Fonctions de la peinture, *except in the cases of the few essays that were published in* Fonctions de la peinture *for the first time; in such cases that book is cited as the essay's source. Dates appearing in parentheses immediately after essay titles refer to the date by which Léger is known to have completed the essay, which often differs from the first publication date. Where an essay appeared concurrently in French and English, both sources are given, with the presumed first publication presented first.*

Collections

Léger, Fernand. *Fonctions de la peinture*. Preface by Roger Garaudy. Paris: Éditions Gonthier, 1965. Translated into English as *Functions of Painting*, ed. Edward F. Fry, trans. Alexandra Anderson, with a preface by George L. K. Morris (New York: The Viking Press, 1973).

Léger, Fernand. *Mes Voyages*. Preface by Louis Aragon. Paris: Éditeurs Français Réunis, 1960. Reprint ed. Paris: L'École des Loisirs, 1997.

Before 1920

"*Les Origines de la Peinture et sa Valeur représentative*" (lecture given at the Académie Wassilief, Paris, 1913). *Montjoie!* (Paris) 1 no. 8 (May 29, 1913): 7, and "*L'Origine de la peinture actuelle et sa valeur représentative*," *Montjoie!* 1 no. 9–10 (June 14–29, 1913): 9–10. Reprinted as a single essay, "The Origins of Painting and Its Representational Value," in *Functions of Painting*, pp. 3–10.

"*Les Réalisations picturales actuelles*" (lecture given at the Académie Wassilief, Paris, 1914). *Les Soirées de Paris* (Paris) 3 no. 25 (June 15, 1914): 349–56. *Les Soirées de Paris* reprinted by Slatkine Reprints, Geneva, vol. II nos. 18–27, 1971. Reprinted as "Contemporary Achievements in Painting" in *Functions of Painting*, pp. 11–19.

1920s

"À Propos du Congrès de Paris." *Comoedia* (Paris), February 7, 1922.

"Actualités." *Variétés* (Brussels) 1 no. 10 (February 15, 1929): 522–25.

"*L'Affaire de l'exposition des arts décoratifs*." *Les Nouvelles Littéraires* (Paris), June 6, 1925.

"*L'Architecture Polychrome*." *L'Architecture Vivante* (Paris) 2 no. 4 (Fall–Winter 1924): 21–22.

"*Au Salon de l'automobile: Gloire du métal*." *L'Intransigeant* (Paris), October 8, 1928.

"*Au Salon des Indépendants*." *Montparnasse* (Paris) 9 no. 28 (December 1, 1923).

"*Autour du* Ballet mécanique" (n.d.). First published in *Fonctions de la peinture*, pp. 164–67. Reprinted as "Ballet Mécanique" in *Functions of Painting*, pp. 48–51.

"*Le Ballet-Spectacle: L'Objet-Spectacle*." *La Vie des Lettres et des Arts* (Paris) no. 15 (1924): 50–52. Reprinted as "The Ballet-Spectacle, the Object-Spectacle" in *Functions of Painting*, pp. 71–73.

"*Les Bals populaires*." *La Vie des Lettres et des Arts* (Paris) no. 15 (1924): 53–55. Reprinted as "Popular Dance Halls" in *Functions of Painting*, pp. 74–77.

"*Chez les cubistes: Notre enquête—I.*" *Le Bulletin de la Vie Artistique* (Paris) 5 no. 21 (November 1, 1924): 486.

"*Correspondance*" (March 1922). *Bulletin de l'Effort Moderne* (Paris) no. 4 (April 1924): 10–12. Reprinted as "A Letter," trans. Charlotte Green, in John Golding and Christopher Green, eds., *Léger and Purist Paris*, exh. cat. (London: Tate Gallery, 1970), pp. 85–86.

"*La Couleur dans la vie*." *Promenoir* (Lyons), 1921.

"*Donnez-nous un sujet*." *L'Intransigeant* (Paris), April 1928.

"*L'École de Paris au Brésil*." *Montparnasse* (Paris) no. 58 (January 1930).

"*L'Esthétique de la Machine*" (May 1923; lecture given at the Baraque de la Chimère, Paris, June 1, 1923). First published as "The Esthetics of the Machine: Manufactured Objects, Artisan and Artist," *The Little Review* (New York) 9 no. 3 (Spring 1923): 45–49, and *The Little Review* 9 no. 4 (Autumn and Winter 1923–24): 55–58. First published in French in two parts, "*L'Esthétique de la Machine: L'Objet Fabriqué—L'Artisan et L'Artiste*," *Bulletin de l'Effort Moderne* (Paris) no. 1 (January 1924): 5–7, and "*L'Esthétique de la Machine—Fin*," *Bulletin de l'Effort Moderne* no. 2 (February 1924): 8–12. Reprinted as "The Machine Aesthetic: The Manufactured Object, the Artisan, and the Artist" in *Functions of Painting*, pp. 52–61.

"*L'Esthétique de la Machine*." *Les Nouvelles Littéraires* (Paris) 2 no. 37 (June 30, 1923): 4. Excerpts republished in Florent Fels, *Propos d'artistes* (Paris: La Renaissance du Livre, 1925), pp. 98–106. Reprinted as "The Machine Aesthetic: Geometric Order and Truth" in *Functions of Painting*, pp. 62–66.

"*Kurzgefasste Auseinandersetzung über das aktuelle künstlerische Sein*" ("*Notes sur la vie plastique actuelle*"). *Das Kunstblatt* (Berlin) 7 (1923): 1–4. Reprinted as "Notes on Contemporary Plastic Life" in *Functions of Painting*, pp. 24–27.

"Mechanical Ballet" (July 1924). *The Little Review* 10 no. 2 (Autumn–Winter 1924–25): 42–44. Also published as "*Ballet Mécanique*" in *L'Esprit Nouveau* (Paris) no. 28 (January 1925): 2,336–37.

"*Meine Berliner Ausstellung*." *Der Querschnitt* (Berlin) VIII no. 1 (January 1928).

"A New Realism—The Object (Its Plastic and Cinematographic Value)" (December 1925). *The Little Review* (New York) 11 no. 2 (Winter 1926): 7–8. Trans. Rosamond Gilder.

"Notations on Plastic Values." In *Fernand Léger*. Exh. cat. for an exhibition at the Anderson Galleries, New York, organized by the Société Anonyme (November 16–28, 1925), pp. 10–11.

"*Note sur l'élément mécanique*" (1923). First published in *Fonctions de la peinture*, pp. 50–52. Reprinted as "Notes on the Mechanical Element" in *Functions of Painting*, pp. 28–30.

"*Notre courrier*." *La Presse* (Paris), January 29, 1928.

"*Paris-Objets-Spectacles-Paris*" (response to an article by Jean Cocteau). *L'Intransigeant* (Paris), February 25, 1929. Slightly modified version of "*La Rue: Objets, Spectacles*."

"*Peinture et Cinéma*." *Les Cahiers du mois* (Paris) no. 16/17 (October 1925): 107–8. Special issue on cinema.

"*Pensées sur l'art*" (1928). In Waldemar George, *Fernand Léger* (Paris: Gallimard, 1929), p. 14.

Preface to *Otto Carlsund*. Exh. cat. Paris: Galerie Mots et Images, 1927.

"*Projet décoratif et fresques*." *L'Architecture Vivante* (Paris) 2 no. 4 (Fall–Winter 1924): 10–11.

"*Réponse à notre enquête: 'Où va la peinture moderne?'*" *Bulletin de l'Effort moderne* (Paris) no. 2 (February 1924): 5.

"*La Roue, sa valeur plastique*." *Comoedia* (Paris), December 1922. Reprinted as "A Critical Essay on the Plastic Quality of Abel Gance's Film *The Wheel*" in *Functions of Painting*, pp. 20–23.

"*La Rue: Objets, Spectacles*." In "*Vers un Paris Nouveau?*" *Cahiers de la République des Lettres, des Sciences et des Arts* (Paris) XII (1928): 102–4. Reprinted as "The Street: Objects, Spectacles" in *Functions of Painting*, pp. 78–80.

"*Si tu n'aimes pas les vacances*." *L'Intransigeant* (Paris), October 21, 1929.

"*Le Spectacle: Lumière—Couleur—Image mobile—Objet-Spectacle*" (lecture given at the Sorbonne, Paris, under the auspices of the Groupe d'études philosophiques et scientifiques, May 1924). *Bulletin de l'Effort Moderne* (Paris) no. 7 (July 1924): 4–7, no. 8 (October 1924): 5–9, and no. 9 (November 1924): 7–9. Reprinted as "The Spectacle: Light, Color, Moving Image, Object-Spectacle" in *Functions of Painting*, pp. 35–47.

"*Vive Relâche*." *L'Action* (Paris), December 18, 1924.

"*Voyage d'artiste: Berlin 1928*." *L'Intransigeant* (Paris), April 16, 1928.

"*Voyage d'artiste: Music-Hall-France-Côte d'Azur*." *L'Intransigeant* (Paris), June 10, 1929.

1930s

"*À Propos du cinéma*." *Plans* (Paris) no. 1 (January 1931): 80–84. Reprinted as "Speaking of Cinema" in *Functions of Painting*, pp. 100–104.

"A-propos of colour." *Transition* (New York) no. 26 (1937): 81. Trans. James Johnson Sweeney.

"*L'Amérique et le chiffre 3*" (dated 1932). *Orbes* (Paris) 2ième série no. 1 (Spring 1933): 30–34.

"*L'Art est entré en cambrioleur*." *Mouvement* (Paris) no. 1 (June 1933).

"*L'Art mural de Victor Servranckx*." *Clarté* (Brussels) 10 no. 7 (July 1937): 20.

"*Avènement de l'objet*." *Le Mois* (Paris) no. 41 (June 1934): 217–24.

"*Le Beau et le vrai*" (excerpted from the lecture "*De L'Acropole à la Tour Eiffel*," given at the Sorbonne, Paris, February 8, 1934). *Beaux-Arts* (Paris) 73 no. 58 (February 9, 1934): 2.

"Beauty in Machine Art." *Design* (Columbus, Ohio) 39 no. 9 (March 1938): 6–7.

"Chicago" (November 1931). *Plans* (Paris) 2 no. 11 (January 1932): 63–68. Excerpts also published as "*Voyage d'artiste: Vingt-quatre heures ou la vie d'un journal à Chicago*." *L'Intransigeant* (Paris), January 4, 1932, p. 5. Reprinted in French and English translation in *Léger et L'Esprit Moderne*, exh. cat. (Paris: Museé d'Art Moderne de la Ville de Paris, 1982), pp. 273–74.

"*Choses d'Amérique*." *La Nouvelle Revue Française* (Paris) 27 no. 308 (May 1, 1939): 902–3.

"*Concours chorégraphique international au théâtre des Champs-Élysées*." *Cahiers d'Art* (Paris) 7 no. 6–7 (July 1932): 288.

"*Couleur dans le monde*" (based on a lecture given in Antwerp, November 1937). *Europe* (Paris) 47 no. 4–7 (May 1938): 99–113. Simultaneously published in *Pein-*

291

tres et sculpteurs de la Maison de la Culture (Paris) no. 5 (May 1938). Reprinted as "Color in the World" in *Functions of Painting*, pp. 119–31.

"*La Couleur et le sentiment.*" *Pour Vous* (Paris) no. 358 (September 26, 1935): 2.

"*De la peinture dansée à la danse sans peinture, spectacle sans décors.*" *L'Intransigeant* (Paris), July 11, 1932, p. 7.

"*De l'art abstrait (II): Réponse de Fernand Léger.*" *Cahiers d'Art* (Paris) 6 no. 3 (1931): 151–52. Reprinted as "Abstract Art" in *Functions of Painting*, pp. 81–83.

"'*Deus ex machina.*'" *L'Intransigeant* (Paris), January 27, 1930.

"*Discours aux architectes*" (lecture given at the fourth Congrès International d'Architecture Moderne, August 1933). *Quadrante* (Milan) 11 no. 5 (September 1933): 44–47. Reprinted with substantial alterations as "The Wall, the Architect, the Painter" in *Functions of Painting*, pp. 91–99.

"*Enquête*" (inquiry into the subject of the art of today). *Cahiers d'Art* (Paris) 10 no. 1–4 (1935): 66–67. Léger's response transcribed by Christian Zervos.

"*Enquête (L'Acte créateur se ressent-il de l'influence des événements environnants…).*" *Cahiers d'Art* (Paris) 14 no. 1–4 (1939): 70–72.

"*Erik Satie illustré par Calder. Pourquoi pas?*" In *Alexander Calder: Volumes—Vecteurs—Densités/Dessins—Portraits*. Exh. cat. Paris: Galerie Percier, 1931.

"*Exposition 1937.*" *Verve* (Paris) no. 1 (1937).

"*Fernand Léger précise.*" *Beaux-Arts* (Paris) no. 18 (May 5, 1933).

"Introduction." In Moï Ver, *Paris: 80 Photographies de Moï Ver* (Paris: Éditions Jeanne Walter, 1931).

"Introduction." In *12 Paintings by Elisabeth Blair*. Exh. cat. New York: John Becker Gallery, Inc., 1933.

"*L'Invasion polychrome.*" *La Bête noire* (Paris) no. 3 (June 1, 1935).

"*Londres.*" *La Nouvelle Revue Française* (Paris) nos. 258 (June 1935) and 264 (September 1935).

"*Mystique de l'objet.*" *Beaux-Arts* (Paris) no. 81 (July 20, 1934).

"The New Realism" (lecture given at The Museum of Modern Art, New York, October 4, 1935). Excerpts published in *Art Front* (New York) 2 no. 8 (December 1935): 10. Trans. Harold Rosenberg. Reprinted in *Functions of Painting*, pp. 109–13. A variant of this text is published as "*Un Nouveau Réalisme: La Couleur pure et l'objet*" in *Fonctions de la peinture*, pp. 77–81.

"*New-York vu par F. Léger.*" *Cahiers d'Art* (Paris) 6 no. 9–10 (1931): 437–39. Reprinted as "New York" in *Functions of Painting*, pp. 84–90.

"*Notre Paysage.*" *L'Intransigeant* (Paris), May 18, 1931.

"*Le Nouveau Réalisme continue*" (from a discussion among Léger, Louis Aragon, and Le Corbusier held at the Maison de la Culture, Paris, in May 1936). *La Querelle du Réalisme* (Paris: Éditions Sociales Internationales, 1936). Also published as "Painting and Reality: a discussion." *Transition* (New York) no. 25 (Fall 1936): 104–8. Trans. Maria Jolas. Reprinted as "The New Realism Goes On" in *Functions of Painting*, pp. 114–18.

"*Où va la peinture? (Conversations recueillies par Jean Cassou, René Crevel, Aragon, Champfleury, etc.).*" *Commune* (Paris) 2 no. 21 (May 1935): 944–46.

"*Préface.*" In *Fernand Léger*. Exh. cat. Brussels: Palais des Beaux-Arts, 1938.

"*Propos sur la couleur dans la vie moderne et au cinéma, sur l'art et la mesure.*" *Pour Vous* (Paris), 1935.

"The Question of 'Truth.'" *Architectural Forum* (New York) 70 no. 2 (February 1939): 137.

"Revival of Mural Art." *The Listener* (London) 18 no. 450 (August 25, 1937): 408–9. Trans. Douglas Lord.

"Stockholm." *Svenska Dagbladet* (Stockholm), September 30, 1934. Trans. Otto Carlsund.

"*Sur la peinture.*" *L'Exposition 1937 et les artistes à Paris* (Paris), 1937.

"*Thèse-Antithèse-Synthèse.*" Exh. cat. Lucerne: Kunstmuseum, 1935.

"*Vouloir construire.*" *Cercle et Carré* (Paris) no. 1 (March 15, 1930).

"*Voyage d'artiste: Au pays de Jean-Jacques.*" *L'Intransigeant* (Paris), May 15, 1933.

"*Voyage d'artiste: Sur les routes d'Espagne.*" *L'Intransigeant* (Paris), November 3, 1930.

"*Voyage d'artiste: Wall Street.*" *L'Intransigeant* (Paris), December 28, 1931.

1940s

"*À Propos du corps humain considéré comme un objet.*" In M.-A. Couturier, Maurice Gagnon, et al., *Fernand Léger, 1938–44: La forme humaine dans l'espace*. See under "Monographs and Exhibition Catalogues." Reprinted as "The Human Body Considered as an Object" in *Functions of Painting*, pp. 132–36.

"*L'Art abstrait.*" *Derrière le miroir* (Paris: Galerie Maeght, Éditions Pierre à feu) no. 20–21 (May 1949).

"*Un Art nouveau sous le ciel californien.*" *La Voix de France* (Paris), November 1, 1941.

"*L'Aventure au pays des merveilles.*" *Ciné-Club* (Paris) 2 no. 1 (October 1948): 1.

"Byzantine Mosaics and Modern Art." *Magazine of Art* (Washington, D.C.) 37 no. 4 (April 1944): 144.

"*Causerie sur l'art*" (from the lecture "*L'Art et le peuple*" given at the Sorbonne, Paris, April 10, 1946). In Léon Moussinac, "*Fernand Léger retrouve la France,*" *Arts de France* (Paris) no. 6 (1946): 36–42. Reprinted as "Art and the People" in *Functions of Painting*, pp. 143–48.

"Color in Architecture." In Stamo Papadaki, ed., *Le Corbusier: Architect, Painter, Writer* (New York: The Macmillan Co., 1948), pp. 78–80.

"*Découvrir l'Amérique.*" *La Voix de France* (Paris), May 15, 1942, p. 9.

"Modern Architecture and Color" (1943). In Charmion Wiegand and Fritz Glarner, *American Abstract Artists* (New York: The Ram Press, 1946), pp. 31–38. Trans. George L. K. Morris. Reprinted in *Functions of Painting*, pp. 149–54.

"Monumentality—A Human Need" (1948), by Léger with Siegfried Giedion and J. L. Sert. Manuscript in the Houghton Library, Harvard University.

"New York–Paris, Paris–New York." *La Voix de France* (Paris), September 15, 1941.

"Nine Points on Monumentality," by Léger with J. L. Sert and S. Giedion (1943). In Siegfried Giedion, *Architecture, You and Me* (Cambridge, Mass.: Harvard University Press, 1958), pp. 48–51.

"*Un Nouvel Espace en architecture.*" *Art d'Aujourd'hui* (Boulogne-sur-Seine) no. 3 (October 1949): 19. Reprinted as "A New Space in Architecture" in *Functions of Painting*, pp. 157–59.

"*L'Oeil du peintre.*" *Variété* (Paris) no. 3 (July 1946): 44–45. Reprinted as "The Painter's Eye" in *Functions of Painting*, pp. 141–42.

"*Pour et contre l'art abstrait.*" *Les Amis de l'art* (Paris) no. 11 (1947).

Preface. In *Peintures et sculptures contemporaines*. Exh. cat. for an exhibition at the Palais des Papes, Avignon, 1947, p. 19.

"*Que signifie: être témoin de son temps?*" *Arts* (Paris) no. 205 (March 11, 1949): 1.

"The Relationship between Modern Art and Contemporary Industry." *Modern Art in Advertising: An Exhibition of Designs for the Container Corporation of America*. Exh. cat. Chicago: The Art Institute of Chicago, 1945.

"*Rousseau peintre classique français.*" *La Voix de France* (Paris), 1942.

"*Willi Baumeister.*" *L'Âge Nouveau* (Paris) no. 44 (1949).

1950s

"L'Adieu de ses amis, les artistes" (Léger et al.), in "Hommage au Père Couturier." L'Art Sacré (Paris) no. 7–8 (March–April 1954): 6.

"Calder." Calder Mobiles and Stabiles. Exh. cat. Paris: Galerie Maeght, 1950. Republished in Derrière le Miroir (Paris: Galerie Maeght, Éditions Pierre à feu) no. 31 (July 1950): n.p.

"C'est comme cela que cela commence" (lecture given at the Académie Léger, Paris, in May 1949). Les Lettres Françaises (Paris) no. 582 (August 25–31, 1955): 3.

"Charlot cubiste." In Pierre Descargues, Fernand Léger (Paris: Cercle d'Art, 1956), pp. 17–18.

Cirque. Paris: E. Tériade, Les Éditions Verve, 1950. The essay in this book is reprinted in Functions of Painting, pp. 170–77.

"Comment je conçois la figure." In André Maurois, Mon ami Léger (Paris: Louis Carré, 1952). Reprinted as "How I Conceive of the Figure" in Functions of Painting, pp. 155–56.

"Le Congrès de Vienne: Le Carnet de Léger." Défense de la paix (Paris), January 1953.

"La Couleur dans l'architecture." In Problèmes de la couleur (Paris, 1954). Reprinted as "Color in Architecture" in Functions of Painting, pp. 183–88.

"De la peinture murale" (1952). Derrière le miroir (Paris: Galerie Maeght, Éditions Pierre à feu), no. 107–9 (1958).

"Fernand Léger: Une Ère nouvelle s'ouvrira pour la peinture lorsque le choix aura été fait entre le figuratif et l'abstrait." Arts (Paris) no. 401 (March 6–10, 1953): 7.

"Hommages de Fernand Léger." Nadia Petrova, peintures et gouaches. Exh. cat. Paris: Galerie Bernheim-Jeune, 1953.

"Lettre de Léger à un ami." Quadrum (Brussels) no. 2 (November 1956): 77–80.

"Les Mains des constructeurs" (1951). Heures Claires (Paris) no. 123 (1955).

"La Marche vers le mur." Les Lettres Françaises (Paris) no. 582 (August 1955).

"The New Landscape." In Gyorgy Kepes, The New Landscape in Art and Science (Chicago: Paul Theobald and Co., 1956), p. 90.

"Notes de Fernand Léger sur Bolivar." Arts (Paris) no. 260 (April 28, 1950): 7.

"Peinture moderne" (1950). Fonctions de la peinture, pp. 36–38. Reprinted as "Modern Painting" in Functions of Painting, pp. 167–69.

"La Peinture moderne devant le monde actuel" (lecture given at the Maison de la Pensée Française, Paris, March 1952). Les Lettres Françaises (Paris) 11 no. 405 (March 13, 1952): 1, 9. Reprinted as "Mural Painting" in Functions of Painting, pp. 178–80.

"Peinture murale et peinture de chevalet" (1950). Fonctions de la peinture, pp. 30–33. Reprinted as "Mural Painting and Easel Painting" in Functions of Painting, pp. 160–64.

"Le Problème de la liberté en art" (1950). Fonctions de la peinture, pp. 34–35. Reprinted as "The Problem of Freedom in Art" in Functions of Painting, pp. 165–66.

"Satie Inconnu." La Revue musicale (Paris) 2 no. 14 (June 1952): 137.

"Sens de l'art moderne." Zodiaque (Saint-Léger-Vauban) no. 18–19 (January 1954).

"Situation de la peinture dans le temps actuel 1951." La Biennale di Venezia (Venice) no. 5 (August 1951): 19.

"Témoignages: Fernand Léger." XXe Siècle (Paris) nouvelle série no. 2 (January 1952): 67–68. Special issue on "Nouvelles Conceptions de l'espace." Reprinted as "New Conceptions of Space" in Functions of Painting, pp. 181–82.

"Vers l'architecture" (January 1953). Fernand Léger. Exh. cat. Paris: Galerie Louis Carré, 1953.

Posthumous

"Muralmåleri och stafflimåleri." Konstrevy (Stockholm) 45 no. 3 (1969): 106–10.

"Les Spartakiades." Fonctions de la peinture, pp. 194–95. Reprinted in Functions of Painting, pp. 189–90.

Exhibition History

Compiled by Kristen Erickson

This Exhibition History records both group and solo exhibitions through 1935; after 1935, it focuses on solo exhibitions.

1907

Grand Palais, Paris. Salon d'Automne. October 1–22.

1908

Grand Palais, Paris. Salon d'Automne. October 1–November 8.

1909

Grand Palais, Paris. Salon d'Automne. October 1–November 8.

1910

Cours de la Reine, Paris. Salon des Indépendants (Salon de la Société des Artistes Indépendants). March 18–May 1.

Brussels. *Exposition Universelle et Internationale.* June–November.

Grand Palais, Paris. Salon d'Automne. October 1–November 8.

1911

Quai d'Orsay, Paris. Salon des Indépendants. April 21–June 13.

7, place A. Steurs, Brussels. Salon des Indépendants. June 10–July 3.

Grand Palais, Paris. Salon d'Automne. October 1–November 8.

Galerie d'Art Ancien et d'Art Contemporain, Paris. Société Normande de Peinture Moderne (second exhibition). November 20–December 16.

1912

Galerie Kahnweiler, Paris. *Fernand Léger.*

Moscow. *Bubnovy valet* (second jack of diamonds exhibition). February–March.

Quai d'Orsay, Paris. Salon des Indépendants. March 20–May 16.

Galeries J. Dalmau, Barcelona. *Exposició d'Art Cubista.* April 20–May 10.

Rouen. Salon de la Société Normande de Peinture Moderne. June 15–July 15.

Grand Palais, Paris. Salon d'Automne. October 1–November 8. Léger exhibited in the Salon and in the section of it called the *Maison Cubiste.*

Stedelijk Museum, Amsterdam. Salon Moderne Kunst Kring. October 6–November 7.

Galerie La Boétie, Paris. Salon de la Section d'Or. October 10–30.

Kunsthaus Lepke, Berlin. *III Juryfreie Kunstschau.* November 26–December 31.

1913

Galerie Kahnweiler, Paris. Solo exhibition.

Khudozhestvenny Salon, Moscow. *Frantsuzskaya vystavka kartin "Sovremmennoe iskusstvo"* (group exhibition). January.

Galerie Miethke, Vienna. *Die neue Kunst.* January–February.

Galerie Berthe Weill, Paris. *Gleizes, Léger, Metzinger.* January 17–February 1.

Armory of the 69th Infantry, New York. *International Exhibition of Modern Art* (the Armory Show). February 17–March 15. Organized by the Association of American Painters and Sculptors, Inc., New York. Traveled: The Art Institute of Chicago (March 24–April 16); Copley Hall (Copley Society of Boston) (April 28–May 19).

Quai d'Orsay, Paris. Salon des Indépendants. March 19–May 11.

Gimbel's Department Store, Milwaukee. *Exhibition of "Cubist" and "Futurist" Pictures.* C. May 11–c. late June. Traveled: William, Taylor, Son & Co., Cleveland (June 20–July 8); Boggs and Buhl, Pittsburgh (July 10–16); Gimbel's Department Store, New York (c. July 20–30);

Gimbel's Department Store, Philadelphia (c. August 1–8); Milwaukee Art Society (April 16, 1914–May 12).

Der Sturm, Berlin. *Erster deutscher Herbstsalon.* September 20–December 1.

1914

Hibiya Art Museum, Tokyo. Woodcut prints. Organized by Der Sturm. March 14–28.

1915

Chez Madame Bongard, Paris. Group exhibition. December.

1916

Der Sturm, Berlin. *XXXXIII Ausstellung: Expressionisten/Futuristen/Kubisten.* July–August.

Salon d'Antin, Paris. *L'Art Moderne en France.* July.

Galerie des Indépendants (Chéron et Cie.), Paris. *Peintres modernes.*

1917

Galerie Montaigne, Paris. Group exhibition. June.

1918

The Penguin (Club), New York. *Exhibition of Contemporary Art.* Opened March 16.

1919

Galerie de l'Effort Moderne, Paris. *Oeuvres par Fernand Léger.* February 5–28.

Mansard Gallery, Heal's, London. *Modern French Art.* July.

Galerie Tivoli, Oslo. Solo exhibition. October 25–November 10.

Galerie de l'Effort Moderne, Paris. Group exhibition. November 5–29.

Galerie Sélection, Antwerp. Solo exhibition.

1920

Grand Palais, Paris. Salon des Indépendants. January 28–February 29.

Galerie Moos, Geneva. *La Jeune Peinture française. Les Cubistes.* February. Organized in collaboration with Léonce Rosenberg.

Galerie La Boétie, Paris. *La Section d'Or.* March.

Maison Watteau, Paris. Salon d'art moderne. Opened December 5.

Geneva. *Exposition Internationale d'art moderne.* December 26, 1920–January 25, 1921.

1921

Grand Palais, Paris. Salon des Indépendants. January 23–February 28.

Galerie de l'Effort Moderne, Paris. *Oeuvres nouvelles par: Georges Braque, Csáky, Juan Gris, Albert Gleizes, Henri Hayden, Auguste Herbin, Jeanneret, Irène Lagut, Jean Lambert, Henri Laurens, Fernand Léger, Jean Metzinger, Piet Mondrian, Pablo Picasso, Ozenfant, Gino Severini, Survage, Georges Valmier.* May 2–25.

Galerie de l'Effort Moderne, Paris. Group exhibition. June 2–25.

Galerie de l'Effort Moderne, Paris. *Les Peintres cubistes d'avant la guerre.* July 1–25.

Galerie de l'Effort Moderne, Paris. *Quelques aspects nouveaux de la tradition.* October 29–November 19.

Lyons. Group exhibition. November 27–December 11. Organized by the Lyons review *Promenoir.*

Grand Palais, Paris. Salon d'Automne. November 1–December 20.

Wanamaker Gallery, Belmaison, New York. *Exhibition of Paintings by French Cubists and Post Impressionists.* November 22–December 18.

1922

Der Sturm, Berlin. March.

Galerie de l'Arte Moderna Italiana, Rome. *Section d'Or* (group exhibition). April 17–May 2.

Galerie de la Licorne, Paris. Group exhibition. October.

Grand Palais, Paris. Salon d'Automne.

November 1–December 17.

Galerie de l'Effort Moderne, Paris. *Synthèse et construction.* Opened November 30.

1923

Grand Palais, Paris. Salon des Indépendants. February 10–March 11.

Hôtel de la Chambre Syndicale de la Curiosité, Paris. Salon de la Folle Enchère. November 15–30.

Maison Watteau, Paris. *Exposition des Franco-Scandinaves et de ses invités.* Opened November 17. First exhibition of the Association des Artistes Scandinaves.

1924

École Spéciale d'Architecture, Paris. *L'Architecture et les arts qui s'y rattachent.* March 22–April 30.

Musée municipal d'Amsterdam. Exhibition of artists associated with the Galerie de l'Effort Moderne. April–May.

Maison Watteau, Paris. *Atelier Fernand Léger.* October 18–December 21. Exhibition of the Association des Artistes Scandinaves.

Galerie Paul Rosenberg, Paris. *Quelques Peintres du XXe siècle.* December 1–20.

1925

Galerie Vavin-Raspail, Paris. *Exposition de la Section d'Or 1912–1925.* January 12–21.

Paris. *Exposition Internationale des Arts Décoratifs et Industriels Modernes.* April–October. Léger exhibited in the French Ambassador's Pavilion and the Pavillon de L'Esprit Nouveau.

Palais de Bois, Paris. Salon des Tuileries. May–June.

Anderson Galleries, New York. *Fernand Léger.* November 16–28. Sponsored by the Société Anonyme.

Salle du Syndicat des Négociants en Objets d'Art, Paris. *Exposition Internationale de l'Art d'Aujourd'hui.* December 1–21.

1926

The Mayor Gallery, London. Artists from the Galerie de l'Effort Moderne. January.

Grand Palais des Champs-Élysées, Paris. *Trente ans d'art indépendant.* February

20–March 21. Retrospective of the Société des Artistes Indépendants.

Steinway Building, New York. *The International Theatre Exposition.* February 27–March 15. Organized by Frederick Kiesler and Jane Heap under the auspices of the Theatre Guild, the Provincetown Playhouse, the Greenwich Village Theatre, and the Neighborhood Playhouse.

Künstlerhaus, Vienna. *Ausstellung Französische Kunst der Gegenwart.* March 5–April 11. Organized by the Gesellschaft zur Förderung Moderner Kunst in Wien, with the Association française d'expansions et d'échanges artistiques.

Galerie des Quatre Chemins, Paris. *Fernand Léger.* May 7–20.

Société de l'Art Contemporain, Antwerp. *Exposition d'art français moderne (Tenttonsteling van Moderne Fransche Kunst).* May 15–June 20.

Galerie d'Art Contemporain, Paris. Exhibition of the Académie Moderne—Léger, Amédée Ozenfant, and their students. June 30–July 13.

The Brooklyn Museum, New York. *The International Exhibition of Modern Art.* November 19, 1926–January 9, 1927. Organized by Katherine Dreier of the Société Anonyme. Traveled: Anderson Galleries, New York (January 25–February 5); Albright Art Gallery, Buffalo (February 25–March 20, 1927); Toronto Art Gallery (April 1–24, 1927).

The Art Institute of Chicago. *Some Modern Paintings.* December 21, 1926–January 24, 1927. Organized by The Arts Club of Chicago.

1927

Oakland Art Gallery, California. *Twenty European Artists.* January 5–29. Circulated by the Western Association of Museum Directors.

Palais de Bois, Porte Maillot, Paris. Salon des Tuileries. C. March–June.

Galerie de l'Effort Moderne, Paris. *Léger.* March 12–31.

The Art Museum of Wellesley College, Wellesley, Mass. *Exhibition of Progressive Modern Painting: From Daumier and Corot to Post-Cubism.* April 11–30.

Galerie Paul Rosenberg, Paris. *Oeuvres de quelques peintres du XXe siècle.* May–June.

Galerie Myrbor, Paris. Group exhibition. June.

Galerie Alfred Flechtheim, Berlin. *Nell Walden-Heimann und ihre Sammlungen.* September 6–28.

The Arts Club of Chicago. *Some Modern Paintings from Myrbor, Paris.* November 20–December 7.

New School for Social Research, New York. Exhibition associated with modern-art course includes Léger works lent by the Société Anonyme. December 12–19.

Gallery of Living Art, New York. Inaugural exhibition (group). December 13, 1927–January 25, 1928.

1928

Galerie Hodebert, Paris. *Peintres Normands.* C. January.

Galerie Alfred Flechtheim, Berlin. *Fernand Léger.* February 6–March 2.

Galerie de l'Effort Moderne, Paris. *Léger.* March.

Galerie Jeanne Bucher, Paris. Group exhibition. May 3–31.

Galerie Myrbor, Paris. Group exhibition of Cubist paintings. June.

Women's City Club, New York. Group exhibition. October 12–November 1. Sponsored by the Société Anonyme.

Galerie Aubier, Paris. Group exhibition. Opened October 22.

Galerie Danthon, Paris. *Exposition d'oeuvres des maîtres de la peinture contemporaine.* November.

The Arts Club of Chicago. *Modern Paintings by Eleven European Artists.* November 12–December 5.

Leicester Galleries, London. Solo exhibition.

1929

Kunsthaus Zürich. *Exposition d'art abstrait et surréaliste.*

The Arts Club of Chicago. *Loan Exhibition of Modern Paintings Privately Owned by Chicagoans.* January 4–18. Traveled: the Saint Paul Library, Saint Paul, Minn. (opened February 1, for two weeks;

sponsored by the Saint Paul School of Art).

Gallery of Living Art, New York. Exhibition of Mrs. Charles H. Russell's collection. January 19–February 19.

Harvard Coop., Cambridge, Mass. *Exhibition of the School of Paris, 1910–1928*. March 20–April 12. Organized by The Harvard Society for Contemporary Art, Inc.

Galerie Paul Rosenberg, Paris. *Braque, Léger, Matisse, Picasso*. April–May.

Galerie de France, Paris. Inaugural exhibition (group). June.

Galerie de la Renaissance, Paris. *L'École de Paris*. October.

Galerie Vignon (formerly Galerie Myrbor), Paris. Inaugural exhibition (group). C. November/December.

Brummer Gallery, New York. Loan exhibition from the Gallery of Living Art, New York. November 30–December 13.

Galerie de Hauke & Co., New York. *Exhibition of Water Colors and Drawings by Nineteenth-Century and Contemporary French Artists*. December.

1930

Galerie de Hauke & Co., New York. *30 Years of French Painting: 30 Paintings by 30 Artists*. October 1–19 [c. 1930].

The Museum of Modern Art, New York. *Painting in Paris from American Collections*. January 18–March 2.

Galerie Paul Rosenberg, Paris. *Quatres Peintres*. March–May 23.

The Arts Club of Chicago. Loans from the collection of Miss Mary Wiborg. C. March 25–May. Selections from the exhibition traveled to The Museum of Modern Art, New York; other selections traveled to the Renaissance Society, University of Chicago.

Galerie de Hauke & Co., New York. *Exhibition of Cubism: Period 1910–1913*. April.

Leicester Galleries, London. *Exhibition of Paintings by Léger, Metzinger, Severini, Viollier, Katchar*. April–May. Organized by Léonce Rosenberg.

Galerie 23 (23, rue La Boétie), Paris. Exhibition of the Cercle et Carré group.

April 18–May 1.

Galerie Le Centaure, Brussels. *Trente ans de peinture française*. June.

Galerie Percier, Paris. *Oeuvres Cubistes*. June.

The Museum of Modern Art, New York. *Summer Exhibition*. June 15–late September.

Galerie Reinhardt, New York. Group exhibition. October–November.

Galerie Paul Rosenberg, Paris. *Fernand Léger*. November 18–December 10.

1931

Galerie Paul Rosenberg, Paris. Group exhibition. January–February.

New School for Social Research, New York. Exhibition arranged by the Société Anonyme for the opening of the new building for the New School for Social Research. January 1–February 10.

Museum of French Art, French Institute in the United States, New York. *Picasso, Braque, Léger*. February.

Durand-Ruel Galleries, New York. *Exhibition of Paintings by Fernand Léger*. February 3–21.

Galerie d'Art du Bucheron, Paris. *Les Ballets Suédois (maquettes de décors, costumes, interprétations)*. Collection Rolf de Maré. May 8–31.

Jacques Seligmann, New York. Summer exhibition (group). C. July.

The Renaissance Society, University of Chicago. *Some Modern Primitives: International Exhibition of Paintings and Prints*. July 2–August 16.

John Becker Gallery, New York. *Fernand Léger: An Exhibition of Drawings, Watercolors and Gouaches*. October 1–23.

The Arts Club of Chicago. Exhibition of paintings, drawings, gouaches, and watercolors by Léger, loaned by the John Becker Gallery, Durand-Ruel Galleries, Jeanne Bucher, and others. November 20–28.

Valentine Gallery, New York. *Since Cézanne*. December 28, 1931–January 16, 1932.

1932

Valentine Gallery, New York. Group exhi-

bition. February 1–20.

Chester Johnson Galleries, Chicago. *Old and Modern Masters*. May.

Galerie Braun, Paris. *Vingt-cinq ans de peinture abstraite*. June 3–16.

Galerie Il Milione, Milan. Solo exhibition of drawings. December 10–26.

1933

The Mayor Gallery, London. *Exhibition of Recent Paintings by English, French and German Artists*. April 20–30.

Kunsthaus, Zurich. *Fernand Léger*. April 30–May 25.

The Mayor Gallery, London. *A Survey of Contemporary Art Arranged in Connection with "Art Now" by Herbert Read*. October 11–November 1.

Julien Levy Gallery, New York. *Twenty-Five Years of Russian Ballet from the Collection of Serge Lifar*. November 2–18. Traveled: The Arts Club of Chicago (November 28–December 23); Smith College Museum of Art, Northampton, Mass. (as *Les Ballets Russes de Serge de Diaghilev*; January 7–22, 1934); The Cleveland Museum of Art (March 16–April 8).

The Arts Club of Chicago. *The George Gershwin Collection of Modern Paintings*. November 10–25.

1934

The Renaissance Society, University of Chicago. *Exhibition of Abstract Painting by Four Twentieth Century Painters: Picasso, Gris, Braque, Léger*. January 12–February 2.

Grand Palais, Paris. Salon des Indépendants (fiftieth-anniversary exhibition). February 2–March 11.

The Mayor Gallery, London. *Twentieth Century Classics*. February 20–March.

Galerie Vignon, Paris. *Objets par Fernand Léger, gouaches—dessins—1933–34*. April 16–28.

The Renaissance Society, University of Chicago. *A Selection of Works by Twentieth Century Artists*. June 20–August 20.

Galerie Moderne, Stockholm. Solo exhibition. September 12–26. Traveled: Göteborg (September 29–October 12);

Oslo (October 15–31).

Junior League Galleries, New York. *Eight Modes of Modern Painting*. October 15–c. October 22. Traveled: Julien Levy Gallery, New York (October 22–November 2). Organized by the College Art Association.

The Arts Club of Chicago. *The Leonide Massine Collection of Modern Paintings*. December 4–31. Traveled: Toledo Museum of Art (January 1935); Marie Harriman Gallery, New York (opened February 18, 1935); Wadsworth Atheneum, Hartford (May 3–October 3, 1935).

1935

Galerie de la Gazette des Beaux-Arts, Paris. *Les Créateurs du Cubisme*. March–April.

Marie Harriman Gallery, New York. *Braque, Gris, La Fresnaye, Léger, Lipchitz, Marcoussis, Picasso*. March 26–April 6.

The Arts Club of Chicago. *The Sidney Janis Collection of Modern Paintings*. April 5–24.

Brussels. *Exposition Universelle et Internationale*. April 27–November 3. Léger exhibited in the *Maison du jeune homme*.

Wadsworth Atheneum, Hartford. *Paintings from the Massine Collection*. May 3–October 3.

The Museum of Modern Art, New York. *Fernand Léger: Paintings and Drawings*. September 30–October 24. Traveled: The Art Institute of Chicago (December 19, 1935–January 19, 1936); Milwaukee Art Institute (January 29–February 25, 1936); Renaissance Society, University of Chicago (March 3–April 6, 1936).

Black Mountain College, North Carolina. Loan exhibition (group) by the Société Anonyme. October 1935–June 1936.

1936

Quest Galleries, Chicago. Watercolors and drawings by Léger. C. April.

1937

Galerie Paul Rosenberg, Paris. *Exposition d'oeuvres de Léger*. February 5–27.

Palais de la découverte, Paris. *Transport des forces*. Installed April 12.

Galerie Jeanne Bucher-Myrbor. Exhibition of preparatory drawings and gouaches for *Transport des forces*. April 30–May 14.

London Gallery, London. *Léger*. October 14–November 13.

Artek, Helsinki. *Fernand Léger/Alexander Calder*. November 29–December 12.

1938

Rosenberg & Helft Gallery, Ltd., London. *Exhibition of Works by Léger*. January 17–February 16.

Pierre Matisse Gallery, New York. *Léger 1937: Paintings and Gouaches*. February 23–March 19.

Palais des Beaux-Arts, Brussels. *Fernand Léger*. May 14–June 5.

The Mayor Gallery, London. *Fernand Léger, période 1912–1916*. June 8–July.

London Gallery, London. Solo exhibition. June 8–July 2.

Katharine Kuh Gallery, Chicago. Solo exhibition. September–October.

Pierre Matisse Gallery, New York. *Léger: Recent Gouaches*. October 25–November 12.

1939

Kestner Gesellschaft, Hannover. *Fernand Léger, André Masson, Woty Werner*.

Consolidated Edison Pavilion, World's Fair, New York. April 30, 1939–?, 1940.

1940

Nierendorf Gallery, New York. *Fernand Léger*. February 20–March 2.

Galerie Mai, Paris. *Oeuvres récentes de Fernand Léger*. March 1–30.

Katharine Kuh Gallery, Chicago. *Léger: Exhibition of New Work*. May.

The Museum of Modern Art, New York. *Composition with Two Parrots by Fernand Léger*. December 27, 1940–January 12, 1941.

1941

Marie Harriman Gallery, New York. *Fernand Léger*. March 4–15.

The Arts and Crafts Club of New Orleans. *Alexander Calder (Mobiles, Jewelry); Fernand Léger (Gouaches, Drawings)*. March 28–April 11.

The Arts Club of Chicago. *Fernand Léger*. May 23–June 14. Traveled: Mills College Art Gallery, Oakland (June 29–July); San Francisco Museum of Art (August 12–September 7; expanded version); then circulated by the Western Association of Art Museum Directors to Stendahl Galleries, Los Angeles (opened September 11) and other venues through 1942.

1942

Buchholz Gallery, New York. *Fernand Léger: Gouaches & Drawings*. October 12–31.

Paul Rosenberg & Co., New York. *Recent Works by Fernand Léger*. October 12–31.

Valentine Gallery, New York. *Léger: New Paintings*.

1943

Jacques Seligmann & Co., New York. *Fernand Léger: "Les Plongeurs"*. April 19–May 6.

Dominion Gallery, Montreal, Canada. *Exhibition of Paintings by Fernand Léger*. May 29–June 9.

1944

Valentine Gallery, New York. *Léger: New Paintings*. March 13–April 8.

The Book Shop, Saint Louis. Solo exhibition. Opened April 30.

Institute of Design, Chicago. *Fernand Léger*. October 14–November 8.

Cincinnati Art Museum. *Paintings by Fernand Léger*. November 14–December 17. Organized by the Cincinnati Modern Art Society.

1945

Robinson Hall, Graduate School of Design, Harvard University, Cambridge, Mass. *Fernand Léger*. January 3–15.

Philadelphia Museum of Art. *The Gallery Collection: Picasso, Léger*. January 10–February 20.

Galerie Louis Carré, Paris. *Fernand Léger, Peintures antérieures à 1940*. January 16–February 5.

Samuel M. Kootz Gallery, New York. *Léger: Oils, Gouaches, Drawings*. Opened April 9.

Valentine Gallery, New York. *Fernand Léger: New Paintings*. April 9–May 5.

1946

Galerie Louis Carré, Paris. *Fernand Léger: Oeuvres d'Amérique 1940–1945*. April 12–May 11.

Paul Rosenberg & Co., New York. Solo exhibition. C. December.

1947

Galerie Louis Carré, Paris. *Oeuvres récentes de Fernand Léger*. April 17–May 3.

Nierendorf Gallery, New York. *Fernand Léger*. April 29–May 12.

Kunsthalle, Bern. *Calder, Léger, Bodmer, Leuppi*. May 4–26.

Stedelijk Museum, Amsterdam. *Alexander Calder and Fernand Léger*. July–August.

1948

Valentine Gallery, New York. *Léger: New Paintings*.

Svensk-Franska Konstgalleriet, Stockholm. *Retrospektiv Utställning Fernand Léger*. May 21–June 30.

Galerie Louis Carré, Paris. *Fernand Léger: 1912–1939/1946–1948*. June 11–July 11.

Sidney Janis Gallery, New York. *Léger 1912–1948*. September 21–October 16.

1949

Salon de Mai, Paris.

Kestner Gesellschaft, Hannover. *Fernand Léger, André Masson, Woty Werner*. July 3–31.

Landesamt für Museen, Sammlungen und Ausstellungen, Freiburg im Breisgau. *Fernand Léger*.

Musée national d'art moderne, Paris. *Fernand Léger. Exposition rétrospective 1905–1949*. October 6–November 13.

1950

Tate Gallery, London. *Fernand Léger: An Exhibition of Paintings, Drawings, Lithographs and Book Illustration*. February 17–March 19. Sponsored by The Arts Council of Great Britain and the Association Française d'Action Artistique.

Galerie Garibaldi, Paris. Retrospective exhibition. C. April.

XXV Venice Biennale, 1950. *Quattro Maestri del Cubismo*. June 8–October 15.

Galerie 16, Zurich. *Léger's Lithographs for "Le Cirque"*. July 1–28.

Galerie Jeanne Bucher, Paris. *Atelier Fernand Léger*. July 15–31.

Buchholz Gallery, New York. *Léger: Recent Paintings & Le Cirque*. November 6–December 2.

Galerie Louis Carré, Paris. *Deauville vu par Fernand Léger*. November 8–December 9.

1951

Kunstforenungen, Copenhagen. *Fernand Léger Udstilling*. January 27–February 25.

Kunstnerforbundet, Oslo. *Fernand Léger*. Opened March 3.

Sidney Janis Gallery, New York. *Early Léger: Oil Paintings 1911–1925*. March 19–April 7.

Louis Carré Gallery, New York. *Léger II*. March 28–April 21. An exhibition on the gallery's seventieth anniversary.

Kunsthalle, Bern. *Fernand Léger*. April 10–May 25.

Maison de la Pensée Française, Paris. *Les Constructeurs et sculptures polychromes*. June 12–October 7.

Palazzo dell'arte e il parco, Milan. Ninth Triennale di Milano. July. Includes an exhibition of seven works by Léger as part of an exhibition of industrial and decorative arts and a mural by the artist in an exhibition of French architecture. Several of his prints are also exhibited.

Galerie Louise Leiris, Paris. *Fernand Léger: Sculptures polychromes et lithographies*. November 27–December 15.

Académie des Beaux-Arts, Salle Foch, Paris. *Exposition Annuelle, Atelier Fernand Léger*. December 11–27.

Saidenberg Gallery, New York. *Léger and Picasso*. Ended December 31.

1952

Riksförbundet för Bildande Konst, Stockholm. *Léger och Nordisk Postkubism*. 1952–53.

Gemeente Musea, Amsterdam. *Fernand Léger: De bouwers*.

Kootz Gallery, New York. *Vlaminck: Fauve Paintings from the Vollard Collection; Léger: Early and Late Paintings; Miró:*

Paintings and Collage. January 28–February 16.

Kunsthalle, Bern. *Fernand Léger.* April 10–May 25.

Galerie de Berri, Paris. *Fernand Léger.* June–July.

Galerie Louis Carré, Paris. *La Figure dans l'oeuvre de Fernand Léger.* June 6–July 10.

XXVI Venice Biennale. Solo exhibition. June 14–October 19.

Sidney Janis Gallery, New York. *Fernand Léger: Paintings.* September 15–October 11.

Perls Galleries, New York. *Fernand Léger.* October 27–November 29.

1953

Galerie Louis Carré, Paris. *Fernand Léger: Sculptures polychromes en céramique.* January 16–February 28.

The Art Institute of Chicago. *Léger: A Survey of His Art.* April 2–May 17. Traveled: San Francisco Museum of Art (June 11–September 2); The Museum of Modern Art, New York (October 20, 1953–January 3, 1954).

Galerie Louis Carré, Paris. *Fernand Léger: Peintures.* May 29–June 27.

Saidenberg Gallery, New York. *Léger.* September 23–November 18.

Galerie Louis Carré, Paris. *Illustrations pour le poème "'Liberté' de Paul Eluard."* October 23–31.

1954

Maurice Bridel et Nane Cailler, Lausanne. *Exposition de Lithographies de Fernand Léger.* September 13–October 2.

Maison de la Pensée Française, Paris. *Fernand Léger: Oeuvres Récentes 1953–1954.* Opened November 9.

Galerie Louis Carré, Paris. *Le Paysage dans l'oeuvre de Léger.* November 19–December 31.

Marlborough Fine Art, London. *Fernand Léger—Paintings, Drawings, Lithographs, Ceramics.* December 1954–January 1955.

Sidney Janis Gallery, New York. *Ceramics by Léger.* Early December–December 30.

Galerie d'Art Moderne, Basel. *Fernand Léger.* December 4, 1954–January 20, 1955.

1955

Museum de Arte Moderna, Rio de Janeiro. *Léger.*

Städtisches Museum, Leverkusen. *Fernand Léger.* February.

Galerie Gerald Cramer, Geneva. *Fernand Léger: Lithographies en couleur.* February–March.

Musée des Beaux-Arts de Lyon. *Fernand Léger.* June 28–September 30.

São Paulo Bienal. July. Léger received the grand prize.

Kassel. Documenta I. July 15–September 18.

Galerie Blanche, Stockholm. *Fernand Léger 1881–1955: Oljemålningar, gouacher, akvareller, teckningar och litografier.* August–September.

The Museum of Modern Art, New York. *Léger Memorial.* August 19–September 30.

Galerie Maeght, Paris. *Hommage à Fernand Léger: Peintures de 1920 à 1930.* C. October–December.

The Arts Club of Chicago. *An Exhibition of Cubism.* October 3–November 4.

Perls Galleries, New York. *Fernand Léger.* October 3–November 12.

1956

Institut Français, Athens. *Dessins et lithographies de Fernand Léger.*

Kunstmuseum, Frankfurt. Solo exhibition.

Museum of Contemporary Crafts, New York. Solo exhibition.

Salon de Mai, Paris. *Hommage à Léger.* May.

Musée des Arts Décoratifs, Paris. *Fernand Léger, 1881–1955.* June 8–October. Traveled: Palais des Beaux-Arts, Brussels (October 12–November 15); Stedelijk Museum, Amsterdam (As *Léger: Wegbereider;* December 11, 1956–January 28, 1957); Stedelijk van Abbemuseum, Eindhoven (February 4–March 12, 1957); Haus der Kunst, Munich (March 19–May 12, 1957); Kunsthalle, Basel (May 22–June 23, 1957); Kunsthaus Zürich (July 6–August 17, 1957).

Paul Rosenberg & Co., New York. *Léger and Masson.* C. mid-November–December 7.

1957

Museum am Ostwall, Dortmund. Solo exhibition.

Sidney Janis Gallery, New York. *Léger: Major Themes.* January 2–February 2.

Sidney Janis Gallery, New York. *Fernand Léger: A Selection of Paintings of His Major Themes 1909–1955.* January 2–February 2.

1958

Galerie Louise Leiris, Paris. *Fernand Léger: Dessins et Gouaches 1909–1955.* February 19–March 22.

Clemens Sels Museum, Neuss. *Léger: Cirque.* May–August.

Perls Gallery, New York. *Fernand Léger and the School of Paris.* November 10–December 20.

1959

Albertina, Vienna. *Fernand Léger: Zeichnungen, Gouachen, Lithographien.* February–March.

Saidenberg Gallery, New York. *Léger: Two Decades.* December 29, 1959–January 31, 1960.

1960

Saidenberg Gallery, New York. *Léger: La Ville* (lithographs). January 12–February 3.

La Porte Latine, Caen. *Fernand Léger.* January 22–February 5.

Galerie Europe, Paris. *F. Léger: Peintures et Gouaches (1918–1955).* March.

Otto Gerson Gallery, New York. *Léger: Sculpture—Ceramics.* September.

The Museum of Modern Art, New York. *Fernand Léger in the Museum Collection.* November 16–January 2, 1961.

Sidney Janis Gallery, New York. *Sidney Janis Presents His 6th Exhibition of Paintings by Fernand Léger, Selected from the Years 1918–1954.* December 5, 1960–January 7, 1961.

1961

Pierre Berès, Inc., New York. *Fernand Léger: "Mes Voyages".*

Svensk-Franska Konstgalleriet, Stockholm. *Fernand Léger.* March 11–29.

Galerie Artemont, Paris. *Léger: Peintures récentes.* December 8–22.

1962

Galerie Claude Bernard, Paris. *Fernand Léger* (drawings). C. January.

Solomon R. Guggenheim Museum, New York. *Fernand Léger: Five Themes and Variations.* February 28–April 29.

Galerie Renée Ziegler, Zurich. *Fernand Léger.* April 6–May 26.

Galerie Berggruen, Paris. *Léger: Contrastes de formes 1912–1915.* C. June.

Palais de la Méditerranée, Nice. *F. Léger: Tapisseries, céramiques, bronzes, lithographies.* July 20–September 30.

1963

Galerija suvremene umjetnosti, Zagreb. *Fernand Léger.* October 10–November 10.

La Nuova Pesa, Rome. Solo exhibition.

1964

Galerie Madoura, Cannes. *Léger: Céramiques et bronzes.*

Galerie Beyeler, Basel. *Fernand Léger.* May–June 1964.

Moderna Museet, Stockholm. *Fernand Léger: 1881–1955.* October 23–November 29.

Galerie d'art moderne, Basel. *F. Léger: Gouaches et dessins de 1921 à 1938.* November 28, 1964–January 25, 1965.

1965

Galerie Chalette, New York. *Fernand Léger: The Figure.* March 29–May 1, extended to May 26.

Galerie Günther Franke, Munich. *Fernand Léger.* April 10–May 10.

Galerie Louis Carré, Paris. *La Peinture sous le signe de Blaise Cendrars: Robert Delaunay, Fernand Léger.* June 17–July 31.

Gimpel Fils, London. *Fernand Léger.* June 22–August 14.

James Goodman Gallery, Buffalo. *Fernand Léger Drawings.* October 18–November 6.

1966

Richard Gray Gallery, Chicago. *Léger: Drawings.* January.

Paul Rosenberg & Co., New York. *Léger.*

January 5–30.

Michael Hertz, Bremen. *Fernand Léger: Werke aus den Jahren 1909 bis 1955.* Mid-February–April 30.

Galerie Georges Bongers, Paris. *Fernand Léger: Gouaches, aquarelles et dessins (1938–1950).* February 17–March 19, extended to April 30.

Musée Cantini, Marseilles. *Fernand Léger.* June–August.

Musée d'Unterlinden, Colmar. *Fernand Léger.* June–September.

International Galleries, Chicago. *Fernand Léger, 1881–1955: A Retrospective Exhibition.* November–December.

1967

Fernand Léger. Circulated by The Museum of Modern Art, New York. Traveled January 13, 1967–February 11, 1968: Washington University, Saint Louis; Cornell University, Ithaca; University of Akron, Akron; Telfair Academy of Arts and Sciences, Savannah; Dartmouth College, Hanover; Vassar College, Poughkeepsie; Des Moines Art Center, Des Moines.

Musée de Tel-Aviv, Israel. *Fernand Léger.* April–May.

Staatliche Kunsthalle, Baden-Baden. *Fernand Léger: Gemälde, Gouachen, Zeichnungen.* June 19–September 10.

1968

Galerie Bonnier, Lausanne. *Léger, Miró, Picasso.* April 25–June 30.

Museum des 20. Jahrhunderts, Vienna. *Fernand Léger.* April 26–June 9.

Svensk-Franska Konstgalleriet, Stockholm. *Fernand Léger.* September 21–October 19.

Nouveau Musée du Havre, Le Havre. *Fernand Léger.* October 12–December 2.

Saidenberg Gallery, New York. *Fernand Léger: Gouaches, Watercolors & Drawings from 1910 to 1953.* November 12–December 7.

Perls Galleries, New York. *Fernand Léger.* November 12–December 21.

1969

Maison de la Culture, Nanterre. *Fernand Léger, Les Constructeurs.*

Musée Galliera, Paris. *Fernand Léger.* February–March.

Galerie Günther Franke, Munich. *Fernand Léger: Gouachen, Zeichnungen und Farbige Graphik von 1928 bis 1955.* May 6–mid-June.

Galerie Beyeler, Basel. *Fernand Léger.* August 1–September 30. Traveled: Waddington Galleries, London (ended May 9, 1970).

Academy of Arts, Honolulu. *Léger and the Machine.* September 11–October 26.

Galerie del Milione, Milan. *Fernand Léger: olii, guazzi, lavis, disegni.* December 13, 1969–January 18, 1970.

Städtische Kunsthalle, Düsseldorf. *Fernand Léger.* December 16, 1969–February 8, 1970.

1970

Centre d'Art International, Paris. *Oeuvres monumentales de Fernand Léger.*

Musée d'Art Contemporain, Montreal. *Fernand Léger—Témoin de Son Temps.* February 27–March 29.

Albert White Gallery, Toronto. *Fernand Léger: 1881–1955.* March 2–April 3.

Blue Moon Gallery, New York. *Léger.* Summer.

Centre Le Corbusier, Forum für Umweltfragen, Zurich. *Fernand Léger.* June 17–July 20.

Tate Gallery, London. *Léger and Purist Paris.* November 18, 1970–January 24, 1971.

Galerie Claude Bernard, Paris. *Fernand Léger: Dessins.* December.

1971

Galerie Claude Bernard, Paris. *Fernand Léger.* February.

Grand Palais, Paris. *Rétrospective Fernand Léger.* October 12, 1971–January 10, 1972. Sponsored by the Réunion des Musées nationaux.

Waddington Galleries, London. Exhibition of Léger and Picasso. C. November.

1972

Blue Moon Gallery, New York. *Fernand Léger: Drawings and Gouaches 1916–1953.*

Michael Couturier et Cie., Paris. Solo exhibition.

Pace Gallery, New York. *Léger: The Late Works.* February 5–March 8.

Fuji Television Gallery Co., Tokyo. *Fernand Léger.* March 10–30.

Galerie Seibu, Tokyo. *Retrospective Fernand Léger.* March 18–April 5. Traveled: Galeries Meitetsu, Nagoya (April 14–26); Centre Culturel de Fukuoka, Fukuoka (May 10–22).

Wally F Galleries, New York. *Léger: Thirty Important Gouaches.* May 16–June 10.

Albert White Gallery, Toronto. *Fernand Léger.* October 14–November 2.

1973

Bodley Gallery, New York. *Léger: Twenty Gouaches.* November 6–December 15.

1974

Galerie Bonnier, Geneva. *Fernand Léger, peintures de 1920–1947.* October.

Blue Moon Gallery and Lerner-Heller Gallery, New York. *An Intimate View of Fernand Léger.* October 8–November 9.

1975

Berggruen & Cie., Paris. *F. Léger: Huiles, aquarelles & dessins.* May.

Galerie Isy Brachot, Brussels. *F. Léger: Peintures-Gouaches.* October 16–November 29.

1976

Fernand Léger. Organized under the auspices of the International Council of The Museum of Modern Art, New York. Traveled: National Art Gallery of South Australia, Adelaide (March 5–April 3); Art Gallery of New South Wales, Sydney (May 13–June 14); National Art Gallery of Victoria, Melbourne (June 29–August 22); City Art Gallery, Auckland (September 6–October 3).

Perls Galleries, New York. *Fernand Léger, Major Oil Paintings.* March 9–April 10.

Galerie Jan Krugier, Geneva. *Fernand Léger: Gouaches et Dessins.* C. July.

1977

Galerie Schmela, Düsseldorf. Solo exhibition.

Musée Ingres, Montauban. *Fernand Léger.* June 23–September 11.

1978

Kunsthalle, Cologne. *Fernand Léger: Das figürliche Werk.* April 12–June 4.

Institute for the Arts, Rice University, Houston. *Léger: Our Contemporary.* April 14–June 11.

Herbert F. Johnson Museum of Art, Cornell University, Ithaca, N.Y. *Fernand Léger: Mural Sketches.* April 20–June 4.

J.P.L. Fine Arts, London. *Fernand Léger: Drawings and Gouaches 1910–1953.* C. May.

1979

Cultureel Centrum, Mechelen. Solo exhibition.

Galerie Berggruen, Paris. *Fernand Léger: Gouaches, Aquarelles et Dessins.* May 29–late July.

Centre culturel Maison Michelet, Château de Vascoeuil, Vascoeuil. *Fernand Léger.* June 2–September 30.

M. Knoedler & Co., New York. *Alexander Calder, Fernand Léger.* October 4–27.

Maxwell Davidson Gallery, New York. *Léger: Works on Paper.* October 23–November 24, 1979.

1980

The Minneapolis Institute of Arts. *Léger's "Le Grand Déjeuner".* April 9–June 1. Traveled: The Detroit Institute of Arts (July 10–August 24).

Staatliche Kunsthalle Berlin. *Fernand Léger 1881–1955.* October 24, 1980–January 7, 1981.

1981

Musée national d'art moderne, Centre Georges Pompidou, Paris. *Fernand Léger: La Poésie de l'Objet 1928–1934.* May 13–July 13.

Musée national Fernand Léger, Biot. *Hommage à Fernand Léger.* May 29–September 28. Traveled: Galerie Beyeler, Basel (October 1981–March 1982).

Galerie Louise Leiris, Paris. *F. Léger: 75 Gouaches et Dessins 1911–1955*. June 16–July 25.

Galerie Felix Vercel, New York. *Centennial Anniversary: Fernand Léger*. October 21–December 31.

Staatsgalerie, Stuttgart. *Fernand Léger: Ausstellung zum 100. Geburtstag*. November 22, 1981–January 31, 1982.

Iolas-Jackson Gallery, New York. *Fernand Léger 1937–1954*. December 10, 1981–January 29, 1982.

1982

Albright-Knox Art Gallery, Buffalo. *Fernand Léger*. January 15–February 28. Traveled: Musée des Beaux-Arts, Montreal (March 11–April 18); Museum of Fine Arts, Dallas (May 12–June 27).

Musée d'Art Moderne de la Ville de Paris. *Léger et l'esprit moderne*. March 17–June 6. Traveled: Museum of Fine Arts, Houston (July 9–September 5, as *Léger and the Modern Spirit [1918–1931]*); Musée Rath, Geneva (November 4, 1982–January 16, 1983).

Museo de Arte Contemporáneo, Caracas. *Fernand Léger*. October.

1983

Verlag Gerd Hatje, Stuttgart. *Fernand Léger: Gouachen, Aquarelle, Zeichnungen*. Traveled: Fundación Juan March, Madrid (April).

Kunstverein, Hamburg. *Fernand Léger: Gouachen, Aquarelle und Zeichnungen, 1910–1955*. October 29, 1983–January 1, 1984.

1984

Maxwell Davidson Gallery, New York. *Fernand Léger: Watercolors from the Collection of Sara and Gerald Murphy*. January 3–February 11.

Maison de la Culture de la Seine, Saint-Denis, Bobigny. *Exposition sur l'oeuvre de Fernand Léger: Les Constructeurs à l'aloès*. January 17–February 29.

Sidney Janis Gallery at FIAC, Grand Palais, Paris. *F. Léger*. October 19–28. Traveled: Sidney Janis Gallery, New York (December 6, 1984–January 5, 1985).

1985

Galerie Gmurzynska, Cologne. *Fernand Léger*. April–July.

Galerie Louise Leiris, Paris. *F. Léger: 55 Oeuvres 1913–1953*. April 24–June 1.

1986

Acquavella Galleries, New York. Solo exhibition.

Galerie Adrien Maeght, Paris. *Fernand Léger*. June–September.

Galerie Tokoro, Tokyo. *Fernand Léger: Peintures, gouaches, aquarelles, dessins, livres illustrés*. October 9–November 8.

1987

Acquavella Galleries, New York. *Fernand Léger*. October 23–December 12.

Whitechapel Art Gallery, London. *Fernand Léger: The Later Years*. November 27, 1987–February 21, 1988. Traveled: Staatsgalerie, Stuttgart (March 26–June 19, 1988).

1988

Centre Animation Université Populaire, Issoire. Solo exhibition.

Centre Culturel, Issoire. *Fernand Léger: Oeuvres de 1928 à 1955*. July 1–September 15. Organized by the Association d'art contemporain.

Fondation Maeght, Saint-Paul. *Fernand Léger Retrospective*. July 2–October 2.

Galerie Louis Carré & Cie., Paris. *Alexander Calder—Mobiles, Fernand Léger—Peintures*. October 13–November 26.

Galerie Beyeler, Basel. *Fernand Léger: Aquarelle, Gouachen, Zeichnungen*. October 15–December 31.

Kunsthalle der Hypo-Kulturstiftung, Munich. *Fernand Léger*. October 25, 1988–January 8, 1989.

Léger's Circus. Organized by The South Bank Centre, London. Traveled: Abbotsholme School, Rochester, England (November 12–December 3), and numerous venues throughout Great Britain through National Touring Exhibitions.

1989

Musée d'Israel, Jerusalem. *Fernand Léger:*

Oeuvres sur papier. April–June.

Edith C. Blum Art Institute, Bard College, Annandale-on-Hudson, N.Y. *The Complete Graphic Legacy of Fernand Léger*. September 3–November 19.

Palazzo Reale, Milan. *Fernand Léger*. November 11, 1989–February 18, 1990.

1990

Galerie Salis, Salzburg. *Fernand Léger: 1881–1955*. *Festspielausstellung* (festival exhibition) organized in cooperation with Artemis, London.

Galerie Gmurzynska, Cologne. *Fernand Léger: Schlüsselwerke*. April 27–June 22.

Galerie Louise Leiris, Paris. *F. Léger: Études et tableaux*. May 15–June 16.

Palazzo Reale, Milan. *Fernand Léger*. November–February. Traveled: Musée d'art moderne Villeneuve d'Ascq (March 3–June 17).

1992

Arnold Herstand & Company, New York. *Fernand Léger, Paintings and Works on Paper*.

Museet för finländsk konst Ateneum, Helsinki. *Léger och Norden*. August 20–October 11. Traveled: Moderna Museet, Stockholm (October 24, 1992–January 1, 1993); Henie-Onstad Kunstsenter, Høvikodden (January 30–March 21, 1993); Statens Museum for Kunst, Copenhagen (April 21–June 20, 1993). Organized by the Moderna Museet, Stockholm.

Museo de arte contemporáneo, Seville. *Fernand Léger: Obras del Museo Nacional Fernand Léger de Biot y Coleccion Particular*. November 25–December 27.

1994

Tel Aviv Museum of Art. *Fernand Léger, Selected Works from a Private Collection*.

Marisa del Re Gallery, New York. *Fernand Léger*. Closed April 2.

The Bunkamura Museum of Art, Tokyo. *Fernand Léger*. April 9–May 29. Traveled: Marugame Genichiro Inokuma Museum of Contemporary Art (June 25–July 30); Aichi Prefectural Museum of Art, Nagoya (August 5–September 11);

The Museum of Modern Art, Ibaraki (September 17–November 3).

Musée national Fernand Léger, Biot. *Fernand Léger: Oeuvres des collections publiques et privées, 1905–1955*. April 24–June 30. Traveled: Nara Prefectural Museum of Art; Takamitsu City Museum of Art.

Kunstmuseum Wolfsburg. *Fernand Léger 1911–1924: The Rhythm of Modern Life*. May 29–August 14. Traveled: Kunstmuseum, Basel (September 11–November 27).

Galerie Beyeler, Basel. *Léger: Werke 1925–1955*. October 22, 1994–January 28, 1995.

1995

Musée national Fernand Léger, Biot. *Fernand Léger et le Spectacle*. June 30–October 2.

1996

Galerie Berggruen & Cie., Paris. *Fernand Léger: Gouaches, Aquarelles & Dessins*. October 2–November 9.

1997

Musée national d'art moderne–Centre de création industrielle, Centre Georges Pompidou, Paris. *Fernand Léger*. May 29–September 29. Traveled: Museo Nacional Centro de Arte Reina Sofía, Madrid (October 28, 1997–January 12, 1998); The Museum of Modern Art, New York (February 15–May 12, 1998).

Lenders to the Exhibition

Stedelijk Museum, Amsterdam

Öffentliche Kunstsammlung Basel, Kunstmuseum

City of Belfort

Musée national Fernand Léger, Biot

The Art Institute of Chicago

Kunstsammlung Nordrhein-Westfalen, Düsseldorf

Scottish National Gallery of Modern Art, Edinburgh

Stedelijk Van Abbemuseum, Eindhoven

Fonds national d'art contemporain, Ministère de la Culture, Paris. Dépôt au Musée de Grenoble

The Menil Collection, Houston

Tate Gallery, London

The Metropolitan Museum of Art, New York

Solomon R. Guggenheim Museum, New York

National Gallery of Canada, Ottawa

Kröller-Müller Museum, Otterlo

Musée d'Art Moderne de la Ville de Paris

Musée national d'art moderne–Centre de création industrielle, Centre Georges Pompidou, Paris

Philadelphia Museum of Art

Graphische Sammlung, Staatsgalerie Stuttgart

Musée d'art moderne de la Communauté Urbaine de Lille, Villeneuve d'Ascq

Hirshhorn Museum and Sculpture Garden, Smithsonian Institution, Washington, D.C.

Kunstmuseum Winterthur

Kunsthaus Zürich

Klaus Hegewisch

Emily Fisher Landau

Mr. and Mrs. Donald B. Marron

Rafael Tudela Reverter

A. Rosengart

Anonymous lenders

Galerie Jan Krugier, Ditesheim & Cie., Geneva

Photograph Credits

Photographs of works of art reproduced in this volume have been provided in most cases by the owners or custodians of the works, identified in the captions. Individual works of art appearing herein may be protected by copyright in the United States of America or elsewhere, and may thus not be reproduced in any form without the permission of the copyright owners. The following and/or other photograph credits appear at the request of the artist or the artist's representatives and/or the owners of the individual works.

All works of Fernand Léger © 1998 Estate of Fernand Léger/Artists Rights Society (ARS), N.Y.

The following list applies to photographs for which a separate acknowledgment is due, and is keyed to page numbers. For clarity, illustrations may also be identified by figure (fig.) numbers.

Albright-Knox Art Gallery, Buffalo: 84, fig. 5.
The Alexander and Louisa Calder Foundation, New York: 51.
L'Architecture d'Aujourd'hui. Collection Avery Architectural and Fine Arts Library, Columbia University in the City of New York: 135; 136, figs. 9 and 10; 137, figs. 12 and 13.
Archives of American Art, Smithsonian Institution, Washington, D.C. Katharine Kuh Papers. Chicago Historical Society: 280, bottom right.
Sanford Roth Collection, Los Angeles: 282, left.
Archives *Cahiers d'Art*, Paris: 272, top.
Archives Georges Bauquier: 262, left and right; 263; 264; 266; 277, left; 278, top left; 284, left.
© 1998 The Art Institute of Chicago. All rights reserved: 94, fig. 17; 240.
The Bancroft Library, University of California, Berkeley: 141, fig. 14; 268, top right and center; 270; 275, bottom; 279, top right.
Henry Beville: 273, left.
© Diane Bouchard, Massachusetts: 279, bottom.
© Estate of Constantin Brancusi/Artists Rights Society (ARS), N.Y. Courtesy Musée national d'art moderne–Centre de création industrielle, Centre Georges Pompidou, Paris: 267, center.
© Gilberte Brassaï. All rights reserved: 94, fig. 16.
Collection Mrs. Francis Brennan: 275, top.
Carnegie Library of Pittsburgh: 16.
© Centre Georges Pompidou, Paris: 197, bottom. Photographs by Philippe Migeat: 158; 231, left. Photographs by Jean-François Tomasian: 156, 251. Photographs by Jacques Faujour: cover; 120; 183; 199; 202, left; 203; 213; 216, left; 228; 231, right; 233; 238; 241; 245.
Sheldan Collins: 254.
Dallas Museum of Art and Honoria Murphy Donnelly: 24, fig. 8.
© Dansmuseet, Stockholm: 267, left; 268, top left.

© 1998 Willem de Kooning Revocable Trust/Artists Rights Society, New York: 47, fig. 16.
Doisneau/Rapho/Liaison Agency: 285.
Honoria Murphy Donnelly: 24, fig. 7.
© Estate of Marcel Duchamp/Artists Rights Society (ARS), N.Y.: 22.
Fortune Magazine: 279, top left.
Galerie Beyeler, Basel: 145.
Galerie Jan Krugier, Ditesheim & Cie., Geneva: 256, right.
Galerie Louis Carré & Cie., Paris: 132.
Graphische Sammlung, Staatsgalerie Stuttgart: 256, left.
Hirshhorn Museum and Sculpture Garden, Smithsonian Institution, Washington, D.C. Photograph by Lee Stalsworth: 221.
Martin S. James: 281, center and bottom.
Jay Gorney Modern Art, New York: 98, 99.
Joan T. Washburn Gallery. Photograph by Geoffrey Clements: 47, fig. 15.
John Portman & Associates. Photograph by Alexandre Georges: 95, fig. 20.
Lilly Joss: 2; 280, top right; 281, left.
François Kollar, © Ministry of Culture, France: 143.
Kröller-Müller Museum, Otterlo: 157, 179. Photographs by Tom Haartsen: 196, left and right.
Kunsthaus Zürich: 204.
Kunstsammlung Nordrhein-Westfalen, Düsseldorf. Photograph © Walter Klein, Düsseldorf: 178, 229.
Kunstmuseum Winterthur: 171.
Alexander Liberman: 271, left; 283, left and right.
© Limot, Igny: 271, top right; 272, bottom.
© Galerie Maeght, Paris: 122, fig. 1.
Alfred Mainzer, Inc., Long Island City, N.Y.: 113.
Matthew Marks Gallery, New York. © Brice Marden/Artists Rights Society (ARS), N.Y.: 60.
© Herbert Matter. Courtesy Staley-Wise Gallery, New York: 276, top.
The Menil Collection, Houston.

Photograph by Hickey-Robertson, Houston: 255.
© 1998 by The Metropolitan Museum of Art, New York. All rights reserved: 169.
Milwaukee Art Museum: 17.
Musée d'art moderne de la Communauté Urbaine de Lille, Villeneuve d'Ascq: 197, top. Photograph by Philip Bernard: 198.
Musée de Grenoble: 222.
Museum Boijmans Van Beuningen, Rotterdam: 112.
© 1998 The Museum of Modern Art, New York. Photograph by David Allison: 18. Photographs by Tom Griesel: 26, figs. 9 and 10; 34; 44; 50; 55; 65; 80; 85, fig. 8; 106–8; 110; 122, fig. 2 (rephotography); 128; 129 (rephotography); 144 (rephotography); 195; 274, left. Photographs by Kate Keller: 84, fig. 6; 164; 167; 184; 185; 210; 212; 239; 242; 243. Photograph by Beaumont Newhall: 275, center. Photograph by Mali Olatunji: 20. Photographs by Rolf Petersen: 48–49. Photographs by Soichi Sunami: 230, left; 284, center.
The Museum of Modern Art Film Stills Archive, New York: 95, figs. 18 and 19; 96; 267, bottom right; 268, bottom.
National Gallery of Canada, Ottawa: 193.
NYT Permissions: 274, top right.
Oakland Tribune: 278, top right and bottom.
Öffentliche Kunstsammlung Basel. Photographs by Martin Bühler: 19; 161; 166; 214; 230, right.
© Palais de la découverte, Paris: 141, fig. 15.
© Philadelphia Museum of Art: 72; 165; 168, right; 181; 205. A. E. Gallatin Collection: 271, bottom right.
The Phillips Collection, Washington, D.C.: 32, fig. 11.
Photofest, New York: 97.
© Photothèque des Musées de la Ville de Paris. Photograph by Delepelaire: 182.
Bertrand Prévost, Paris: 186; 201; 211; 216, right; 217, top and bottom; 218; 219; 220.
RCHME, © Crown: 115.
Regen Projects, Los Angeles: 92, figs. 12–14. Photograph by Stephen White: 88. Photograph © 1995 Douglas M. Parker: 89. 88 and 89 also courtesy Lari Pittman.
Regen Projects, Los Angeles, and Jay

Gorney Modern Art, New York. Photograph © Oren Slor: 87. Also courtesy Lari Pittman.
© Réunion des Musées nationaux. Photographs by Gérard Blot: 223, 257.
Rockefeller Archive Center: 277, right.
Roger-Viollet (rephotographed by Jim Strong, New York): 77.
© 1966 and courtesy Edward Ruscha: 109, fig. 28.
San Francisco Museum of Modern Art: 284, top.
Scottish National Gallery of Modern Art, Edinburgh: 14; 244; 256, center. Antonia Reeve Photography: 194.
Sidney Janis Gallery, New York: 282, right.
Reprinted with the permission of Simon & Schuster Books For Young Readers from *Eloise* by Kay Thompson. Drawings by Hilary Knight. © 1955 by Kay Thompson. © renewed 1983 by Kay Thompson: 93.
© The Solomon R. Guggenheim Foundation, New York. Photographs by David Heald: 85, fig. 7; 159; 259. Hilla von Rebay Foundation Archives: 280, left.
Stedelijk Museum, Amsterdam: 162.
© Frank Stella/Artists Rights Society (ARS), N.Y. Photograph © Centre Georges Pompidou, Paris, by Philippe Migeat: 61.
Collection Robert Storr: 273, right.
© Tate Gallery, London, 1998: 200, 252.
© Time Inc. Reprinted by permission. Courtesy Philadelphia Museum of Art: 276, bottom.
© Michael Tropea: 170.
Urban Archives, Temple University, Philadelphia: 280, top left.
Venturi, Scott, Brown and Associates: 109, fig. 29.
Waddington Galleries, London. Photograph by Prudence Cuming Associates, Limited, London: 136, fig. 11.
Wadsworth Atheneum Archives: 274, bottom right.
© Elke Walford, Hamburg: 192.
© 1980 Warner Bros. Inc.: 96.
The Yale Collection of American Literature, Beinecke Rare Book and Manuscript Library, Yale University: 269.
Yale University Art Gallery: 32, fig. 12.
© Dorothy Zeidman: 168, left; 172; 173; 202, right.

Index of Illustrations

In this index to the plate section and to works by Léger illustrated as figures in the essay section, the abbreviation (p) indicates paintings, (d) indicates works on paper.